Echoes of Women's Voices

Echoes of Women's Voices

Music, Art, and Female Patronage
in Early Modern Florence

KELLEY HARNESS

The University of Chicago Press CHICAGO & LONDON

Kelley Harness is associate professor of music at the University of Minnesota, Twin Cities.

The University of Chicago Press, Chicago 60637
The University of Chicago Press, Ltd., London
© 2006 by The University of Chicago
All rights reserved. Published 2006
Printed in the United States of America

14 13 12 11 10 09 08 07 06 05 1 2 3 4 5

ISBN: 0-226-31659-9 (cloth)

This book has received the Weiss/Brown Publication Subvention Award from the Newberry Library. The award supports the publication of outstanding works of scholarship that cover European civilization before 1700 in the areas of music, theater, French or Italian literature, or cultural studies. It is made to commemorate the career of Howard Mayer Brown. A Dragan Plamenac Publication Endowment Fund from the American Musicological Society is also gratefully acknowledged.

Library of Congress Cataloging-in-Publication Data

Harness, Kelley Ann, 1960 –
 Echoes of women's voices : music, art, and female patronage in early modern Florence / Kelley Harness.
 p. cm.
 Includes bibliographical references (p.) and index.
 ISBN 0-226-31659-9 (cloth : alk. paper)
 1. Women art patrons—Italy—Florence—History—17th century. 2. Medici, House of—Art patronage. 3. Florence (Italy)—Kings and rulers—Art patronage. 4. Arts, Italian—Italy—Florence—History—17th century. 5. Music—Italy—Florence—17th century—History and criticism. I. Title.

NX705.5.I82 F584 2006
700'.945'5109032—dc22 2005013127

Contents

Illustrations

Plates

Following page 208

Figures

Tables

Musical examples

Abbreviations

Archives and Libraries

CS-Pnm Prague, Národní Muzeum
I-Bc Bologna, Civico Museo Bibliografico Musicale
I-Faa Florence, Archivio Arcivescovile
I-Fas Florence, Archivio di Stato
 Collections
 Croc Corporazioni religiose soppresse dal governo francese,
 Convento 107, Monastero di Santa Croce
 CRS Compagnie religiose soppresse da Pietro Leopoldo
 DG Depositeria generale, parte antica
 GM Guardaroba Medicea
 MDP Archivio Mediceo del Principato
 Misc. Med. Miscellanea Medicea
 SMN Archivio del R. Arciospedale di S. Maria Nuova
I-Fd Florence, Archivio dell'Opera del Duomo
I-Fl Florence, Biblioteca Medicea Laurenziana
I-Fn Florence, Biblioteca Nazionale Centrale
I-Fr Florence, Biblioteca Riccardiana e Moreniana
I-Fs Florence, Biblioteca del Seminario Maggiore
I-MOas Modena, Archivio di Stato
 Collection
 AF Cancelleria ducale, Ambasciatori — Firenze
I-Rasv Vatican City Archivio Segreto Vaticano
I-Rvat Rome, Biblioteca Apostolica Vaticana

Notes on Transcriptions of Documents

Throughout the book I have indicated my expansion of abbreviations by means of italics. I have not expanded the following conventional abbreviations.

S.A.S.	Sua Altezza Serenissima	Cav.re	Cavaliere
S.A.	Sua Altezza	Ser.ma	Serenissima
V.A.	Vostra Altezza	Ill.re/Ill.mo	Illustre/Illustrissimo
V.A.S.	Vostra Altezza Serenissima	R.do	Reverendo
V.S.	Vostra Signoria	Oss.mo	Osservandissimo

Notes to the Reader

Editions of Musical Examples

My editions of all musical examples are based on seventeenth-century printed or manuscript sources. Note values have been retained except in the case of example 7.5, but bar lines have been regularized, abbreviations expanded, and spelling and punctuation have been normalized silently, following the prescriptions of Giuseppina La Face Bianconi ("Filologia dei testi poetici nella musica vocale italiana," *Acta musicologica* 66 [1994]: 1–21; I would like to thank Kathleen Hansell for calling my attention to this article). I have replaced redundant ties (e.g., two tied half notes in a single measure) with single-note equivalents. Continuo figures have been rendered using modern symbols (e.g., a ♮ replaces a ♯ above a G to indicate a major third). Editorial accidentals and basso continuo figures are surrounded by square brackets. Source accidentals hold for the measure in which they appear.

In my discussion of music, I have used the Helmholz system of pitch nomenclature (middle C = c′).

Monetary Denominations

Florentine account books were maintained using four principal denominations—the scudo (represented by ♥ in this study), the lira (₤), the soldo, and the denaro (*piccolo*)—typically separated by decimal points, a practice I will follow in my transcriptions. Thus, a payment of 2.4.13.8 equals 2 scudi, 4 lire, 13 soldi, and 8 denari. Equivalences were as follows: 1 scudo = 7 lire; 1 lira = 20 soldi; 1 soldo = 12 denari. The scudo represents an accounting place marker left over from the first third of the sixteenth century, when one gold florin equaled ₤7. By 1556 the official exchange rate for a gold scudo, according to Carlo M. Cipolla (*Money in Sixteenth-Century Florence* [Berkeley, CA, 1989],

62), was 7 lire, 12 soldi, while in the 1620s, a gold scudo was valued at 7½ lire (as indicated, e.g., in I-Fas, DG 1007, no. 176).

Dates

During the period under consideration, Florence used a calendar in which the new year began on 25 March, the Feast of the Annunciation. I have left the dates in the *stile fiorentino*, following the year, when appropriate, with the modern date in square brackets.

Acknowledgments

This book would not have been possible without access to manuscripts and primary materials in the archives and libraries of Italy, and I would like to thank those institutions and their staffs for their generous help over the years, in particular Lorenzo Fabbri, archivist of the Opera di Santa Maria del Fiore, and the staffs of the Archivio di Stato in Modena, the Archivio di Stato in Florence, the Biblioteca Nazionale Centrale, the Biblioteca Riccardiana e Moreniana, and the Biblioteca Seminario Arcivescovile Maggiore in Florence. Special thanks to Rosa di Luca, who in 1995 was vice-direttrice of the Collegio Statale delle SS. Annunziata, the school that now occupies the Villa Poggio Imperiale. Sig.ra di Luca generously allowed me access to the villa and its surviving artwork, including the frescoes that adorn the walls of present-day classrooms. I still look back fondly on an hour spent taking notes and photographs amid a sea of desks and book bags while the students were at lunch.

The ability to carry out this archival research was aided by support from the Fulbright program, the University of Minnesota Faculty Summer Research Fellowship program, and the McKnight Summer Research Grant program. For funding the course releases that allowed me time to write the book, I would like to thank the University of Minnesota School of Music and the Faculty Humanities Fellowship program, sponsored by the University of Minnesota Humanities Institute. A generous subvention from the Dragan Plamenac Publication Endowment Fund of the American Musicological Society and the Weiss/Brown Publication Subvention Award of the Newberry Library helped subsidize many of the production costs associated with the book, assistance I gratefully acknowledge here.

Many individuals have contributed to my understanding of this subject as well as to specific chapters of the book. Most important, I would like

to thank John Walter Hill, my adviser for the dissertation on which some chapters of the book are based and friend and mentor in the years since graduation. Suzanne Cusick, Donna Cardamone Jackson, and Elissa Weaver provided insightful suggestions that have made this a better book than it otherwise would have been. Leofranc Holford-Strevens, Lucia Marchi, and Ron Martinez kindly helped with some difficult Italian and Latin transcriptions and translations, while the following individuals generously shared their expertise on a wide variety of subjects: Robert Judd, Robert Kendrick, Jeffrey Kurtzman, Craig Monson, Arnaldo Morelli, and Riccardo Spinelli. At the University of Chicago Press, Kathleen Hansell and Yvonne Zipter offered valuable suggestions and helped keep the book more or less on schedule. Sincere thanks to you all.

Finally, I would like to acknowledge the tremendous support of my partner, Lynn Hyldon, and to express my thanks both for her encouragement as the book neared completion and for her insistence that I stop and play every now and then. I dedicate the book to her.

Introduction

On 3 October 1626, Dimurgo Lambardi, secretary to the regents of Flor-
ence—grand duchesses Christine of Lorraine and Archduchess Maria Mag-
dalena of Austria—drafted the following letter to the Florentine secretary
of state, Andrea Cioli, then resident in Rome:

> Their Highnesses heard with particular pleasure the praises that the Pope gave to
> Sig. Salvadori for his *Judith*, and he truly merited the honor that it pleased His Ho-
> liness to bestow on him. [~~Their Highnesses also say~~] I desire very much [~~Sig. Sal-~~
> ~~vadori~~] that, if Your Illustrious Lordship should have occasion to be with the
> Pope and should find him unoccupied with serious business, you [~~would not re-~~
> ~~frain from~~] would take some favorable moment to disabuse His Holiness of the
> idea that the work was deliberately thought out, prepared, and performed in or-
> der to apply to the Barberini, because actually it was unexpected and improvised,
> and put together, one can say, in just a few hours. (Doc. 4.2)

Sent just a week after the court had welcomed papal nephew and nuncio Car-
dinal Francesco Barberini to Florence with a performance of an opera en-
titled *La Giuditta*, Lambardi's letter is an extraordinary example of what a
modern-day political commentator might term "damage control." By stress-
ing the work's lack of preparation Lambardi's patrons attempted to distance
themselves from any perception that the opera—whose subject matter nar-
rates the decapitation of a powerful political and military figure by a pious
widow with traditional associations to Florentine civic liberty—was delib-
erately intended as a commentary on the current political quarrels between
Pope Urban VIII and Florence. But of course the very existence of a letter as-
serting that the work did not refer to the Barberini family confirms that it
could be and was interpreted that way by some.

Besides its specific relevance for *La Giuditta*, Lambardi's letter highlights two issues important for any study of seventeenth-century patronage: the degree to which artworks, including musical spectacles, were believed capable of delivering specific, often politically charged messages, and the means by which both seventeenth-century audiences and modern day scholars might determine whose messages such works communicated. Lambardi's request that Cioli smooth over a potentially damaging situation by convincing the pope that *La Giuditta* should not be construed as a reflection of recent antagonisms—and note that Lambardi never actually says that the work does not refer to the Barberini family but simply that Cioli must convince the pope that it does not—demonstrates not only the belief in such messages but an awareness that musical spectacles were subject to a multiplicity of interpretations.[1] A similar situation appears to have arisen the following year, when the court abandoned its plans to stage the opera *Iole ed Ercole* as part of the wedding celebrations for Princess Margherita de' Medici and Prince Odoardo Farnese of Parma after Francesca Caccini convinced the princess and her mother (again, Archduchess Maria Magdalena) that its plot might be understood by some to mean that the princess wished to control her husband.[2] In both cases, the archduchess appears to have negotiated a path between her desire to contain the messages of individual works and her concern to allow the interpretive ambiguity that might deflect potentially dangerous readings.

Lambardi's initial draft also speaks directly to the issue of authorship, providing evidence of his patrons' involvement that would have been obscured in the letter's final version. He wrote on behalf of the grand duchesses, who originally wished to convey two messages: (1) their pleasure at the praise Urban VIII had bestowed on one of their employees and (2) their concern that

1. This intentional ambiguity contrasts with a slightly later incident in France, the *comédie héroïque* entitled *Europe*, whose performance Cardinal Richelieu sponsored in 1642. The work's strikingly explicit preface states that the comedy intended to depict "the Spanish ambitions to become masters of all Europe and the protection that the [French] king and his allies give to [protect] it from servitude" ("l'ambition des Espagnols pour se rendre maîtres de l'Europe et la protection que lui donne le Roi avec ses alliés pour la garantir de servitude"). French text given in J. Lough, "Drama and Society," in *The New Cambridge Modern History*, vol. 4, *The Decline of Spain and the Thirty Years War, 1609–48/59*, ed. J. P. Cooper (Cambridge, 1970), 252.

2. The source of this anecdote is the account of Andrea Cavalcanti (I-Fr, Ms. 2270, fols. 288r–289v), transcribed in both Tim Carter, *Jacopo Peri (1561–1633): His Life and Works*, 2 vols. (New York, 1989), 1:344–35; and Warren Kirkendale, *The Court Musicians in Florence during the Principate of the Medici with a Reconstruction of the Artistic Establishment* (Florence, 1993), 325–26. Based on documentary evidence surrounding the Medici-Farnese wedding, I propose in chap. 6 that the incident occurred in 1627.

the pope might have misunderstood their intentions through a misreading of the opera's plot. Possibly at the request of one or both of the grand duchesses, in the second sentence Lambardi crossed out "Their Highnesses" and took responsibility for the second item, distancing his patrons from actual participation in the work's planning and execution and making himself the author of the false claim that *La Giuditta* was put together without forethought, in just a few hours. As the secretary well knew, Archduchess Maria Magdalena participated actively in all stages of production of court spectacles, from suggesting subject matter to auditioning singers and attending rehearsals. Not only did she commission these works but she also contributed directly to their content and eventual performance.

But she did not do it alone. Rulers were active, although not sole authors of their self-fashioning. In sixteenth- and seventeenth-century Florence, as elsewhere in contemporary Europe, both male and female patrons relied on the counsel of family members, trusted associates and advisers, and artists themselves during both the commission and execution stages of a project. And despite Lambardi's claim that *La Giuditta* was "practically improvised"— asserted, no doubt, to dispel the notion that the grand duchesses had spent any time whatsoever working out the opera's inflammatory message—court spectacles required careful planning and a concerted effort by a wide spectrum of craftspeople. If, as I propose, patronage might be viewed as a means of communication, then it is important to remember that a variety of individuals, some of them in competition, took part in the conversation. Poets, composers, singers, instrumentalists, painters, and architects, as well as seamstresses, carpenters, and masons, all participated in the overall product. Many of these individuals had to make choices as they crafted their contributions to the whole, thus granting each a degree of autonomy, and to deny their influence runs the danger of oversimplifying what were undoubtedly the very complicated realities of early modern patronage.[3] Yet with the material evidence gone for so many of these contributions, we can often only speculate as to the artistic freedom individual participants exercised. The surviving documentary record clearly favors the experiences of the patron. It is this

3. A clear picture of the hierarchical distribution of effort that went into a court performance emerges from the series of instructions issued during the preparations for *La fiera* by Michelangelo Buonarroti the Younger (I-Fas, MDP 1848, fols. 221r–222r) during the early months of 1619. Letters to the grand ducal treasury, Guardaroba, majordomo, and members of the court's musical establishment (Giovanni del Turco) and the city's acting companies (represented by Jacopo Cicognini, Michele Bandini, and Cosimo Lotti) instructed the recipients to procure and coordinate the individuals and items necessary for the production.

body of evidence that forms the basis of this book, alongside the poetic texts, descriptions, and, in some cases, music, the study of which—in combination—may shed light on the messages of specific performances.

Among the contributors to court spectacle, poets needed to be especially cognizant of the needs of their patrons, for they produced what was often the only lasting record of a work. While music and visual arts certainly shaped a performance's overall meaning, the contributions of these arts were also more ephemeral than those of the words, which were often concretized through print and circulated to individuals not physically present at the performance. Poets who devised plots with potentially damaging allegorical messages might have their works removed from consideration, as court poet Andrea Salvadori apparently experienced with *Iole ed Ercole*.

At the same time, an unemployed author who hoped for a position at court might offer works to the grand duke or to one of his familiars in order to demonstrate an understanding of the potential patron's tastes and needs.[4] The case of Florentine poet Jacopo Cicognini provides an illuminating example. Beginning around 1613 and continuing throughout his life Cicognini sought an official post at court.[5] Although unsuccessful in this pursuit, he did emerge as one of the city's leading authors, becoming the most prolific supplier of plays for the city's confraternities, especially his own Compagnia di Sant'Antonio di Padova, also known as San Giorgio. Members of the grand ducal family made a habit of attending confraternity plays during carnival season, and the importance of these audience members was not lost on the members of the companies. The chronicler of San Giorgio's performance of Cicognini's play on the subject of Saint Agatha alludes to the care with which the confraternity cultivated its relationship with the court, observing that *Sant'Agata*'s carnival performances of 1622 fulfilled a voluntary obligation to "satisfy the courteous audience, not only the entire Florentine nobility, but those who matter more, all the princes."[6] The Compagnia di San Giorgio and, undoubtedly, other theatrical companies may have viewed the annual performance of a comedy as an obligation owed to the grand ducal family, in return for which the company garnered prestige by counting the Medici fam-

4. This appears to have been Galileo's strategy when he offered his discovery of the "Medicean Stars" to Grand Duke Cosimo II in his *Sidereus nuncius* (1610); see Mario Biagioli, *Galileo, Courtier: The Practice of Science in the Culture of Absolutism* (Chicago and London, 1993), 88–89, esp. 24.

5. Anna Maria Crinò, "Documenti inediti sulla vita e l'opera di Jacopo e di Giacinto Andrea Cicognini," *Studi seicenteschi* 2 (1961): 259.

6. "Di soddisfare alla benigna audienza non solo di tutta la nobiltà fiorentina, ma quello che più importa tutti i Principi" (I-Fas, CRS 134, no. 2, fol. 23v, dated 30 December 1621).

ily among its prominent and visible supporters—an instance in which *cliente-lismo* (clientage, or social patronage) joins with the *mecenatismo* (arts patronage) that will be the more regular subject of my book.[7] The Medici apparently encouraged competition among the city's theatrical companies: in June of 1622 they invited the San Giorgio troupe to court in order to perform the Saint Agatha play for a visiting Spanish ambassador, and in 1625 the company's chronicler boasted that, although three different companies had mounted carnival plays that year, their production of Cicognini's *Il voto d'Oronte* was singled out for a command performance at the palace, this time as part of the festivities honoring Prince Władisław of Poland.[8] Companies with such aspirations would have kept the Medici family in mind from the very beginning of a play's preparations. Cicognini's own on-going hopes for a court post may well have been responsible for his authorship of at least two plays intended for performance at the Monastero di Santa Croce, commonly known as La Crocetta, in which several Medici princesses resided.

The triangulated relationship between Cicognini, the Crocetta, and the Medici court once again problematizes the issue of authorship, a concern especially relevant to studies of women's patronage. Which women were Cicognini's intended patrons in this case, the princesses at the convent or the regents from whom he hoped for more permanent employment? To what degree did his own understanding of themes and approaches appropriate for cloistered women inform the details of his plays, and how did his view of convent life and the purpose of convent theater differ from that of the nuns who actually performed the works?[9] The messages exchanged in both art and

7. On the differences between *mecenatismo* and *clientelismo* and the need for scholars to consider both, see F. W. Kent and Patricia Simons, "Renaissance Patronage: An Introductory Essay," in *Patronage, Art, and Society in Renaissance Italy*, ed. F. W. Kent and Patricia Simons (Canberra, 1987), 1–21; and Tracy E. Cooper, "*Mecenatismo* or *Clientelismo?* The Character of Renaissance Patronage," in *The Search for a Patron in the Middle Ages and the Renaissance*, ed. David G. Wilkins and Rebecca L. Wilkins (Lewiston, NY, 1996), 19–32. See also Werner L. Gundersheimer, "Patronage in the Renaissance: An Exploratory Approach," in *Patronage in the Renaissance*, ed. Guy Fitch Lytle and Stephen Orgel (Princeton, NJ, 1981), 3–23; and Ronald Weissman, "Taking Patronage Seriously: Mediterranean Values and Renaissance Society," in *Patronage, Art, and Society*, ed. Kent and Simons, 25–45.

8. I-Fas, CRS 134, no. 2, fol. 37r, repeated on fol. 64r (4 February 1624 [1625]): "Mentre che in quel istesso tempo in Firenze dalla compognia [*sic*] di S. Bernardino si recitava una lor commedia et anchora in casa Sig. Bardi un altra si conpiaque le serenissime altezze chiamarci a palazzo e si recito in nella loro scena."

9. On convent theater and, in particular, nuns as authors of plays, see Elissa B. Weaver, *Convent Theatre in Early Modern Italy: Spiritual Fun and Learning for Women* (Cambridge, 2002). See also Weaver, "Spiritual Fun: A Study of Sixteenth-Century Tuscan Convent Theater," in *Women*

theater were not unidirectional, and distinguishing, as far as is possible, the influences of female patrons from that of their male relatives or advisers has been a constant feature of much recent scholarship on female patrons.

Although musicologists have known about the importance of women patrons to Renaissance music history since William Prizer's important work on Isabella d'Este and Lucrezia Borgia, the most concentrated work on women's activities as patrons during the sixteenth and seventeenth centuries has come from the discipline of art history, where scholars have studied the patronage of individual women and female institutions.[10] These and other scholars have also addressed issues intrinsic to the study of female patronage. Among the questions they have asked, the following are particularly relevant for a study of early modern Florence: How is it possible to detect female patronage in light of legal systems and traditions of documentation in which women's decisions often went unrecognized? Do patterns emerge from studies of female patrons? In what ways do the choices made by female patrons differ from their male counterparts? How much real "choice" did women have, and what roles did class and geography play in that choice?

in the Middle Ages and the Renaissance: Literary and Historical Perspectives, ed. Mary Beth Rose (Syracuse, NY, 1986), 173–205, "Le muse in convento: La scrittura profana delle monache italiane (1450–1650)," in *Donne e fede: Santità e vita religiosa in Italia,* ed. Lucetta Scaraffia and Gabriella Zarri (Rome, 1994), 253–76, and "The Convent Wall in Tuscan Convent Drama," in *The Crannied Wall: Women, Religion, and the Arts in Early Modern Europe,* ed. Craig A. Monson (Ann Arbor, MI, 1992), 73–88.

10. William Prizer, "Isabella d'Este and Lucrezia Borgia as Patrons of Music: The Frottola at Mantua and Ferrara," *Journal of the American Musicological Society* 38 (1985): 1–33, and "Renaissance Women as Patrons of Music: The North-Italian Courts," in *Rediscovering the Muses: Women's Musical Traditions,* ed. Kimberly Marshall (Boston, 1993), 186–205.

Several collections of articles have appeared on the subject of female art patronage in the past decade: entire issues of *Renaissance Studies* (vol. 10 [1996], ed. Jaynie Anderson), and *Quaderni storici* (vol. 35 [2000], ed. Sara F. Matthews-Grieco and Gabriella Zarri), as well as Cynthia Lawrence, ed., *Women and Art in Early Modern Europe: Patrons, Collectors, and Connoisseurs* (University Park, PA, 1997); and Sheryl E. Reiss and David G. Wilkins, eds., *Beyond Isabella: Secular Women Patrons of Art in Renaissance Italy* (Kirksville, MO, 2001). For other secular women patrons, see also Catherine King, "Medieval and Renaissance Matrons, Italian-Style," *Zeitschrift für Kunstgeschichte* 55 (1992): 372–93; Catherine King, "Women as Patrons: Nuns, Widows, and Rulers," in *Siena, Florence and Padua: Art, Society, and Religion, 1280–1400,* ed. Diana Norman, 2 vols. (New Haven, CT, 1995), 2:243–66; Carolyn Valone, "Roman Matrons as Patrons: Various Views of the Cloister Wall," in *The Crannied Wall,* ed. Monson, 49–72; and Carolyn Valone, "Piety and Patronage: Women and the Early Jesuits," in *Creative Women in Medieval and Early Modern Italy: A Religious and Artistic Renaissance,* ed. E. Ann Matter and John Coakley (Philadelphia, 1994), 157–84.

To address the first question, art historians have turned to documentary evidence other than legal contracts, employed inductive methodologies, and questioned the very nature by which the "patron" is determined. Roger Crum has introduced the very useful concepts of the potential patron or potential user, by which is recognized the important influence exerted by the woman for whom an artwork was intended, even if she herself did not commission or pay for it.[11] Here subject matter plays an important role: the frequency with which female images appear in works securely commissioned by women might in turn suggest that the conspicuous presence of female imagery in other works points similarly to the involvement of a female patron.

Of course, such imagery undoubtedly stemmed in part from the pervasive view that the most appropriate images for women were paintings of women. Women were also the most frequent recipients of treatises (both prescriptive and apologetic) about their sex.[12] The problem of determining the degree to which women exercised control over the works they commissioned is thus at least as vexing for female patrons as it is for their male counterparts.[13] On the one hand, the contract Queen Maria de' Medici drew up with Peter Paul Rubens in 1622, commissioning a cycle of paintings depicting her life, stipulated explicitly that the painter was to conform to a (now lost) written program "in accord with the Queen's intention" and that, furthermore, Maria reserved the right to order changes in both number and representation of the figures in the finished works.[14] Yet for the series of famous women whose

11. Roger J. Crum, "Controlling Women or Women Controlled? Suggestions for Gender Roles and Visual Culture in the Italian Renaissance Palace," in *Beyond Isabella*, ed. Reiss and Wilkins, 37–50.

12. Jaynie Anderson, "Rewriting the History of Art Patronage," *Renaissance Studies* 10 (1996): 130–31.

13. Creighton E. Gilbert advocates a more balanced approach to patronage studies, one that recognizes a wider continuum of influence on the part of the Renaissance patron, including the possibility of, in some cases, no influence at all on subject matter ("What Did the Renaissance Patron Buy?" *Renaissance Quarterly* 51 [1998]: 392–450). See also Alison Wright and Eckart Marchand, "The Patron in the Picture," in *With and Without the Medici: Studies in Tuscan Art and Patronage, 1434–1530*, ed. Eckart Marchand and Alison Wright (Aldershot, 1998), 1–18.

14. Ronald Forsyth Millen and Robert Erich Wolf, *Heroic Deeds and Mystic Figures: A New Reading of Rubens' Life of Maria de' Medici* (Princeton, NJ, 1989), 8. On this cycle as well as the French queen's other commissions, see Deborah Marrow, *The Art Patronage of Maria de' Medici* (Ann Arbor, MI, 1982); Géraldine A. Johnson, "Imagining Images of Powerful Women: Maria de' Medici's Patronage of Art and Architecture," in *Women and Art in Early Modern Europe*, ed. Lawrence, 126–53; Mary D. Garrard, *Artemisia Gentileschi: The Image of the Female Hero in Italian Baroque Art* (Princeton, NJ, 1989), esp. 154–65; and Elaine Rhea Rubin, "The Heroic

states would encircle her palace's dome, the queen left the choice of specific images to her advisers. And how much direct control were other, nonroyal patrons, such as women cloistered in convents, able to exert? Julian Gardner has challenged historians to question notions of patron-artist relationships when dealing with nuns. Since male intermediaries often handled the details of commission and execution for cloistered nun patrons, Gardner questions how many of a painting's iconographical details should be attributed to the intermediary, rather than the patron.[15] On the other hand, while nuns may not always have determined the precise nature of artworks that ended up in their convent, Kate Lowe reminds us that, in Florence at least, nuns in the convents most known for their artistic patronage were also from wealthy families, typically of a higher class than their male go-betweens.[16] Her balanced article points to the various expectations of suitability and convention, access and class that must be considered when studying nuns' patronage.

Class and marital status were important determinants in the nature of a woman's patronage. Widows tended to be the most prolific patrons, possibly due to tradition but also stemming from their increased access to money. Convents who drew their inhabitants from wealthy families tended to be more active patrons than those whose relatives were of more modest means. And women who exercised real political authority, such as the Florentine regents, had both the most pressing need to convey images of themselves and the means to pay for it. Like their male counterparts, women commissioned or otherwise sponsored works that both reflected and helped construct their status within contemporary hierarchical social structures.

In a series of articles published over the past decade and a half, Claudio Annibaldi has proposed a theory of musical patronage concerned precisely with music's ability to symbolize the social status of a patron, either "by dis-

Image: Women and Power in Early-Seventeenth-Century France, 1610–1661" (Ph.D. diss., George Washington University, 1977).

15. Julian Gardner, "Nuns and Altarpieces: Agendas for Research," *Römisches Jahrbuch der Bibliotheca Hertziana* 30 (1995): 45, 55.

16. Kate Lowe, "Nuns and Choice: Artistic Decision-Making in Medicean Florence," in *With and Without the Medici*, ed. Marchand and Wright, 130. Gary Radke offers documentary evidence to demonstrate that the nuns of San Zaccaria in Venice controlled the execution of their artistic commissions, while Christina McOmber provides similar evidence for the Roman convent of SS. Domenico e Sisto. Radke, "Nuns and Their Art: The Case of San Zaccaria in Renaissance Venice," *Renaissance Quarterly* 54 (2001): 430–59; McOmber, "Recovering Female Agency: Roman Patronage and the Dominican Convent of SS. Domenico e Sisto" (Ph.D. diss., University of Iowa, 1997).

playing compositional qualities that parallel the sophisticated tastes of the class in question," what Annibaldi terms "humanistic patronage," or "through reference to repertories traditionally associated with the élite class," which he calls "conventional patronage."[17] Both terms are certainly apt descriptions for the patronage activities of the Medici grand dukes who, since the first half of the sixteenth century, commissioned performances of large-scale musico-theatrical events in part to assert their status among the European aristocracy. Chapter 1 will address some of the ways in which stage design, art, and music in these court spectacles reflected social hierarchies and also combined to convey specific, politically charged meanings in the decades before the advent of a female regency.

The regents Maria Magdalena and Christine of Lorraine maintained this tradition: state visits by representatives from the European superpowers of Spain, Austria, and France, as well as the papacy, were always occasions for large-scale musical spectacles—important assertions of continuity and confirmation that the grand ducal family's magnificence had not waned during an interregnum. These visits also provided opportunities for the regents not only to show off the talents of individuals in their employ but also to reinforce the social status of both patron and audience members through their sponsorship of performances featuring genres and styles appropriate to their class.

But is it also possible for these objects of patronage to distinguish the gender of their patrons? I intend to argue that it is and that, furthermore, aristocratic women in Florence exercised control over the depictions of their gender in the works they commissioned. Surviving documents make it clear that Archduchess Maria Magdalena was the public face of the regency. They also confirm her active role as a patron, one who not only commissioned works but—in the case of theatrical works—participated in their execution. The archduchess oversaw the preparations for festivities in a variety of dramatic genres, from fully sung operas on both sacred and secular themes to

17. These articles include Claudio Annibaldi's introduction to *La musica e il mondo: Mecenatismo e committenza musicale in Italia tra Quattro e Settecento*, ed. Claudio Annibaldi (Bologna, 1993), 9–43; Annibaldi, "Per una teoria della committenza musicale all'epoca di Monteverdi," in *Claudio Monteverdi: Studi e prospettive*, ed. Paola Besutti, Teresa M. Gialdroni, and Rodolfo Baroncini (Florence, 1998), 459–75; Annibaldi, "Towards a Theory of Musical Patronage in the Renaissance and Baroque: The Perspective from Anthropology and Semiotics," *Recercare* 10 (1998): 173–82; and Annibaldi, "Uno 'spettacolo veramente da principi': Committenza e ricezione dell'opera aulica nel primo Seicento," in *"Lo stupor dell'invenzione": Firenze e la nascita dell'opera*, ed. Piero Gargiulo (Florence, 2001), 31–60. The quotations are from "Towards a Theory of Musical Patronage," 176.

spoken comedies with musical *intermedi* and equestrian entertainments. De-
spite their variety of genres and heterogeneity of subject matter, these works
are remarkable for the degree to which they are dominated by female pro-
tagonists, many of which recur in works of literature and art commissioned
by or dedicated to the archduchess, the focus of chapter 2. The subjects of
the theatrical works fall into four main, but interrelated categories: virgin
martyr legends (chap. 3), the Bible (chap. 4), epic-chivalric poems (chap. 5),
and mythology (chap. 6).

The sudden shift to sacred subjects not only reiterated themes long held
to be appropriate for women, but could be promoted as an innovation analo-
gous to the invention of opera itself—confirmation of the originality con-
sidered essential to princely patronage.[18] The grand duchesses also forged
strong bonds with the city's religious establishments, especially its female
monasteries. Recent scholarship has demonstrated the importance of both
convents and individual nuns as patrons.[19] For cloistered nuns in monaster-
ies, such commissions often provided the only outlet by which they could
communicate with the outside world.[20] Chapters 7 and 8 will focus on one
such community, the residents (most, but not all of them nuns) of the Mo-
nastero di Santa Croce (La Crocetta), whose importance as an institutional
patron of art and music seems to have emerged quite suddenly during the last
two decades of the sixteenth century. For a convent such as the Crocetta, the
purchase of new altarpieces and the sponsorship of music for voices and in-
struments on the convent's principal feasts allowed the nuns to demonstrate
affluence both visually and aurally in precisely the years in which its founder
emerged as a possible candidate for canonization. A close examination of the
surviving altarpieces and the motets likely performed in the convent church
suggests that while these material objects were undoubtedly the result of both

18. Annibaldi, "Towards a Theory of Musical Patronage," 176.

19. Besides the authors cited in nn. 15 and 16 above, see Ann M. Roberts, "Chiara Gam-
bacorta of Pisa as Patroness of the Arts," in *Creative Women in Medieval and Early Modern Italy*, ed.
Matter and Coakley, 120–54; Mary-Ann Winkelmes, "Taking Part: Benedictine Nuns as
Patrons of Art and Architecture," in *Picturing Women in Renaissance and Baroque Italy*, ed. Geral-
dine A. Johnson and Sara F. Matthews Grieco (Cambridge, 1997), 91–110; and Kate Lowe,
"Elections of Abbesses and Notions of Identity in Fifteenth- and Sixteenth-Century Italy,
with Special Reference to Venice," *Renaissance Quarterly* 54 (2001): 389–429.

20. In those convents with a tradition of musical performance and composition, of
course, the nuns' own voices communicated their messages; see Craig A. Monson, *Disembod-
ied Voices: Music and Culture in an Early Modern Convent* (Berkeley, CA, 1995); Robert L. Kendrick,
Celestial Sirens: Nuns and Their Music in Early Modern Milan (Oxford, 1996); and Colleen Reardon,
Holy Concord within Sacred Walls: Nuns and Music in Siena, 1575–1700 (Oxford, 2002).

the nuns' expressed wishes and individual artists' understanding of the purpose for which the works were intended, they did serve to emphasize symbols endowed with particular significance by the nuns.

The situations of the female regents in the 1620s and the nuns of the Crocetta in the 1580s and 1590s are similar, not just that in both situations women were recognized as patrons, but also that these women communicated to an outside, largely male audience through the works they commissioned. Their messages could be apprehended on a variety of levels. For the citizens of Florence in the late sixteenth century, especially those in the neighboring San Giovanni and Santa Croce districts of the city, the Crocetta's sudden decision to celebrate its principal feasts with concerted music could not have passed unnoticed and would have rendered the convent church much more similar to several of the city's larger, male religious establishments. In the case of works sponsored by the court, art, texts, and music combined to create an artistic context dominated by themes of women who were effective spiritual and political leaders.

Yet these works were commissioned and executed at a time in which real women's access to speech—the most direct and potentially public form of communication—was highly contested. The sixteenth and seventeenth centuries witnessed an intensification of the debate over women's public roles. In this period, silence was second only to chastity—to which it was closely linked—among the virtues women were expected to possess. Most male authors of contemporary treatises for or about women dealt with what was seen as the problematic issue of the female voice. Some, such as Torquato Tasso, subscribed to an Aristotelian view that attributed specific virtues to women and men—a scheme in which silence was always the province of the female sex.[21] Others invoked biblical commonplaces, repeating the words or attitudes of Paul (e.g., 1 Tim. 2.11–12: "Let a woman learn in silence with all submissiveness. I permit no woman to teach or to have authority over men; she is to keep silent"). In Florence the attempted silencing of women's voices was matched by an analogous effort to contain their bodies: in 1610 a French visitor to Italy, Balthazar Grangier de Liverdis, observed that "in Florence women are more enclosed than in any other part of Italy; they see the world only from

21. Torquato Tasso, *Della virtù femminile e donnesca*, in *Prose filosofiche*, 2 vols. (Florence, 1847), 2:367. For summaries of views on female silence expressed by other sixteenth- and seventeenth-century authors, see Ruth Kelso, *Doctrine for the Lady of the Renaissance* (Urbana, IL, 1956); Ian Maclean, *The Renaissance Notion of Woman: A Study in the Fortunes of Scholasticism and Medical Science in European Intellectual Life* (Cambridge, 1980); and Constance Jordan, *Renaissance Feminism: Literary Texts and Political Models* (Ithaca, NY, 1990).

the small openings in their windows." [22] Yet the early modern era saw—and heard—numerous examples of women who would not be silent, including poets and other writers, composers, and singers, many of whom used their voices to comment on or better their own situations or the lives of others— women such as Moderata Fonte, Lucrezia Marinelli, Arcangela Tarabotti, Maddalena Casulana, Laura Peverara, Anna Guarini, Livia d'Arco, and Tarquinia Molza. Patronage provided women yet another avenue for communication. The act of supporting a social institution or commissioning works of art, music, and theater made important, often very visible statements about a woman's devotion, her family, her social status, and her own individual tastes. But as Lambardi's letter demonstrates, works themselves also had communicative potential. Uncovering some of these messages in late sixteenth- and early seventeenth-century Florence is the subject of this book.

In 1977 John Hale assessed the first years of the reign of Grand Duke Ferdinando II as a mere "echo of women's voices." [23] The dismissive phrase referred to the continued political influence of Christine of Lorraine and Maria Magdalena after Ferdinando's assumption of personal rule. In the chapters that follow, my aim is not to dispute Hale's assertion but to expand it: during the early modern period in Florence, the city resounded with the echoes of women's voices, and at least some of their messages were communicated by means of artistic patronage.

22. Cited in Judith C. Brown, "A Woman's Place Was in the Home: Women's Work in Renaissance Tuscany," in *Rewriting the Renaissance: The Discourses of Sexual Difference in Early Modern Europe*, ed. Margaret W. Ferguson, Maureen Quilligan, and Nancy J. Vickers (Chicago, 1986), 215.

23. J. R. Hale, *Florence and the Medici: The Pattern of Control* (London, 1977), 178. I would like to thank Colleen Reardon for reminding me of this quotation and for her suggestion that it might make a good title for my book.

Modes of Artistic Communication and Perception in Early Modern Florence

To audience members attending court-sponsored performances in the sixteenth and seventeenth centuries, events both on and off the stage communicated contemporary notions of decorum, social distinction, and political authority. Through the expenditure of vast financial and labor resources on a single event a ruler proclaimed his magnificence. Performances reinforced the concept of absolutism through single-point perspective, in which the sight lines converged at a single focal point—the eye of the ruler.[1] Niccolò Sabbatini stresses this point in his 1638 treatise on stagecraft:

> It appears reasonable to me, having by now finished treating how the stage should be made, to say something of how, and in what location, should be accommodated the place for the prince or other personage who will be attending. Therefore, on this account, one will have to choose the place as near as possible to the focus point, and it should be high enough above the plane of the room so that, being seated, the sight line is in the same plane as the vanishing point, so that everything painted on the scenery will appear better [from there] than from any other place.[2]

1. Roy Strong, *Art and Power: Renaissance Festivals, 1450–1650* (Woodbridge, Suffolk, 1984), 32–35; and Kristiaan P. Aercke, *Gods of Play: Baroque Festive Performances as Rhetorical Discourse* (Albany, NY, 1994), 33–34. See also James Saslow, *The Medici Wedding of 1589: Florentine Festival as Theatrum Mundi* (New Haven, CT, 1996), 82, 98.

2. "Mi pare ragionevole, essendosi di già finito di trattare come si debba fare la scena, di dire anco come, et in qual sito, si debba accomodare il luogo per il Prencipe od altro personaggio che vi doverà intervenire. Si averà per tanto in considerazione di far elezione di luogo più vicino che sia possibile al punto della distanza, e che sia tanto alto dal piano della sala che, stando a sedere, la vista sia nel medesimo piano del punto del concorso, che così tutte le

Because perspective demands a certain distortion of the sizes of objects por-trayed, the prince in a sense actually controls the theatrical space, forcing the spectators, for a few hours, at least, to share his particular view of the de-picted universe.[3] He becomes at once the spectacle's sponsor and also its principal audience.[4]

Audience members witnessed and participated in this self-reflexive per-formance. The Medici family sat on a raised platform on the floor, its prin-cipal seat—the *primo luogo*—reserved for the ruling grand duke, around which were arranged members of the court and visiting dignitaries, in order of im-portance. Such seating arrangements both displayed and helped to construct political hierarchies, and the court diarist always recorded carefully the pre-cise location of each family member in attendance. The importance with which not only the court but other spectators as well invested this visual confirma-tion of status can be seen in the minor flurry of correspondence generated in 1624 when Cesare Molza, the resident ambassador from Modena, believed himself to have been snubbed based on his seat assignment for the recent per-formance of the opera *Sant'Orsola*.[5] In one of several letters to the duke and prince of Modena, Molza substantiated his complaint by appending a seat-ing chart and legend for the performance (fig. 1.1). His diagram depicts not only the disputed area—the galleries under the three windows at the right edge of the drawing—but also the tiered seating for ladies and gentlemen, who were segregated by gender. Invited commoners sat behind the grand ducal platform, on which the young princes and princesses sat in a row near-est the stage, while their elders were placed behind them. The then fourteen-year-old Grand Duke Ferdinando II (1610–70) and the visiting Archduke Karl of Austria sat just left and right of center in Molza's drawing, flanking Archduchess Maria Magdalena, who sat in the single perfect seat.

Maria Magdalena's occupation of the *primo luogo* was not merely symbolic: jointly with her mother-in-law Christine of Lorraine, she in fact ruled Tus-

cose segnate nella scena appariranno meglio che in alcuno altro luogo" (Nicola Sabbattini, *Pratica di fabricar scene, e machine ne' teatri* [Ravenna, 1638; reprint, Rome, 1955], 48).

3. On distortions of perspective in two-dimensional art, see Erwin Panofsky, "Die Per-spektive als 'symbolische Form,'" in *Vorträge der Bibliothek Warburg 1924–1925* (Leipzig, 1927), translated as *Perspective as Symbolic Form* by Christopher S. Wood (New York, 1991), 40.

4. Expanding on Matteo Pellegrini's observations that the princely patron is owed and already possesses anything a client can offer him (*Che al savio è convenevole il corteggiare libri IIII* [Bologna, 1624]), Mario Biagioli (*Galileo, Courtier: The Practice of Science in the Culture of Absolutism* [Chicago and London, 1993], 49–54, 103–33) has asserted that, under absolutism, the ruler was viewed as the "ultimate author" of his clients' works.

5. The relevant correspondence is in I-MOas, AF 53, fasc. 18, fols. 42v–43r, 128r–129r, 176r.

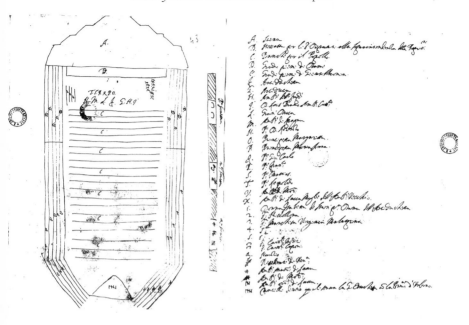

FIGURE 1.1. Cesare Molza, diagram (with legend) of the seating arrangement for *La regina Sant'Orsola*, 1624 (I-MOas, AF 53, fasc. 18, fols. 43r–v).

cany from February 1621 until July 1628 as a regent for her son Ferdinando, the only period of female rule in the two-hundred-year history of the Medici principality. Grand Duke Cosimo II (1590–1621) had created the regency in his testament, which stipulated that, in the event of his premature death, his wife (Maria Magdalena) and his mother (Christine) should govern Tuscany until Ferdinando's eighteenth birthday. The will prescribed both the powers and the limitations of the regents, who were to rule with full sovereignty, aided by a council of four ministers and two secretaries of state.[6] Cosimo's testament provided the legal authority for Christine and Maria Magdalena to exercise political power during the potentially unstable period that would result from the lack of an adult male heir. It restricted foreign influence over the city and prevented Cosimo's male relatives from gaining political influence and subverting the legitimate line of succession. The plan was successful, and Ferdinando officially assumed full responsibility for governing Tuscany on 14 July 1628.

Cosimo's will also created an uneasy alliance between two women with

6. [Jacopo] Riguccio Galluzzi (*Istoria del Granducato di Toscana sotto il governo della Casa Medici*, 5 vols. [Florence, 1781], 3:394–96) reported the particulars of Cosimo's will. Maria Magdalena also refers to her late husband's testament in a document of 5 October 1621 (I-Fas, DG 1008, no. 228).

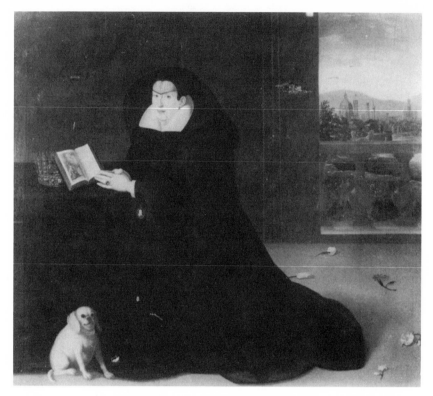

FIGURE 1.2. Tiberio Titi, *Christine of Lorraine* (1618) (Florence, Villa Poggio Imperiale)

similar religious views but opposing political positions and national loyalties. Christine of Lorraine (1565–1636) was French, the daughter of the Valois princess Claudia and Charles III, duke of Lorraine (fig. 1.2). She had lived with her maternal grandmother, the queen dowager of France, Catherine de' Medici, from 1575 until 1589, the year of Catherine's death and Christine's marriage to Grand Duke Ferdinando I. Christine would have witnessed her grandmother's use of the court *fête* to further her own political agenda, and she actually owned some of the most impressive reminders of these festivities, the Valois tapestries, which Catherine contributed to Christine's wedding trousseau.[7] Christine herself wielded considerable political power during her

7. Catherine had served as regent for her son, King Charles IX, from 1560 to 1563. For descriptions of her fetes as well as analyses of their political significance, see Strong, *Art and Power*, 98–125; and Robert M. Isherwood, *Music in the Service of the King: France in the Seventeenth Century* (Ithaca, NY, 1973), 59–88. While Strong (101) cautions against overestimating the historical accuracy of the Valois tapestries as depictions of the fetes, he does acknowledge that the tapestries attest to the festivities' importance to Catherine and the French court. Fran-

tenure as the grand duchess of Florence (1589–1609).[8] She participated actively in the preparations for her son's wedding to Maria Magdalena of Austria in 1608.[9] After her husband's death on 7 February 1609, Christine appears to have displayed openly an ambition to control the actions of her son Grand Duke Cosimo II, who was just nineteen years old when he assumed power: the Venetian resident ambassador Giacomo Vendramin noted, in a dispatch of 1610, that "the grand duchess wants thus to govern everything absolutely, without any thought to the reputation and the benefit of her son."[10] Her interest in political power may have led her to commission a biography of the Medici dynasty's first grand duke, her father-in-law Cosimo I. In 1611 the historian Domenico Mellini dictated this work to Christine's chaplain, Dimurgo Lambardi.[11] That same year, Christine commissioned a series of engravings by Jacques Callot on the life of her deceased husband, Ferdinando I.[12]

But Christine's most conspicuous acts of patronage were on behalf of the city's religious establishments, in particular its female monasteries, instrumental in constructing her reputation for great piety. Her interest in these institutions began nearly immediately after her arrival in the city, and in 1592 Pope

ces Yates interprets the tapestries more literally, accepting them as guides to the content of Valois festivities. See Frances A. Yates, *The Valois Tapestries* (London, 1959), esp. 51–108; and Margaret M. McGowan, *L'Art du ballet de cour en France, 1581–1643* (Paris, 1963), 40–47. The political messages communicated by courtly songs on behalf of Catherine has been explored recently in Jeanice Brooks, *Courtly Song in Late Sixteenth-Century France* (Chicago and London, 2000), esp. 10–13, 39–41, 209–27.

8. Gaetano Pieraccini, *La stirpe de' Medici di Cafaggiolo: Saggio di ricerche sulla trasmissione ereditaria dei caratteri biologici*, 3 vols. (Florence, 1924–25), 2:309–10. Pieraccini's relatively uncomplimentary portrait of the grand duchess, whom he characterizes as a power-seeking religious bigot, remains the only biography of Christine. Cristofano Bronzini praised the grand duchess as an exemplary mother in his treatise *Della dignità, e nobilità delle donne*, 8 vols. (Florence, 1622–32), 6:104–13, noting that both her male and female children were educated in languages, history, and statecraft (112–13).

9. Tim Carter, "A Florentine Wedding of 1608," *Acta musicologica* 55 (1983): 89–107.

10. "La signora Gran Duchessa voglia così assolutamente governar il tutto, senza pensar punto alla riputatione, et al beneficio del figliuolo," in *Storia arcana ed aneddotica d'Italia raccontata dai veneti ambasciatori*, ed. Fabio Mutinelli, 4 vols. (Venice, 1855–58), 3:599. Pieraccini (*La stirpe de' Medici*, 2:346) wrongly identifies Maria Magdalena as the grand duchess to whom Vendramin refers. For additional testimony confirming Christine's desire for power, see A. Donnadieu, *L'Hérédité dans la maison ducale de Lorraine-Vaudémont* (Nancy, 1922), 178–81.

11. Domenico Mellini, *Ricordi intorno ai costumi, azioni, e governo del Sereniss: Gran Duca Cosimo I*, ed. Domenico Moreni (Florence, 1820).

12. Thomas Schröder, ed., *Jacques Callot: Das gesamte Werk*, 2 vols. (Munich, 1971), 2:914–34; and Edwin de T. Bechtel, *Jacques Callot* (New York, 1955), 16, 37.

Clement VIII granted the grand duchess license to enter Florentine convents during the day with her daughters. Her relationship with the Monastero di Santa Croce (commonly known as La Crocetta) led to that convent's emergence as the principal residence of unmarried Medici princesses. Her concern for religious orthodoxy also led directly to the historical document with which she is most famously associated, Galileo Galilei's *Lettera a Madama Cristina di Lorena Granduchessa di Toscana* of June 1615.[13] In his letter to the grand duchess, Galileo expanded on an earlier letter of 21 December 1613 written to his disciple Benedetto Castelli, a document that in turn responded to a discussion about the earth's motion that had involved both Castelli and Christine, among others.[14] Castelli had reported the gist of that conversation to Galileo in a letter of 14 December, in which he assured his former teacher that, although Christine "began to argue against me using the Holy Scriptures" (*cominciò . . . a argomentarmi contro con la Sacra Scrittura*) he had acquitted himself well, convincing the grand duke and duchess and possibly even Christine, who, although she continued to contradict him, may have simply wanted to hear his answers.[15] Using Christine's own arguments, Galileo's letter addressed the relationship between science and religion, and in it, citing the authority of the Church Fathers Augustine and Jerome, he attempted to persuade the grand duchess that those who sought to discredit the Copernican system by means of biblical quotations erred in their logic, for they interpreted literally scriptures that were intended to teach faith, not astronomy.

 Although in 1628 the ambassador from Lucca reported that the then sixty-three-year-old grand duchess claimed to want to finish her days in a convent, she never withdrew completely from political affairs.[16] She did spend increasingly less time at the Pitti Palace, preferring to reside in the apartment she had built next to the Crocetta. Her withdrawal from court life and its intrigues found symbolic reiteration in her commissions for the villa she purchased in 1627 and renamed La Quiete, a theme whose iconographic program was invented by Alessandro Adimari and realized artistically by Giovanni da

13. Galileo Galilei, *Le opere di Galileo Galilei*, ed. Antonio Garbasso and Giorgio Abetti, 20 vols. (Florence, 1929–39), 5:307–48. A translation into English appears in Galilei, *Discoveries and Opinions of Galileo*, trans. Stillman Drake (New York, 1957), 173–216.

14. For an overview of the events leading to the *Lettera a Madama*, see Jerome J. Langford, *Galileo, Science, and the Church*, 3d ed. (Ann Arbor, MI, 1992), 50–78.

15. "Restava solo Madama Serenissima, che mi contradiceva, ma con tal maniera che io giudicai che lo facesse per sentirmi." The entire letter can be found in Galileo, *Opere*, 11:605–6.

16. Pieraccini, *La stirpe*, 318–19. See also Ilaria Pagliai, "Luci ed ombre di un personaggio: Le lettere di Cristina di Lorena sul 'negozio' di Urbino," in *Per lettera: La scrittura epistolare femminile tra archivio e tipografia secoli XV–XVII*, ed. Gabriella Zarri (Rome, 1999), 441–66.

San Giovanni.[17] Christine died at the Medici villa in Castello on 20 December 1636.

During the period of the regency, the more active role was assumed by Cosimo's widow, Archduchess Maria Magdalena of Austria (fig. 1.3). Like her mother-in-law, Maria Magdalena belonged to one of the most powerful families in Europe. As the granddaughter of the Habsburg emperor Ferdinand I, she could claim the title of archduchess, a title she apparently preferred to grand duchess.[18] Her sisters' marriages to the kings of Spain and Poland linked her to other European powers. And, even more important to her position as coruler of Florence, her brother was the current Holy Roman Emperor, Ferdinand II (reigned 1619–37), whose vigorous anti-Protestant policies she wholeheartedly endorsed. Their father, Archduke Karl (d. 1590), and mother, Marie of Bavaria (d. 1608), raised the children to support the militant Jesuits: Karl had invited the order to Graz in 1573 to open a college, which was elevated to the position of a university in 1586 and remained an intellectual center of Counter Reformation ideology into the seventeenth century.[19] The university was also one of three Jesuit colleges known for its active musical life, and music would have found an important place in the students' frequent performances of didactic plays, performances that Maria Magdalena and her siblings witnessed.[20] In a letter that she wrote to her

17. Alessandro Adimari, *La Quiete: Ovvero sessanta emblemi sacri* (Florence, 1632). See Claudio Pizzorusso, "'La Quiete': Giovanni da San Giovanni e Alessandro Adimari," *Artista: Critica dell'arte in Toscana* 1 (1989): 86–97; and Litta Medri, "La *Quiete* di Giovanni da San Giovanni," in *Villa la Quiete: Il patrimonio artistico del Conservatorio delle Montalve*, ed. Cristina De Benedictis (Florence, 1997), 103–8. Christine hoped that the villa would become a spiritual retreat for subsequent generations of Medici princesses; see Gabriele Corsani, "Le trasformazioni architettoniche del complesso della Quiete," in *Villa la Quiete*, ed. De Benedictis, 2–3, 20–21.

18. Estella Galasso Calderara, *Un'amazzone tedesca nella Firenze Medicea del '600: La Granduchessa Maria Maddalena D'Austria* (Genoa, 1985). Although relying on documentary evidence to a greater extent than her eighteenth- and nineteenth-century predecessors, Galasso Calderara reproduces the anticlerical biases of Galluzzi and Pieraccini, painting a picture of an overweight religious bigot, rapacious for power yet unable to wield it effectively.

19. Robert Bireley, *Religion and Politics in the Age of the Counterreformation: Emperor Ferdinand II, William Lamormaini, S.J., and the Formation of Imperial Policy* (Chapel Hill, NC, 1981), 7; and Robert A. Kann, *A History of the Habsburg Empire, 1526–1918* (Berkeley, CA, 1974), 138.

20. Thomas Culley, S. J., "The German College in Rome: A Center for Baroque Music," in *Baroque Art: The Jesuit Contribution*, ed. Rudolf Wittkower and Irma B. Jaffe (New York, 1972), 112. See also Culley, *Jesuits and Music, I: A Study of the Musicians Connected with the German College in Rome during the Seventeenth Century and of Their Activities in Northern Europe* (Rome and St. Louis, MO, 1970), 16; and Rudolf Flozinger, "Musik im grazer Jesuitentheater," *Historisches Jahrbuch der Stadt Graz* 15 (1984): 9–26.

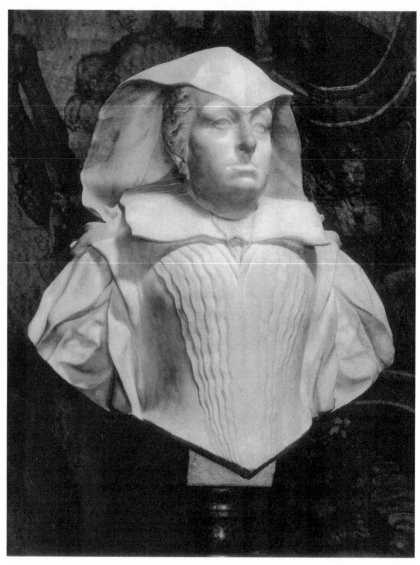

FIGURE 1.3. Giovan Battista Foggini, posthumous bust of Archduchess Maria Magdalena (1683) (Florence, Uffizi). Photo credit: Alinari/Art Resource, New York.

brother shortly before her departure for Florence, the archduchess included a lively and detailed account of that year's carnival season, which had included numerous works staged by traveling English comedians as well as two Jesuit plays.[21] The Graz court also boasted a remarkably large musical establishment, one that specialized in the sacred music favored by Archduke Karl.[22] As adults, both Emperor Ferdinand and Maria Magdalena remembered the lessons of their childhoods, particularly the ways in which music and theater could propagate the Catholic agenda.[23]

Religious themes predominate in the paintings, music, and theatrical works commissioned by Maria Magdalena, a sacred bias that has in the past earned the period a reputation for artistic sterility that mirrors the charges of political decadence leveled by Galluzzi and other historians.[24] But Maria Magdalena's commissions can best be understood as self-fashioning, that is, a process in which visual images create symbolic responses to historical events and assert the legitimacy of an individual ruler, by constructing concrete personifications of the attributes with which she—in this case—wanted to identify publicly. Seen thus, the musical spectacles sponsored by the archduchess are not anomalies within an otherwise pastoral and mythological operatic landscape but, rather, clear examples of continuity between the period of the regency and the reigns of previous Medici grand dukes, all of whom recognized the political importance of public images. And during both the sixteenth and seventeenth centuries, in the politicized world of court spectacle, words, visual images, and music contributed to a work's messages.

21. Orlene Murad, *The English Comedians at the Habsburg Court in Graz, 1607–1608* (Salzburg, 1978).

22. Hellmut Federhofer, *Musikpflege und Musiker am Grazer Habsburgerhof der Erzherzöge Karl und Ferdinand von Innerösterreich (1564–1619)* (Mainz, 1967), esp. 23–54.

23. On Ferdinand's patronage of music, see Steven Saunders, "The Hapsburg Court of Ferdinand II and the *Messa, Magnificat et Iubilate Deo a sette chori Concertati con le trombe* (1621) of Giovanni Valentini," *Journal of the American Musicological Society* 44 (1991): 395–403, as well as his *Cross, Sword, and Lyre: Sacred Music at the Imperial Court of Ferdinand II of Habsburg (1619–1637)* (Oxford, 1995), esp. chap. 1.

24. Galluzzi, *Istoria*, 3:393. Angelo Solerti describes the court's musical atmosphere under the regency as "something oppressive and gloomy" [*qualque cosa di pesante e di tetro*] (*Musica, ballo e drammatica alla corte Medicea dal 1600 al 1637: Notizie tratte da un diario, con appendice di testi inediti e rari* [Florence, 1905; reprint, New York and London, 1968], xii). Warren Kirkendale (*The Court Musicians in Florence during the Principate of the Medici with a Reconstruction of the Artistic Establishment* [Florence, 1993], 371) erroneously claims that the grand duchess suppressed musical and theatrical activities during the regency.

"Il buono uso dell'architettura": Cosimo I (1519—74)

The manufacture and control of imagery preoccupied all the Medici grand dukes, beginning with the first, Cosimo I. Cosimo was elected duke of Florence in January 1537, and among his first political acts was the renovation of the hall of the Great Council (also known as the Sala Grande) in the Palazzo della Signoria. Surrounded by statues of his ancestors and scenes from the city's past, Cosimo later asserted his own place within that history, overseeing it symbolically from his position in the ceiling painting known as *The Apotheosis of Cosimo I*, which Giorgio Vasari claimed was the "key and conclusion" to the room's narrative.[25] Vasari prefaced his explication of the room's allegorical program with his own interpretation of the political statement made when Cosimo appropriated the building that had served as a symbol of the Republic:

> As he was created duke of this republic in order to preserve the laws and to add to them those which assure that its citizens live in justice and peace, his greatness depends on the origin of this palace and its old walls. But since they were disarranged and broken up, he desired to restore them with order and measure and by placing over them these correct and well-composed decorations. In this way he also made it known that in dealing with difficult and faulty matters he knew how to employ ease, perfection and good practice, whether in architecture or in governing the city and the dominion.[26]

25. Giorgio Vasari, *Ragionamenti*, in *Le opere*, ed. Gaetano Milanesi, 9 vols. (Florence, 1906), 8:220—21. On Vasari's interpretive program as an ex post facto invention—one supervised by Cosimo himself—see Paola Tinagli, "The Identity of the Prince: Cosimo de' Medici, Giorgio Vasari and the *Ragionamenti*," in *Fashioning Identities in Renaissance Art*, ed. Mary Rogers (Aldershot, 2000), 189—96, and "Claiming a Place in History: Giorgio Vasari's *Ragionamenti* and the Primacy of the Medici," in *The Cultural Politics of Duke Cosimo I de' Medici*, ed. Konrad Eisenbichler (Aldershot, 2001), 63—76.

26. Translation in Jerry Lee Draper, "Vasari's Decoration in the Palazzo Vecchio: The *Ragionamenti* Translated with an Introduction and Notes" (Ph.D. diss., University of North Carolina at Chapel Hill, 1973), 89. The original Italian reads:

> Che poi che egli fu creato duca di questa repubblica, per conservar le legge, e sopra quelle aggiugner que' modi che rettamente faccin vivere sotto la iustitia e la pace i suoi cittadini e che dependendo la grandezza sua da l'origine di questo palazzo e mura vecchie, e benchè sieno sconsertate e scomposte, gli è bastato l'animo di ridurle con ordine e misura e sopr'esse ponendovi, come vedete, questi ornamenti diritti e ben composti, e 'l far conoscere anche nelle cose difficili ed imperfette, che ha saputo usare la facilità e la perfezione ed il buono uso dell'architettura, così come anche ha fatto nel modo del governo della città e del dominio. (Vasari, *Ragionamenti*, 14)

Duke Cosimo's self-fashioning consistently emphasized continuity with the most illustrious members of the older branch of the Medici family—Cosimo il Vecchio and Lorenzo il Magnifico—while simultaneously claiming his own superiority.[27] While his ancestors had been subject to the vicissitudes of Fortune, these images argued, Cosimo tamed it; he would restore the golden age to Florence. Divine Providence and his own *virtù* had destined Cosimo to rule—an iconographic program reproduced throughout the grand duke's rule, often under his direct supervision.[28] One of the earliest and most elaborate iterations of this theme occurred during the celebration of his marriage to Eleanora of Toledo in 1539. The highlight of these festivities was Antonio Landi's play *Il commodo,* with *intermedi* by Giovanni Battista Strozzi (text) and Francesco Corteccia (music), which took place on 9 July 1539 in the second courtyard of the Medici Palace on Via Larga.[29] Against the north wall was the stage, with its realistic view of Pisa, the setting for the play. Twelve huge paintings, each measuring approximately 16 by 10 feet, flanked the seating area on the east and west walls. To the right of the spectators (i.e., on the east wall), six paintings recalled significant events in the history of the Medici family in Florence, especially focusing on previous Medici contacts with Naples, the home of the bride, while on the opposite wall, paintings depicted

27. Janet Cox-Rearick, *Dynasty and Destiny in Medici Art: Pontormo, Leo X, and the Two Cosimos* (Princeton, NJ, 1984), esp. 3–9, 233–91.

28. For examples, see Kurt W. Forster, "Metaphors of Rule: Political Ideology and History in the Portraits of Cosimo I de' Medici," *Mitteilungen des Kunsthistorischen Institutes in Florenz* 15 (1971): 65–104; Paul Richelson, *Studies in the Personal Imagery of Cosimo I De' Medici, Duke of Florence* (New York and London, 1978); Michel Plaisance, "La politique culturelle de Côme I^er et les fêtes annuelles a Florence de 1541 a 1550," in *Les fêtes de la Renaissance,* ed. Jean Jacquot and Elie Konigston, 3 vols. (Paris, 1956–75): 3:133–52; David Roy Wright, "The Medici Villa at Olmo a Castello: Its History and Iconography" (Ph.D. diss., Princeton University, 1976), esp. 325–33; and Eve Borsook, "Art and Politics at the Medici Court I: The Funeral of Cosimo I de' Medici, *Mitteilungen des Kunsthistorischen Institutes in Florenz* 12 (1965–66): 31–54.

29. The principal description of the festivities is Pierfrancesco Giambullari, *Apparato et feste nelle nozze del Illustrissimo Signor Duca di Firenze, et della Duchessa sua consorte, con le sue Stanze, Madriali, Comedia, et Intermedii, in quelle recitati* (Florence, 1539). That same year, Francesco Corteccia published his musical contributions: *Musiche fatte nelle nozze dello illustrissimo Duca di Firenze il signor Cosimo de' Medici et della illustrissima consorte sua mad. Leonora da Tolleto* (Venice, 1539). The description, play, and *intermedi* have been translated into English and integrated with the appropriate music in Andrew C. Minor and Bonner Mitchell, *A Renaissance Entertainment: Festivities for the Marriage of Cosimo I, Duke of Florence, in 1539* (Columbia, MO, 1968). To view a model of the stage and surrounding decorations, see Elvira Garbero Zorzi and Mario Sperenzi, *Teatro e spettacolo nella Firenze dei Medici: Modelli dei luoghi teatrali* (Florence, 2001), 145–46. See also A. M. Nagler, *Theatre Festivals of the Medici, 1539–1637* (New Haven, CT, and London, 1964), 5–12.

moments in the life of young Cosimo himself. Relationships in subject matter occur between paintings directly across from one another, that is, between past and present, and it is in this placement that the full allegorical message emerges.[30]

Beginning with the southernmost pair of paintings, that is, those furthest from the stage, Cosimo il Vecchio's return from exile in 1434—the event that to many Renaissance historians signaled the beginning of the family's control of Florence—was paired with the birth of his namesake. The second painting on the east depicted Lorenzo il Magnifico negotiating to save Florence from war with both Naples and the papal states following the Pazzi conspiracy, that is, in the aftermath of internal dissension, while on the west a unified council of forty-eight elected Cosimo as the new leader of Florence. In the third position, a state arrival by the Medici pope Leo X was placed opposite a scene from book 20 of Livy, the expulsion of three Capuan ambassadors from the Roman senate. According to Vasari, this referred to the three Florentine cardinals who had come to Florence in order to question Cosimo's rule.[31] Both paintings assert Medici power over the Church, from within and from without.

The fourth pair of paintings juxtaposed militaristic images of Cosimo with his father, Giovanni delle Bande Nere. On the east wall, Giovanni was shown capturing Biagrassa from the French in 1524, while the west wall painting reminded the audience of the more recent 1537 defeat of anti-Medici exiles at Montemurlo. The next set of paintings stressed the history of a reciprocal and beneficial relationship between the empire and Florence, whose continuity was essential to Florence's future independence: on the east, the audience viewed the coronation of Charles V by Pope Clement VII, a Medici pope, while on the opposite side Cosimo I appeared wearing the full ducal insignia granted him by Charles V.[32]

Much as Vasari would later assert that the *Apotheosis of Cosimo I* panel seemed to him to be the teleological goal of every other visual image in the Sala Grande, the final paintings—those nearest the stage and thus most often in view of the audience—served as the logical conclusion to those preceding them spa-

30. The paired nature of the paintings has also been noted by Forster, "Metaphors of Rule," 91–92; and Claudia Rousseau, "The Pageant of the Muses at the Medici Wedding of 1539 and the Decoration of the Salone dei Cinquecento," in *"All the world's a stage . . .": Art and Pageantry in the Renaissance and Baroque,* ed. Barbara Wisch and Susan Scott Munshower, 2 vols. (University Park, PA, 1990), 2:423.

31. Minor and Mitchell, *A Renaissance Entertainment,* 134n73.

32. According to Minor and Mitchell (ibid., 134–35n75), the depiction of the coronation predated Cosimo's actual meeting with the emperor.

tially. In his (sometimes inaccurate) description of the courtyard decorations, Vasari singled out these two works by Bronzino as the most praiseworthy paintings of the set. According to Giambullari, "The last on this [i.e., the east] side was the painting showing us the many difficulties of Duke Alessandro in Naples, with the firm opposition of his powerful adversaries."[33] By contrast, on the west wall Bronzino depicted the Neapolitan proxy wedding of Cosimo I and Eleanora of Naples.[34] In short, Cosimo, with his marriage to Eleanora, had arrived at an equal footing with Naples, something his predecessors had failed to accomplish.

During the course of the performance, musical *intermedi* between the acts of the spoken comedy contributed to a sense of what Nino Pirrotta has termed "temporal perspective," that is, the compression created by temporary shifts from real to musical time.[35] By means of stage machinery designed to reinforce this sense of temporal progress, the architect Bastiano da Sangallo, known as Aristotile, also ensured the proper movement of the audience's eyes from the past to the glorious present. Vasari described in detail the device that accomplished this feat:

> Next he arranged—with much ingenuity—a wooden lantern for use on an arch behind all the stage buildings, with a sun one *braccio* high [approx. two feet], made with a crystal ball full of distilled water, behind which were two lit torches that made it shine in such a way that it rendered luminous the sky of the stage and scenery, so that it appeared [to be] truly the living and natural sun. And this sun, I tell you, having around it an ornament of golden rays, which covered the curtain, was pulled little by little by means of a little winch, in such a well-ordered way, that at the beginning of the comedy it appeared that the sun was rising, and that, [having] climbed to the middle of the arch, it descended so that at the end of the comedy it went below [the horizon] and set.[36]

33. Translation in ibid., 132.

34. Vasari mistakenly identifies the subject of this painting as the marriage of Duke Alessandro de' Medici.

35. Nino Pirrotta and Elena Povoledo, *Music and Theatre from Poliziano to Monteverdi*, translated by Karen Eales (Cambridge, 1982), 156–57.

36. The original reads:

> Appresso ordinò con molto ingegno una lanterna di legname a uso d'arco dietro a tutti i casamenti, con un sole alto un braccio, fatto con una palla di cristallo piena d'acqua stillata, dietro la quale erano due torchi accesi, che la facevano in modo risplendere, che ella rendeva luminoso il cielo della scena e la prospettiva in guisa, che pareva veramente il sole vivo e naturale; e questo sole, dico, avendo intorno un ornamento di razzi d'oro che coprivano la cortina, era di mano in mano per via d'un arganetto tirato con sì fatt'ordine, che a principio della comedia pareva che si levasse il sole, e che sa-

Thus in the final *intermedio*, as the personage of Night arrives and the sun is in the west, all eyes would have been drawn to the magnificent painting of the bridal couple, the illumination of a new era in Florentine politics.

Music and Words: Grand Duke Ferdinando I and *L'Euridice*

This new era continued under two of Cosimo's sons: Francesco (1541–87) and, more important, Ferdinando (1549–1609), whose reign carried Tuscany into the seventeenth century. Like his father, Ferdinando stressed the continuity of the Medici lineage and claimed to have restored a Florentine golden age.[37] But the increased importance of divine-right theories subtly altered symbols of the grand duke himself. Images of a godlike Ferdinando replaced those of the heroic Cosimo, whom God had destined to rule Florence. Musical spectacles affirmed symbolically Ferdinando's absolute control over Tuscany's natural, political, social, and artistic realms.[38] One of the new resources in the grand duke's self-fashioning was the newly invented genre that came to be known as opera.[39]

Among the most pressing of Ferdinando's foreign policy initiatives was the restoration of Tuscany's relationship with France, a political strategy believed necessary to maintain the grand duchy's equilibrium between the European superpowers of France and Spain. His marriage to Christine of Lorraine in 1589 was an early step in this direction. Ferdinando also took an active and conspicuous role in the conversion of Henri IV to Catholicism in 1593, Henri's official assumption of the French crown in 1594, and the negotiation of the Treaty of Vervins between France and Spain in 1598.[40] In 1599

lito infino al mezzo dell'arco scendesse in guisa, che al fine della comedia entrasse sotto e tramontasse. (Vasari, *Opere*, 6:442)

37. Strong, *Art and Power*, 135, 137, 150; Saslow, *The Medici Wedding of 1589*, 31–35.

38. Samuel Berner, "Florentine Society in the Late Sixteenth and Early Seventeenth Centuries," *Studies in the Renaissance* 18 (1971): 204, and "Florentine Political Thought in the Late Cinquecento," *Il pensiero politico* 3 (1970): 187–93.

39. Lorenzo Bianconi has stressed Baroque court opera's political function—see *Il Seicento* (Turin, 1982), translated as *Music in the Seventeenth Century*, trans. David Bryant (Cambridge, 1987), 171.

40. Eric Cochrane, *Florence in the Forgotten Centuries, 1527–1800: A History of Florence and the Florentines in the Age of the Grand Dukes* (Chicago, 1973), 101; J. R. Hale, *Florence and the Medici: The Pattern of Control* (London, 1977), 151, 162–64; and Strong, *Art and Power*, 144–45. On Ferdinando's involvement with Henri's conversion and the wedding negotiations, see Galluzzi, *Istoria*, 3:164–85, summarized in Claude Palisca, *Studies in the History of Italian Music and Music The-*

the grand duke arranged for a marriage between his niece, Maria de' Medici, and the French king, and the wedding took place in a proxy ceremony of 5 October 1600, with Ferdinando himself standing in for the groom. Undoubtedly because the marriage marked the first instance in recent memory in which a member of the Medici family married a reigning monarch, the court celebrated the event lavishly. As is well known, besides the festivities commissioned by the grand ducal family, Ferdinando granted Jacopo Corsi the honor of arranging a performance of a new type of theatrical work, one in which all the lines were sung, rather than spoken. On 6 October, in a room in the Medici palace, Corsi presented *L'Euridice*, with poetry by Ottavio Rinuccini and music by Jacopo Peri and Giulio Caccini, both Medici employees.[41] By contrast to other works performed as part of the wedding festivities, *L'Euridice* did not follow the traditional path of encomiastic spectacle but, rather, precipitated a subtler approach to allegory: not only its plot and words but also its music contributed to the work's allegorical messages.

To the audience members who attended the performance, two characteristics of *L'Euridice* must have seemed particularly noteworthy. Not only did its characters deliver their lines solely in music, but its plot deviated significantly from the best known versions of the Eurydice tale, such as those by Virgil or, more recently, Poliziano. This Orpheus negotiated successfully with Pluto for his wife's unconditional release, thus eliminating the need for her second disappearance. Rinuccini actually invited comparison with his poetic models by alluding to them in the libretto's closing scene. Exorcizing the effect of Eurydice's laments in the traditional sources, all of which call attention to Orpheus's failure, Rinuccini's Euridice affirms her husband's success. Her words even recall those earlier laments: in answer to a nymph's question of how she could be alive, Euridice delivers the matter-of-fact declaration "Tolsemi Orfeo del tenebroso regno" [Orpheus took me away from the gloomy realm]. Rinuccini's choice of the word *togliere*, a verb implying forceful action, recalls Poliziano's use of the same verb in Eurydice's lament ("Ecco ch'i' ti

ory (Oxford, 1994), 439–42, and Bojan Bujić, "'Figura poetica molto vaga': Structure and Meaning in Rinuccini's *Euridice*," *Early Music History* 10 (1991): 50–53.

41. Each composer subsequently published his own score of the music: Jacopo Peri, *Le musiche di Iacopo Peri . . . sopra L'Euridice* (Florence, 1601; reprint, New York, 1973); and Giulio Caccini, *L'Euridice* (Florence, 1600; reprint, Bologna, 1968). I have recently examined differences in musical characterization and political allegory in these two scores; see Kelley Harness, "Le Tre Euridici: Characterization and Allegory in the *Euridici* of Peri and Caccini," *Journal of Seventeenth-Century Music* 9, no. 1 (August 2003) [http://sscm-jscm.org].

son tolta a gran furore"), verified by Orpheus ("Ohimè, se' mi tu tolta").[42] By appropriating and neutralizing this verb, Rinuccini confirms that Florence's new Orpheus has indeed surpassed his humanistic ancestor.[43]

Who was this new Orpheus? It seems unlikely that Rinuccini intended to cast Henri in this allegorical role: the French king did not even bother to fetch his bride from Florence, much less the underworld. Barbara Hanning has suggested that a long-standing connection between the Medici family and Orpheus influenced Rinuccini's choice of subject, while Bojan Bujić has argued convincingly that Orfeo may have been intended as a symbolic representation of Ferdinando himself.[44] Orpheus had often been viewed as analogous to the Old Testament David, a figure with strong Florentine associations as a symbol of good government.[45] Orpheus was a peacemaker and a symbol of balance and, thus, an appropriate symbol for Ferdinando's efforts

42. Angelo Poliziano, *Fabula di Orfeo*, lines 308, 312, in *Stanze, Orfeo, Rime*, ed. Sergio Marconi (Milan, 1981), 149.

43. Although Peter Dronke ("The Return of Eurydice," *Classica et Mediaevalia* 23 [1962]: 198–215) has demonstrated the persistence, into the seventeenth century, of a version of the story in which Orpheus successfully rescues Eurydice from the underworld, it still appears far less frequently in art and literature than Virgil's well-known tale. In his dedication of the libretto to Maria de' Medici, Rinuccini explained his alteration of the fable's ending as more suitable for an occasion of such happiness, and his self-conscious justification of the decision clearly indicates his belief that audience members did view Eurydice's second death as essential to the story (Barbara Russano Hanning, *Of Poetry and Music's Power: Humanism and the Creation of Opera* [Ann Arbor, MI, 1980], 270). Rinuccini's unconventional ending also has a visual counterpart in the particularly Roman approach to artistic representations of the Orpheus myth in the sixteenth century, one that emphasized the heroic Orpheus. Marcantonio Raimondi issued at least two engravings that depicted Orpheus leading Eurydice from the underworld without a hint of impending tragedy; see Giuseppe Scavizzi, "The Myth of Orpheus in Italian Renaissance Art, 1400–1600," in *Orpheus: The Metamorphoses of a Myth*, ed. John Warden (Toronto, 1982), 136–38.

44. Hanning, *Of Poetry and Music's Power*, 52–53; Bujić, "'Figura poetica molto vaga,'" 47–56. Hanning ("Glorious Apollo: Poetic and Political Themes in the First Opera," *Renaissance Quarterly* 32 [1979]: 485–513) has also demonstrated the close political associations between Apollo, the principal character in Rinuccini's *Dafne*, and Medici iconography, noting that Orfeo was often described as the sun god's progeny.

45. Erwin Panofsky, *Studies in Iconology: Humanistic Themes in the Art of the Renaissance* (Oxford, 1939; reprint, New York, 1972), 19. See also Andrew Butterfield, "The Evidence for the Iconography of David in Quattrocento Florence," *I Tatti Studies: Essays in the Renaissance* 6 (1995): 115–33. Karla Langedijk (*The Portraits of the Medici: 15th–18th Centuries*, 3 vols. [Florence, 1981–87], 1:133) cites an instance in which a visual allegory of Ferdinando's victory over the Turks appeared immediately below a representation of David and the ark.

to restore political equilibrium to Florence.[46] Finally, Orfeo's demonstrated power over nature reiterates another prevailing theme in Ferdinando's self-fashioning, evident in improvement projects ranging from draining marshes and fortifying the port at Livorno to assisting the city's silk industry by arranging for the planting of mulberry trees between Florence and the cities of Pisa and Pistoia.[47]

But of course Orpheus was also the consummate musician. The very popularity of the Orpheus theme in early opera attests to the era's widely held belief that music possessed a special ability to move human affections and, by extension, behavior. Within the context of court spectacle, music could reinforce the messages of visual and verbal media. One of its most crucial contributions was to the dramatic construction of characters. The belief in not only the possibility but also the desirability of such musical characterization dates to the earliest theorizing by members of the Florentine Camerata, a loosely organized group whose interests included exploration of the expression of emotions through poetry and music. In his *Dialogo della musica antica e della moderna* (1581), Vincenzo Galilei—through the words of his interlocutor Giovanni Bardi, the founder of the Camerata—exhorted contemporary composers to abandon what he considered their superficial imitation of the words and instead turn their attention toward theatrical declamation.[48] His suggestion that contemporary composers should attend performances of spoken

46. Earlier in the sixteenth century, another powerful member of the Medici family used a representation of Orpheus as a political proclamation of restored peace and order: ca. 1516–17 Pope Leo X, through Cardinal Giulio de' Medici, commissioned Baccio Bandinelli's Orpheus statue for the Palazzo Medici-Riccardi, a statue intended to fill the location vacated by Donatello's David. On the iconographical relevance of this statue, and on Orpheus as a symbol for the good prince, see Karla Langedijk, "Baccio Bandinelli's Orpheus: A Political Message," *Mitteilungen des Kunsthistorischen Institutes in Florenz* 20 (1976): 33–52. The literature dealing with Orpheus imagery in the Renaissance is vast; I have found the following sources particularly helpful: Elizabeth A. Newby, *A Portrait of the Artist: The Legends of Orpheus and Their Use in Medieval and Renaissance Aesthetics* (New York and London, 1987), esp. 62–221; F. W. Sternfeld, *The Birth of Opera* (Oxford, 1993), 1–30; Scavizzi, "The Myth of Orpheus in Italian Renaissance Art," 111–62; D. P. Walker, "Orpheus the Theologian and Renaissance Platonists," *Journal of the Warburg and Courtauld Institutes* 16 (1953): 100–120, esp. 100–103; and Celine Richard, "La légende d'Orphée et d'Eurydice au XVI^e et au XVII^e siècles," in *Les Métamorphoses d'Orphée* (Brussels, 1995), 43–47.

47. Saslow, *The Medici Wedding of 1589*, 11–12; Strong, *Art and Power*, 127; and Hale, *Florence and the Medici*, 150.

48. Vincenzo Galilei, *Dialogo della musica antica et moderna*, ed. Fabio Fano (Florence, 1581; reprint, Rome, 1934), 89.

plays and "observe, when one quiet gentleman speaks with another, in what manner he speaks, how high or low his voice is pitched, with what volume of sound, with what sort of accents and gestures, and with what rapidity or slowness his words are uttered" appears to be a prescription for the style of sung declamation described by Jacopo Peri in 1601, in the well-known preface to his music of *L'Euridice*.[49] But Galilei's prescriptions also confirm his belief in a composer's ability to render audible social and cultural distinctions. By proposing that composers consider "the prince when he chances to be conversing with one of his subjects and vassals; when with the petitioner who is entreating his favor; how the man infuriated or excited speaks; the married woman, the girl, the mere child, the clever harlot" and so on, Galilei presumes that class, age, gender, and sexual maturity are encoded into theatrical characters' words and manner of performance.[50] His assertion that ancient musicians "first examined diligently the quality of the person who was speaking: the age, the sex, with whom, and that which [the person] sought to accomplish by such means" [*essaminava prima diligentissimamente la qualità della persona che parlava, l'età, il sesso, con chi, e quello che per tal mezzo cercava operare* (90)] makes it clear that he felt that modern musicians could and should participate in this semiological enterprise.

The musical language of early Florentine opera allows for a number of techniques by which a composer might represent traits such as self-control, resolve, and agency, as well as immoderation, vacillation, and passivity. Composers created their characters through the presence or absence of musical techniques that bear an iconic relationship to the traits represented.[51] For example, unlike its later Venetian counterpart, early Florentine opera relies only rarely on florid singing, and thus the appearance of highly decorative arias

49. Translation of the Galilei quotation is by Oliver Strunk in Gary Tomlinson, ed., *The Renaissance*, vol. 3 of *Strunk's Source Readings in Music History*, rev. ed. (New York, 1998), 187. Galilei's original Italian reads: "Osservino di gratia in qual maniera parla, con qual voce circa l'acutezza e gravità, con che quantità di suono, con qual sorte d'accenti e di gesti, come profferite quanto alla velocità e tardità del moto, l'uno con l'altro quieto gentilhuomo" (*Dialogo*, 89).

50. Translation by Strunk in Tomlinson, ed., *The Renaissance*, 187–88; the original is: "Considerino quando ciò accade al Principe discorrendo con un suo suddito e vassallo; quando al supplicante nel raccomandarsi; come ciò faccia l'infuriato, ò concitato; come la donna maritata; come la fanciulla; come il semplice putto; come l'astuta meretrice" (*Dialogo*, 89).

51. My own analyses are indebted to Suzanne Cusick's study of *La liberazione*, especially her description of the musical construction of Melissa's rationality ("Of Women, Music, and Power: A Model from *Seicento* Florence," in *Musicology and Difference: Gender and Sexuality in Music Scholarship*, ed. Ruth Solie [Berkeley, CA, 1993], 295–96); and Eric Chafe, *Monteverdi's Tonal Language* (New York, 1992).

signals an exuberance that contrasts sharply with the more usual manner of delivering text in recitative. Such melodic extravagance can function as an icon of excess, and composers often reserved its use for those principals carried away by immoderation. But even recitative can be more or less expressive, as Giovanni Battista Doni noted slightly later in the century.[52] And the unexpected harmonic juxtapositions, chromaticism, dissonance, affective use of rhythm, and rhetorical figures that characterize the most expressive recitatives typically coincide with those moments during which a character possesses the least self-control, not only mirroring immoderation but helping to construct it as well.

The degree to which a character's vocal line participates in the underlying harmonic scheme can also influence the audience's perception of that character as either possessing or lacking control and agency. Tonally directed vocal lines that reinforce a clear harmonic plan, formally articulated by means of "attention-getting" cadences with motion by fifth in the bass and a stepwise descent in the voice (ex. 1.1a), create an aural sense of purpose, and when used to deliver a forceful text can impart assertiveness to the character singing.[53] By extension, other means of harmonic articulation might highlight a character's temporary (sometimes feigned) helplessness, for example, "less attention-getting" cadences in which the voice repeats the note of resolution (ex. 1.1), or thwarted cadences (ex. 1.1c), in which a suspension inflects the underlying harmonic direction toward a cadence only to be derailed when the vocal line does not or cannot participate. Cadences can thereby function as barometers of musical control and, in combination with other musical parameters such as melodic range, singing style, and harmonic vocabulary, provided composers with a means of delineating a character's status, age, and, sometimes, gender.

Returning to Jacopo Peri's music for *L'Euridice*, we see that the composer most often credited with the invention of recitative appears to have taken Galilei's prescriptions seriously. His score provides ample illustrations of the means by which a composer might construct characters through music. The clear differences in the musical and textual language of the opera's principal characters reflect not only specific moments in the drama but also each character's station. For example, among the main female personages, only women of high rank—Proserpina and Venus—influence the course of the drama, and

52. Giovanni Battista Doni, *Annotazioni sopra il compendio de' generi e de' modi della musica* (Rome, 1640), 60–62.

53. I have borrowed the term "attention-getting cadence" from Margaret Murata, *Operas for the Papal Court, 1631–1668* (Ann Arbor, MI, 1981), 105–8.

they do so through their speech. The two goddesses appear only in scene 4, and the same singer probably sang both roles.[54] Venus delivers Orfeo to the underworld and commands him to arm his soul with strength and hope, while in her second and final recitative she uses the imperative no fewer than five times in twelve lines, first ordering Orfeo to look around him, then to release his noble song. She even recommends a strategy: "prega, sospira, e plora"— a suggestion Orfeo obeys with success. In Peri's setting Venus punctuates these instructions by frequent strong cadences.

While Venus demonstrates agency through commanding speech, Proserpina exerts her will using seductive rhetoric. Her nine-line speech constitutes but a single, complex sentence, as she weaves an elaborate grammatical construction that first flatters her husband Pluto, then reminds him of the joys of sexual love, appealing to his own status as a lover so that he might yield to Orfeo's request (ex. 1.2). Proserpina begins her entreaty on the A harmony that concluded Orfeo's previous recitative, and she reiterates his argument. She leaps up to a′ in an appropriately solemn rhythm, and she continues to appeal to Pluto's majesty by echoing his own musical thumbprint, a stately ascending triad. She affirms her love for Pluto and pauses expectantly on an E chord (mm. 14–15) before beginning the conditional clauses by which she attempts to establish a logical relationship between her love for Pluto and Orfeo's love for Euridice. In her first supposition she draws out the E harmony before concluding by fifths motion to D. Her second assumption also proceeds to D but from the flatter direction. Proserpina then makes the link between these two situations by using this shared D to initiate an extended cadence to G at the implied "then" statement, "di sì gentil'amante acqueta'l pianto." The melodic climax of her recitative coincides with her description of Orfeo (m. 28), after which her melodic line reverses course in a carefully directed descent toward the final cadence.

But of course Orfeo is much more than merely the *gentile amante* pitied by Proserpina: he is the opera's most fully realized character, and he not only delivers the highest percentage of the work's poetic lines but also effects the plot's resolution. As befitting a superior orator, his wide range of musical styles demonstrates not only his capacity for grief and joy but, more important, his ability to control both his dramatic and musical surroundings. Rinuccini's use of the word *rimbombare* (resound) in three of Orfeo's principal speeches confirms that his self-identity resides in sound. In his first speech, "Antri ch'a miei lamenti," Orfeo first addresses anthropomorphized objects of nature, then gods and goddesses, namely, Apollo and Venus, and finally,

54. Palisca, *Studies in the History of Italian Music,* 445–47.

Euridice herself, confidently asserting his influence over the natural, celestial, and human realms. The speech also bears a metonymic relationship to the larger plot, which moves from nature to the realm of gods and goddesses and concludes with an emphasis on the human. In other words, Orfeo is central to both the plot's details and its construction.

Orfeo demonstrates his mastery over the subterranean world in scene 4, in many ways the highpoint of the drama, for it is the scene in which the demigod persuades Pluto to relinquish Euridice to the world of the living. Within the demands of verisimilitude this scene is crucial, for the audience must see, or better, hear, that Orfeo actually triumphs over Pluto, the opera's central message. To achieve this end, Rinuccini's libretto depicts a resourceful rhetorician, who musters at least three separate arguments in favor of his position. The differences between Orfeo and Pluto are also made audible by an equivalent contrast of final cadence. Each of Pluto's first five speeches ends on C, as the god firmly states his inability or unwillingness to grant Orfeo's request. Orfeo is equally tenacious, however, asserting the preeminence of the G final with which he concludes four of his five speeches.[55] Peri mirrors Pluto's ultimate concession by concluding his final speech in F, and Orfeo's celebratory "O fortunati miei dolci sospiri" appropriates Pluto's F and carries it to his own tonal realm of G. Orfeo thus emerges as both powerful and eloquent, using tonal planning to assert his will yet able to harness musical expressivity in his efforts to persuade his opponent.

At the conclusion of the opera, Orfeo confirms explicitly that his ability to persuade Pluto stemmed directly from his skill as an orator, acknowledging to his friends that what appeared to be a complete loss of control was actually a calculated attempt to achieve his goal. He reveals to his friends the same type of musical mastery he used to convince the powerful god (ex. 1.3): line 1 and the first half of line 2 follow a single-minded harmonic trajectory, moving from C, that is, appropriating the concluding harmony of his companion's previous question, through F then to B♭. He repeats the forceful opening dactyl at "fervidi," then halfway through the line he demonstrates his ability to reverse strategy without warning, as a sudden chromatic bass ascent replaces its earlier motion by fifth. Melodically, the dactyls give way to syncopation on "flebili," followed by a monotone, colorless g. Orfeo resumes his more assertive vocal line at "temprai," reinforced by the bass's reiteration of its earlier motion from C to B♭. The strong cadence on the grammatically

55. Gary Tomlinson (*Monteverdi and the End of the Renaissance* [Berkeley, CA, 1987], 132–33) has noted the similarities between Peri's use of tonal juxtaposition (which he characterizes as G minor/F major) and Monteverdi's music for Orpheus's underworld scenes in *L'Orfeo*.

incomplete "ch'io" allows Orfeo to heighten anticipation for his answer, while in line 4 the two melodic descents of a fifth (d'-g then c'-f) clothe an extended cadence to F, marked by faster bass motion. The flatter F, possibly an allusion to Pluto and the underworld, acts now as part of an extended cadence to G, as the harmonies ascend by fifths from F to D before reversing direction for the strong concluding cadence. Orfeo makes a dramatic pause before his peroration (m. 10) and reserves the final iteration of d'—the melodic highpoint of the speech—to highlight the trophy he has won through eloquence.

Euridice confirms Orfeo's superhuman achievement on her return to the world of the living in the opera's final scene. Unlike her recitatives at the beginning of the opera, in which her music is indistinguishable from that of her companions, Euridice now echoes her husband's musical language. Her speech recalls the prescriptions of sixteenth-century marriage treatises, whose authors typically exhort wives to reflect their husbands' images, often using unambiguous terms such as "mirror" or "chameleon."[56] Even Sperone Speroni, often cited as an advocate of women, advised wives that their husbands ought to guide their voices.[57] Juan Luis Vives's recommendation that a wife should be "one person with her husband," directing both her thoughts and words to the goal of demonstrating that the two are of one flesh, seems to find its aural counterpart in Euridice's music of this final scene.[58] In her first two speeches she uses the imperative five times, three of them in successive lines. Her commands, such as "now recognize my customary inflections" [*riconoscete omai gl'usati accenti*] and "hear the sound of these propitious words" [*udite il suon di queste voci amiche*], explicitly call attention to her own speech.

Peri's music mirrors Euridice's newfound assertiveness. In her first recita-

56. The mirror and chameleon images appear in, respectively, Alessandro Piccolomini, *Della institutione di tutta la vita dell'huomo nato nobile e in città libera* (Venice, 1552), bk. 9, sig. I6; and Pietro Belmonte, *Institutione della sposa* (Rome, 1587), sig. Bv; both are cited in Constance Jordan, *Renaissance Feminism: Literary Texts and Political Models* (Ithaca, NY, and London, 1990), 145.

57. Sperone Speroni, "Della cura famigliare," in *Dialoghi* (Venice, 1596), sig. H2v, cited in Jordan, *Renaissance Feminism*, 153n22.

58. Vives stresses this marital joining in chaps. 1–4 of the "Marriage" section of his *De institutione feminae Christianae*; see *The Education of a Christian Woman: A Sixteenth-Century Manual*, ed. and trans. Charles Fantazzi (Chicago and London, 2000), 175–222. Although Vives's emphasis on companionship as a principal reason for marriage distinguishes his treatise from others on the topic, his descriptions of a wife's duties are consistent with other Renaissance writers. For summaries of these views see Ruth Kelso, *Doctrine for the Lady of the Renaissance* (Urbana, IL, 1956), 78–121; and Ian Maclean, *The Renaissance Notion of Woman: A Study in the Fortunes of Scholasticism and Medical Science in European Intellectual Life* (Cambridge, 1980), 17–20, 55–60.

tive of this scene (ex. 1.4), each of the opening two lines concludes with a strong cadence, first to G, then to A. The rhythmic squareness of her declamation, unusual for Peri, underscores the forceful assertion created by her immediate repetition of "quella" in line 1. Peri regularly introduces B♭ accidentals during the first line, then clears them away at line 2 as if in obedience to Euridice's "sgombrate" command. The short speech employs the widened harmonic vocabulary more often associated with Orfeo. Its harmonic extremes, G minor and E major, are also the two chords whose sudden juxtaposition in scene 2 mirrored the harshness of Euridice's misfortune. She appropriates the musical symbols of her death and enlists them in service to the strong cadences that punctuate her commands.

As noted above, Rinuccini called attention to his alteration of the traditional narrative by writing a libretto in which Euridice affirms her husband's success using language derived from these earlier versions. The audience certainly would have noticed the opera's deviation from its classical sources and might therefore have invested the alteration with particular meaning. Peri realized the importance of this moment: Euridice's single line takes the form of a response to a question that had moved to the sharp end of the natural hexachord, concluding with a cadence to A. With great deliberation Euridice guides this sharp extreme back to the neutral realm of happy endings (ex. 1.5), treating A as the dominant of D, then moving by fifth motion through G, then C, and finally cadencing on F. Her vocal line clarifies her statement's meaning, first through the stress on the initial syllable of the dactylic "tolsemi" created by leaping down a fourth on the weak syllables, then by the rhythmic emphasis with which she names her liberator. The deliberate descent from c″ to f′ accompanying the final cadence underscores Euridice's clarity of purpose in this, her final utterance.

Through their construction of a Euridice whose musical style ultimately mirrors that of her husband, Peri and Rinuccini confirmed her position as the true and legitimate spouse of Arcadia's foremost orator. The creation of a well-suited pair in turn sheds light on one possible reading of the opera's political allegory. Following a long-established tradition of treating Eurydice as an allegorical object, whose acquisition and subsequent loss reflect the abilities and character of Orpheus, the Euridice who mirrors Orfeo's character, whose very existence demonstrates his *virtù*, may be seen to represent Florence itself.[59] The resulting allegory might be summarized as follows: Ferdi-

59. On the tradition of treating Eurydice as an allegorical object, see Newby, *A Portrait of the Artist*, 77–128. For a summary of later fourteenth-century Christian allegories of the fable, see Sternfeld, *The Birth of Opera*, 7–16. A classic study of mythological figures' roles in Re-

nando I, determined to reverse the close alliance with the Habsburgs that had dominated Medici foreign policy, single-handedly restores equilibrium to Florence by means of two French marriages, the second of which also carries the hope of restoring peace in France by means of Henri's conversion. Florence expresses her joy at Ferdinando's success and proclaims him the city's true and legitimate ruler.

Music plays a crucial role in this reading of *Euridice*. More important, Peri's surviving musical score suggests that composers of early seventeenth-century operas did attempt to realize characters musically. In 1621, the issue of the musical construction of female characters would become especially important and increasingly politicized, as government of the grand duchy succeeded to women. Court sponsorship of art, music, and theater began to promote a new vision of legitimate authority, presenting Florentine audiences and influential visitors with numerous models of virtuous and powerful leaders, all of them female.

naissance allegory remains Jean Seznec, *The Survival of the Pagan Gods: The Mythological Tradition and Its Place in Renaissance Humanism and Art,* trans. Barbara F. Sessions (New York, 1953).

EXAMPLE 1.1. Three cadence types in early seventeenth-century opera

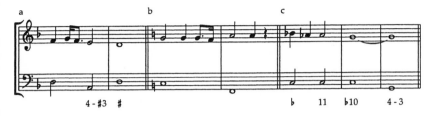

4 - ♯3 ♯ ♭ 11 ♭10 4 - 3

EXAMPLE 1.2. Jacopo Peri, *L'Euridice*, scene 4. Proserpina appeals to Pluto: "Oh king, in whose appearance I am so satisfied that it is sweet and dear to me to exchange the serene and clear sky for these shadows, oh, welcome lover, if you ever found collected in this breast a pleasant liquid for your amorous thirst, if to your free and unfettered heart these tresses were sweet snares and traps, [then] appease the tears of such a gentle lover."

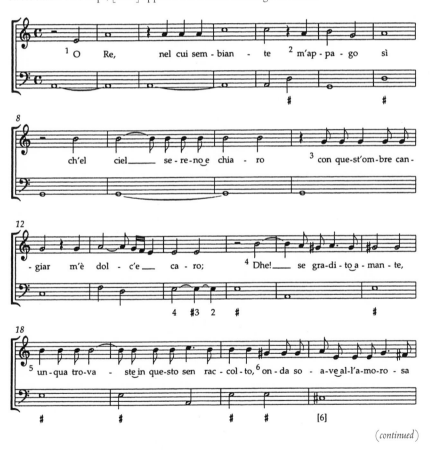

(*continued*)

EXAMPLE 1.2. (*continued*)

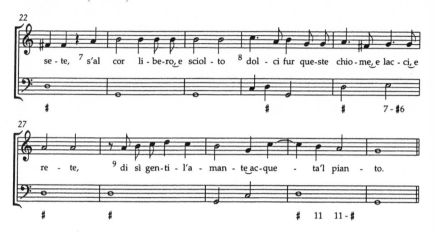

EXAMPLE 1.3. Jacopo Peri, *L'Euridice*, final scene. Orfeo responds to his friends: "I tempered so sweetly modes now gentle, now sad, [such] fervid prayers and weak sighs, that I aroused pity in the implacable heart. Thus the dear beauty was the reward, was the trophy for my singing."

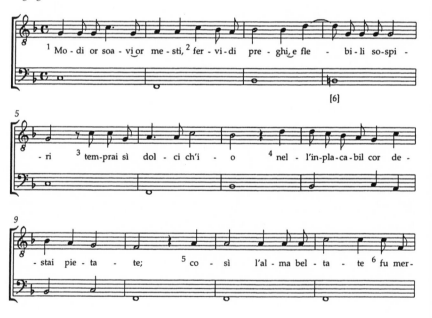

EXAMPLE 1.3. (continued)

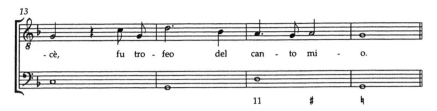

EXAMPLE 1.4. Jacopo Peri, *L'Euridice*, final scene. Euridice's first speech to her friends on returning from the underworld: "I am she, she for whom you wept. Clear away all sadness, beloved maidens, why are you still doubtful, why are you pensive?"

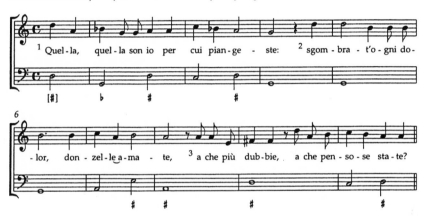

EXAMPLE 1.5. Jacopo Peri, *L'Euridice*, final scene. Euridice's final speech: "Orpheus took me away from the gloomy realm."

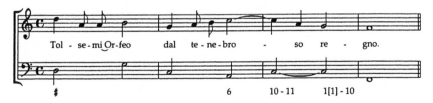

"A more than virile prudence"

Archduchess Maria Magdalena

The ancients pretended that Minerva had her birth only from the head of Jove; in my opinion, they wanted to signify in this way that women had no part in prudence, but whoever was the author of such a silly lie should be silent, because, although there might be some truth in it among common women, it is absolutely false among noble women. We saw in our archduchess a more than virile prudence: we saw her, in managing royal affairs, join native talent to a firmness of perfect judgement; we saw her most vigilant in her government.[1]

With these words of 1631, the Medici court poet Andrea Salvadori paid homage to the city's former grand duchess, Maria Magdalena, crediting her with Florence's political stability at a time when much of northern Italy had been devastated by war. It was for her funeral that the poet composed the tribute, which not only eulogized Maria Magdalena as an exemplary mother, wife, and sister but as a brave, pious, and wise ruler, lauding her as the new Astraea, whose just government was admired widely throughout Italy (413). Salvadori also praised the archduchess's activities as a patron, citing her support not only of religious institutions (412–13) but of the arts and sciences, singling

1. "Finsero gl'antichi che solo dalla testa di Giove avesse il suo natale Minerva; vollero à mio giudizio in tal guisa significare, che le donne non hanno parte nella prudenza, ma taccia pure qualunque egli si fosse l'autore di si vana finzione, poscia che quando ciò sia vero tra le femmine del volgo, è falso assolutamente tra le Donne Reali. Vedemo noi nella nostra Arciduchessa prudenza più che virile, la vedemo ne Reali maneggi congiungere a una nativa [f]inezza d'ingegno, saldezza di perfetto giudizio, la vedemo vigilantissima nel suo governo" (Andrea Salvadori, *Orazione panegirica,* in *Poesie,* 2 vols. [Rome, 1668], 2:414). A manuscript copy survives in I-Fn, Manoscritti II.II.505, *olim* Magliabechiano [Magl.] XXXVII.169. Future references will be to the published version and will be in the text. Salvadori delivered his oration on 15 November 1631 in the Congregazione di Beato Ippolito Galantini.

out for particular praise her positive and lasting influence on Florentine music and theater: "Because of her, melody returned to its first glory; because of her, theater saw its ancient greatness" [*Per lei tornò la melodia alla sua prima gloria: per lei vide il Teatro la sua antica grandezza* (417)]. Salvadori was right—the period of the regency was one of the most musically active decades of the early seventeenth century in Florence, with performances of four fully sung operas. Maria Magdalena's tastes in music and theater were probably formed during her childhood in Graz: among the didactic works performed by the students at the Jesuit university were plays based on the lives of Saint Dorothy (1595, 1607), Saint Catherine of Alexandria (1597), Saint Helen (1601), Judith (1603), Saint Cecilia (1603), and Saint Mary Magdalen (1604).[2] The archduchess continued this tradition in Florence, most conspicuously after her assumption of political power in 1621. Religious heroines became the most visible symbols of the Medici court during the decade of the 1620s, and this new emphasis on sacred subjects sparked both the later praise of Salvadori and the condemnation of historians of subsequent centuries.[3]

Through her patronage Maria Magdalena followed the example of her Medici predecessors. As seen in the previous chapter, many of the earliest images to allegorize the first grand dukes of Florence emphasized dynastic continuity and identified the Medici rulers with mythological gods. As a woman and a foreigner, Maria Magdalena's needs differed from her male counterparts, who derived at least a portion of their legitimacy from their position within a system of male succession that stretched back, in the popular imagination at least, to Cosimo il Vecchio. Instead of mythological and dynastic themes, therefore, Maria Magdalena turned to subjects that could both assert women's political rights and provide a spiritual basis for that legitimization, namely, the numerous exemplary women who populate the bible and hagiography—women who drew their power and authority directly from God.

2. Jean-Marie Valentin, *Le théâtre des Jésuites dans les pays de langue allemande: Répertoire chronologique des pièces représentées et des documents conservés (1555–1773)*, 2 vols. (Stuttgart, 1983–84), 1:29–97. See also Hannes Drawetz, "Die geistliche und weltliche Dramatik an der Grazer Universität," *Zeitschrift des historischen Vereines für Steiermark* 53 (1962): 345; Rudolf Flozinger, "Musik im grazer Jesuitentheater," *Historisches Jahrbuch der Stadt Graz* 15 (1984): 11–13; and Theodor Graff, "Grazer Theaterdrucke: Periochen und Textbücher (16.–18. Jh.)," *Historisches Jahrbuch der Stadt Graz* 15 (1984): 250.

3. Maria Magdalena was acutely aware of the need for those in political power to foster the appearance of piety; she counseled her son Matthias, then governor of Siena, to frequent those churches with the greatest confluence of people [*dov'è maggiore il concorso del popolo*], cited (and condemned) by Estella Galasso Calderara, *Un'amazzone tedesca nella Firenze Medicea del '600: La Granduchessa Maria Maddalena D'Austria* (Genoa, 1985), 126.

Biblical women and saints informed the subjects of four large-scale spectacles presented at court from 1621 to 1628, while assertive female protagonists appeared in four additional secular works (table 2.1).[4] These eight performances were indispensable components of the festivities surrounding the visits of high-ranking visitors of state—the very occasions for which political allegory was necessary—and as we shall see in subsequent chapters, documentary evidence confirms that Maria Magdalena took an active role in choosing subject matter, auditioning singers, and attending rehearsals.

Four categories emerge among these spectacles' valiant female protagonists. First are the virgin martyrs: Saint Agatha converts the people of Catania to Christianity and liberates them from a despotic Roman proconsul, while Saint Ursula similarly saves Cologne from the Huns with the help of her 11,000 virgins, achieving through chastity what the Roman army is unable to accomplish in armed combat. The category of the chaste widow is exemplified by the heroine Judith, who vanquishes Holofernes and rescues the Jewish people through the singularly decisive act of decapitating the general using his own sword (*La Giuditta*). As an example of the third category—the beneficent sorceress—Melissa single-handedly defeats Alcina and frees Ruggiero from the bonds of illicit love in *La liberazione di Ruggiero*. And the mythological goddess Venus enforces the decree of Jupiter and brings about the marriage between Flora and Zephyr, thus ensuring the renewal of spring (*La Flora*). These heroines reminded potential allies and enemies alike of the political clout wielded by the spiritually armed woman.

Similar images pervaded the literary and visual arts connected to or commissioned by Maria Magdalena. Niccolò Lorini del Monte—the same Do-

4. I have used the term "court performance" to refer to performances that took place in any one of four locations: the Uffizi, the Palazzo Pitti, the Casino Mediceo, which was at that time the residence of Cardinal Carlo de' Medici, and the Villa Poggio Imperiale, Maria Magdalena's own villa. A court diary compiled by Cesare Tinghi and others provides the most extensive contemporary descriptions of these performances (I-Fn, Gino Capponi 261, vols. 1 and 2 [through November 1623]; I-Fas, Misc. Med. 11 [through 1644]). Angelo Solerti transcribed many, but not all entries concerning music and spectacle in *Musica, ballo e drammatica alla corte Medicea dal 1600 al 1637: Notizie tratte da un diario, con appendice di testi inediti e rari* (Florence, 1905; reprint, New York and London, 1968), 157–95. See also Tim Carter, *Jacopo Peri (1561–1633): His Life and Works*, 2 vols. (New York and London, 1989), 1:85–102; Federico Ghisi, "Ballet Entertainments in Pitti Palace, Florence, 1608–1625," *Musical Quarterly* 35 (1949): 434–36; Warren Kirkendale, *The Court Musicians in Florence during the Principate of the Medici with a Reconstruction of the Artistic Establishment* (Florence, 1993), 163, 230, 321–24, 371–72, 594–95, 608–13; Sara Mamone, *Il teatro nella Firenze medicea* (Milan, 1981), 12–13; A. M. Nagler, *Theatre Festivals of the Medici 1539–1637* (New Haven, CT, and London, 1964), 134–61; and Robert L. Weaver and Norma W. Weaver, *A Chronology of Music in the Florentine Theater, 1590–1750* (Detroit, 1978), 103–12.

minican priest who bore responsibility for forwarding to Rome Galileo's letter of 1613—praised the strength and spiritual integrity of Agatha, Ursula, and Judith, among others, in his *Elogii delle più principali S. donne del sagro calendario,* which he dedicated to Maria Magdalena in 1617.[5] A few years later, a similar but much lengthier treatise was also dedicated to the archduchess: Cristofano Bronzini's multivolume work entitled *Della dignità, e nobiltà delle donne.*[6] Bronzini included the archduchess among the worthy women of history, describing her as "a new Amazon in Tuscany" [*una nuova Amazone in Toscana*], and he praised her hunting and riding abilities, as well as her strength, prudence, goodness, clemency, liberality, and religious devotion.[7] Bronzini also linked court spectacle to his proposed reassessment of female virtues: he inserted a lengthy description of the 1626 Judith opera within his presentation of the Old Testament heroine, whom he cited as a model of women's strength, wisdom, and courage.[8]

In 1622, shortly after assuming power, Maria Magdalena purchased the Villa Baroncelli, which she renamed Villa Poggio Imperiale in honor of her Habsburg lineage.[9] Over the next two to three years Poggio Imperiale would emerge as the archduchess's most conspicuous and lasting monument to heroic female *virtù.* For each of the rooms associated most closely with her, Maria Magdalena commissioned ten lunette frescoes depicting heroines from history, hagiography, and the Bible, including nearly all the protagonists featured

5. Niccolò Lorini del Monte, *Elogii delle più principali S. donne del sagro calendario, e martirologio romano, vergini, martiri, et altre* (Florence, 1617), 42–56, 298–312.

6. Bronzini intended to organize his treatise along lines similar to Boccaccio's *Decameron,* expanded to include twenty-four dialogues that take place over a period of four weeks. Only the first eight dialogues were actually published. I would like to thank Suzanne Cusick for first calling my attention to the published treatise. A manuscript of the entire work is also extant ("Della dignità, e nobiltà delle donne," I-Fn, Magl. VIII.1513–38).

7. Cristofano Bronzini, *Della dignità, e nobiltà delle donne,* 8 vols. (Florence, 1622–32), 3:54–76.

8. Bronzini, "Della dignità, e nobiltà delle donne," I-Fn, Magl. VIII.1522/1, pp. 209–36.

9. The villa is now the Collegio Statale delle SS. Annunziata. For a history of Poggio Imperiale, see Ornella Panichi, *Villa di Poggio Imperiale: Lavori di restauro e di riordinamento 1972–1975* (Florence, n.d.), and "Due stanze della villa del Poggio Imperiale," *Antichità viva* 12, no. 5 (September–October 1973): 32–43; Matteo Marangoni, *La villa del Poggio Imperiale* (Florence, n.d.); and Cesare da Prato, *R. Villa del Poggio Imperiale oggi R. Istituto della SS. Annunziata: Storie e descrizioni* (Florence, 1895). The following studies are devoted to the artworks commissioned for individual rooms: Fiammetta Faini Guazzelli, "La volticina del Poggio Imperiale: Un'attribuzione sbagliata," *Antichità viva* 7, no. 1 (January–February 1968): 25–34; Silvia Meloni Trkulja, "Appendice: I quadri della Sala dell'Udienza," *Antichità viva* 12, no. 5 (September–October 1973): 44–46; and Julian Kliemann, *Gesta dipinte: La grande decorazione nelle dimore italiane dal Quattrocento al Seicento* (Milan, 1993), 181.

TABLE 2.1. Florentine State Spectacles Featuring Female Protagonists, 1621–28

Date of Performance	Title (Date of Publication) / Location of Manuscript Libretto	Female Protagonist	Poet	Composer(s)	State Occasion
22 June 1622	Il martirio di Sant'Agata (Florence, 1624)	Saint Agatha	Jacopo Cicognini	Giovanni Battista da Gagliano and Francesca Caccini	Visit of Don Manuel de Zuñiga, count of Monterey and ambassador from Spain
3 February 1623; repeated 8, 21 February	Le fonti d'Ardenna: festa d'arme e di ballo (Florence, 1623); text alone in Salvadori, Poesie, 1:394–408	Melissa	Andrea Salvadori	Marco da Gagliano	Visit of Henri II Bourbon, prince of Condé
6 October 1624	La regina Sant' Orsola (argomento pub. Florence, 1624)	Saint Ursula	Andrea Salvadori	Marco da Gagliano (music lost)	State visit of Archduke Karl of Austria

Date	Work	Character	Librettist	Composer	Occasion
28 January 1625	*La regina Sant' Orsola* (Florence, 1625; also Salvadori, *Poesie*, 1:1–90 and I-Fn, Magl. VII.1285, fols. 276r–316bis)	Saint Ursula	Andrea Salvadori	Marco da Gagliano (music lost)	Visit of Prince Władysław of Poland
3 February 1625	*La liberazione di Ruggiero dall'isola d'Alcina* (libretto and score published Florence, 1625)	Melissa	Ferdinando Saracinelli	Francesca Caccini	Visit of Prince Władysław of Poland
10 February 1625	*La precedenza delle dame* (Florence, 1625; also Salvadori, *Poesie*, 1:422–31)	Pallas Athena	Andrea Salvadori	Jacopo Peri (music lost)	Visit of Prince Władysław of Poland
22 September 1626	*La Giuditta* (Salvadori, *Poesie*, 1:91–128; I-Rvat, Barb. lat. 3839, fols. 66r–94v)	Judith	Andrea Salvadori	Marco da Gagliano (music lost)	Visit of Cardinal Francesco Barberini, papal nuncio, and his papal legation
14 October 1628	*La Flora* (libretto and score published Florence, 1628)	Venus	Andrea Salvadori	Marco da Gagliano and Jacopo Peri	Marriage of Princess Margherita de' Medici and Duke Odoardo Farnese

in the musical spectacles performed at court during her rule. Other rooms portrayed the deeds of past and present Habsburg emperors. A rhymed, hendecasyllabic quatrain accompanied each fresco, fixing the meaning of each visual image by interpreting the relevance of its scene to history and Christianity.

Unlike her contemporary, Queen Maria de' Medici of France, whose own image figured prominently in the series of allegorical representations that she commissioned from Rubens, Archduchess Maria Magdalena chose to depict illustrious representatives of her family and her gender in Poggio Imperiale. Her commissions were intended, no less than those by the queen of France, to legitimate her exercise of power, but rather than encomia they functioned as metaphors. Visitors to Maria Magdalena's villa would undoubtedly have recognized that its two prominent trajectories of praise—exemplary women and the Habsburg dynasty—intersected in the person of the archduchess.

In her bedroom the archduchess surrounded herself with frescoes of female saints, namely (starting with the west wall and proceeding counterclockwise), Christina of Bolsena, Agnes, Cecilia, Agatha, Barbara, Margaret, Apollonia, Dorothy, Lucy, and Helen.[10] Although nine of these saints were virgin martyrs—Saint Helen is the only exception—the quatrains below each lunette focus on a variety of attributes. Individual saints are praised for their chastity and their steadfast faith, but others are commended for their courage and daring. For example, disdaining death, Saint Apollonia deprives her tormentors of satisfaction by leaping into the fire, while Saint Helen's discovery of the cross exceeds all exploits of contemporary explorers:

> Let even he, who with productive mind
> discovered a new world and a new people,
> yield to you Helen, for it is a greater challenge
> to have found the sacrosanct wood.[11]

10. At least four painters have been credited with one or more of these frescoes: Matteo Rosselli (Christina of Bolsena and Margaret), Ottavio Vannini (Agnes and Apollonia), Anastasio Fontebuoni (Agatha), and Domenico Pugliani (Helen). I have been unable to find attributions for the remaining frescoes in the bedroom. See Giuseppe Cantelli, "Mitologia sacra e profana e le sue eroine nella pittura fiorentina della prima metà del Seicento (I)," *Paradigma* 3 (1982): 161 and fig. 66, for the attribution to Pugliani, and his *Repertorio della pittura Fiorentina del Seicento* (Fiesole, 1983), 82, 131, 138, for those to Fontebuoni, Rosselli, and Vannini (Apollonia only). Roberto Contini adds the Agnes fresco to those works credited to Vannini (*Bilivert: Saggio di ricostruzione* [Florence, 1985], 60n107). Filippo Baldinucci confirms only the Fontebuoni attribution (*Notizie dei professori del disegno da Cimabue in qua*, ed. Ferdinando Ranalli, 5 vols. [Florence, 1845–47], 4:336).

11. "CEDA PUR QUEL CHE COL FELICE INGEGNO / RITROVÒ NUOVO MONDO E GENTE NUOVA / ELENA CEDA À TE CH'È MAGGIOR PROVA / AVER TROVATO IL SACROSANTO LEGNO."

Courageous deeds are also the common attribute of the biblical heroines who guarded the adjacent antechamber: the pharaoh's daughter who rescued Moses, Moses' sister Miriam, the mother of the Maccabean martyrs, Rebekah, Zipporah, Susanna, Deborah, Jael, Judith, and Esther.[12] Their lunettes illustrate the bold, and sometimes transgressive, acts performed by women in the Old Testament in order to uphold God's will. Zipporah herself circumcises her son in order to save Moses from death (Exod. 4:24–26), while Rebekah deceives her husband Isaac in order to fulfill the prophecy that her younger son Jacob would rule his older brother Esau (Gen. 25:23, 27:1–29). Besides what its quatrain describes as Rebekah's "beautiful fraud," fully half of the antechamber lunettes condone deception in light of the greater good: Pharoah's daughter saves and hides the infant Moses (Exod. 2:1–22), Esther initially hides her Jewish heritage from her husband (Esther 2:20), Judith promises sex and delivers decapitation to the general Holofernes (Jth. 12:14–20; 13:1–9), and Jael extends hospitality to the fleeing Sisara, then drives a tent peg into his head (Judg. 4:17–24). This concentration of subject matter suggests that Maria Magdalena and her advisers had read Agrippa, whose defense of the female sex noted: "Does one not see also in Holy Scripture the iniquity of the woman more often blessed and praised than the good actions of the man?"[13]

Defending God's will sometimes required military action, according to the anteroom frescoes. The lunettes of Deborah, Jael, and Judith make this point explicit, and their adjacent positioning on the south and west walls creates a narrative of female heroism: Deborah leads her troops into battle, liberating

12. I have located attributions for seven of the lunettes: to Bartolomeo Salvestrini for Deborah (Contini, *Bilivert*, 60n107); Giovanni Battista Ghidoni for Susanna (Roberto Contini, "Una mappa dell'influsso di Artemisia Gentileschi a Firenze," in *Artemisia*, ed. Roberto Contini and Gianni Papi [Rome, 1991], 195n13); Giovan Battista Vanni for Esther and Judith (Francesca Baldassari, "Giovan Battista Vanni," in *Il Seicento fiorentino: Arte a Firenze da Ferdinando I a Cosimo III*, 3 vols. [Florence, 1986], 3:178); and Francesco Montelatici, also known as Cecco Bravo, for Miriam (Anna Barsanti, "Cecco Bravo [Francesco Montelatici]," in *Il Seicento fiorentino*, 3:49) and for Judith (Cantelli, "Mitologia sacra e profana," 162 and fig. 69). Contini (*Bilivert*, 60n107) notes the strong possibility that students of Giovanni Bilivert also executed the frescoes on the subjects of the Maccabees and Rebekah. Cantelli stands alone in his attribution of the Judith fresco to Cecco Bravo, and the work is not mentioned in two recent studies on the painter, Giovanni Pagliarulo, "*Iuvenilia* di Cecco Bravo," *Paradigma* 11 (1996): 31–48; and Anna Barsanti and Roberto Contini, eds., *Cecco Bravo, Firenze 1601-Innsbruck 1661: Pittore senza regola* (Milan, 1999).

13. Henricus Cornelius Agrippa, *Declamatio de nobilitate et praecellentia foeminei sexus* (Anvers, 1529), translated into English by Albert Rabil, Jr., as *Declamation on the Nobility and Preeminence of the Female Sex* (Chicago, 1996), 67.

the people of Israel by putting Sisera to flight (Judg. 4:1–16) and driving him to his fate at the hand of Jael, depicted in the next lunette. Beside Jael appeared a similar story, that of Judith, but in this fresco the painter stressed the heroic aftermath of the heroine's actions. The quatrains accompanying both the Jael and Judith frescoes conclude with the assertion that, with God's help, gender is not a barrier to heroic deeds. Jael's story reminds the spectator that "the weak hand overcomes the prouder [ones]" [*che debil mano i più superbi atterra*], while Judith's actions confirm "the Lord has conquered by the hand of Woman" (see fig. 4.3, 125). Through their actions all the women depicted except Susanna and, possibly, Rebekah, save the people of Israel, providing models for and legitimization of women's exercise of government.

But the room with the greatest communicative potential was the archduchess's audience room—the physical space most closely linked to her political persona. Conforming to contemporary notions of decorum, in which a room's decorations should reflect its purpose, the archduchess met important state visitors under the watchful gaze of ten historical female sovereigns: Matilda, Galla Placidia, Costanza of Sicily, and Isabella of Castile, as well as saints Ursula, Pulcheria, Clothilde, Catherine of Alexandria, Augusta of Treviso, and Elizabeth of Portugal (see app. A).[14] Although the worthies depicted in the ten paintings date from the fourth to sixteenth centuries, all were Christian women of royal birth. Virgins, wives, and widows all received representation. Half had governed states: like the archduchess, Galla Placidia, Pulcheria, and Costanza had served as regents for their younger, inexperienced male relatives, while Matilda and Isabella exercised independent rule of their own inheritances. All were renowned for their piety—more than half were saints—and the lunettes celebrated their contributions to the church. The saints Ursula, Catherine of Alexandria, and Augusta of Treviso endured martyrdom for their faith. The frescoes credit Clothilde and Isabella with expanding the reach of Catholicism, while the empresses Galla Placidia and Pulcheria receive praise for protecting Christian realms from destruction by invaders.[15]

Many of these female figures recur in other projects connected to or car-

14. Attributions are as follows: Matteo Rosselli for Matilda, Galla Placida, Pulcheria, and Elizabeth of Portugal (Cantelli, "Mitologia sacra e profana," 161 and fig. 65; *Repertorio*, 131); and Ottavio Vannini for Ursula and Clothilde (Cantelli, *Repertorio*, 138). On seventeenth-century notions of decorum, see John Beldon Scott, *Images of Nepotism: The Painted Ceilings of Palazzo Barberini* (Princeton, NJ, 1991), 14.

15. Pulcheria's fresco and its quatrain appear to credit the empress for saving Constantinople from attack by the Huns.

ried out by the archduchess during the period of the regency, attesting to the unified nature of her self-fashioning. She personally exerted influence on behalf of the canonization of Elizabeth of Portugal (1271–1336), efforts that were successful on 25 May 1625.[16] Ursula was the protagonist of an opera staged twice during the period of the regency. Five of the audience room subjects also appeared in the contemporaneous treatise by Bronzini, and in three cases his descriptions may have influenced the artists who executed the villa's frescoes. Just as the single sentence that Bronzini devotes to Queen Costanza of Sicily notes that her prudent use of clemency ensured her own immortality, the fresco depicts the magnanimous queen showing mercy to Prince Charles of Salerno, despite her subjects' desire to avenge the death of her cousin Conradin at his hands.[17] While a heavenly dove descends with the holy oil of consecration, the Frankish queen Clothilde oversees the baptism of her husband Clovis in the fresco painted by Ottavio Vannini, a scene that Bronzini described in detail.[18] The military armor of Matilda of Canossa, who confidently leads the pope back to Rome, recalls Bronzini's lengthy description of "The Great Countess," in which he praises her chastity, wisdom, eloquence, and courage (fig. 2.1). Matilda accomplished more for the church and the papacy than any of the kings or emperors who were her contemporaries, Bronzini asserts—she was an unconquered warrior for God.[19]

Maria Magdalena and her advisers appear to have chosen subjects that would remind those seeking an audience with the archduchess of the wide range of virtues of which female rulers were capable. In 1622 Bronzini had already acknowledged the breadth of virtues possessed by the archduchess,

16. Maria Magdalena's efforts are recognized in a letter from Miguel Suares to the archduchess, dated 28 May 1625, which contains news of the canonization (I-Fas, MDP 6081, n.p.).

17. Bronzini, *Della dignità*, 6:73. Bronzini cites bk. 5 of the sixteenth-century *Compendium* by Collenuccio. This account, which includes a dialogue between the queen and her prisoner, also appears to be the source for the quatrain accompanying the Poggio Imperiale fresco. See Pandolfo Collenuccio, *Compendio de le istorie del regno di Napoli*, ed. Alfredo Saviotti (Bari, 1929), 183–84.

18. Bronzini, *Della dignità*, 5:4–5.

19. "Havendo ella fatto per la Chiesa di Dio, e per li Sommi Pontefici, li quali furono ne' suoi tempi, più di quello, che mai facesse alcun Rè, ò Imperatore: Stata guerriera invitta per Dio" (Bronzini, *Della dignità*, 2:57; see also 100–129). Bronzini praises the political leadership of both Isabella and Pulcheria (3.18, 21–32; 5.18–19), but the Poggio Imperiale frescoes illustrate events not included in the treatise. Bronzini does not mention Columbus in his description of the Queen of Spain, but, in reference to her expulsion of the Moors from Granada, he does praise her sole desire to enlarge the realm of Catholicism ("non haveva altro in cuore, che ad ampliare la Fede Cattolica di Christo Signor Nostro" [3:23]).

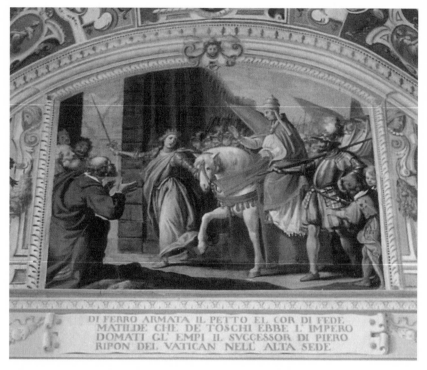

FIGURE 2.1. Matteo Rosselli, *Matilda Leads Pope Gregory VII Back to Rome* (Florence, Poggio Imperiale). Photograph by author.

whom he praised as "a true portrait of strength, prudence, goodness, clemency, generosity, humanity, and religion, and a compendium of perfect glory."[20] The Poggio Imperiale frescoes realize visually this compendium, with additional explication provided by the interpretive quatrains. For example, as the armed Matilda reinstates the pope on his rightful throne, her upraised sword recalls representations of both Strength (Fortezza) and Justice (Giustizia) as described by Cesare Ripa.[21] The remaining frescoes provide examples of the other attributes that Bronzini associated with the archduchess, namely, courage (Ursula), religion (Clothilde), prudence (Galla Placidia and Pulcheria), clemency (Costanza), magnanimity (Isabella), eloquence (Catherine), fortitude (Augusta), and liberality (Elizabeth). At least one of the frescoes also provides commentary on the benefits of patronage—as a clear demonstra-

20. "Un vero Ritratto di fortezza, di Prudenza, di Bontà, di Clemenza, di Liberalità, d'Humanità, e di Religione, ed un Compendio di perfetta Gloria" (Bronzini, *Della dignità*, 3:54).
21. Cesare Ripa, *Iconologia* (Padua, 1611; reprint, New York and London, 1976), 181, 202–3.

tion of the extent to which proprietary claims accrued to a patron, the quatrain beneath the lunette of Isabella of Spain reads:

> If Columbus furrows the deep expanse of inhospitable sea
> and arrives at a new land,
> Oh famous Isabella, to you should be credited
> the immortal discovery of the new world.[22]

Although the subjects of the ten lunettes were all Christians, who accomplished their feats on behalf of and, in some cases, due to the intervention of God, Maria Magdalena's audience room also asserted that women from the pre-Christian era provided exemplary models of chastity, fidelity, and leadership. The vehicles for this message were four large canvases depicting Artemisia, Semiramis, Lucretia, and Sophonisba.[23] The subjects appear to have been chosen with particular concern for their relevance to the archduchess's situation.[24] Queen Artemisia (d. ca. 340 B.C.) was a widow who demonstrated her continued devotion to her husband by drinking a potion made from his ashes. She ruled the kingdom for approximately three years after her husband's death, during which time she was renowned for her military expertise.[25] Semiramis (Sammu-ramat) was an Assyrian queen from the ninth cen-

22. "SE DI INOSPITO MARE IL SEN PROFONDO / APRE IL COLOMBO E A NOVA TERRA ARRIVA / O FAMOSA ISABELLA A TE S'ASCRIVA / LA SCOPERTA IMMORTAL DEL NOVO MONDO."

23. Meloni Trkulja, "Appendice," 44–46. The archduchess apparently asked Cardinal Giulio de' Medici to help her locate artworks with appropriate, nonlascivious female subjects: see Elena Fumagalli, "Pittori senesi del Seicento e committenza medicea: Nuove date per Francesco Rustici," *Paragone* 479–81 (1990): 71–72.

24. The principal source for the subject matter of all four paintings was apparently Giovanni Boccaccio, *De mulieribus claris*, possibly in its Italian translation by Giuseppe Betussi, published as *Libro di M. Gio. Boccaccio delle donne illustri* (Venice, 1545). Subsequent quotations will be drawn from this edition. For a side-by-side Latin and English edition, see Giovanni Boccaccio, *Famous Women*, ed. and trans. Virginia Brown (Cambridge, MA, 2001).

25. Boccaccio (fols. 71r–74r) conflates two queens named Artemisia who lived a century apart—the fifth-century B.C. warrior praised by Herodotus and the fourth-century B.C. wife of King Mausolus. This combined Artemisia was also predominant in the seventeenth century, as the account of Bronzini (*Della dignità*, 2:81–85) demonstrates. Bronzini devotes almost his entire entry to the successes of Artemisia as a ruler and a warrior; her drinking of her husband's ashes is mentioned only as part of a poem by Cesare Cremonino that Bronzini reproduces (2:84–85). Maria Magdalena later may have wanted to distance herself from Artemisia: in her funeral oration Andrea Salvadori argues that the widowed archduchess was nothing like the queen of Caria, for she did not built a pompous mausoleum for her dead

tury B.C., credited with the restoration of Babylon but infamous for her military and sexual exploits.[26] By contrast, the sixth-century B.C. Roman matron Lucretia was an exemplum of chastity, having committed suicide after being raped.[27] According to Livy, Queen Sophonisba of Numidia (d. 203 B.C.) drank poison rather than become a Roman captive.[28]

The four paintings depict heroines who remained steadfastly loyal to their husbands, conserving their husbands' reputations and, in the cases of Artemisia and Semiramis, maintaining the strength of their realms. But the lives and deeds of three of these four women—at least as they were understood in the seventeenth century—also rendered each problematic. Lucretia's suicide was clearly difficult to reconcile with Christian belief. Sophonisba's suicide in order to avoid becoming a prisoner had even less moral support than did Lucretia's. Furthermore, in Livy's account, repeated by Boccaccio, not only had Sophonisba convinced her first husband King Syphax to switch his

husband, nor did she drink his ashes. Rather, she prayed for his soul and kept his memory in her heart (*Poesie*, 2:411).

26. The legendary life of Semiramis was recounted by numerous authors from antiquity through the early seventeenth century. Boccaccio (*Delle donne illustri*, fols. 2v–4v) devoted his second chapter to her. Bronzini (*Della dignità*, 2:46–64) treats the queen in an exceptionally long essay, praising her rule of forty-two years (48) and stressing her modesty, claiming (56) that the tales of Semiramis's concupiscence were lies "written by dishonest, iniquitous, and treacherous men" [*scritte da Huomini mendaci, iniqui, e perfidi*]. For an excellent overview of treatments of Semiramis through the seventeenth century, see Wendy Beth Heller, "Chastity, Heroism, and Allure: Women in the Opera of Seventeenth-Century Venice" (Ph.D. diss., Brandeis University, 1995), 363–77.

27. Boccaccio, *Delle donne illustri*, fols. 59v–60v, who draws on Livy (*Ab urbe condita libri*, 1.57.7–59.1), although because the narrative is fairly consistent throughout other Renaissance sources (e.g., Juan Luis Vives, *The Education of a Christian Woman: A Sixteenth-Century Manual*, trans. Charles Fantazzi [Chicago and London, 2000], 60, 85–86, 300–301; or Agrippa, *Declamation*, ed. Rabil, 73–74) any of them could have been consulted. See Livy, *Ab urbe condita libri*, trans. Frank Gardner Moore, Loeb Classical Library, 14 vols. (Cambridge, MA, and London, 1949), 8:407–21. Bronzini did not mention Lucretia in his published treatise. Maria Magdalena may have had a particular interest in Lucretia: on 16 April 1621 she authorized the payment of 205¾ scudi to Abraham van Kinder, apparently a Flemish dealer living in London, for a "statuetta di Lucrezia Romana, fatta di mano di Alberto Duro [Albrecht Dürer]" (I-Fas, DG 1007, no. 65bis and 66; I-MDP 1848, fol. 704r). I have been unable to locate this or any other statuette by Dürer: it may, however, be the statuette of Lucretia attributed to the circle around Wenzel Jamnitzer dating from ca. 1540–45 and located in Florence's Museo Nazionale in the Bargello. See E. F. Bange, *Die Kleinplastik der deutschen Renaissance in Holz und Stein* (Florence, 1928), 89 and plate 97.

28. Livy, *Ab urbe condita libri*, 30.12.11–15.8, transmitted faithfully by Boccaccio, *Delle donne illustri*, fols. 88v–90v.

allegiance from Rome to Carthage, thus precipitating his defeat by the Romans, but then she agreed to marry his conqueror, King Masinissa.[29] And the supposed sexual misdeeds of Semiramis rendered her questionable as a model for queenly conduct: according to Boccaccio even her son numbered among her numerous lovers. But as with the room's frescoes, translating a narrative to the medium of visual art allowed the painter to isolate a single praiseworthy event from the lives of these heroines. All four paintings focus on the means by which women might exercise political power, a topic that would have been of concern to a female regent. In the case of Artemisia and Semiramis, the scenes chosen are consistent with each queen's standard iconography.[30] Francesco Curradi's *Artemisia* presents the pensive queen, who holds in her right hand a drink made from the ashes of her dead husband. Her consumption of his ashes demonstrates her devotion but it also allows her literally to internalize his essence, legitimating her continued rule after his death.

Lucretia exercised no direct political power. She ruled over nothing but herself, and her own body was the realm for whose inviolability she ultimately died. Renaissance conduct manuals often repeated her story, which became a popular subject for seventeenth-century Italian painters, who most often depicted her suicide or, in second place, the actual rape. But paintings of the moments following the suicide, such as the scene painted by Francesco Rustici for the audience room, appear much less frequently.[31] Lucretia's male relatives surround and support her lifeless body, as witnesses to both her suicide and the reason behind it. Their presence is crucial in order to highlight the political ramifications of Lucretia's act. The foregrounding of Lucius Junius Brutus, who removes the dagger from Lucretia's breast, emphasizes the narrative's continuation into military action, for according to Livy, it was at this moment that Brutus swore to avenge Lucretia and rid Rome of its kings.[32] In Maria Magdalena's audience room, the painting allowed the archduchess to reiterate the link between female chastity and the welfare of the state.

29. Livy, *Ab urbe condita libri*, 30.13.11–12; Boccaccio, *Delle donne illustri*, fol. 89r.

30. Based on the number of entries in A. Pigler, *Barockthemen: Eine Auswahl von Verzeichnissen zur Ikonographie des 17. und 18. Jahrhunderts*, 2d ed., 3 vols. (Budapest, 1974), 2:332, 341, 370–72, 403–9, 433–37.

31. Ibid., 2:403–8.

32. From Livy, *Ab urbe condita libri*, 1.59.1. Boccaccio (*Delle donne illustri*, fol. 60v) refers to the consequences only vaguely, noting that Lucretia's action led to Roman liberty. For the importance of the male onlookers as a reminder of the civic ramifications of Lucretia's suicide, see Maureen Quilligan, *The Allegory of Female Authority: Christine de Pizan's Cité des Dames* (Ithaca, NY, 1991), 156–61.

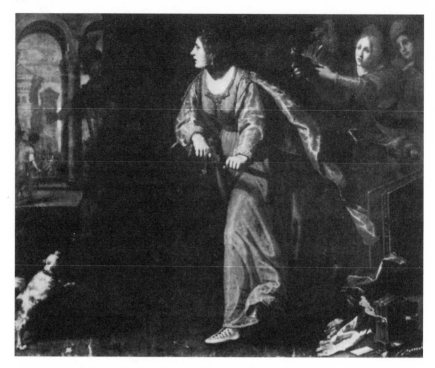

FIGURE 2.2. Matteo Rosselli, *Semiramis* (Florence, Villa della Petraia)

The paintings of Sophonisba and Semiramis problematize simple binary relationships between gender and behavior. Queen Semiramis was a heroine who was often described as occupying both masculine and feminine spheres. Boccaccio makes this point throughout his chapter on the Assyrian queen: he stresses her androgyny and her "manly spirit" in war, then notes the "feminine cunning" with which she exploits it. According to Boccaccio, by initially disguising her sex Semiramis demonstrated her awareness of a predicament that would still have been familiar to a female ruler in the seventeenth century: "It was almost as if she wanted to infer that not sex, but spirit, was appropriate for governing."[33] Present within Boccaccio's description is the scene painted by Rosselli, in which Semiramis leaps from her toilette with her hair only half done, in order to take up arms and quell a rebellion in her realm (fig. 2.2). The painter captures Semiramis's sense of purpose as she crosses the room from the domestic, interior scene at the right of the painting toward the outside, public sphere seen through the window on the left. Viewers would

33. "Volendo quasi per cio inferire, non il sesso, ma l'animo esser conveniente all'imperio" (Boccaccio, *Delle donne illustri*, fol. 3r).

have recalled Boccaccio's description of the incident, in which the queen abandoned all "womanly pursuits" until she achieved military victory.[34]

By contrast, Rutilio Manetti's melodramatic painting of *Masinissa and Sophonisba* alters the version of the story transmitted by Livy, Petrarch, and Boccaccio, all of whom relate that only Sophonisba's servant witnesses her suicide (plate 1). Manetti instead juxtaposes the newly married couple, in a composition apparently derived from the Byzantine chronicler John Zonaras.[35] Manetti does rely on Livy for his depiction of the impetuous warrior, whose mental instability after Sophonisba's death so concerned Scipio Africanus that he sent for the young king, fearing that he might do something desperate.[36] As Sophonisba drinks the poison, her new husband swoons in the arms of a servant, while the erect posture of his wife embodies the strength of spirit [*fortezza d'animo*] later accorded her by Bronzini, who notes that the queen faced her destiny "without for a moment sighing or [without] the smallest tear" [*senza punto di sospiro, ò di minima lagrima*], that is, without exhibiting the emotional behavior that in the Manetti painting is the sole province of its male character.[37]

Paintings of unswerving, active heroines dominated Maria Magdalena's bedroom, antechamber, and audience room in Villa Poggio Imperiale. But the archduchess was also particularly devoted to representations of her more contemplative namesake. For her chapel in Poggio Imperiale she commissioned a Magdalen cycle from Francesco Curradi, while, according to the 1625 inventory, twenty-five other Magdalen paintings adorned other walls in her villa, including Pietro Perugino's *Maddalena* (ca. 1494; now in Florence, Galleria Palatina) and Alessandro Allori's *Cristo in casa di Marta e Maria* (1605; now in Vienna, Kunsthistorisches Museum).[38] These works join other early

34. Boccaccio, *Delle donne illustri,* fol. 3v. The scene figures prominently in descriptions of Semiramis by Petrarch (*Triumphus Fame,* 2.103–5; see Francesco Petrarca, *Rime, Trionfi e poesie Latine,* ed. Ferdinando Neri et al. [Milan, 1951], 540) and, citing Petrarch, Bronzini (*Della dignità,* 54–55).

35. Included in Cassius Dio Cocceianus, *Dio's Roman History,* trans. Earnest Cary, 9 vols. (London, 1914), 2:222–57. Zonaras furthermore confirms that the union between Sophonisba and Masinissa is the legitimate one, reporting that the two had been engaged before Sophonisba's father decided that a marriage with King Syphax would better suit his political purposes. Bronzini (*Della dignità,* 5:82) also cites Zonaras as his source, but he does not describe a scene in which Masinissa witnesses his wife's suicide.

36. Livy, *Ab urbe condita libri,* 30.15.9.

37. Bronzini, *Della dignità,* 5:82.

38. I-Fas, GM 479, opening 1. See Marilena Mosco, "La cappella della Maddalena nella villa di Poggio Imperiale a Firenze," in *La Maddalena tra sacro e profano,* ed. Marilena Mosco (Mi-

seventeenth-century Florentine paintings of the Magdalen that art historians have associated with the archduchess, especially those by Artemisia Gentileschi, Rutilio Manetti, and Fabrizio Boschi.[39] The often ostentatiously pious archduchess even had herself portrayed as Saint Mary Magdalen, in a painting commissioned from court portraitist Justus Sustermans between 1625 and 1630 (fig. 2.3). The portrait is a relatively early example of the fashion of Magdalen portraits that became more prevalent during the later seventeenth and eighteenth centuries, and it marks Sustermans's first attempt at allegorical portraiture of Medici women, which he followed with portraits of the archduchess's daughter Margherita, as well as numerous renderings of Vittoria della Rovere, the future bride of Ferdinando II.[40]

Maria Magdalena and her family also celebrated the saint's feast day (22 July) with Mass and vespers in the archduchess's private chapel in the Pitti Palace, followed by a banquet and a short devotional drama with music. These may have been the occasions for performance of two Florentine monodies on the subject of Saint Mary Magdalen, Andrea Falconieri's "Maddalena chiedendo a Dio pietate" from his *Libro quinto delle musiche a una, due, e tre voci* (Florence, 1619), and Girolamo Frescobaldi's "Maddalena alla Croce," a spiritual sonnet from the first volume of his *Arie* (Florence, 1630).[41] The

lan, 1986), 158–59, 237–39; Evelina Borea, *Caravaggio e caravaggeschi nelle gallerie di Firenze* (Florence, 1970), 55–60; Simona Lecchini Giovannoni, *Alessandro Allori* (Turin, 1991), 80; and Pietro Scarpellini, *Perugino* (Milan, 1984), 101.

39. On the Gentileschi painting, see R. Ward Bissell, "Artemisia Gentileschi—a New Documented Chronology," *Art Bulletin* 50 (1968): 156, amplified in his *Artemisia Gentileschi and the Authority of Art: Critical Reading and Catalogue Raisonné* (University Park, PA, 1999), 26–29, 209–11; Mosco, "La cappella," 237; Mary D. Garrard, *Artemisia Gentileschi: The Image of the Female Hero in Italian Baroque Art* (Princeton, NJ, 1989), 40, 45; and Roberto Contini and Gianni Papi, eds., *Artemisia* (Florence, 1991), 129. For the Manetti, see Borea, *Caravaggio*, 55–56, 59–60; also Alessandro Bagnoli, ed., *Rutilio Manetti, 1571–1639* (Florence, 1978), 95–111.

40. Mary Haskins, *Mary Magdalen: Myth and Metaphor* (New York, 1993), 297–316. For descriptions and, in some cases, reproductions of these portraits, see Karla Langedijk, *The Portraits of the Medici: 15th–18th Centuries*, 3 vols. (Florence, 1981–87), 2:1224–5 (Margherita), 1475–1500 (Vittoria). Vittoria della Rovere appears to have taken this practice to extremes: Langedijk lists portraits in which the grand duchess is depicted not only as Saint Victoria but as Helen, Margaret, Ursula, and the Virgin Mary as well. See also Claudio Pizzorusso, *Sustermans: Sessant'anni alla corte dei Medici* (Florence, 1983), 35–43.

41. For the archduchess's patronage of music depicting the Magdalen, see Dinko Fabris, *Andrea Falconieri napoletano: Un liutista-compositore del Seicento* (Rome, 1987), 84–86; Frederick Hammond, *Girolamo Frescobaldi* (Cambridge, MA, 1983), 265, and "Girolamo Frescobaldi: New Biographical Information," in *Frescobaldi Studies*, ed. Alexander Silbiger (Durham, 1987), 22. I have

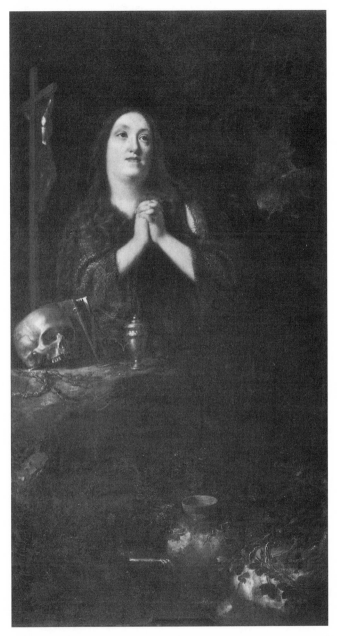

FIGURE 2.3. Justus Sustermans, *Archduchess Maria Magdalena as Saint Mary Magdalen.* Photo credit: Alinari/Art Resource, New York.

practice may date from the first year of Maria Magdalena's arrival in Florence: the two surviving manuscript copies of the five-act play by Riccardo Riccardi entitled *Conversione di Santa Maria Maddalena* indicate that the work was "made by him to be performed with a musical setting in the ancient manner of tragedies, for the most happy marriage of the Most Serene Prince of Tuscany Don Cosimo de' Medici," that is, Cosimo's 1608 marriage to Maria Magdalena.[42] The manuscripts also contain a stanza not found in the play's published version of 1609, one that anticipates Sustermans's portrait by twenty years. Like the visual portrait, Riccardi imbues the archduchess with the strongly felt piety of Saint Mary Magdalen, then links that virtue to her political stature by identifying the archduchess not only with her namesake but also Astraea, the personification of justice:

> And here, to the new goddess of Florence,
> whence she is happy and serene,
> o gracious Astraea of Austria and Graz,
> I want to reenact, on this humble stage,
> the lofty conversion of the Magdalen;
> of your Magdalen, whom you so honor,
> for her name and her virtue adorn you.[43]

Court diaries, combined with surviving manuscript and printed plays, allow for a partial reconstruction of the Magdalen repertory performed during the 1620s (table 2.2). Like Sustermans's portrait and the majority of the Poggio Imperiale Magdalen paintings, these devotional plays stress images of the

analyzed the relationships between text and music as they relate to Magdalen icongraphy; see Harness, "*Amazzoni di Dio*," 286–94.

42. "Fatta da lui Rappresentar ~~cantando~~ con [un] Aria musicale alla maniera Antica delle Tragedie, nelle felicissime nozze del Ser.mo Principe di Toscana, Don Cosimo de Medici" (I-Fr, Ricc. 2242, fols. 27r, 39r). Riccardi may have intended to follow the model of Jacopo Corsi, who arranged for the performance of *L'Euridice* in 1600. Like Corsi in 1600, Riccardi enjoyed the recent elevation of his family's social standing due to his relationship with Grand Duke Ferdinando I; the nobility of the Riccardi family was recognized on 15 October 1606. See Paolo Malanima, *I Riccardi di Firenze: Una famiglia e un patrimonio nella Toscana dei Medici* (Florence, 1977), 87–94. However, the printed descriptions of the festivities make no mention of the work, which was probably not performed.

43. "E qui di Flora alla Novella dea / Ond'è lieta e serena, / O d'Austria, e Grazia graziosa Astrea, / Rassembrar voglio in questa umile scena / L'alta Conversion di Maddalena: / Di Maddalena tua che tanto pregi / Che di suo nome, e sua virtù ti fregi" (I-Fr, Ricc. 2242, fol. 27v).

TABLE 2.2. Saint Mary Magdalen Plays Performed at Court or Dedicated to
Archduchess Maria Magdalena

Year of Performance (22 July, unless otherwise indicated)	Title (Date of Publication) / Location of Manuscript Libretto	Author/Composer (If Known)	Description
October 1608?	*Conversione di Santa Maria Maddalena ridotta in tragedia* (Florence, 1609); two manuscript copies in I-Fr, Ricc. 2242, fols. 27r–55v, 195r–201v, 203r–206v.	Riccardo Riccardi	According to the manuscript copy, intended for a sung performance during the festivities marking the wedding of Maria Magdalena to Cosimo de' Medici; probably not performed
1620	Pastoralina	Unknown; music by Francesca Caccini (lost)	I-Fn, Gino Capponi 261, vol. 2, fol. 259r (incomplete description in Solerti [1905; reprint, 1968], 155)
1622	*Dialogo della vita contemplativa et della vita attiva* (I-Fr, Ricc. 2782, fols. 343r–348v)[a]	Jacopo Cicognini [Giovan Maria Cecchi]	I-Fn, Gino Capponi 261, vol. 2, fol. 523r; transcribed in Solerti (1905; reprint, 1968), 163
1624	*Amore divino et del Timore divino* (lost)	Jacopo Cicognini	I-Fas, Misc. Med. 11, fol. 60r; transcribed in Solerti (1905; reprint, 1968), 173
1625	*Trionfo del disprezzo del mondo* (lost)[b]	Jacopo Cicognini; music by Filippo Vitali (lost)	I-Fas, Misc. Med. 11, fol. 134r; transcribed in Harness (1996), 396–97
1626	*Rappresentazione di Santa Maria Maddalena* (lost)	Unknown	I-Fas, Misc. Med. 11, fol. 175r; transcribed in Harness (1996), 398–99
1627	*Santa Maria Maddalena trionfante in Cielo* (I-Fs, C.V.37)[c]	Ferdinando Saracinelli	I-Fas, Misc. Med. 11, fol. 201r; transcribed in Harness (1996), 403–4
1628	*La spelonca di Marsilia* (I-Fn, Magl. VII.604, fols. 78r–92v)[d]	Unknown, possibly Ferdinando Saracinelli	Date of performance included in the manuscript of the play *(continued)*

TABLE 2.2. (*continued*)

Year of Performance (22 July, unless otherwise indicated)	Title (Date of Publication) / Location of Manuscript Libretto	Author/Composer (If Known)	Description
1629	Festa di Santa Maria Maddalena (in Parducci [1904], 181–97)	Francesco Bracciolini	Solerti (1905; reprint, 1968), 195
Before 1621	Unfinished scenes between Saint Mary Magdalen and Martha (I-Fn, Magl. VII.902, fols. 105r–107r)	Ottavio Rinuccini	Possibly not performed
Unknown	Madalena convertita (I-Fr, Ricc. 3093)	Giovan Domenico Peri d'Arcidosso (1564–1639)	Dedicated to Archduchess Maria Magdalena

Sources. Giovammaria Cecchi, *Commedie,* ed. Michele dello Russo (Naples, 1869); Konrad Eisenbichler, "The Religious Drama of Giovan Maria Cecchi" (Ph.D. diss., University of Toronto, 1981); Kelley Harness, "*Amazzoni di Dio:* Florentine Musical Spectacle under Maria Maddalena d'Austria and Cristina di Lorena (1620–30)" (Ph.D. diss., University of Illinois at Urbana-Champaign, 1996); Pietro Parducci, ed., *Spigolature letterarie* (Rome and Milan, 1904); and Angelo Solerti, *Musica, ballo e drammatica alla corte Medicea dal 1600 al 1637: Notizie tratte da un diario, con appendice di testi inediti e rari* (Florence, 1905; reprint, New York and London, 1968).

[a] This work was discovered by John Walter Hill, who kindly informed me of its existence. See Harness (1996), 275–79, 415. Although credited to Cicognini in both the court diary and the source manuscript, it is nearly identical to the play by Giovan Maria Cecchi entitled *Duello della vita attiva e contemplativa* (Cecchi 1869, 97–120). The Cecchi work also answers one of the problems posed by the Riccardiana manuscript, whose list of interlocutors includes characters not found in the play. These characters all appear in Cecchi's *Duello.* See also Eisenbichler (1981), 103–13.

[b] Although a work with this title is extant (I-Fr, Ricc. 2782, fols. 343r–348v), the play actually fits the description of the *Dialogo della vita contemplativa* performed at court in 1622, whereas it bears no resemblance to the description of the work performed at court in 1625.

[c] For a description of this work, see Harness (1996), 281–82, 416.

[d] I would like to thank Professor John Walter Hill for calling my attention to this manuscript. See Harness (1996), 282–84, 416–17.

penitent, tearful Magdalen in her grotto.[44] Their lyrical natures distinguish them from the spectacles that the archduchess commissioned for foreign dignitaries and invited guests. This difference might be attributed to the more intimate surroundings in which these works were performed, attended only by the archduchess and her immediate family. For large-scale public spectacles, especially those performed for state visitors, the ruler of Florence was required to maintain a posture of strength, and this resulted in protagonists such as Saint Agatha, Saint Ursula, and Judith, women whose actions were heroic and public.

Like other seventeenth-century rulers, Maria Magdalena recognized the political benefits of sponsoring extravagant spectacles. The presence of similar or identical images across a wide spectrum of artistic domains suggests that she consciously sought to evoke images of worthy women as the essential component in her own self-fashioning. Her case presents us with a situation in which a woman herself determines the depictions of her gender. The archduchess chose carefully the subjects of these symbolic manifestations of statecraft, paying attention to the dual function of court spectacle, which needed to provide symbols of Florence and its current ruler as well as to respond allegorically to current political events. Although the female images associated symbolically with the regents changed over the course of the decade in response to specific political situations, all of the protagonists share one important trait: chastity. Maria Magdalena clearly realized that, for a ruler, the appearance of honor was a necessity. She also realized that, for a woman, honor was synonymous with sexual virtue.

44. The penitent Magdalen was also the subject of at least one and, possibly, two poems by Andrea Salvadori. The list compiled by Biscioni (I-Fn, Magl. IX.69, pp. 905–6) includes a work entitled "Pianto di S. Maria Maddalena nella grotta di Marsilia," giving the location of its manuscript as the library of the Nunziata. A sonnet by Salvadori on this subject, although not bearing Biscioni's title, is among the Salvadori poems collected in I-Fn, Magl. VII.357, p. 417.

CHAPTER 3

Amazons of God

Virgin Martyr Spectacles, 1621–25

The virgin martyr was the first type of chaste heroine to appear in regency-sponsored spectacles. Certainly other female rulers made virginity central to their self-fashioning, with Elizabeth I of England serving as the best-known example. But the regents clearly were no longer virgins; in fact, their political power derived from proven reproductive ability. Maria Magdalena and her advisers appear to have believed that virginity, exemplified by the virgin martyrs, provided the most efficacious symbol of a woman's legitimate exercise of political power. For while virgin martyr legends topped the list of approved reading for women as models of sanctity and chastity, they also offered protagonists who almost always exhibited transgressive behavior in their refusal to conform to patriarchal norms.[1] Their legends were loci in which contradictions within seventeenth-century gender ideologies were situated—areas of dissent that created symbolic space for real women to maneuver.[2] In an era in which the Catholic church actively reasserted hierarchical male author-

Portions of this chapter have appeared in my article "Chaste Warriors and Virgin Martyrs in Early Florentine Opera," in *Gender, Sexuality and Early Music*, ed. Todd Borgerding (New York and London, 2002), 71–121.

1. For an interpretation that views these legendary martyrs as models for potentially transgressive acts by real women of the middle ages, see Jocelyn Wogan-Browne, "Saints' Lives and the Female Reader," *Forum for Modern Language Studies* 27 (1991): 314–32, esp. 323. A recent study that deals with virgin martyr legends as potentially contradictory models of women's speech is Maud Burnett McInerney, "Rhetoric, Power, and Integrity in the Passion of the Virgin Martyr," in *Menacing Virgins: Representing Virginity in the Middle Ages and Renaissance*, ed. Kathleen Coyne Kelly and Marina Leslie (Newark, NJ, 1999), 50–70.

2. My understanding of the concept of maneuverability is indebted to Ann Rosalind Jones, *The Currency of Eros: Women's Love Lyric in Europe, 1540–1620* (Bloomington, IN, 1990), esp. 11–15.

ity, virgin martyrs exemplified the defense of the faith promulgated by the Counter-Reformation, but in active roles of ministry and martyrdom that were, by the seventeenth century, largely cut off from women.[3] They were spiritual and often political leaders, embodying attributes such as courage, spiritual integrity, and wisdom—all traditional kingly virtues, and all characteristics that most likely would have been considered male in the sixteenth and seventeenth centuries.[4] Thus the creation of a personal mythology centered around virginity allowed female rulers to confront the paradox of womanly versus kingly behavior unique to female monarchs.

Virgin martyrs by definition also separated the image of Woman from that of female sexuality. The constant affirmation of chastity was symbolically important to the female regents, for, through the act of exercising political power, they had exceeded the societal roles traditionally assigned to women, potentially linking them to other transgressions, namely, sexual ones.[5]

3. Ruth P. Liebowitz, "Virgins in the Service of Christ: The Dispute over an Active Apostolate for Women during the Counter-Reformation," in *Women of Spirit: Female Leadership in the Jewish and Christian Traditions,* ed. Rosemary Ruether and Eleanor McLaughlin (New York, 1979), 131–52.

4. Elizabeth Castelli, "Virginity and Its Meaning for Women's Sexuality in Early Christianity," *Journal of Feminist Studies in Religion* 2 (1986): 77; Jane Tibbetts Schulenburg, "The Heroics of Virginity: Brides of Christ and Sacrificial Mutilation," in *Women in the Middle Ages and the Renaissance: Literary and Historical Perspectives,* ed. Mary Beth Rose (Syracuse, NY, 1986), 31; and John Bugge, *Virginitas: An Essay in the History of a Medieval Ideal* (The Hague, 1975), esp. 49–52. For lists of gendered binary opposites that would have informed Renaissance thought, see Ian Maclean, *The Renaissance Notion of Woman: A Study in the Fortunes of Scholasticism and Medical Science in European Intellectual Life* (Cambridge, 1980); Caroline Walker Bynum, "'. . . And Woman His Humanity': Female Imagery in the Religious Writing of the Later Middle Ages," in *Gender and Religion: On the Complexity of Symbols,* ed. Caroline Walker Bynum, Stevan Harrell, and Paula Richman (Boston, 1986), 257; and Suzanne G. Cusick, "Gendering Modern Music: Thoughts on the Monteverdi-Artusi Controversy," *Journal of the American Musicological Society* 46 (1993): 4.

5. Women's role in politics was a topic much debated during the sixteenth and seventeenth centuries. While several authors, including Bronzini, argued in favor of women's political role, others, following Aristotle, deplored women's participation in government. For titles of sixteenth- and seventeenth-century treatises that addressed this issue, see Constance Jordan, *Renaissance Feminism: Literary Texts and Political Models* (Ithaca, NY, and London, 1990); Maclean, *Renaissance Notion of Woman,* esp. 60–61 and 110n66; Ginevra Conti Odorisio, *Donna e società nel Seicento* (Rome, 1979), 35–78; and Ruth Kelso, *Doctrine for the Lady of the Renaissance* (Urbana, IL, 1956). For a study of the ways in which Renaissance European society linked the transgression of female domesticity to sexual transgression, see Ann Rosalind Jones and Peter Stallybrass, "Fetishizing Gender: Constructing the Hermaphrodite in Renaissance Europe," in *Body Guards: The Cultural Politics of Gender Ambiguity,* ed. Julia Epstein and Kristina Straub (New York, 1991), 101–2.

At a time in which unmarried women were viewed as vulnerable to men, control over a female ruler's sexuality became a state concern, for the entire system of political succession could be jeopardized should a widowed queen (or grand duchess) remarry. Maria Magdalena's conspicuous identification with women who actively repudiated their sexuality assured Florentines, as well as the outside world, of the orderly succession of power to the appropriate male heir.

The prominence of symbols of virginity in the self-fashioning of Maria Magdalena thus not only distanced the archduchess from the many negative images of women and women rulers that had been in circulation since before the sixteenth century but actually offered church-sanctioned examples of women who exercised spiritual and temporal authority.[6] As seen in chapter 2, visual depictions of virgin martyrs dominated the iconographic program in her bedroom at the Villa Poggio Imperiale, appearing in the audience room frescoes, as well. The archduchess also commissioned dramatic works based on the legends of these heroic saints. In these spectacles, Florentine poets used not only subject matter but also precise words and formal structures to create female protagonists resonant with contemporaneous understandings of virginity. And music, whose ability to move its listeners remained a central tenet of seventeenth-century operatic philosophy, brought these virgins (and their messages) to life.

Female Virginity in the Seventeenth Century

The Catholic Church's position on the need for celibacy in some of its members (as opposed to the equally desirable temporary virginity, which ends at marriage) has remained constant to the present day and need not be debated here. Of greater relevance is an attempt to understand what were believed to be the spiritual, civic, and political ramifications of female virginity, especially during the later sixteenth and early seventeenth centuries, a period during which Catholicism consciously reasserted those of its tenets most under attack by Protestantism, including celibacy. Not surprisingly, during the very first year of its operation, Paolo Manuzio's Roman press, the Catholic Reformation's vehicle of orthodoxy, produced three editions and/or translations of patristic writings on virginity, while between 1565 and 1572 the press published Mariano Vittori's nine-volume *opera omnia* of Saint Jerome, possibly the

6. For an excellent study of another queen regnant who took care to distance herself from sexuality, see Jeanice Brooks, "Catherine de Médicis, *nouvelle Artémise:* Women's Laments and the Virtue of Grief," *Early Music* 27 (1999): 419–35.

Church's most outspoken champion of female celibacy.[7] Because these works issued from church fathers and saints, later authors could invoke their positions on virginity without the need to demonstrate their authority. As a result, many of the commonplaces articulated within patristic writings on virginity continued to be relevant through the seventeenth century. For example, since women were oftentimes believed e to be less able than men to control their lust, a woman's willful preservation of *integras* (wholeness) was a demonstration of remarkable spiritual fortitude. Virginity itself was also believed to *confer* extraordinary strength, which became a defining attribute especially of the virgin martyr, who harnessed her valor in defense of the faith.[8] Finally, by exceeding the bounds of what was considered womanly behavior, the virgin transcended not only her traditional societal duties but also her corporeal nature, achieving what Anton Blok has described as a liminal state mediating such binary opposites as earth and heaven or female and male.[9]

Assertions of a virgin's gender liminality recur both outright and metaphorically in patristic writings. Gregory of Nyssa explains the phenomenon using the metaphor of dryness. In chapter 19 of *De virginitate*, he expands on the biblical account in which Miriam celebrates the successful crossing of the Red Sea (Exod. 15:20−21) in order to prove that the prophetess and her followers were truly virgins: "For, as the tambourine produces a loud sound, having no moisture in it and being quite dry, so also virginity is clear and

7. Eugene F. Rice Jr., *Saint Jerome in the Renaissance* (Baltimore, 1985), 154−55. Manuzio published three separate volumes entitled *De virginitate* in 1562, one each by the saints John Chrysostom and Gregory of Nyssa, plus an anthology of treatises by Ambrose, Jerome, and Augustine. See Francesco Barberi, *Paolo Manuzio e la stamperia del popolo Romano (1561−1570) con documenti inediti* (Rome, 1942; reprint, Rome, 1985), 113−17, 140−43.

8. On Renaissance authors who echoed these sentiments, see Margaret L. King, *Women of the Renaissance* (Chicago and London, 1991), 93−95.

9. Anton Blok, "Notes on the Concept of Virginity in Mediterranean Societies," in *Women and Men in Spiritual Culture, Fourteenth to Seventeenth Centuries: A Meeting of South and North*, ed. Elisja Schulte van Kessel (The Hague, 1986), 29−31. The topic of female virginity in the patristic age has generated a great deal of literature in recent years. See, particularly, Gillian Cloke, *"This Female Man of God": Women and Spiritual Power in the Patristic Age, A.D. 350−450* (London, 1995); Peter Brown, *The Body and Society: Men, Women and Sexual Renunciation in Early Christianity* (New York, 1988); Margaret R. Miles, *Carnal Knowing: Female Nakedness and Religious Meaning in the Christian West* (New York, 1991), 62; Castelli, "Virginity and Its Meaning for Women's Sexuality," 61−88; Jo Ann McNamara, "Sexual Equality and the Cult of Virginity in Early Christian Thought," *Feminist Studies* 3, nos. 3/4 (Spring−Summer 1976): 145−58; and Rosemary Radford Ruether, "Misogynism and Virginal Feminism in the Fathers of the Church," in *Religion and Sexism: Images of Woman in the Jewish and Christian Traditions*, ed. Rosemary R. Ruether (New York, 1974), 150−83.

noised abroad and has nothing in itself of the life-preserving moisture of this life. If it was a tambourine, a dead body, which Miriam used, then virginity is the deadening of the body, and it is perhaps not unlikely that it was being a virgin that set her apart."[10] Throughout the works of Saint Jerome, including his most widely circulated promotion of virginity, letter 22 to Eustochium, he speaks of the need to dry the wetness of lust.[11] Situating the church fathers' assertions within Renaissance beliefs concerning sex and physiology, sixteenth- and seventeenth-century readers most likely understood Gregory and Jerome to be saying that for virgins, the moist humor that was believed dominant in women had been replaced by the more masculine dry humor.[12] This interpretation receives added force when combined with another common trope by which early Christian writers expressed the virgin's gender liminality, that she had "become male."[13] In Jerome's often quoted commentary on Paul's epistle to the Ephesians: "As long as a woman is for birth and children, she is different from man as body is from soul. But when she wishes to serve Christ more than the world, then she will cease to be a woman, and will be called man."[14] Medieval theologians repeated this trope, praising exceptional women's "virile strength" or "manly vigor."[15] The association between

10. Gregory of Nyssa, "On Virginity," in *Saint Gregory of Nyssa: Ascetical Works*, trans. Virginia Woods Callahan (Washington, DC, 1967), 61.

11. For a translation of the complete letter, see *A Select Library of Nicene and Post-Nicene Fathers of the Christian Church*, 2d ser., vol. 6, *St. Jerome: Letters and Select Works*, trans. W. H. Fremantle (Grand Rapids, MI, 1954), 22–41. See also Neil Adkin, "On Some Figurative Expressions in Jerome's 22nd Letter," *Vigiliae Christianae* 37 (1983): 39.

12. Renaissance medical thinkers subscribed to the theories of Aristotle and Galen, in which women were characterized as possessing moister humors than men. For an excellent overview of Renaissance theories of sex difference and physiology, see Maclean, *Renaissance Notion of Woman*, 28–46.

13. The first description of this phenomenon occurs in the Gospel of Thomas, in which Jesus makes Mary male, stating: "For every woman who makes herself male will enter the kingdom of heaven." Quoted in Elizabeth Castelli, "'I Will Make Mary Male': Pieties of the Body and Gender Transformation of Christian Women in Late Antiquity," in *Body Guards*, ed. Epstein and Straub, 30. See also Cloke, *"This Female Man of God,"* 57–81, 157–221; and Wayne A. Meeks, "The Image of the Androgyne: Some Uses of a Symbol in Earliest Christianity," *History of Religions* 13 (1974), esp. 180–97.

14. Saint Jerome, "Commentariorum in Epistolam ad Ephesios," in *Patrologiae cursus completus, series latina*, ed. J.-P. Migne, 221 vols. (Paris, 1844–64), 26:567. English translation in Mary Daly, *The Church and the Second Sex* (New York, 1968), 43, cited in Marina Warner, *Alone of All Her Sex: The Myth and the Cult of the Virgin Mary* (New York, 1983), 73.

15. These praises come from Gregory of Tours and Leander of Seville, respectively, cited in Jane Tibbetts Schulenburg, *Forgetful of Their Sex: Female Sanctity and Society, ca. 500–1100* (Chi-

feminine virility and virginity was pervasive, as witnessed by Isadore of Se-
ville's etymological link between the feminine categories of virago and virgo
precisely due to their shared resistance to sexual passion.[16] The repertory of
fourteenth-century *cantari* poems included an entire category of tales in which
a warrior maiden was granted a female-to-male sex change as a heavenly re-
ward for the valiant defense of her virginity.[17] In the world of drama, from
fifteenth-century *sacre rappresentazioni* through the seventeenth-century sacred
tragedies of the Jesuits, a favorite theme was the heroic virgin martyr, whose
virginity conferred on her extraordinary physical strength, enabling her to
endure tortures and overcome tyrants.[18] This is the inherited tradition on
which Maria Magdalena and her circle of artistic advisers based their under-
standing of the virgin martyr legends. The surviving libretti for the two vir-
gin martyr spectacles performed in Florence during the regency—*Il martirio
di Sant'Agata* and *La regina Sant'Orsola*—clearly affirm this interpretation, for in
each work, words, grammar, dramatic structure, and, I would argue, music,
illustrate a heroine's transcendence of typical female behavior.

Cicilia sacra (1621)

Before turning to these Florentine works, however, we should first look at a
play that may have influenced the archduchess's later patronage—*Cicilia sacra*
by Annibale Lomeri, performed for the archduchess and her children on
18 June 1621 in Siena, by the Compagnia detta di Santa Croce, whose rooms

cago, 1998), 1. See also Barbara Newman, *From Virile Woman to WomanChrist: Studies in Medieval
Religion and Literature* (Philadelphia, 1995), esp. 1–45. Yet Caroline Walker Bynum ("' . . . And
Woman His Humanity,'" 269) argues that the concept of "becoming male," was a male con-
struction, reflecting men's greater preoccupation with religion as reversal (273); by contrast,
women tended to use ordinary female roles to express their understanding of their own union
with Christ (274).

16. Wendy Chapman Peek, "King by Day, Queen by Night: The Virgin Camille in the
Roman d'Eneas," in *Menacing Virgins*, ed. Kelly and Leslie, 71.

17. Margaret Tomalin, *The Fortunes of the Warrior Heroine in Italian Literature: An Index of Eman-
cipation* (Ravenna, 1982), 38–43.

18. Louise George Clubb, *Italian Drama in Shakespeare's Time* (New Haven, CT, and London,
1989), 210–19. For a list of the characteristics of late sixteenth- and early seventeenth-century
sacred tragedy, see Clubb, "*The Virgin Martyr* and the *Tragedia Sacra*," *Renaissance Drama* 7 (1964):
106–11. On the virtuous, sometimes virginal, heroines of later Venetian opera, see Wendy Hel-
ler, "The Queen as King: Refashioning Semiramide for *Seicento* Venice," *Cambridge Opera Journal*
5 (1993): 93–114, esp. 113; and Daniel E. Freeman, "*La guerriera amante:* Representations of Ama-
zons and Warrior Queens in Venetian Baroque Opera," *Musical Quarterly* 80 (1996): 431–60.

were under the church of Saint Agostino.[19] Saint Cecilia was thus the first
virgin martyr to appear as the subject of a court performance after the death
of Cosimo II. The choice was an appropriate one—in a possible extension
of virginity's association to *integras*, early Christian commentators linked vir-
ginity and celestial music, characterizing virgins as individuals in tune with
the music of the spheres.[20] And Cecilia's connection with celestial and, later,
audible music had rendered her a patron saint of music since the fifteenth
century.

Lomeri's play recounts the central events in the saint's legend. Cecilia, a
young Roman woman dedicated to virginity, is engaged to marry Valerian.
While others prepare her bridal chamber, she sings to God in her heart, pray-
ing to remain chaste in marriage. On her wedding night she informs Valerian
of her vow to remain celibate, and she warns him that an angel guards jeal-
ously her virginity. She convinces her husband to search out Pope Urban
as evidence of her claim. Valerian does so and is converted, as is his brother,
Tiburtius. The Roman prefect Almachius ultimately executes all three.[21]

Lomeri acknowledges Cecilia's status as a patron saint of music by incor-
porating two madrigals into the dramatic action: a solo sung to the organ by
Cecilia herself (1.3), then a duet with Valerian (2.2).[22] These madrigals al-
lowed the poet to juxtapose dramatically Cecilia's pure, heavenly music with
the sensual singing of sirens, which the allegorical personage of Virginity

19. Annibale Lomeri, *Cicilia sacra in drammatica poesia . . . recitata in Siena all'A.A. Sereniss., di To-
scana il 18 Giugno 1621* (Arezzo, 1636), located in Siena, Biblioteca communale, V12.0.18. Tinghi
described this performance (I-Fn, Gino Capponi 261, vol. 2, fol. 388, partially transcribed in
Angelo Solerti, *Musica, ballo e drammatica alla corte Medicea dal 1600 al 1637: Notizie tratte da un diario,
con appendice di testi inediti e rari* [Florence, 1905; reprint, New York and London, 1968], 161), but
he misidentified the play's author as Annibale Ulma. For the Company of Santa Croce, only
a few records survive in the state archives in Siena. These indicate that the company was made
up of both male and female members, but unfortunately, aside from a single document dated
1439, no records exist from before 1659.

20. Thomas H. Connolly, "The Legend of St. Cecilia. II. Music and the Symbols of Vir-
ginity," *Studi musicali* 9 (1980): 7–19. See also Connolly, *Mourning into Joy: Music, Raphael, and Saint
Cecilia* (New Haven, CT, and London, 1994). On virginity and *integras*, see Warner, *Alone of All
Her Sex*, 72–73.

21. Jacobus de Voragine, *The Golden Legend: Readings on the Saints*, ed. William Granger Ryan,
2 vols. (Princeton, NJ, 1993), 2:318–23; Enrico Josi, "Cecilia, santa, martire di Roma," in *Bi-
bliotheca Sanctorum*, 13 vols. (Rome, 1961–70), 3:1064–81.

22. Musical *intermedi*, by an unnamed composer, also followed each of the play's five parts.
All of the music has apparently been lost. Throughout the book, in designating parts of plays
(and in some cases operas), my practice has been to use Arabic numerals separated by a pe-
riod to indicate act and scene.

condemns in the work's prologue. Virginity compares the sirens, who entice unsuspecting souls with their sensual songs, to pleasure (*diletto*) and custom (*costume*), from whose turbulent effects on the soul Virginity offers refuge. She praises Rome for its traditional veneration of virgins, from the goddess Diana to the Virgin Mary. And she beseeches her listeners to turn away from Mars and Venus and to worship instead Mary and Christ, a movement away from mythology toward religion that foreshadows the change in operatic subject matter that coincided with the advent of the regency.

The most important characteristic Lomeri's *Cicilia* shares with later regency spectacles is the explicit recognition of a tradition of women in positions of spiritual leadership. In the prologue (p. 14), Virginity includes Cecilia among heaven's children and heroes, and she specifically confirms that women's capacity for valor is equal to that of men:

E questo è vero sì, che non sol puote	And this is true, as well, that not just
a la palma aspirar chi di molt'anni	the aged one, wise because of experience,
per lungo corso è saggio, e a cui virile	and whose virile virtue inflames his breast can
virtute accende il sen; ma si discuopre	aspire to the palm [of martyrdom]; but equal valor
pari valore, e egual coraggio regna	is revealed and equal courage reigns
ancor ne' petti feminili, e imbelli,	even in feminine and peaceable breasts,
e ne' prim'anni fanciulleschi, e infermi.	and in the first years of innocent childhood.

Cicilia appears to have made a lasting impression on the archduchess, for the following year she sponsored a performance that reenacted the martyrdom of a female saint traditionally linked with Cecilia: Saint Agatha, a saint whose image would soon occupy a position adjacent to that of Cecilia in the archduchess's bedroom.[23]

Il martirio di Sant'Agata (1622)

Jacopo Cicognini's *Il martirio di Sant'Agata* [The martyrdom of Saint Agatha], performed in the Casino Mediceo on 22 June 1622, was the first large-scale dramatic spectacle sponsored by the regents.[24] It welcomed their first impor-

23. Thomas Connolly, ("Legend of Saint Cecilia," pt. 2, 23) has noted that Agatha and Cecilia were linked in Trastevere, home of Cecilia's cult, and that both saints share similarities with popular deities, namely, Isis and Bona Dea.

24. The only analysis of this play to date is C. Naselli, "'Il Martirio di S. Agata' di un drammaturgo del Seicento: Jacopo Cicognini," *Archivio storico per la Sicilia orientale* 23–24 (1927–28): 195–220. See also Mario Sterzi, "Feste di corte e feste di popolo in Firenze sui primordi del secolo XVII (Jacopo Cicognini e il suo teatro)," *La Rassegna*, ser. 4, 33 (1925): 119–21. Cicognini's *Sant'Agata* was the second theatrical depiction of the saint to coincide with Maria Magdalena's years in Florence: between 1614 and 1623 Michelangelo Buonarroti the Younger

tant visitor, the Spanish ambassador to Rome, Don Manuel de Zuñiga, count of Monterey.[25] The ambassador's visit most likely stemmed from the treaty signed one month earlier by representatives from France and Spain. Its intent was to resolve territorial disputes in the Valtelline, an important Alpine region linking Italy with the Tyrol and South Germany, traditionally Catholic but controlled by the Protestant Swiss Grisons, and now disputed by France, Spain, and Austria.[26] The terms of the treaty stipulated that the region should be placed under the control of a neutral third party. Eleven-year-old Ferdinando II of Tuscany was one of the nominees for this position, as were Pope Gregory XV and the duke of Lorraine. According to Riguccio Galluzzi, the regents desired ardently to take on this responsibility.[27] For the principal entertainment during the ambassador's visit, they chose a work that depicted women as liberators and protectors—the role they hoped to assume in the Valtelline. They were apparently successful, for Galluzzi notes that their zeal and ambition convinced the Spanish minister to entrust the charge to the Medici family.[28]

Cicognini's Saint Agatha play had been staged during the carnival season earlier that year, by the men and boys of the Compagnia di Sant'Antonio di Padova. The company had presented the play seven times during January and February, including a performance on 10 February that Maria Magdalena and

wrote *Il velo di S. Agata* (Florence, Archivio Buonarroti, Buonarroti, 78) for his nieces in the Florentine convent of Sant'Agata. See Elissa B. Weaver, *Convent Theatre in Early Modern Italy: Spiritual Fun and Learning for Women* (Cambridge, 2002), 70n64. Florence's cathedral owned a portion of the saint's veil, which was carried in religious processions and invoked against fire. See George Kaftal, *Iconography of the Saints in Tuscan Painting* (Florence, 1952), col. 8n.

25. I-Fas, Misc. Med. 436, fol. 161r. Tinghi does not include the ambassador's name in his description, transcribed in Solerti, *Musica*, 162. Brief descriptions can also be found in I-Fas, Misc. Med., 443, fol. 124v, repeated in the Settimani diary, I-Fas, Manoscritti, 133, fol. 116r.

26. See Rémy Pithon, "Les débuts difficiles du ministère de Richelieu et la crise de Valteline (1621–1627)," *Revue d'histoire diplomatique* 74 (1960): 298–322, and "La Suisse, théâtre de la guerre froide entre la France et l'Espagne pendant la crise de Valteline (1621–1626)," *Schweizerische Zeitschrift für Geschichte* 13 (1963): 33–53. Other useful sources include A. D. Lublinskaya, *French Absolutism: The Crucial Phase, 1620–1629*, trans. Brian Pearce (Cambridge, 1968), 176–248 and Ludwig Pastor, *Geschichte der Päpste seit dem Ausgang des Mittelalters*, 16 vols. (Freiburg im Breisgau, 1891–1933), translated by F. I. Antrobus, R. F. Kerr, and Ernest Graf as *The History of the Popes from the Close of the Middle Ages*, 40 vols. (St. Louis, MO, and London, 1910–53), 27:198–218.

27. [Jacopo] Riguccio Galluzzi, *Istoria del Granducato di Toscana sotto il governo della Casa Medici*, 5 vols. (Florence, 1781), 3:407–9.

28. Ibid., 408. Due to previous political connections between the Medici and Spain, France balked at the choice of the grand duke and his regents as governors of the Valtelline, preferring the duke of Lorraine. The decision was postponed and never resolved.

her children attended.[29] Cicognini himself had suggested the subject matter for that year's carnival performance, which he may have hoped would appeal to the regents and thereby further his attempts to secure a court position.[30] His title character portrayed precisely those attributes with which the regents would have wanted to identify: strength, courage, and tenacity.

The spectacle must have pleased the archduchess, for the regents requested that the confraternity repeat it to honor the ambassador's visit. They also took an active interest in the preparations—Maria Magdalena herself inspected the scenery two days before the performance.[31] The regents placed the resources of the grand ducal household at Cicognini's disposal, including one of their most prized musicians, Francesca Caccini, in order to present the sumptuous type of spectacle that would reflect the court's wealth and generosity.[32] According to Cicognini's dedication to the published version of his play, for its court performance the company and court employees further enriched Sant'Agata by the inclusion of stage machinery and more musical numbers, which featured choruses, ballets, additional musicians, and female voices.[33] The audience of 22 June 1622, which included the Spanish ambas-

29. See Solerti, Musica, 162. The company's records (I-Fas, CRS 134, no. 2, fols. 23v–27v, 29v) form the basis for Giuseppe Baccini's discussion of the work in his Notizie di alcune commedie sacre rappresentate in Firenze nel secolo XVII (Florence, 1889), 10–14. These records note that Giovanni Battista da Gagliano, the confraternity's maestro di cappella, provided the musical settings for the work's carnival performances, and he was paid 30 scudi for his efforts (fol. 27v), although he may have distributed it among the performers (Warren Kirkendale, The Court Musicians in Florence during the Principate of the Medici with a Reconstruction of the Artistic Establishment [Florence, 1993], 372). For the original carnival performances, this music consisted of four solo songs, sung by the following members (fol. 24r): Paolin del frate (Agatha), Scipioncino (Spirit of Saint Agatha), Paolo Ardinghelli (Free Will), and Niccolo Santini (angel), as well as choruses sung by Prudent Virgins (prologue), the nine daughters of Afrodisia (act 1), and angels (act 5).

30. See my introduction to this volume, 4.

31. Solerti, Musica, 162.

32. I-Fas, CRS 134, no. 2, fol. 29v. Medici household documents include two requests for additional costumes, properties, shoes, and stockings (I-Fas, GM 391, fols. 683r [17 June 1622], 684r [11 June 1622]). Both petitions were addressed to Grand Duke Ferdinando II, and both were granted. I have found no ducal treasury documents from 1622 that make specific reference to payments connected with the Sant'Agata performance.

33. Jacopo Cicognini, Il martirio di Sant'Agata (Florence, 1624). Cicognini's praise of the compositional skill of Francesca Caccini remains the only source to credit her involvement in Sant'Agata, for her name is absent from descriptions in both confraternity records and court diaries. Cicognini's shrewd inclusion of Caccini's name in the 1624 printed libretto allowed him to ally his work with a favored singer who was also involved in a public feud with Cicognini's chief rival, Andrea Salvadori. In a letter to court secretary Andrea Cioli, who was

sador and his entourage, the Medici court, and three hundred invited guests, would most certainly have been amazed and entertained, not only by the spectacular scenic effects and numerous musical interludes but also by Cicognini's truly comic play, a prose adaptation of his 1614 *dramma per musica.*

Cicognini loosely based his plot on the saint's legend, in which Agatha, a young Sicilian noblewoman from Catania who has made a vow of chastity, is persecuted by Quintianus, Roman proconsul to Sicily, who covets both the young woman's wealth and her body. To achieve both ends he places her in the care of the aptly named Aphrodisia, who with her nine daughters is charged with convincing Agatha to accept Quintianus and to worship his gods. Agatha's steadfast refusal leads to her imprisonment and torture, but each travail bolsters her constancy, which she exhibits in a series of verbal confrontations with the proconsul. She is eventually killed by fire, but her martyrdom leads to the conversion of the city's populace and to Quintianus's death by means of an earthquake. Saint Agatha not only delivers Catania from the despotic proconsul but also protects it from subsequent eruptions of Mount Etna.[34]

Cicognini retains every important event of this legend, although the scenes of torture take place off stage, narrated after the fact by characters who have witnessed the events.[35] He compresses the narrative to fit within twenty-four hours, beginning after Quinziano consigns Agatha to the house of Afrodisia and concluding with the soul of Agatha ascending to receive the palm leaf accorded Christian martyrs.[36] As was his practice, Cicognini amplifies the meaning of the legend by mirroring it with a second, secular plot.[37] He in-

the dedicatee of the published play, Cicognini complains of the "envious poet" who was conspiring against him; to thwart this unnamed rival's efforts, Cicognini asked Cioli to distribute a copy of *Sant'Agata* in Rome. See Anna Maria Crinò, "Documenti inediti sulla vita e l'opera di Jacopo e di Giacinto Andrea Cicognini," *Studi seicenteschi* 2 (1961): 266.

34. de Voragine, *The Golden Legend,* 1:154–57. Francesco Zambrini has collected a particularly Tuscan version of the legend, reprinted in *Collezione di leggende inedite, scritte nel buon secolo della lingua Toscana,* 2 vols. (Bologna, 1855), 2:335–47. See also Giuseppe Consoli, *S. Agata V.M. Catanese,* 2 vols. (Catania, 1951); Aristide Raimondi, "Note sulla fortuna della leggenda di S. Agata dal Trecento al Seicento, in Italia," *Archivio storico per la Sicilia orientale* 12 (1915): 135–62; and Gian Domenico Gordini, "Agata," in *Bibliotheca Sanctorum,* 1:320–27.

35. Unlike the *sacra rappresentazione* genre, the seventeenth-century sacred tragedy typically moved such violent action offstage (Clubb, "*The Virgin Martyr* and the *Tragedia Sacra,*" 109).

36. Throughout the discussion of both virgin martyr spectacles, I will refer to the virgin martyrs by the English versions of their names. For all other characters, I will use the Italian versions of names when referring to Italian plays and Latin when citing the legends.

37. The fullest treatment of Cicognini's life and works remains Mario Sterzi, "Jacopo Cicognini," *Giornale storico e letterario della Liguria* 3 (1902): 289–337, 393–433. Additional infor-

troduces the character of Armidoro, a youth from Palermo who is in love with the saint and has followed her to Catania. For the first half of the play Armidoro languishes in prison because of the proconsul's belief that he and other Christians have stolen a statue of Venus.[38] Cicognini also includes a secular counterpart to Agatha: Laurinda, a young women from Palermo who possesses "a magnanimous and virile" heart and is in love with Armidoro. Laurinda rescues her beloved by wearing male attire and posing as her twin brother, Laurindo. That brother, a secret Christian, is the true thief of the Venus statue.[39] Stock character types such as a braggart captain, a parasite, a bawd, and wise and foolish servants round out the list of secondary characters.

Cicognini precedes the action of the play with a prologue in which the personage of Free Will (Libero Arbitrio), a figure whose contribution to the process of redemption had been specifically denied by Luther, praises Agatha's courage and strength [*Di Christo ancella coraggiosa, e forte*]. His reference to the impregnable fortress [*inespugnabile fortezza*] conferred by faith recalls virginity's association with *integras*. Five prudent virgins frame the quatrains sung by Free Will with a two-stanza refrain, in which they exhort the audience to pay attention to Agatha's example.

Two central, related themes dominate the play: the denigration of female sexuality and the virility of its heroines. Agatha is martyred not only for her Christian beliefs but for her refusal of Quinziano's sexual advances. Laurinda follows Agatha's example by agreeing ultimately to a chaste marriage with Armidoro. Agatha's repudiation of sexuality foreshadows her torture: the removal of her breasts, those uniquely female body parts that at once connote eroticism and motherhood.[40] The stolen statue is of the Roman goddess of love, while implications of the name of Agatha's jailer, Afrodisia, are self-

mation can be found in Silvia Castelli, "La drammaturgia di Iacopo Cicognini" (Tesi di Laurea, Storia dello spettacolo, Università degli studi di Firenze, Facoltà di lettere e filosofia, 1988–89).

38. Cicognini's invention of the whole episode of the Venus statue, around which much of the plot revolves, most likely stems from the saint's legend, during which Agatha contemptuously compares the proconsul's wife to Venus (de Voragine, *Golden Legend*, 1:155).

39. Cicognini's son Giacinto Andrea played both parts. The younger Cicognini's libretti (esp. *Giasone*) established many of the conventions of later Venetian operas. See Ellen Rosand, *Opera in Seventeenth-Century Venice: The Creation of a Genre* (Berkeley, 1991), 267–80, 322–60. Giacinto's participation in his father's plays may have acquainted him with some of these scene types, e.g., the music scene, which occurs in *Sant'Agata* (1.6).

40. The removal of Agatha's breasts was the most frequently depicted scene of the saint's iconography; see C. Squarr, "Agatha von Catania," in *Lexikon der christlichen Ikonographie*, ed. Engelbert Kirschbaum et al., 8 vols. (Freiburg im Breisgau, 1968–76), 1:47.

evident. Cicognini intensifies Afrodisia's personification of evil by making her not only a lascivious woman but a witch as well. Her death at the end of the play (5.5) comes as a result of her attempt to sway Agatha from her vow, confirmed explicitly by her servant: "And this is the end that this disgraceful woman has brought upon herself, for she wanted to make that Christian girl who was in her house lose her virginity, which (and I do not doubt it a bit) was the reason for her death."[41]

Music and dance constitute important weapons in the arsenal Afrodisia aims at Agatha's impregnable fortress of virginity. Cicognini expands on a similar scene from a Florentine *sacra rappresentazione* devoted to Saint Agatha, in which one of Afrodisia's daughters assures her mother that dancing will provide the key to changing Agatha's heart [*So che la faremo un po['] mutare / s'ella ci vede ballare una danza, / il suo cuor si verrà a sollevare / e piglierà nostri modi, ed usanza*].[42] In *Sant'Agata*, Afrodisia and her daughters attempt to use music's link to the senses (and, by extension, to the sensual) to entice Agatha to follow their worldly example, and they perform a *mascherata*, which also functions as the musical *intermedio* between acts 1 and 2. The *mascherata* comprises three separate musical sections: (1) the chorus "Con dolcezza incomparabile," in which the daughters express their intention to awaken Agatha's cold heart; (2) a strophic solo, "Volgi il guardo oh Giovinetta," which calls attention to Agatha's physical beauty; and (3) a strophic choral refrain, "Girate girate," during which the singers promenade in interwoven lines. Music for the strophic solo and choral refrain has been preserved, with altered texts, in Giovanni Battista da Gagliano's *Varie musiche* of 1623.[43] The strophic solo appeared as "Non sdegnar tra i nostri balli," that is, beginning with the third stanza from Cicognini's play and with slight modifications in the text, most notably the

41. "E questo è il fine, che ha fatto questa Donna disgratiata, che voleva far perdere la virginità à quella Donzella christiana, che stava in casa sua il che (e non ne dubito punto) è stato cagione della sua morte" (Cicognini, *Il martirio di Sant'Agata*, 120).

42. *La rappresentazione di Sant'Agata vergine, e martire* (Florence, 1591), sig. A3r. An edition of the *rappresentazione* had been published in Siena just the previous year: see Alfredo Cioni, *Bibliografia delle sacre rappresentazioni* (Florence, 1961), 74–77; and also Paul V. Colomb de Batines, comp., *Bibliografia delle antiche rappresentazioni sacre e profane stampate nei secoli XV e XVI* (Milan, 1958), 21–22.

43. Giovanni Battista da Gagliano, *Varie musiche* (Venice, 1623), 15. The work has been reprinted in facsimile in *Florence*, vol. 1 of *Italian Secular Song, 1606–1636*, ed. Gary Tomlinson, 7 vols. (New York, 1986), 277–316. My findings mark the second time that theatrical music has been recovered from this collection: John Walter Hill matched several of its works to texts contained in Cicognini's *Il gran natale di Christo*, also performed in 1622 ("Florentine *Intermedi Sacri e Morali*, 1549–1622," in *La musique et le rite sacré et profane: Actes du XIII^e Congrès de la Société Internationale de Musicologie*, 2 vols., ed. Marc Honegger and Paul Prevost [Strasbourg, 1986], 2:272).

substitution of the phrase "Amorosa giovinetta" for Cicognini's "Volgi il guardo, oh giovinetta" (fig. 3.1). The energetic rhythms of the corrente make the musical setting appropriate for a seductress. In the first line, an immoderate melisma disrupts the momentum to the text's accented penultimate syllable, resulting in a musical phrase that exceeds the four-measure boundary of the aria's other phrases. The rising bass figure that elides lines 2 and 3 goes beyond that function to carry the voice to the climax of the aria, which in the version performed as part of *Sant'Agata* first falls on the word "alletta" (entice), whose meaning is also the central theme of the play, the attempted seduction of Agatha.

These solo stanzas alternate with three stanzas beginning "Girate, girate." The chorus reiterates the emphasis on Agatha's physical beauty, devoting each stanza to a different body part: eyes, cheeks, and lips. The daughters' stanzas were likely sung to the music Gagliano published with the text "Gioite, gioite" in his *Varie musiche* (ex. 3.1). Although the text resemblances are less conspicuous between the *Sant'Agata* chorus and Gagliano's 1623 print, sharing only a single verse ("Ridete ridete"), the setting published in 1623 almost certainly was that used by Gagliano in *Sant'Agata*. The texts have identical structures and accentuation patterns, and the opening lines of each stanza of both texts consist of the repetition of a verb in its second-person plural conjugation. Since numerous settings survive of the "Gioite" text, indicating a fairly widespread popularity, Gagliano probably set this text first and then reused the music in *Sant'Agata*.[44] Like the solo stanzas, the musical setting is a corrente but with the more regular phrases necessary for an actual dance. Whereas in "Volgi il guardo" the singer hopes to tempt Agatha through song, this chorus emphasizes movement. Whether or not it was composed originally with the *Sant'Agata* text in mind, the music of 1623 corresponds closely to the meaning of Cicognini's words. The opening leap of a fourth to and away from d″ in the first measures coincides with the command "turn" in the text, an initial upward motion that also depicts aurally the opening hop of the corrente. The buoyant musical setting features rhythmically and melodically repetitive phrases, typically with a single harmony per measure, sounded on beats 1 and 3. Gagliano accelerates the harmonic rhythm to highlight important words of the text, most notably leading to the chorus's central command—"ardete d'amore" (burn with love).

Agatha's refusal to allow herself to be tempted by the *mascherata* leads Afrodisia to complain of the young woman's obstinacy. She accuses Agatha of

44. Six additional settings of the text are listed in *Il nuovo Vogel: Bibliografia della musica italiana vocale profana pubblicata dal 1500 al 1700*, ed. Emil Vogel et al., 3 vols. (Staderini, 1977).

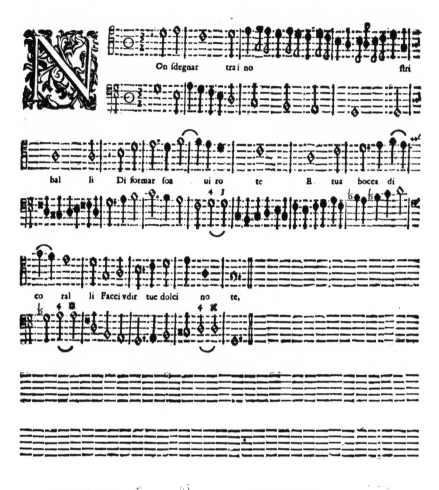

On fdegnar tra i no ftri

bal li Di formar foa ui ro te R. tua bocca di

co ral li Facci vdir tue dolci no te,

Amorofa giouinetta	Nel bel volto che natura
Non fdegnar d'Amor il foco	Di fua mano in ciel compofe
Noftra fchiera oggi t'alletta	Fa mirar trà neue pura
Alli fcherzi,al canto al gioco	Fiammeggiar tue viue rofe.

FIGURE 3.1. Giovanni Battista da Gagliano, *Varie musiche* (Venice, 1623), 15. Copyright 1986 from *Italian Secular Song, 1606–1637*, vol. 1, *Florence,* ed. Gary Tomlinson. Reproduced by permission of Routledge / Taylor & Francis Books, Inc. Translation of "Volgi il guardo, oh giovinetta" in *Sant'Agata* according to the text found in the 1624 print (i.e., beginning with the altered first line of the second musical stanza): "Turn your head oh youthful girl, do not disdain love's fire; our band today allures you to fun, to song, to play. In the beautiful face, which nature formed by its own hand in heaven, let your living roses be seen blazing in pure snow. Do not disdain to form sweet circles amid our dances, and let the sweet notes from your coral mouth be heard."

gender disloyalty: "This is no longer a woman, but a cruelest monster in human disguise" [*questa non più donna, ma sotto humano aspetto, crudelissimo mostro* (31)]. Her charges provide but one instance of the second theme that runs through *Sant'Agata:* its heroines' recognized transgressions of typical female behavior. In the work's secondary plot Laurinda disguises herself as a man to save her beloved, then asserts (while still in disguise) that courageous actions can cross gender lines and that only societal norms dictate appropriate male and female behavior: "My sister Laurinda would have done the same [i.e., rescue Armidoro], for holding within herself a great and virile heart, she would not have feared to do that which I have done, if having been born a woman had not forbidden it to her." [45] Throughout the play, Agatha's adversaries berate her for unwomanly behavior, and they castigate her for being obstinate, rigid, and hard.[46] The recurrent references to Agatha's "hardness" may in part represent a pun on the saint's name (Agata = agate), but they also stem from her legend, in which the thwarted Aphrodisia compares the durability of Agatha's Christian faith to stones and iron, noting that all are equally difficult to soften.[47] When, in the strophic chorus added for the court performance, agents of the underworld condemn Agatha for this hardness and promise to soften her through force and deceit, Cicognini affirms that those who would oppose a strong woman in her quest for spiritual independence are in league with the devil. These enemies of chastity have merely confirmed Agatha's position as a Christian heroine, for those "flaws" in her womanliness were to be understood by the audience as the attributes of militant Catholicism — resolve, boldness, and fearlessness — with which any seventeenth-century leader would want to be associated.

Agatha also exhibits what would have been understood as "unwomanly" behavior through her command of rhetorical skills. Cicognini uses language to reinforce Agatha's spiritual fortitude and extraordinary strength — female virginity's defining characteristics according to the patristic writers. One means by which he accomplishes this is through contrast: Agatha's authoritative speech stands in relief against the uncontrolled outbursts of the principal male character, Armidoro — the verbal equivalent to Rutilio Manetti's depiction of Sophonisba and Masinissa (plate 1). Harboring an unrequited

45. "La mia sorella Laurinda haverebbe fatto l'istesso, che racchiudendo in se un cuor magnanimo, e virile, non haverebbe temuto di far quello, che ho fatt'io, se l'esser nata donna, non glielo havesse vietato" (Cicognini, *Il martirio di Sant'Agata*, 72).

46. Hardness and imperviousness often testified to a virgin's *integras* in visual representations; see Marina Warner, *Monuments and Maidens: The Allegory of the Female Form* (New York, 1985).

47. de Voragine, *Golden Legend*, 1:154. Afrodisia levels similar charges against Agatha in the *sacra rappresentazione*.

love for Agatha, Armidoro laments his fate and hers in three highly emo-
tional speeches (1.5, 2.7, and 3.7), in which he punctuates his words with sighs
and exclamations. For example, in act 2.7, Saint Agatha's young suitor la-
ments the loss of both his freedom and his beloved: "Oh among all lovers,
unfortunate Armidoro, memorable example of most unhappy love, as if so
many fierce enemies, such adversity were not enough, now this was added,
that a king should become my rival; now go, now go, miserable lover, and die
a servant, where you used to believe you lived as a fortunate consort; oh Aga-
tha, at one time mine, one time my dear life, today my dear death—what
news do you give me?"[48] His disjointed outbursts, interrupted by exclama-
tions and full of text repetition, expose the lover's anguish. Cicognini in-
verts the gender roles typical of the lament, in which men such as Aeneas or
Theseus abandon their lovers, namely, Dido and Ariadne, ostensibly for the
higher good.[49] Instead it is the male character who is left weeping, and like
his classical female counterparts, his laments are unsuccessful, failing to bring
about the desired result. Armidoro and the play's other male interlocutors
watch, recount, and respond to events in the plot, but they take no part in
determining its outcome. These characters choose ultimately the solitary life
of hermits, by contrast to the play's active, female liberators, who illustrate
the type of woman able to manage the political challenges of the Valtelline.

With the destruction of the statue of Venus by the citizens of Catania,

48. "Oh fra tutti gl'amanti sfortunato Armidoro, memorabile esempio d'infelicissimo
amore, non bastavano tanti fieri nemici, tante avversità, se anco non mi si aggiungeva questa,
che un Re mi fusse divenuto rivale, hor và, hor và, misero amante, e muori Servo, ove credevi
vivere avventurato Consorte, oh Agata un tempo mia, un tempo mia cara vita, oggi mia cara
morte, che novella mi date?" (Cicognini, *Il martirio di Sant'Agata*, 54–55).

49. Tim Carter, "Intriguing Laments: Sigismondo d'India, Claudio Monteverdi, and
Dido *alla parmigiana* (1628)," *Journal of the American Musicological Society* 49 (1996): 32–69, esp. 55–
56; Leofranc Holford-Strevens, "'Her Eyes Became Two Spouts': Classical Antecedents of
Renaissance Laments," *Early Music* 27 (1999): 379–93; and Suzanne G. Cusick, "Re-Voicing
Arianna (and Laments): Two Women Respond," *Early Music* 27 (1999): 437–48. The articles
by Holford-Strevens and Cusick form part of an entire issue of *Early Music* devoted to the la-
ment, in all six of whose articles (those cited above plus Laurie Stras, "Recording Tarquinia:
Imitation, Parody and Reportage in Ingegneri's 'Hor che'l ciel e la terra e'l vento tace,'" 358–
77; Tim Carter, "Lamenting Ariadne?" 395–405; Anne MacNeil, "Weeping at the Water's
Edge," 406–17; and Jeanice Brooks, "Catherine de Médicis") the lament is clearly viewed as
a female genre. See Susan McClary, "Constructions of Gender in Monteverdi's Dramatic Mu-
sic," *Cambridge Opera Journal* 1 (1989): 203–23 (reprinted as chap. 1 in her *Feminine Endings: Mu-
sic, Gender, and Sexuality* [Minneapolis, 1991], esp. 46–48), for a discussion of the possible "ef-
feminizing" role of the lament when delivered by a male character, in this case, Orpheus.

newly converted by Agatha's example, Agatha achieves her final victory over the goddess of love—a goddess whose very existence celebrated physical love between women and men and emphasized the depiction of women as sexual beings. Agatha's ultimate martyrdom is also her final triumph and victory, for with her death and the ensuing earthquake, which kills Quinziano, she liberates all of Catania and becomes the city's patron saint. In scene 12, after an angel appears to tell the characters that the proconsul is dead, trampled to death by his own horse during the earthquake, he praises Agatha as Catania's liberator [*Di Catania divien liberatrice* (5.12)], while in the next scene Laurinda receives similar acknowledgment for having freed Armidoro. The angel's speech foreshadows the scene that would soon depict Agatha in the archduchess's bedroom in her villa. Its explanatory quatrain also emphasizes Agatha's martyrdom as the cause of the destruction of God's enemies:

SOVRA UN LETTO DI FIAMME, AGATA BELLA	Upon a bed of flames, beautiful Agatha
TIEN NELL'AMATO CIEL LE LUCI IMMOTE,	keeps her eyes fixed on her beloved heaven;
TREMA LA TERRA, E L'EMPIA REGIA SCOTE,	the earth trembles and the impious royal palace shakes,
E MUOR L'INIQUA TURBA A DIO RIBELLA	and the iniquitous crowd, rebellious to God, dies.

La regina Sant'Orsola (1624 and 1625)

Chaste, commanding heroines also populated the genre of fully sung opera during the period of the regency, beginning with Saint Ursula, the title character of an operatic collaboration between Andrea Salvadori and Marco da Gagliano. The court first presented *La regina Sant'Orsola* on 6 October 1624 and mounted a repeat performance on 28 January 1625, both in honor of state visits by Maria Magdalena's relatives: her brother Archduke Karl of Austria (1590–1624) and her nephew Prince Władysław (1595–1648), son of her late sister Anna (d. 1598) and King Zygmunt III of Poland.[50]

50. All music has been lost. For the 1624 performance, only the *Argomento* remains (Florence, 1624), although its flood-damaged condition has rendered it unavailable for consultation. Both an *Argomento* and libretto survive from the 1625 performance (both Florence, 1625). The 1625 libretto was also reprinted in Andrea Salvadori, *Poesie*, 2 vols. (Rome, 1668), 1:1–90. A manuscript version of the libretto can be found in I-Fn, Magl. VII.1285, fols. 276r–316bis. Unless otherwise noted, all quotations from the opera are from the 1625 edition of the libretto. With the poet's own acknowledgment that he lengthened the libretto for publication, it has become impossible today to determine the exact extent of the differences among the performances of 1624 and 1625 and the opera's published libretto of 1625. Tinghi's description

Saint Ursula seems to have held particular significance for Archduchess Maria Magdalena. Her story was chosen to inaugurate the new genre of sacred opera: an Ursula opera had been planned as early as 1620, the year in which the court began its preparations for the marriage of Claudia de' Medici to Federigo della Rovere, but it was cancelled after the death of Cosimo II on 28 February 1621.[51] In 1620 Suor Orsola Fontebuoni sent Gerolamo Baldinotti's *Commedia di Santa Orsola* to Maria Magdalena for the princess Margherita.[52] As noted in the previous chapter, Ursula was among the female worthies depicted in the Poggio Imperiale frescoes—not, as might be expected, among the saints but in the politically charged space of the audience room (fig. 3.2).

Ursula also numbered among the female saints singled out by Lorini del Monte in his *Elogii delle più principali S. donne*. Whether or not Lorini's treatment provided the impetus for the Saint Ursula opera, his emphasis on the militaristic elements of the legend is consistent with Salvadori's later depiction of the saint. Lorini begins his account by relating an event that, he claims, must stupefy Christianity. He describes a war, one in which thousands are killed, but one not fought by men, beasts, angels, or birds. Instead, this great war is fought by beings praised as celestial garnets, the earth's flowers, and heaven's

of the 1624 performance (Solerti, *Musica*, 174–76) lists scenes in an order that differs from the published libretto, suggesting that Salvadori rearranged the scenes for the 1625 revival.

51. On 6 October 1620 Secretary of State Curzio Picchena reported to Catherine de' Medici, duchess of Mantua, that the court had commissioned an "Istoria di Sant'Orsola" as part of the celebrations for the upcoming marriage (I-Fas, MDP 6108, fol. 1042r), and Tinghi records rehearsals beginning 26 October 1620 and continuing through early 1621 (Solerti, *Musica*, 156–59). The court secured the services of at least one outside virtuoso: on 22 December 1620 the Mantuan tenor Francesco Rasi reported that the grand duke and archduchess had given him the part of "un prencipe de' Romani" to prepare for the upcoming performance (Kirkendale, *Court Musicians*, 594–95; Susan Parisi, "Ducal Patronage of Music in Mantua, 1587–1627: An Archival Study" [Ph.D. diss., University of Illinois, 1989], 486, 644–46). Rasi may have misunderstood the nature of the role, for the opera does not include a Roman prince, whereas Ireo is clearly a prince, but from England. Francesca Caccini may also have been involved in this earlier production; on 28 January 1624 she sang Salvadori's verses for Saint Cordula, one of Ursula's followers and the secondary female role in the opera (Kirkendale, *Court Musicians*, 322).

52. I-Fas, MDP 6081, n.p., letter of 12 February 1620. Suor Orsola, for many years the *badessa* of the Monastero di San Mercuriale in Pistoia, corresponded with the archduchess for more than a decade, from 1616 to 1627; see Manuela Belardini, "'Piace molto a Giesù la nostra confidanza': Suor Orsola Fontebuoni a Maria Maddalena d'Austria," in *Per lettera: La scrittura epistolare femminile tra archivio e tipografia secoli XV–XVII*, ed. Gabriella Zarri (Rome, 1999), 359–83.

FIGURE 3.2. Ottavio Vannini, *Martyrdom of Saint Ursula* (Florence, Poggio Imperiale). Photograph by author.

stars. These beings group themselves into a huge army, organized into battalions and squadrons, and they fight with impressive results: "Their enemies' squadrons broken, human blood spilled, enemies hacked to pieces and gloriously put to flight" [*rotti gli squadron de' nimici, sparso sangue umano, tagliati i nimici a pezzi, e messigli gloriosamente in fuga* (298)]. The author craftily piques his readers' interest before identifying these warriors, finally revealing that he is speaking of the sainted virgins and martyrs of the church, elected by God as combatants in his fearsome army.[53] From these courageous warriors Lorini selects a subset, Ursula and her virgins, whom God made into a powerful army so that they might combat the devil and barbarous Huns.[54] Lorini concludes his account with praise: "O most blessed virgin Ursula and her companions, who, armed with prayers and other spiritual exercises were so very strong against the devil and fought virilely; they were victors in this new and unusual war."[55]

This figurative battle with the devil becomes an actual one in Salvadori's libretto for *La regina Sant'Orsola*. As political allegory Salvadori's opera fulfilled

53. "Sono state le sante vergini, e martiri della Chiesa, da Dio elette per combattenti, poiché di loro ha lo Dio de gli eserciti fatto una terribilissima soldatesca" (Niccolò Lorini del Monte, *Elogii delle più principali S. donne del sagro calendario, e martirologio romano, vergini, martiri, et altre* [Florence, 1617], 298).

54. "Ecco, che d'undicimila di loro (in circa) ha fatto Iddio oggi un' esercito poderoso, e combattuto col Diavolo, e con gli Unni popoli barbarissimi" (ibid.).

55. "O beatissima vergine Orsola, e le compagne, che armate d'orazioni, ed altri esercizi spirituali furono fortissime contro il Demonio, e combatterono virilmente[;] furono vincitrici in questa nuova, ed insolita guerra" (ibid., 310).

both general and specific functions for Maria Magdalena's government. Ursula provided yet another model of the strong, powerful woman necessary to the archduchess's self-fashioning. But the opera also provided an appropriate focus for Maria Magdalena's immediate goals. The year 1624 was a difficult one for the regents. The marriage they had arranged in 1623 between Ferdinando II and princess Vittoria della Rovere, by which Florence had hoped to acquire the duchy of Urbino, was initially a political triumph. But this victory was neutralized after the August 1623 election of Pope Urban VIII, who immediately declared that the one-time papal fief would revert to papal control on the death of the elderly duke of Urbino. Cardinal de' Medici and Cardinal Barberini negotiated a treaty to this effect on 30 April 1624.[56] Maria Magdalena was meanwhile involved in her own foreign policy initiatives, both of which required papal backing for their success. In response to the French league formed by France, Venice, and the duke of Savoy, the Medici, led by the archduchess, advocated a Catholic league comprising Tuscany, Spain, the Holy Roman Empire, the papal states, Poland, Genoa, and other Italian states.[57] Maria Magdalena also hoped to strengthen Florence's ties with her Habsburg relatives by marrying her daughter Margherita to her nephew, Prince Władysław. In order to do this, she needed to nullify the contract promising Margherita to Prince Odoardo of Parma, a task for which she needed the pope's approval. In a dispatch of 26 October 1624, Cesare Molza, the resident ambassador from Modena, explicitly confirms Maria Magdalena's hopes for this marriage, commenting that "when he [Prince Władysław] comes to Florence, the prepared festivities will be performed, and also the marriage between him and the Princess Margherita will be negotiated, a result desired by the Archduchess."[58]

These matters were at the top of Maria Magdalena's agenda in 1624, when she began to prepare festivities intended for later that year to celebrate what

56. Galluzzi, *Istoria*, 3:424–26.

57. I-MOas, AF 53, fasc. 18, fols. 200r–201r. Given her French background, one can hardly imagine that Christine of Lorraine would have supported such an alliance. According to Galluzzi, the league was proposed by the Spanish ambassador, the duke of Pastrana, but Grand Duke Ferdinando II was to appear as the project's author (*Istoria*, 3:428–29). Maria Magdalena, therefore, pressed for the league on her son's behalf. See also Suzanne G. Cusick, "Of Women, Music and Power: A Model from *Seicento* Florence," in *Musicology and Difference: Gender and Sexuality in Music Scholarship*, ed. Ruth Solie (Berkeley, 1993), 283–84.

58. "Quando verrà in Firenze, si faranno le feste scritte, et anche si trattarà maritaggio fra lui, e la Principessa Margherita, effetto desiderato dall'Arciduchessa (I-MOas, AF 53, fasc. 18, fol. 92r). Cusick ("Of Women, Music, and Power," 284n7) cites other documents that detail the court's negotiations in Rome.

was to have been a joint state visit by Władysław and her brother. The two ended up arriving separately, Karl in late September of 1624, and Władysław early the following year. As she had done in 1622, Archduchess Maria Magdalena assumed an active role in the opera's preparation and performances. The court diarist Cesare Tinghi credited the archduchess with responsibility for the content of *Sant'Orsola:*

> And one will not forget to mention and simply record the performance and entertainment of *Santa Orsola* commissioned by the Most Serene Archduchess for the coming of the Most Serene Archduke Karl of Austria, brother of the Most Serene Archduchess . . . The Most Serene Archduchess, having resolved to put on the above-named entertainment, summoned Sig. Andrea Salvadori, Florentine, poet of Their Highnesses, and proposed to him the subject of the *rappresentazione* of the martyrdom of Saint Ursula with the eleven thousand virgins her companions, killed by Gauno, king of the Huns.[59]

In a letter of 31 July 1624, Cesare Molza confirmed that Maria Magdalena was in charge of the preparations.[60] Three weeks earlier, he had informed the duke of Modena that the lavish festivities were intended especially to impress the prince of Poland.[61] Molza's dispatch of 6 July estimated that the scenery alone would cost ▼6,000; by late September the court had spent nearly four times that amount, according to the gossipy ambassador, who reported Grand Duke Ferdinando's displeasure on 21 September (doc. 3.1).

Although since mid-July 1623, payment orders to the treasury were headed solely by the name of Ferdinando, the wording of Molza's dispatch implies not only that the fourteen-year-old grand duke was not particularly interested in spectacle but also that he was not in charge of the financial decisions regarding *Sant'Orsola*. It may have been Archduchess Maria Magdalena who, on 10 October 1624, requested ▼500 for gifts to the three principal singers.[62]

59. I-Fas, Misc. Med. 11, fol. 81v, transcribed, with some errors, in Solerti, *Musica*, 174.

60. I-MOas, AF 53, fasc. 16, fol. 148r.

61. I-MOas, AF 53, fasc. 16, fol. 86r. Molza repeats the information in a dispatch written the same day to the prince of Modena, fol. 88r. Molza also claimed that the court was hoping to rescind its previous marriage arrangements between Princess Margherita and the prince of Parma and instead marry her to the prince of Poland, having sent to Parma secretary Bartolini and the principal state adviser, Count Orso d'Elci, to negotiate a marriage with the "Principessa minore" (Anna). A letter dated the same day (fol. 95r) relates that Karl and Prince Władysław were scheduled to arrive in September of 1624.

62. I-Fas, MDP 163, fol. 163r, is a payment order from the court to Alessandro Caccini, general treasurer, dated 10 October 1624. Tinghi records gifts of ▼200 to Francesco Campagnolo, ▼100 to "Prete Pienza basso musico," whom Warren Kirkendale (*Court Musicians*, 298)

And it was to the regents that Ferdinando Saracinelli directed his 21 October request for an additional ▾482 to pay fifty-five musicians, presumably the singers of the fifteen other solo roles, chorus members, and instrumentalists.[63] These payments account for only a small percentage of the ▾20,000 budget mentioned by the disapproving grand duke. Ferdinando may have been simply exaggerating, but an examination of treasury payments to the household account for October 1624 reveals an exceptionally large number of payments for extraordinary expenses, totaling more than ▾11,000.[64]

Surviving documents also confirm that Maria Magdalena took an active role in the preparations for the performances of *Sant'Orsola* by attending most, if not all, the rehearsals. Ambassadorial dispatches and Tinghi's court diary record that the archduchess, often accompanied by her brother-in-law, Cardinal Carlo de' Medici, attended rehearsals throughout August and September before the 1624 performance, beginning again at the end of November in preparation for the January revival.[65] Molza even saw fit to inform his patron that the archduchess eagerly attended rehearsals immediately after her release from bed following a knee injury.[66]

But the most remarkable aspect of Maria Magdalena's concern for the opera's preparations is her interest and involvement in the process of actually selecting singers. For the 1624 performance, she borrowed Loreto Vittori and Francesco Campagnolo from other courts, after which she wrote letters of thanks to their respective patrons, Cardinal Barberini and the duke of Man-

has identified as Aldobrando Trabocchi, and a gold chain worth ▾200 to the castrato Loreto Vittori (I-Fas, Misc. Med. 11, fol. 83r, transcribed in Solerti, *Musica*, 177).

63. I-Fas, MDP 1703 (n.p.), letter dated 16 October 1624 from Ferdinando Saracinelli to an unnamed court secretary, possibly Curzio Picchena, who in turn provided a summary of the request as supporting documentation for the actual payment order (I-Fas, DG 1013, no. 125), which was headed by the name of Ferdinando II and dated 21 October 1624.

64. The Guardaroba at this time usually received ▾285/week from the treasury. Only one surviving treasury document specifically refers to the expenses for the 1625 festivities: Vincentio Vespucci's reckoning that the costs for the visit of the Polish dignitaries exceeded ▾8,000, 2,150 of which were incurred in the performance of *Sant'Orsola* and the hunt that had taken place on 31 January (I-Fas, DG 1014). The letter is preceded by a request to the grand duke (no. 329) for an additional ▾6,000 to pay the remaining bills associated with Władysław's visit. Cusick, "Of Women, Music, and Power," 284n9, refers also to a document addressed to Christine of Lorraine in which Vespucci lists the excessive costs of 9,000 florins in connection with the 1625 performance of *Sant'Orsola*.

65. I-Fas, Misc. Med. 11, fols. 64v, 67v, 69r, 70r, 70v, 71r, and 96v–102r. Some of the entries are reprinted in Solerti, *Musica*, 173, 177–78. The Molza documents can be found in I-MOas, AF 53, fasc. 17, fols. 89v, 118r, 148v.

66. I-MOas, AF 53, fasc. 17, fols. 160r–v. Dispatch dated 28 September 1624.

tua.[67] The surviving draft of her letter to the duke of Mantua demonstrates her desire to associate herself conspicuously with the opera, for emendations include the replacement of the words "our spectacle" with "my spectacle" for the final version (doc. 3.2).

Maria Magdalena was even more intimately involved with the casting of singers for the 1625 revival of *Sant'Orsola*. A series of letters between Maria Magdalena, her secretaries, and Ferdinando Saracinelli, who was in charge of the festivities, provides a vivid and often amusing picture of the difficulties posed by the revival. The correspondence demonstrates Maria Magdalena's acquaintance with singers in or around Florence not officially employed by the court and confirms both that she had enough musical knowledge to choose the best singer at an audition and that, in casting decisions, hers was the deciding voice.

The first exchange of letters concerned the problems created by the departure of Vittori and Campagnolo, which necessitated recasting the two principal roles and finding replacements for several minor parts. Saracinelli begins by apprising the archduchess of the results of the recent audition of three singers from outside the court's musical establishment: Bargellini, Minucci from Volterra, and Rigogli.[68] Francesca Caccini and Marco da Ga-

67. I-Fas, MDP 111, fol. 168r. Vittori (1600–1670) had been employed at the Florentine court from 1619 to 1621 until he was "loaned" permanently to the Ludovisi household in 1621. A letter of 26 November 1624 written by Ferdinando Saracinelli (doc. 3.5) confirms that Vittori sang the title role of Saint Ursula. Francesco Campagnolo (1584–1630), a virtuoso tenor in the employ of Duke Ferdinando of Mantua, had accompanied the duke and duchess to Florence for their visit of 1624, staying on after their departure to sing in *Sant'Orsola* and Peri's *Canzone delli lodi d'Austria*, both performed for Archduke Karl in October of 1624; see Parisi, "Ducal Patronage," 427. Although no source mentions the role sung by Campagnolo in the opera, his stature as a virtuoso matches the importance and the nature of the role of Ireo, Ursula's betrothed, whose laments and attempts at persuasion through rhetoric seem best suited to a virtuoso tenor, in the pattern of other early seventeenth-century tenor roles, most notably, Orpheus. And it was possibly for Monteverdi's Orpheus, Francesco Rasi, that the role was originally intended. Since Rasi was no longer alive in 1624, the archduchess appears to have requested another tenor from Mantua. Beginning with Emil Vogel ("Marco da Gagliano: Zur Geschichte des florentiner Musiklebens von 1570–1650," *Vierteljahrsschrift für Musikwissenschaft* 5 [1889]: 421; and Parisi, "Ducal Patronage," 427), musicologists have assumed that Campagnolo stayed in Florence and also performed in the 1625 revival of *La regina Sant'Orsola* for the prince of Poland, but Maria Magdalena's letter to the duke of Mantua of 12 October 1624 proves that Campagnolo returned to Mantua after the 1624 performance (doc. 3.2).

68. Very little biographical information is known for these three singers. A Benedetto Rigogli is mentioned by Cinelli as the poet of a *balletto a cavallo* performed in Florence in 1652 and was an active member of the Compagnia dell'Arcangelo Raffaello from 1612 to 1630. See

gliano had judged Minucci and Rigogli unsuitable, but they would withhold their final decision until after the arrival of Giovanni Battista da Gagliano, who would also audition them (doc. 3.3). The archduchess suggested yet another possibility: Honorato Magi, who would not officially enter the court rolls until 1628 (doc. 3.4).[69] Magi, a tenor, was presumably proposed for the role of Prince Ireo.

Saracinelli also had to recast several soprano roles, and again, Maria Magdalena offered advice and suggestions. The part of Saint Ursula originally sung by Vittori had been given to Maria Botti, one of Francesca Caccini's pupils, which left vacant the part of Urania, Botti's role in the first performance.[70] Saracinelli also informed the archduchess that they needed to choose a new singer for the role of Saint Michael, as well as for the chorus of eleven virgins, one of whom, Emilia Grazi, was now pregnant (doc. 3.3).[71] In what would become the recurring theme of this series of letters, Saracinelli hints at the behind-the-scenes antagonisms that threatened to derail the performance throughout the rehearsal period. From the outset, key members of

John Walter Hill, "Oratory Music in Florence, I: *Recitar Cantando*, 1583–1655," *Acta musicologica* 51 (1979): 130.

69. The archduchess later attempted to secure an ecclesiastical post for Magi that would locate him nearer the court, first on 25 February 1626 (I-Fas, MDP 120, fol. 11r) and then on 9 March 1625 [1626] (I-Fas, MDP 112, fol. 73r). By 10 May 1627 Magi was referred to as a "Musico di Palazzo" (I-Fas, MDP 1438, fol. 129v), officially entering the court rolls on 24 November 1628, according to Frederick Hammond, "Musicians at the Medici Court in the Mid-Seventeenth Century," *Analecta Musicologica* 14 (1974): 165. See also Kirkendale, *Court Musicians*, 376–77.

70. Maria Botti was probably one of the *discepole* who sang with Francesca Caccini in Archduchess Maria Magdalena's chapel on 28 March 1619 (Solerti, *Musica*, 144), for she appears shortly thereafter in the court's household accounts, having received clothing from the Guardaroba on 22 May 1619 (I-Fas, GM 391, fol. 307r; also cited in Kirkendale, *Court Musicians*, 350n91). This document refers to Botti as "Maria di Lorenzo Botti," allowing for the identification of Botti as the Maria di Lorenzo Botti who received annual disbursements of ▼29.2.1 from the household accounts. These payments were recorded from 5 August 1622 to 24 July 1626 (I-Fas, GM 406, 415, 427), with additional payments of ▼11.3.5.8 on 9 November 1624 (I-Fas, GM 415, fol. 24r) and 16 October 1626 (I-Fas, GM 427, opening 83). Maria Botti's final mention in the court's salary rolls occurred on 3 March 1632 (Kirkendale, *Court Musicians*, 384), several years after her active singing career appears to have ended.

71. Emilia Grazi was the daughter of Orazio Grazi, *sotto* maestro di cappella at the cathedral. She was on the court payroll from 20 May 1612 until 22 January 1623 (Kirkendale, *Court Musicians*, 349), after which time she received the interest on ▼300 deposited in the Monte di Pietà by Maria Magdalena (I-Fas, MDP 1838, fol. 89r; and I-Fas DG 1012, no. 6, which includes the original petition, dated 9 February 1622 [1623]).

the court's artistic establishment attempted to influence both casting and musical decisions: the librettist Andrea Salvadori wanted a castrato in the household of the Rinuccini family to be cast as Saint Michael, and he proposed that Domenico Sarti, a castrato employed by the Medici, should take over the parts vacated by Maria Botti.[72] Francesca Caccini opposed Salvadori's suggestion and instead attempted to assert proprietary rights over her student's former roles, insisting "that since she composed this part, it would seem owed to her that her brother Scipione sing it." The archduchess was decisive in her response, proposing that Domenico Sarti sing the roles of both Urania and Saint Michael, since he would have plenty of time for a costume change, while the chorus parts should be given to the Rinuccini castrato and Scipione Caccini (doc. 3.4).

Archduchess Maria Magdalena was required to amend these decisions almost immediately, for Saracinelli's subsequent letters of November reveal that Maria Botti could not learn her part (docs. 3.5–6). On 26 November 1624 he recounted the events of the previous day's rehearsal, or what appears to have been a coaching session, during which in two hours Botti managed to get through only the first twenty-five verses—in other words, her first speech. Saracinelli's letter also implies that meddling by Giovanni Battista da Gagliano and other court musicians may have added to the girl's confusion. On Vittori's departure Gagliano and a "Gianni," possibly Giovanni Del Turco, had assumed responsibility for teaching Maria Botti her new music, a usurpation that infuriated Francesca Caccini. Furthermore, Caccini claimed, Botti was now singing badly on purpose. Botti herself fueled this imbroglio by claiming to have been ill-treated at the hands of Caccini—charges that then led to the intervention of Botti's parents, who insisted on accompanying the girl to subsequent rehearsals. Saracinelli asked the archduchess to audition three singers for the part: Maria Botti, Domenico Sarti, and the unnamed Rinuccini castrato (doc. 3.5). In his postscript, Saracinelli reiterates that Maria Magdalena herself must resolve the conflict:

> But however it may be, let Her Serene Highness, for the love of God, command, so this negotiation can be resolved, and in whatever fashion [it ends], there will be problems. Sig. Andrea wants Maria, La Cecchina does not want anyone, Maestro Marco would like Loreto, Sig. Jacopo his own [candidate], and I our castrato,

72. I have been unable to identify the castrato proposed for the role of Saint Michael. Cesare Molza's dispatch of 7 September 1624 (I-MOas, AF 53, fasc. 17, fol. 107r) mentions the arrival of a priest related to the Rinuccini family [*un Prete de Rinuccini suo parente*], who had come from Sicily, where he had been in service to Cardinal Ridolfi. The priest, according to Molza, planned to retire to the parsonage of the archbishopric [*Canoniche dell'Arcivescovado*].

if for no other reason than because that was the first aria composed for Saint Ur-
sula. But our duty would be—leaving aside all passion—[to ensure] that [the
part] will be sung by the one who performs it best, by the one who most pleases
Her Serene Highness.[73]

On 28 November (doc. 3.7), Saracinelli repeated his request for the arch-
duchess's intervention.[74] Two days later, Maria Magdalena issued the edict
that appears to have concluded the matter (doc. 3.9):

> Now that we have heard our little castrato and also the women, according to the
> wish we had, we have thoroughly considered and reconsidered who should per-
> form our service, and have resolved therefore that our above-named castrato
> should sing the part of Saint Ursula with either the aria by Muzio or by the Mae-
> stro di Cappella, according to whichever seems best to you. We would like you to
> make sure that he studies with great assiduousness and diligence, pressing him also
> to learn well the gestures and all the other things that are needed to bring honor.
> Moreover, we command that you immediately let Maria know that we have cho-
> sen the part of Urania for her, being satisfied that La Cecchina will compose for
> her an appropriate aria for the words that have been changed. And the castrato of
> Rinuccini will sing the part of Saint Michael, as we decided awhile ago. We leave
> the rest to your judgment and care, and may the Lord God preserve you.[75]

Sant'Orsola marked an important departure in Maria Magdalena's patron-
age, for it was the first five-act, continuously sung opera performed in Flor-
ence since the advent of the regency in 1621. Its sacred topic was also new to
Florentine audiences. In the *Argomento* published in the 1625 libretto, Salvadori
attempts to legitimate the new subject matter by portraying it as the logical
outgrowth of earlier Florentine inventions: "Nor, perhaps, is it no small glory

73. As the documents (3.5–3.10) make clear, the "first aria composed for Saint Ursula" to
which Saracinelli refers was by Muzio Effrem, apparently for the never performed 1621 ver-
sion of the opera. Effrem composed the role for Arcangiola Palladini (doc. 3.5), a singer, tap-
estry weaver, and painter in service to the court until her death on 18 October 1622, who may
have been Effrem's student and with whom he frequently performed. For a brief biography
of the singer, see Maria Giovanna Masera, "Una cantante del Seicento alla corte Medicea: Ar-
cangiola Palladini," *La rassegna musicale* 16 (1943): 50–53. A letter of 29 June 1622 (I-Fas, GM
391, fol. 714r) confirms that Domenico Sarti also studied with Muzio Effrem.

74. While she was at Poggio Imperiale, the archduchess also received updates on the fes-
tivities' various events from Cardinal de' Medici: her response of 28 November 1624 (I-Fas,
MDP 111, fols. 213r–v) thanks him for the news and appoints him her representative, not-
ing that, "as for the music, all this discord will be resolved" [*Della Musica si accorderà tutto quel
che discorda*].

75. Maria Magdalena's reference to *women* is unclear, for throughout the exchange of let-
ters, Maria Botti is the only woman who was considered for the role.

of the Tuscan name, for just as under the auspices of the Most Serene Grand
Dukes, the practice of the ancient Greek musical dramas was renewed in this
theater, so today in this same theater a new field has been opened, which
treats, with more usefulness and delight, true and sacred Christian actions,
the vain fables of the pagans having been abandoned."[76] Salvadori explained
the rationale behind such subject matter in his dedication of the libretto to
Prince Władysław: "For a prince, defender of the faith, poetry in praise of a
princess who died for the glories of the Christian name is very appropriate"
[*A Principe difensore della Religione, benissimo si conviene Poesia in lode di Principessa morta
per gloria del Nome Cristiano* (6)].[77] Salvadori also praises Władysław's recent
military successes over the Turks, Tartars, and Muscovites—applause ech-
oed by the personage of Arno in the opera's prologue. By depicting the battle-
field successes of the prince as religious victories, Salvadori's encomiastic pro-
logue set up a plot strongly dependent on military imagery. The centrality of
these types of images to Ursula's iconography made Salvadori's depiction of
Ursula's spiritual battles and, more important, her victories a nearly perfect
choice to promote Maria Magdalena's hoped-for Catholic League.[78] Phrases
reminiscent of Lorini's treatise permeate the libretto: Ursula, with her bri-
gade of eleven thousand virgins, is frequently described as the general of her
army, whose epithets include "chaste warriors," "modest army," and "ama-
zons of god." Salvadori also juxtaposed scenes of Ursula's troops with those
featuring the other two armies central to his plot, the Huns and the Romans.
Ursula herself calls attention to the unusual gender of her warriors, drawn
from the "unwarlike" sex. In a stroke of dramatic genius, Salvadori reenacts
this inversion in one of the opera's most spectacular moments—the on-stage
battle between the Huns and the Romans—to reiterate traditional beliefs
concerning female courage. In a seventeenth-century prefiguration of the "you
throw like a girl" playground taunt, the Hun army challenges the Romans to
battle: "Oh Roman women: timid beasts remain hidden in their dens, but

76. "Né forse è poca gloria del nome Toscano, che si come sotto gl'auspici de' Serenis-
simi Gran Duchi, prima in questo Teatro fù rinovato l'uso de gl'antichi Drammi di Grecia in
Musica, così oggi in questo medesimo, sia stato aperto un nuovo campo, di trattare con più
utile, e diletto, lasciate le vane favole de['] Gentili, le vere, e sacre azzioni Cristiane" (Andrea
Salvadori, *La regina Sant'Orsola* [Florence, 1625], 13).

77. The topic was also highly appropriate for the visit of Archduke Karl, who had served
as the grand master of the Teutonic Order since 1619.

78. For an overview of the militaristic imagery, both literary and visual, commonly asso-
ciated with the saint, see Gabriella Zarri, "Ursula and Catherine: The Marriage of Virgins in
the Sixteenth Century," in *Creative Women in Medieval and Early Modern Italy: A Religious and Artis-
tic Experience*, ed. E. Ann Matter and John Coakley (Philadelphia, 1994), 243–49.

true warriors go out on the battlefield to confront the enemy ranks."[79] The
Romans respond: "Soon you will realize, when we take up arms, whether we
are manly hearts or vile little women."[80] This tactic of disparaging soldiers
by accusing them of effeminacy continues into the next act, as Gauno berates
his army for a recent loss, suggesting that his soldiers leave the manly job of
war and turn to women's work with the distaff and spindle.[81] Salvadori al-
lows his male characters to express these beliefs in order to disprove them
through the courageous actions of Ursula and her followers. The *intermedio*
that follows act 3, sung by the chorus of Christian captives, makes this point
explicit, affirming that, contrary to their perceived nature, women equal men
in their capacity for strength and zeal (62–63):

Ecco ch'ardon non sol d'invitto zelo	Behold, that not only virile, strong breasts
viril petti robusti,	burn with unconquered zeal
e gloriose Palme	and have glorious [martyrs'] palms
han dalla rabbia di Tiranni ingiusti;	because of the fury of unjust tyrants;
ma frali, e timid'alme	but I see frail and timid souls
del più debile Sesso, io veggio audaci	of the weaker sex boldly
sprezzar croci, flagelli, e rote, e faci.	scorning crosses, scourges, [torture] wheels, and torches.

Ursula's martyrdom provides the greater victory, for through her sacrifice
she liberates Cologne, something the Roman army is unable to accomplish
through warfare.

As did Cicognini in *Sant'Agata,* Salvadori elaborates on the legendary Ur-
sula's refusal of her tormentor's sexual advances by focusing the opera's plot
more narrowly around the issue of sexuality, specifically contestation over a
woman's right to withhold her sexuality, a choice guaranteed by God and re-
sistant to both illegitimate (Gauno) and legitimate (Ireo) claimants.[82] This
was, of course, an underlying theme in all versions of the legend, since the

79. "O femmine Romane: / stan le timide Fiere / ascose entro le tane: / ma l'anime guer-
riere, / escono in Campo ad affrontar le schiere" (Salvadori, *La regina Sant'Orsola,* 47).

80. "Tosto v'accorgerete / alla prova dell['']armi, / se siam' petti virili, / o femminelle
vili" (ibid., 48).

81. "Lasciate della guerra il nobil uso / e tra femmine vili / la man volgete alla conoc-
chia, e al fuso" (ibid., 53).

82. Following Geoffrey of Monmouth's twelfth-century version of the legend, Salvadori
chose Gauno (Guanius) as the name for his king of the Huns. For a summary of Geoffrey's
additions to Ursula's legend, see S. Baring-Gould and John Fisher, *The Lives of the British Saints,*
4 vols. (London, 1907–13), 4:325–27. Concerning Ursula's legend, cult, and iconography, see
Frank Günter Zehnder, *Sankt Ursula: Legende, Verehrung, Bilderwelt,* 2d ed. (Cologne, 1987); and
Guy de Tervarent, *La légende de Sainte Ursule dans la littérature et l'art du Moyen Age,* 2 vols. (Paris, 1931).

whole point of Ursula's elaborate shipboard journey was to avoid marriage and to remain a virgin. But Salvadori develops this topic into one of the central themes of his libretto, and to do so he makes significant alterations to the legend. One of his most notable changes is the inclusion of extraneous personages who summarize the legendary events that lead to the saint's final hours, allowing Salvadori to observe the unity of time and also enabling him to create an interpretative frame for his plot. Three of the characters appear in the opera's first scene, and they personify the evil against which Ursula fights only metaphorically in the previous sources. Asmodeo is the demon of lust, according to Salvadori's list of characters.[83] Joining him are Lucifer and Infernal Fury. This opening scene informs the audience that Saint Ursula's initial actions against sexuality have set in motion the events that will lead to her martyrdom. Appropriating what traditionally had been understood as God's decision to make martyrs out of Ursula and her followers, in Salvadori's version Lucifer condemns Ursula to death after Asmodeo complains that she has removed an excessive number of women from the pool of potential sexual partners, depriving Hell of future inhabitants (1.1):

Ah cruda, ah che non solo	Ah harsh woman, ah for not only did she
fece Tempio del Ciel le caste membra;	make a heavenly temple of her own chaste limbs,
ma tutto desolando il regno mio,	but completely depopulating my realm,
di seguaci Donzelle immenso stuolo	she takes away from my fire an immense crowd of
toglie al mio foco, e 'l serba puro a Dio.	female disciples and keeps them pure for God.

Salvadori includes an even more bizarre twist on the traditional legend in act 3.4. Ireo's servant narrates the events leading to the massacre, beginning with the arrival of the Huns, who are intent on first raping, then killing Ursula and her followers. But the virgins have a counterstrategy:

Alzano allora un grido	The humble little virgins
l'umili Verginelle,	then raise a cry,
e quel Nome chiamato,	and, having invoked that name
dalle stelle adorato, e da gl'Abissi,	adored by the stars and by the abysses,
tutte prostrate a terra,	all of them prostrate on the ground,
tutte, tenendo i lumi al Cielo affissi,	all keeping their eyes fixed on Heaven,
attendon liete la spietata guerra.	they happily await the pitiless attack.
O divino stupore, al santo Nome	Oh divine amazement: at the holy name
ne' barbarici cori in tutto spento	the evil desire of vile lust

83. Clubb (*Italian Drama in Shakespeare's Time,* 217) notes that generic demons named Asmodeo appear frequently in Italian sacred tragedies.

di libidin' infame il rio talento,	is extinguished in the barbaric hearts.
gridan di rabbia pieni,	They cry, enraged:
Pera chi Cristo adora:	"Perish, whoever adores Christ,"
e tratti all'istess'ora	and at the same time,
gli scelerati ferri,	their wicked swords drawn,
corron' à lacerare i casti seni.	they run to lacerate the chaste breasts.

Throughout the repertory of virgin martyr legends, God intervenes frequently to deal with those men who seek to relieve the heroines of their virginity. Salvadori's libretto credits the virgins themselves with this miracle. Their ability to render the Huns impotent thwarts their enemies, saves their virginity, and causes their ultimate victory—martyrdom. Similarly, Ursula's rejections of Gauno and her insistent refusal to praise Venus lead to her own death.[84]

Although all the music for *Sant'Orsola* has been lost, the survival of its 1625 libretto allows us to hypothesize generally as to its nature. The predominance of seven- and eleven-syllable lines in *versi sciolti* points to an opera in which recitative is the principal expressive vehicle—typical of Florentine operas of this time. For Ursula, Salvadori chose words and syntax characteristic of a heroine whose speech is forthright rather than ornate or highly rhetorical. Following the example of Cicognini in *Il martirio di Sant'Agata*, Salvadori also highlighted Ursula's strength and agency by contrasting her speeches to those of the principal male character, Prince Ireo, the saint's spurned fiancé. Ireo's words reveal the leading male character to be emotionally unstable and dramatically impotent, reduced to ineffectual pleading and unrestrained outbursts, rather than decisive action.[85] In each of his appearances in the first four acts, his speeches are filled with emotionally charged language, suggest-

84. In act 1.1, Asmodeo complains of Ursula's blasphemy against Venus, later denigrated as the "filthy goddess" [*sozza Dea*] by Ursula's follower, Cordula, in 5.2. And in 4.3 the chorus of Huns sings a hymn to Venus in the hopes of persuading Ursula to submit to their king.

85. Andrea Salvadori confirms this characterization by his description of the prince in the work's published *Argomento* of 1625, the edition to which the following page numbers refer. According to the *Argomento*, in nearly every one of his scenes Ireo laments: in 3.3 he mourns the loss of his kingdom, his enslavement, and above all, the danger in which he sees his beloved Ursula [*piange Ireo le sue miserie, la perdita del regno, la schiavitudine, e sopra tutto il pericolo, in che vede l'amata Donna* (10–11)]; in 4.2 he "exaggerates his love and his present miseries" [*esaggera il suo amore, e le presenti miserie*] to Ursula, who dismisses him (12); and finally in 4.4, after having witnessed Ursula's martyrdom, Ireo "laments more than in all the other scenes, feeling simultaneously diverse affections of the soul" [*si lamenta più che in tutte l'altre scene, sente nell'istesso tempo diversi affetti nell'animo* (13)].

ing delivery by means of highly expressive vocal writing. For example, in act 3.4, on learning of the massacre of Ursula's virginal companions and of Gauno's lust for the beautiful Queen Ursula, who must now choose between the Hun or death, Ireo erupts into a lament in which he complains selfishly of his own misfortunes:

Quando, già mai si vide,	Whenever was there seen,
quando, misero mè, giamai s'udio	when (poor me), whenever was there heard
tenor di fiera Stella equale al mio?	a condition of cruel fortune equal to mine?
Non ti bastò privarmi	Was it not enough to deprive me,
implacabil Destin del patrio Regno;	oh implacable destiny, of my kingdom?
non ti bastò legarmi	It was not enough for you to bind
alle piante real servil catena;	my royal feet with servile chain,
che per maggior mia pena,	so that to increase my pain,
innanzi à gl'occhi miei,	in front of my own eyes,
vuoi, ch'io veggia Colei,	you want me to see her,
colei, ch'è la mia vita,	her, who is my life,
da Barbaro spietato	abducted from me
esser à me rapita?	by a pitiless barbarian?
Deh pria, che questo veggia, ò Cielo, ò Fato,	Oh, before I see this, oh heaven, oh fate,
di sì misera vista, il pensier solo	may just the thought of such a miserable sight
ancida il cor di duolo.	kill my heart with sorrow.

The verses provided Gagliano numerous occasions for expressive musical details, for example, the repeated "quando," which begins Ireo's rhetorical question only to be interrupted by the "misero me" interjection. Gagliano might well have used chromaticism, dissonance, or harmonic extremes to mirror Ireo's complaints of harsh fortune and pain. Musical repetition—possibly beginning on a higher pitch—would have provided an appropriate musical equivalent to Ireo's angry "Non ti bastò" phrases of lines 4 and 6, while his dejected description of his murdered heart might well have been delivered with a sinking melodic line, possibly one that simply dies away without achieving a cadence.

Ireo is also unsuccessful in his attempt to save Ursula by pleading with Gauno (fig. 3.3), after which he delivers what Salvadori describes as the character's most expressive lament. The young prince experiences in rapid succession the emotions of despair, anger, loss, vengeance, resignation, indecision, and resolve. Short recitative interjections and choral commentaries punctuate his lengthy recitative, which constitutes the entirety of act 3.4. Ireo's plaint resembles others written by Salvadori. The text is composed largely of urgent *settenari*, with frequent repetition of words and entire lines as Ireo becomes increasingly agitated. Salvadori imposes order on the prince's rapidly shifting

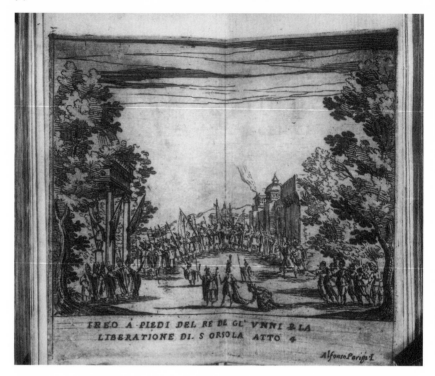

FIGURE 3.3. Alfonso Parigi, Ireo at the feet of the king of the Huns, in Andrea Salvadori, *La regina Sant'Orsola* (1625). Reproduced by permission of the Biblioteca Nazionale Centrale, Florence.

emotions by means of the short refrain that begins the lament and concludes each of its first three sections (76–78):[86]

Toglietemi di vita	Take away my life,
fierissimo dolore,	cruelest sadness,
aspra pena infinita,	harsh, infinite pain,
toglietemi di vita.	take away my life.

The refrain's accent pattern foreshadows another of Salvadori's recitatives, "Uccidimi dolore," part of Iole's lament that the poet may have extracted from the never performed opera *Iole ed Ercole.*[87] The two laments share a sim-

86. This tighter formal construction is typical of the operatic lament genre; see Ellen Rosand, "The Descending Tetrachord: An Emblem of Lament," *Musical Quarterly* 65 (1979): 347.

87. The lament was published as one of four recitatives in Salvadori's posthumous *Poesie,* 1:471–476. Peri's musical setting appears in two manuscripts, the so-called Roudnici manuscript (CS-Pnm, II.La.2, 45–49) and I-Bc, Q.49, fols. 21r–23r. The two manuscripts' readings of this work are nearly identical, varying principally in the placement of ties. See Paul

ilar structure, for in Iole's lament Salvadori uses the "uccidimi" phrase as part of a five-line refrain, which returns to conclude the first section of text. In their declamation and formal arrangements, both Salvadori texts recall Rinuccini's more famous "Lasciatemi morire" from the opera *Arianna*, set to music by Claudio Monteverdi. Jacopo Peri's musical setting of "Uccidimi dolore" calls attention to these textual similarities by modeling the beginning of that lament on Monteverdi's *Arianna* setting. Although we cannot know for certain, Gagliano may have paid similar homage to the well-known setting, especially since we have Saracinelli's evidence that at least one court singer viewed Gagliano's music for the opera as derivative of that by other composers (doc. 3.7).

Ireo regains his royal dignity only after witnessing Ursula's martyrdom, the event that causes his conversion. In his final scene and for the first time in the opera, he responds to a situation without laments, and he instead vows to follow Ursula's example (5.4). The model that Ursula provides—both to Ireo and to the opera's audience—is that of self-control and leadership. Like Agatha, she conveys her wishes bluntly and directly in order to achieve her goals. Numerous sixteenth- and seventeenth-century treatises warned that persuasive eloquence in a woman's mouth might expose its possessor as a dangerous seductress.[88] For Ursula and Agatha, however, language and its delivery allow them to command with force.

But Saint Ursula's traditional legend did not focus on her rhetorical gifts. Unlike a majority of her cohorts, a lengthy, written-out verbal exchange with her tormentor does not precede the description of Ursula's martyrdom in the *Golden Legend*. Salvadori turned instead to what appears to have been an iconographic tradition particular to Tuscany—one that highlighted a more argumentative protagonist. Possibly the earliest instance of this new, contentious

Nettl, "Über ein handschriftliches Sammelwerk von Gesängen italienischer Frühmonodie," *Zeitschrift für Musikwissenschaft* 2 (1919–20): 83–93; and Nigel Fortune, "A Florentine Manuscript and Its Place in Italian Song," *Acta musicologica* 23 (1951): 124–36.

88. Ann Rosalind Jones (*The Currency of Eros*, esp. 15–28), examines this as an underlying concern for female writers during the sixteenth and early seventeenth centuries. See also Peter Stallybrass, "Patriarchal Territories: The Body Enclosed," in *Rewriting the Renaissance: The Discourses of Sexual Difference in Early Modern Europe*, ed. Margaret W. Ferguson, Maureen Quilligan, and Nancy J. Vickers (Chicago and London, 1986), 123–42. Wendy Beth Heller has demonstrated persuasively the ways in which seventeenth-century Venetian operas resolve the conflict inherent in a system that values women's silence, yet by necessity requires female characters to sing expressive arias. Chaste heroines are identified by their laments, which were socially acceptable outlets for female expression (Heller, "Chastity, Heroism, and Allure: Women in the Opera of Seventeenth-Century Venice" [Ph.D. diss., Brandeis University, 1995], esp. 137–285).

Ursula appears in two fourteenth-century Tuscan manuscripts.[89] In several respects this variant diverges significantly from the legend as transmitted in the *Golden Legend*.[90] One of its most striking departures is its emphasis on Ursula's powerful speech. Throughout the story, the author appears to have invented scenarios solely in order to allow the depiction of a vocally commanding Ursula, and her speeches gain immediacy through presentation in the first person. This Ursula usurps her father's role and speaks directly to the foreign delegation, convincing them to accept her conditions and rendering them nearly speechless by her words. She preaches to the nobility of her own country, and she converts and baptizes her future husband and his father. During the pilgrimage she prays, admonishes, and exhorts her followers. And, finally, she verbally stands up to her tormentor, here described as the sultan of the Saracens. Ursula's commanding speech propels her not simply beyond gender but beyond humanity: "And Ursula spoke in front of all the people: and never was there a philosopher, nor man born of flesh, who spoke so wisely and miraculously; and all the people said: this is neither woman nor man, indeed it is an angel come from heaven."[91]

A fifteenth-century Tuscan source, the *Sacra rappresentazione di Sant'Orsola* attributed to Castellano Castellani, also emphasizes the assertive, eloquent Ursula.[92] Castellani includes several scenes that demonstrate the saint's verbal prowess: she assumes responsibility for addressing the foreign ambassadors and informing them of her conditions, she converts the pagan king and prince,

89. Zambrini, *Collezione*, 1:177–212.

90. These narratives are of the so-called eastern variant, in which Ursula and her followers come from the east, in this case Hungary, rather than Britain. See Baring-Gould and Fisher, *Lives of the British Saints*, 313–23. The Tuscan manuscripts alter the traditional legend in other significant ways: Ursula's future father-in-law is described as a Muslim rather than the king of England; and this king and his son are not baptized in their own country, where they await Ursula's return from her voyage, but come to her for baptism, eventually joining her in the pilgrimage.

91. "E Orsola fece parlamento davanti a tutta gente: e giamai non fu filosofo, né uomo di carne nato, che parlasse così saviamente e miracolosamente; e diceano tutte le genti: questa no[n] è femina né uomo, anzi è agnolo del cielo venuta" (Zambrini, *Collezione*, 1:199).

92. Colomb de Batines (comp., *Bibliografia*, 45) lists a 1509 edition of this work, which was lost by the nineteenth century. Alessandro d'Ancona included the 1516 edition of the work in his *Sacre rappresentazioni dei secoli XIV, XV e XVI*, 3 vols. (Florence, 1872), 2:409–44, attributing it to Castellani. The original, now lost, version most likely dates from the second half of the fifteenth century. See Ludovico Zorzi, *Carpaccio e la rappresentazione di Sant'Orsola: Ricerche sulla visualità dello spettacolo nel Quattrocento* (Turin, 1988), 12–13. Alfredo Cioni (*Bibliografia*, 244–47) cites subsequent Florentine editions through 1589, noting additional Sienese editions of 1581, 1608, and 1621.

and she verbally challenges her enemy, Julian, prince of the Huns. Whereas the Ursula of the fourteenth-century legend uses her confrontation with the Saracens to confirm her group's dedication to the Christian faith even in death, Castellani's Ursula defiantly refuses her enemy's sexual advances and insults him (441):

Confonditi, tiranno ingrato e rio,	Be confounded, you ungrateful and evil tyrant,
privo d'ingegno, ragione e intelletto:	without wits, reason, and intellect:
aspetta pur che ti castighi Dio,	just wait for God to castigate you
O velenoso mostro al ciel dispetto.	oh poisonous monster, unpleasing to heaven.
Guarda chi mi richiede il corpo mio!	Look who asks me for my body!
Un che all'inferno è in sempiterno eletto.	One who is permanently destined to hell.
Lupo, drago, leon, fiera selvaggia,	You wolf, dragon, lion, fierce wild beast,
guarda che sopra a te l'ira non caggia.	watch out so that [divine] wrath does not fall on you.

Ursula's abuse provokes Julian to his rash deed, and as he plunges an arrow into her breast he blames her for his actions [*Poi che tu m'hai condotto a questa sorte* (441)]. As a result, Ursula's martyrdom appears to stem more from her refusal of Julian than from her Christianity.

Salvadori continues this Tuscan tradition of the verbally assertive virgin in *La regina Sant'Orsola*. In the majority of the scenes in which she appears (2.2, 4.1–3, and 5.7), Ursula is the unshakable voice of faith, encouraging her followers and refusing to submit to the requests or demands of the male characters. In her first appearance in the opera, Ursula exhorts her troops to bravery, a parallel to the scenes in which leaders of the Huns and Romans motivate their own soldiers. She rallies her chaste army with promises of heavenly glory, and her speeches, although relatively long, are succinct and clearly organized by means of frequent full stops.

Gagliano undoubtedly would have amplified Ursula's commanding persona through melodic and harmonic control, expressive restraint, and resolute cadences, that is, musical devises that actually resemble the characteristics of self-control, resolve, and efficacy. In her on-stage appearances before martyrdom, Salvadori's verses offer no occasion for the virgin to sing anything but recitative, and Gagliano would likely have reinforced musically the emotional reserve exhibited in the majority of these speeches. For example, the exhortation with which Ursula concludes act 4.2 presents a commanding protagonist who orders Prince Ireo to model his behavior on her female followers:

Sù Giovine reale,	Courage, royal youth,
da tenere donzelle	take your example from young girls
di Cristiana virtù prendi l'esempio:	of Christian *virtù:*
vanne tra 'l popol empio,	go among the impious populace,

và generoso eroe, confessa Cristo;	go, generous hero, acknowledge Christ;
e fa di nuovo Regno in Cielo acquisto.	and gain a new realm in heaven.

The frequent imperative verbs she directs toward Ireo provided opportunities for musically forceful language, while her final four commands create the forward-moving momentum that Gagliano often used as an occasion for an extended cadential preparation.

As in the *sacra rappresentazione* Ursula remains fearless in the face of death. Since the seventeenth-century operatic stage was much less likely than the *sacra rappresentazione* genre to depict horrible death on-stage, Salvadori avoids a gruesome reenactment of her martyrdom by having the entire episode related after the event by her lieutenant, Cordula (5.2). The danger of this dramatic strategy is that it weakens the immediacy of the plot's pivotal event. But Salvadori takes care to preserve the argumentative Ursula even after her death, and he achieves this by structuring Cordula's narration so that she repeats Ursula's actual words:

Stanne da me lontano	Stay far from me,
barbaro scelerato,	wicked barbarian,
e non osar la temeraria mano	and do not dare to stretch your temerarious hand
stender in questo corpo à Dio sacrato.	toward this body consecrated to God.
Serva son io di Cristo, e sua Consorte:	I am Christ's servant and his consort:
ti basti à darmi morte,	may the fact that I disdain false gods and adore
a mandarmi contenta al mio bel Coro,	Christ be sufficient cause for you to give me death,
ch'i falsi dei disprezzo, e Cristo adoro.	to send me, content, to my beautiful choir.

Like her saintly predecessor Agatha, the stoic Ursula finally rejoices at the end of the opera, as she ascends to heaven amid her company of virgins and the holy martyrs, while beneath her Roman soldiers execute their ballet, visually confirming the restoration of order. For the first and only time in the opera, Salvadori gives the saint a closed form, in this case a strophic canzonetta of *ottonari* and *quinari piani* and *sdruccioli*. Ursula has accomplished her earthly mission, and she is now free to sing with the angels.

As women who conspicuously and heroically renounced sexuality, both Agatha and Ursula provided public images of the female gender distant from its identification with sexuality, which had provided many of the weapons used to denigrate women in contemporaneous misogynistic writings. Ursula's ultimate rejection and defeat of not only Gauno and the Huns but also the ideals of Venus and Mars that the Huns embody, coupled with the opera's final, spectacular destruction of Mars's temple, mark the culmination of a series of attacks on the once-revered gods and goddesses of Greek mythology.

As Salvadori himself claimed in 1625, the mythological subjects that had formed the basis of earlier Florentine operas had been reduced to "the vain fables of the pagans."

The image of the virgin martyr was thus a fitting choice for the self-presentation of Maria Magdalena. Like the archduchess, saints Ursula and Agatha held positions of political influence as queens or noble women. Both were active proponents of the Catholic faith, and as such achieved positions of spiritual power, while their virginity caused them to transcend the restrictions normally faced by women, allowing them to be defined on the basis of personal *virtù* rather than biological function. By commissioning artistic, visual, and musical re-creations of their stories, Maria Magdalena reminded both her subjects and foreign visitors of other women who had, with God's help, achieved goals traditionally reserved for men. Through her own active promotion of a Catholic league and her conspicuous sponsorship of religious spectacle, Maria Magdalena attempted to display visually her position among God's chosen representatives on earth as Tuscany's own Amazon of God.

Documents for Chapter 3

Document 3.1. I-MOas, AF 53, fasc. 17, fol. 148v. Ambassadorial dispatch from Ambassador Cesare Molza of Modena to the duke of Modena, 21 September 1624.

. . . Vanno provando la Rappresentazione di *Santa Orsola*, et ultimamente sendo da un Cav.re principale stato domandato al Gran Duca, che gli ne parea, S.A. rispose, ch'era bella, ma che gli pareano più belli m / 20 [*ventimila*] scudi spesi in essa rappresentazione. . . .

They are rehearsing the *Rappresentazione di Santa Orsola*, and recently, the Grand Duke having been asked by a principal courtier how he liked the spectacle, His Highness responded that it was beautiful but that he considered the 20,000 scudi spent on it more beautiful.

Document 3.2. I-Fas, MDP 111, fol. 168r. Draft of a letter from Maria Magdalena to the duke of Mantua, 12 October 1624.

Mi promesse V.A. gran cose del Cav.re Campagnuola et delle sue virtù, ma veram*en*te mi sono riuscite molto mag*gio*ri di quel che ella le rappresentò, poiché si è portato di una maniera in q*ue*sta mia festa che se ne torna hora costà con tutta la lode, et glorioso à servire l'A.V. et io ho voluto accompagnarlo con la pr*e*sente mia lettera. . . .

Your Highness promised me great things of Cavalier Campaguola [Campagnolo] and of his talents, but truly they seemed to me even greater than how you portrayed them, because he has acted in such a manner in my spectacle that he now returns with all the praises, glorious to serve Your Highness. And I wanted to send my present letter along with him. . . .

Document 3.3. I-Fas, MDP III, fols. 182r–v. Letter from Ferdinando Saracinelli to Maria Magdalena, 23 October 1624.

Sere*nissi*ma Padrona: Il Sig. Bargellini mi ha risposto, che sarà sempre prontissimo ad obbedire a cenni di V.A.S. Il Sig. Minucci venne da Volterra, l'ha sentito M*aest*ro Marco et la Cecchina, concordemente giudicano, che la soffitienza non arrivi di gran lunga al bisogno nostro, et al desiderio ch'egl'ha di servire, ond'io ringratiandolo l'ho licentiato nel miglior' modo che ho saputo. Il Rigogli si porta bene, dubbitano di poca voce, à si gran' Theatro, à me non pare, tuttavia per giocare al sicuro siamo restati come torna il fratello di M*aest*ro Marco di Villa, di provar' sul luogo proprio, et in ogni caso si provederà al servitio di V.A.S. Il Sig. Andra [sic] vorrebbe, che il castrato del Sig. Rinuccini facesse San' Michele, et il nostro cantasse ne Cori, et recitasse la parte d'Urania, la q*u*ale faceva la Maria. La Cecchina s'oppone dicendo che, per haver' composto lei questa parte gli parrebbe dovere, che la cantasse Scipione suo Fr*at*ello, già ch'egl'è una delle nove Muse e per che passa poca intelligenza tra il Sig. Andrea et lei, ho detto che l'imparino tutti due, et che poi V.A.S. comanderà, [fol. 182v] sarà anche necessario pensare à cori delle sante Vergini già che la Maria fa la Sant'Orsola, l'Emilia è gravida, et quella del Nasi mi dicono ch'ell'è più di là, che di qua.

Mandai à V.A.S. la listra [sic] di giovinetti nobili, per servitio del Sig. P*rincipe* Gio*van* Carlo et un'altra per servitio dell'altra festa, et la Cecchina dice, che non può o non vuole andar' più innanzi se prima non viene l'avviso del gusto di V.A.S. La supplico in cio à riposarsi sopra di me, et se gli volessi dire, le cagioni che mi hanno mosso, alla novità di quelle parti, sarei troppo noioso. Che la mia lett*er*a sia capitata à V.A. ne sono certis*sim*o, così per la risposta del Sig. Demurgo, come per l'ordine che ha havuto, il Sig. Marchese Guicciardino.

Confesso à V.A. liberamente, ch'io sono restato mortificatissimo, mentre vedo di non esser' degno nepure d'un' semplice avviso, posso havere errato per ingnoranza [sic], et per questo meritar' tanto gastigo, et esser' forse stato troppo ardito, in haver' scritto à V.A.S. quanto occorreva per suo servitio, ma la devota mia servitù, et il desiderio di operar' bene dovrebbero interceder per me perdono. . . .

Most Serene Mistress: Sig. Bargellini has responded to me that he will always be most ready to obey any sign from Your Most Serene Highness. Sig. Minucci came from Volterra, and Maestro Marco [da Gagliano] and La Cecchina [Francesca Caccini] heard him, and both judge that his capacity does not meet our need, nor his desire to serve, by a great deal, so that, thanking him, I have dismissed him in the best way I know how. Rigogli acts well, [but] they doubt the sufficiency of his voice in such a large theater, although it doesn't appear that way to me. Nevertheless, to play it safe, we agreed that, as soon as the brother [Giovanni Battista da Gagliano] of Maestro Marco returns from the villa, we will audition [him, i.e., Rigogli] in the actual place, and in any case we will provide the service to Your Serene Highness. Sig. Andrea [Salvadori] would like for the castrato of Sig. Rinuccini to perform [the part of] Saint Michael, and for ours [Domenico Sarti] to sing in the chorus and to perform the part of Urania, which Maria [Botti] performed. La Cecchina opposes this, saying that since she composed this part, it would seem owed to her that her brother Scipione sing it, who is already one of the nine muses. And since there is little concord between her and Sig. Andrea, I have asked both candidates to learn [the part], and then Your Most Serene Highness will decide. It will also be necessary to consider the chorus of the holy virgins, since Maria is Saint Ursula, Emilia [Grazi] is pregnant, and that one of Nasi's they tell me is more dead than alive.

I sent Your Serene Highness the list of noble boys to serve Prince Giovan Carlo and another to serve at the other entertainment, and La Cecchina says that she cannot or will not go further until she first is advised of Your Highness's wishes. I will ask [Your Highness] to trust me in this, and if I wished to tell you the reasons that moved me to recast those parts, it would take too long. I am most certain that my letter arrived to Your Highness, due to Sig. Demurgo's response as well as the order that Sig. Marchese Guicciardino has received.

I freely confess to Your Highness that I am most mortified, since I see that I am not worthy of even a simple note. I may have erred through ignorance, and for this merit such castigation, and perhaps I have been too bold to have written to Your Most Serene Highness what was necessary for your service, but my devoted service, and the wish to do well should intercede for me by way of pardon. . . .

Document 3.4. I-Fas, MDP 111, fol. 180r. Draft of a letter from Maria Magdalena to Ferdinando Saracinelli, 26 October 1624.

. . . Ci piace quanto havete avvisato per conto del Bargellini, et del Minucci, et se il Rigogli non habbia voce bastante à cotesto theatro, si potrà mettere nel suo medesimo luogo, et parte il frate Don Honorato di Santa Trinità, che sì ne offerisce.

Ma non vogliamo già far torto al nostro Castratino col mandarlo ne Cori, anzi gli darete non solo la parte di Urania, ma anche quella di San Michele, poi che trà l'una, et l'altra si interpone tanto tempo, che è molto bastante à mutarsi di abiti, et mettisi pure nel coro quello del Rinuccini.

Et se la Cecchina voglia qualche parte per il suo fratello, potrete dargli quella dell'Emilia, ò altra ne cori, rimettendoci inciò al vostro giudizio—et il Sig.re Iddio vi [protegga].

We are pleased at your advice regarding Bargellini and Minucci, and if Rigogli has insufficient voice for that theater, the brother Don Honorato [Magi] of Santa Trinità can be put in the same part, since he has offered to do it.

But we do not want to wrong our castrato [Domenico Sarti] by sending him to the chorus, but rather you will give him not only the part of Urania, but also that of Saint Michael, since between the [entrances of] one and the other there is plenty of time to change costumes, and instead let that one of Rinuccini be put in the chorus.

And if La Cecchina wants some part for her brother, you can give him that of Emilia or some other in the chorus, leaving it to your judgement. And God protect you.

Document 3.5. I-Fas, MDP 1703 (without foliation). Letter from Ferdinando Saracinelli to an unnamed recipient, 26 November 1624.

Molto Ill.re et Molto R.do Sig. mio Oss.mo: È arrivato questa sera l'Ill.mo Sig. Cardinale de Medici, et in particolare mi ha detto che io procuri, che la Maria non sia strapazzata dalla Cecchina et tutto per ordine della Ser.ma Arciduchessa Padrona. Io confesso ingenuamente che nel tempo che la Maria è stata à Casa la Signora Francesca non ho mai veduto si non onorarla come Figliola ben è vero che la Francesca ha havuto strasordinariamente [sic] per male, che il fratello del Maestro di Cappella, et il Gianni, habbino insegnato alla Maria l'aria di Maestro Marco, subbito partito Loreto, et che hora conforme all'ordine lasciato dalla Ser.ma non hab-

bino voluto che la Cecchina insegni la detta parte alla Maria. Et io in questo particolare non ci ho fatto diligenza perché non havessero poi à dire che la Cecchina gliene havesse insegnata al roverscio, et à me bastava di havere l'intento mio, cioè, chela l'imparasse bene, ora la Cecchina grida Misericordia et dice che è stata assassinata dalla Maria, et che cantò l'aria sua à posta male, in questo ci sarebbe molto che dire perché in verità il giorno innanzi, che la provasse in presenza di S.A., Messer Angiolo, et me, le stemmo intorno ai primi 25 versi due ore. Ma la non volle far' punto punto di quello che noi gli dicemmo, basta dice la Cecchina, che, si come è stata abbile à insegnare alla Maria molte cose, così gli havrebbe potuto imparare questa parte.

Accennai al Sig. Niccolini, che dicesse alla Ser.ma che questa mattina questi Signori del balletto della Santa Orsola havrebbero provato il ballo, si come hanno fatto et è riuscito per Eccellenza. Dissi ancora che oggi sarei andato à Casa la Cecchina, et che harei sentito la Sant'Orsola cantata dalla Maria. Licentiata la gente restai con il Sig. Andrea, per sentirla, et il Padre, et la Madre, non vollsono [sic] che la Cantasse, et ella disse non la sapere, et che voleva di molto tempo à scordarsi di quella della Cecchina. Io oltra molte altre infinite cose sofferte, confesso che questa mi dette molta noia. Tuttavia non volsi replicare altro, et feci più tosto il balordo, come ho fatto in molte altre cose per levar' confusioni. Mi parve poi che ero quivi, et vedevo fare certe risate che à me non pi[a]quero punto, di voler chiarire qualched'uno con far cantare la Sant'Orsola dell'Arcangiola al nostro Castratino. Il quale pareame che la dicesse in maniera, che quelli che dianzi ridevano, cominciono à mutar faccia, et il padre della Maria à dare ne cimbali, che non vuole che la sua figliola sia strapazzata, et vadia à cimento. Io replicai che mi maravigliavo di lui, che havesse, tanto ardire, di volermi legare le mani nel servitio di S.A. et che non solo Domenico sapeva l'aria di Mutio, ma che il castrato del Rinuccini, cantava quella del Sig. Jacopo, et se più vi fossero stati in Fiorenza abbili, à questo servitio che à più gl'havesse fatti imparare. Insomma l'istesso Sig. Andrea, sopre l'aspettation' sua, confessò, che s'era arrivato tanto in la che ne restava maravigliato, si come quei vecchioni del mestiere che vi furono, cioè di nostri musici; et anche di quelli studenti di Maestro Marco. Sappi dunque S.A.S. quanto passa, et di me disponga come vuole, et degli strapazzi ricevuti, perché di quanto ho sentito et mi è stato ridetto, et ho anche veduto, et toccato con mano, tutto mi sono messo sotto alli piedi, et attenderò à servir' così, sin tanto che io perda poi il credito affatto, et che l'Altezze Loro mi levino questa briga per bocca dissutile.

Ricevarei per favore particolarissimo che S.A.S. sentisse tutti 3 questi soggetti, et risolvesse poi quello comanda che facci la detta Sant'Orsola, accio si potessino scrivere i libri, et tirare innanzi l'opera et provarla.

La parte dell'Urania è bassa per il nostro Castrato dico quella che cantava la Maria, et il Sig. Andrea mi dice forse perché non si canti quell'aria, che ha ridotto quella parte in quadernarij et disse haver mutato anche il prologo, cioè ridotto in altro metodo di versi. Questo l'accenno, accio S.A.S. sappia che non mancano fastidij; Ma come S.A. risolverà chi voglia che facci la Sant'Orsola, mi da poi il quore, che resti ben servita; Ma vorrei haver' questo gusto che sentisse tutt'à tre questi soggetti; et vedesse la fatiga, et lo studio che si è fatto, et poi, eleggesse quello che più gli piace; Non restò meno maravigliata che infuriata la Cecchina et si voltò al Sig. Andrea aspramente tanto che si hebbe à rimediare et mettere, un tantino la flemma da parte. Partimmo alla fine parve à me con gusto, et così io starò attendendo i comandamenti di S.A.S., alla quale mi farà gratia V.S. di leggere questa mia lunga diceria, et di rappresentarle, la devotissima mia servitù. . . .

Il Sig. Cardi*na*le mi dice che domani vuole sentire l'aria di Sant'Orsola dell'Arcangiola, quella della Maria non credo che la sentirà gia[c]ché il padre, non degna. Ma com'unque si sia S.A.S. per l'amor di Dio, comandi, che qu*es*to negotio si risolva, et in qualunque modo, vi sarà di fastidij. Il Sig. Andrea vuole la Maria[,] la Cecchina non vorebbe nessuno[,] M*esser* Marco vorrebbe Loreto, il Sig. Jacopo il suo, et io il nostro castrato, si non p*er* altro almeno p*er*ché quella fu la prima aria che fosse fatta p*er* la Sant'Orsola. Ma il dovere sarebbe lasciando ogni passione, che la cantasse, chi la dice meglio chi più piace à S.A.S.

My Most Illustrious and Reverend, Most Observant Lord: This evening the Most Illustrious Signore Cardinal de' Medici arrived, and he told me in particular to make sure that Maria [Botti] is not ill-used by La Cecchina [Francesca Caccini], by the order of our mistress, the Most Serene Archduchess. I confess in all honesty that in all the time Maria has been at [Caccini's] house, I have never seen the Signora Francesca honor her as anything but a daughter, although it is certainly true that Francesca took it extraordinarily badly that the brother of the Maestro di Cappella [i.e., Giovanni Battista da Gagliano] and Gianni [Giovanni del Turco?] taught Maria the aria by Maestro Marco immediately after Loreto [Vittori] departed, and that now, in conformity with the order left by Her Serene Highness, they have not wanted La Cecchina to teach that part to Maria. And I have not diligently followed up on this matter [i.e., that Francesca Caccini teach her the part] so that they would not be able to say that La Cecchina taught it to her backward [i.e., wrong]. It was enough for me to fulfill my intention, that is, that she learn it well. Now La Cecchina cries "Misericordia" and says that she has been assassinated by Maria, and that she sang her aria badly on purpose. On this matter there would be much to say, because truthfully, the previous day she rehearsed it before His Highness, Maestro Angiolo, and me, [and] we spent two hours on the first twenty-five verses. But [Maria] did not want to do anything we suggested to her. "Enough" says La Cecchina: since she has been able to teach Maria many things, she would have been able to teach her this part.

I alluded to Sig. Niccolini that he should tell Her Most Serene Highness that this morning those ballet dancers for *Sant'Orsola* rehearsed the dance, because they have done so, and it succeeded excellently. I also said that today I would go to La Cecchina's house, and that I would hear *Sant'Orsola* sung by Maria. Having dismissed the others, I remained with Signor Andrea to hear her. Her father and mother did not want her to sing it. She said she did not know it and that more time was necessary to forget that [version] by La Cecchina. I, besides the infinite other things I have endured, confess that this annoyed me greatly. Nevertheless, I did not wish to reply otherwise, and I preferred to play the stupid man, as I have done in many other cases to avoid an uproar. It then occurred to me, since I was there and saw people laughing, which I did not like at all, to enlighten some [of them] by having the [part of] Saint Ursula [composed] for Arcangiola [Palladini] sung by our little castrato, who, it seemed to me, performed it in such a manner that those who at first laughed began to change expression. And Maria's father went crazy [and said that] he didn't want his daughter to be overworked and to be put at risk. I replied that I marveled at him, that he had great boldness to bind my hands in service to Her Highness, and that not only Domenico knew the aria by Mutio, but also that Rinuccini's castrato was singing that by Sig. Jacopo [Peri], and if there were more [singers] capable of this service here in Florence, more would have been taught. In sum, the same Sig. Andrea, beyond all his expectations, confessed that so much had happened

here that he was amazed, just as were those old men of the profession that were there, that is, our musicians, and those students of Maestro Marco. Therefore, let Her Highness know what has occurred and let her do with me as she wishes. And [also let Her Highness know] of the insults [I] received, because I have put behind me everything I have heard and has been reported to me, as well as what I have seen and touched with my hand. And thus I will wait to serve, until I lose credit completely and Their Highnesses remove me from this task because of my inopportune mouth.

I would consider it a particular favor if Her Serene Highness would listen to all three of these candidates and then resolve by command who should sing the said [part of] Saint Ursula, so that the books can be written and the opera may be pushed forward and rehearsed.

The part of Urania is low for our castrato, that is, [the part] that Maria used to sing. Sig. Andrea tells me, since perhaps this [earlier] aria may not be sung, that he has reduced that section to quatrains, and he claimed to have changed even the prologue, that is, shortened it to another pattern of verses. I mention all to you so that Her Serene Highness knows that problems are not lacking. But as soon as she decides who she wants to sing the [part of] Saint Ursula, she must let me know, so that she remains well-served. But I would like the satisfaction that she listen to all three candidates and see the work and the study that has been done and then choose that one who most pleases her. La Cecchina was no less astonished than infuriated, and she turned on Sig. Andrea so harshly that we had to step in to intercede and to put aside our tiny bit of calmness. We left at the end with pleasure, so it seems to me. Therefore, I will await the orders of Her Most Serene Highness, to whom I would be thankful if Your Lordship would read this gossip of mine, telling her of my most devoted service. And I kiss the hands of Your Lordship. Florence, 26 November 1624.

P.S. The Sig. Cardinal tells me that tomorrow he wants to hear the aria of Sant'Orsola [written] for Arcangiola. I do not think he will hear the one [written for] Maria, since her father does not agree. But however it may be, let Her Most Serene Highness, for the love of God, command, so this negotiation can be resolved, and in whatever fashion [it ends] there will be problems. Sig. Andrea wants Maria, La Cecchina does not want anyone, Maestro Marco would like Loreto, Sig. Jacopo his own [candidate], and I our castrato, if for no other reason than because that was the first aria composed for Saint Ursula. But our duty would be—leaving aside all passion—[to ensure] that [the part] will be sung by the one who performs it best, by the one who most pleases Her Serene Highness.

Document 3.6. I-Fas, MDP 1703 (n.p.). Letter from Ferdinando Saracinelli to an unnamed court secretary, 27 November 1624.

Oggi quando mi credevo di andare al Casino del Sig. Cardinale intendo che egli è in Palazzo, et va alla Crocetta, l'ho servito sino alla carrozza, et ammi detto, che questa sera all'Ave Maria sarebbe à Pitti et prima che si provasse il Balletto à Cavallo la Sant'Orsola si potrebbe provare. Ora siamo vicino alle 2 hore, et non è tornato, onde ho messo l'animo in pace che non se ne habbia da far'altro. Mi resta dire, come non dovendo più andare al Casino per oggi, me ne andai a casa il Sig. Salvadori et trovandovi il fratello del Maestro di Cappella, mi vollero in ogni modo menare à casa la Maria, per sentirla et io ancorché hiersera ricevessi, quell'affronto dal Padre nulla di meno vuolsi correre risco del secondo.

Ho sentito la Maria si porta bene et servirà bene S.A.S. et farà onore à sé, al poeta, et a

chi gli insegna. Ma se lei, la canta bene, gl'altri non si stanno. Son' ben restato affrontato, et maravigliato, et me ne dorrò con il Sig. Card*inale* il q*uale* altro non mi disse hiersera, si non che facessi intendere alla Cecchina, che non istrapazzasse la Maria, et intanto, fece intendere alla Maria p*er* il Gianni, che al dispetto del mondo, et delle trombe, la Ser.ma voleva che la Maria cantasse q*uest'*opera, et in presenza mia mi hanno spi[a]ttellato questi ordini, che pur dovevano venire à me et non al Gianni. Metto q*uesta* con l'altre, nel sentir la Maria trovo la parte sbassata, intendo ~~forse~~ mutatione di parole, acciò l'aria di Mutio non ci habbia più luogo.

Insomma, à me da malam*ente* l'animo di servir così; ma comincio à giudicare ancora, come mai sarà possibile, che mentre si prova la Sant'Orsola la Cecchina habbia da poter vivere, p*er*ché cognosco quegli humori, et quelle lingue, et so in altre occ*asio*ne quello hanno detto, et quello diranno anche adesso. Dall'altra parte, vedo che se non si canta l'aria del M*aes*t*r*o di Cappella che tutto il mondo gridarà Misericordia. Gli giuro che mi duole di esser guarito del piede, et potevo pure siccome sono stato 3 giorni nell'letto, havere occ*asio*ne di starmi due mesi, accio loro Alt*ezze* havessiro provveduto à chi gli servire in q*uesti* intrighi, et diavolerie. Assolutam*ente* non bisogna che facci più conto la Maria che la Cecchina gli insegni una nota si non al roverscio, et io quanto à me la consigliarò à lasciare la parte della Santa Cordola, et ad attendere, solam*ente* all'altra. Et intanto prego Dio che me si svolga un altra volta il piede, et bramo il male per quiete, et p*er* riposo. Starò aspettando che S.A.S. comandi avvertendo che facci buono il detto del Sig. Card*inale* cioè che non vuole che la Cecchina insegni alla Maria, p*er*ché si altrimente fosse, sarebbe un aggiungere fuoco à fuoco, il Padre non vuole che la Cecchina la senta ne tampoco quegli altri; accordatiss*im*i che se la dice nulla, di gridar Misericordia et prorompere, in qualsivoglia parole, et Ingiurie, et io vedendomi poi portar poco rispetto non vorrei che la mia grandiss*im*a patienza fosse alfine vinta dall'impertinenza di Maria, che non ha pari.

Starò attendendo quello devo fare, et intanto prego V.S. di nuovo à favorirmi d'infastidir di nuovo la Ser.ma con q*ueste* mie lettere . . .

Today, when I thought to go to the Casino of the Sig. Cardinale, I hear that he is in the palace and will go to the Crocetta; I served him up to his carriage, and he told me that this evening at [the time of] the Ave Maria he would be at the Pitti, and that before the horse ballet was rehearsed *Sant'Orsola* could be rehearsed. Now it is close to two hours [after sundown], and he has not returned, so that I have put my soul at peace, for nothing else can be done. It remains for me to say that, since I no longer needed to go to the Casino today, I went to the house of Sig. Salvadori, finding there the Maestro di Cappella's brother. They wanted, in any case, to take me to Maria's house in order to hear her, and even though just yesterday I received that affront from her father, nonetheless it was wanted [that I should] run the risk of a second.

I heard [that] Maria acts well and will serve Her Serene Highness well and will bring honor to herself, to the poet, and to whomever teaches her. But even if she sings well, the others are not satisfied. I remain completely insulted and stunned, and I will complain about it to the Cardinal, who said nothing to me yesterday, except that I should make La Cecchina understand that she is not to scold Maria, and meanwhile make Maria understand, through Gianni, that despite the world and the gossips, the Most Serene [Maria Magdalena] wanted Maria to sing this opera, and in my presence these orders were revealed, which were supposed

to come to me and not to Gianni. I add this [offense] to the others: in hearing Maria I find the part debased, [and] I hear changes in the words, so that the aria by Mutio no longer fits.

In sum, it badly affects my spirit to serve this way, but I also begin to wonder if it will ever be possible, while *Sant'Orsola* is rehearsed, for La Cecchina to survive, because I know these emotions, and those tongues, and I know what they have said on other occasions, and what they will say even now. On the other hand, I see that if the aria by the Maestro di Cappella is not sung, all the world will cry "Misericordia." I swear to you that it pains me for my feet to have recovered, and since I was in bed for three days, I could have stayed there two months, so that Their Highnesses would have had to find someone [else] to serve them in these intrigues and devilries. Maria should absolutely no longer rely on La Cecchina, for she will not teach her any notes except wrong ones. And as for me, I will advise her to leave the part of Saint Cordula and to concentrate solely on the other.[93] And in the meantime I pray to God that my foot will twist again, and I desire the misfortune for peace and quiet. I will be awaiting what Her Serene Highness commands, warning that I will act on the words of the Cardinal, that is, that he does not want La Cecchina to teach Maria, because if it were otherwise, it would be adding fire to fire. The father wants neither La Cecchina nor any of the others to hear her. We all completely agree, for if she says anything it's to cry "Misericordia" and to burst out in some choice words and accusations, and, seeing that she has little respect for me, I would not want my great patience to be conquered finally by the impertinence of Maria, who in unsurpassed [in this].

I will be awaiting that which I should do, and in the meantime pray Your Lordship anew to favor me by again troubling Her Most Sereneness with these my letters. . . .

Document 3.7. I-Fas, MDP 1703 (n.p.). Letter from Ferdinando Saracinelli to an unnamed court secretary, 28 November 1624.

Ho ricevuto la Cortesissima sua delli 27. che mi ha infinitamente consolato, et sarò lesto Domenica mattina di buon'ora, con chi mi occorrerà venire, et menarò meco il Castratino, il Sig. Andrea et dua [*sic*] che suonano et inviarò i suoni innanzi, per via della dispenza. Quanto alle donne, io non ci pensarò punto, perché vorrà venire il Padre, con la figliola la Madre, et vorrano ancora o il Gianni o il Fratello del Maestro di Cappella; Ma non so già se potremo noi in un guscio ordinario menare oltra li sopradetti, il castrato del Rinuccini, et il Sig. Jacopo Peri, che vorrà essere à sonargliene. Ma V.S. vedrà che il padre della Maria ha da fare le fortune, quando sapra che si habbiano da far' queste prove. Et Maestro Marco si dorrà che l'aria di Mutio sia anteposta alla sua. Ma à questo ci sarebbe remedio di quietarlo, con fare impa-[ra]re al nostro castrato l'aria del Maestro di Cappella. Così, la Cecchina non si dorrebbe, il Sig. Andrea potrebbe aggiungere quante parole volesse et come ho detto Maestro Marco restarebbe sodisfatto, et ogn'uno quieto, et à quello del Rinuccini si potrebbe fare imparare il San Michele Arcangiolo. Supplico la Ser.ma à farmi gratia di non mostrare di saper nulla quanto ad accrescimento ò mutamento di parole, perché il Sig. Andrea facilmente lo dirà à S.A. lui medesimo et quando non gliene voglia dire, l'esortarò io a farlo, giaché egli mi ha pregato che di cio non dicesse niente a S.A. Intanto S.A. sentirà che l'aria del Maestro di Cap-

93. Possibly *La liberazione di Ruggiero*, also performed as part of the festivities and discussed in chap. 5.

pella assomiglia à quella di Mutio, se bene il Sig. Andrea disse che quella di Mutio assomigliava à quella del M*aes*tro di Cappella. Ma M*esser* Piero disse, che era rubbata di peso di peso in molti luoghi, siché cantando quella del M*aes*tro di Cappella cantava quasi quella di Mutio, et non si darà disgusto à quell'huomo.

. . . Non posso dire il gusto del Sig. Card*ina*le giaché come scrissi, egli sfuggi la squola et poiché S.A. si risolve a sentirla lei, non starò à fare altra deligenza se S*ua Signoria* Ill.ma non comanda.

I received your most courteous letter of the 27th, which consoled me infinitely, and I will be swift early Sunday morning with whomever needs to come with me, and I will bring with me the little castrato [Domenico Sarti], Sig. Andrea and two instrumentalists. And I will send the instruments ahead, by means of the *dispensa* [presumably the Guardaroba]. As for the women, I will not worry at all about it, because the father will want to come, as well as the mother with her daughter, and either Gianni or the Maestro di Cappella's brother will want to come. But I really do not know if, in an ordinary carriage, we will be able to bring, besides those above-named, the castrato of Rinuccini and Sig. Jacopo Peri, who will want to accompany him. But Your Lordship will see that Maria's father will want extra money when he finds out that there are to be these rehearsals. And Maestro Marco will complain that Mutio's aria is preferred to his. But for this, the remedy to quiet him would be to have our castrato taught the aria of the Maestro di Cappella. In this way, La Cecchina would not complain, and Sig. Andrea could add as many words as he wanted. And, as I have said, Maestro Marco would be satisfied, and everyone [would be] happy, and Rinuccini's castrato could be taught [the role of] Saint Michael the Archangel. I implore Her Highness to favor me by not revealing that she knows anything about the adding or changing of words, because Sig. Andrea will certainly tell Her Highness this himself, and if he does not want to tell her, I will exhort him to do so, since he has begged me to say nothing of it to Her Highness. Meanwhile, Her Highness will hear that the Maestro di Cappella's aria resembles that of Mutio, although Sig. Andrea said that [the aria] by Mutio resembled the one by the Maestro di Cappella. But Messer Piero said that in many places it was completely plagiarized, so that [in] singing the aria by the Maestro di Cappella one was singing nearly that by Mutio, and it will not give offense to that man.

. . . I cannot speak of the Sig. Cardinal's pleasure, since, as I wrote, he avoids the school, and since Her Highness has resolved to hear it herself, I will not make any other effort if Your Most Illustrious Lordship does not command it.

Document 3.8. I-Fas, MDP 1703 (n.p.). Letter from Ferdinando Saracinelli to an unnamed court secretary, 28 November 1624.

A' ore dicennove, ho ricevuto la lettera di V.S. delli 27. Et alle 20 ore, ho ricevuto la seconda delli 28. Alla prima ho risposto, et consegnato la lettera al Sig. Cav.re Carlotti. Alla seconda, dirò di nuovo che inviarò gl'istrumenti costà, che saranno necessarij per q*ue*ste prove et ho pensato così all'improviso, come nemico delle confusioni et delle cicalate, che S.A.S. mi comandi per una di V.S. che la vuole far' le prove di tutti 3 questi soggetti, ma per meglio gustarli, vuole che vadino ad uno ad uno, et che p*er* il primo vuole che sia Domenico, et con q*ue*sto verrò ogni volta che S.A.S. comanda, cioè o sabbato o Domenica o quando vorrà, et quanto all'arrivare all'ora che S.A.S. vuole, da me non resterà. Ma p*er* un solo, quando, non

vi sia altro impedimento che della consulta Domenica doppo desinare in un ottavo di ora si spedisce. Et piacendogli poi Domenico, vorrei, che senza ordinarmi altro, il giorno doppo mi facessi scrivere, che il gusto di S.A.S. et il comandamento è che Domenico la Canti, et che rimetta in me se o l'aria di Mutio o quella di Maestro Marco, et se il Sig. Andrea il quale io menarò dicesse nulla di nuove parole, ò mutamenti, che gli rispondesse, che anche di questo scrivarà à me quanto occorre, et che anche in questo à me S.A. si rimettesse, che darò sodisfatione al Sig. Andrea quanto vuole, poiché il tempo lo permette, et così, credo che tutti resteranno si non sodisfatti, almeno manco disgustati, et io harò campo di servire V.A.S. et l'Altezze loro, non havranno tanti rompimenti di capo, et il servitio assolutamente camminara bene. Et la Cecchina si quietarà, et potrà meglio fare quello deve, che in verità par'proprio che faccino in prova per restar' questa donna accio non possa bene servir S.A.S. Non sarà più lungo, per vedere questa Neaga questa sera et stare attendendo i comandamenti di S.A.S.

At roughly 3 P.M. I received Your Lordship's letter of the 27th. And the following hour I received the second of the 28th. I responded to the first and delivered the letter to Sig. Cavaliere Carlotti. As to the second, I will say anew that I will send there the instruments that will be necessary for these auditions. And, just all of a sudden, I thought, as an enemy of confusion and chatter, that Her Most Serene Highness should command me, through a [letter] from Your Lordship, that she wants to rehearse all three of these candidates, but that, in order to better enjoy them, she wants them to go one by one, and for the first she wants Domenico. And I will come with this one [i.e., Domenico] anytime that Her Serene Highness commands, that is, Saturday, or Sunday, or whenever she wishes, and at the time that Her Most Serene Highness wishes and she will not be [disappointed] by me. But for just one [candidate], when there is no other obstacle except the council, it could be settled on Sunday afternoon in an eighth of an hour. And if Domenico is pleasing to her, I would like that without ordering anything else of me, the next day you have me write that the pleasure and command of Her Most Serene Highness is that Domenico sing it, and that [the choice] of either the aria by Mutio or that by Maestro Marco rests with me, and if Sig. Andrea, whom I will bring, should say nothing of new words or changes, [she] would respond to him that even about this she will write to me everything that is necessary, and that also in this Her Highness would entrust me to give as much satisfaction to Sig. Andrea as he wants, because time allows it. And this way, I believe that everyone will remain, if not satisfied, then at least not unhappy, and I will be free to serve Your Serene Highness and Their Highnesses, they will not have such headaches, and the service absolutely will proceed well. And La Cecchina will quiet down, and she will be better able to do what she must, for in truth, it appears to me that in rehearsal they behave in order to impede this woman so that she cannot serve well Her Most Serene Highness. It will not be much longer until [I] see this [Sig.a?] Neaga this evening, and I remain waiting for the commandments of Her Most Serene Highness and of Your Lordship. . . .

Document 3.9. I-Fas, MDP 111, fol. 215r. Draft of a letter from Maria Magdalena to Ferdinando Saracinelli, 30 November 1624.

Hora, che noi habbiamo sentito il nostro castratino, et anche le donne, conforme al desiderio, che ne tenevamo, habbiamo ancora molto bene considerato, et digrumato quel che compia al nostro servizio et ci risolviamo perciò che il sudetto nostro Castratino canti la parte di Santa

Orsola con l'Aria però, o di Muzio o del Maestro di Cappella, secondo, che à voi parrà più à proposito, et vogliamo, che lo facciate studiare con ogni sorte di assiduità [e] diligenza, premendo anche che egli impari bene, et i gesti, et tutto quel più, che bisogni per farsi honore. Comandando noi di più, che voi facciate subito sapere alla Maria che le habbiamo destinato la parte di Urania, contentandoci che la Cecchina le facci l'Aria proporzionata alle parole che si sono mutate; et il castrato del Rinuccino canterà la parte di S. Michele; si come un pezzo fa gli havevamo destinata. Rimettendoci nel restante al giudizio et all'accuratezza vostra, et il Sig. Iddio vi conservi.

The English translation appears in the body of the chapter.

Document 3.10. I-Fas, MDP 1703 (n.p.). Letter from Ferdinando Saracinelli to [Prince Giulio], 2 December 1624.

Per reverenza, non risponderò alla lettera della Ser.ma Arciducessa Padrona ma V.S. mi honorerà di dirgli, come prima che ad ogn'altro conferii i comandamenti di S.A.S. al Sig. Andrea che mandai à chiamare, gli dette un poco di noia da principio, ma non fummo arrivati à San Giovannino dove era il castratino a cantare che egli si quietò, et di quivi, con il detto castrato andammo da Maestro Marco il quale quando vidde che io mi compiaqui che si cantasse la sua aria restò consolatissimo.

Ho mandato alla Cecchina le nuove parole dell'Urania, et mi ha giurato di voler' fare ogni sforzo che la Maria si facci onore. L'Ill.mo Sig. Cardinale comandò al Sig. Carlo Rinuccini, quanto V.A. gli haveva comandato, in questo potremmo haver qualche difficultà ma si andrà rimediando, et S.A.S. sarà avvisata.

Domenico cominciò subbito à cantare la parte di Loreto, et ne disse un gran' brandello, senza punto errore. Perché era tardi ritornai à Pitti, et non si mancarà d'ogni diligenza, così ne gesti, come in ogn'altra Cosa accio egli, si facci onore, et serve bene. . . .

Out of respect I will not respond to the letter of the Most Serene Archduchess, [my] mistress, but Your Lordship would honor me by telling her that before everyone else I gave the orders of Her Most Serene Highness to Sig. Andrea, whom I sent for. At first, it gave him a little annoyance, but we had no more arrived at San Giovannino, where the little Castrato was to sing, than he quieted down. And from there, with the said castrato we went to Maestro Marco['s house], who, when he saw that I had decided that his aria was [to be] sung, remained most consoled.

I sent the new words of Urania to La Cecchina, and she has promised to make every effort so that Maria excels. The most Illustrious Sig. Cardinal ordered Sig. Carlo Rinuccini that which Your Highness had commanded of him. In this we may have some difficulty but it will be remedied, and Her Serene Highness will be informed.

Domenico began immediately to sing the part [written for] Loreto [Vittori], and he sang a large part of it without a single error. Because it was late I returned to the Pitti. And we will not lack diligence [in teaching him] either gestures, or anything else, so that he will serve well and bring honor.

EXAMPLE 3.1. Giovanni Battista da Gagliano, "Gioite, gioite," in *Varie musiche* (Venice, 1623), retexted as the refrain sung by Afrodisia's daughters: "Turn, turn, beautiful, pretty eyes; let not cruelty render you disdainful, reluctant for fun. You refuse splendor, but immediately, immortal, you double your arrows; burn with love! Uncover, uncover the vivacious roses; oh flowering cheeks, oh food of kisses, clear away the horror of biting cares with the dawn of lilies, among vermillion flowers; burn with love! Laugh, laugh, shining coral, among such happy voices form the words; uncover the joys that descend into the heart with the flash of a smile, in the heaven of a beautiful face; burn with love!"

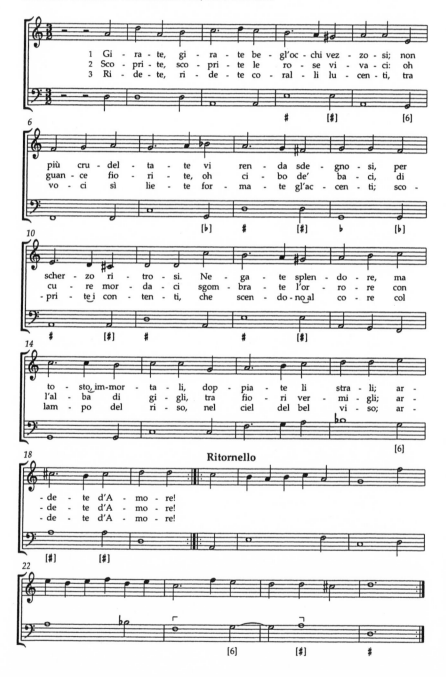

CHAPTER 4

"Una forte, magnanima, e generosa vedova"

Judith

A similarly chaste but more problematic heroine defeated another earthly embodiment of Mars in one of the court's most important theatrical commissions of 1626. That autumn, Archduchess Maria Magdalena found herself in a politically treacherous situation, faced with the impending visit of Cardinal Francesco Barberini, nephew to Pope Urban VIII. As papal nuncio, the cardinal had recently negotiated the Treaty of Monzon between France and Spain, and he planned a brief stopover in Florence on his way back to Rome. His visit posed a dilemma for the archduchess: on the one hand, since both regents had actively worked to avoid war in the Valtelline, the treaty was a victory of sorts.[1] But the Medici court's relationship with the papacy had been severely strained since 1623, after Urban VIII's pressure to annex Urbino.[2] The elderly Duke Francesco Maria II della Rovere was not in good health, and the regents sought to exercise their claim to at least a part of the duchy before his death, in particular, the regions of Montefeltro and San Leo, since at least one of these regions, Montefeltro, was traditionally an imperial, rather than a papal, fief.[3] Complicating matters still further was the

1. Although this fact was probably unknown to the regents, Cardinal Barberini did not actually participate in the treaty negotiations, which were concluded directly by representatives from France and Spain before his arrival, in order to avoid papal interference. See Ludwig Pastor, *The History of the Popes from the Close of the Middle Ages,* trans. F. J. Antrobus, R. F. Kerr, and Ernest Graf, 40 vols. (St. Louis, MO, and London, 1910–53), 28:96.

2. Furio Diaz, *Il Granducato di Toscana: I Medici* (Turin, 1976), 380–81.

3. [Jacopo] Riguccio Galluzzi, *Istoria del Granducato di Toscana sotto il governo della Casa Medici,* 5 vols. (Florence, 1781), 3:420; and Filippo Ugolini, *Storia dei conti e duchi d'Urbino,* 2 vols. (Florence, 1859), 2:446–66. As late as October 1628, Alvise Contarini, Venetian ambassador in England, could report to the doge and senate that he had heard that the emperor had promised

archduchess's desire to ensure papal support for her brother's war against the
Protestants.

Maria Magdalena thus needed a subject that could allegorize the cardinal's
recent diplomatic success but also bolster her own political position, both in
the eyes of the Barberini family and to her own subjects. She and her advis-
ers chose the biblical heroine Judith, the beautiful and devout widow of Be-
thulia who saves her people from the Assyrian general Holofernes. Andrea
Salvadori recounted Judith's heroic deed in *La Giuditta,* a three-act opera with
framing *intermedi,* all set to music, now lost, by Marco da Gagliano.[4] Surviv-
ing documents point to the hurried nature of the opera's preparations: al-
though the regents had known of the upcoming visit since receiving a papal
brief of 26 January 1626 and, according to Florentine Secretary of State Cur-
zio Picchena, had begun making general preparations for the visit by the fol-
lowing month, no theatrical entertainments are mentioned until much later
in the year.[5] Grand Duke Ferdinando approved the expenditure of 500 scudi
for the comedy on 10 September 1626, the day before Cardinal Barberini's ar-
rival in Florence, and under the guidance of Ferdinando Saracinelli the court
presented the opera just twelve days later.[6]

Urbino to the grand duchy following the death of its duke (*Calendar of State Papers and Manu-
scripts relating to English Affairs Existing in the Archives and Collections of Venice and in Other Libraries of
Northern Italy,* ed. Rawdon Brown et al., 38 vols. [London, 1864–1947], 21:360).

4. The court diarist devoted only a few lines to the opera, and these have been reprinted
in Angelo Solerti, *Musica, ballo e drammatica alla corte Medicea dal 1600 al 1637: Notizie tratte da un dia-
rio, con appendice di testi inediti e rari* (Florence, 1905; reprint, New York and London, 1968), 186–
87. *La Giuditta* was apparently not published in 1626, but it was included in Andrea Salvadori's
posthumous *Poesie,* 2 vols. (Rome, 1668), 1:91–128. All subsequent citations from the libretto
refer to this source. Margaret Murata (*Operas for the Papal Court, 1631–1668* [Ann Arbor, MI,
1981], 196n10) also uncovered a manuscript libretto of *La Giuditta* in the Barberini archives
(I-Rvat, Barb. lat. 3839, fols. 66r–94v), the context of which I will discuss below.

5. On the papal brief, see Pastor, *History of the Popes,* 28:94–96; Picchena's letter is dated
21 February 1625 [1626] (I-Fas, MDP 1407). Salvadori may have begun work on the libretto
by 10 August 1626, the date on which the archduchess informed the prince of Poland that her
court poet was too busy in her service to compose anything else at the time (I-Fas, MDP 115,
fol. 107r).

6. I-Fas, DG 1015, no. 265. Francesca Caccini's complaint that Ferdinando Saracinelli was
too busy with the opera's preparations to attend to her request (I-Fas, MDP 1449 [n.p.], let-
ter of 15 September 1626) confirms Saracinelli's continued supervision of the court's musico-
theatrical festivities. Although Warren Kirkendale (*The Court Musicians in Florence during the Prin-
cipate of the Medici with a Reconstruction of the Artistic Establishment* [Florence, 1993], 608, and *Emilio de'
Cavalieri "Gentilhuomo Romano": His Life and Letters, His Role as Superintendent of All the Arts at the Me-
dici Court, and His Musical Compositions* [Florence, 2001], 296) asserts that Saracinelli fulfilled this

Unlike her theatrical predecessors, the virgin martyrs whose temporal victories resulted from God's vengeance for their deaths, Judith herself liberates the Jewish people through the singularly decisive act of decapitating her enemy, making her the most active as well as most controversial female protagonist depicted during the period of the regency. Judith was also the most multivalent of the regency's vehicles of self-fashioning, having acquired multiple moral and symbolic implications in the preceding centuries.[7] She was a frequent subject in Renaissance art, more so than any heroine of the regency spectacles except Mary Magdalen. Consequently, only through an understanding of these visual representations, many of them works with which the opera's audience would have been familiar, can we hope to comprehend fully the allegorical messages encoded within Salvadori's opera.

The Judith Tradition in Florence

In part because of the historical inaccuracies found in the book of Judith, modern theologians have tended to view it as a moral tale rather than a his-

capacity on an ad hoc basis only, Florentine documents of the decade suggest that the position, while unofficial, was an ongoing one: besides the correspondence concerning *Sant'Orsola* discussed in the previous chapter, in a letter of 26 May 1621 Saracinelli intervened on behalf of two Florentine musicians, Antonio del Franciosini and Bartolomeo Bettini (I-Fas, MDP 1703 [n.p.]), while in 1622 he updated the court on the musical progress of Emila Grazi (I-Fas, MDP 1716, cited in Suzanne C. Cusick, "'Who is This Woman . . . ?': Self-Presentation, *Imitatio Virginis* and Compositional Voice in Francesca Caccini's *Primo Libro* of 1618," *Il saggiatore musicale* 5 [1998]: 39n39). Ferdinando Bardi, author of the *Descrizione* of the festivities celebrating the 1637 marriage of Grand Duke Ferdinando II and Vittoria della Rovere, explicitly names Saracinelli, author of an equestrian entertainment performed on the occasion, as the superintendent for most court festivities held during the past several years ("oltre all'haver sopr'inteso a quasi tutte le feste, che da molti anni in qua si sono fatte in questa corte" [38]). Saracinelli's supervisory experience, coupled with his authorship of seven texts (all from *La liberazione di Ruggiero* but until now unattributed) in the anonymous theater treatise *Il corago* make him a possible candidate for that work's authorship. One of the texts, "Chi nel corso di sua vita" (no. 30), contains an alteration in line 6 not found in the published libretto or score. In their edition of the treatise, Paolo Fabbri and Angelo Pompilio have proposed Pierfrancesco Rinuccini as a likely author (Fabbri and Pompilio, eds., *Il corago, o vero alcune osservazioni per metter bene in scena le composizioni drammatiche* [Florence, 1983], 6; and Roger Savage and Matteo Sansone, "*Il Corago* and the Staging of Early Opera: Four Chapters from an Anonymous Treatise *Circa* 1630," *Early Music* 17 [1989]: 495–511).

7. For a comprehensive overview of the Judith narrative through the twentieth century, as well as its psychological implications, see Margarita Stocker, *Judith, Sexual Warrior: Women and Power in Western Culture* (New Haven, CT, 1998).

torical document, a position strengthened by the book's carefully constructed binarisms.[8] Early Christian authors also stressed Judith's allegorical function over her more problematic role as an ideal of female behavior. If she was to be an exemplar for real women in early Christianity, it was as a role model for chastity, not tyrannicide.[9] Consequently, early commentaries on the biblical heroine tended to present Judith as a prefiguration of the Virgin Mary, with a concurrent focus on her chastity.[10] In his version of the book of Judith for the Latin Vulgate, Saint Jerome added the phrase, "and chastity was joined to her virtue" (16:26), and phrases from the book of Judith formed part of the liturgy of certain Marian feasts.[11] In accordance with his views on the transformational powers of virginity, Jerome also introduces, in his translation, the "chastity + virtue = manliness" equation that recurs throughout his writings on virginity: "For thou has done manfully, and thy heart has been strengthened, because thou hast loved chastity, and after thy husband hast not known any other" (Jth. 15:11).[12] To the patristic writers, then, Judith's ability to perform heroic deeds was dependent on distancing her from sexuality. Some accounts even described the widow as a virgin.[13]

Judith's deed itself was also viewed allegorically, receiving descriptive rather than prescriptive treatment. Prudentius, in his *Psychomachia* (ca. 405), associates Judith with the maidens who battle the vices in armed conflict, men-

8. Ibid., 5–6. I have used the following editions and translations of the biblical sources: *The Holy Bible Translated from the Latin Vulgate* (Baltimore, 1899; reprinted, Rockford, IL, 1971); *The Book of Judith*, trans. and with commentary by Morton S. Enslin; ed. Solomon Zeitlin (Leiden, 1972); A. M. Dubarle, *Judith: Formes et sens des diverses traditions*, 2 vols. (Rome, 1966); and Carey A. Moore, *The Anchor Bible Judith: A New Translation with Introduction and Commentary* (Garden City, NY, 1985).

9. Stocker, *Judith, Sexual Warrior*, 3.

10. Frank Capozzi, "The Evolution and Transformation of the Judith and Holofernes Theme in Italian Drama and Art before 1627" (Ph.D. diss., University of Wisconsin—Madison, 1975), 15. For the fullest discussion of Judith and chastity, see Elena Ciletti, "Patriarchal Ideology in the Renaissance Iconography of Judith," in *Refiguring Woman: Perspectives on Gender and the Italian Renaissance*, ed. Marilyn Migiel and Juliana Schiesari (Ithaca, NY, 1991), 41–43.

11. Ciletti, "Patriarchal Ideology," 42.

12. Leslie Abend Callahan, "Ambiguity and Appropriation: The Story of Judith in Medieval Narrative and Iconographic Traditions," in *Telling Tales: Medieval Narratives and the Folk Tradition*, ed. Francesca Canadé, Diana Conchado, and Giuseppe Carlo Di Scipio (New York, 1998), 83. See also Marina Warner, *Monuments and Maidens: The Allegory of the Female Form* (New York, 1985), 163–64.

13. Ciletti, "Patriarchal Ideology," 43, 63.

tioning her explicitly in the speech whereby Chastity commemorates her victory over Lust.[14] Images from this work recurred well into the seventeenth century, and its central battle, during which Humility decapitates Pride, provided the pose that remained central to Judith's iconography.[15] Undoubtedly one of the best known artistic renderings of this stance, both in Maria Magdalena's time and in the present, is Donatello's bronze statue now in the Palazzo Vecchio in Florence (fig. 4.1). As noted by Elena Ciletti, from its inception this statue has been the subject of a variety of interpretations, possessing an "iconographic density" that allowed various factions within Renaissance Florence's shifting political landscape to claim the work in support of sometimes opposing ends.[16]

One such instance of political appropriation concerns the use of the statue at differing moments in its history as both a pro-Medici and anti-Medici symbol. Although art historians cannot confirm that the statue was originally a Medici commission, its first documented location was the garden of Piero de' Medici's palace.[17] By 1469 the work's column bore two inscriptions, one of which explicitly tied it to the *Psychomachia* tradition in which Humility vanquishes Pride: "Regna cadunt luxu, surgunt virtutibus urbes / Cesa vides humili colla superba manu" [Kingdoms fall through luxury, cities rise through virtues. Behold the neck of pride severed by the hand of humility].[18] In the second inscription, connected more closely to Piero himself, the statue was presented as the symbol of Florentine civic liberty, guided, however, by the Medici: "Salus Publica. Petrus Medices Cos. Fi. libertati simul et fortitudini hanc mulieris statuam quo cives invicto constantique animo ad rem pub. redderent dedicavit" [The salvation of the state. Piero de' Medici son of Cosimo dedicated this statue of a woman both to liberty and to fortitude, whereby the citizens with unvanquished and constant heart might return to the republic].[19]

14. Callahan, "Ambiguity and Appropriation," 85; Warner, *Monuments and Maidens*, 149–53.

15. Louis Réau, *Iconographie de l'art Chrétien*, 3 vols. (Paris, 1955–59), 1:330.

16. Ciletti, "Patriarchal Ideology," 58. For summaries of the varying interpretations of this statue, see H. W. Janson, *The Sculpture of Donatello* (Princeton, NJ, 1963), 198–205; and Michael Greenhalgh, *Donatello and His Sources* (London, 1982), 181–92.

17. Janson (*Sculpture of Donatello*, 198) dates the work ca. 1460 and suggests (203) that Donatello may have intended it for Siena, while more recently, John Pope-Hennessy (*Donatello Sculptor* [New York, 1993], 278–80) has disputed the Siena provenance and proposed that Donatello began work on the sculpture in late 1454 or early 1455.

18. Janson, *Sculpture of Donatello*, 198.

19. I have here used the English translation that appears in Christine M. Sperling, "Donatello's Bronze 'David' and the Demands of Medici Politics," *Burlington Magazine* 134 (1992):

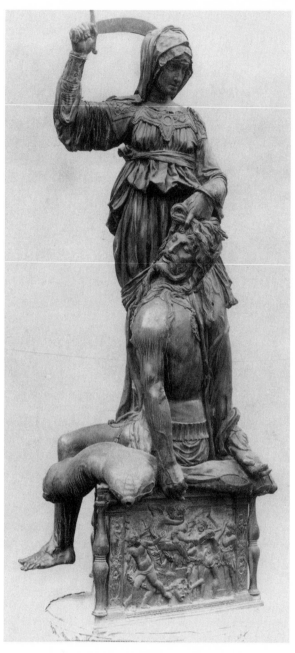

FIGURE 4.1. Donatello, *Judith* (Florence, Palazzo Vecchio). Photo credit: Alinari/Art Resource, New York.

As interpreted by this second inscription, Donatello's statue appears to represent the Medici family's conscious political move to mask symbolically their actual erosion of Florentine republicanism.[20] Florentine citizens clearly treated Donatello's *Judith* as a Medici symbol when, after their 1494 expulsion of the Medici, they moved the statues of Judith and her male counterpart, David, to the building most clearly associated with the new republic, the Palazzo della Signoria. *Judith* was installed conspicuously outside the Palazzo on 21 December 1495, with a new, ironic inscription, in which the leaders of the restored republic proposed their own definition of the *salus Publica:* "EXEMPLUM SAL PUB CIVES POS MCCCCXCV" [Placed by the Citizens as an Example of Public Health 1495].

This attempt to appropriate previous Medici symbols in service to the republic was apparently unsuccessful, for as late as January 1504, the statue's earlier connotations had not been forgotten.[21] It was at this time that *Judith*'s position in front of Palazzo della Signoria was debated in connection with the deliberations concerning the most suitable location for Michelangelo's *David.* In an often quoted condemnation of the *Judith*, the herald of the Signoria, Francesco di Lorenzo Filarate, proposed that the *David* should replace Donatello's statue since "the Judith is a deadly sign and inappropriate in this place because our symbol is the cross as well as the lily, and it is not fitting that the woman should slay the man, and, worst of all, it was placed in its position under an evil constellation because, since then, things have gone from bad to worse."[22]

The statue fell victim to several relocations in the years and centuries to follow: it was moved inside the Palazzo della Signoria on 8 June 1504, then to the first arch of the Loggia dei Lanzi on 10 May 1506. It was repositioned again in 1582, still inside the Loggia but to the arch facing the Uffizi, in or-

21n6. Janson (*Sculpture of Donatello*, 200) has linked this second inscription to Piero's defeat of the Pitti conspirators in 1466. Greenhalgh (*Donatello and His Sources*, 187) strengthens Janson's hypothesis through his discovery that the opening words of the *Judith* inscription recur on a 1478 medal commemorating the event.

20. Bonnie Bennett and David Wilkins, *Donatello* (Oxford, 1984), 85. According to these authors, the Donatello *Judith* is one of a triumvirate of tyrannicides (the others being David and Hercules) celebrated in Medici commissions from the late fifteenth century.

21. Saul Levine, "The Location of Michelangelo's *David:* The Meeting of January 25, 1504," *Art Bulletin* 56 (1974): 37.

22. "La iuditta e segnio mortifero e non sta bene havendo noi la + per insegnia et el giglio non sta bene che la donna uccida l'homo et maxime essendo stata posta chon chattiva chonstellatione perché da poi in qua siete iti di male in peggio." The translation and transcription are from Levine, "Location," 36–37. See also Janson, *Sculpture of Donatello*, 199.

der to make room for Giambologna's *Rape of a Sabine,* and this was its location in 1626, the year that Salvadori wrote *La Giuditta* for a performance that occurred just a few feet away.[23]

Although in the instance of Donatello's statue David replaced Judith, the two figures remained linked as emblems of Florence, specifically as symbols of the decisive way in which the city dealt with outside aggression. Lorenzo Ghiberti paired them in his celebrated baptistery doors, placing Judith, who grasps the head of the now-vanquished Holofernes, as a border to the David and Goliath panel.[24] During the 1504 deliberations regarding the placement of Michelangelo's *David,* Sandro Botticelli argued in favor of erecting the statue outside Santa Maria del Fiore, balanced by a Judith on the opposite side.[25] Inside the cathedral, a page from an antiphonary compiled circa 1508–26 combined Judith (in a pose derived from Ghiberti) with symbols and mottos of the Florentine republic.[26] The third of the triumphal arches to herald Pope Leo X's entry into Florence in 1515 allegorized the theme of *fortezza* through depictions of Judith and Holofernes, Samson destroying the temple, and David and Goliath.[27]

These representations of Judith as a politicized heroine, who symbolized the ideals of Florentine republicanism and civic humanism, joined with verbal messages in Lucrezia Tornabuoni de' Medici's *Storia di Iuditta,* probably written sometime after the death of her husband, Piero de' Medici, in 1469, and the contemporaneous *Rappresentazione di Judith Ebrea,* written in 1486 and published in Florence in 1518, with subsequent editions appearing throughout the seventeenth century.[28] Although the Florentine *sacra rappresentazione,*

23. Yael Even interprets the 1582 relocation of the *Judith* as part of an ongoing "remasculinization" of the Loggia by the grand dukes, in "The Loggia dei Lanzi: A Showcase of Female Subjugation," *Woman's Art Journal* 12, no. 1 (Spring–Summer 1991): 10–14. For the history of the statue after 1504, see Janson, *Sculpture of Donatello,* 199–201; and Bennett and Wilkins, *Donatello,* 231n31.

24. See Ciletti, "Patriarchal Ideology," 61n42; and Mary D. Garrard, *Artemisia Gentileschi: The Image of the Female Hero in Italian Baroque Art* (Princeton, NJ, 1989), 283–84.

25. Bennett and Wilkins, *Donatello,* 83. See also Garrard, *Artemisia Gentileschi,* 316–17.

26. I-Fd, Cod. L n. 20, fol. 2; discussed and reproduced in Marica S. Tacconi, "I libri corali pre-Tridentini della cattedrale di Firenze: Aspetti liturgico-musicali," in *Atti del VII centenario del duomo di Firenze,* vol. 3, *"Cantate Domino": Musica nei secoli per il Duomo di Firenze,* ed. Piero Gargiulo, Gabriele Giacomelli, and Carolyn Gianturco (Florence, 2001), 48 and plate 4.

27. Anthony M. Cummings, *The Politicized Muse: Music for Medici Festivals, 1512–1537* (Princeton, NJ, 1992), 72.

28. Lucrezia Tornabuoni de' Medici, *I poemetti sacri di Lucrezia Tornabuoni,* ed. Fulvio Pezzarossa (Florence, 1978), 201–48, and, in English, *Sacred Narratives,* ed. and trans. Jane Tylus

following the *Psychomachia*, is built around binary oppositions, especially pride versus humility, republican ideals prominently inform its details.[29] In a manner consistent with medieval art, the *sacra rappresentazione* emphasizes the reason for Judith's deed, concluding with the heroine's triumphant return with her trophy, after which the Jews defeat the Assyrian army.[30]

By contrast, later Renaissance representations of Judith tended to focus solely on the central, climactic event of the decapitation.[31] In Florence this concentration on the killing of Holofernes could support the late fifteenth-century interpretation of Judith as a vanquisher of tyrants and emblem of civic virtue.[32] But in other instances, this scene could highlight a dangerous, erotic Judith. The feminine wiles and seductive clothing by which Judith deceived Holofernes—those aspects of the story minimized by the early church fathers—rose to dominate artistic depictions. Some painters even portrayed a nude Judith, emphasizing her sensual nature, with the result that Judith was conflated with Salome, Delilah, and other "dangerous" biblical women, forgetting the civic and religious ramifications of her act.[33] Possibly the best known Florentine example of this sexualized Judith is Cristofano Allori's *Judith* (fig. 4.2), the most famous of the painter's works. The origins of the interpretive connection between this Judith and female sexuality are nearly contemporaneous with the work's execution. Filippo Baldinucci first related the autobiographical nature of the painting, in which the artist him-

(Chicago, 2001), 118–62. I would like to thank Elissa Weaver for calling my attention to Tornabuoni's poem. On the *sacra rappresentazione*, see Capozzi, "Evolution and Transformation," 32–58; and Alfredo Cioni, *Bibliografia delle sacre rappresentazioni* (Florence, 1961), 197–200. Cioni errs by conflating the Judith *rappresentazione* and *La rappresentazione di Quirico e Judith*, which presents a completely different story.

29. Capozzi, "Evolution and Transformation," 43.

30. Ibid., 15.

31. Garrard, *Artemisia Gentileschi*, 282–83. In Réau's partial list of artistic representations of Judith (*Iconographie*, 1:331–32), single images far outnumber the narrative cycles, which seem to have disappeared after the sixteenth century.

32. Réau, *Iconographie*, 1:330; Capozzi, "Evolution and Transformation," 9–10, 31, 58. Other late fifteenth-century Florentine Judiths include Andrea Mantegna's drawing of Judith with her maid (1491) and Botticelli's *Discovery of the Body of Holofernes* (ca. 1470–87). Botticelli's panel was in the collection of Antonio de' Medici until his death in 1632, at which time it was moved to the Uffizi. See Garrard, *Artemisia Gentileschi*, 549n22. According to Réau (*Iconographie*, 1:335), the Botticelli panel is one of only two works devoted to this topic. The other work is the fifteenth-century *tapisserie de Tournai*.

33. Ciletti, "Patriarchal Ideology," 46–52; Garrard, *Artemisia Gentileschi*, 296.

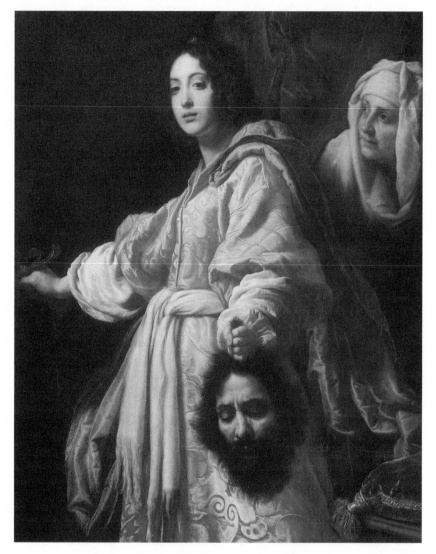

FIGURE 4.2. Cristofano Allori, *Judith* (Florence, Galleria Palatina, Palazzo Pitti). Photo credit: Alinari/Art Resource, New York.

self appears as Holofernes, with his former lover, La Mazzafirra, as the imposing Judith, and La Mazzafirra's mother as her elderly servant.[34] In his poem describing the painting, Gianbattista Marino emphasizes the sensual

34. Filippo Baldinucci, *Notizie dei professori del disegno da Cimabue in qua*, ed. Ferdinando Ranalli, 5 vols. (Florence, 1845–47), 3:726–27.

nature of the Bethulian widow by evoking the Petrarchan duality of love and death:[35]

Di Betulia la bella	The beautiful, ferocious
vedovetta feroce	little widow of Bethulia
non ha lingua né voce, e pur favella;	has neither tongue nor voice, yet speaks.
e par seco si glorii e voglia dire:	And she appears proud of herself and seems to say:
—Vedi s'io so ferire!	"See that I know how to wound!
E di strale e di spada,	And by arrow and by sword,
di due morti, fellon, vo' che tu cada:	villain, I want you to fall by means of two deaths:
da me pria col bel viso,	first by my beautiful face,
poi con la forte man due volte ucciso.	then by my strong hand, killed twice."

Archduchess Maria Magdalena, with whom Allori enjoyed a close relationship, was familiar with at least one copy of the work, for she mentioned it in a letter of 4 November 1616.[36] An unfinished version entered the Guardaroba on 20 September 1620, where it remained until 22 December 1626, coincidentally the year of Salvadori's *La Giuditta*, when it was loaned, still incomplete, to Cardinal Carlo de' Medici.[37] Ottavio Rinuccini (1562–1621), a poet closely connected to the archduchess, composed a sonnet devoted to a copy of Allori's painting that had been sent to Rome.[38] Unlike Marino's stanza, Rinuccini's sonnet emphasizes the painting's heroic aspects. He does not describe Judith's beauty but, rather, her nobility. And he extends his de-

35. Garrard, *Artemisia Gentileschi*, 299. I have used Giovanni Getto's edition of the Marino poem (*Opere scelte di Giovan Battista Marino e dei Marinisti*, 2 vols. [Turin, 1962], 1:254). See also Claudio Pizzorusso, *Ricerche su Cristofano Allori* (Florence, 1982), 71–73.

36. Rossella Tarchi, "Una lettera di Maria Magdalena d'Austria sulla reliquia della Santa Croce in S. Maria Impruneta," *Rivista d'arte* 41 (1989): 164–65. Claudio Pizzorusso has found ample documentary support of the archduchess's close relationship with Allori (*Ricerche*, 12), including a document of 22 April 1620, which lists three paintings commissioned by Maria Magdalena, including two portraits of herself.

37. Allori's *Judith* was so popular during the early seventeenth century that he made numerous copies of it, resulting in confusion over the work's chronology, as well as the location of the original. See John Shearman, "Cristofano Allori's 'Judith,'" *Burlington Magazine* 131 (1979): 3–10; Claudio Pizzorusso, "Un documento e alcune considerazioni su Cristofano Allori," *Paragone* no. 337 (March 1978), 60–75; and Miles Chappell, ed., *Cristofano Allori, 1577–1621* (Florence, 1984), 78.

38. The sonnet appears in Rinuccini's posthumously published *Poesie* (Florence, 1622), 108. The title of Rinuccini's contemporaneous collection of sacred poetry (*Versi sacri cantati nella cappella della Serenissima Arciduchessa d'Austria G. Duchessa di Toscana* [Florence, 1619]) demonstrates the poet's association with Maria Magdalena.

scription beyond the event captured in Allori's painting to narrate Israel's joy
at its daughter's courageous deed.[39]

Quando grave la man del teschio infido,	When the glorious woman, boldly brandishing the
trofeo più d'altro, e glorioso e raro,	bloodied steel, her hand heavy with the infidel
vibrando ardita il sanguinoso acciaro	skull, brought to her paternal home the trophy
traea l'inclita Donna al patrio nido,	more glorious and rare than any other, the packed
di letizia, e d'onor sì lieto grido	crowds of Israel raised such a happy cry of joy
le folte turbe d'Isdraelle alzaro,	and of honor, that it flew not just from shore to
che delle nubi, e delle stelle a paro	shore, but swiftly to both clouds and stars.
ratto volò non pur di lido in lido.	
Tal né di minor suon ferì le stelle	So, nor with lesser sound, did the Tiber's [Romans']
stupor del Tebro, in contemplando espressa,	amazement strike the stars, in contemplating how
la trionfante Ebrea dal Tosco Apelle.	the Tuscan Apelles had expressed the triumphant
Scorgendo ne' color la morte impressa	Hebrew woman, perceiving, impressed in colors,
l'ardire, il core (opre sublimi, e belle,)	death, boldness, [bravery of] heart (works sub-
onde vinta riman Natura istessa.	lime and beautiful), through which nature herself
	is defeated.

By 1626, then, Judith's image had symbolized both extreme civic action
and also the dangers women posed to men. But she was also a religious sym-
bol, and in yet another example of the ways in which Judith's iconographic
density allowed for appropriation by both sides of an issue, during the Re-
naissance both Protestants and Catholics cited Judith's example as an inspi-
ration for their own cause. To the Protestants, Judith could serve as an al-
legory of their underdog status in relationship to the monolithic institution
of Catholicism.[40] Conversely, during and after the Council of Trent, Judith
gained importance as a Catholic heroine, whose defeat of Holofernes pre-
figured Catholicism's suppression of Protestant heresy. Judith's own canoni-
cal legitimacy became a subject of religious debate.[41] Luther, while acknowl-
edging the value of the Apocrypha, of which the book of Judith is a part,
had separated it from the Old and New Testaments in his Bible. In response,
the Council of Trent affirmed the Apocrypha's canonicity in 1546, includ-
ing the book of Judith.[42] Protestants continued to view the Apocrypha as

39. I would like to thank Ron Martinez for his help in translating this sonnet.

40. Stocker, *Judith, Sexual Warrior*, 55–59. See also Richard E. Schrade, "Martin Böhme's
Judith (1618): An Anti-Catholic Drama on the Reformation Centenary," in *Theatrum Europaeum:
Festschrift für Elida Maria Szarota*, ed. Richard Brinkmann et al. (Munich, 1982), 217–39.

41. Ciletti, "Patristic Ideology," 38n3, 43. See also Capozzi, "Evolution and Transforma-
tion," 90, 122; and Garrard, *Artemisia Gentileschi*, 289.

42. Capozzi, "Evolution and Transformation," 90.

nonscriptural, and in 1626, coincidentally the very year of *La Giuditta*'s performance, the first copies of the King James Bible without the Apocrypha appeared.[43]

Post-Tridentine representations of Judith underscored the story's didactic possibilities. Following the prescriptions of reforming art theorists, who advocated art that appealed directly to the viewer's emotions, Judith paintings were often highly dramatic, focusing on the human conflict between Judith and Holofernes.[44] Caravaggio's *Judith Beheading Holofernes*, circa 1590–95, is one of the first and most influential examples of this new artistic treatment.[45] However, the emphasis on the dramatic moment of decapitation, combined with the frequent stress on the sensual, armed, and therefore dangerous aspects of Judith, ran the danger of overshadowing the reason for her violent act.[46]

Two Widows in Florence: Judith and Archduchess Maria Magdalena

Maria Magdalena's tenure in Florence coincides with an apparent rehabilitation of the Judith story. The archduchess appears to have had a particular fondness for the heroine, possibly fostered during her childhood in Graz. The Judith theme appeared in German Jesuit scholastic dramas, and during her childhood in Graz the archduchess undoubtedly witnessed some of these productions.[47] Several Judith paintings with Medici connections date from Maria Magdalena's years in Florence.[48] Although only one of them can be securely claimed as a direct commission from the archduchess, three portray Judith in a manner consistent with other works associated with the arch-

43. Morton S. Enslin, introduction to *The Book of Judith*, ed. Enslin and Zeitlin, 51.

44. Capozzi, "The Evolution and Transformation," 4, 158. The predominance of the decapitation scene in art through the 1630s is confirmed in A. Pigler, *Barockthemen: Eine Auswahl von Verzeichnissen zur Ikonographie des 17. und 18. Jahrhunderts*, 2d ed., 3 vols. (Budapest, 1974), 1:191–98.

45. Garrard, *Artemisia Gentileschi*, 289.

46. Ibid., 295.

47. Jean-Marie Valentin (*Le théâtre des Jésuites dans les pays de langue allemande: Répertoire chronologique des pièces représentées et des documents conservés [1555–1773]*, 2 vols. [Stuttgart, 1983–84], 1:57) notes a 2 February 1603 performance of a Judith play in Graz. For lists of other Judith plays in Latin and German from this period, see Edna Purdie, *The Story of Judith in German and English Literature* (Paris, 1927), 1–22; and Otto Baltzer, *Judith in der deutschen Literatur* (Berlin, 1930), esp. 4–22, 54–55.

48. The archduchess would also have known about another Judith painting, which may now be lost. The 1625 inventory of her villa lists a painting by Rutilio Manetti measuring $2\frac{1}{2}$ by 2 braccia whose subject is Judith beheading Holofernes (I-Fas, GM 479, opening 4). The work is not mentioned in Alessandro Bagnoli, ed., *Rutilio Manetti, 1571–1639* (Florence, 1978).

duchess, that is, as a powerful combination of chastity and female strength.[49] In Artemisia Gentileschi's *Judith and Her Maidservant* (Florence, Galleria Palatina, Palazzo Pitti) Judith and her maid prepare to leave Holofernes's tent, Judith still holding the sword, while the maid carries the head in a basket.[50] The heroic Judith is also the subject of the second, slightly later Gentileschi Judith, in which a more mature Judith concentrates on the task of decapitation, an event that is gruesomely intensified by the spurting blood that seems to leap from the canvas (plate 2).[51] Here Gentileschi divided the traditional motives for the decapitation between the painting's two female fig-

49. Another painting on this subject preceded the archduchess's arrival by only six years: Jacopo Ligozzi's *Judith*, signed and dated 1602. This painting, executed for Grand Duke Ferdinando I, was a copy of a work by Raphael. See Anna Rosa Masetti, "Per una 'Giuditta' di Raffaello," *Critica d'arte*, n.s., 27, fasc. 114 (November–December 1970): 72–80. In this painting, the artist depicts Judith's "immobile terribilità" immediately before executing the still-sleeping Holofernes (72). Her elegant costume confirms her chastity, and her upraised sword, reminiscent of the Donatello *Judith*, clearly places the painting within the *Psychomachia* tradition, as Chastity overcomes Lust.

50. To this painting art historians have assigned dates ranging from 1612 to 1614. Mary Garrard (*Artemisia Gentileschi*, 40) places it in the period shortly after Gentileschi's arrival in Florence, shown by Elizabeth Cropper to have occurred in 1613. See Elizabeth Cropper, "New Documents for Artemisia Gentileschi's Life in Florence," *Burlington Magazine* 135 (1993): 760–61. Roberto Contini and R. Ward Bissell date the work slightly earlier, and both scholars have identified the painting as the one Orazio Gentileschi promised to Christine of Lorraine on 3 July 1612. See Bissell, "Artemisia Gentileschi—a New Documented Chronology," *Art Bulletin* 50 (1968): 154–55, and *Artemisia Gentileschi and the Authority of Art: Critical Reading and Catalogue Raisonné* (University Park, PA, 1999), 198–203; and Roberto Contini, "Giuditta e la fantesca," in *Artemisia*, ed. Roberto Contini and Gianni Papi, exhibition catalog, Florence, Casa Buonarroti, 18 June–4 November 1991 (Florence, 1991), 122–24. For a transcription of Gentileschi's letter to the grand duchess, see Leopoldo Tanfani Centofani, *Notizie di artisti tratte dai documenti pisani* (Pisa, 1897), 221–24.

51. Art historians agree in dating this work ca. 1620, although for varying reasons: Garrard (*Artemisia Gentileschi*, 51, 501n79) identifies this painting as the one mentioned by Artemisia in a 1620 letter to Grand Duke Cosimo II. Gianni Papi, in his catalog entry "Giuditta che decapita Oloferne (Uffizi)," in *Artemisia*, ed. Contini and Papi, 150–53, argues that the letter to Cosimo II referred to a now-lost Hercules and, based on stylistic evidence, he proposes that Artemisia painted the Uffizi *Judith* shortly after her 1620 departure from Florence, sending the finished canvas to the grand duke shortly before his death in February 1621. Bissell (*Artemisia Gentileschi*, 214–15) arrives at the same date, based primarily on Gentileschi's letter of 1635 to Galileo, in which the painter reminded her friend of the *Judith* she had presented to Cosimo as a means of reminding Galileo that he had once before helped her secure payment from the Medici court.

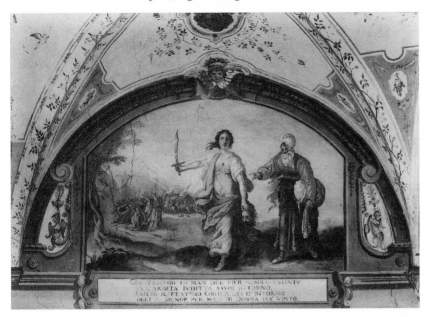

FIGURE 4.3. Giovanni Battista Vanni or Francesco Montelatici, called Cecco Bravo, *Judith* (Florence, Villa Poggio Imperiale)

ures: while her maid recalls the act's ultimate religious significance, forming the termination of the cruciform sword, Judith becomes the emblem for human vengeance.[52]

Although Maria Magdalena was most likely familiar with most if not all of these paintings and sculptures, she cannot be connected directly with their creation. She did, however, commission at least one work on the topic—the fresco depicting Judith's triumphant return with Holofernes's head that was one of the ten lunettes of biblical heroines that she commissioned for her antechamber in the renovated Poggio Imperiale, completed circa 1624. The fresco has been attributed to both Giovanni Battista Vanni and Francesco Montelatici, better known as Cecco Bravo (fig. 4.3).

The Poggio Imperiale fresco represents the "official" view of the Judith story during the regency in much the same way as would Salvadori's opera just

52. Garrard, *Artemisia Gentileschi*, 325. Another Judith painting that may have been connected to Maria Magdalena is the anonymous *Giuditta decapita Oloferne* now on deposit in the Palazzo Pitti. Gianni Papi ("Giuditta che decapita Oloferne," 150) has tentatively attributed the work to Francesco Rustici (d. 1626), a Sienese artist closely associated with the archduchess, having contributed paintings on the subjects of Lucretia and Saint Mary Magdalen for her Villa Poggio Imperiale.

a few years later. The artist exchanges the dark, oppressive atmosphere inside the tent, which dominates other sixteenth- and seventeenth-century paintings of the subject, for the open air and Judith's triumphal return. Like the other frescos in the villa, an interpretative quatrain accompanies the lunette:

> With the skull of the proud enemy, deceased, in hand
> this bold Judith thus returned;
> Around her the joyful chorus sings:
> "Today, the Lord has conquered by the hand of Woman."

The poem's last line confirms that Judith exemplifies not merely a single exceptional instance of female bravery but also embodies the notion — one resonant with the villa's artistic program as a whole — that all women, with God's help, are innately capable of such an action.[53] The painting depicts and elaborates on these poetic sentiments. It is possibly the only artistic representation of the early seventeenth century to focus on Judith's triumphant return to Bethulia, a subject treated more than a century earlier in Sandro Botticelli's *Return of Judith to Bethulia.* Unlike Botticelli's version of the scene, in which Judith, sword at waist level, is followed by her maid, who carries the head in a sack, the Poggio Imperiale Judith centralizes all power within herself, relegating her maid to the dramatic and artistic periphery. In her pose, recalling Ghiberti, one of Judith's bared, muscular arms points the raised sword upward to the source of her victory, while the other holds the severed head of the conquered Holofernes, the weight of which provides a counterbalancing downward momentum. No hint of the seductress remains — this Judith reclaims her role as a civic heroine, in a room dedicated to examples of female bravery.

La Giuditta

This was the visual tradition that Andrea Salvadori inherited when he began to compose the libretto for *La Giuditta.* Although he based most of the opera's material on the Vulgate translation of the book of Judith, he also drew on many of the numerous poetic and dramatic treatments of the subject. His indebtedness to the fifteenth-century *Rappresentazione di Juditta Ebrea* emerges in several of the libretto's details, including the comic scene in the Assyrian

53. The lunette's quatrain modifies slightly the Vulgate text (Jth. 16:7): "Dominus autem omnipotens nocuit eum; / et tradidit eum in manus feminae, et confodit eum" [But the almighty Lord injured him; and consigned him to the hand of a woman, and [she] wounded him].

camp (act 2.4) and the commentary by a chorus of vanquished kings, an expansion of the on-stage lament of the defeated King Arphaxed in the *sacra rappresentazione*.[54] In at least one important instance, Salvadori also modeled his poetic verse on that of his fifteenth-century model: in the *rappresentazione*, before Judith decapitates Holofernes, she specifically asks God to amplify her female strength ("Esaudi Dio hor le preci verginee / E dà vigore alle forze feminee"), a reference to her gender that is not found in the corresponding moment in the book of Judith.[55] At the same dramatic point in *La Giuditta* (act 2.5), Salvadori elaborates on these two important lines, making the gender reference even more explicit (112). Gagliano may have given Judith's three climactic words, "Una femina sola," a distinctive musical setting:

Or di debile donna	Now rule the right arm of a weak woman
reggi la destra, e invigorisci l'alma,	and invigorate her spirit,
onde del domator di tanti Regi,	so that over the tamer of so many kings,
una femina sola abbia la palma:	one woman alone might have victory.

Salvadori also appears to have been familiar with two post-Tridentine didactic plays: (1) Cesare Sacchetti's *La gloriosa e trionfante vittoria donata dal Grande Iddio al popolo Hebreo per mezzo di Giudith sua fedelissima serva, ridotta in comedia* (Florence, 1564; reprint, 1575); and (2) Giovanni Agnolo Lottini's *Giudetta* (Venice, 1601; reprint, Florence, 1602).[56] Two nonbiblical incidents in Sacchetti's comedy recur in Salvadori's libretto. In both plots, Holofernes's advisers shame the lovesick general into more forcefully imposing his will on Judith.[57] Similarly, Salvadori's emphasis on Judith's wisdom may stem from act 2.6 of Sacchetti's work, in which Abra describes her mistress as a scholar, who "after hours always reads and studies the books of Moses, discussing all the prophets, investigating and considering, one by one, all the written words" [*sempre fuori del orare legge, e studia, i libri di Mose, discorrendo tutti i profeti, investigando, e considerando ad uno, ad una tutte le parole scritte*]. Although Salvadori's approach differs from that of Lottini, who set his entire play in the city of Bethulia, having

54. For a description of comic elements in the *sacra rappresentazione*, see Capozzi, "Evolution and Transformation," 66n72.

55. *La rappresentazione di Judith Ebrea* (Siena, 1610), sig. A1.

56. The 1564 print of Cesare Sacchetti's *La gloriosa* is cited in Capozzi, "Evolution and Transformation," 94–101. Leone Allacci (*Drammaturgia* [Venice, 1755; reprint, Turin, 1961], 412) lists only the 1575 edition.

Allacci (*Drammaturgia*, 412) does not include the 1601 edition of Giovanni Agnolo Lottini's *Giudetta: sacra rappresentazione* but lists editions of 1602 and 1606 (Serravalle di Venezia: Marco Claseri).

57. Capozzi, "Evolution and Transformation," 99–100.

various personages report on the events in the Assyrian camp, in Salvadori's *intermedi* to *La Giuditta*, he does borrow imagery from Lottini's prologue, in which Fortezza urges her audience to follow Judith's example and to oppose Turkish aggression.[58]

Rather than constructing a plot that would attempt to fix the meaning of the Judith story by focusing on a single interpretation, Salvadori, likely encouraged by Maria Magdalena, allowed *La Giuditta* to embrace the ambiguity inherent in the accumulated tradition. His libretto allows for the possibility of both allegorical and heroic interpretations: this Judith is at once the militant church decapitating heresy, the spirit of Florence protecting its interests, and a strong and clever young widow capable of defeating a seemingly more powerful man.

Salvadori musters all of *La Giuditta*'s components—prologue, *intermedi*, and the opera proper—in support of these interpretations. Of course the image of Judith as an allegory of the Church Triumphant dovetailed neatly with the reason for Cardinal Barberini's visit, that is, the celebration of the treaty that reconciled (at least for the moment) two powerful Catholic countries. The *intermedi* that precede and follow the action praise explicitly the Barberini family's role in this reconciliation. In the first *intermedio*, Appennino, the geographical backbone and allegorical representation of Italy, honors the cardinal in mythological terms, describing him as both Atlas's nephew and Jupiter's messenger, that is, Mercury, who has convinced the bellicose Mars to drop his sword.[59] The reference links the *intermedio* to the opera but intensifies the ambiguity of interpretation. In act 2.4 Holofernes's soldiers describe their general as Mars, but as the audience already knew and as the next scene would reveal, when this Mars's sword fell, it fell on his own neck and by a woman's hand.

The final *intermedio* praises the Barberini's reunification of Catholic countries in even more explicit terms. Here Iris, emissary of peace and Juno's messenger, informs her mistress and Jupiter that the bees must be credited with

58. Ibid., 155. Salvadori's libretto became the source for another work. Martin Opitz used Salvadori's opera as the source for his second libretto, *Judith*, composed ca. 1627–29. Anton Mayer, "Quelle und Entstehung von Opitzens Judith," *Euphorion* 20 (1913): 39–53. Opitz's work in turn influenced succeeding generations of German and Scandinavian poets: see Mara Wade, "The Reception of Opitz's *Judith* during the Baroque," *Daphnis* 16 (1987): 147–65; and Mara R. Wade and Kenneth H. Ober, "Martin Opitz's *Judith* and Mogens Skeel's *Dansktalende Judith*," *Scandinavian Studies* 61 (1989): 1–11.

59. Of course among Mercury's other attributes was his position as a master thief, possibly a sly reference to what was seen as the Barberini family's underhanded confiscation of Urbino.

securing peace in Europe. Jupiter invites the bees to join the stars, and with the help of elaborate machinery, they take their place in the zodiac. Bees were, of course, the most distinctive feature of the Barberini coat of arms. But they were also honored symbols of Christian unity.[60] The *intermedio* closes with the arrival of Europe, who calls together her provinces, now united under the sun, the astrological sign that Urban VIII believed ruled his horoscope.[61] Once again Salvadori links the *intermedi* with the plot of the opera, for the provinces' on-stage appearance recalls act 3 of *La Giuditta*, during which the kings previously held captive by Holofernes enter the action in order to praise their benefactor. As was typical in all early Florentine operas, the restoration of order is then confirmed visually by means of the closing ballet, here executed by sixteen courtiers, who represented the European provinces.[62]

This commemoration of Catholic reunification formed a necessary backdrop by which Maria Magdalena could assert the goal of her proposed Catholic League: armed combat against all enemies of the church. This message was a central component of the archduchess's personal iconography, and it was stressed in nearly every spectacle with which she was connected. In his last stanza of the first *intermedio*, Appennino promises the cardinal his (i.e., Italy's) support through a donation of his resources, if, in imitation of the pope's zealous predecessors Urban and Pius, Urban VIII will renew the holy war with the "rebellious Asia."[63] In the final *intermedio*, Juno expresses the hope that Iris's intervention will turn Mars's bellicosity toward a location more deserving of it, namely, Thrace, while at the conclusion of that same *intermedio* Europe praises the Barberini and optimistically predicts that under the sun's influence Europe may now eclipse the moon of Asia, referencing a symbol of Islam.

Salvadori's first *intermedio* also reminds the Barberini family of its bond with Florence. After his initial stanzas, Appennino summons two of his major rivers, Arno and Tiber, the rivers of Florence and Rome and therefore of importance to the Barberini family's history, to welcome the cardinal back to Italy from the north. The personified rivers confirm their shared origins

60. George Ferguson, *Signs and Symbols in Christian Art* (New York, 1954), 5.

61. Frederick Hammond, *Music and Spectacle in Baroque Rome: Barberini Patronage under Urban VIII* (New Haven, CT, 1994), 20.

62. The libretto simply states, "Qui ballano le Provincie d'Europa." More detailed information about the participants appears in the ambassadorial dispatch of 22 September, from Cesare Molza to the duke of Modena (doc. 4.1). Molza and the court diarist (see Solerti, *Musica*, 187) differ in their tallies of the number of dancers in the final ballet.

63. Here Appennino most likely refers to Urban II, who proclaimed the first crusade in 1095, and Pius IV, who convened the Council of Trent.

("Versiamo ambi german fiumi reali" [98]) and promise to praise the Barberini family by means of the complementary artistic realms of their two cities: while Rome pays architectural homage to the Barberini, Florence offers praise through its native arts of poetry and song. Appennino, Arno, and Tiber are linked not only by the content of their speeches but also through a shared poetic and, possibly, musical structure. Each personage sings in six-line stanzas, with a rhyme scheme of *ABbACC*.[64] Salvadori's distribution of formally identical stanzas to all three of the *intermedio's* interlocutors would have offered Gagliano an opportunity to introduce comparable musical unity, as was his habit, by having the personages deliver their stanzas over related or identical harmonies.

By stressing the bonds shared by Rome and Florence, Salvadori, on behalf of Maria Magdalena, may have hoped to reduce the recent tensions between the Medici court and the papacy. But Judith was also historically a symbol of Florentine agency in response to a more powerful outside aggressor. Unlike the political implications of Judith imagery in fifteenth- and sixteenth-century Florence, in 1626 an actual female ruler presided over the city, with the effect that Judith could act as the allegorical representation not only of Florence but also of Archduchess Maria Magdalena herself. In this capacity Judith is best seen as a continuation of the chaste heroines of the virgin martyr spectacles. Judith was not only the most potent of these amazons of God, she was, as we have seen, the most problematic, especially as a potential model for subversive female behavior. Salvadori's libretto addresses these concerns, although in a manner that might have been unsettling to male audience members. He immediately tackles the issue of Judith's gender in the work's prologue, two of whose traditional functions were to expose the opera's plot and to justify its innovations.[65] Calliope, the muse of epic poetry and mother of Orpheus, delivers *La Giuditta's* prologue in four quatrains of *endecasillabi*. Addressing her remarks to the cardinal himself, Calliope summarizes and interprets the opera's plot in her first three stanzas, clearly depicting Judith as a political liberator in stanza 2 (96):

Ella d'Assiria il capitan superbo She cut off the most horrible head
la testa orribilissima recise: of the proud Assyrian captain.

64. Only Appennino's second stanza deviates from this pattern, with a rhyme scheme of *AbbACC*, possibly a poetic or typographical defect. Throughout the book, I will diagram rhyme schemes using lower case for seven-syllable lines and upper case for eleven-syllable lines.

65. Barbara Russano Hanning, *Of Poetry and Music's Power: Humanism and the Creation of Opera* (Ann Arbor, MI, 1980), 2–4. Salvadori reserves the prologue's third typical function, praise of the noble audience, for the *intermedi*.

Ella Israel in libertà rimise,	She delivered Israel to liberty,
e riscosse Sion dal giogo acerbo.	and freed Zion from the bitter yoke.

But Calliope goes on to remind the cardinal of other dangerous, sword-wielding women whose actions proved detrimental to the men who dared to cross them, namely, Medea and Phaedra, whose stories appeared in Greek tragedy, the genre that provided one of the inspirations for the earliest operatic experiments.[66] Once again, the Florentines have surpassed their models, according to Calliope, who judges that *La Giuditta*'s subject matter improves on the ancient Greeks' depiction of women as wanton and evil. Tuscany has become the home to a new type of theater and a new vision of women (96):

Magnanima Giuditta, era più giusto,	Magnanimous Judith, it would have been more just
che lasciando il cantar Fedra impudica,	for the ancient stage, abandoning the singing of the
o spietata Medea, la scena antica	immodest Phaedra or the ruthless Medea,
cantasse da te tronco il fiero busto.	to have sung about the proud head that you cut off.
Ma poscia che sdegnaro Argo, e Micene	But since Argos and Mycenae disdained to hear
la Donna udir fatta dal cielo ardita:	the woman made bold by heaven,
ora dal Sol del Vaticano udita	now, heard by the sun of the Vatican,
pregio sarà de le Toscane scene.	she will be the glory of the Tuscan stages.

Thus, just as Judith was a multivalent symbol in art, capable of symbolizing numerous moral and political positions, Salvadori's *La Giuditta* evokes multiple allegorical interpretations, no one of which invalidates the others. At the level closest to the surface, the opera demonstrates that a woman's initiative can defeat the agents of heresy and destruction, in conformity with Counter-Reformation representations of the heroine as the personification of the church. But the audience would not have forgotten Judith's particular importance to their city, for which she symbolized Florentine resistance to powerful outside aggressors. As has been seen, she shared this symbolism with David, and Salvadori explicitly renews the connection to her male counterpart when Judith invokes the example of David in her prayer for strength in act 2.5. In light of the recent antagonism between Florence and Rome over the fate of Urbino, a more topical allegorical interpretation of *La Giuditta* also emerges: Florence, in particular its female leadership, did not intend to relinquish passively what it perceived as its rightful territory, even in the face of the papacy.

66. Medea used a sword to kill her brother, and she went on to murder others, including her own children, all for Jason, who used then abandoned her. Phaedra turned her blade on herself, but her wrongful accusations against her stepson Hippolytus led to his exile. See Edith Hamilton, *Mythology* (Boston, 1942), 168–79, 220–23.

Throughout its history, Judith's story was perceived as the most prob-
lematic when it intersected with the deeds—real or imagined—of actual
women. Just such a concern may have prompted the regents to dictate the
extraordinary letter of 3 October 1626 cited at the beginning of this book.
One week after the opera's performance, secretary Dimurgo Lambardi spe-
cifically asked Florentine Secretary of State Andrea Cioli to make sure that
the pope understood that the work did not refer to the Barberini family
(doc. 4.2).

The Dramatic and Musical Characterization of Judith

By means of the prologue and two *intermedi*, Salvadori built a symbolic frame
for his opera that linked the multiple interpretations of the book of Judith
to the political realities facing Maria Magdalena, her subjects, and her guest.
In the three acts of the opera proper, the poet created a protagonist whose
characterization was consistent with the heroines of his previous libretti for
the archduchess. To this end, once again plot, syntax, and, presumably, mu-
sic combined to construct a powerful female character who could believably
defeat her enemies and liberate her people.

Salvadori remained faithful to his source, the book of Judith, confining
the opera's plot to the final twenty-four hours of the story in order both to
satisfy the Aristotelian unity of time and to conclude the opera with Judith's
triumphal return to Bethulia. By this means he ensured that the opera clearly
underscored the political nature of Judith's action. While the off-stage de-
capitation concludes act 2, the entirety of the opera's third act dwells on the
ramifications of the decapitation, depicting the reinvigoration of Bethulia's
soldiers (scene 1), the demoralization of Holofernes's camp (scene 3), the lib-
eration of Bethulia and the freeing of the captive kings (scenes 4 and 6), and
the conversion of those kings to Judaism (scene 5).

As he had done in *Sant'Orsola*, Salvadori problematizes issues of gender and
behavior to affirm that his protagonist's act subverts society's (incorrect) per-
ception of "femaleness." In act 1.1, Holofernes's advisers shame their gen-
eral into action by reminding him that, as a powerful military leader used to
taking what he wants, he should not let his desires be thwarted by a mere
woman (100):

Mille, e mille tu freni invitte schiere	You control undefeated armies of valiant
de' valor[o]si Assiri,	Assyrians, thousands and thousands [of men],
e non avrai potere	and you will not be able
di piegare una donna a' tuoi desiri?	to bend a woman to your desires?

Reminiscent of the on-stage taunts exchanged by the Roman and Hun armies in his *Sant'Orsola*, Salvadori also incorporates a scene in which characters actually deny the possibility of valor in women. By means of this dramatic device, Salvadori emphasizes the heroic and transgressive nature of Judith's actions. In act 2.4, Holofernes's soldiers comment on what they believe to be their general's seduction of Judith. Stressing the affinity between female beauty and male valor, exemplified by Venus and Mars, the soldiers assign traditional, gender-based characteristics to Judith and Holofernes. Ircano, the captain of the guard, explicitly deemphasizes the possibility that Judith might demonstrate valor by attributing to her an opposing characteristic, that is, treachery (110):

Ella per lui trafitta	Pierced, because of him,
d'amorosa ferita	with an amorous wound, she
venuta è sola a ritrovarlo in campo,	has come alone to the camp to find him;
la sua Patria ha tradita.	she has betrayed her country.

But Judith's actions reveal her to be the most "virile" of the opera's principal characters, and her most explicit demonstration of that status, her decapitation of the mighty Holofernes, occurs immediately after the Assyrian soldiers' denial of women's heroic potential. In this scene (act 2.5), both Judith and her maid emphasize the widow's transcendence of what was believed to be typical female behavior. Following the precedents found in the book of Judith, the two women repeat phrases such as "debile donna," "una femina sola," "per man d'una donna," or simply the word "donna" both to exaggerate the shame of Holofernes's defeat and to assert that, with God's help, those who are physically weak may overcome more powerful adversaries.

Salvadori ensured that Judith's verses affirm her strength of purpose. She emerges as the opera's most commanding figure by comparison to the other principal characters, Holofernes and Abra, her maid. Just as visual artists typically used age or race to distinguish between Judith and her maid, Salvadori used language to depict a volatile maidservant. In act 1.3, Abra reacts emotionally to what she perceives as Holofernes's threat to her mistress's chastity, and she laments Judith's decision to attend the banquet. In the decapitation scene of act 2, while standing guard outside Holofernes's tent, Abra sings a recitative soliloquy made up of rapidly shifting *affetti.*

Even more dramatic is the contrast between Judith and Holofernes. Although Holofernes, his enemies, and his followers describe the general as a fierce warrior, his actual words instead recall the dramatic tradition of the love-struck youth who hopes to win some favor from his beloved. In the op-

era's first scene, Holofernes boasts of his military victories but confesses that
he himself has been conquered by love, an emotional shift that may have
signaled more expressive vocal writing. He laments that Judith's beauty has
killed him, a figurative expression that will become quite literal by the opera's
end. This statement marks the first instance of Salvadori's widespread use of
double entendre in this libretto, a technique inherited from his biblical
source. Holofernes regains his self-control only after his advisers urge him to
exercise his masculine and political prerogatives, and in another instance of
double entendre, he boasts that his sword will fell the impious ones ("Tosto
vedrò perir l'empia Masnada, / o trafitta cadrà da questa spada" [99]), pre-
dicting his own fate.

The lovesick Holofernes reappears at the beginning of act 2. He pleads to
the stars, asking them to tarry in order that he might extend his time with the
beautiful Judith (106–7):

Sfavillate ridenti,	Oh bright, nocturnal stars,
chiare notturne stelle,	let your shining rays
vostri raggi lucenti,	sparkle, smiling,
che quante in ciel voi sete,	for as many as you are in heaven,
tanti saranno in terra i miei contenti:	so many will be my pleasures on earth:
sfavillate ridenti,	oh bright, nocturnal stars,
chiare notturne stelle,	let your shining rays
vostri raggi lucenti;	sparkle, smiling;
e tu, quanto tu puoi,	and you, shadowy night,
ne le Cimmerie grotte	remain as long as you can
trattienti ombrosa notte,	in the Cimmerian caves,
che mentr'aver poss'io	for while I can have
la mia bella Giuditta,	my beautiful Judith,
altro giorno, altro sol più non desio.	I no longer desire another day, another sun.

These verses are the most expressive of the libretto, and Salvadori's use of a
refrain gives them a tighter formal organization than would have been usual
for recitative. Gagliano may have set the speech using the lyrical style of the
madrigal. The generic nature of Holofernes's soliloquy suggests that both
text and music may have predated their appearance in *La Giuditta.* The only
mention of Judith is in the penultimate line, which does not rhyme with any
other line in the speech and may have been incorporated later into the poem.

Holofernes's words and, most likely, his music reveal that in *La Giuditta* the
ferocious general's character resembles the unhappy male lovers common to
regency plays and operas. Similarly, in a manner congruent with the virgin
martyrs and epic heroines who preceded her in these spectacles, throughout

much of *La Giuditta* Judith displays a sense of calm purpose that Gagliano may have strengthened musically by means of rational, tonally inflected melodic lines, frequent cadences, and an overall avoidance of musical extremes. But when interacting with Holofernes or his minions, Judith employs an expressivity that was relatively uncommon in the recitatives of the female protagonists in other regency operas, where its absence served to underscore the powerful heroines' self-control. *La Giuditta* required a different approach, for its protagonist allows herself to be viewed as a sexual object in order to achieve her ultimate goal. As part of this image, Gagliano's Judith might well have sung the most seductive music of the regency heroines.

Precisely this type of scene takes place in act 1.2, Judith's first appearance on stage. In this scene Argeo (Vagao), Holofernes's chamberlain, invites the widow to the general's banquet. Judith feigns modesty in response to Holofernes's attentions. Her self-effacing questions, drawn in part from the Vulgate (Jth. 12:13–14) once again exhibit the double meanings that pervade the libretto, as she affirms obedience to "her lord," which Argeo interprets incorrectly to mean Holofernes (103):

Deh, qual ombra di merto	Oh, what shadow of merit
mi rende degna del sublime onore?	renders me worthy of the sublime honor?
Ma chi son'io, che voglia	But who am I, that I should want
contrastar'al voler del mio Signore?	to oppose the wishes of my lord?
Verrò com'a lui piace,	I will come if he pleases,
verrò, ché del mio cor'il freno ei regge,	I will come, for he rules the power of my heart,
ed il suo cenno à la mia vita è legge.	and for my life, his call is law.

Judith displays her true strength in her scenes with her maid. Following Abra's lengthy speech lamenting her mistress's flirtation with dangers to her chastity (act 1.3), the imperious Judith commands her maid to put her trust in God. Although her response is but five lines long it includes three full stops, and its calm resolve and even tone suggest that its most appropriate musical setting would have been recitative without chromatic inflection.

Judith's successful completion of her mission in act 2 leads to the triumphant act 3, whose scenes remind the audience that her decapitation of Holofernes is not the culmination of the narrative but, rather, the means by which she achieves her true goal—the liberation of Bethulia. Salvadori underscores the festive nature of the act through frequent use of the chorus. He also gives the act a coherent formal construction by means of solo and choral refrains—organization that contrasts with the recitative dominated acts 1 and 2. One of the most tightly structured of these scenes occurs when the Bethulian women joyously celebrate Judith's accomplishment (3.4). Abra de-

livers the first refrain, a joyful *ottonari* quatrain sung three times, which gives
the scene its musical coherence and triumphal mood (118–19):

Ecco là l'orribil fronte	Behold there the horrible face,
orgogliosa, à Dio ribella:	prideful, rebellious to God:
d'Israel vendicò l'onte	this chaste widow
questa casta vedovella.	avenged the insults to Israel.

Recalling the militaristic imagery earlier used by Salvadori to describe Saint
Ursula, Abra goes on to praise her mistress as the avenger of Israel's honor,
the conqueror [*vincitrice*] and tamer [*domatrice*] of the ferocious Assyrian army.

Judith answers Abra with a moralistic recitative drawn directly from the
book of Judith (16:7–8). She warns against an overreliance on earthly power,
admonishing the audience to pay heed to the true meaning of her story, a
moral that clearly served the purposes of the female regents: when guided by
God, women acquire the spiritual and physical strength necessary to over-
come their enemies (118):

Non Titani, o Giganti	Neither titans, nor giants
[h]an domato Oloferne:	have tamed Holofernes:
Debile man di donna	the weak hand of a woman
ha troncato di lui la vita, e i vanti.	has cut short his life and his boasts.

After this emphatic statement Judith joyously asks her followers to sing
God's praises (118):

Dunque tra lieti canti	Therefore, among happy songs
diasi lodi al mio Dio,	let us give praise to my God,
che salvò la mia gente, e l'onor mio.	who saved my people and my honor.

Judith repeats this refrain at the conclusion of her second speech in the
scene. Answering questions posed by the women's chorus, Judith decisively
ends the debate over the degree to which she exercised sexuality to achieve
her goal. She informs her followers, and the audience, that heaven intervened
and caused Holofernes to fall asleep, effectively quelling his "impure fire."
She assures her listeners: "just as I left, so today I return to you, ever pure in
heart and in appearance [i.e., body]" [*qual fei partita / tal'oggi à voi ritorno / pura
sempre nel core, e ne' sembianti* (119)].

The final scene of the act and of the opera is a small-scale version of the
choral finales that concluded other operas of the decade. Salvadori gives the
scene poetic and musical unity by means of an *ottonari* quatrain ("Viva Dio
Betulia viva") that is sung three times by the returning Hebrew soldiers. The
refrain serves to unify a scene that is otherwise divided into two halves. In the

first half, Ozias, the prince of Bethulia, praises Judith for her chastity, beauty, and virtue, and, by means of the telescoping effect achieved by the *anaphora* at the pronoun *tu*, he explicitly credits the heroine with the liberation of the city (121):

Tu per nostra salute	You, for our salvation,
troncasti à lui l'abbominata testa:	severed his abominable head:
tu n'hai data la vita,	you have given us life,
tu libertà gradita.	you, welcomed liberty.

Just as Saint Ursula closed her opera with her first use of stanzaic poetry and, possibly, a tuneful aria, in the second half of the final scene, Judith sings three stanzas of *ottonari* addressed to the country she has just saved. She affirms her continued desire to serve God and, expanding the closing verses of the book of Judith, clearly declares her intention to remain celibate. The heroine covers her hair with a veil, renounces the ornaments by which she seduced Holofernes, and retires to her solitary cell, having demonstrated, like her predecessors Agatha and Ursula, that when the situation requires, and with God's help, women can conquer male tyranny and liberate an entire population.

This allegorical interpretation of Judith as an exemplum of the female ruler is confirmed in a contemporaneous document that is itself connected closely to Archduchess Maria Magdalena. Cristofano Bronzini, on day 12 of his treatise, *Della dignità, e nobiltà delle donne*, not only uses the biblical story of Judith as an example of a woman who saved an entire people, but he specifically refers to the performance of *La Giuditta*, quoting extensively from its libretto.[67] Bronzini originally intended to provide his readers with the proper context in which to understand the opera, for he also recounts the reason for the work's performance, that is, to celebrate the visit of Cardinal Barberini and his retinue, on their way to Rome after concluding peace between France and Spain. The regency, at least initially, wanted the Barberini family, in particular, Pope Urban VIII, to appreciate and comprehend the opera's meaning, for in addition to the libretto manuscript mentioned above, someone at court, possibly Maria Magdalena, sent the pope a copy of just those pages in the treatise that pertain to the performance and interpretation of *La Giuditta*.[68] And just as the court later sought to distance the Barberini family from the

67. I-Fn, Magl. VIII.1522/1, 209–36.

68. Margaret Murata (*Operas for the Papal Court*, 196n10) uncovered the document (I-Rvat, Barb. lat. 4059, fols. 105r–119v), presuming it to be a diplomatic dispatch. Further references to Bronzini's treatment of the opera will cite this manuscript.

opera's unflattering political implications, Bronzini eventually decided to eliminate the description of the cardinal's visit, crossing out the entire section in the autograph.

Bronzini makes reference to Judith twice earlier in the published portions of his treatise. The more extensive of these occurs on day 2, as part of a broader defense of women's participation in public life and politics. Bronzini's male advocate of women's equality, Onorio, cites Judith among those women whose counsel was ultimately sounder than that of men.[69] Perhaps not coincidentally, three of the four other women cited, Esther, Deborah, and Jael, appeared alongside Judith in the frescoes that decorated Maria Magdalena's Villa Poggio Imperiale.

In his day 12 account, Bronzini elaborates on the opera's plot by incorporating incidents from the biblical source that Salvadori, respecting the unity of time, chose not to include in his libretto. Often, Bronzini freely embellishes his source. For example, while providing the background to the opera's plot, summarized by Salvadori in the work's *argomento*, Bronzini draws on completely unrelated material to allow his readers to imagine more vividly the first encounter between Judith and Holofernes. In a flight of poetic fancy, Bronzini offers a somewhat altered quotation from Tasso's *Gerusalemme liberata* (fols. 107r–108v). Tasso's octaves describe a parallel but morally opposite incident (4.34–42): Armida enters the camp of the crusaders, intending to entice, through feigned modesty, their leader, Godfrey, and thus wreak havoc among the Christians. Through his inclusion of these stanzas, now adapted to correspond to the imagined encounter between Judith and Holofernes (alterations indicated in boldface type below), Bronzini stresses the heroine's cunning, clearly enunciated in the final couplet of Tasso's stanza 38 (fols. 107v–108r):

Tace e la guida ove tra i grandi eroi	He is quiet and guides her to where, among the grand heroes,
all'hor dal **vulgo Oloferne** *s'invola,*	Holofernes then removes himself from the commoners.
Essa inchinoll[o] riverente, e poi	She bowed to him reverently, and then,
vergognosetta, non facea parola,	a little bashful, said not a word.
Ma quei rossor, ma quei timori suoi	But Holofernes reassures and relieves those blushes,
rassicura **Oloferne**, *e riconsola,*	those fears of hers,
siché i pensati inganni alfine spiega	so that finally she unfolds the well thought-out deceptions
in suon che di dolcezza i sensi lega.	in speech whose sweetness binds the senses.

69. Cristofano Bronzini, *Della dignità, e nobiltà delle donne*, 8 vols. (Florence, 1622–32), 2: 44–45.

Bronzini also exercises poetic license in his elaboration of Judith's life after her heroic deed. Deviating from Salvadori's version and reordering the events described in the biblical source, he introduces a penitential element: the woman who used beauty and seduction to achieve her worthy goals now refutes these attributes through mortification and fasting. Bronzini has recast Judith, who, biblically, was a devout but worldly woman, in a role that closely links her to traditional models of female asceticism, a realm familiar to Florentine audiences of the 1620s.

Bronzini does not restrict himself solely to description, however: his account serves as evidence for his interlocutors' arguments. And since Onorio's assertions go unchallenged by Tolomei, the work's misogynistic antagonist, Bronzini's interpretations—of both the figure of Judith and the opera itself—remain unambiguous. He emphasizes Judith's chastity, but he also reiterates her shrewdness, for example: "And thus Judith knew well how to impress her lively words on Holofernes and on the souls of the principal Assyrian barons" [*E così bene seppe Juditta imprimere in Oloferne, e negl'animi de' principali Baroni Assiri le sue vivaci parole* (fol. 109r)]. Bronzini is also careful to quote nearly every poetic verse in *La Giuditta* in which Salvadori asserts Judith's position as a powerful woman strengthened by God.

The context in which Bronzini offers Judith's example of heroic female action is itself an interpretation. The passage begins with a statement by Vittoria, described by Bronzini in his *argomento* as a Mantuan noblewoman, who asserts that God created women in such a manner that they might frequently remedy the ills of humankind (fol. 105r). Another interlocutor concurs, granting women an unlimited capacity for valor when supported by God, citing Judith as a specific example of one such powerful and active woman who saved her people from external threat (ibid.):

> E quante volte una sol donna, ò giovane, ò donzella, ò vedova, ò matrona, che ella fusse, fece vedere al mondo quanto (con l'aiuto del Cielo) ella potesse? Eccovene un raro esempio di vedova casta, bellissima, e forte, e vedova di tanto giudicio, e coraggio (quale fu Juditta) che sola (con l'aiuto superno però) libera la patria con tante provincie, regi, e regni, e tante migliaia di migliaia di genti, dalla strage, che crudelissima le si apparechiava con tanta gran ruina, impietà, ed empito, dall'esercito del fiero, ed oltremodo tremendo Oloferne?

> [And how many times did one woman alone, either young girl or maiden, or widow, or matron, whatever she was, show the world how much (with heaven's help) she could do? Behold here a rare example of a chaste, beautiful, and strong widow, and a widow of such judiciousness and courage (as was Judith), that she all alone (with heavenly help, however) frees her homeland, with all its provinces,

kings, and realms, and many thousands of thousands of people, from the slaugh-
ter that most cruelly was prepared for them with such great ruin, mercilessness,
and violence by the army of the cruel and exceedingly terrible Holofernes?]

Bronzini summarizes his account of Judith by characterizing her as "una
forte, magnanima, e generosa vedova" (fol. 118r). Salvadori's *La Giuditta* simi-
larly concludes the series of "guerriere di Dio" that dominated regency spec-
tacles during the 1620s, heroines intended to legitimate symbolically the po-
litical rule of yet another strong, magnanimous, and generous widow, the
Archduchess Maria Magdalena.

Documents for Chapter 4

**Document 4.1. I-MOas, AF 55, fasc. 27, fols. 125r–126r. Dispatch from Ambassador Ce-
sare Molza to the Duke of Modena, 22 September 1626.**

. . . Hieri la Ser.ma per il Sig. Cav.re Cosimo Antella fece invitare per oggi l'Ambasciatrice mia
à vedere rappresentare l'opera di Judit preparata solennemente con musica, e bellissimi inter-
medi; rispose l'Ambasciatrice che rendea humilmente grazie à S.A. dell'honore, il quale quando
non havesse per avventura altro oggetto, che del proprio gusto, volentieri se n'asterrebbe,
stando il fresco accidente della Ser.ma Infanta. À che la Ser.ma fece replicare per il medesimo
Cav.re Antella, che questa era opera spirituale, e che non v'era scrupolo alcuno, però che an-
dasse pure, come farà questa sera, parendo à me, che non si possa ricusare. . . .

 La rappresentazione è stata, come ho detto, Judit, che tagliò il capo ad Oloferne recitata
in musica mirabilmente con machine, ed un balletto di sedici cavalieri leggiadramente fatto
nel fine.

 Il teatro era copioso di dame, ma non quanto le altre volte.

 Li Padroni stavano in seguente ordine tutti del pari. Ser.ma Arciduchessa, Sig. Cardinale Bar-
berino, Sig. Cardinale Sacchetti, Gran Duca, Sig. Principe Giovan Carlo, e Sig. Principe Mat-
tias, dinanzi à quali sedeva la Sig.a Principessa Margherita, Sig.a Principessa Anna, Sig. Prin-
cipe Francesco, e Sig. Principe Leopoldo. . . .

Yesterday Her Highness [Maria Magdalena], by means of Cav. Cosimo Antella, invited the
ambassadress, my [wife], to see the work *Judith* performed today, solemnly prepared with mu-
sic and beautiful *intermedi*. The ambassadress replied that she humbly thanked Her Highness
for the honor, which, if it depended only on her taste, she would abstain from attending, be-
cause of the recent accident [death] of the Infanta [of Modena]. To which Her Highness re-
plied, again by means of Cav. Antella, that this was a spiritual work, and that she should not
have any scruples [about it], so that she could attend, as she will this evening, it appearing to
me that it is not possible to refuse. . . .

 The work was, as I have said, *Judith*, who decapitated Holofernes, recited in music ad-
mirably with machines, and a ballet of sixteen knights performed prettily at the end.

 The theater was full of ladies, but not as many as at other times.

 The persons of high rank sat in the following order, all at an equal level: Her Highness

the Archduchess, Cardinal Barberini, Cardinal Sacchetti, the Grand Duke, Prince Giovan Carlo, Prince Matthias; in front of them sat the Princess Margherita, Princess Anna, Prince Francesco, and Prince Leopoldo. . . .

Document 4.2. I-Fas, MDP 1409 (n.p.). Draft of a letter dated 3 October 1626, from Dimurgo Lambardi (Florence) to Andrea Cioli, Florentine secretary of state (Rome).

Lor Alt*e*zze sentirono con particolar gusto le lodi che il Papa diede al S*ignor* Salvadori, intorno alla sua Juditta, e veram*en*te egli meritava l'honore che Sant*i*tà S*ua* s'è compiaciuta di fargli. [Dicono ben le Alt*e*zze loro] Desidero bene [il Salvadori] che, se V.S. Ill.ma havrà occasione d'esser col Papa, e che lo trovi disoccupato da negozii gravi, [ella non lasci di] pigli qualche contratempo, per disingannar S*ua* Santità, che l'opera fusse stata meditata, e fatta, e tenuta à posta per applicarla à Barberino, perché in effetto è stata impensata ed improvisa, e tessuta, si può dire in pochissime hore. [Potrà V.S. Ill.ma offerire alla Sant*i*tà S*ua* che il Salvadori sarà pronto] Dice che è una bagatella ma s'offerisce di condurre nella med*esi*ma brevità di giorni un'altra simile composizione à gusto di S*ua* Santità, la quale [egli] però supplica di comandarglielo, e proporgli il suggetto, perché in questa maniera la Sant*i*tà S*ua* n'havrebbe una riprova molto certa[issima, con suo stupore, e con maggiore [accreditamento] e stima del Poeta]. . . .

Their Highnesses heard with particular pleasure the praises that the Pope gave to Sig. Salvadori for his *Judith*, and he truly merited the honor that it pleased His Holiness to bestow on him. [Their Highnesses also say] I desire very much [Sig. Salvadori] that, if Your Illustrious Lordship should have occasion to be with the Pope and [should] find him unoccupied with serious business, you [would not refrain from] would take some favorable moment to disabuse His Holiness [of the idea] that the work was deliberately thought out, prepared, and performed in order to apply to the Barberini, because actually it was unexpected and improvised, and put together, one can say, in just a few hours. [Your Illustrious Lordship could tell His Holiness that Salvadori will be ready] He [Salvadori] says that it is a trifle, but offers to prepare, within the same brief period, another, similar composition to the taste of His Holiness, whom he asks to order it from him, and to propose the subject to him, for in this manner His Holiness would have more secure proof of it [with his amazement, and with greater credit and consideration of the poet].

"She hoped to see in the triumphs of religion the triumphs of her house"

Epic-Chivalric Poems and the Equestrian Ballets

Secular female warriors also appeared regularly during the 1620s, as participants in equestrian ballets and other dramatic combat genres. The archduchess's active role in the preparations for these events provided an outlet for her passionate interest in riding and hunting.[1] More so than their sacred counterparts, these entertainments linked Maria Magdalena's patronage to that of her dead husband Cosimo II, who was often credited for the Florentine revival of ancient equestrian genres.[2] Such entertainments allowed first Cosimo, then his widow, to draw on the horse's association with the Roman emperors, a link made conspicuously in Florence's equestrian monuments to Grand Dukes Cosimo I and Ferdinando I.[3] Audience members may well

"Desiderava ne i trionfi della Religione vedere i trionfi della sua Casa" (Andrea Salvadori, *Orazione panegirica*, in *Poesie*, 2 vols. [Rome, 1668], 2:405). This chapter is an expansion of my article entitled "Habsburgs, Heretics, and Horses: Equestrian Ballets and Other Staged Battles in Florence during the First Decade of the Thirty Years War," in *L'arme e gli amori: Ariosto, Tasso and Guarini in Late Renaissance Florence: Acts of an International Conference, Florence, Villa I Tatti, June 27–29, 2001*, ed. Massimiliano Rossi and Fiorella Gioffredi Superbi, 2 vols. (Florence, 2004), 2:255–83.

1. Cristofano Bronzini (*Della dignità, e nobiltà delle donne*, 8 vols. [Florence, 1622–32], 3:57–58) praises the archduchess's innate riding abilities and confirms her active participation in the preparations for equestrian entertainments in 1616 and 1617. In his *Poesie*, 2:89–90, Andrea Salvadori included two sonnets on the subject of the archduchess's hunting prowess.

2. Simoncarlo Rondinelli, *Le fonti d'Ardenna* (Florence, 1623), sig. [A4r–B1r].

3. Giambologna modeled his colossal equestrian monument to Cosimo I on the *Marcus Aurelius* statue in Rome, which also influenced Pietro Tacca's statue of Ferdinando I. Grand Duke Ferdinando commissioned both statues: Giambologna installed the monument to Ferdinando's father in the Piazza della Signoria in 1594, while his student Tacca placed the grand duke's own statue in the Piazza della SS. Annunziata in 1608. Although Giambologna's *Cosimo* was Florence's first permanent equestrian monument, it had been preceded by numerous

have viewed these spectacles as the flesh-and-blood equivalents of their city's bronze statues. Both the statues and the equestrian ballets were outdoor public genres whose subjects provided symbols of imperial absolutist authority, examples of Christian knights, and demonstrations of princely attributes.[4]

Equestrian ballets also allowed the archduchess to recall publicly her Habsburg relatives' sponsorship of specially trained horses and precision horsemanship—after all, in 1562 her uncle Archduke Maximilian II had introduced the Spanish horses that would lend their name to the imperial riding school in Vienna, while in 1580 her father Archduke Karl had founded the stud farm that produced the famed Lipazzaners.[5] As we have seen, the conspicuous celebration of the Habsburg dynasty was crucial to Maria Magdalena's self-fashioning. Her decision to rename her villa Poggio Imperiale provides evidence of her desire to stress her imperial heritage, as do many of the paintings that she commissioned to decorate it.[6] Visitors to the "Sala de' forestieri" were surrounded by canvases of the archduchess's relatives, including her mother, father, brothers, sisters, cousins, nieces, and nephews, as well as her uncle Matthias, holy Roman emperor from 1612 to 1619. Those siblings who had acquired exceptional rank received special acknowledgment: separate canvases were devoted to her brother, Emperor Ferdinand II, as well as to the queen and king of Poland, her sister and brother-in-law.[7]

These works confirmed the political authority wielded by current members of the Habsburg dynasty. Paintings in two other rooms reconstructed the source of her family's power—their willingness throughout history to

temporary monuments, often erected as part of the decorations honoring Medici weddings and funerals. On the two bronze statues and the tradition of which they are a part, see H. W. Janson, "The Equestrian Monument from Cangrande della Scala to Peter the Great," in *Aspects of the Renaissance*, ed. Archibald R. Lewis (Austin, TX, 1967), 73–85; Virginia Bush, *The Colossal Sculpture of the Cinquecento* (New York, 1976), esp. 179–96; Michael P. Mezzatesta, "Marcus Aurelius, Fray Antonio de Guevara, and the Ideal of the Perfect Prince in the Sixteenth Century," *Art Bulletin* 66 (1984): 620–33; Walter Liedtke, *The Royal Horse and Rider: Painting, Sculpture, and Horsemanship, 1500–1800* (New York, 1989); and Mary Weitzel Gibbons, "Cosimo's *Cavallo:* A Study in Imperial Imagery," in *The Cultural Politics of Duke Cosimo I de' Medici*, ed. Konrad Eisenbichler (Aldershot, 2001), 77–102.

4. Liedtke (*The Royal Horse and Rider*, 37) notes the prominence of these three themes (singly or in combination) in equestrian portraiture from ca. 1550 to ca. 1650.

5. Ibid., 92n7.

6. According to Ornella Panichi, *Villa di Poggio Imperiale: Lavori di restauro e di riordinamento, 1972–1975* (Florence, n.d.), 17, the renaming occurred on 23 May 1624.

7. Based on the villa's inventory of 1625 (I-Fas, GM 479, opening 16, 18, 26–28). Two of Maria Magdalena's sisters (in succession) married Zygmunt III, King of Poland: Anna (d. 1598) and Constance (d. 1631). It is unclear from the inventory which sister was depicted in the portrait.

defend Europe against threats posed by non-Catholics. These messages were located in frescoes by Matteo Rosselli, which dominated the rooms reserved for the archduchess's son Ferdinando. In the four frescoes adorning the walls of Ferdinando's antechamber, Maria Magdalena reminded the future grand duke of the Catholic zeal demonstrated by two of his ancestors—his uncle Ferdinand, the current emperor, and an even more illustrious forebear, Charles V.[8] Emperor Ferdinand is shown protecting the religious integrity of his empire by ordering Protestants from his realm, presumably a reference either to his expulsion of Protestants from Inner Austria in 1599–1600 or to the later expulsions in Bohemia after the Habsburg victory at White Hill in 1620.[9] The archduchess hoped that her son would later emulate the actions of her brother, for the accompanying quatrain exhorts: "Look, oh kings, and admire the zeal of the second Ferdinand: 'leave my realm,' he commands, 'all those unfaithful to God. I do not want as a servant anyone who does not serve heaven'" [*Mirate, o regi, et ammirate il zelo / del secondo Ferdinando: il regno mio / lasci, ei comanda, ogni infedele a Dio. / Non vo' per servo, chi non serve al Cielo*]. The two frescoes depicting scenes from the life of Charles V celebrate battlefield victories against the Turks: the emperor is shown chasing Süleyman the Magnificent from Vienna in 1532 and conquering Tunis three years later.

In Ferdinando's bedroom, more distant ancestors surrounded the crown prince, Rudolph I (1218–91) and Maximilian (1459–1519). Rudolph is praised as the first Habsburg prince to ascend to the throne of the Holy Roman Emperor, rewarded with the imperial throne for his faithful service to God, according to the south wall fresco.[10] On the west wall, Rudolph receives homage from other European rulers, below which a quatrain proclaims the destiny of his progeny: they will sustain Europe and the Catholic faith, their fidelity and watchfulness symbolized by the dog who peers at the viewer from the lower right-hand corner (fig. 5.1).[11] Across the room, Maximilian

8. Julian Kliemann, *Gesta dipinte: La grande decorazione nelle dimore italiane dal Quattrocento al Seicento* (Milan, 1993), 181, 186–87.

9. On these events, see Geoffrey Parker, "The Habsburgs and Europe" and R. J. W. Evans, "The Imperial Vision," both in *The Thirty Years' War*, ed. Geoffrey Parker, 2d ed. (London, 1997), 6, 75–77.

10. The accompanying quatrain implies that Rudolph received his reward directly from heaven, a possible reference to the lack of an actual papal coronation. Its text reads: "LASCIA AL SACRO MINISTRO IL SUO DESTRIERO, / ET A DIO SERVE IL GRAN RIDOLFO A PIEDE. / MIRA IL CIEL' LA BELL'OPRA, E PER MERCEDE / L'INNALZA AL SOGLIO DEL ROMANO IMPERO."

11. Cesare Ripa (*Iconologia* [Padua, 1611; reprint, New York and London, 1976], 164–66) included a figure of a dog in both of his descriptions of "Fedeltà."

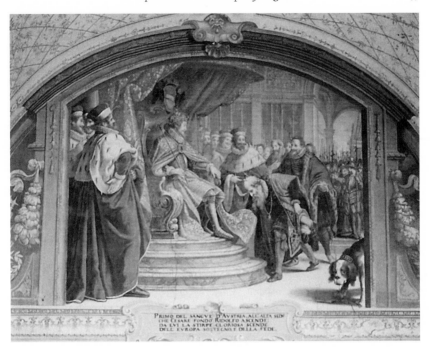

FIGURE 5.1. Matteo Rosselli, *Homage to Rudolph I* (Florence, Villa Poggio Imperiale)

takes on the "impious mob" from Switzerland, an idealistic retelling of the 1499 war between the Swabian League and the Swiss cantons.[12] Many of these themes were reiterated in a work commissioned by Archduchess Maria Magdalena to honor the 1624 visit of her brother Archduke Karl. Andrea Salvadori's *Canzone delli lodi d'Austria*, set to music by Jacopo Peri, was performed by the Mantuan tenor Francesco Campagnolo at Poggio Imperiale on 7 October 1624.[13] The ten stanzas of the *Canzone* confirm the fam-

12. Falling plaster has rendered illegible parts of the accompanying quatrain, while the north-wall fresco of Maximilian is hidden behind a window shade.

13. Andrea Salvadori, *Canzone delle lodi d'Austria* (Florence, 1624). The performance date comes from Cesare Molza, the ambassador from Modena (I-MOas, AF 53, fasc. 18, fol. 55v), who notes the singing of "some compositions in praise of the house of Austria" [*vi furono cantate in musica altre compositioni in lode di Casa d'Austria*]. It conflicts with the 28 September 1624 date cited by Angelo Solerti (*Musica, ballo e drammatica alla corte Medicea dal 1600 al 1637: Notizie tratte da un diario, con appendice di testi inediti e rari* [Florence, 1905; reprint, New York and London, 1968], 173) and repeated by Warren Kirkendale (*The Court Musicians in Florence during the Principate of the Medici with a Reconstruction of the Artistic Establishment* [Florence, 1993], 229–30, 310, 612), an earlier performance that must have been a rehearsal, since the archduke did not even arrive in Florence until 30 September 1624, an event that Molza describes in detail (I-MOas, AF 53, fasc. 17,

ily's duty to uphold the Catholic faith, and the initial verses of stanza 5 ("Austria Sol di Germania, Austria sostegno / immortal della Fede") resemble the final lines of the contemporaneous Rudolph fresco. Subsequent stanzas praise many of the same ancestors depicted in the villa's frescoes and portraits.

The entire period of Maria Magdalena's rule coincided with the first decade of the Thirty Years' War (1618–48), that series of interrelated dynastic and religious conflicts that devastated much of Europe. Regency spectacles are filled with exhortations to the political leaders of Europe to put aside internecine quarrels in order to concentrate on the threat posed from outside the Catholic Church. Nowhere are these prescriptions more overt than in the horse ballets and other dramatic combat genres, which assumed a more conspicuous role in court entertainments after 1616.[14] The descriptions contained within several of the surviving libretti for these spectacles offer reasons why these entertainments grew to such importance for the Medici court. First, like opera, the horse ballet and its generic relatives demonstrated the Florentine reinvigoration of an ancient genre—an ancestor it promptly surpassed, according to Simoncarlo Rondinelli in his description of *Le fonti d'Ardenna* (1623). Rondinelli promoted these knightly exercises [*cavallereschi esercizi*] as a means for Florence to regain its past glories, and he claimed that Athens, Sparta, and Rome itself would concede the superiority of the modern genres to their ancient counterparts.[15] In his description of the *Guerra d'amore* (1616), Andrea Salvadori stresses both the novelty of the genre in modern times and its resemblance to Trojan equestrian genres described by Virgil.[16] Also im-

fol. 164r; fasc. 18, fol. 50v) and is confirmed in the Settimani diary (I-Fas, Manoscritti, 133, fol. 248r).

14. Possibly the first such entertainment in Florence was the *balletto de' cavalli* performed as part of the festivities honoring the marriage of Crown Prince Cosimo II de' Medici and Archduchess Maria Magdalena in 1608, described in Camillo Rinuccini, *Descrizione delle feste fatte nelle reali nozze de' Serenissimi Principi di Toscana D. Cosimo de' Medici, e Maria Maddalena Arciduchessa d'Austria* (Florence, 1608), 50–53, 89–95. See Tim Carter, "A Florentine Wedding of 1608," *Acta musicologica* 55 (1983): 103. For descriptions of other equestrian entertainments, see Solerti, *Musica;* Federico Ghisi, "Ballet Entertainments in Pitti Palace, Florence, 1608–1625," *Musical Quarterly* 35 (1949), 421–36; A. M. Nagler, *Theatre Festivals of the Medici, 1539–1637* (New Haven, CT, and London, 1964); and, more generally, Paul Nettl, "Equestrian Ballets of the Baroque Period," *Musical Quarterly* 19 (1933): 74–83. The collaboration between Ferdinando Saracinelli and Francesca Caccini is the only one of these works to have been studied extensively; see particularly Suzanne G. Cusick, "Of Women, Music, and Power: A Model from *Seicento* Florence," in *Musicology and Difference: Gender and Sexuality in Music Scholarship*, ed. Ruth Solie (Berkeley, 1993), 281–304.

15. Rondinelli, *Le fonti d'Ardenna*, sig. [A4v].

16. Andrea Salvadori, *Guerra d'Amore* (Florence, 1616), reprinted in Salvadori, *Poesie*, 1: 316–58.

portant was the practical purpose of the equestrian entertainment: it allowed knights to hone their battle skills in peacetime, while demonstrating to Florentines and outsiders the grand duke's ability to activate this potential, if necessary. The published descriptions of both *La disfida d'Ismeno* (1628) and *Armida e Amor Pudico* (1637) confirm the military prowess of the Tuscan cavaliers and Medici princes, and in the latter work, the narrator links explicitly the Florentine nobility's valor in mock battles to the ability to succeed in actual combat.[17]

During the period 1621–28, Maria Magdalena honored three visitors with performances of horse ballets or staged combats featuring dramatic action and music. For source material suitable to represent themes of dynasty and religious conflict, court poets turned most often—unsurprisingly—to two sixteenth-century works that also dealt with these issues: *Orlando furioso* by Lodovico Ariosto and *Gerusalemme liberata* by Torquato Tasso.[18] The poems remained relevant to contemporary audiences: although both narratives unfold in a lively series of skirmishes fought over a lover or even an emblem, these diversions always take place with the underlying knowledge that the true battle will be waged between Christian and non-Christian, the enactment of which culminates both epics.

Le fonti d'Ardenna (1623)

As with the plays and operas based on saints' legends, the plots for the *balletti abbattimenti* often deviated significantly from their ostensible source material. Florentine poets most often constructed plots that revisited personages at some point after the events narrated in the poetic source. Characters thus bring with them their personalities and their histories, which then inform their actions in new situations. During the period of the regency, the first work of this type was Andrea Salvadori's *Le fonti d'Ardenna* [The fountains of

17. Andrea Salvadori, *La disfida d'Ismeno* (Florence, 1628), reprinted in Salvadori, *Poesie*, 1: 409–21. The later edition will be the source for all following quotations from this work. The source for *Armida e Amor Pudico* is the *Descrizione delle feste fatte in Firenze per le reali nozze de Serenissimi Sposi Ferdinando II Grand Duca di Toscana, e Vittoria Principessa d'Urbino* (Florence, 1637); see p. 51 for the assertion of military prowess.

18. In 1626 the court also celebrated the visit of Archduke Leopold of Austria—another of the archduchess's brothers—with a performance of Salvadori's *Medoro*, whose libretto was based on *Orlando furioso*. This was apparently a spoken version of the opera by Marco da Gagliano and Jacopo Peri that had been performed on 25 September 1619 to commemorate the accession of yet another brother—Ferdinand—to the imperial throne. See Solerti, *Musica*, 149–50, 186; and Kirkendale, *Court Musicians*, 225–26.

the Ardennes], performed on 3 February 1623 by the Accademia de' Ruggi-
nosi, with music, now lost, by Marco da Gagliano.[19] According to the pub-
lished description, Salvadori himself provided the invention for the work,
which the academy presented as part of the festivities honoring the visit of
the prince of Condé, Henri II.

Condé's visit occurred during the height of tensions over the Valtelline
territory. The prince was an ardent anti-Protestant: he had pushed King
Louis XIII into war with the Huguenots in 1622, and he had enjoyed nu-
merous military successes in that campaign. These victories came to an abrupt
end when the French armies reached Montpellier, and, in disgust over what
appeared to him to be Louis's willingness to sign a peace treaty with the French
Protestants in order to divert his military forces to support Swiss Protestants,
Condé left for Italy on 9 October 1622, intending to make a pilgrimage to
Loreto then to visit the important cities of Italy.[20]

Condé's presence in Italy may have unnerved many of his hosts, especially
since the prince apparently let it be believed that he had come to Italy to par-
ticipate in negotiations over the Valtelline on behalf of the French king.[21]
Archduchess Maria Magdalena still hoped to ensure her son's nomination to

19. The most complete description of the work and its performance is the account writ-
ten by the academy's secretary, Simoncarlo Rondinelli, *Le fonti d'Ardenna.* The citations and
page references that follow are from this print. The text alone was reprinted in Salvadori, *Poe-
sie,* 1:394–408. Cesare Tinghi included a brief entry on this work (I-Fn, Gino Capponi 261,
vol. 2, fols. 563v–564r; shortened and altered slightly in Solerti, *Musica,* 164–65). Tinghi also
recorded that the archduchess occupied the *primo luogo* for the performance, followed by (in
order): Cardinal Carlo de' Medici, Grand Duke Ferdinando II, the prince of Condé, and Don
Lorenzo de' Medici.

20. On the life and career of the Prince of Condé, see esp. H. d'Orléans, duc d'Aumale,
Histoire des princes de Condé pendant les XVI^e et XVII^e siècles, 7 vols. (Paris, 1863–96), 3:1–306. Also
useful are Berthold Zeller, *Richelieu et les ministres de Louis XIII de 1621 a 1624: La cour, le gouverne-
ment, la diplomatie d'après les archives d'Italie* (Paris, 1880), esp. 59–105, 166–70, 308–10; and Louis
Batiffol, *Le Roi Louis XIII a vingt ans* (Paris, 1910), 189–90.

21. The ambassador from Modena, Paolo Boiardo, relayed this commonly held opinion
about the prince's real purpose in Italy in his dispatch dated 27 January 1623 (I-MOas, AF 49,
fasc. 4, fol. 47r). The papal nuncio Alfonso Giglioli also noted Condé's desire to involve him-
self in these negotiations, but as early as 25 October 1622 he expressed doubt that the prince
carried enough weight with the French king to warrant entrusting him with such an impor-
tant matter (I-Fas, Carte Strozziane, serie prima, 164, fols. 29v–30r; also 85v–86r). When he
was in Rome, Condé had secretly persuaded the pope to accept trusteeship of the Valtelline,
but contemporary French pamphlets argued that he did it to further his own goal, the secu-
larization of the abbey at Déols: see Zeller, *Richelieu,* 169; and Aumale, *Histoire,* 141–45.

the position of protector over the disputed territory. In June of 1622 she had persuaded the Spanish ambassador to support Florence's claim, and she must have hoped to impress Condé in similar fashion eight months later. The regents welcomed the French prince as a Catholic hero, a message reinforced by the theatrical spectacles performed during his visit. On 6 February 1623, the court sponsored a performance of Jacopo Cicognini's *La finta mora*, with music by Filippo Vitali, a play strongly Catholic in its orientation. The personage of Religion delivered the prologue, calling the play's characters—and presumably, its audience—to arms against the Turks, while the main plot of the drama centers around the conversion of a Muslim princess.[22] *Le fonti d'Ardenna* commented even more explicitly on current political events.

For his "entertainment of arms and dance" [*festa d'arme e di ballo*], Salvadori extracted characters from *Orlando furioso* then reinserted them into a new dramatic context, whose action he distributed over four sections. In part 1, the sorcerers Merlin and Melissa devise a plan to rid the world of the fountain of disdain, whose waters cause all who drink from them to despise love. Merlin predicts that this will lead to a battle between those knights who defend the fountain and those who instead champion love, and, since the outcome of such a conflict is uncertain, he suggests that Melissa, proven friend to magnanimous women, seek out the loveliest of the Tuscan ladies to influence the result. According to the descriptions of their costumes, both Merlin and Melissa wore attire similar to the priests and priestesses of the ancient Gauls and Belgians (sig. C1r). They conversed in music with instrumental accompaniment, probably in recitative. The second section offers the verbal equivalent of battle, a sung debate [*contrasto*] between the allegorical personages of Love [Amore] and Disdain [Sdegno], each seconded by the appropriate trio of Graces and Furies.[23] Then the six combatants enter, with one member of each three-man squadron delivering a lengthy recitative. The two groups begin to battle, escalating to a ferocity that alarms the spectators. In the midst of such violence, Melissa returns with her troop of Tuscan ladies, who honor the French prince by their costumes "alla Franzese": dresses, embroidery, and stockings designed to explore all possible combinations of the three colors— red, blue, and yellow—of the Condé coat-of-arms, which featured three

22. Jacopo Cicognini, *La finta mora* (Florence, 1625). See Mario Sterzi, "Jacopo Cicognini," *Giornale storico e letterario della Liguria* 3 (1902): 411–12.

23. The closed rhymes of these verses, combined with the frequent use of *quaternari, quinari,* and *ottonari,* suggest that the debate was carried out with music in the tuneful canzonetta style.

gold fleurs-de-lis plus the red Bourbon baton on a blue field.[24] Melissa and her followers interrupt the fighting and, simultaneously with the simulated battle taking place upstage, they initiate a more pleasing ballet, accompanied by four strophic *canzonette* sung by a chorus of Love's supporters. The battling knights gradually desist and join the ladies, after which Disdain concedes defeat, Merlin dispatches the fountain of disdain to the Underworld, and the chorus accompanies the *corrente* danced by the knights and ladies with a two-stanza *canzonetta.*

Salvadori derived his material mostly from *Orlando furioso,* which he supplemented with descriptions drawn from two other Renaissance sources: Boiardo's *Orlando innamorato* and Ripa's *Iconologia.*[25] For example, the association between Melissa and Merlin derives from Ariosto's epic, but the Merlin still in possession of a physical body comes from *Orlando innamorato.* The wizard's repentance at having created the fountain of disdain also refers to the earlier epic (1.3.32–34). A similar conflation informs the debate between Disdain and Love: in *Orlando furioso* Disdain leads Rinaldo to his fountain so that the knight might finally extinguish his unrequited love for Angelica (42.53–67), while in *Orlando innamorato* Cupid and the Graces compel the same warrior to drink from Love's stream (2.15.44–63). Disdain's costume reproduces faithfully the description of Sdegno by Ripa: he has the legs and feet of a lion and a helmet in the shape of a bear's head that belches flames, while he carries a broken chain that symbolizes his dissolution of the bonds of love.[26]

But the key to understanding the allegorical message of this work lies in Salvadori's choice of combatants and their resulting costumes and insignia. Alcestes, Orlando, and Rodomonte defend the fountain of disdain. Although in *Orlando furioso* these knights do not benefit from the effects of the fountain, they are nevertheless apt candidates, since all three endure repeated, often humiliating rejections by their lovers.[27] Love finds its champions in Brandi-

24. Jiří Louda and Michael Maclagan, *Lines of Succession: Heraldry of the Royal Families of Europe* (New York, 1991), table 68. Rondinelli reports (*Le fonti d'Ardenna,* sig. E3r–E4v) that the ladies' costumes included such "French" characteristics as low-cut bodices and puffy sleeves, blonde hair bedecked with jewels and flowers, colorful stockings, and shoes cut in the French style.

25. Matteo Maria Boiardo, *Orlando innamorato,* trans. and ed. Charles Stanley Ross (Berkeley, 1989); and Ripa, *Iconologia.*

26. Ripa, *Iconologia,* 473. The same images recur in the Rome (1603) and Padua (1624) editions, according to Yassu Okayama, *The Ripa Index: Personifications and Their Attributes in Five Editions of the Iconologia* (Doornspijk, 1992), 248.

27. Alcestes is not an actual character in *Orlando furioso* but rather the subject of a tale told to Astolfo by Lydia, Alcestes's ungrateful widow, whose own behavior led to her husband's death (34.11–43).

marte, Mandricardo, and Ruggiero. By devoting eight pages to the knights' costumes and armor, more than twice the number of pages needed for their actual speeches, Rondinelli invests the visual aspects of the work with particular significance. His description confirms that the knights' armor remained true to *Orlando furioso:* Orlando wears his quartered red and white (8.85), and Rodomonte terrifies the audience with his armor of scaly dragon's skin (14.118). Salvadori inverts Rodomonte's banner as described in *Orlando furioso,* replacing the lady leading a bridled lion (14.114) with a dragon strangling a Siren.

Among the knights who affirm love, the costume of Brandimarte, while not a re-creation of his armor as described in *Orlando furioso,* amplifies canto 43.161, as Fiordiligi mourns her husband's death, regretting that she had not been there to shield him with her head ("Fatto scudo t'avrei con la mia testa").[28] Salvadori grants her wish, for in *Le fonti d'Ardenna* Brandimarte carries an image of Fiordiligi on his shield and in his heart, and his costume is covered with golden *fiordiligi,* that is, fleurs-de-lis.[29]

Mandricardo and Ruggiero share the device over which they fought so bitterly in *Orlando furioso,* the argent eagle on an azure background (26.98–110; 30.18–68.). Ruggiero refers to this earlier dispute when, as spokesman for the group, he asks his companions to put aside their former differences, asserting that love "today wants us to be united" [*vuol, ch'oggi insieme uniti* (sig. E1v)]. These are not minor concessions: after all, in *Orlando furioso* Ruggiero killed Mandricardo, now one of his comrades-in-arms. Ruggiero asks Brandimarte to put his allegiance to love above his friendship with Orlando.

In *Le fonti d'Ardenna,* Salvadori creates a new bipartite division, one in which Christians and non-Christians—symbolized by the fleur-de-lis and two eagles—unite to battle their common enemy, those who disdain love—represented by the dragon. Dragons were often used in Christian art to represent evil or heresy.[30] The fleur-de-lis was the most recognized emblem of France,

28. Ariosto may have intended Fiordiligi's lament as a self-indicting comparison with the more successful Fiordelisa in *Orlando innamorato* (3.7.32–33), who shielded [*reparava*] her husband and thereby protected him.

29. These colors are not associated with Brandimarte in the epic but may instead refer to Fiordiligi, who wears a white gown with golden band in canto 31.38. The conspicuous presence of the fleur-de-lis on Brandimarte's costume suggests that it was the knights defending love that Cesare Tinghi believed represented French paladins [*paladini di francia*] (I-Fn, Gino Capponi 261, vol. 2, fol. 563v). This would make the knights who disdain love the foreigners [*cavalieri stranieri*] (ibid.).

30. Derived from Revelations, bk. 12. See John Vinycomb, *Fictitious and Symbolic Creatures in Art with Special Reference to Their Use in British Heraldry* (London, 1906; reprint, Detroit, 1969), 69–83.

just as the two-headed imperial eagle represented the empire. The promi-
nent visual display of these emblems allowed Salvadori and the Accademia
Rugginosi, on behalf of the Medici family, to convey a message at the top of
Archduchess Maria Magdalena's political agenda: the Catholic powers of
France, Spain, and the empire must stop fighting each other in order to join
in battle against a much more dangerous enemy, the dragon of heresy. If they
put these minor differences behind them, they will, with the help of the pow-
erful woman leading Florence, succeed in the larger and more important
undertaking.[31]

La liberazione di Ruggiero dall'isola d'Alcina (1625)

The need for continued vigilance against heresy also informed the subject
matter of Ferdinando Saracinelli's *La liberazione di Ruggiero dall'isola d'Alcina*,
set to music by Francesca Caccini and performed at Poggio Imperiale on
3 February 1625.[32] Archduchess Maria Magdalena commissioned *La libera-
zione* as part of the celebrations for Prince Władysław of Poland.[33] As was her
custom, she attended nearly every rehearsal of the work, and she even at-
tempted to borrow outside talent—this time four-footed—from Modena,
Mantua, and possibly, Ferrara, as well as from other members of the Medici
household.[34]

31. Merlin's presence may also have functioned as a confirmation of Condé's own opin-
ion that Louis XIII should concentrate his forces against the Protestants, rather than the Val-
telline, for Merlin's most extensive prophesy in *Orlando furioso* cites the numerous French kings
who faced disaster when trying to conquer Italy (canto 33.10–57).

32. Solerti, *Musica*, 180–83. Both libretto and score were published in 1625: Ferdinando
Saracinelli, *La liberazione di Ruggiero dall'isola d'Alcina: Balletto rappresentato in musica* (Florence, 1625);
and Francesca Caccini, *La liberazione di Ruggiero dall'isola d'Alcina: Balletto composto in musica* (Flor-
ence, 1625). I would like to thank Suzanne Cusick for sending me a copy of this score. Both
the score and libretto have recently been reissued in a facsimile edition, with a foreword by
Alessandro Magini (Florence, 1998).

33. Although scholars have tended to refer to *La liberazione* as an opera, both the score and
libretto designate the work a *balletto*. Saracinelli expanded the initial dialogue interchange that
typically preceded the *balletto a cavallo* proper into a potentially free-standing work, whose
length approaches that of the earliest *favole per musica*. *La liberazione* consists of 733 lines: by con-
trast, in *Le fonti d'Ardenna* 230 lines precede the combat scene, while the total number of lines
equals 357. *L'Euridice* by Ottavio Rinuccini numbers 790 lines.

34. The archduchess wrote letters to a Sig. Prospero Bentivoglio and to her sister-in-law
Duchess Caterina of Mantua on 17 and 24 December 1624 (I-Fas, MDP III, fols. 232r, 237r),
confessing that she did not have access to as many trained horses as she needed in order to

Unsurprising in light of the archduchess's plan to arrange a marriage between her daughter and Władysław, ensuring dynastic continuity through an appropriate marital alliance emerges as one of the central themes in *La liberazione*. And once again Ariosto's beneficent sorceress Melissa is crucial to the plot. In its principal source, *Orlando furioso* (cantos 7 and 8), Melissa—disguised as the old sorcerer Atlante and aided by a magic ring—must free Ruggiero from Alcina's enchantment so that he might return to Bradamante and found the Este dynasty. But military themes are at least as important in *La liberazione*, and to that end Saracinelli altered significantly Ariosto's epic. Most of the changes result from his conflation of *Orlando furioso* with Tasso's *Gerusalemme liberata*.[35] For example, both scenes featuring Alcina and Ruggiero—the first an amorous debate between two lovers and the second an actual confrontation between the sorceress and the knight who has abandoned her—have no clear parallels in *Orlando furioso*. Although Ariosto describes briefly the sensual nature of their life on the enchanted island (7.30–32), he includes no actual dialogue. Stanzas 17–26 of canto 16 in *Gerusalemme liberata*, by way of contrast, are nearly identical in content to the *La liberazione* episode: Rinaldo and Armida debate the accuracy with which a mirror can reflect a woman's true likeness. Both Rinaldo and Saracinelli's Ruggiero conclude that they themselves can provide the truest reflections of their lovers, and their declarations share several key phrases, indicated in boldface type below.[36]

achieve the particular effect she desired ("noi non habbiamo quel numero di cavalli, che per tal'effetto vorremmo"). Caterina responded on 4 January (I-Fas, MDP 6084, fol. 729r), expressing her mortification that she could not be of service, since their horses were too young and little trained. Maria Magdalena fared better with Prince Alfonso d'Este of Modena, who loaned her two horses for the festivities (I-Fas, MDP 6085 [n.p.], dated 11 January 1625). The letters from Caterina Gonzaga and Alfonso d'Este are cited in Cusick, "Of Women, Music, and Power," 285n9. In the same footnote Cusick notes the conflict that arose when the archduchess insisted on using horses belonging to her brother-in-law Don Lorenzo, an incident reported gleefully by the ambassador from Modena (I-MOas, AF 53, fasc. 18, fols. 249r–250r, 259r–260r). For transcriptions and translations of the relevant portions of the letters, see my "*Amazzoni di Dio*: Florentine Musical Spectacle under Maria Maddalena d'Austria and Cristina di Lorena (1620–30)" (Ph.D. diss., University of Illinois at Urbana-Champaign, 1996), 393–95.

35. While both Suzanne Cusick ("Of Women, Music, and Power," 288n15) and Rodrigo de Zayas ("Ferrara, Firenze e una donna," *Schifanoia* 5 [1989]: 23–33) have commented on Saracinelli's reliance on *Gerusalemme liberata* for his own libretto, neither has explored systematically the degree to which the Florentine poet based both characters and situations on Tasso's epic.

36. All quotations from Tasso are from the following edition: Torquato Tasso, *Gerusalemme liberata*, ed. Lanfranco Caretti (Turin, 1993).

Ruggiero, in *La liberazione* (p. 12) Tasso, *Gerusalemme liberata* (16.21–22)

Taci, ché sol nel cielo,
nel sole, e nelle stelle
puoi vagheggiar le tue sembianze belle.
Ma se prendi diletto
di rimirar quaggiù quel che tu sei,
lascia il vetro mendace, aprimi il petto:
diran gl'incendij miei,
dirà quivi il tuo volto,
ch'io porto in seno un Paradiso accolto.

[Be silent, for only in the heavens, in the sun and in the stars can you gaze fondly at your beautiful semblance. But if you take delight in looking down here [to see] what you are, leave the false glass, open up my breast: my flames will speak, your face [reflected] in here will tell [you] that I carry a paradise in my heart.]

L'uno di servitù, l'altra d'impero
si gloria, ella in se stessa ed egli in lei.
"Volgi," dicea, "deh volgi," il cavaliero
"a me quegli occhi onde beata bèi,
ché son, se tu no 'l sai, ritratto vero
de le bellezze tue gli incendi miei;
la forma lor, la meraviglia a pieno
più che il cristallo tuo mostra il mio seno.
Deh! Poi che sdegni me, com'egli è vago
mirar tu almen potessi il proprio volto;
ché il guardo tuo, ch'altrove non è pago,
gioirebbe felice in sé rivolto.
Non può specchio ritrar sì dolce imago,
né in picciol vetro è un paradiso accolto:
specchio t'è degno il cielo, e ne le stelle
puoi riguardar le tue sembianze belle."

[The one in servitude, the other in command, glory, she in herself, and he in her. "Turn," he said, "oh turn," [said] the knight, "to me those eyes with which, happy one, you [cause] delight, for even if you do not know it, my passions are the true portrait of your beauties, my love demonstrates much more fully their shape and wonder than can your crystal. Oh, since you disdain me, might you at least admire how beautiful is your face, for your glance, which is not satisfied looking anywhere else, would rejoice happily, reflected in itself. A mirror cannot portray such a sweet image, nor can a paradise be contained in a little glass: heaven is a mirror worthy of you, and you can look at your beautiful semblance in the stars."]

Spectators would have recognized the allusion to Tasso, for the mirror was a common feature of artistic depictions of the garden scene with Armida and Rinaldo, including the painting by Girolamo Frilli Croci purchased just three months before the performance of *La liberazione* by the archduchess's brother-in-law, Cardinal Carlo de' Medici (fig. 5.2).[37]

Caccini depicts musically the charged atmosphere surrounding the lovers.

37. See the catalog entry on this painting by Elena Fumagalli in *L'arme e gli amori: La poesia di Ariosto, Tasso e Guarini nell'arte fiorentina del Seicento,* ed. Elena Fumagalli, Massimiliano Rossi, and Riccardo Spinelli (Florence, 2001), 195–96.

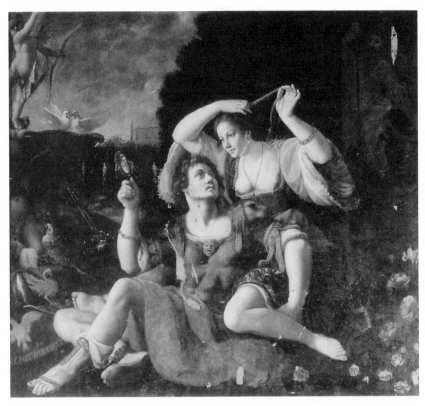

FIGURE 5.2. Girolamo Frilli Croci, *Armida and Rinaldo* (Florence, Depositi delle Gallerie)

In his first speech of the work, Ruggiero—an overly emotional tenor in the recent tradition of Ireo from *Sant'Orsola*—complains passionately of the torments caused by his love for Alcina (ex. 5.1). Since Alcina clearly returns his passion, Ruggiero's complaints are merely feigned, serving as a vehicle through which he can vent his exaggerated sentiments. Caccini exploits an arsenal of expressive devices to heighten the emotional appeal of the impetuous knight. At measures 6–8, claiming to be mortally wounded by Alcina, Ruggiero exaggerates the pain of his wounds in rhythmic syncopation, coupled with a descending vocal line and dissonances. A liberal use of expressive leaps gives poignancy to his petitions, for example, the d″–g♯′ descent on "cor mio" (m. 10), an exclamation stressed by its separation from the beginning of the text line. The rash Ruggiero then accuses Alcina of inflicting "pains and torments" on him, and he propels his claims by means of a sudden burst of eighth notes. Expressive leaps punctuate his next lines, as he equates Alcina's glances with wounds in the b♭′–f♯′ leap on "ferita" (mm. 15–16), then im-

mediately reverses the b♭′ by the b♮′ at "misera," both of which sound harshly dissonant against the D harmony, as Ruggiero melodramatically overstates his case.

Caccini also appears to have captured the essentially fickle nature of Ruggiero through her harmonic choices. Cadences to E (m. 8), G (m. 14), and A (m. 25) imply finals of G and A, creating a conflict that mirrors Ruggiero's own confusion, as Cusick has already noted.[38] Three other speeches are marked by sudden shifts of key signature, creating a hexachordal uncertainty found only in the music of this character, including even the speech in which he professes his constancy.[39]

Following Tasso's handling of this amorous interchange, Saracinelli concludes the scene with Alcina's announcement that she must depart to attend to her realm. Caccini offers the audience an early insight into Alcina through her musical setting of her farewell: among her enumeration of the auditory delights with which she hopes Ruggiero will amuse himself in her absence, she includes the sweet songs of the sirens, whose imagined vocal pyrotechnics she briefly imitates in her own florid eruption, the only instance in the entire work in which a principal character sings a melismatic passage (ex. 5.2).

Tasso also influenced Saracinelli's construction of the final scene between the two lovers in *La liberazione*. The jilted Alcina vows to regain Ruggiero through pity and seduction, and on encountering her former lover, she attempts to persuade him using these very techniques. When she fails, she turns to recrimination and anger, tactics that also prove unsuccessful. Ariosto provides no similar model: his Alcina laments Ruggiero's disappearance (8.12 – 13) then musters her troops in pursuit, intending to take him back by force (10.48 – 51). But in *Gerusalemme liberata*, an abandoned Armida plans to regain Rinaldo through false supplication. And when her plot fails to convince him to return, she accuses him of treachery and threatens revenge (16.36 – 67).[40]

Francesca Caccini confirms this cunning Armida-like Alcina in her musical setting of these lines, emphasizing Alcina's ability to manipulate speech for the purposes of persuasion (ex. 5.3). Alcina attempts to regain Ruggiero's love by convincing him of her emotional distress, characterized by a sudden inability to create musical order: throughout her entire speech her vocal line does not participate in a single strong cadence. At measure 5, as she begins her attempt to convince Ruggiero of her overwhelming sorrow, her initial b♮′

38. Cusick, "Of Women, Music, and Power," 290.

39. See Harness, "*Amazzoni di Dio*," 167–73.

40. Armida's wrath dissipates in the poem's final canto, and she offers to be Rinaldo's maidservant (20.136).

contrasts sharply with her b♭' of the previous measure, and, seeking to project an image of complete despair, she sings in dissonance with the prevailing harmony. Hoping to soften Ruggiero's heart with her tears, she begins her pathetic, chromatically inflected melisma on "pianto" with a harsh dissonance. In measures 11–12 she tries to impress on Ruggiero the misery caused by his abandonment through a chromatic ascent at "immenso dolor," but while the subsequent melodic and harmonic movement is toward e', the unexpected 11–10 suspension at measure 14 destroys the E harmony's effectiveness as a resolution, and Alcina proves that her murdered soul is indeed powerless.

Alcina then becomes frantic: in short imperative phrases, she orders Ruggiero to witness her tears and listen to her wails. Saracinelli builds this agitation into the poetic verses by separating the two imperative commands, "Rimira 'l pianto mio" and "senti le strida" with a prominent caesura, then by repeating the "senti" command in the next line. Caccini incorporates the same agitation into the music of these lines, gradually increasing the speed of declamation for each of the three musical phrases and causing each to climax melodically on a successively higher pitch, culminating on the e″ that begins the third phrase, as Alcina literally wails her despair (mm. 15–18). The section concludes with a return of the opening "Ferma, ferma" refrain, once again ending without a cadence.

Caccini continues to exploit the affective devices of dissonance and chromatic alteration as Alcina orders Ruggiero to view the eyes he once praised as stars, which are now filled with tears. Once again a suspension deflects the momentum away from any cadential closure (mm. 21–27). Alcina concludes her attempt to gain the pity of her former lover by recalling the mirror imagery from their opening scene. Whereas she had earlier asked Ruggiero to perceive her true self by viewing her face in the mirror, she now asks her lover to look at her face itself, which has become the mirror that reflects her sadness. She makes her despair audible in a vocal line frequently in conflict with the underlying harmony. Although the bass makes the necessary E–A motion to conclude the speech, Alcina does not participate in the cadence: she is only able to repeat pitifully her a'.

Since Alcina's strategies of arousing pity or love in Ruggiero fail, her final words to him are of recrimination. Saracinelli intended for these lines to be sung by one of Alcina's damsels, according to the printed libretto, recalling the similar scene in *Orlando furioso* (10.40–43). Caccini's decision to give the words to Alcina not only corresponds more closely to Tasso's parallel scene, but it also endows the recitative with much more dramatic potency by making it the culmination of a series of highly emotional speeches that the sorceress delivers over the course of the scene. Alcina's highly expressive recitative

recalls her earlier, conscious attempts to regain Ruggiero's love by manipulating his emotions. Unable to gather the control needed to impose order on her words by means of cadential closure, Alcina concludes her recitative with a refrain introduced earlier by her ladies (ex. 5.4)—a slur against Ruggiero's humanity that recalls not only Armida's similar incrimination of Rinaldo (*Gerusalemme liberata*, 16.57) but also Tasso's own source for this scene, Dido's accusations leveled at the departing Aeneas (*Aeneid*, 4.365–367). With this line, Alcina reaches the depths of despair, and as she sinks, she progresses ever further in a flat harmonic direction. Her melodic $g\flat'-f'$ motion precludes the possibility of a strong cadence to F, and with the harmonic ornamentation over the bass's sustained f, her speech and her hopes fade away.

Throughout *La liberazione*, Alcina embodies immoderation, and her excesses lead to her eventual defeat. In four of her fourteen speeches she even surpasses the normal harmonic vocabulary of early seventeenth-century Florentine opera through the introduction of chords as extreme as E♭ minor and c♯ minor, just as her unashamed sexuality, and her expression of it with Ruggiero, exceeds the range of socially acceptable behavior and must be squelched by Melissa, the standard-bearer for modest love and marriage.[41] By contrast, the sorceress Melissa avoids melodic and harmonic extremes, and she achieves her goals due to her ability to control the arena of language. She successfully imposes her will on both Ruggiero and Alcina. Suzanne Cusick has already suggested that diatonicism and avoidance of expressivity produce a musical rationality that allows the desexed heroine to control her own music's sensual pleasure, just as she ultimately overcomes the unrestrained sensuality embodied by Alcina.[42] But the forcefulness of Melissa's words also derives from a conflation of the Melissa character as depicted by Ariosto with another of his beneficent sorceresses, Logistilla, as well as with Carlo and Ubaldo, the male rescuers of Rinaldo in *Gerusalemme liberata*. Like the virgin martyrs, the Melissa who appears in *La liberazione* disassociates herself from her gender—not only does she adopt male disguise but she appropriates male speech as well.

While in *Orlando furioso* it is Logistilla, Alcina's sister and chaste embodiment of rationality, who defeats Alcina's armies (10.51–55, 15.10), in *La liberazione* Melissa accomplishes this deed. Likewise her force of personality alone restores rationality to Ruggerio: this Melissa has no need of a magic ring. Saracinelli makes an important departure from Ariosto here—in *Orlando furioso* the disguised Melissa upbraids Ruggiero principally for abandoning his

41. Cusick, "Of Women, Music, and Power," 297, 302. See also Harness, *"Amazzoni di Dio,"* 151–67, 173–85.

42. Cusick, "Of Women, Music, and Power," 295.

destiny, especially Bradamante and their future offspring (7.56 – 64). But in *La liberazione* (ex. 5.5), Melissa confines her argument to Ruggiero's abandonment of his comrades in arms, charging: "The entire world flares up in military passions, all of Libya and Europe go to war. Every stronger soul scorns the risks of death, and you, badly counseled, love being beloved by a filthy witch?" Audience members might understandably have been bewildered as to which side of the conflict Melissa intended Ruggiero to rejoin, for at this point in *Orlando furioso* Ruggiero belongs to the non-Christian knights. The confusion stems from Saracinelli's appropriation of canto 16, stanza 32 of *Gerusalemme liberata*—the scene in which Ubaldo chastises the Christian knight Rinaldo (shared line in boldface):

> Ubaldo incominciò parlando allora:
> **"Va l'Asia tutta, e va l'Europa in guerra:**
> chiunque e pregio brama e Cristo adora
> travaglia in arme or ne la siria terra.
> Te solo, o figlio di Bertoldo, fuora
> del mondo, in ozio, un breve angolo serra;
> te sol de l'universo il moto nulla
> move, egregio campion d'una fanciulla."

[Ubaldo then began speaking: "All of Asia and Europe go to war: whoever longs for esteem and adores Christ now fights in the land of Syria. A small secluded spot encloses you alone in idleness, away from the world, oh son of Berthold; you alone are unmoved by the turmoil of the universe, distinguished champion of a girl."]

Like the speeches of Ubaldo and Carlo, intended to remind Rinaldo of his military duty, not his progeny, in *La liberazione* Melissa never even mentions Bradamante in the words she speaks directly to Ruggiero.[43] Her sole purpose is to return him to battle, and, like her other speeches in the opera, she asserts her will through forcefulness. By contrast to Alcina, Melissa commands, rather than persuades Ruggiero, and even in this most impassioned of her speeches she maintains musical self-control. Her entire speech is circumscribed within a narrow melodic range, and she orders her words according to both musical and syntactical logic. Aside from the sixteenth notes that accompany her brief flashes of anger, her declamation is without rhythmic extremes, often in insistent anapests. She uses harmonic excess only to jolt Ruggiero out of his complacency. For example, when she berates Ruggiero for his foolishness, contemptuously reminding him that while all of Europe is at war, he dallies with the "filthy witch," she emphasizes the point by pausing

43. In her opening soliloquy, Melissa does allude to her promise to Bradamante.

on a decorated cadence to G (mm. 23–24). This extravagant cadence contrasts sharply with the earlier unadorned motion to E by which she punctuated "guerra" (m. 16), creating a sarcastic distinction between Ruggiero's current sensual excesses and the Spartan life of the warrior that he has mistakenly abandoned. Throughout her speech Melissa glorifies images of war and disparages those of sensual love. She demands to know whether Ruggiero's foolish acts are to be the fruits of her (or, since she is disguised as Atlante, his) labors, a paraphrase of *Orlando furioso* (7.56), and she reenacts musically this effort in a deliberate, controlled ascent, culminating in the g′ that marks the result of this toil (mm. 7–9). But the yield is bitter, Melissa informs Ruggiero, and she harshly distorts the c′–g′ fifth outlined in her earlier measures to a g′–c♯′ tritone at measure 9. Melissa also uses declamation to contrast those warriors risking death to the lovesick Ruggiero. The marchlike delivery of measures 17–20 by which she re-creates the movements of the fearless warriors is replaced abruptly with the flaccid rhythms of measures 22–23 as Melissa dismisses Ruggiero's mistaken belief in Alcina's love.

Melissa next rebukes Ruggiero for the effeminacy to which sensual excesses have led him (mm. 25–40). Demanding that Ruggiero gaze on his former weapons, now reduced to baubles, just as his warrior's temperament has been softened by his illicit love for Alcina, she accuses Ruggiero of the typically female vice of immodesty [*impudico*]. In her cadence to A at measures 30–31, Melissa mirrors her earlier cadential motion to G, reminding Ruggiero by association that his victories are destined to be military, not sensual ones.

The speech closes with a call to action: Melissa has made Ruggiero aware of his failings, now she will show him what he must do to redress them. Her remedy necessitates that Ruggiero move from the realm of the feminine to the masculine. She orders him to disassociate his warrior's arm from its mincing ways and to remove the necklaces from his virile neck (mm. 41–46), recalling not only Ruggiero's situation but also Rinaldo's embarrassment at his effeminate ornaments, the divestiture of which signals his desire to return to battle (*Gerusalemme liberata*, 16.30, 34). In accordance with the great value that Melissa places on Ruggiero's regained masculinity, she stresses her declamation of "viril" through rhythmic elongation, contemptuously assigning "monili e vezzi" to a lower, subordinate pitch level (mm. 45–46). Melissa makes her call to action a harmonic shift, as well. She replaces her earlier sharp harmonies with a solid B♭ chord (m. 41), and the chromatic alterations of the previous measures abruptly cease. The harmonic rhythm slows markedly, with chords proceeding by deliberate fifth motion. Melissa also restricts even further her melodic movement, much of which consists of a descending pat-

tern of monotone recitation on the pitches f', e', and d'. In her final challenge to Ruggiero, Melissa verbalizes her doubts in a brief hesitation before the final "è vaga" (mm. 53–54), and she plants the seeds that she hopes will spur him to action. Her speech ends with a decisive cadence to D.

This emphasis on the glorious military career promised to Ruggiero recalls the prologue to *La liberazione*, in which Neptune informs the audience that he has left his realm solely to see the warrior who had defeated Muscovites, Turks, and Tartars. His vassal and tributary, the Vistula, hails Władysław as "this unconquered Mars" [*questo invitto Marte* (6)]. These praises echo those offered to Władysław at the 28 January performance of Salvadori's *La regina Sant'Orsola*, in whose prologue the personage of Arno enumerates the prince's military victories against the same three enemies. Salvadori's dedication to Władysław presents these accomplishments in a light probably not intended by the prince, however; whereas his involvement in the war with Muscovy and the successful battle against the Turks in 1621 stemmed from the dynastic and territorial ambitions of the Wasa family, Salvadori converts them into religious crusades, casting Władysław into the role of a defender of religion.[44]

The similarity of these two works allows us to place in a clearer context Saracinelli's reliance on Tasso and the effect of that borrowing on one allegorical implication of *La liberazione*. Both *Sant'Orsola* and *La liberazione* seem determined to cast Władysław in the role of contemporary Catholic hero, even though he was nothing of the sort. Melissa's first speech to Ruggiero hints at the reasons behind such a depiction. She warns the young knight that in choosing to be a lover, rather than one of the warriors risking death in battle,

44. Salvadori appears to have overstated the prince's victories: Władysław marched his troops toward Moscow in 1617, claiming the title of tsar that Russian boyars had promised Poland in an agreement of 1610. Although he gained some territory, his siege of Moscow was unsuccessful, and he negotiated a treaty on 11 December 1618 by which Poland retained only Smolensk and Seversk; see F. Nowak, "Sigismund III, 1587–1632," in *The Cambridge History of Poland*, vol. 1, *From the Origins to Sobieski (to 1696)*, ed. W. F. Reddaway et al. (Cambridge, 1950), 469. The 1620–21 war with Turkey ended more favorably, due to the battle at Khotyn (Chocim), in which an outnumbered Polish force withstood assaults by combined Turkish and Tartar forces, commanded by Sultan Osman II himself. The battle concluded with an honorable peace agreement signed 9 October 1621, which reiterated the terms of an earlier treaty of 1617, namely, that Poland would attempt to control the Cossacks and maintain a policy of nonintervention in Moldavia, Walachia, and Transylvania, while the Turks would agreed to rein in the Tartars. See Nowak, "Sigismund III," 469–72; Norman Davies, *God's Playground: A History of Poland*, 2 vols. (New York, 1982), 1:458–61; and E. Schütz, *An Armeno-Kipchak Chronicle on the Polish-Turkish Wars in 1620–1621* (Budapest, 1968), 17.

Ruggiero has been "mal consigliato," a phrase given rhythmic emphasis by Caccini (ex. 5.5, mm. 20–21). Badly counseled by whom? In *Orlando furioso* the only counsel Ruggiero receives is Astolfo's warning to avoid Alcina—good advice that he promptly ignores. But the Habsburg family was disappointed that the Polish Sejm had refused to finance any further military action against the Ottoman Empire or Sweden, with whom Poland had signed truces in 1621 and 1622. For the Sejm these proposed incursions were motivated solely by the dynastic ambitions of King Zygmunt and his son.[45] But her own sympathies suggest that Archduchess Maria Magdalena would instead have seen these as religious wars against Muslims and Lutherans. And while King Zygmunt supported the Habsburg fight on behalf of Catholicism, Władysław was known to be much more moderate—he had Protestants as friends and had even contemplated marriage with a Protestant princess.[46] The Confederation of Warsaw (1573) guaranteed freedom of confession, a pledge upheld even by the fervently Catholic Zygmunt.[47] Within this historical and political context, *La liberazione* appears to reiterate the archduchess's characteristic dynastic agenda but with particular respect to Poland: the Church militant, represented by the Habsburgs and more specifically Maria Magdalena herself, calls Władysław to forgo his complacent tolerance and instead battle as part of a Catholic league against the Ottoman Empire and Protestantism. Through a marriage with Princess Margherita (the Medici equivalent of Bradamante), Władysław will ensure the continuation of his legacy through a new fruitful union with Florence.

La disfida d'Ismeno (1628)

Maria Magdalena's plans were unsuccessful, but her message remained consistent, reappearing three years later in 1628, during the festivities that celebrated the marriage of Princess Margherita de' Medici and Duke Odoardo Farnese of Parma.[48] On 17 October the court presented Andrea Salvadori's

45. Nowak, "Sigismund III," 473; and Davies, *God's Playground*, 1:461.

46. Marriage discussions between Władysław and Elizabeth, the daughter of King James I, took place between 1608 and 1611, according to J. Fedorowicz, *England's Baltic Trade in the Early Seventeenth Century: A Study in Anglo-Polish Commercial Diplomacy* (Cambridge, 1980), 140. On the character of Władysław, including his religious tolerance, see W. Czaplinski, "The Reign of Władysław IV, 1632–48," in *The Cambridge History of Poland*, ed. Reddaway et al., 1:488–89. Protestant support was critical to Władysław's eventual election as King of Poland in 1632.

47. J. Umiński, "The Counter-Reformation in Poland," in *The Cambridge History of Poland*, ed. Reddaway et al., 1:409.

48. Salvadori, *La disfida*, 411–12.

La disfida d'Ismeno [Ismen's challenge], a battle on horseback with pistols and rapiers based on *Gerusalemme liberata*. The coincidence of the groom's Christian name with the male member of Tasso's most prominent married couple, Edward (Odoardo) and Gildippe, undoubtedly inspired the choice of subject matter, but the spectacle also acknowledged the young duke's passion for arms and chivalry. This predilection was known in Florence: in January 1627 an emissary from Parma had assured the archduchess of Odoardo's fondness for games of arms, hunting, riding, and jousting.[49] The court diarist singled out *La disfida* as the highlight of the wedding festivities, and even before the event the Florentine secretary of state Andrea Cioli promised Parma an extraordinary joust unlike anything previously attempted in Florence.[50]

As he had done in *Le fonti d'Ardenna*, Salvadori revisited personages after the conclusion of the epic's events. He chose eight figures from *Gerusalemme liberata*, then inserted them into a narrative linked both to the current celebrations in Florence as well as to the contemporary political situation in Europe, as summarized in the work's *argomento:*

> The sorcerer Ismen, eternal enemy of the Latin name, makes Solyman and Argante, called from the Underworld, the leaders of two valorous squadrons of Asian knights, then in the Sala Regia of Tuscany he challenges to battle the flower of Western knights, gathered there to honor the marriage of the Most Serene [Duke] of Parma. The European knights accept the challenge, and under the es-

49. Letter of 23 January 1627, transcribed in Umberto Benassi, "I natali e l'educazione del Duca Odoardo Farnese," *Archivio storico per le province Parmensi*, n.s. 9 (1909): 203. Throughout the article (99–227) Benassi stresses Odoardo's bellicose tendencies, which he exhibited even as a child, according to contemporary biographer Ippolito Calandrini, "L'heroe d'Italia overo Vita del Serenissimo Odoardo Farnese," an unfinished manuscript dated ca. 1644 and cited frequently by Benassi. At the time of the wedding, Odoardo had not yet acceded to his own personal rule: since his father's death in 1622, the duchy had been governed by a regency, first of Odoardo's uncle, Cardinal Odoardo (d. 21 February 1626), then of his mother, Duchess Margherita Aldobrandini Farnese. Odoardo assumed full control of his inheritance on 24 August 1629. See Benassi, "I natali," 173, 197, 225.

50. I-Fas, Misc. Med., 11, fol. 229r. An abbreviated transcription can be found in Solerti, *Musica*, 189–93. Cioli's letter of 5 September 1628 (I-Fas, MDP 179, fol. 79r) claims the joust will be "estraordinaria, perché in questo paese almeno à mio tempo non se ne sono più fatte à questa usanza." But ten days later he confessed (I-Fas, MDP 179, fol. 94v) that the preparation time had proven too short to achieve the desired effects of gravity and seriousness, so that the joust would appear "pleasant and ridiculous" ("Vedrà poi V.S. Ill.ma quando sarà qua, che nel figurarsi la giostra, che io le accennai doversi fare in questa città, non l'ha punto indovinata; perché in cambio di cosa grave, e seria le riuscirà piacevole, e ridicolosa; non si potendo veramente in tanta brevità di tempo fare quel che si sarebbe desiderato per gusto del Ser.mo Sig. Duca").

cort of Rinaldo and Tancred they go to battle. The Sage of Armenia, the same one who sent Charles and Ubaldo to free Rinaldo from Armida, stops this fight and makes it understood that the days destined for the joys of love must not be outraged by the furies of war. Then comes, on a triumphal float, the valorous couple of Gildippe and Edward, lovers and spouses so celebrated by Tasso for their fidelity and valor. Gildippe gives her own garland, obtained from Immortality, to the Most Serene Bride, and Edward gives the Most Serene Groom, heir to his name, his shield and sword, and, wishing him better fortune against the common enemy, rejoices that a new Edward is united with a new Gildippe.[51]

Salvadori's dramatic choices mirror Tasso's own organizational technique of balancing characters who are formally parallel but morally opposite.[52] He offsets two Asian generals, Solyman and Argantes, with the Europeans Rinaldo and Tancred. The apostate sorcerer, Ismen, has a counterpart in the Wiseman from Armenia, a misreading or deliberate alteration of Tasso's Wiseman of Ascalon. And, although not moral opposites, Tasso's married warriors, Gildippe and Edward, mirror the newly married Margherita and Odoardo, who are drawn into the drama from the moment the action begins, when Ismen bursts into the celebrations in progress inside the Pitti Palace.

In several important respects, however, Salvadori departs from his sixteenth-century source. In order to make the plot appropriate to a marriage celebration, he reverses the approaches toward warfare taken by Ismen and the Sage of Ascalon in Tasso's epic. *La disfida* begins with Ismen's challenge to the knights in attendance to leave their dancing to take up arms and horses against his warriors ("Udite or dunque voi / l'altissima Disfida / de'

51. From Salvadori, *Poesie*, 1:410:

Il Mago Ismeno, eterno nemico del nome Latino, chiamati da l'Inferno Solimano, ed Argante, fagli guide di due valorose squadre de' Cavalieri d'Asia: quindi nella Regia Sala di Toscana sfida a battaglia il fiore de' Cavalieri d'Occidente, quivi adunati per onorar le Nozze del Serenissimo di Parma: Accettano i Cavalieri d'Europa la disfida, e sotto la scorta di Rinaldo, e di Tancredi vengono a battaglia. Termina questa pugna il Saggio d'Armenia, quegli, che mandò Carlo, ed Ubaldo à liberar Rinaldo da Armida, e fa vedere, che i giorni destinati alle gioie d'Amore, non devono esser oltraggiati dalle furie della guerra. Viene dipoi sopra un Carro trionfale la valorosa coppia di Gildippe, ed Odoardo, Amanti, e Sposi tanto celebrati dal Tasso per fedeltà, e per valore: Gildippe dà alla Serenissima Sposa la sua propria Ghirlanda ottenuta dall'Immortalità, ed Odoardo dà al Serenissimo Sposo, erede del suo nome, il suo Scudo, e la Spada, ed augurandogli miglior fortuna della sua contro il commun nemico, gioisce, ch'un nuovo Odoardo sia unito ad una nuova Gildippe.

52. Ralph Nash, introduction to Torquato Tasso, *Jerusalem Delivered: An English Prose Version*, trans. Ralph Nash (Detroit, 1987), xxii.

miei difesi Eroi; / e quì lasciando i balli / feroci omai trattate armi, e cavalli"
[412]). In *Gerusalemme liberata* Ismen creates mischief in order to divert the
Christian warriors from their purpose, while it is the Sage of Ascalon who
induces Rinaldo to return to battle. The sage reminds the young knight that
good lies in the difficulties of battle (17.61), "not under the shade on a soft
beach among fountains and flowers, nymphs and sirens" [*non sotto l'ombra in
piaggia molle / tra fonti e fior, tra ninfe e tra sirene*]. By contrast the Sage of *La dis-
fida*—who enters the arena on a white unicorn, recalling the Farnese crest—
cautions the warriors to save their energies for a more important battle, one
away from Italy (418): "And here war and furor have no further place. An-
other theater awaits the challenge of Asia and Europe; here let there be re-
joicing, and may only the fire of love inflame royal souls" [*E quì guerra, e furor
non han più loco. / Altro teatro attenda / la disfida de l'Asia, e de l'Europa; / quì si gioisca,
e solo / foco d'amore alme reali accenda*].[53]

Salvadori also alters Tasso's depiction of Gildippe, one of several heroic
women warriors in *Gerusalemme liberata*. Tasso describes her prowess in battle
in more detail than that of her husband, referring to her as the Christian
counterpart to Clorinda (9.71). "With virile right hand the lady grasps her
good sword" [*Con la destra viril la donna stringe, . . . la buona spada* (20.33)] and wins
first honors in the final battle. But in his plot for *La disfida*, Salvadori makes
the two attributes shared by Tasso's couple—valor and faithfulness—gen-
der specific: Gildippe gives Margherita a garland as a symbol of fidelity, while
Edward alone claims valor. He exhorts his namesake to resume his fight
against the infidels, and he presents the younger Odoardo with his shield and
sword for that purpose, predicting his namesake's greater fortune in the Chris-
tian cause. In a speech that recalls both the tone and actual language of the
Wise Man's narration of the ancestors and progeny of Rinaldo (17.93—94),
Edward augurs even greater victories by the offspring of the new couple.[54]

This downplaying of Gildippe's role as a warrior in favor of an emphasis
on Odoardo as the hope for Christianity departs significantly from the fe-
male warriors who had dominated the decade. A similar change characterizes
the battlefield challenges delivered by the Asians and Europeans. The taunts

53. On the appearance of the Farnese unicorn as part of the funeral apparatus of Odoardo's
immediate namesake, his uncle, Cardinal Odoardo, see Albano Biondi, "L'immagine dei primi
Farnese (1545–1622) nella storiografia e nella pubblicistica coeva," in *Le corti Farnesiane di Parma
e Piacenza, 1545–1622*, vol. 1, *Potere e società nello stato Farnesiano*, ed. Marzio A. Romani (Rome,
1978), 227.

54. In Edward's prophesy, Salvadori retains the geographical landmarks present in Tasso,
notably the Taurus mountains and the Euphrates, while converting the French fleurs-de-lis
to blue Farnese lilies.

recall the parallel scene in *Sant'Orsola:* the Asian herald mocks the European tournaments held for the delight of the ladies, while the European herald contrasts the effeminate inhabitants of Asia to the virile people of Europe, noting that even though they may wield weapons, women are, after all, just women.[55] But unlike the earlier opera, the disparagement of the female sex goes unanswered; the gender remains unredeemed by the courageous deeds of a female protagonist. The regency had ended with the eighteenth birthday of Ferdinando II, and its passing obviated the need for symbolic displays of powerful female leaders. From this point onward, Maria Magdalena devoted her energies to the interests of her son and his rule, a point made even more explicit in the other major spectacle performed during the wedding festivities, Andrea Salvadori's *La Flora.*

55. The Asian herald's words are (413): "Io non so, Cavalieri d'Europa, come voi avvezzi per diletto di Dama, e con gioco veramente puerile à rompere in un finto Affricano di legno, una debil lancia; non so, dico, come abbiate à sostener l'impeto de' veri, e vivi Cavalieri dell'Asia." The European herald responds (415): "Ogn'altra cosa poteva esser da noi più facilmente creduta, fuori che gl'effemminati abitatori dell'Asia con armi cosi terribili, avessero già mai à sfidare à battaglia i virili popoli dell'Europa. Ma che? ancora Iole portò una volta la Clava d'Ercole, e Venere pigliò talora l'asta di Marte, ma nel volerle adoprare, l'un'e l'altra s'accorge d'esser femmina."

EXAMPLE 5.1. Francesca Caccini, *La liberazione di Ruggiero* (Florence, 1625), 19–20: "I adore you, my soul, for my sweet and happy fortune, as much as I owe it to you that, even though I live, because of you [I am] wounded to death. But you, my love, do not feel what pains and what torments the pretty archer shoots from your eyes. Every glance is a wound: how miserable my life [would be] if the delightful and beautiful, clearest stars [i.e., eyes], reason for my languishing, should not know how to heal as well as how to wound."

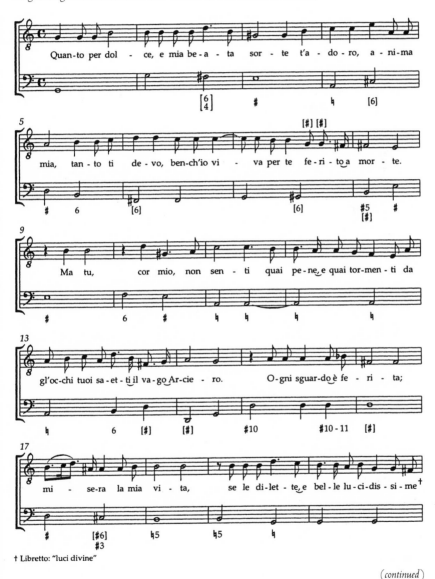

Quan-to per dol - ce, e mia be-a - ta sor - te t'a - do - ro, a - ni-ma

mia, tan-to ti de-vo, ben-ch'io vi - va per te fe-ri-to a mor - te.

Ma tu, cor mio, non sen - ti quai pe-ne e quai tor-men-ti da

gl'oc-chi tuoi sa-et-ti il va-go Ar-cie - ro. O-gni sguar-do è fe - ri - ta;

mi - se-ra la mia vi - ta, se le di-let - te, e bel-le lu-ci-dis-si-me†

† Libretto: "luci divine"

(*continued*)

EXAMPLE 5.1. (*continued*)

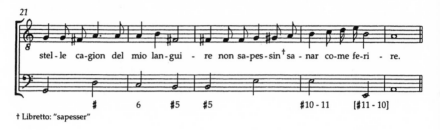

21

stel - le ca-gion del mio lan-gui - re non sa-pes-sin†sa - nar co-me fe-ri - re.

6 #5 #5 #10 - 11 [#11 - 10]

† Libretto: "sapesser"

EXAMPLE 5.2. Francesca Caccini, *La liberazione di Ruggiero* (Florence, 1625), 24: "and from the swans and sirens [are heard] the sweet songs that put Argus to sleep."

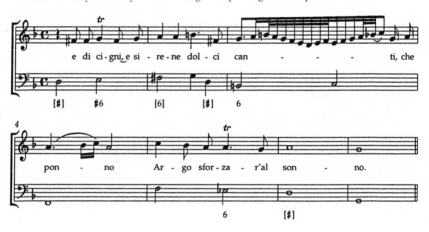

tr

e di ci-gni̯e si - re-ne dol - ci can - - - ti, che

[#] #6 [6] [#] 6

4

tr

pon - no Ar - go sfor-za - r'al son - no.

6 [#]

EXAMPLE 5.3. Francesca Caccini, *La liberazione di Ruggiero* (Florence, 1625), 53–54: "Stop, stop, cruel one; where are you going, pitiless one? Where, ingrate, are you leaving me in a fit of tears? At least slow the haste of your departure; let the immense pain murder my soul. Look at my tears, hear my wail, listen to my just quarrel. Stop, stop, cruel one, and these lights [i.e., eyes], which just awhile ago you used to call stars and suns, see how they are now turned into rivers because of you. See yourself reflected in this face, where joy and laughter used to have their place; you will see your lack [of faith] and my faith, and that, amid pain and sorrow, how much of the world's sadness is gathered there."

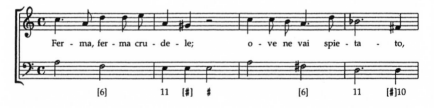

Fer - ma, fer - ma cru - de - le; o - ve ne vai spie - ta - to,

[6] 11 [#] # [6] 11 [#]10

EXAMPLE 5.3. (*continued*)

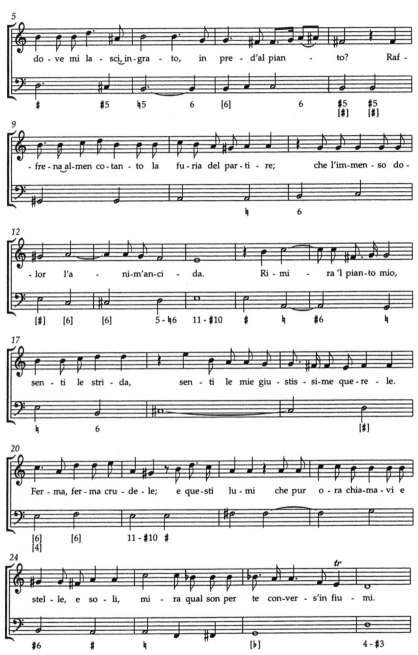

(*continued*)

EXAMPLE 5.3. (*continued*)

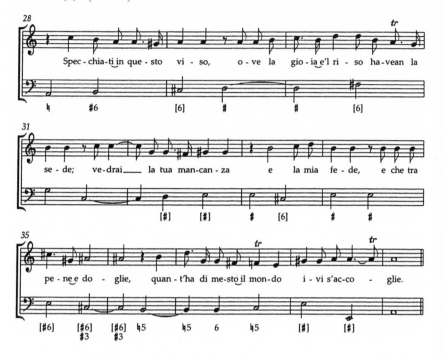

EXAMPLE 5.4. Francesca Caccini, *La liberazione di Ruggiero* (Florence, 1625), 57: "Oh savageness of a tiger, oh heart of stone."

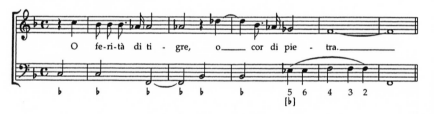

EXAMPLE 5.5. Francesca Caccini, *La liberazione di Ruggiero* (Florence, 1625), 35–36: "Atlante comes to you to know what foolishness causes you to disgrace yourself on these shores. Are these the fruits I reap from my long labors? The entire world flares up in military passions, all of Libya and Europe go to war. Every stronger soul scorns the risks of death, and you, badly counseled, love being beloved by a filthy witch? Immodest Ruggiero, where is your invincible sword, where [is] the shiny steel that rendered you so renowned? Look: with what baubles, with what profane verses did you blemish those arms? 'Ruggiero the conqueror dedicated his heart to Alcina, his arms to love.' Remove, fool that you are, jewelry and necklaces from the warrior's arm and virile neck. Leave the iniquitous witch and move to confront enemy armies, if your good soul is still desirous of glory."

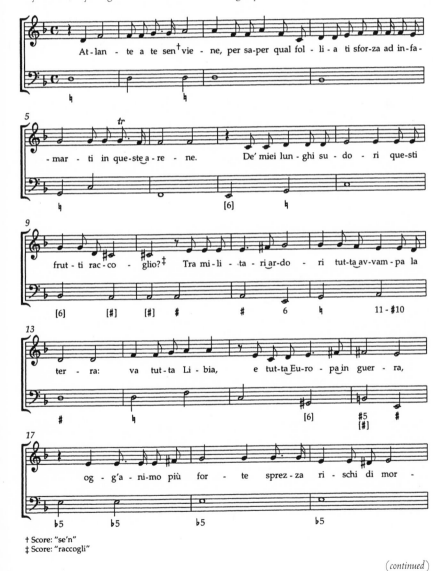

† Score: "se'n"
‡ Score: "raccogli"

(*continued*)

EXAMPLE 5.5. (*continued*)

† Score incorrectly reads ⌐
‡ Score: ♯

EXAMPLE 5.5. (*continued*)

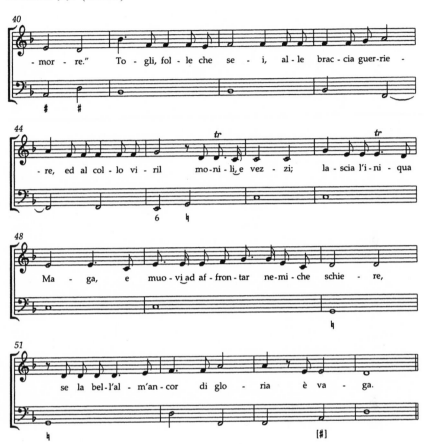

"Now it suits me to beseech"

End of the Regency, End of a Decade (1628–30)

Ferdinando had officially assumed full responsibility for governing Tuscany on 14 July 1628, an event unmarked by any large-scale musical spectacles. An ambassadorial dispatch of 22 October 1628 suggests that the young grand duke began to exercise actual authority only gradually: the resident ambassador from Modena during this period, Tiburtio Masdoni, remarked specifically on Ferdinando's increased control beginning in October, adding that one of his first decisions concerned the formation of a sacred musical establishment, separate from that of the cathedral, beginning with the hiring of Girolamo Frescobaldi (doc. 6.1).[1] And it was during the October wedding festivities of Princess Margherita de' Medici and Duke Odoardo Farnese that Florentine court spectacles returned to the symbols of male rule. Nowhere was this more apparent than in Andrea Salvadori's five-act opera *La Flora*, set to music by Marco da Gagliano and Jacopo Peri.[2] While ostensibly the re-enactment of the advent of spring and earth's subsequent renewal, the opera's

Sections of this chapter first appeared in my article *"La Flora* and the End of Female Rule in Tuscany," *Journal of the American Musicological Society* 51 (1998): 437–76.

1. This document is the earliest reference to Frescobaldi's tenure in Florence. The proposed musical chapel never materialized.

2. Peri composed only the music for the personage of Chloris, who is transformed into Flora at the opera's conclusion. Gagliano published the musical score in the year of the opera's performance (Florence, 1628; reprint, Bologna, 1969). The libretto appeared in three different editions in 1628, one by Cecconcelli, which included Alfonso Parigi's engravings of the stage scenery, and two by Zanobi Pignoni, one of which also included *La disfida d'Ismeno*. The opera was reprinted in Salvadori's *Poesie*, 2 vols. (Rome, 1668), 1:167–249. Subsequent references to the libretto are to the Cecconcelli edition of 1628.

symbols were apt descriptions of both a marriage and a change in political regime.[3]

Delays and Deception: Preparations for a Wedding

Archival documents establish that the archduchess continued her active role in planning the court's theatrical events by arranging the 1628 spectacles. Except for the treasury records, the handful of surviving documents to describe the preparations recognize Maria Magdalena as the driving force behind the entertainments. As she had done throughout the decade, she oversaw the details of the opera's rehearsals. She asked Salvadori to attend a rehearsal and report back to her on its progress, which he did on 18 January 1628 (doc. 6.2). Deeming her presence at rehearsals crucial, even when hosting visiting dignitaries, she simply invited them along, as was the case with English ambassador Thomas Roe (doc. 6.3).[4] Maria Magdalena may have even suggested the plot of *La Flora*, as we shall see.

But the archduchess also bears responsibility for much of the political maneuvering that delayed the wedding for whose festivities the opera was intended. The union fulfilled a marriage contract that the Medici and Farnese families had negotiated in 1620. According to the contract's terms, Maria Magdalena's oldest daughter, Princess Maria Cristina de' Medici (b. 1609) would marry Odoardo Farnese unless prevented by a physical debility, in which case the Medici family would satisfy the contract by substituting another prin-

3. Tim Carter (*Jacopo Peri [1561-1633]: His Life and Works*, 2 vols. [New York and London, 1989], 1:99) notes the plot's pun on the name Margherita, which means "daisy." The personage of Flora appeared frequently in works celebrating Medici weddings and births: a personification of the goddess honored Duke Cosimo I and Eleanora of Toledo at their wedding banquet of 1539 (Andrew C. Minor and Bonner Mitchell, *A Renaissance Entertainment: Festivities for the Marriage of Cosimo I, Duke of Florence, in 1539* [Columbia, MO, 1968], 166–76). Images of Flora as harbinger of spring remained important to Medici iconography beyond Cosimo's rule, appearing frequently in artistic works associated with his son, Francesco (Janet Cox-Rearick, *Dynasty and Destiny in Medici Art: Pontormo, Leo X, and the Two Cosimos* [Princeton, NJ, 1984], 285–86). The goddess also appeared as the subject of octaves published to celebrate the birth of Ferdinando II, Francesco Campani's *La celeste Flora* (Florence, 1610).

4. The attendance of Ambassador Roe and his wife at this dress rehearsal is confirmed by a diplomatic dispatch dated 30 September 1628 from Agostino Vianuol, Venetian secretary at Florence, to the doge and senate: see the *Calendar of State Papers and Manuscripts relating to English Affairs Existing in the Archives and Collections of Venice and in Other Libraries of Northern Italy*, ed. Rawdon Brown et al., 38 vols. (London, 1864–1947), 21:324.

cess. Since Maria Cristina had entered the Monastero della SS. Concezione, known as the Monastero Nuovo, by 1621, the Farnese family expected the next oldest daughter, Margherita (b. 1612), to take her place as Prince Odoardo's bride.[5] But as shown in chapter 3, beginning in at least July 1624, hoping to forge even stronger links between the Medici and the Habsburg dynasties, Archduchess Maria Magdalena attempted to arrange a more prestigious marriage between Margherita and her nephew, Prince Władysław of Poland. Nearly two years later, the resident ambassador from Modena reported that the regents, using the pretext of ill health, were still stalling plans for a union with the Farnese.[6]

Maria Magdalena ultimately failed in her attempts to alter the agreement with Parma, and on 14 February 1627 the court announced the official engagement of Odoardo and Margherita, with a wedding planned for the fall.[7] Arrangements for the festivities in Florence were underway in the spring of 1627: on 2 May Maria Magdalena requested the services of Loreto Vittori from his current patron, Cardinal Ludovico Ludovisi (doc. 6.4), and the following week (10 May) a contralto from Castiglione Fiorentino named Marco Ghirlandi wrote to offer his services.[8] Secretary Dimurgo Lambardi accompanied Maria Magdalena's request for Vittori with his own letter addressed

5. I-Fas, MDP 6086, fol. 59r. See Gaetano Pieraccini, *La stirpe de' Medici di Cafaggiolo: Saggio di ricerche sulla trasmissione ereditaria dei caratteri biologici,* 3 vols. (Florence, 1924–25), 2:525; Carter, *Jacopo Peri,* 1:96n7.

6. I-MOas, AF 55, fasc. 25, fol. 48r.

7. Members of the Farnese court expected the Parma festivities to take place in mid-October (Umberto Benassi, "I natali e l'educazione del Duca Odoardo Farnese," *Archivio storico per le province Parmensi,* n.s. 9 [1909]: 99–227, esp. 208). On these entertainments (delayed until 1628), see Tim Carter, "Intriguing Laments: Sigismondo d'India, Claudio Monteverdi, and Dido *alla parmigiana* (1628)," *Journal of the American Musicological Society* 49 (1996): 32–69; also Lina Balestrieri, *Feste e spettacoli alla corte dei Farnese* (Parma, 1981), 25–29; Carter, *Jacopo Peri,* 1:95–101; Irving Lavin, "Lettres de Parmes (1618, 1627–28) et débuts du théâtre Baroque," in *Le Lieu théâtral à la Renaissance,* ed. Jean Jacquot (Paris, 1964), 105–58; Irene Mamczarz, *Le Théâtre Farnese de Parme et le drame musical italien (1618–1732)* (Florence, 1988), 465–74; and Stuart Reiner, "Preparations in Parma—1618, 1627–28," *Music Review* 25 (1964): 273–301. For additional information concerning the wedding itself, see Paolo Minucci del Rosso, "Le nozze di Margherita de' Medici con Odoardo Farnese duca di Parma e Piacenza," *La rassegna nazionale,* ser. 1, 21 (1885): 551–71, vol. 22, 550–70, and vol. 23, 19–45.

8. I-Fas, MDP 1438, fols. 129r–v. This period also coincides with Claudio Monteverdi's letter (5 June 1627) stating that the Medici family had at one time considered asking him to compose music for the Florentine entertainments. See Claudio Monteverdi, *Lettere, dediche e prefazioni,* ed. Domenico de' Paoli (Rome, 1973), 254.

to Andrea Cioli, the Florentine secretary of state, confiding to his superior that the archduchess was determined to head off the possibility of competing demands from Parma for the castrato.[9] As a result, Maria Magdalena succeeded in her attempts to secure Vittori for the Florentine festivities, and he arrived in Florence by late September 1627, having left Rome on the thirteenth of that month.[10] Ferdinando signed the initial disbursement of treasury funds for the opera on 28 June 1627.[11]

The regents postponed the union once again, however, after Queen Maria de' Medici of France made an eleventh-hour bid for a marriage between Margherita and her own son, Duke Gaston d'Orléans.[12] By late November 1627, the future grand duke Ferdinando II entered the dispute, favoring the alliance with France despite the lobbying efforts of Cardinals Aldobrandini and Ludovisi on Parma's behalf.[13] The situation remained unresolved by February of 1628, when Maria Magdalena was forced to allow Vittori to return to the papal chapel.[14] The Medici still had not agreed to an actual wedding date by 29 July 1628, when the lutanist Andrea Falconieri wrote to the court asking

9. I-Fas, MDP 1409 (n.p.).

10. Bianca Maria Antolini, "La carriera di cantante e compositore di Loreto Vittori," *Studi musicali* 7 (1978): 169.

11. The relevant treasury documents (I-Fas, DG 1016, no. 152, and I-Fas, DG 1017, nos. 214 and 330) record that the court spent a total of 3,360 scudi on the festivities, 2,708½ for the comedy (*La Flora*) and 651½ for the *festa a cavallo* (*La disfida*). This amount seems quite reasonable when compared to the 30,255½ scudi spent for the comedy and *intermedi* performed in 1589 to celebrate the wedding of Christine of Lorraine and Grand Duke Ferdinando I (James Saslow, *The Medici Wedding of 1589: Florentine Festival as Theatrum Mundi* [New Haven, CT, and London, 1996], 177).

12. [Jacopo] Riguccio Galluzzi, *Istoria del Granducato di Toscana sotto il governo della Casa Medici*, 5 vols. (Florence, 1781), 3:435–36. See also Minucci del Rosso, "Le nozze," 21 (1885): 553; Reiner, "Preparations in Parma," 291–92; Pieraccini, *La stirpe*, 2:533; and Benassi, "I natali e l'educazione del Duca Odoardo Farnese," 210–21.

13. Fulvio Testi reports the cardinals' intervention in letters dated 16 October and 20 November 1627 (*Lettere*, 3 vols., ed. Maria Luisa Doglio [Bari, 1967], 1:117, 132). Not coincidentally, these very cardinals were on hand to witness the fruits of their diplomatic efforts.

14. Maria Magdalena supplied the singer with a letter addressed to Cardinal Ludovisi in which she expressed her hope that Vittori could return to Florence as soon as the preparations resumed (I-Fas, MDP 6102, n.p.). Bianca Maria Antolini ("La carriera di cantante e compositore di Loreto Vittori," *Studi musicali* 7 [1978]: 149) also reports that Vittori reappeared in the Sistine chapel registers by 10 March 1628. The Farnese court appears to have been more optimistic concerning the eventual outcome: three papal singers were still in Parma in May of 1628 (Lavin "Lettres de Parmes," 126).

for employment in the Parma festivities.[15] On 15 August, Ambassador Masdori reported to the prince and duke of Modena that, although he had no official news concerning the wedding, he knew that the youths chosen to recite the comedy had once again begun to rehearse.[16] One week later, the same ambassador related that the court now blamed all delays on the volatile political situation at La Rochelle.[17] Only the impatient Odoardo Farnese, who finally wrote to the Medici court sometime before 25 August, with the news that he would leave for Florence on 20 September, appears to have convinced them that the wedding would take place, whether they liked it or not.[18] Vittori returned to Florence by 19 September, presumably accompanied by Falconieri.[19] Four other singers, two of them female, also arrived in Florence during this time.[20] The court diarist noted the resumption of rehearsals on

15. I-Fas, MDP 1414, fols. 393r–v. For subsequent letters in the Falconieri/Cioli correspondence of 1628, see Frederick Hammond, "Musicians at the Medici Court in the Mid-Seventeenth Century," *Analecta Musicologica* 14 (1974): 168; Dinko Fabris, *Andrea Falconieri Napoletano: Un liutista-compositore del Seicento* (Rome, 1987), 40–42; and Harness, "*Amazzoni di Dio:* Florentine Musical Spectacle under Maria Maddalena d'Austria and Cristina di Lorena (1620–30)" (Ph.D. diss., University of Illinois at Urbana-Champaign, 1996), 405–10.

16. I-MOas, AF 59, unnumbered fascicle, n.p.

17. I-MOas, AF 59. The wealthy seaport of La Rochelle had become a center of French Protestantism in the mid-sixteenth century, and this, coupled with its tradition of strong independent self-government, led it into a series of political and military skirmishes with Louis XIII and his principal adviser, Cardinal Richelieu, beginning in 1616. The last and most devastating of these battles began in July 1627, when French troops under Richelieu's direction effectively blockaded the city in order to starve its citizens into submission. This siege intensified after the defeat of La Rochelle's English allies on 11 May 1628, and it lasted until 28 October 1628. Maria Magdalena and other Italian rulers had a compelling interest in these developments, for they momentarily diverted France from interfering in the dispute over the Mantuan succession. Her concern was warranted: freed from an internal religious war, Louis XIII and his army entered Italy in March 1629. For a richly documented history of La Rochelle and the attitudes and events that led to the 1627–28 siege, see Kevin C. Robbins, *City on the Ocean Sea, La Rochelle, 1530–1650: Urban Society, Religion, and Politics on the French Atlantic Frontier* (Leiden, 1997), esp. 1–8, 335–53. See also R. Mousnier, "French Institutions and Society, 1610–61," in *The New Cambridge Modern History*, vol. 4, *The Decline of Spain and the Thirty Years War 1609–48/49*, ed. J. P. Cooper (Cambridge, 1970), 474–502.

18. Dispatch to Modena dated 25 August 1628 (I-MOas, AF 59).

19. Dispatch of 19 September 1628 (I-MOas, AF 59).

20. I-Fas, Misc. Med., 264, ins. 50. The four unnamed singers left Florence on 22 October, each having been paid 1½ lire per day for the forty-two days spent in Florence. One of the female singers may have been the same young woman who spent five months in Florence between September 1627 and February 1628, also mentioned in the above expenditure list.

27 September.[21] On 30 September 1628, the gossipy ambassador to Modena reported that the endless and troubled negotiations were the source of some humor for the adolescent grand duke, who attempted (unsuccessfully) to convince his younger sister that her wedding had been delayed yet again, due to Cardinal Aldobrandini's gout.[22] Duke Odoardo arrived in Florence on 6 October, and the ring ceremony took place in the duomo five days later.[23] On 14 October the court presented *La Flora*.

Intrigues similar to those that plagued the actual wedding beset the festivities intended to celebrate it. Not only did rehearsals suffer from the interruptions created by the continual postponements, but the work itself was apparently changed midstream. Andrea Cavalcanti (1610–73) claimed that the archduchess ordered *La Flora* to replace the spectacle originally intended for the celebrations—Salvadori's *Iole ed Ercole*—when Francesca Caccini pointed out that some audience members might interpret *Iole*'s plot as an allegorical representation of Margherita's wish to control her future husband.[24] In brief, his story is this: (1) Francesca Caccini, angered by Salvadori's partiality in favor of whichever female singer he desires at the moment, begins to insult him publicly, making him a laughing stock at court; (2) for his revenge, Salvadori writes several octaves disparaging women singers; (3) Caccini's resulting anger is so great that the archduchess is forced to intercede; (4) Salvadori has meanwhile written *Iole ed Ercole* in preparation for the upcoming wedding with the duke of Parma, and both the music and the stage machinery are finished; (5) for her revenge, Caccini convinces Princess Margherita that the opera might be interpreted by some as an attempt to teach her bridegroom to toe the line [*insegnar filare*], and the princess convinces her mother to have the opera changed, giving Salvadori only eight days to write a new work; and (6) in return, Salvadori casts Caccini as the personage of Discord in another entertainment.

The survival of the misogynistic octaves described by Cavalcanti verifies this part of his report. Poems entitled "Donne musiche parlano dall'Inferno,"

21. I-Fas, Misc. Med., 11, fol. 221v.

22. I-MOas, AF 59, unnumbered fascicle.

23. I-Fas, Misc. Med., 436, fol. 24r; Misc. Med., 439, fol. 87v.

24. I-Fr, Ricc. 2270, fols. 288r–289v, transcribed in Carter, *Jacopo Peri*, 1:344–46; Warren Kirkendale, *The Court Musicians in Florence during the Principate of the Medici with a Reconstruction of the Artistic Establishment* (Florence, 1993), 325–26. The only surviving music from the opera is Peri's lament, *Uccidimi dolore*, discussed previously here in chap. 3, although a manuscript collection of plays and poetry from the sixteenth and seventeenth centuries does include a poem with the first line "Volgi Iole i tuoi bei lumi" (I-Fr, Ricc. 2971, fols. 472v–473v).

appear in two seventeenth-century manuscripts, both of which attribute the work to Salvadori.[25] Remarkably, the majority of the personages who participate in Salvadori's description of infernal music-making reappear as characters in *La Flora*, namely, Cupid, Venus, Berecinthia, Corilla, Pluto, and the three Graces:

Donne noi siam, che su le regie scene	We are women who upon royal stages
cantammo il pianto de' mortali amanti,	sang the grief of mortal lovers,
e qual in alto mar false Sirene	and as false sirens in the deep sea
usammo all'aria falseggiati pianti.	we used false tears in our arias.
Hor condannate a le Tartaree arene	Now condemned to the Tartarean shores
paghiamo il fio de' falseggiati canti	we pay the penalty for false songs,
ché su le spalle il musico Plutone	for upon our shoulders the musician Pluto
la battuta ci fa con un bastone.	beats time with a stick.
Maestro di cappella è Satanasso,	Satan is the maestro di cappella,
ci fa cantare un mesto madrigale.	who makes us sing a sad madrigal.
Amor fa da sopran, Corilla il basso,	Cupid takes the soprano, Corilla the bass,
cantan le Grazie come tre cicale.	the three Graces sing like three cicadas.
Venere e Berecintia a capo basso	Venus and Berecinthia, their heads bowed,
seguon la trista musica infernale	follow the sad, infernal music,
e quando erriamo il diavolo Astarotto	and when we err, the devil Astarotto
ci dà con un tizzone un scappellotto.	gives us a smack with a branding iron.
Sia maladetto all'hor, che Re, Mi, Dù	May it thus be cursed, that re mi do
imparammo a cantare, e fa, sol, fa	we learned to sing, and fa sol fa,
che non staremmo come stiam quaggiù	otherwise we would not be down here like we are
a far la serenata a chi verrà.	to serenade whomever will come.
Donne, s'in voi pietade hor regna più	Women, if pity still reigns in you
udite il canto ove condotte n'ha;	hear where singing has led us;
cantammo pria nel mondo, hora pianghiamo;	earlier, we sang in the world; now we weep;
musiche fummo, hor diavolesse siamo.	we were musicians, now we are devils.
Stracciate le cartelle o Canterine,	Tear up the score, oh women singers,
date un calcio ai liuti, e ai chitarroni,	kick the lutes and the chitarrones;
se non che dopo morte, poverine,	otherwise, poor little ones, after death
verrete a far la Zolfa co' demoni.	you will come to make solfège with demons.
Questi alla prima stracceranvi il crine	These at first will tear your hair,
e 'l volto graffieranvi con gl'ugnioni,	and they will scratch your face with their nails,
poi, dandovi solenne bastonate,	then, giving you solemn blows,
diran: "Madonne, a questo suon cantate!"	they will say: "Ladies, sing to that tune!"

25. I-Fn, Magl. VII.358, fols. 84v–85r and I-Fn, Magl. VII.59, fols. 50r–v, the source of the above transcription. Suzanne Cusick, in a private correspondence in 1994, has informed me that the octaves probably formed part of the 1621 Epiphany celebrations.

It is unclear when the events described by Cavalcanti took place. Discord was an interlocutor in the *intermedi* performed as part of the 1626 festivities celebrating the second marriage of Claudia de' Medici, but it seems unlikely that the incident preceded the official engagement announcement of early 1627, especially since Archduchess Maria Magdalena was still actively pursuing alternate marriage alliances for Margherita. Since Cavalcanti's account of the Salvadori/Caccini feud is but one of a series of Florentine anecdotes collected after the actual events described in them took place, it seems possible that he may have confused the order of events or specific details in his narrative. A revised appraisal, one that incorporates the existing documents, yields two possible hypothetical scenarios. For example, if Salvadori cast Caccini as Discord before she launched her plot against his *Iole*, the following scenario emerges: (1) angry over the difficulties she raised during the revival of *Sant'Orsola*, the latest in a series of events in his feud with her, Salvadori casts Caccini as Discord for the 1626 wedding festivities; (2) in early 1627 Odoardo and Margherita become officially engaged, and the court begins preparations for the festivities that are to be performed in the fall, at which Salvadori's *Iole* is to figure prominently; (3) due to Caccini's efforts at sabotage, Archduchess Maria Magdalena deems *Iole* unsuitable, and Salvadori must write a new work very quickly; (4) he avenges himself by writing an opera whose central characters are all drawn from the poem in which he had earlier attacked Francesca Caccini; and (5) Caccini, incensed at this insult, and possibly feeling abandoned by her supporters, leaves the court sometime after 29 May 1627, moves to Lucca, and marries Tomaso Raffaelli on 4 October 1627.[26] Alternatively, if Cavalcanti mistook the role of Discord for Gelosia, a personage who actually appears in *La Flora*, then his order of events may remain intact. In either case, *La Flora*'s composition must date from between May 1627 and early September 1628.

Salvadori's Libretto: Characters and Structure

Clearly, the archduchess had caused many of the wedding's delays and postponements. But in *La Flora*, a maternal figure, Venus, emerges as the cham-

26. I-Fas, DG 1523, opening 91, first noted by Tim Carter, *Jacopo Peri*, 1:98n75. See also Kirkendale, *Court Musicians*, 308. On Caccini's marriage to Raffaelli, see Suzanne G. Cusick, "Thinking from Women's Lives: Francesca Caccini after 1627," *Musical Quarterly* 77 (1993): 484–507, esp. 490–96. Caccini's letters to Michelangelo Buonarroti the Younger of January 1627, which attest to her feelings of abandonment, have been published in Maria Giovanna Masera, *Michelangelo Buonarroti il Giovane* (Turin, 1941), 99–100.

pion of a marriage that will directly benefit Tuscany—indeed, all of human-
kind—through the creation and production of flowers, the visual emblems
of spring. Salvadori makes this point explicit in the work's *argomento*.[27]

> It was ordained by Jupiter that the earth, in order to compare with the heavens,
> should have its own stars, that is, flowers. These were to be born from the love of
> Zephyr, the spring wind, and Chloris, nymph of the Tuscan fields. Therefore he
> sends Mercury to inform Berecinthia, goddess of the earth, and the nymphs of the
> fields. Venus, meanwhile, [having] disembarked with her entire court on the
> Tyrrhenian shores, hears from Zephyr of his love toward Chloris, and [she] as-
> sures him that the nymph will be his. But Cupid, for his own purpose contradict-
> ing her and denying absolutely that [the marriage] will take place, is chased from
> her with harsh words. Upon finding him, Mercury, with the song of the Graces,
> lures him to sleep and, stealing [Cupid's] weapons from him at that time, carries
> them to Venus, and with the golden arrow, the one that induces reciprocated love,
> she causes Chloris to become enamored of Zephyr. The satyrs see Cupid without
> weapons and jeer at him, and Venus, for greater spite toward him, sends the bow
> and the golden arrow to Jupiter, throws the other one of lead, which generates
> hate, into the sea, and keeps the torch for herself. Cupid, now fiercely indignant,
> causes the Underworld to open and extracts Jealousy from there. This one, by
> means of a double lie managed by Pan, disturbs the joys of the two lovers in such
> a way that Zephyr, driven away by Chloris, leaves the Tuscan fields prey to the
> tempests. Then, the nymphs' gladness changed to tears, Neptune, for fear of Jeal-
> ousy, returns the arrow of lead to Cupid, Jupiter [returns] the golden arrow and
> bow, and Venus [returns] the torch. Cupid having recovered his tears that have
> fallen to the ground, [they] become flowers. Chloris, her name then changed to
> that of Flora, predicts the future grandeurs of Florence, so named after her. The
> Muses, having seen the flowers born, carry their fountain to irrigate them, and
> Apollo praises the lilies in particular, emblem of Florence and of the Most Serene
> House of Parma.[28]

27. I have used the lengthier *argomento* found in the libretto, in this case the edition pub-
lished by Cecconcelli, rather than the version published with the musical score.

28. In Salvadori's original (*La Flora* [Florence, 1628]), the *argomento* reads as follows:

> Era ordinato da Giove, che la Terra à paragon del Cielo, avesse le sue Stelle, cioè i
> Fiori: questi dovevano nascere dagl'Amori di Zeffiro, Vento di Primavera, e di Clori
> Ninfa de' campi Toscani: manda perciò Mercurio ad avvisarne Berecintia, Dea della
> Terra, e le Ninfe de' campi. Venere intanto con tutta la sua Corte sbarcata nelle rive
> Tirrene, ode da Zeffiro il suo amore verso Clori, e l'assicura, che sarà sua quella Ninfa;
> ma Amore per un suo fine contradicendola, e negando assolutamente, che ciò segua, è
> da Lei con aspre parole discacciato: trovatolo allora Mercurio, col canto delle Grazie,
> l'invita al sonno, e furandogli in quel tempo l'armi, le porta à Venere; et ella con la
> Saetta d'Oro, che induce corrispondenza, fa innamorare Clori di Zeffiro: veggono i

Several themes in the libretto invite allegorical interpretation. The long de-
layed joining of Chloris and Zephyr parallels the numerous postponements
of Margherita and Odoardo's wedding. Jealousy's near success at derailing the
union of Chloris and Zephyr—mischief that Cupid instigates—appears re-
markably similar to Maria de' Medici's attempts to block the Florence-Parma
marriage in favor of a Florentine alliance with France, which Ferdinando II
supported. Disagreement over the Chloris-Zephyr union causes friction be-
tween a powerful mother (Venus) and her son (Cupid), which leads Venus
to appropriate the source of her son's power, his weapons, and to use them
in his place. In doing so, she acts on behalf of Jupiter, the largely absent male
authority figure who appears on stage only at the very end of the opera, in or-
der to return Cupid's golden arrow and bow. The paternal god may represent
Cosimo II, who had negotiated the original marriage contract between Flor-
ence and Parma and under the terms of whose will Florence had until re-
cently been governed.[29] When Jupiter relinquishes his claim to any portion
of Cupid's weapons, the lingering influence of Cosimo II yields to Ferdi-
nando's personal rule.

Although in the plot of the musical score it is the joyful tears of the groom,
that is, Zephyr, that bloom into flowers, in Salvadori's libretto Cupid's tears
cause the appearance of the preordained flowers. The young god's trials emerge
as prerequisites for the fulfillment of Jupiter's command, just as Ferdinando
had to study and mature in order to assume his place as grand duke of Tus-
cany. Thus the renewal of springtime, combined with the traditionally close
association between Florence and Flora, the goddess of spring, allegorizes the
restoration of male Medici rule. Only through the magnanimous gesture of

Satiri Amor senz' armi, e lo beffeggiano; e Venere, per maggior dispetto di Lui manda
l'Arco, e lo Strale d'Oro à Giove, getta l'altro di Piombo, che genera odio, in Mare, e
per sé ritien la Face. Amore allora fieramente sdegnato, fa aprir l'Inferno, e ne cava la
Gelosia: questa, per mezzo d'una doppia menzogna maneggiata da Pane, turba in
maniera le gioie de' due Amanti, che Zeffiro, scacciato da Clori, lascia i campi Toscani
in preda alle Tempeste: cangiata allora la letizia delle Ninfe in pianto, Nettunno, per
timore della Gelosia, rende lo Strale di Piombo ad Amore, Giove la Saetta d'Oro, e
l'Arco, e Venere la Face: recuperate Amor le sue lagrime cadute in terra divengono
Fiori: Clori allora mutato il suo nome in quel di Flora, augura le future grandezze di
Fiorenza, così detta da Lei: le Muse, visti nati i Fiori portano ad irrigargli il lor Fonte,
et Apollo loda particolarmente i Gigli, Insegna di Fiorenza, e della Serenissima Casa
di Parma.

29. The presence of Jupiter also links the opera to Cosimo I who, as founder of the reign-
ing Medici dynasty, was often associated with this "father of the gods." See Mario Biagioli,
Galileo, Courtier: The Practice of Science in the Culture of Absolutism (Chicago, 1993), 106.

a powerful woman, however, can Florence achieve this rejuvenation. *La Flora* goes beyond merely acknowledging the new political regime: it symbolically reenacts the transfer of power from female to male rule. The creative team behind the opera, including Maria Magdalena herself, depicted the exchange as a necessary step in the continued good government of Florence, and both words and music play crucial roles in clarifying this message.

La Flora returned to the pastoral themes of the earliest Florentine operas, in which nymphs and shepherds romp in Tyrrhenian fields while gods and goddesses decide their fates. This reversion, a significant departure from the regency's program of predominantly religious spectacles, served in itself to dramatize the change of regime. *La Flora*'s title character also presents an ideal of femaleness that differs radically from her predecessors in the regency spectacles—strong, active women such as Agatha, Ursula, and Judith, whose actions saved entire nations. In *La Flora* the passive Chloris, who wants to become a chaste follower of Diana (act 2.2), must be coerced into a marriage she does not desire—a possible reference to the Farnese family's exertion of pressure on Florence in order to force the regents to honor the 1620 marriage contract.[30] Later, she gullibly believes Cupid and Pan's lies of Zephyr's infidelity—hardly a heroine in the manner of the decade's earlier spectacles. She plays no part in the restoration of her happiness, and in the final scene of the opera, as her new husband changes her name to Flora, her function as mother of the flowers subsumes her individuality.

But the opera did provide continuity with the female protagonists of regency spectacles through the character of Venus. Salvadori represents the goddess as a decisive, resourceful woman: she arranges the theft of her petulant son's weapons, uses them to inflict amorous wounds on Chloris, and cedes graciously the powers she has appropriated in order to ensure Zephyr and Chloris's marriage and effect the plot's resolution. This role, although central to *La Flora*, is an accretion to the opera's classical source, Ovid's *Fasti*. Ovid's tale also served as an inspiration for Alessandro di Mariano Filipepi, better known as Sandro Botticelli, in his *Primavera* (plate 3).[31] Just as it provided only part

30. In this and in subsequent references to the opera, scene numbers will refer to the scene divisions as they occur in Salvadori's libretto. The musical score notes the division between scenes 1 and 2 in act 1, after which it discontinues identifying individual scenes within the acts.

31. Concerning Ovid and the other classical sources of Botticelli's painting, see Charles Dempsey, *The Portrayal of Love: Botticelli's Primavera and Humanist Culture at the Time of Lorenzo the Magnificent* (Princeton, NJ, 1992), 20–49. Warren Kirkendale (*Court Musicians*, 231) also notes the shared subject matter of Salvadori's opera and the Botticelli painting.

of the invention for Botticelli's painting, however, Ovid's text furnished only
a broad outline for Salvadori's libretto, that is, Zephyr's pursuit of Chloris
and the perpetual spring resulting from their union:

> I who am now called Flora was formerly Chloris: a Greek letter of my name is cor-
> rupted in the Latin speech. I was Chloris, a Nymph of the happy fields, where, as
> you have heard, dwelt the fortunate men of the olden days. Modesty shrinks from
> describing my figure: but it procured the hand of a god for my mother's daughter.
> It was spring, and I was roaming; Zephyr caught sight of me; I retired; he pursued
> and I fled; but he was the stronger, and Boreas had given his brother full right of
> rape by daring to carry off the prize from the house of Erechtheus. However, he
> made amends for his violence by giving me the name of bride, and in my marriage
> bed I have no complaint. I enjoy perpetual spring; always is the year in fullest blos-
> som; the tree is clothed with leaves, the ground with pasture. In the fields that are
> my dower I have a fruitful garden, fanned by the breeze and watered by a spring
> of running water. This garden my husband filled with noble flowers and said,
> "Goddess, be queen of flowers."[32]

Besides Chloris and Zephyr, of the other central personages in *La Flora*—
Venus, Cupid, Mercury, and the Graces—only the Graces appear in Ovid's
tale, as part of a later description of spring's flowers.[33] But classical sources
also connect Mercury, Venus, and Cupid with fertility, rendering them appro-
priate symbols of the springtime renewal celebrated in Salvadori's libretto.[34]
These sources do not provide precedents for Salvadori's use of these person-
ages as the central agents in the drama of Flora and Zephyr, but here Botti-
celli's painting may provide a clue.

Maria Magdalena undoubtedly knew the *Primavera*, which had hung in the
Medici villa at Castello since some point in the rule of Cosimo I.[35] In 1608,

32. Ovid, *Fasti*, 5.195–213, quoted and translated in Dempsey, *Portrayal of Love*, 32.

33. Ovid, *Fasti*, 5.219. Lucretius (*De rerum natura* 5.737–40) names Venus, Cupid, Zephyr,
and Flora as harbingers of spring but without involving them in any dramatic interaction.

34. On the fecundity associated with Flora that assured her association with Venus as an
embodiment of sexuality, see Julius S. Held, "Flora, Goddess and Courtesan," in *Essays in
Honor of Erwin Panofsky*, ed. Millard Meiss, 2 vols. (New York, 1961), 1:201–18, esp. 203–5.
Held (204) also cites a sixteenth-century description of Zephyr as Venus's messenger, a post
similar to the one he occupies in *La Flora*. Most of the opera's other personages are also asso-
ciated with fertility. See Charles Dempsey, *Portrayal of Love*, esp. chap. 1, and "*Mercurius Ver:* The
Sources of Botticelli's *Primavera*," *Journal of the Warburg and Courtauld Institutes* 31 (1968): 251–73.

35. Botticelli's painting was originally intended for the palace in Via Larga belonging to
Lorenzo and Giovanni di Pierfrancesco de' Medici. It remained in the Villa di Castello un-
til at least 1761. See Luciano Berti, ed., *Gli Uffizi: Catalogo generale* (Florence, 1979), 177; Ronald

the year of her marriage to Cosimo II, she had enjoyed a brief stay at the villa on 16–17 October before her triumphal entry into Florence.[36] The Castello villa's close association with springtime images dates to the earliest years of Cosimo I's reign, when his refurbishment of the villa and its gardens introduced the theme of springtime renewal as an allegorical affirmation of God's promise to restore Medici rule.[37] During the 1620s, Castello laborers revitalized this connection by coming to the Palazzo Pitti to celebrate the *Maggio*, a Tuscan ritual of spring.[38] In 1628, by appropriating specific symbols of Florence's first grand duke, Maria Magdalena and her artistic advisers reasserted Ferdinando II's own place in the Medici dynasty.[39]

Art historians have proposed a variety of allegorical interpretations for Botticelli's *Primavera*. All agree, however, that Venus commands the focal point of the painting, an interpretation dating from Vasari's description of it in 1550

Lightbown, *Sandro Botticelli*, 2 vols. (Berkeley, 1978), 2:52; and Webster Smith, "On the Original Location of the *Primavera*," *Art Bulletin* 57 (1975): 36–37. For transcriptions of household inventories from 1598 and 1638 showing the location of the painting, see Herbert P. Horne, *Alessandro Filipepi Commonly Called Sandro Botticelli, Painter of Florence* (London, 1908), 349–50.

36. Estella Galasso Calderara, *Un'amazzone tedesca nella Firenze Medicea del '600: La Granduchessa Maria Maddalena D'Austria* (Genoa, 1985), 42.

37. The historical source of these springtime images was the unseasonably warm weather that accompanied the January 1537 election of Cosimo I. See David Roy Wright, "The Medici Villa at Olmo a Castello: Its History and Iconography" (Ph.D. diss., Princeton University, 1976), 257. The transfer of three Botticelli paintings (*Primavera, Birth of Venus*, and *Minerva and the Centaur*) during these renovations most likely reflects their appropriateness in illustrating the villa's larger iconographic program (Wright, "The Medici Villa at Olmo a Castello," 343–47). Wright suggests that, as the traditional messenger of Zeus, the figure of Mercury in the *Primavera* painting might have been understood as "the bringer of the omen of the new spring of peace and plenty to come to Florence under Cosimo I" (345). He also notes Mercury's position in fifteenth-century iconography as *psychopompus*, "the agent of fate who awakens the dead plants and seeds in the earth" (345).

38. Angelo Solerti, *Musica, ballo e drammatica alla corte Medicea dal 1600 al 1637: Notizie tratte da un diario, con appendice di testi inediti e rari* (Florence, 1905; reprint, New York, 1968), 106–7, 130–31, 185. In at least one instance, a *Maggio* featured the personages of Zephyr and Flora, Girolamo Paponi's "Maggio dialogo di Zefiro e Flora" (I-Fn, Magl. VII.265), which its author dedicated to Archduchess Maria Magdalena in commemoration of her family's military victories. Although the dialogue is undated, Paponi's references to Emperor Ferdinand II (crowned 1619), recent Habsburg victories in Prague and Bohemia, and "sainted" Cosimo II, suggest that he composed it shortly after Cosimo's death in February 1621.

39. Wright ("The Medici Villa at Olmo a Castello," 351) speculates that Cosimo I's own mother, Maria Salviati, was responsible for the Castello iconography, which, if true, would bear a remarkable resemblance to the circumstances surrounding the commissioning of *La Flora*.

as "Venere che le Grazie la fioriscono, dinotando la Primavera."[40] All the figures in the *Primavera* appear prominently in the plot of *La Flora:* Mercury and the Graces occupy the left side, Zephyr effects the Chloris/Flora transformation on the right, and Venus and Cupid dominate the painting's central position. Botticelli's arrangement of these figures may also point to the source for Cupid's initial opposition to the marriage between Zephyr and Flora in *La Flora,* for Botticelli's Cupid also turns away from the lovers, aiming his arrow instead at Castità, one of the Graces. And in the *Primavera,* Botticelli did not depict the lascivious Venus but, rather, a goddess of moderation, dignity, and decorum, whose mantle and veiled hair confirm her position as a matronly goddess of marriage.[41]

This is precisely Salvadori's portrayal of Venus: she controls not only the opera's plot, but its very structure. Her five scenes, symmetrically placed at the beginning, middle, and end of the opera, contain the three episodes essential to the plot: Venus promises to help Zephyr, resulting in the first confrontation with Cupid (1.2, 1.3); the power struggle between Venus and Cupid escalates, with Venus emerging victorious (3.5); and Venus relinquishes her power and resolves the conflict with her son (5.8, 5.10).

These five scenes represent only one level of Salvadori's tightly controlled dramatic design. In his libretto he clearly distinguishes among three generations of women—Berecinthia, Venus, and Chloris—creating a hierarchy that mirrored the three generations of women participating in Medici court life, and, at least temporarily, in politics: Christine of Lorraine, Maria Magdalena of Austria, and Margherita de' Medici. While Venus moves the plot forward, Berecinthia, the mother of the earth, appears only in the opera's first and last scenes (1.1, 5.10), framing the dramatic action but outside it. Salvadori concentrates the majority of scenes featuring Chloris, the youngest member of

40. Giorgio Vasari, *Le vite dei più eccellenti pittori, scultori ed architetti,* 4 vols., ed. Carlo L. Ragghianti (Milan, 1942–49), 1:867. Giambologna's sculpture of the goddess also occupies a central position in Castello's garden (Wright, "The Medici Villa at Olmo a Castello," 288).

41. Edgar Wind, *Pagan Mysteries in the Renaissance* (Middlesex, 1967), 119; Dempsey, *Portrayal of Love,* 69; and Ronald Lightbown, *Sandro Botticelli: Life and Work* (New York, 1989), 127. Salvadori may have intended a reference to another artistic topos in his libretto, the punishment of Cupid, a chastisement that Venus exacts by confiscating her mischievous son's arrows. The Medici collection contained at least one representation of this topos, painted by Alessandro Allori ca. 1560–70. For a list of the pre-1628 paintings that explore this subject, see Jane Davidson Reid, *The Oxford Guide to Classical Mythology in the Arts, 1300–1990s,* 2 vols. (New York, 1993), 1:413–15. Concerning the Allori painting, see Fern Rusk Shapley, *Paintings from the Samuel H. Kress Collection: Italian Schools, Sixteenth to Eighteenth Century,* 3 vols. (London, 1966–73), 3:17–18 and fig. 33.

the triumvirate, in the middle three acts of the opera, adding color without directly affecting the dramatic outcome.

Musical Structure and Characterization

Salvadori framed the dramatic action with seven-stanza commentaries in praise of Margherita and Odoardo and their respective cities. Each is delivered by a personage who appears only once in the opera: in the prologue, Hymen, the god of marriage, blesses the couple and their future offspring, while in what functions as an epilogue, separated by musical style from the preceding scene, Apollo, the god symbolizing order and balance, praises the lily and decrees the closing ballet.[42] In his musical setting Marco da Gagliano emphasized the framing nature of the prologue and epilogue by setting each to the musical style that would later be termed "special recitative" by Giovanni Battista Doni and by punctuating each with what is essentially the same instrumental ritornello, consisting of an extended cadence to G.[43] This G final also helps create the coherent tonal plan by which Gagliano reinforces Salvadori's tightly structured architecture.[44] Not only does it begin and end the opera, but it also concludes each of the five acts and nineteen of the work's thirty scenes.[45]

Both poet and composer also provided *La Flora* with a clear large-scale structure by means of the choral ensembles that appear during and at the ends of acts. These choruses function as both *intermedi*, providing colorful diversions between the acts of the opera, and as the logical conclusions to the

42. In his musical setting, Gagliano upset Salvadori's symmetry by eliminating prologue stanzas 4–6. This excision actually contributes to a greater sense of balance, however, since the removal of the three six-line prologue stanzas results in a total prologue length of twenty-four lines, roughly equivalent to the twenty-eight line epilogue.

43. Giovanni Battista Doni, *Annotazioni sopra il compendio de' generi e de' modi della musica* (Rome, 1640), 61. Doni viewed this style, which he described as "midway between the narrative and expressive [styles of recitative]" [*La qualità della sua melodia è mezzana tra la Narrativa, e l'Espressiva*], as particularly apt for stanzaic poetry.

44. Barbara Russano Hanning (*Of Poetry and Music's Power: Humanism and the Creation of Opera* [Ann Arbor, MI, 1980], 106–7) notes a similar tonal coherence in Gagliano's earlier *Dafne* (1608).

45. The only other finals on which multiple scenes end are D, which closes five scenes, and F and A, with two scenes each. More than half of the individual musical sections— 123 out of 237—also end on G. Secondary areas of importance are C (thirty-four cadences), D (twenty-seven cadences), F (twenty-six cadences), and A (twenty-two cadences).

scenes that precede them.[46] Gagliano linked each closing chorus to the music of the previous scene, and in all cases but one (act 3) he repeated the concluding chorus at least once, often increasing the number of repetitions specified in the libretto in order to build elaborate musical finales.

Against this tightly organized structure, the drama unfolds in its predominant type of musical delivery, recitative. Both Gagliano and Salvadori used poetic and musical style to distinguish between the plot's central and peripheral characters. Venus and Cupid, the two personages who actually cause the plot to unfold, sing only *settenari* and *endecasillabi*, the verse types of recitative. Salvadori restricts *quaternari* and *ottonari*, verse types of the light-hearted canzonetta, to the choruses or to personages such as Chloris, Zephyr, and Pan, whose presence adds color and variety but contributes little to the dramatic resolution. Salvadori and Gagliano similarly limit the opera's infrequent closed musical forms to these characters.

Lacking the emotional restraint and personal agency of their elders, the young lovers, Chloris and Zephyr, communicate consistently by means of the musical and emotional excesses of florid arias and expressive recitative. Chloris first appears on the stage singing four highly decorative stanzas, with melismas that grow in length to culminate in a two-and-a-half measure florid explosion near the end of the fourth stanza (act 2.1). She sings her buoyant vocal line while gazing happily at the sea in anticipation of spring's arrival, and her musical style confirms her position as the perfect mate for Zephyr, the exuberant spring wind whose own virtuosic stanzas immediately follow hers. Salvadori, Gagliano, and Peri confirm the would-be lovers' compatibility: both Chloris and Zephyr sing *ottonari* quatrains arranged in an *abab* rhyme scheme, and both deliver their stanzas in florid strophic variations over a walking bass.

The young lovers' immoderation also extends to emotionally charged recitative. Sudden tonal juxtapositions, syncopations, chromaticism, and affective rhetorical figures dominate their musical utterances. Zephyr demonstrates his tendency toward impulsive behavior in his first appearance in the opera

46. For general overviews of the opera's musical style, see Primarosa Ledda's preface to the facsimile edition (Marco da Gagliano, *La Flora* [Bologna, 1969]); Angela Teresa Cortellazzo, "Il melodramma di Marco da Gagliano," in *Congresso internazionale sul tema Claudio Monteverdi e il suo tempo: Relazioni e comunicazioni,* ed. Raffaello Monterosso (Verona, 1969), 583–98; and Nino Pirrotta, "Gagliano, Marco," in *Enciclopedia dello spettacolo,* ed. Francesco Savio et al., 9 vols. (Rome, 1954–62), 5:817–18, who notes the choruses' integration into the dramatic action. For a fuller discussion of Gagliano's construction of choral finales in *La Flora,* see Harness, "*Amazzoni di Dio*," 319–27.

(1.2), delivering a brief but impassioned lament after overhearing Cupid's refusal to enamor Chloris. He sings a second lament following Chloris's unjust accusation of infidelity (4.4), then a third, even longer (ninety lines) lament after the mischievous Pan deceives him into believing that Chloris has actually deserted him in order to join her new lover. Delivered principally in rapid *settenari*, Zephyr's initial reaction oscillates between anger and despair, and Gagliano imitates the wind's vacillating emotions by composing recitative that shifts between sharp and flat harmonies, as well as between the contradictory finals of G and A. In his opening measures (ex. 6.1), Zephyr's anger at the "treacherous" Chloris culminates in a strong cadence to A (m. 16), while his desire for death leads instead to G (m. 23), a final confirmed by the second cadence (m. 38).

Gagliano uses the entire musical arsenal of expressive recitative in this lament. Sudden harmonic juxtapositions call attention to affective moments in the text, for example, the jarring F chord that interrupts the static E harmony just as Zephyr complains of Chloris's pitiless arrows (m. 3). Another interruption (mm. 19–20) suggests the phantom of Zephyr's imagination—the rival who has stolen his beloved's heart. The relatively flat harmonies of measures 24–31 shift sharp-ward without warning at measure 31, coinciding with Zephyr's scathing commentary on the female sex.

Harsh dissonances, affective leaps, and rhythmic syncopation also allow Gagliano to create musical speech that heightens the emotional content of the text. Zephyr's initial regulated ascent from g♯' to c″ (mm. 1–5) loses its momentum at measure 5 as he reveals the devastating effects of Chloris's stinging words, and his vocal line reverses itself to b', creating a dissonance with the underlying A harmony, a harshness affirmed by its repetition at "trafiggete" and resolved by leap to another dissonance, f♯'. He proclaims his betrayed faith with yet another dissonance, this time his c″ against the continuo's E chord with a sharp third (m. 15). Melodic leaps of fourths, fifths, and especially tritones allow Gagliano to re-create Zephyr's building anguish in this section of the lament, while desperate syncopations (mm. 24–25) heighten the aggrieved lover's complaints of fraud and betrayal.

Gagliano also illustrates Zephyr's loss of emotional control by means of "defective" musico-rhetorical figures. One of the recurring musical characteristics of this section of recitative is the ineffective assertion of control: Zephyr's continual attempts to direct his melodic lines toward rational goals inevitably end in failure. For example, the musical phrases with which he accuses his former beloved of perfidy and treachery (mm. 8–12) gradually ascend to ever higher pitch goals, c″, d″, and e″, and Gagliano calls attention to

the phrases' musical similarity by setting each to a similar rhythmic pattern. But the arrival on e″ (m. 12) does not provide a conclusive resolution, and Zephyr falls back to a lower pitch level and the sharp E-major harmony, realizing that Chloris, no matter what he might call her, is still the one he loves more than his own life.

Zephyr once again treads the melodic ascent c″ to d″ to e″ at measures 20–22 as he redirects his anger toward his imagined rival. Gagliano divides Salvadori's verse into three sections, the first two of which begin with "altri." Gagliano's setting of these two short phrases, creating musical parallelism through rhythmic and melodic contour, leads the listener to expect a third, culminating phrase. At first these expectations seem justified, as the musical phrase beginning "ed io" continues the upward motion. But again, as Zephyr realizes the personal ramifications of what he believes to be Chloris's infidelity, he falters: his melodic line suddenly sags to a′, then g′. As his own text and cadence to G confirm, at this point the only action that Zephyr can accomplish is his own death.

Zephyr reiterates his harmonic goal of G in the last measures of this section of the lament, but in order to do so he must move beyond his own tragedy to the more impersonal realm of the maxim (mm. 31–38). And this is precisely what he does harmonically, beginning his phrase on E as though to reiterate his earlier A final but then continuing though the circle of fifths to cadence instead on the more neutral G.

Strongly affective musical language also characterizes Chloris's recitatives. One of her most anguished musical utterances appears in act 5, a speech that gains much of its expressive force through its musical depiction of a character initially determined to retain her composure but ultimately unable to do so (ex. 6.2). She first addresses the happy couple Corilla and Lirindo (mm. 1–6), attempting to conceal her anguish at what she believes to be her lover's infidelity by delivering advice in neutral, repeated-note declamation over an essentially static G harmony. But congratulating her friends reminds Chloris of her own loss, and, during the space provided through Peri's extended rest (mm. 7–8), she struggles to maintain her equilibrium. Her pain overcomes her feigned stability, and as she reenters on a lower pitch, she expresses her wish to die. The imperative "Lasciatemi" dominates this section of her lament, recalling Ottavio Rinuccini and Claudio Monteverdi's more famous *Lamento di Arianna*. Following Rinuccini's earlier poetic model, Salvadori invests the command with rhetorical force through *anaphora*, using it to begin lines 4, 5, and 7. Peri amplifies the word's insistence through the musical equivalent of the rhetorical device of *gradatio*, that is, beginning each succes-

sive repetition a third or fourth higher as Chloris's despair mounts. As she
reflects on Zephyr's deceit she reaches the melodic climax of the speech, a
harsh e♭″ that clashes with the underlying G chord (m. 14). Peri repeats the
dissonance two measures later, explicitly linking Zephyr's harshness to Chlo-
ris's desire for death. In one of the composer's most striking uses of rhythm
for expressive effect, with each repetition of "Lasciatemi" he elongates the
pattern and creates less emphatic declamation, as Chloris enacts the death for
which she longs. Throughout Chloris's recitatives Peri often illustrates the
young woman's inability to act by withholding or weakening cadences. In this
lament, at Chloris's emphatic final plea for death, her uninflected vocal line
gradually descends over a static C-minor chord only briefly enlivened by new
harmonies (mm. 17–20), and she fades away without reaching the cadence
prepared by the 4–3 suspension of the last measure.

In contrast to the impassioned outbursts of Zephyr and Chloris, Venus's
emotional restraint persists even in the midst of confrontation, as seen in
both act 1.2 and 3.5. In her struggle for control of Love's weapons, either
metaphorically, as in act 1.2, or literally in act 3.5, Venus's music provides ex-
amples of the self-control and rationality from which she draws her strength.
Her declamation features only limited use of expressive devices such as chro-
matic alteration, dissonance, and syncopation, relying instead on vocal and
harmonic control to assert her resolve. Cupid, by contrast, is a pouting, petu-
lant child, who resorts to affective devices in a whining attempt to get his
own way.

Act 1.2 presents the first of these power struggles, as Cupid obstinately re-
fuses to honor Venus's pledge to unite Zephyr and Chloris. The second and
more extensive confrontation between Venus and Cupid takes place in act 3.5,
which is the structural and dramatic midpoint of the opera (ex. 6.3). Venus
now controls Cupid's weapons, the theft of which she has engineered, and
Cupid attempts to regain them through threats. The goddess coldly informs
her son that she has stolen his weapons in order to teach him never to dis-
obey her. Gagliano reinforces the strength of Venus's will by punctuating
"voluto" with a plagal cadence to C (m. 1). The A chord of the next phrase
initiates a long controlled progression by fifths to the closing cadence on G
(m. 7), as the goddess proclaims her right to possess the opera's central final.
She displays the same sense of melodic purpose in these measures, gradually
ascending in increments no greater than a third, with a slowly building in-
tensity that matches the warning of the text. The enjambment of the final
two verses propels her to the culminating d–c″ dissonance on "Fanciul," as
she disdainfully addresses her son (m. 6).

Although Cupid swears revenge, his music belies the force of his words.

Compared with Venus's tightly regulated ascent, Cupid's vocal line seems undirected, meandering over a sustained F harmony for seven-and-a-half of its ten measures. He turns suddenly to G without preparation, in order to stake his own claim to the opera's final, but it remains an unconvincing display of bravado.

Venus's response demonstrates her triumph over Cupid, and frequent cadences affirming G reiterate her greater mastery of the dominant harmonic language. She challenges Cupid to oppose her (m. 18), even allowing him time to respond in the short rest that separates the verse's two phrases, then she laughs at his impotence. She ridicules his pride with a jeering a–g′ dissonance (m. 20), while through rhythmic pointedness she creates a caricature of the "plucked Cupid" [*spennacchiato Cupido* (mm. 21–23)]. Gagliano once again illustrates Venus's self-discipline by means of carefully directed, gradually ascending phrases, first as the goddess admires her handiwork (mm. 24–29), and again as she returns to the business of punishing Cupid (mm. 29–34). Although each phrase concludes with a cadence to G, their opposing emotional content necessitates that each approach the final from a different direction. Venus triumphantly declares the validity of Chloris and Zephyr's marriage beginning on C, the fifth below the G final. A sudden turn to the harsher A major foreshadows the menacing nature of her second ascending phrase. Poetically, Salvadori has prolonged Venus's description of the intended punishment by prefacing the principal clause of her sentence, "vedi quel ch'io far voglio," with a lengthy, anticipatory dependent clause. Gagliano mirrors the poet's intent by setting the entire sentence to an even more concentrated preparation for the cadence to G at measure 34, which again coincides with the verb that most clearly represents Venus's strength of will [*voglio*]. In this scene and in her two scenes in act 1, Venus's strength and agency derive from harmonic and melodic control.

This musical depiction of Venus as an assertive female leader corresponds to the other portrayals of women seen during the regency of Maria Magdalena. But by the time the court actually witnessed *La Flora*, Maria Magdalena had relinquished rule to her son, just as Venus cedes her power to Cupid in order to achieve her larger goal, the marriage of Chloris and Zephyr. The dramatic representation of this transfer of power, with its resulting reconciliation and resolution, takes place in act 5.8, as Venus restores Cupid's weapons to him (ex. 6.4). That Venus initially concedes power unwillingly is underscored by the emphasis on "M'è forza," which Gagliano separates from the remainder of the opening phrase and repeats a fourth higher with greater rhythmic emphasis (mm. 5–6). Even in defeat, however, Venus retains harmonic control, completing eight fully prepared cadences in twenty-five lines.

Each of her first four cadences coincides with an important action or concession: she agrees to request, rather than command (m. 11), she reaffirms Cupid's position as her son (m. 19), she acknowledges the efficacy of his revenge (m. 29), and finally, she petitions for peace (m. 36). Not coincidentally, each of these cadences is to D, the opera's secondary tonal area, rather than to G, the modal final that has dominated Venus's recitatives to this point.

As part of her efforts to pacify her son, Venus must confess her mistakes. Gagliano calls attention to these instigators of discord through tonal disjunctions: the sudden E♭ chord at "orgoglio," for example, returns to F major (m. 10) only when Venus admits that her pride was out of place. Gagliano uses this type of tonal juxtaposition throughout the opera but only rarely in Venus's music. The composer suggests the end of Venus's ascendancy by other means as well: her vocal lines are less restrained, and she adopts the rhetorical strategies of the other characters in her attempts to placate her son. Her octave leap to the startlingly tuneful exclamation, "Non più, non più disdegno" (mm. 20–22), shifts Venus's attention back to her apology and away from her sotto voce insults (mm. 15–19). Gagliano turns the phrase into a refrain, repeating it a fourth lower at measures 24–26, as Venus attempts to prove the sincerity of her praise.

Gagliano corroborates Venus's intention to restore Cupid's power through the purposeful declamation that emphasizes her conciliatory "sia tuo" (m. 37) and "tu vuoi" (m. 44). The pitch elision that links the text lines "Sù vieni in queste braccia" and "O dolcissimo figlio" (mm. 48–49), as the goddess calls her son to her arms, anticipates the hoped-for resolution.

Venus's abdication resolves the dramatic conflict, and the music of the final scene ratifies the denouement through continual reiteration of cadences to G. Cupid dismisses Jealousy and reunites Zephyr and Chloris, then Zephyr transforms Chloris into Flora, goddess of flowers, mother of heroes, and provider of offspring—in other words, the embodiment of the maternal virtues earlier attributed to Venus. In her opening twelve-measure aria, Flora exhorts the Tyrrhenian fields, and by extension, Florence, to rejoice in her married happiness (ex. 6.5). Her new position also allows Flora to appropriate many of Venus's earlier musical indices of strength. Cadences to G articulate the ends of both the aria (m. 12) and recitative (m. 39), and they punctuate her praises of her namesake city (m. 25), while secondary cadences to C and D also emphasize G as the modal center. Flora delivers her self-praises in forceful spondaic rhythms (mm. 23, 26), and she exhibits her newly found harmonic control in the lengthy preparation for the final cadence to G (mm. 33–39).

Correspondingly, the relinquishing of power renders Venus inconsequential to the remainder of the drama. As a result, for her final measures Gagliano replaces the goddess's earlier restrained recitative with tunefulness (ex. 6.6). A meandering melody supplants her earlier tonally directed phrases. And for the first and only time in the opera, she sings a melismatic passage, an excess that confirms her new position among the opera's colorful but nonessential participants. Unlike *La Flora*'s other central characters, all of whom conclude their recitatives with cadences to G in this final scene, Venus closes on F, completely outside the G hexachord. Thus, Venus has been conclusively removed from the sphere of harmonic and dramatic activity, just as Maria Magdalena was officially displaced from the seat of power on Ferdinando's eighteenth birthday. As the end of her rule drew near, the archduchess sought imagery that would portray the political succession as a necessary step in the continued good government of Florence.[47] In *La Flora*, Venus willingly abdicates her power to this end, and through Venus, Maria Magdalena herself concedes that "instead of ruling, today it suits me to beseech."

After *La Flora*

La Flora celebrated the new era in Florentine politics that commenced with the personal rule of Grand Duke Ferdinando II. But external political concerns, plus a possible disinterest on the part of the grand duke, caused a sharp decline in the court's sponsorship of musical spectacles after the 1628 wedding festivities.[48] Ferdinando was among the Italian rulers who watched as the conflict escalated between Spain and France over the succession of Mantua, and their worries intensified as Emperor Ferdinand II's troops approached Mantua in September of 1629. To the dismay of all Italy, the imperial army sacked Mantua on 18 July 1630. The plague that followed quickly swept through northern Italy, reaching Florence by August 1630 and killing 6,921 people in four months.[49] This total accounts for more than two-thirds of the

47. A similar intention seems to have motivated an English court masque very closely related to *La Flora*, Ben Jonson and Inigo Jones's *Chloridia*, which was performed on 22 February 1631 as the second of a pair of masques intended to inaugurate King Charles I's personal rule. The masque's opening argument is nearly an exact translation of *La Flora*'s *argomento*. For the complete text, see Ben Jonson, *The Complete Masques*, ed. Stephen Orgel (New Haven, CT, and London, 1969), 462–72.

48. The number of court festivities decreased dramatically after 1629. Solerti observed that he found nothing worth mentioning for the years 1631–33 (*Musica*, 196n2).

49. Galluzzi, *Istoria*, 3:453–54. See also Galasso Calderara, *Un'amazzone tedesca*, 131.

10,000 person drop in population that occurred from 1622 to 1630.[50] Ferdinando's energies appear to have been directed more toward the preservation of a grand duchy to rule than toward the use of musical spectacle to legitimate his right to rule it.

The troubled years of 1629–30 saw the production of only a handful of dramatic entertainments, many of them sponsored by the city's confraternities. The Compagnia di Sant'Antonio di Padova gave three performances of an anonymous play on the subject of the prodigal son during the carnival season of 1629, as well as, in a singularly unfortunate choice, given the plague that was to sweep through Florence within seven months, three performances during carnival 1630 of a revival of Giovanni Maria Cecchi's *L'ammalata* [The sick girl], performed with musical *intermedi*.[51] On 1 March 1629, the Compagnia dell'Arcangelo Raffaello performed Jacopo Cicognini's *Il trionfo di David*.[52] Ferdinando II and Maria Magdalena, as well as the princes and princesses, attended this performance, the only one of these three plays for which they are known to have done so.[53] Girolamo Bartolommei's *Il riscatto d'Amore*, which was dedicated to Ferdinando II on 15 August 1629, takes as its subject matter the joyful return of Cupid after his abduction by women, haters of love, a possible commentary on the predominance of virgin martyr spectacles during the period of the regency. Jupiter intercedes and, with the help of his agent Venus, wins Cupid's release by tricking the women.[54]

Bartolommei's play, like the other spectacles dating from after the regency, focuses on issues of male agency and male power. In particular, *Il trionfo di David* symbolized a return to male rule in its choice of subject matter, for the personage of David had long been a symbol of Florentine virility—first for

50. Eric Cochrane, *Florence in the Forgotten Centuries, 1527–1800: A History of Florence and the Florentines in the Age of the Grand Dukes* (Chicago and London, 1973), 196.

51. I-Fas, CRS 134, no. 2, fols. 48r, 50r–v, and no. 3, fols. 73v, 75v. Giuseppe Baccini mentions these performances (*Notizie di alcune commedie sacre rappresentate in Firenze nel secolo XVII* [Florence, 1889], 18–19) but gives incorrect dates.

52. John Walter Hill, "Oratory Music in Florence, pt. 1, *Recitar Cantando*, 1583–1655," *Acta musicologica* 51 (1979): 108–36, esp. 126.

53. I-Fas, CRS 162, no. 23 [*olim* 22], fols. 162r–164v, transcribed in Guido Burchi, "Vita musicale e spettacoli alla Compagnia della Scala di Firenze fra il 1560 e il 1675," *Note d'archivio per la storia musicale*, n.s., 1 (1983): 26–30. The court diary also mentioned the performance (I-Fas, Misc. Med., 11, fol. 232r), but Solerti apparently did not locate this description. Solerti interpreted literally the date of 1628 that was given as the year of the performance in the 1633 edition of the work, but the date follows the old Florentine calendar and actually took place in 1629.

54. I-Fn, Magl. VII.1386, fols. 83–130. Bartolommei retitled the work *L'amor castigato* and published it in his *Drammi musicali* (Florence, 1656).

the restored republic and later for the Medici grand dukes. As already noted, David shared his typology, in which a seemingly defenseless individual conquers a physically superior foe, with Judith, the protagonist of a regency spectacle in 1626. Just as in 1504 Donatello's *Judith* yielded its position outside the Palazzo della Signoria to Michelangelo's *David*, which was deemed a more fitting symbol of the virile republic, in 1629 David once again replaced Judith as a symbol of Florentine civic identity.

Documents for Chapter 6

Document 6.1. I-MOas, AF 59, unnumbered fascicle, n.p. Excerpt from a dispatch sent by Tiburtio Masdoni, resident ambassador from Modena, to the duke of Modena, 22 October 1628.

Il Ser.mo *Gran* Duca hà cominciato ad esercitare il Governo, et oltre l'haver rivocata la facoltà dell'armi và formando una Compagnia di Musici ecce*ll*enti per far capella senza haver'à servirsi più di quei del Duomo, et oltre l'haver fermo il Frescobaldi famoso con grossa provisione, ha presi anche altri al suo servizio.

The Most Serene Grand Duke has begun to exert his rule, and besides having revoked the right of arms, he is forming a company of excellent musicians to make a chapel without having to make any more use of these [musicians] of the duomo, and besides having secured the famous Frescobaldi with a huge provision, he has also taken others into his service.

Document 6.2. I-Fas, MDP 1703 (n.p.). Letter of Andrea Salvadori (Florence) to Dimurgo Lambardi (at Poggio a Caiano), 18 January 1627 [1628].

Conforme al comandamento della Ser.ma Arciduchessa nostra Sig.ra avvisatomi da V.S., intervenni alla prova della Comedia, la quale riuscì bene né vi mancorno Musici. Favorì ancora il Sig. Cardinale della sua presenza accioche andasse con quiete: fu invitato per il prossimo merco*ledì* stante la festa della Conversion di San Paolo, che viene martedì. Il tutto V.S. mi farà grazia far sapere a S.A.

In accordance with the command of the Most Serene Archduchess our Lady, reported to me by Your Lordship, I attended the rehearsal of the comedy, which succeeded well and musicians were not lacking. The Sig. Cardinal [de' Medici] also favored them with his presence so that all would proceed smoothly. He was invited for next Wednesday since next Tuesday is the Feast of the Conversion of Saint Paul. Your Lordship will honor me [if he would] make everything known to Her Highness. . . .

Document 6.3. I-Fas, Misc. Med., 11, fol. 221v. Court diarist's entry of 27 September 1628.

E perché la sera delli 28 stante nel Salone Grande delle Commedie si provava la Commedia che si doveva recitare alle Nozze del Du*ca* di Parma, la Sig.ra Arciduchessa che doveva *essere*

p*rese*nte quando si provava fece invitare *detto* Sig. Amb*asciato*re, et la Moglie, q*u*ali accettarno, et sentirno la sud*etta* Commedia incognitamente.

And due to the fact that, on the evening of the 28th in the Salone Grande delle Commedie, the comedy was rehearsed that had to be recited for the wedding of the Duke of Parma, the Lady Archduchess, who had to be present when it was rehearsed, invited the said Sig. Ambassador and his wife, who accepted and, incognito, heard the aforementioned comedy.

Document 6.4. I-Fas, MDP 119, fol. 307r (draft copy in MDP 6102 [n.p.]). Letter from Archduchess Maria Magdalena of Austria to Cardinal Ludovico Ludovisi, 2 May 1627.

Dovendosi al prossimo Autunno celebrare le nozze della Principessa Margherita mia Figliuola col Sig. Duca di Parma, et disegnandosi per maggiore espressione di Allegrezza di fare allora alcune feste, et rappresentazioni io desidererei di poter' havere il Cava*lier* Loreto Musico, et serv*itore* di V.S. Ill.ma, del cui virtuoso merito questa Casa altre volte s'è valuta con molta sua sodisfazione, et honore. Et ancorché io sappi di certo, che V.S. Ill.ma per il solito suo cortese affetto verso di me, non mancherebbe à quel tempo di favorirmene, con tutto però dubitando insieme, che fra tanto questo mio desiderio non possa esser prevenuto da altri, prego fin da hora V.S. Ill.ma di questo favore, il quale sarà tenuto da me in part*icolare* stima.

Needing to celebrate the marriage of my daughter Princess Margherita to the Duke of Parma next autumn, and planning, for the greatest expression of happiness, to present at that time some festivities and [theatrical] performances, I would like to be able to have Cavalier Loreto, Your Illustrious Lordship's musician [castrato] and servant, whose virtuous merit this House has at other times used to its great satisfaction and honor. And although I know for certain that Your Lordship, with his usual courteous affection toward me, would not fail to favor me with it at that time, nonetheless worrying that, in the meantime, this desire of mine could be preempted by others, I ask Your Illustrious Lordship right now for this favor, which will be held by me in particular esteem.

EXAMPLE 6.1. Marco da Gagliano, *La Flora* (Florence, 1628), 102, beginning of Zephyr's second lament: "Sharpest words, most pitiless arrows, which, as many as you are, pierce my soul. My lady is treacherous, my faith is betrayed, a traitor is she whom I love more than life. My faith is betrayed, I am deluded, and someone else enjoys my beautiful treasure, someone else rejoices, someone else is happy, and I die. O such fraud, such betrayal, I have never seen, nor never heard before. To call me inconstant and to be so unfaithful? 'O miserable [is] the lover who ever trusts in woman, O miserable [he] who believes that perfidy could ever have faith.'"

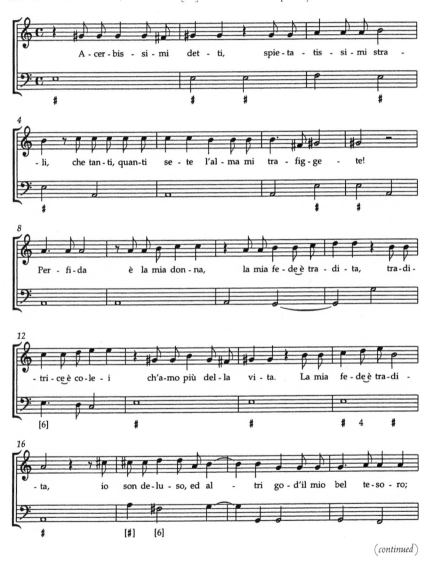

(*continued*)

EXAMPLE 6.1. (*continued*)

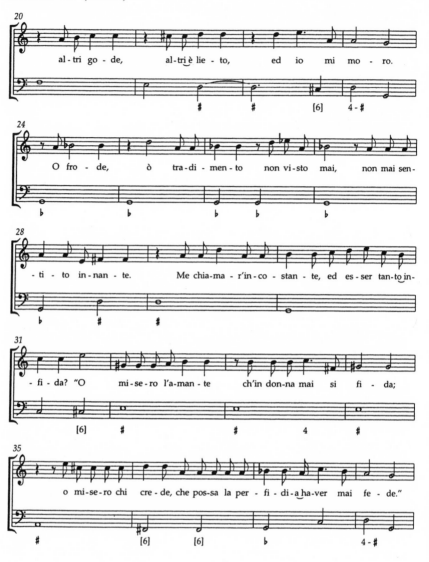

EXAMPLE 6.2. Jacopo Peri, *La Flora* (Florence, 1628), 127, Chloris's lament: "Fortunate Corilla, fortunate Lirindo, you follow the beautiful desire that enamors you. Leave me to die, leave me to grieve my betrayed faith and another's harsh deceit; leave me to die amid such great anxiety."

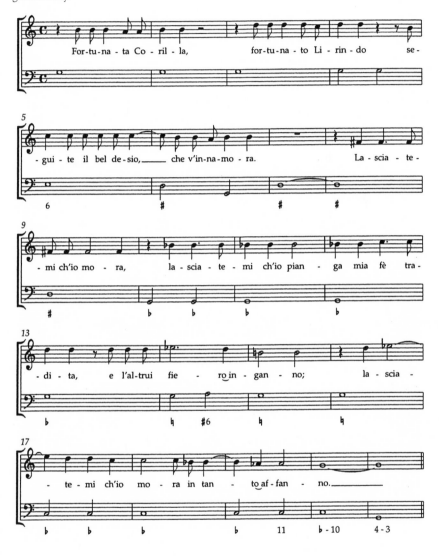

EXAMPLE 6.3. Marco da Gagliano, *La Flora* (Florence, 1628), 62–63, Venus and Cupid's second argument:

"[VENUS:] I have wanted precisely this: from now on learn not to be contrary to my wishes, proud and wicked little boy.

[CUPID:] Mother, for this I swear by the inviolable river Styx, I swear to exact a revenge so cruel for such an offense, that with sharp grief, today the whole world will feel the punishment.

[VENUS:] What can you do? I laugh at your proud boldness, plucked [i.e., flightless] Cupid. This gentle couple, Zephyr and Chloris, enjoy their pure passions, loving and being loved. And so that you no longer boast of giving others mourning, watch what I am going to do."

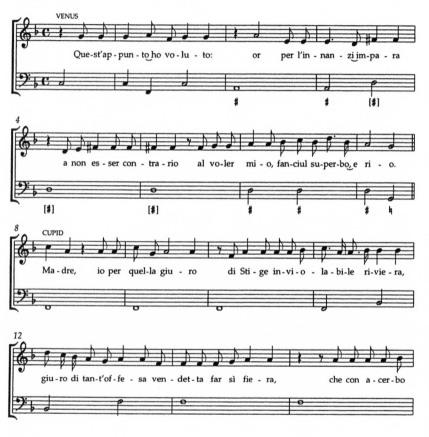

EXAMPLE 6.3. (continued)

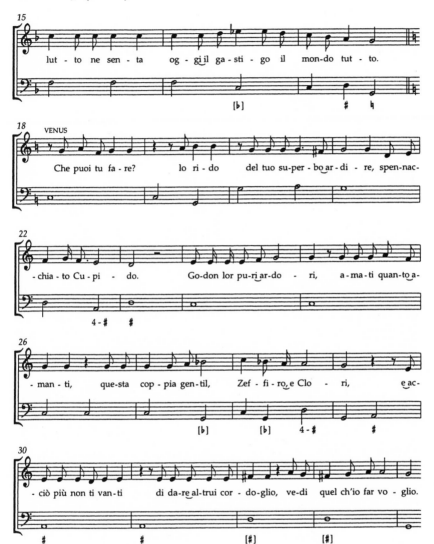

EXAMPLE 6.4. Marco da Gagliano, *La Flora* (Florence, 1628), 130–32, Venus concedes: "I am forced, finally, if I want to make Zephyr and Chloris happy in love, I am forced to put aside anger and pride, and instead of ruling, today it suits me to beseech. Come, and let proud Cupid be beseeched. (Although cruel, although perverse and wicked, ultimately he is my son.) No more, no more disdain, son, comfort of the heavens and of the gods: no more, no more disdain. Today you are vindicated enough. Behold, I come to placate you. Behold, I carry your beautiful torch from the heavens. I will shout at you no more, and I ask peace from you. Let it be your gift, not mine, the dear joy of a heart in love. I will discuss this no more: make happy whomever you want with your ardor. Come up into these arms, oh sweetest son. Come, because I want to give you on your lips and on your eyes, hundreds and hundreds and thousands and thousands of kisses."

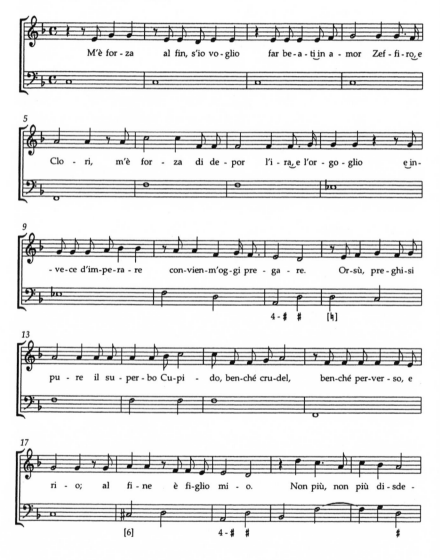

EXAMPLE 6.4. (*continued*)

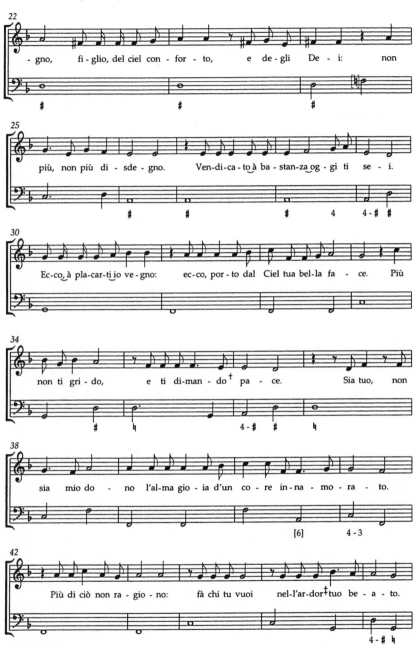

† Libretto: "domando"
‡ Libretto: "foco"

(*continued*)

EXAMPLE 6.4. (*continued*)

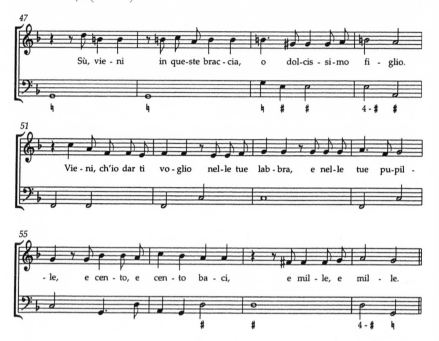

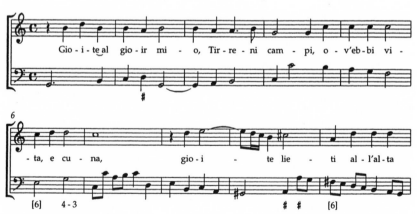

EXAMPLE 6.5. Jacopo Peri, *La Flora* (Florence, 1628), 140, Flora's final speech: "Rejoice at my joy, Tyrrhenian fields, where I had life and birth; rejoice happily at my great fortune. In your breast let a new, great city arise, named after me: Flora, who may govern the dear beautiful Etrurian countryside; Flora, place of glory and beauty. This [city], always glorious in the studies of Mars and Minerva, famous mother of heroes because of her magnanimous offspring, may she be the flower of Italy and the sun of Europe."

EXAMPLE 6.5. (*continued*)

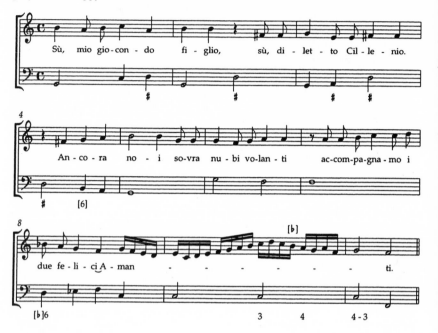

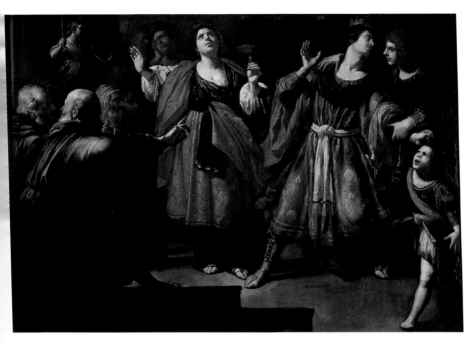

PLATE 1. Rutilio Manetti, *Massinissa and Sophonisba* (Florence, Uffizi)

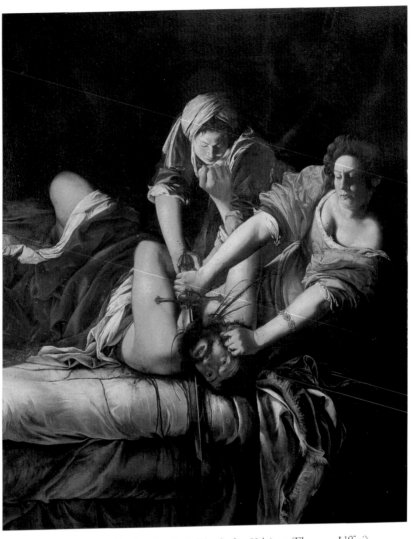

PLATE 2. Artemisia Gentileschi, *Judith Beheading Holofernes* (Florence, Uffizi)

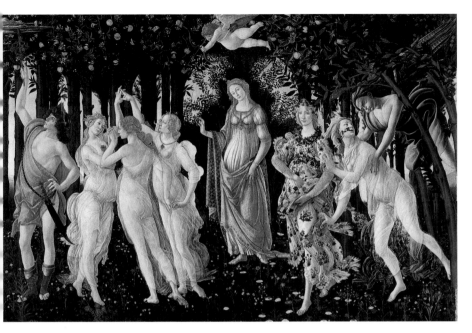

PLATE 3. Sandro Botticelli, *Primavera* (Florence, Uffizi)

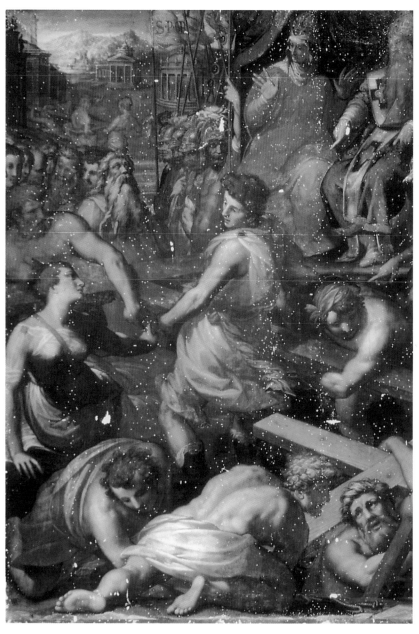

PLATE 4. Francesco Morandini, *Invention of the Holy Cross* (Florence, Museo del Cenacolo di Andrea del Sarto a San Salvi)

CHAPTER 7

"One of the most perfect unions of the spiritual and the temporal imaginable"

The Monastero di Santa Croce

Among the events that took place during the first years of Ferdinando's personal rule was the beatification hearing for Suor Domenica Narducci, better known as Domenica da Paradiso (1473–1553), who in 1513 had founded the Domenican Monastero di Santa Croce, commonly known as La Crocetta. During her lifetime Domenica had been venerated throughout the city as a holy woman, renowned for her visions, prophecies, and prayers on behalf of the city.[1] Christine of Lorraine claimed particular devotion to Domenica and her convent, and in 1624 she began her campaign for Domenica's beatification.[2] Both Christine and Maria Magdalena of Austria testified at the hear-

1. Gerardo Antignani, *Vicende e tempi di Suor Domenica dal Paradiso* (Siena, 1983), 243–45; Rita Librandi and Adriana Valerio, *I sermoni di Domenica da Paradiso: Studi e testo critico* (Florence, 1999); Lorenzo Polizzotto, "When Saints Fall Out: Women and the Savonarolan Reform in Early Sixteenth-Century Florence," *Renaissance Quarterly* 46 (1993): 486–525; Adriana Valerio, *Domenica da Paradiso: Profezia e politica in una mistica del Rinascimento* (Spoleto, 1992); Valerio, "La parole influente: Domenica da Paradiso (1473–1553)," in *Women Churches: Networking and Reflection in the European Context*, ed. Angela Berlis et al. (Kampen, 1995), 126–32; and Valerio, "Domenica da Paradiso e la mistica femminile dopo Savonarola," *Studi medievali*, ser. 3, 36 (1995): 345–54.

2. Ignazio del Nente, *Vita e costumi ed intelligenze spirituali della venerabil madre Suor Domenica dal Paradiso fondatrice del Monastero della Croce di Firenze dell'ordine di S. Domenico scritta dal Padre Fr. Ignazio del Nente del medesimo ordine*, 2d ed. (Florence, 1743), 377. This appears to be an unchanged edition of del Nente's earlier *Vita*, published in Venice in 1662 with a slightly different title. Unless stated otherwise, all quotations are from the 1743 ed. The fullest account of the beatification proceedings is in Giulia Calvi, *Storie di un anno di peste*, trans. Dario Biocca and Bryand T. Ragan Jr. as *Histories of a Plague Year: The Social and the Imaginary in Baroque Florence* (Berkeley, 1989), 199–226. The beatification was not approved; Urban VIII issued a decree to this effect on 15 July 1634. Antignani (*Vicende e tempi*, 224–27) recounts subsequent attempts in the eighteenth and nineteenth centuries.

ings, which began in late 1630. Christine alluded to the convent's dual purpose in her praise of its founder: "Yet she founded this convent and provided it with so many good rules and regulations that it seemed to us one of the most perfect unions of the spiritual and the temporal imaginable. It will certainly stand out for all those who, as we have often done, consider the rules and administration that she initiated."[3]

Although members of the Medici family had demonstrated limited support for the convent since the second half of the sixteenth century, Christine's efforts signal a new stage of interest, one determined to demonstrate Domenica's reciprocal concern for the grand dukes and their families. In the biography that the grand duchess commissioned from her confessor Ignazio del Nente, the former spiritual mother to many of the Savonarolan sympathizers who led the Florentine republics of 1494–1512 and 1527–30 was transformed into the "court saint" praised by the grand duchess.[4] Del Nente's account stressed Domenica's role in the increased political fortunes of the Medici, highlighting her predictions of the two instances when the Medici returned to power in the early sixteenth century. He appears to have invented incidents calculated to demonstrate her fondness for the family, in particular Duke Cosimo I, whose consolidation of Medici control over the city occurred during the final two decades of Domenica's life. Del Nente provided elaborate descriptions of her visions of assassination attempts on the life of Duke Cosimo I, which she then thwarted by means of prayers and advance warning.[5]

3. "Ha fondato questo monastero et ordinatolo con sì belle regole et ordini che ci pare una delle più perfette economie sì nello spirituale come nel temporale che si potessero inventare e certissima sarà chiunque considerarà, sì come più volte noi haviamo fatto, l'ordini e i modi di governo che essa ha istituito" (I-Rasv, S. Congregazione dei Riti, *filza* 776, fol. 123r, in Calvi, *Storie di un anno di peste*, 219, translation in *Histories of a Plague Year*, 205).

4. Del Nente was the prior of the Dominican monastery of San Marco, and his biography seems modeled on early sixteenth-century lives of what Gabriella Zarri has termed "living saints," many of them, like Domenica, Dominican tertiaries ("Living Saints: A Typology of Female Sanctity in the Early Sixteenth Century," in *Women and Religion in Medieval and Renaissance Italy*, ed. Daniel Bornstein and Roberto Rusconi, trans. Margery J. Schneider [Chicago, 1996], 219–303). Adriana Valerio (*Domenica da Paradiso*, 59–76) asserts that del Nente's claims are without documentary basis, although subsequent biographers have adopted them uncritically, for example, Aladino Moriconi's *La venerabile Suor Domenica dal Paradiso: La popolare mistica taumaturga del secolo d'oro fiorentino, 1473–1553* (Florence, 1943).

5. Del Nente, *Vita*, 321–22, 345–46. Del Nente claimed to have based his biography on the *Vita* by Domenica's confessor, Francesco da Castiglione (d. 1542). Curiously, another *Vita*, by Filippo Maria Baldassare Scarlatti, also claims to be copied from Castiglione (with the additions of Raffaele Talenti, Castiglione's successor as confessor to the convent) but makes no mention of any visions on behalf of the grand duke (I-Fr, Moreniana, 331).

Each incident confirms the reverend mother's particular fondness for the duke and her concern for both his welfare and the related political health of the city. For example:

> She was praying at this time with much charitable affection for the health of Duke Cosimo, and she saw his danger by means of the image of some men who were striving to break down an opposing wall, which was like a solid defense against a whirlpool of deep water, so that, with that wall ruined, the full current of that swollen stream could flow with vehemence against it, whence, warned mercifully by God with that fearsome image, she set herself to multiply her prayers for his safety. And meanwhile she warned the mother of the duke, so that he would not overlook the remedies of the prayers of God's servants. After a few days the Mother Suor Domenica came out into the choir completely pallid and sorrowful; convening there all the sisters, she exhorted and obliged them to pray for Duke Cosimo and for his city; and then, without sleep, she continued her orations throughout the night and was foretold of the danger; because at midnight a Spaniard attempted maliciously to wound the duke with a dagger, but he was immediately anticipated, thrown back, and killed by the duke's bodyguards. Thus God in his mercy and because of the prayers of the just and of our Mother preserved unhurt such a valorous and just prince for the city and for his state.[6]

The Medici family acknowledged the nuns' prayers on behalf of Cosimo by sending them four lire every three months in his memory, beginning 17 February 1559.[7] Thus, by the second half of the sixteenth century, that is, after Domenica's death, the relationship between her followers and the Medici family was seen to be reciprocal: the Crocetta bestowed spiritual legitimacy

6. Del Nente, *Vita* (321–22):

Orava in questo tempo con molto affetto di carità per la salute del Duca Cosimo, e vide un suo pericolo per immagine d'alcuni, i quali si sforzavano di fiaccare un muro opposto, come saldo riparo a un gorgo d'acqua profonda, acciocchè rovinata quella parete, sboccasse con impeto contro di lui tutta la corrente di quella fiumana; onde avvertita pietosamente da Dio con quella figura di timore, si pose a moltiplicare le preci per la sua salvezza. Ed in tanto mandò ad avvisare la madre del Duca, che non trascurasse i rimedi dell'orazioni de' servi di Dio. Dopo alcuni giorni uscì la madre Suor Domenica in coro tutta pallida e accorata, dove convocando tutte le Suore l'esortò ed obbligò a orare per lo Duca Cosimo, e per la sua Città; ed ella poi, senza sonno proseguì tutta la notte l'orazioni, e fu presaga del pericolo; perchè a mezza notte uno Spagnolo tentò malignamente di ferire con un pugnale il Duca; ma fu subito da' famigliari del Duca prevenuto, rigettato ed ucciso. Così Iddio per sua pietà, e per l'orazioni de' giusti e della nostra Madre conservò salvo alla Città, e al suo Stato così valoroso e giusto Principe.

7. I-Fas, Croc 61, opening 59.

on the members of the Medici family, and they in turn conferred honors and privileges on the convent.[8] The Medici became the Crocetta's most important patron, which in turn influenced directly the convent's relationships with its own clients. And both parties clearly felt that it was in their best interests to promote the historical interrelationships between the Medici family and the founder of the Crocetta, Domenica da Paradiso.

Domenica da Paradiso

Yet during her lifetime, Domenica's relationship with the Medici family was much more ambiguous. Born on 8 September 1473 in the Florentine suburb of Paradiso, she arrived in Florence in December of 1499, during a period of Medici exile, and she and her informal group of female followers allied themselves with the followers of the recently executed Savonarola known as the Piagnoni, from whom Domenica received spiritual guidance.[9] On 28 April 1506 Fra Jacopo da Sicilia, vicar-general of the Tusco-Roman Congregation and another Savonarolan sympathizer, gave Domenica permission to wear the habit of a Dominican tertiary.[10] She became renowned throughout Florence for her prophecies.

Relations between Domenica and the friars of San Marco had cooled considerably by late 1509, apparently due to Domenica's determination to expose the fraudulent claims of Dorotea da Lanciuole, another Dominican mystic. On 22 October 1509, the master general of the Dominican Order, Fra Tommaso da Vio Gaetano, ordered the friars to cease all contact with the headstrong Domenica. Four days later, Florentine archbishop Cosimo de' Pazzi approved the addition of a distinctive small red cross to Domenica's habit, while also confirming that thereafter she and her followers would be subject to the archbishop, rather than the Dominican order.[11]

8. Polizzotto ("When Saints Fall Out," 522n143) has also noted that Domenica's increasingly close relationship with the Medici family actually altered the nature of Crocetta: while Domenica and many of her followers were drawn from the peasant class, after 1516 girls and women from the city's most prominent families began to enter Crocetta. On the mutually beneficial relationship enjoyed by convents and political rulers, see Gabriella Zarri, "Monasteri femminili e città (secoli XV–XVIII)," in *Storia d'Italia*, Annali 9, *La chiesa e il potere politico dal Medioevo all'età contemporanea*, ed. Giorgio Chittolini and Giovanni Miccoli (Turin, 1986), 380–81.

9. Polizzotto, "When Saints Fall Out," 486–523; Valerio, *Domenica da Paradiso*, 21–40.

10. His Savonarolan sympathies eventually led to Fra Jacopo's removal from his post as vicar-general; see Lorenzo Polizzotto, *The Elect Nation: The Savonarolan Movement in Florence, 1494–1545* (Oxford, 1994), 172n9, 173.

11. Polizzotto, "When Saints Fall Out," 519.

The archbishop's decree also stipulated that Domenica might found a convent, and it guaranteed archiepiscopal support for the endeavor. Domenica purchased land just east of the SS. Annunziata in January 1511, and construction began on 9 February. The Monastero di Santa Croce would be bounded on the south by the Via della Crocetta (now Via Laura) and on the north by the Via del Mandorlo (now Via G. Giusti). On the east ran the Via degli Orti (now Via della Pergola), while on the west was Via San Sebastiano (now Via Gino Capponi).[12] The next Florentine archbishop, Giulio de' Medici, helped fulfill the promises of his predecessor. Domenica and her fourteen followers processed into their new home on 28 April 1513, and Leo X granted the brief of approval on 27 May 1515.[13] The convent church was completed shortly afterward, dedicated by the archiepiscopal Vicar Pietro Andrea Gammaro on 8 June 1515, and on 18 October of that year, twenty women received the distinctive habit with the red cross.[14]

Given the turbulence of the first decades of the sixteenth century, Domenica's prophecies concerning the city's relationship with the Medici family seem unsurprising. She predicted the destruction of the Florentine republic in 1512 just days before the Medici family returned to take control of the city.[15] In 1530 she foresaw the second, and final, return of the Medici, and her predictions influenced the actions of Florentine citizens, as recorded by Bernardo Segni.[16] According to Segni, his father Lorenzo advocated the republic's reconciliation with the Medici mainly on the advice of Domenica, who had persuaded him of the inevitability of Medici rule, cautioning of the damage that would result if the return needed to be accomplished through force.[17]

In both cases Domenica—who claimed not to be political—prophesied, but did not endorse, Medici control of the city.[18] Yet she did benefit from

12. Moriconi, *La venerabile Suor Domenica*, 487.

13. Del Nente, *Vita*, 224, repeated in Giuseppe Richa, *Notizie istoriche delle chiese Fiorentine*, 10 vols. (Florence, 1754–62; reprint, Rome, 1972), 2:271–72; Moriconi, *La venerabile Suor Domenica*, 514; and Antignani (*Vicende e tempi*, 76–77), who includes the names of the fourteen women who processed with Domenica into the convent.

14. Antignani, *Vicende e tempi*, 82–83.

15. Valerio, *Domenica da Paradiso*, 65, gives the date as 22 August 1512.

16. Bernardo Segni, *Storie fiorentine*, 3 vols. (Milan, 1805), 1:192, cited in Calvi, *Histories of a Plague Year*, 208. See also Moriconi, *La venerabile Suor Domenica*, 598–601.

17. "Di questo son io ben consapevole, che ella diceva, che i Medici avevano a ritornare, e che la Città non pigliando da sé quel partito, lo piglierebbe per forza con infinito suo danno" (Segni, *Storie fiorentine*, 1:192). For more on this account, see Calvi, *Histories of a Plague Year*, 208–9.

18. Valerio, *Domenica da Paradiso*, 61–64.

their regained power. She and her fourteen followers processed into their new home just eleven days after a Medici pope—Leo X—named his cousin Giulio as the new archbishop of Florence. When Fra Tommaso Caiani brought charges of heresy against Domenica in 1519, her confessor Francesco Onesti da Castiglione claimed that the charges were in retribution for Domenica's refusal to plot against the Medici. She was subsequently cleared.[19]

In the sixteenth century, Florentines viewed the reverend mother as a visionary preacher and advocate for the city, whose visions and prayers had saved Florence from natural calamities such as torrential rain and plague. One of the most significant and remembered of these intercessions concerned the Florentine plague of 1527: according to the account related by del Nente, while Domenica knelt in prayer before an image of the Blessed Virgin Mary—an image that had saved the convent from fire in 1515—the Virgin appeared to her and told her that the plague would end if she would make the sign of the cross over the city. Domenica implored both her confessor and the other nuns in the convent to do as the Virgin asked, the air of the city soon cleared itself of the contagion, and by 15 October only two cases of the disease remained.[20]

Music and Art at La Crocetta before 1584

The miraculous image of the Madonna was not the only artwork that the Crocetta possessed, although the incomplete nature of the surviving financial records from before about 1580 prohibits us from knowing fully the extent to which the nuns patronized art and music during Domenica's lifetime.[21] A document entitled "Obblighi di Messe," copied in 1764, confirms that Domenica established a tradition of celebrating the following feasts with a sung mass, that is, in plainchant: Christmas, Holy Thursday through Saturday, Easter, the Invention of the Holy Cross (3 May), Pentecost, the feast day of Saint Dominick (4 August), the Assumption of the Blessed Virgin Mary (15 August), the Exaltation of the Cross (14 September), All Saints' Day (1 November), and the Commemoration of the Dead (2 November).[22] Sung

19. Polizzotto, *The Elect Nation*, 309.

20. Del Nente, *Vita*, 275–76, repeated in Richa, *Notizie istoriche*, 2:274.

21. The convent's financial documents, court records, and a few miscellaneous items are located in the Archivio di Stato in Florence. Although a handful of these documents date from the period of Domenica's lifetime, the majority are from 1580 onward. Antignani (*Vicende e tempi*, 249–55) has summarized the contents of those manuscripts still in the possession of the reconstituted Monastero di Santa Croce in Florence.

22. I-Fas, Croc 102, ins. 6, n.p.

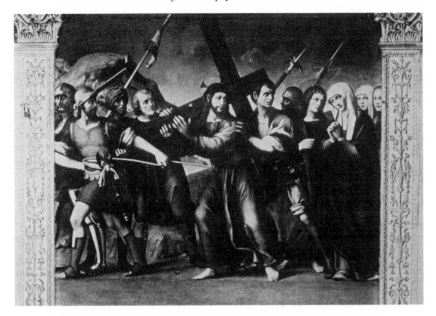

FIGURE 7.1. Antonio del Ceraiolo (?), *Way to Calvary* (Florence, Santo Sprito)

masses also celebrated a novice's profession of vows, as well as the nuns' contribution to the Forty Hours rotation. In addition, the list continues, it had become usual for the convent to offer a sung Mass on 4 May to commemorate deceased nuns. The same document notes that for both feasts of the Holy Cross, priests sang the Mass, stipulating that for the Exaltation of the Cross, the priests came from the Congregation of the Visitation.

Even fewer records document commissions to Florentine artists during the first sixty years of the convent's existence, a paucity of evidence exacerbated by the dispersal and destruction of the artworks themselves after the convent's suppression in 1866–67. Thanks to the extensive work undertaken in the eighteenth century by Giuseppe Richa and more recently by Walter and Elizabeth Paatz, we do have some knowledge of the convent's architecture and its artistic possessions.[23] One of the earliest works is the *Way to Calvary* altarpiece now in the Antinori Chapel in Florence's Santo Spirito (fig. 7.1). Art historians have attributed the painting variously to Antonio del Ceraiolo (fl. 1520–38), Ridolfo del Ghirlandaio (1483–1561), or their student Michele di Ridolfo del Ghirlandaio, also known as Michele Tosini (1503–77). Although all recent scholarship notes that before its removal to Santo

23. Richa, *Notizie istoriche*, 2:263–75; Walter Paatz and Elisabeth Paatz, *Die Kirchen von Florenz: Ein kunstgeschichtliches Handbuch*, 6 vols. (Frankfurt am Main, 1940–55), 1:702–9.

Spirito the painting resided in the Crocetta, no contemporary source con-
firms this.[24]

Two other paintings can be placed with certainty in the Crocetta during
Domenica's lifetime: a crucifixion scene, now ruined, including Mary, John, a
nun, and a monk, completed by an anonymous painter circa 1520 on the back
wall of the convent structure, and a now lost oil painting of the Last Supper
by Giovanni Antonio Sogliani (1492–1544), located in the refectory.[25] To-
gether these three works confirm the convent's veneration of the cross and es-

24. The first scholar to assign this painting's provenance to the Crocetta appears to be
Géza de' Francovich, based on a personal communication from a Padre Bellandi. Francovich
attributed the work to Michele di Ridolfo del Ghirlandaio; see "Benedetto Ghirlandaio,"
Dedalo: Rassegna d'arte, year 6, 3 (1925–26): 708, 737n5; repeated in Paatz and Paatz, *Die Kirchen,*
1:707; 5:145, 194n196. Everett Fahy ("Les cadres d'origine de retables florentins du Louvre,"
Revue du Louvre et des Musées de France 26 [1976]: 14n9) first attributed the work on stylistic
grounds to Antonio del Ceraiolo. Fahy also suggested that the Crocetta work was actually
commissioned by the Antinori family, who seemed to have a particular fondness for this oth-
erwise infrequently depicted scene, having commissioned two additional works (one by Bia-
gio d'Antonio, originally in the Antinori chapel and now in the Louvre; and the other by Ri-
dolfo Ghirlandaio, originally for the church of San Gallo, now in the National Gallery of
London). The best documented history of the painting is by Elena Capretti, "La pinacoteca
sacra," in *La chiesa e il convento di Santo Spirito a Firenze,* ed. Cristina Acidini Luchinat and Elena
Capretti (Florence, 1996), 245, 290. Capretti proposes the following chronology: in the 1480s,
Biagio d'Antonio painted a version of the topos for the Antinori chapel; some decades later,
during the first half of the sixteenth century, Antonio del Ceraiolo painted an altarpiece de-
rived from the Santo Spirito work, and this work belonged to the Crocetta; Biagio's work was
shipped to Paris in 1812, where it still resides in the Louvre, and it was replaced in Santo Spi-
rito by Antonio del Ceraiolo's version. Heidi Josepha Hornik repeats the more traditional at-
tribution to Michele del Ghirlandaio ("Michele di Ridolfo del Ghirlandaio [1503–77] and
the Reception of Mannerism in Florence" [Ph.D. diss., Pennsylvania State University, 1990],
222–23 and fig. 10).

25. Giorgio Vasari, *Le vite de' più eccellenti pittori, scultori ed architetti,* in *Le opere,* ed. Gaetano Mi-
lanesi, 9 vols. (Florence, 1906), 5:125; repeated in Richa, *Notizie istoriche,* 2:272–73; Paatz and
Paatz, *Die Kirchen,* 1:705, 707. Sogliani may have made something of a specialty in refectory
scenes: among his best known works are the frescoes of Saint Dominick in the refectory of
San Marco in 1536, specifically the *Mensa di San Domenico.* See Anna Forlani Tempesti, "Angelo
in piedi," in *Il primato del disegno* (Florence, 1980), 211. Although the small *Visitation* painting (be-
fore ca. 1475) by Pietro Perugino (ca. 1448–1523), now in the Gallery of the Accademia in
Florence, belonged to the Crocetta until its suppression (Pietro Scarpellini, *Perugino* [Milan,
1984], 72), it may have come into the convent's possession only in the later eighteenth cen-
tury: neither Richa nor Paatz and Paatz include it in their lists of the works belonging to the
Crocetta.

pecially the events immediately preceding the Crucifixion. Female figures may be present in a work's composition, but they are not its focus. This situation would change drastically—and publicly—in the paintings that the Crocetta commissioned for its exterior church in the 1580s.

Expansion and Renovation:
The Crocetta and Its Artistic Commissions, 1584–93

Although Domenica da Paradiso died in 1553, her fame continued to grow, as did the convent she founded. On 14 September 1573, the Feast of the Exaltation of the Cross, Archbishop Antonio Altoviti consecrated the exterior, public church, granting indulgences to the faithful who attended the church on that day or its anniversaries.[26] Around this same time the nuns apparently commissioned a fresco for their garden wall from Alessandro Fei, also called Barbiere (1543–92), in which was depicted the resurrection of Christ amid the Blessed Virgin Mary, Saint Mary Magdalen, and Domenica da Paradiso. Raffaello Borghini mentions the work, which he describes as "the resurrection of Christ with many figures in various postures" [*la Resurrettione di Christo con molte figure in variate attitudini*] in his *Il riposo*, whose publication date of 1584 gives the *terminus ad quem* for the fresco.[27] The fresco, now badly deteriorated, provides an important link between the paintings executed during the lifetime of Domenica and the more numerous works that date from later in the century: although the painting depicts an incident from the life of Christ, female figures now assume a much more prominent role.

This trend would continue into the next decade. In 1584 the nuns of the Crocetta undertook an expansion of their external church, which was to be accomplished by building a new wall between the choir and the internal church, which at that time housed Domenica's body. Cardinal Alessandro de' Medici, first cousin to the deceased Grand Duke Cosimo I and currently archbishop of Florence (later Pope Leo XI), ordered the casket opened in front of witnesses, and the body was discovered to be solid and intact. The archbishop commissioned a new casket for the reclothed body, whose head was

26. Antignani, *Vicende e tempi*, 251–52.

27. Raffaello Borghini, *Il riposo* (Florence, 1584; reprint, Milan, 1967), 634. See also Paatz and Paatz, *Die Kirchen*, 1:703, 705. Richa (*Notizie istoriche*, 2:272) notes that the figures' "belle attitudini" were also much respected by Vasari, although the praise does not appear in his *Vita*. If Richa is correct, then the *terminus ad quem* can be moved forward to 1574, the year of Vasari's death.

now adorned with a floral garland, her body similarly surrounded by roses and lilies.[28] On 7 April 1585 the new sepulcher was interred in a small room to the left of the main altar.[29]

The discovery of Domenica's uncorrupted body during the 1584 enlargement seems to have precipitated a new wave of artistic activity on behalf of the convent's exterior church, including commissions for frescoed decorations and altarpieces for the central and two side altars. Like the works dating from the first half-century of the convent's existence, the paintings reflect the central importance of crucifixion imagery to the devotional life of Crocetta's nuns. But these later works fulfilled a different purpose, for they were intended for the exterior church, that is, as one means by which the nuns could relay their values to the outside world. Several of the paintings celebrate the convent's founder with a particular emphasis on her powerful connections to both the celestial and political realms, while others, in a striking elaboration on the themes favored earlier by the nuns, stress women's involvement with the history of the holy cross.

The Crocetta's surviving financial records confirm that between 1584 and 1586 the convent paid two artists—Francesco Morandini, known as il Poppi (1544–97) and Giovanni Balducci, called Cosci (ca. 1560–after 1631)—a total of roughly 300 scudi for three altarpieces, facade decorations, and frescoes.[30] Only the altar paintings survive, now housed in the Museo del Cenacolo di Andrea del Sarto a San Salvi.[31] But documentary evidence and contemporary accounts allow us to confirm the content of all the works. The lost paintings are all by Balducci: besides the facade sgraffito (a technique in which plaster or some other soft medium is scratched in order to reveal the

28. Del Nente, Vita, 376. Calvi (Histories of a Plague Year, 215) has identified the types of flowers based on the transcript of the canonization proceedings.

29. Richa, Notizie istoriche, 2:265. Richa incorrectly suggests that Christine's veneration of Domenica began in 1584, i.e., five years before her marriage to Ferdinando.

30. Croc 20, fol. 1r, records a payment of £280 on 1 June 1585 to "Maestro Giovanni di Bastiano Balducci pittore, sono per resto di Pitture fatte nella nostra Chiesa; che tutto ascende alla somma di £602 portò da dì 31 d'Ottobre sino à detto dì." The same book later records payments to Francesco Morandini da Poppi and his apprentice (garzone) for the other two altarpieces at 100 scudi each, first noted by Alessandra Giovannetti, ed., Francesco Morandini detto il Poppi: I disegni, i dipinti di Poppi e Castiglion Fiorentino (Poppi, 1991), 172. She cites the following documents: Croc 4, fols. 165v, 174v; Croc 20, fols. 2r, 3v, 12v [for the Invention], 41v, 45r, 51v, 60r [for the Crucifixion]; Croc 37, fols. 8v, 9r. She also notes an additional notice of a payment to Balducci (Croc 4, fol. 155r) in Francesco Morandini detto il Poppi (Florence, 1995), 63n5.

31. Serena Padovani and Silvia Meloni Trkulja, Il cenacolo di Andrea del Sarto a San Salvi: Guida del Museo (Florence, 1982), 34–38 and plates 12–14.

colored undersurface), he decorated Domenica's new tomb with two an-
gels "of excellent coloring" [*di ottimo colorito*] according to Richa, and he fres-
coed the apse vault with four scenes from Christ's passion and a depiction of
Pope Leo X offering the Breve della Fondazione to a kneeling Domenica da
Paradiso.[32]

The major commissions, however, were for the three new altarpieces: Bal-
ducci's *Coronation of the Virgin with Angels,* Francesco Morandini's *Invention of the
Holy Cross,* and the same artist's *Crucifixion.*[33] These three paintings stress the
significant role women played in the history of the Catholic church. Like his
fresco commemorating the foundation of the convent, the first work to be
completed—Balducci's altarpiece for the right side chapel—would have car-
ried potent reminders of the convent's own history and inhabitants. The
painting was intended to surround the miraculous Madonna believed to have
been the site of the vision that allowed Domenica to stop the progress of the
Florentine plague of 1527.[34] By locating the tabernacle containing the image
within an altarpiece in the public church, the convent reminded the Floren-
tine faithful of the efficacy of nuns' prayers and their city's indebtedness to
the convent.

Angels dominate the composition (fig. 7.2). From the heavens, God the
Father, the Holy Spirit (in the form of the dove), and angels look down on
the now absent Madonna and Child, while two putti appear poised for her
coronation. These putti are balanced by the two at the bottom of the paint-
ing, whose banner reads "GLORIA IN EXCELSIS DEO." In the guise of ide-
alized young women, fourteen garlanded angels, seven on each side, adore the
Blessed Virgin while holding Marian attributes.[35] Their faces may have re-
minded the nuns' relatives of the presence and prayers of their young kins-
women behind the convent grate.

32. Richa, *Notizie istoriche,* 2:273 (although incorrectly naming the pope Leo XI); Paatz and
Paatz, *Die Kirchen,* 1:705–6.

33. Filippo Baldinucci (*Notizie dei professori del disegno da Cimabue in qua,* ed. Ferdinando Ranalli,
5 vols. [Florence, 1845–47], 3:92–93) mistakenly credits Balducci with all three altar paintings.

34. After the convent's suppression in the late nineteenth century, the nuns took the im-
age with them, and it is now located in the reconstituted monastery; see Antignari, *Vicende e
tempi,* 233.

35. Padovani ("Giovanni Balducci, detto il Cosci," in *Il cenacolo di Andrea del Sarto,* ed. Pado-
vani and Trkulja, 37) erroneously names this painting *Gloria di Angeli e Santi,* but all of the figures
(except God) clearly have wings, while none wears a halo. Richa (*Notizie istoriche,* 2:273) iden-
tifies the work as "gli Angioli, che mettono in mezzo la miracolosa Immagine di Maria, che
sull'Altare più volte donò tante somme d'oro, e d'argento alla Venerabil Fondatrice." I would
like to thank Professor Michael Stoughton for his insightful comments on this painting.

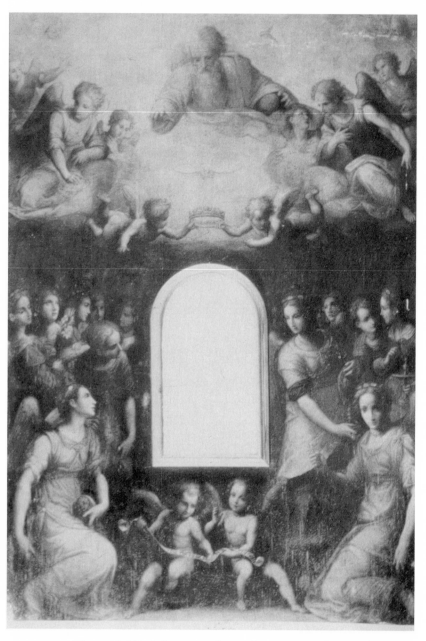

FIGURE 7.2. Giovanni Balducci, *Coronation of the Virgin* [now separated from the painting] *by God the Father with Angels* (Florence, Museo del Cenacolo di Andrea del Sarto a San Salvi)

Francesco Morandini executed the two remaining altarpieces. He presumably completed the painting for the high altar by 2 July 1585, the date on which nuns paid eight priests, six sopranos, and four clerics for the altar's consecration, and on 6 July 1585 the nuns paid Morandini £266, augmenting a £210 installment from the previous month.[36] The painting's placement in the center of the apse would have rendered it the most visible to the outside world, and for its subject the nuns of Crocetta chose the invention of the cross, in commemoration of the convent's titular feast (plate 4). Cruciform imagery fills the composition, from the depiction of the crucifixes themselves to the intersecting pikes of the soldiers, as well as the crossed direction of the arms of Macarius, bishop of Jerusalem, and the empress Saint Helen, who was believed responsible for finding the cross and returning it to Christendom.[37] The nuns of the Crocetta clearly intended to emphasize the empress's role in this historic and, for the convent, self-defining event, as can be seen through comparison of Morandini's finished work with a preparatory drawing for the painting (fig. 7.3).[38] In the earlier sketch, while Helen and Macarius oversee the procession of the crucifixes from their seats in the upper-right corner, the bishop's central position at the termination of the crossbeam seems to grant him the greater authority. The nuns may have indicated their dissatisfaction with this composition, for in the finished altarpiece the painter reversed the positions of the two rulers, moving Macarius toward the margin while highlighting Helen, then confirming her importance by means of her vivid red gown, which immediately captures the eye of the viewer.

Morandini also included prominent female figures in his other altarpiece, the *Crucifixion* intended for the left chapel, for which the convent paid him 100 scudi in 1586 (fig. 7.4).[39] In Richa's description of the convent's paintings, he singled out this work for special praise, while also correcting Baldinucci's earlier incorrect attribution to Balducci.[40] The light that illuminates the painting's lower-right corner highlights the sorrowful Marys as they comfort

36. I-Fas, Croc 20, fols. 2r–3v. These documents are also cited in Giovannetti, *Francesco Morandini*, 104. Giovannetti reports that the convent paid Morandini 100 scudi for this altarpiece; I have been able to find payments totaling only 68 scudi (£210 + 266, at 7£/scudo).

37. The figures have traditionally been identified as Helen and Constantine. The correct identification of the male figure as Macarius appears in Massimiliano Rossi, "Francesco Bracciolini, Cosimo Merlini e il culto Mediceo della croce: Ricostruzioni genealogiche, figurative, architettoniche," *Studi seicenteschi* 42 (2001): 259n156.

38. Simonetta Prosperi Valenti Rodinò, ed., *Disegni fiorentini 1560–1640 dalle collezioni del Gabinetto Nazionale delle Stampe* (Rome, 1979), 16; Giovannetti, ed., *Francesco Morandini*, 30.

39. Giovannetti, *Francesco Morandini*, 105–6.

40. Richa, *Notizie istoriche*, 2:273.

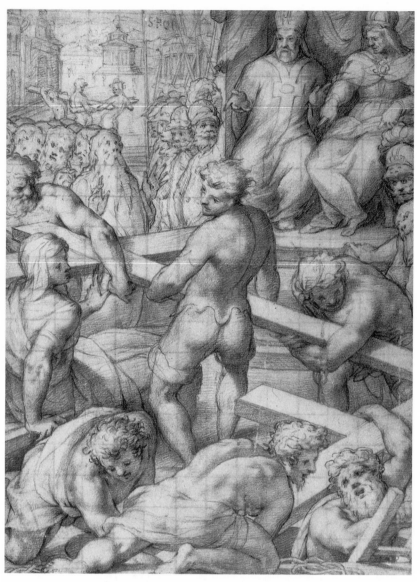

FIGURE 7.3. Francesco Morandini, preparatory drawing for the *Invention of the Holy Cross* altarpiece (Rome, Gabinetto Nazionale delle Stampe e dei Disegni).

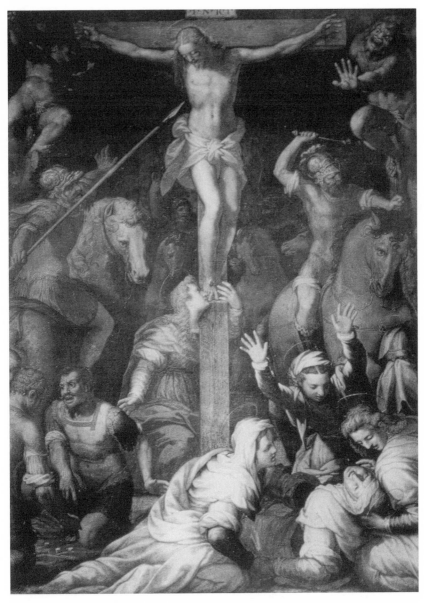

FIGURE 7.4. Francesco Morandini, *Crucifixion* (Florence, Museo del Cenacolo di Andrea del Sarto a San Salvi)

the Blessed Virgin, making these holy women the dramatic focus within the somewhat crowded composition.[41]

After the installation of these paintings in the exterior church, the nuns most likely would have been unable to see them clearly, due to the restrictions of clausura. The altarpieces were intended for public viewing, and they served to communicate the history and values of the convent to the citizens of Florence. The various construction projects of the next decade continued to emphasize locations in which existed the greatest permeability between the cloister and the outside world—the church and the parlor. By early 1592 builders completed a new wall separating the nuns' choir from the exterior church, and the convent paid Agostino Ciampelli (1565–1630) £280 to decorate the grate through which the nuns might view the high altar, as well as for painting the arch and draperies in the church.[42] The nuns also had a second parlor built—work that stretched from at least May 1593 to the beginning of 1594—and once again they called on Ciampelli to provide the necessary artwork. On 13 November 1593 he earned an additional £336 for painting a confessional inside the convent, an *Annunciation* on the secular side of the new parlor grate, and the arms of the convent on both sides of the same grate.[43]

Music at the Crocetta, 1593–1647

The noise and disruptions of construction would have dominated day-to-day life at the Crocetta for much of 1592–94. But this period also witnessed the emergence of a new, sweeter sound—the music of instruments and voices, which complemented the newly expanded church and offered an aural testament to the convent's new prestige as an institutional patron. After three-quarters of a century of celebrating the Mass and Office with plainchant, on 3 May of 1593 the nuns of Crocetta highlighted their titular feast with polyphony. Of the roughly 67¾ lire spent on the occasion, nearly two-thirds went for music: "£40.14 to the musicians and to the organist for Mass and Vespers in music on the day of the Holy Cross, and [that is] £6 to the maestro of said music, £26.13.8 [i.e., 26 lire, 13 soldi, 8 denari] to ten singers at four *giuli* (= £2.13.4) a head, £5.6.8 to the organist, and £2.13.8 to two friars from the Annunziata for singing just in the morning" (doc. 7.1, fol. 67r). The

41. Giovannetti, *Francesco Morandini*, 55, 105–6.

42. I-Fas, Croc 21, fol. 25v.

43. Croc 21, fol. 88v. The expenses for the new parlor totaled more than £1,500 in fiscal year 1593 (Croc 37, opening 217), with most of the construction taking place from May 1593 (Croc 21, fol. 68v) to March 1594 (Croc 21, fol. 95r).

convent's other principal feast commemorated the consecration of the convent church, whose anniversaries (referred to as the *Festa della Sacra*) were celebrated on the feast of the Exaltation of the Cross (September 14). In September 1593 the nuns nearly doubled the amount they had spent on music just four months earlier: "£70.13.4 to musicians [i.e., adult singers] for two Vespers and High Mass in music, [plus] £10 to four sopranos, £37.6.8 to players of various instruments, namely, the transverse flute, the trombone, the violin, the viola [da gamba?], the cornetto, the lute, and a contralto, and £11 to the priests for the ordinary chorus" (doc. 7.1, fol. 83r). Thus began the Crocetta's emergence as a patron of concerted sacred music, a position it would maintain, albeit at continually reduced levels, until 1647.[44]

The account books for the Crocetta reveal that the convent spent the most money on concerted music during the first years it began hiring outside musicians: in 1593 the nuns paid £158.14 to singers and instrumentalists, while in 1594 they spent £165.13.4 (table 7.1).[45] These totals are considerably higher than the fifteen-year average (1593–1607) of approximately £123 per year. Except for the first year of concerted music, the convent typically spent more on the feast of the Invention of the Cross than it did for the feast commemorating the foundation of its church: the fifteen-year average for the Invention feast is £67 per year, by contrast to the Exaltation feast's £55 per year average. The greater devotion of financial resources to the feast of the Invention of the Cross reflects its priority as the titular. This feast's association with music dates from the very early years of the convent, when it provided the temporal location for one of the convent's miraculous events—one that both corroborated the importance of the feast to the Crocetta and provided the celestial authority for celebrating that connection with music. Del Nente related the incident in his biography:

> Having returned to her earlier strength, and being at a meal in the refectory with the sisters on the day of the Invention of the Cross, she [Domenica] heard resounding in the church an extraordinarily sweet song, so that she immediately left the table and ran to the oratory inside the monastery, and she found that angels

44. In 1631 the nuns confined their celebrations of both feasts to plainchant out of respect for the plague (Croc 28, fols. 54v, 66r). They also refrained from polyphony in 1633 (Croc 28, fols. 104v, 115v).

45. By comparison, between September 1583 and September 1592, the convent spent an average of £32 on music for the Invention of the Cross, sometimes with an added commemoration for the convent's deceased sisters, and somewhat less, approximately £24, for the Exaltation feast, totaling approximately £56 per year. I-Fas, Croc 4, beginning fol. 106v; Croc 20, Croc 21, through fol. 50v.

TABLE 7.1. Payments by the Crocetta to Singers and Instrumentalists for the Feasts of the Invention (3 May) and Exaltation (14 September) of the Holy Cross, 1593–1607 (Summarized from Documents 7.1–7.3)

Date	Amount Spent on Polyphony	No. of Services (Where Noted)	Maestro	Choir Size, Including Boy Sopranos	Violin	Viola [da gamba]	Flute (Transverse)	Cornetto	Trombone	Lute	Other	Organ
May 1593	£40.14	2	1	10	1
September 1593	£118	3	...	Unknown	1	1	1	1	1	1	Contralto with instruments	...
May 1594	£93.6.8	3	1	12 (including maestro)	1	...	1	1	1	1	Violone and chitarrone	1
September 1594	£72.6.8	3 (singers)	1	11	1	1	[1]	1	+2 sopranos with instruments	1
May 1595	£63	3	1	12	1	1	...	1	1	1	+1 unspecified	...
September 1595	£61.16.8	2	1	Unknown	5 instruments	1
May 1596	£94.16.8	...	1	16	1	1	1	1	1	1	Harpsichord +1 soprano	1
September 1596	£55	3	...	10	1	...	[1]	1	1
May 1597	£53.10	3	...	10	Violone	1
September 1597	£42	...	1	14	1
May 1598	£80	3	...	13	1	...	Concerto of 8–9 voices/instruments	...

Date	Amount			Choir		1 doubles cornetto				Theorbo	
September 1598	£59.10	...	1	10	1	4 instruments
May 1599	£100	3	1	12	1	...	1	1	...	1	
September 1599	£56	12	5 wind instruments
May 1600	£82	9	1	1	...	1	1	1	
September 1600	£59	2	...	14	
May 1601	£81	3	1	16 [12–13]	1	Unspecified
September 1601	£56.10	...	1	9	1	3 instruments
May 1602	£56	3	...	14 [9]	1	Unspecified
September 1602	£44	...	1	10 [8]	...	1	...	1	1	1	Unspecified
May 1603	£55.6.8	11 [8]	1	...	1	1	
September 1603	£50	14 [7–8]	...	1	...	1	1	1	Unspecified
May 1604	£70	...	1	14 [8]	1	...	1	1	
September 1604	£35.13.4	10 [7–8]	1	1	1	Unspecified
May 1605	£37.6.8	10 [8]	1	1	
September 1605	£36.6.8	10 [8]	Unspecified
May 1606	£54.13.4	2	...	13 [8]	1	1	1	1	1	1	
September 1606	£43.13.4	10	1	
May 1607	£50.13.4	2	...	13 [9]	1	1	1	1	1	1	
September 1607	£46.13.4	10 [7]	1	1	1	1	1	1	

Note

In column 4 (choir), brackets signify an estimated choir size based on the amount spent, preceded by the total number of *musici e sonatori*, plus any sopranos (see p. 229). In column 7 (flute), brackets indicate that the document refers to the instrument as *flauto* (which may refer to a recorder), rather than the more usual *traversa*.

were processing around the altar of the church, and celebrating and singing with
sweetest harmony, they were blessing God. The Mother then made humbly her
usual adjuration, and in the name of the Triune God, pressed them to say who
they were. They responded that they were angels of God, ambassadors sent to her
in order to inform her that her spouse answered her prayers and consecrated that
altar with an indulgence, granting the remission of sins to all the faithful who
should gather in that church to pray on the feast of the Invention of the Cross and
on Good Friday, as she had requested.[46]

The records of the 1590s offer the most explicit evidence concerning the
nature of the Crocetta's special music, confirming not only the presence of in-
strumentalists but listing what instruments they played. Some entries also list
pay rates, although these were apparently not consistent, even among the var-
ious categories of musicians paid, namely, maestros, organists, adult singers,
boy sopranos, and instrumentalists. Maestros and organists were the highest
paid, often receiving £8 for their efforts. Instrumentalists were next, earning
four *giuli* (= £2.13.4) per service in 1594. Adult singers appear to have made
half that amount, while sopranos, presumably boys, occupied the lowest po-
sition on the wage scale. The most explicit description of wages is found in
the convent's *Entrata e Uscita* book for fiscal year 1593, which itemizes expenses
and income by category, similar to modern general ledger accounts. The
expenses for music at the feast of the Invention of the Holy Cross in 1594
totaled £93.6.8 (also confirmed in doc. 7.1, fol. 98r), broken down as fol-
lows: "£48 paid to nine singers—£8 to the maestro di cappella, £1.10 each
[per service] to the others, and 2 *giuli* [= £1.6.8] apiece to three sopranos;
£45.6.8 to eight players of various instruments, that is, violin, cornetto, trom-

46. Del Nente, *Vita* (275):

Essendo ritornata nelle sue prime forze, e stando nel giorno della Invenzione della
Croce con le Suore in Refettorio a mensa, sentì, che nella chiesa risuonava un dolcis-
simo canto; onde subito uscita da tavola corse nell'oratorio interno del monastero, e
trovò che gli Angioli stavano in giro all'altar della chiesa, e con un'armonia soavissima
festeggiando e cantando, benedicevano Dio. La Madre allora fece umilmente la sua
solita adjurazione, e in nome di Dio Trino e Uno, gli forzò a dir chi ei fussero. Questi
risposero, ch'erano Angioli d'Iddio, mandati Ambasciadori a lei, per significarle come
il suo sposo gratificava le sue preghiere, e consecrava quell'altare all'Indulgenza, conce-
dendo nella solennità della Invenzione della Croce, e del venerdì santo a tutt'i fedeli,
che fossero concorsi in quella chiesa a orare, la remissione de' loro peccati, siccomi el-
l'aveva domandato.

Antignani (*Vicende e tempi*, 250) cites a document of 5 September 1518, in which Giulio de' Me-
dici, then Archbishop of Florence, granted indulgences to the faithful who visited the church
on the Invention of the Holy Cross or on Holy Friday.

bone, lute, transverse flute, violone, and chitarrone; and £8 [of this total went] to the organist, and, to the others who performed in two services, that is, Mass and Vespers the actual day of the feast, 4 *giuli* [= £2.13.4] each per service; and the above-named singers [performed] three services, that is, both Vespers and the High Mass, all in music."[47] This document also reveals that the number of services a musician performed determined his pay. The Crocetta usually sponsored special music at Mass and Second Vespers, while on a few occasions musicians also performed at First Vespers the night before. Unlike the more typical understanding of the term *coro* as a designation for a musical ensemble that might perform with other such groups, the Crocetta documents consistently refer to individual services as *cori*, made clear in payments such as the one above and that of 30 May 1598 (doc. 7.2, fol. 51v), which recorded a payment of £38 "to thirteen singers for three choruses (that is, the [two] Vespers and High Mass of that feast)."

As the years progressed the specificity of the payment documents declined. Beginning sporadically in 1601, then regularly after May 1608, the records indicate only that the convent paid "*n* musici e sonatori di vari strumenti," an equation that yields different results depending on whether the number given (*n*) refers to the combined total of singers and instrumentalists or solely to singers, to which were then added an unspecified number of instrumentalists (table 7.2). Since the total number of *musici* paid in later years often comes close to the typical choir size from the earlier period (compare with table 7.1), while the annual expenses for music dropped to an average of eighty-six lire, the number probably represents a combined total of singers and instrumentalists. After September 1608 documents no longer separate adult singers from the boy sopranos. From September 1617 to May 1647 the Crocetta shifted to a type of contractor system, in which a single individual assumed responsibility for providing music and paying the musicians (table 7.3). Not only do the records become correspondingly less precise in terms of participants, but the payments themselves decrease significantly, stabilizing at £77 per year for

47. I-Fas, Croc 37, Entrata e Uscita Seguito B, 1585–96, opening 216, "Spese di Nostra Sagrestia, [fiscal year]1593": "£48 portorno cont*anti* 9 Musici; £8 al Maestro di Cappella; e gl'altri £1.10 per ciascuno; et tre soprani a 2 giuli l'uno; £45.6.8 a 8 sonatori di più varii strumenti, cioè Violino, Cornetto, trombone, leuto, traversa, violone, et chitarrone; et £8 a l'organista e gl'altri che servirno à 2 cori, cioè la messa, e vespro del giorno proprio della festa, à 4 giuli per coro ciasched'uno; e i soprad*etti* musici à 3 cori, cioè ai duoi vespri, e la messa grande, t*utto* di Musica." The various currency denominations make calculations a bit tricky, since they must be carried out in base 20 (for soldi) and base 12 (for denari). Thus, £1.10 \times 8 (singers) \times 3 (services) = £24.240 = £36, and £1.6.8 (2 *giuli*) \times 3 (sopranos) = £3.18.24 = £4. These totals, plus the £8 paid to the maestro, account for the £48 paid to singers.

TABLE 7.2. Payments for Music at the Crocetta, 1608–21

Date	Amount Spent on Polyphony (in Lire)	Maestro	Musici e Suonatori	Instruments (Besides Organ)	Organ	Total Performers
May 1608	85.13.4 (including *canto fermo*)	No	10 (+3 sopranos)	Yes	[1]	13
September 1608	47.13.4	No	7 (+3 sopranos)	Yes	[1]	10
May 1609	60.6.8	No	14	Yes	[1]	14
September 1609	No polyphony	1	1
May 1610	55	No	12	Yes	[1]	12
September 1610	No polyphony	1	1
May 1611	47	No	11	Yes	...	11
September 1611	51.17.4 (including organ tuning)	No	12	Yes	[1]	12
May 1612	59	No	13	Yes	[1]	13
September 1612	29.6.8	No	9 *musici* only	No	1	10
May 1613	47.6.8	No	14	Yes	[1]	14
September 1613	41.6.8	No	11 *musici* only	No	[1]	11–12
May 1614	65.13.4	No	14	Yes	1 (paid additional £1.6.8)	14–15
September 1614	42.13.4	No	10 *musici* only	No	1 (paid £5.6.8)	11
May 1615	54	No	12	Yes	[1]	12
September 1615	37.6.8	No	10 *musici* only	No	1	11
May 1616	36.13.4	No	8	Yes	[1]	8
September 1616	41	No	11 *musici*	No	1	12
May 1617	66	No	14	Yes	[1]	14
September 1617	44	Orazio Grazi, sotto maestro di cappella	[6]	[4]	Lorenzo Bandini (paid £6)	[11]
May 1618	58	No	10	Yes	1	11
September 1618	44 (2 *cori*)	Orazio Grazi	6 singers	4	Lorenzo Bandini (paid £5)	11

TABLE 7.2. *(continued)*

Date	Amount Spent on Polyphony (in Lire)	Maestro	Musici e Suonatori	Instruments (Besides Organ)	Organ	Total Performers
May 1619	46	No	11	Yes	[1]	11
September 1619	19.6.8	No	Unknown	No	1 (paid £5)	Unknown
May 1620	52.8	No	12	Yes	1 (paid £5)	13
September 1620	31.6.8	No	Unknown	No	1 (paid £5)	Unknown
May 1621	53	No	12	Yes	1 (paid £5)	13
September 1621	35.3.4	No	8	Yes	1 (paid £4.10)	9

Note. Brackets indicate that the document includes the organist in the total number of *suonatori*.

most of the period 1623–36, then dropping to £49–50 per year as the convent ceased funding performances of polyphony for the Exaltation of the Cross feast. After May 1647 the special music stopped altogether.

The size of the choir also declined gradually over the period 1593–1607, although the precise number of singers paid after 1601 is more difficult to confirm, due to the new manner of recording payments noted above. From 1593 to 1601, the convent typically paid between eight to ten adult male singers plus three or four boy sopranos. A uniquely explicit document from September 1594, which undoubtedly reflects the typical disposition of voices, reveals that the adult choir was made up of an equal number—three each—of basses, tenors, and altos, plus two sopranos, while another two sopranos performed concerted music with the instrumental ensemble (doc. 7.1, fol. 111r). Beginning in 1602 the adult singers typically numbered five, while the sopranos remained at three. A payment of £39 to Orazio Grazi in September 1618 for six singers and four instrumentalists—the last instance in which a document records the number of musicians—confirms that by that date the choir had shrunk even further, possibly also indicative of an increased emphasis on sacred monody (doc. 7.6, fol. 8v). The reduced amounts of £42 and £35 paid to Giovanni Battista da Gagliano between 1622 and 1637 suggest that the total size of his musical ensemble was slightly smaller still (table 7.3).

The number and variety of instruments also dwindled during this period. The first years of special music featured mixed ensembles of typically six or seven performers, usually with several representatives of three categories of instruments: chordal (organ, harpsichord, lute, and chitarrone), bass melodic (violone and viola [da gamba]), and soprano (violin, cornetto, and transverse

TABLE 7.3. Payments by the Crocetta to Named Musicians, 1617–47

Date	Payment (in Lire)	Individual / Title	Contribution (Document)
16 September 1617	38	Orazio Grazi, sotto maestro di cappella	"Che fece la Musica" (Croc 25, fol. 109r)
16 September 1617	6	Lorenzo Bandini	"Per sonar l'Organo" (Croc 25, fol. 109r)
15 September 1618	39	Orazio Grazi	"Per la Musica à 2 Cori à 4 strumenti e 6 voci" (Croc 26, fol. 8v)
15 September 1618	5	Lorenzo Bandini	"Per sonar l'Organo" (Croc 26, fol. 8v)
7 May 1622	56	Filippo Vitali	"Per la Musica 3 Cori" (Croc 26, fol. 129r)
16 September 1622	35	Giovanni Battista da Gagliano	"Per la Musica" (Croc 26, fol. 144r)
9 May 1623	42	Giovanni Battista da Gagliano	"Per 2 Cori della Musica" (Croc 26, fol. 160r)
16 September 1623	35	Giovanni Battista da Gagliano	"Per la Musica" (Croc 27, fol. 8r)
14 April 1624	28	Giovanni Battista da Gagliano	"Per la Musica . . . questa mattina che S.or M.a Christina [Peruzzi] ha fatto Professione, e preso il velo nero" (Croc 27, fol. 23v)
14 April 1624	2	Orazio Grazi	"Per contralto . . . questa mattina che S.or M.a Christina [Peruzzi] ha fatto Professione, e preso il velo nero" (Croc 27, fol. 23v)
6 May 1624	42	Giovanni Battista da Gagliano	"Per 2 Cori della Musica" (Croc 27, fol. 25v)
3 June 1624	35	Giovanni Battista da Gagliano	"Per la Musica; . . . la mattina della santissima Trinità, à 2 del presente che S.re Anna Maria Figliuola di Don Alonso Peres Spagnuolo, ha preso l'habito . . ." (Croc 27, fol. 27v)
16 September 1624	35	Giovanni Battista da Gagliano	"Per la Musica" (Croc 27, fol. 41v)

TABLE 7.3. *(continued)*

Date	Payment (in Lire)	Individual / Title	Contribution (Document)
6 May 1625	42	Marco da Gagliano, maestro di cappella	"Per 2 Cori della Musica" (Croc 27, fol. 56r)
11 May 1625	35	Marco da Gagliano	"Per la Musica"—vestation ceremony for Maria Vettoria Medici (Croc 27, fol. 56v)
15 June 1625	35	Giovanni Battista da Gagliano	"Per la Musica" profession and taking veil—Anna Maria Peres (Croc 27, fol. 59r)
17 September 1625	35	Giovanni Battista da Gagliano	"Per la Musica" (Croc 27, fol. 74r)
16 May 1626	42	Giovanni Battista da Gagliano	"Per 2 Cori della Musica" (Croc 27, fol. 88r)
17 September 1626	18.10	Giovanni Battista da Gagliano	"Per un Coro solo alle Messa Cantata" (Croc 27, fol. 103v)
16 May 1627	42	Giovanni Battista da Gagliano	"Per 2 Cori della Musica" (Croc 27, fol. 118v)
16 September 1627	35	Giovanni Battista da Gagliano	"Per la Musica a 2 Cori" (Croc 27, fol. 130r)
26 May 1628	42	Giovanni Battista da Gagliano	"Per 2 Cori della Musica" (Croc 27, fol. 140v)
27 September 1628	35	Giovanni Battista da Gagliano	"Per la Musicha a 2 Cori" (Croc 28, fol. 6v)
20 May 1629	42	Giovanni Battista da Gagliano	"Per 2 cori della Musica" (Croc 28, fol. 17r)
14 September 1629	35	Giovanni Battista da Gagliano	"Per 2 cori della Musica" (Croc 28, fol. 28v)
7 May 1630	42	Giovanni Battista da Gagliano	"Per 2 cori della Musica" (Croc 28, fol. 38r)
10 October 1630	35	Giovanni Battista da Gagliano	"Per 2 cori della Musica" (Croc 28, fol. 48v)
15 June 1632	42	Giovanni Battista da Gagliano	"Per 2 cori della Musica" (Croc 28, fol. 75r)
28 September 1632	35	Giovanni Battista da Gagliano	(Croc 28, fol. 94r)
10 May 1634	42	Giovanni Battista da Gagliano	"Per 2 cori della Musica" (Croc 28, fol. 124r)
3 October 1634	35	Giovanni Battista da Gagliano	"Per 2 cori della Musica" (Croc 28, fol. 132v)

(continued)

TABLE 7.3. (*continued*)

Date	Payment (in *Lire*)	Individual / Title	Contribution (*Document*)
4 July 1635	42	Giovanni Battista da Gagliano	"Per 2 cori della Musica" (Croc 28, fol. 143r)
4 June 1636	42	Giovanni Battista da Gagliano	"Per 2 cori della Musica" (Croc 28, fol. 161r)
September 1636	35	Giovanni Battista da Gagliano	"Per 2 cori della Musica" (Croc 28, fol. 172v)
27 May 1637	42	Giovanni Battista da Gagliano	(Croc 29, fol. 10v)
8 May 1638	52	Giovanni Battista da Gagliano	"Per 2 cori della Musica" (Croc 29, fol. 28v)
17 May 1639	49	Giovanni Battista da Gagliano	"Per 2 cori della Musica" (Croc 29, fol. 51r)
9 May 1640	49	Giovanni Battista da Gagliano	"Per 2 cori della Musica" (Croc 29, fol. 70r)
10 May 1641	50	Giovanni Battista da Gagliano	"Per 2 cori della Musica" (Croc 29, fol. 91r)
10 May 1642	50	Giovanni Battista da Gagliano	"Per 2 cori della Musica" (Croc 30, op. 7)
16 May 1643	50	Giovanni Battista da Gagliano	"Per 2 cori della Musica" (Croc 30, op. 35)
10 May 1644	50	Giovanni Battista da Gagliano	"Per 2 cori della Musica" (Croc 30, op. 55)
13 May 1645	50	Giovanni Battista da Gagliano, maestro di cappella	"Per 2 cori della Musica" (Croc 30, op. 73)
50 May 1646	50	Giovanni Battista da Gagliano, maestro di cappella	"Per 2 cori della Musica" (Croc 30, op. 93)
4 May 1647	50	Giovanni Battista da Gagliano, maestro di cappella	"Per 2 cori della Musica" (Croc 30, op. 111)

flute). After May 1600 the typical ensemble was a wind trio (flute, cornetto, trombone) plus organ, often augmented by a solo violin (table 7.1). The resulting ensemble would have been able to double the voices, with the violin and cornetto taking the soprano and alto parts, the flute—which sounded an octave higher than written—playing the tenor, and the trombone on bass.[48]

The Crocetta documents are noteworthy for the precision with which they record the presence of specific instruments during the musical celebra-

48. On the flute as a transposing instrument, typically used for the inner voices in mixed consorts, see Howard Mayer Brown, *Sixteenth-Century Instrumentation: The Music for the Florentine Intermedii* (n.p., 1973), 62–63.

tions of the Holy Cross feasts. But the performances chronicled by these documents were also remarkable, especially in Florence. While recent scholarship has demonstrated that many religious establishments in Italy—including convents—hired instrumentalists to participate in liturgical music during the sixteenth century, those Florentine churches with regular musical establishments appear to have been less inclined toward large instrumental forces, relying on one or two cornetti and trombones plus organ, as was the case at Santissima Annunziata and Santa Maria Novella, or using no instruments at all besides organ, apparently the norm at Santa Maria del Fiore and the Baptistry of San Giovanni.[49] On at least two occasions each year, the Crocetta appears to have sponsored the most elaborate concerted music of any religious institution in the city, save possibly that of Santa Felicità when the Medici family was in attendance.[50]

Many Italian churches outside Florence had both the inclination and financial resources to employ greater numbers of instrumentalists, typically wind players.[51] Of particular relevance to the Crocetta, San Martino in Lucca

49. Frank D'Accone has studied the musical life of Florence's principal churches in numerous important articles—see, in particular "Repertory and Performance Practice in Santa Maria Novella at the Turn of the Seventeenth Century," in *A Festschrift for Albert Seay: Essays by His Friends and Colleagues,* ed. Michael D. Grace (Colorado Springs, CO, 1982), 71–136, "The Musical Chapels at the Florentine Cathedral and Baptistry during the First Half of the Sixteenth Century," *Journal of the American Musicological Society* 24 (1971): 1–50, "The Florentine Fra Mauros: A Dynasty of Musical Friars," *Musica Disciplina* 33 (1974): 77–137, and "Singolarità di alcuni aspetti della musica sacra fiorentina del Cinquecento," in *Firenze e la Toscana dei Medici nell'Europa del '500: Atti del convegno internazionale di studi, Firenze, 9–14 giugno 1980,* ed. Gian Carlo Garfagnini, 3 vols. (Florence, 1983), 2:513–37. See also Warren Kirkendale, *The Court Musicians in Florence during the Principate of the Medici with a Reconstruction of the Artistic Establishment* (Florence, 1993), 645.

50. The court diarist, Cesare Tinghi, records performances of elaborate music for three or four choirs on the Wednesday of Holy Week, usually celebrated in the Medici church of San Nicolo in Pisa while the court made its annual retreat there, but on those few occasions during which the court remained in Florence during Holy Week, similar music—including the group of female singers that performed from the corridor—filled their Florentine church of Santa Felicità. See Angelo Solerti, *Musica, ballo e drammatica alla corte Medicea dal 1600 al 1637: Notizie tratte da un diario, con appendice di testi inediti e rari* (Florence, 1905; reprint, New York, 1968), 28, 31, 38, 58, 64, 85, 106, 129, 144, 158, 161–62, 169, 184–85.

51. See, for Padua, Jessie Ann Owens, "Il Cinquecento," in *Storia della musica al Santo di Padova,* ed. Sergio Durante and Pierluigi Petrobelli (Vicenza, 1990), 57–79; for Siena, Frank D'Accone, *The Civic Muse: Music and Musicians in Siena during the Middle Ages and the Renaissance* (Chicago, 1997); and, for Rome, Noel O'Regan, "The Performance of Roman Sacred Poly

made a regular practice of hiring instrumentalists from outside the city to perform concerted music at First Vespers and High Mass of the city's principal religious and civic feast, the Exaltation of the Cross.[52] Siena's wind band made the trek in 1578, while musicians in the employ of the grand duke of Florence performed in Lucca on several occasions, including 1570, 1576, 1586, and 1591.[53]

Personnel and Repertories

The Florentine group that traveled to Lucca in 1591 was the instrumental ensemble commonly known as the Franciosini, founded by cornettist Bernardo Pagani during the years 1586–93 and made up of Florentine orphan boys.[54] A letter written by Alessandro Striggio in August 1586 confirms that two of Pagani's students had performed in churches in Pistoia and Lucca by 1586. The eight-member group participated in the 1589 festivities celebrating the marriage of Grand Duke Ferdinando I and Christine of Lorraine, and the grand duchess appears to have emerged as a patron of the group. The Franciosini were also the principal instrumentalists for the city's religious establishments: members provided music to at least four Florentine churches during the late sixteenth and early seventeenth centuries. Warren Kirkendale has described the group's participation in a procession in Santa Trinità in 1586 and as performers at San Pancrazio from 1599 to 1605.[55] Various members of

choral Music in the Late Sixteenth and Early Seventeenth Centuries: Evidence from Archival Sources," *Performance Practice Review* 8 (1995): 126, 141.

52. Luigi Nerici, *Storia della musica in Lucca* (Lucca, 1879; reprint, Bologna, 1969), 381–411. Nerici (382) also notes that the invited instrumental group typically concluded the events of the vigil with a concert in the church. Second vespers was not sung with polyphony until the beginning of the eighteenth century (Nerici, 383).

53. Ibid., 386–87; D'Accone, *Civic Muse*, 571; Kirkendale, *Court Musicians*, 650. With the exception of a forty-year period between 1670 and 1710, the city's celebration of its principal civic and religious feast, documented for most of the years between 1545 and 1817, seems to have involved hiring outsiders (*forestieri*). Nerici (*Storia della musica*, 384–89) lists some of these musicians. See also Gabriella Biagi Ravenni, "Nomi, cognomi, e patria de i virtuosi sì di voci che d'istrumenti che sono intervenuti alle nostre funzioni di S. Croce," in *I tesori della musica lucchese: Fondi storici nella biblioteca dell'Istituto Musicale "L. Boccherini." Catalogo della mostra bibliografica e documentaria*, ed. Giulio Battelli (Lucca, 1990), 105–15, and Biagi Ravenni, *Diva Panthera: Musica e musicisti al servizio dello stato lucchese* (Lucca, 1993), 87–104.

54. The most complete history of the group is found in Kirkendale, *Court Musicians*, 107–13, from which the following information is drawn.

55. Ibid., 109, 650.

the group made regular appearances at Santissima Annunziata and Santa Maria Novella: from 1595 to 1602 Antonio Lassagnini ("il Biondino") and Paolo Grazi performed on the trombone, cornetto, and organ at Annunziata, joined by Giovanni Battista Jacomelli on organ, while Santa Maria Novella documents record regular payments to one or more of the Franciosini between 1584 and 1609.[56] Although most documents refer to the group performing on organ or wind instruments, its versatile members were proficient not only on cornetti and trombones but also on violins, transverse flutes, viole da gamba, and keyboard instruments—that is, the principal instruments heard at the Crocetta until at least 1600. Others also sang: Vergilio Grazi was paid as a singer at Santa Maria Novella from 1588 to 1590 and at the Santissima Annunziata in 1592, while the trombonist Giovanni Battista Signorini was also a tenor.[57] The Franciosini's participation in the 1591 celebration of the Exaltation of the Sacred Cross in Lucca—the same feast that first witnessed the inclusion of concerted music at the Crocetta—confirms that the group's repertory already included music appropriate for performance at the convent.[58] Members of the Franciosini appear to be the most likely candidates for the instrumentalists who appeared at the Crocetta. Perhaps Giovanni Battista Signorini, one of the group's original members (and later husband to Francesca Caccini), was the "Giovanni Battista" paid £42 for the concerto of eight singers and instrumentalists in May 1598 (doc. 7.2, fol. 51v).

The only instruments to appear in the Crocetta documents that are outside of the Franciosini's purview are the plucked strings, namely, the lute and chitarrone—instruments that suggest that the music at Crocetta featured some works for one to two solo voices plus continuo accompaniment. While the lute appeared fairly regularly at the convent, the bass instrument, designated as both chitarrone and theorbo in the convent documents, was named only twice, first in May 1594 and again in May 1599.[59] The chitarrone was a

56. Ibid., 648–49; Mario Fabbri, "La vicenda umana e artistica di Giovanni Battista Jacomelli 'del Violino' deuteragonista della camerata fiorentina," in *Firenze e la Toscana dei Medici,* ed. Garfagnini, 2:419–20. For Santa Maria Novella, see D'Accone, "Repertory and Performance Practice in Santa Maria Novella," 77–84.

57. D'Accone, "Repertory and Performance Practice in Santa Maria Novella," 77, 127, and "The Florentine Fra Mauros," 132; and Kirkendale, *Court Musicians,* 648–49.

58. Kirkendale (*Court Musicians,* 109) notes that eight part-books of *sinfonie* for the Franciosini appear in Guardaroba inventories of 1654 and 1670.

59. Although Robert Spencer ("Chitarrone, Theorbo and Archlute," *Early Music* 4 [1976]: 408) suggests that the two terms may have referred to different instruments before 1600 and that before 1594 the term "chitarrone" referred to a restrung bass lute without unstopped

relatively new instrument, the first mention of which occurred just a few years before its appearance at the Crocetta, in a Medici household inventory dated 1587.[60] It appeared in the spectacular Florentine *intermedi* of 1589, where it accompanied both solo and ensemble singing. Cristofano Malvezzi—one of the festivities' principal composers—names the three performers on the instrument on that occasion: Antonio Archilei, Jacopo Peri, and Antonio Naldi, credited as the instrument's inventor by most of his contemporaries.[61] All three of these musicians were also in the employ of the Medici family in 1594 and 1599, and it seem likely that at least one of them played at the convent.

The Crocetta obtained singers from at least three of the city's other religious institutions, with a particular emphasis on those establishments located near the convent. For their first venture into elaborate feast-day music, the nuns paid £2.13.8 to two friars from Santissima Annunziata who sang in the morning (doc. 7.1, fol. 67r). In a rare instance of polyphonic Holy Week music at the Crocetta, in 1598 the nuns hired a maestro and singers from the hospital of Santa Maria Nuova, an institution not previously known to have possessed a musical establishment in the sixteenth and seventeenth centuries (doc. 7.2, fol. 47r).[62] The convent's connection to the hospital, whose chapel had provided the nuns with priests and clerics in previous years, was probably accomplished through Romolo Nannucci, who was a chaplain at the convent as well as chamberlain to the hospital. Santa Maria Nuova's account

contrabass strings, other scholars have argued that the two plucked instruments are the same. See Douglas Alton Smith, "On the Origin of the Chitarrone," *Journal of the American Musicological Society* 32 (1979): 460–61; and Kevin Mason, *The Chitarrone and Its Repertoire in Early Seventeenth-Century Italy* (Aberystwyth, Wales, 1989). The matter becomes still more confused by sixteenth-century references to a *tiorba* as a hurdy-gurdy type of instrument associated with blind men (Smith, 457–61).

60. Piero Gargiulo, "Strumenti musicali alla corte Medicea: Nuovi documenti e sconosciuti inventari," *Note d'archivio*, n.s., 3 (1985): 67, cited in Victor A. Coelho, *The Manuscript Sources of Seventeenth-Century Italian Lute Music* (New York, 1995), 38. I would like to thank Nina Treadwell for calling my attention to this reference.

61. Smith, "On the Origin of the Chitarrone," 440–62.

62. My examination of Santa Maria Nuova's *entrata e uscita* books for the dates 1 October 1591–14 August 1596 revealed no payments to musicians (I-Fas, SMN, nos. 4562 and 4564 through fol. 61r). Guido Pampaloni cites a description of the procession that commemorated the groundbreaking of Bernardo Buontalenti's enlargement of the men's hospital (25 March 1575), which included the singing of the *Te Deum*, as well as plainchant and polyphonic hymns and psalms (*Lo spedale di S. Maria Nuova e la costruzione del loggiato di Bernarndo Buontalenti ora completata dalla Cassa di Risparmio di Firenze* [Florence, 1961], 22–23).

books reveal that, for a brief period, the hospital's chapel did pay an individual listed as maestro di cappella or, in other entries, maestro *di musica.* These payments do not appear on a regular basis, and they seem to have lasted for just over a year (15 August 1596–3 September 1597) to two individuals: Claudio Arbandi, who received irregular payments from 15 August 1596 to 9 May 1597, and Piero Poiteret (possibly Porteret), who was paid three times from 18 July to 3 September 1597.[63] Poiteret still retained his title of maestro di cappella by 10 December 1597, the date on which he was reimbursed for wine that he had purchased for the cellar and the last date for which the hospital's account books record such a maestro.[64]

Santa Maria Nuova also employed an organist, and this individual may have assumed the duties of the maestro after the hospital ceased funding that position, a situation similar to the one that arose at Santa Maria del Carmine.[65] From 12 April 1597 through at least March 1628, Santa Maria Nuova paid five organists in succession:[66]

Giuliano Spalieni (or Spulieri) (12 April 1597–22 August 1598)[67]
Luca Bati (26 September 1598–27 February 1599)[68]
Piero Bracciolini (1 May 1599–21 February 1603)[69]

63. The hospital paid Arbandi (whose name also appears as Arbaldi and Arbanudi) just over 38 scudi (=▾) in seven installments: I-Fas, SMN, no. 4564, fols. 61r (▾7.3), 64r (▾3.5), 64r (▾3.5), 69r (▾4 [although since the record makes no mention of music, it may have been a payment for another service]), 71r (▾6), 72r (▾1 [again, without mentioning music]), and 76v (▾12.3.13.4).

The same account book records payments to Piero Poiteret on fols. 83v (▾2 —"a uso della Musica"), 84r (▾3), 85r (▾2.3).

64. I-Fas, SMN, no. 4564, fol. 91v.

65. D'Accone, "The Florentine Fra Mauros," 83n26.

66. These dates refer to the date of payment, not the date of service. Payments to the organist were typically made after the services had been rendered.

67. I-Fas, SMN, no. 4564, fols. 74v (▾40 —the size of this payment suggests that it covers several months), 88r (▾4), 98r (▾26), 104r (▾18.4), and 108v (▾7.3.10).

68. Beginning with Bati's tenure, payments to the organist stabilize at ▾2 per month (I-Fas, SMN, no. 4564, fols. 110r, 112r, 115v, 117r, 119r, and 120r).

69. Bracciolini's pay rate appears to have been the same as his predecessor's, although he collected it at the end of every two-month period (I-Fas, SMN, no. 4564, fols. 123v–254r). Thus his first payment on 1 May 1599 (fol. 123v) covered the months of March and April, and his final payment on 21 February 1603 covered the months of January and February. Before his employment at Santa Maria Nuova, Bracciolini served as the organist at San Pancrazio from 1593–94; see Kirkendale, *Court Musicians,* 333n5.

Lorenzo Bandini (12 April 1603–14 November 1624)[70]
Jacopo del Franciosino (4 March 1626–2 March 1628)[71]

All five may have performed at the Crocetta, but only one is named explic-
itly in the convent's documents—Lorenzo Bandini, who at least twice dur-
ing his tenure as organist at Santa Maria Nuova walked a few steps down the
street to perform at the Crocetta (table 7.3).

Notice of Luca Bati's brief tenure as the organist at Santa Maria Nuova
fills in part of the biographical lacuna between his position as maestro di cap-
pella at the cathedral in Pisa, which ended 15 November 1596, and his ap-
pointment as the maestro at Santa Maria del Fiore on 1 February 1599.[72] He
may have been the first in a long line of cathedral musicians who would pro-
vide the convent with polyphonic music through the first half of the seven-
teenth century. Evidence of this relationship is clear in the later account books:
from September 1617 to May 1647 the convent paid Orazio Grazi, Filippo
Vitali, Marco da Gagliano, and Giovanni Battista da Gagliano to arrange for
special music (table 7.3). At the time of their involvement at the Crocetta,
Grazi and the Gagliano brothers held concurrent posts at the cathedral.[73]
Even more tellingly, the payment documents refer to each man by his cathe-

70. Bandini began his service on 1 March 1603 (I-Fas, SMN, no. 4564, fol. 258r). Time
did not permit me to examine the records for every year between 1603 and 1624, but he ap-
pears to have been the organist during this entire period. His pay rate started at ▾2 per month,
although he often collected several months' worth at one time (I-Fas, SMN, no. 4564, fols. 258r
and 265r; no. 4566, fols. 81r, 86v, 95v, 193r, 241r, 260v; no. 4571, fols. 52v, 58r, 66r, 69r; no. 4572,
fol. 92v). Bandini was among the musicians who in 1581 attested to the quality of the restora-
tions made to one of the organs in the cathedral; see Gabriele Giacomelli and Enzo Settesoldi,
Gli organi di S. Maria del Fiore di Firenze: Sette secoli di storia dal '300 al '900, (Florence, 1993), 68, 225.

71. In 1626 and 1628 Jacopo was paid a yearly salary of ▾24, that is, equal to the amount
received by his predecessors. His disbursement in 1627 was for ▾30 (I-Fas, SMN, no. 4572,
fols. 129v, 162r, 194v). I could find no payments for the years 1629–30 in this register.

72. See Frank A. D'Accone, "The Sources of Luca Bati's Sacred Music at the Opera di
Santa Maria del Fiore," in *Altro Polo: Essays on Italian Music in the Cinquecento,* ed. Richard Char-
teris (Sydney, 1990), 159, 168.

73. Filippo Vitali (1599–1654) resided intermittently in Florence until at least 1631: he
served as maestro di cappella to the Accademia dei Rugginosi ca. 1620–23, and he contributed
to court festivities in 1623. He held no official post at the court or cathedral until his ap-
pointment as maestro di cappella in 1651, following a career in the papal chapel. For Vitali's
appointment in 1651, see John Walter Hill, "The Musical Chapel of the Florence Cathedral
in the Second Half of the Seventeenth Century: Vitali, Comparini, Sapiti, Cerri," in *Atti del
VII centenario del duomo di Firenze,* vol. 3, *"Cantate Domino": Musica nei secoli per il Duomo di Firenze,* ed.
Timothy Verdon and Annalisa Innocenti (Florence, 2001), 175–94.

dral title, that is, *sotto* maestro di cappella for Grazi and maestro di cappella for Marco da Gagliano, while Giovanni Battista, who seems to have taken over as the convent's permanent musical director beginning in September 1622, was not given the title maestro di cappella in the convent records until May 1645, that is, after he had officially assumed the position at the cathedral.[74] In other words, from 1617 to 1647, musicians designated as maestro di cappella in Crocetta's pay records actually held that position at the cathedral.

What implication does this hold for those earlier documents that also refer to payments to a maestro di cappella? Clearly these documents may also refer to cathedral masters. As described above, Luca Bati, maestro from 1599 to 1608, possibly participated in the convent's music while at Santa Maria Nuova. Even more intriguing is the case of Cristofano Malvezzi, maestro di cappella from 1574 to 1599. Malvezzi was born in Lucca, the city whose citywide celebration of the Exaltation of the Holy Cross was well-known and often celebrated by musicians from all over Italy, and his father had been the organist at San Martino, the cathedral that sponsored the festivities.

Marco da Gagliano is, of course, the best-known of the Crocetta's temporary maestros, having served since 1608 as the maestro di cappella at the cathedral and as a principal composer of Florentine operas during the first three decades of the seventeenth century. His younger brother Giovanni Battista was the musician who regularly provided the convent with feast-day music for more than twenty years. The younger Gagliano brother deserves the honorary title of "hardest-working musician in Florence," simultaneously holding positions at the Medici court (beginning 1624), the cathedral and baptistry (beginning 1621), and the Compagnia dell'Arcangelo Raffaello (1620–25), in addition to providing occasional music for the Crocetta and other Florentine churches and academies.[75]

74. Orazio Grazi held no official appointment at court but was a singer at the cathedral, appointed to the position of *sotto* maestro di cappella in 1606. See Piero Gargiulo, *Luca Bati, madrigalista fiorentino* (Florence, 1991), 24; and Kirkendale, *Court Musicians*, app. D. Grazi also performed at S. Maria Novella in the late sixteenth century (D'Accone, "Repertory and Performance Practice in Santa Maria Novella," 109, 127), and he sang in the 1608 *intermedi* celebrating the marriage of Archduchess Maria Magdalena and Cosimo II (Tim Carter, "A Florentine Wedding of 1608," *Acta musicologica* 55 [1983]: 106).

75. Marco da Gagliano (1582–1643) succeeded Bati, who had been his teacher, as maestro di cappella of the cathedral, a position he held until his death in February 1643. See Edmond Strainchamps, "Marco da Gagliano in 1608: Choices, Decisions, and Consequences," *Journal of Seventeenth-Century Music* 6 (2000) (http://www.sscm-jscm.org/jscm/v6/n01/Strainchamps.html).

Giovanni Battista (1594–1651) claimed to have acted as the unofficial maestro of the cathe-

The connections between the Crocetta and the cathedral and baptistry may point to another source for the singers who performed at the convent. Frank D'Accone has demonstrated that by 1502 the cathedral's chapel was charged with singing the fifth vespers psalm (*Laudate Dominum*) at the feast of the Invention of the Holy Cross and that by 1540 the duties of the singers who performed at both the cathedral and baptistry included the performance of polyphony at vespers and High Mass for the Holy Cross feasts, a practice that continued for the Invention feast until at least 1651.[76] The document of 1651 also stipulates that the maestro must not "cease using works that are normally sung in the chapel with universal approval in order to introduce new ones," suggesting that the cathedral would have provided the convent both a ready-made repertory as well as singers used to performing it.

The archives of the Opera of Santa Maria del Fiore include several manuscripts that contain polyphonic settings of liturgically appropriate texts, including numerous Magnificats by Luca Bati, as well as his four settings of three of the five appropriate vespers psalms.[77] Frank D'Accone has noted the stylistic homogeneity of the psalm settings in one of these books of polyphony, MS 16, all of which are set in *alternatim* and are related to the traditional psalm tones through both paraphrase and structure. The polyphonic settings also feature conservative harmony, inclusion of at least one movement in triple time, and textural variety through the reduction of the number of voices in one or more of the setting's inner movements.[78] Many of these same musical characteristics describe aptly the polyphonic psalm settings composed by Giovanni Battista da Gagliano—the Florentine composer who supplied special music to the convent for almost his entire adult life.

Giovanni Battista's setting of *Dixit dominus, tertii toni* (I-Fd, MS 22, fols. 43v–47r) bears a close resemblance to the settings of an earlier generation (ex. 7.1). In five voices without basso continuo, it is intended for *alternatim* performance, with the odd-numbered verses set polyphonically. While the psalm tone is clearly evident in the long notes of the intonation, it also reappears in

dral since ca. 1624 (the year he entered the court rolls), due to his brother's ill health. See Kirk-endale, *Court Musicians*, 370–76; John Walter Hill, "Oratory Music in Florence, pt. 1, *Recitar Cantando*, 1583–1655," *Acta musicologica* 51 (1979): 121.

76. D'Accone, "The Musical Chapels," 5, 26–36 and documents dated 1540 and 1651.

77. D'Accone, "The Sources of Luca Bati's Sacred Music," 159–77. Five psalms were proper to the vespers services of both Holy Cross feasts: *Dixit Dominus, Confitebor tibi, Beatus vir, Laudate pueri,* and *Laudate Dominum.*

78. D'Accone, "The Sources of Luca Bati's Sacred Music," 170–71. See also Frederico [*sic*] Ghisi, "Luca Bati maestro della cappella granducale di Firenze," *Revue belge de musicologie* 9 (1954): 106.

each subsequent verse in loose paraphrase. At verse 7, Gagliano introduces textural variety by a sudden reduction from five to three voices, while triple meter appears at the doxology. Possibly the most prominent characteristic of Gagliano's setting of the psalm is his marked concern to maintain the traditional structure of the psalm: he typically distinguishes the bipartite structure of the psalm verse with a corresponding shift in musical texture, often punctuated by a medial cadence, most often to the reciting tone. In verse 3, the stately descending gesture whose imitative entries culminate in the forceful declaration of "emittet dominus ex Sion" is followed by the sprightlier anapests of "dominare" and a half-verse dominated by imitative writing and rhythmic animation. Gagliano is also willing to subdivide the psalm verse into even smaller segments. These compositional choices seem inspired by particularly vivid moments in the text: for example, the deliberate rhythms and homophony by which the composer highlights the gravity of "juravit dominus" (m. 17) contrast with the slightly faster pacing and overlapping duets of "et non penitebit eum." In this verse, the textural break after "dominus" is more extreme than that at the medial division, suggesting the composer's willingness to bend the psalm structure slightly in service to the meaning of the text.

Giovanni Battista da Gagliano also provided polyphonic settings of the Magnificat and the five proper vespers psalms in his *Psalmi Vespertini* of 1634.[79] This collection, whose alto part has not survived, was undoubtedly intended to serve the various institutions throughout the city at which the composer was employed. The book begins with what Jeffrey Kurtzman has termed the "male" *cursus,* that is, the psalms for many of the feasts commemorating Christ and male saints and categories of individuals.[80] The feasts of the Invention and Exaltation of the Cross fall into this group. Although the works in the 1634 collection are not *alternatim* settings, they do provide evidence of Gagliano's care to recall the plainchant manner of psalm recitation and his concern for a polyphonic setting that reflected the meaning of the text. At least four of the six settings feature prominent statements of the psalm tone—a number that might increase if the print's lost alto part resurfaces. These four

79. Giovanni Battista da Gagliano, *Psalmi vespertini cum litaniis Beatissimae Virginis quinis vocibus modulandi . . . opus tertium* (Venice, 1634).

80. Jeffrey Kurtzman, *The Monteverdi Vespers of 1610: Music, Context, Performance* (Oxford, 1999), 500. The contents of the 1634 collection would also have allowed for performance of complete psalm cycles on Sundays, and its concluding three psalms complete the female *cursus.* I would like to thank Professor Kurtzman for sharing his information on the contents of this book with me.

works are notable for the composer's inventive treatment of the cantus firmus, for no two of them employ precisely the same techniques. In *Dixit Dominus*, the cantus initially presents the transposed psalm tone over an active basso continuo. The tone continues in the cantus for the second half of the verse, over imitation in the other voices on a motive derived from the opening figure, and it returns at "Sicut erat" of the doxology, where it appears in the quintus part. *Laudate Dominum* also begins with the psalm tone in the cantus over a much quicker continuo part, but it maintains its rhythmic distinction even after the other voices enter in imitation for the second half of the verse. As with *Dixit Dominus* the psalm tone returns in the doxology, this time divided between the tenor (at *Gloria patri*) and quintus (at *Sicut erat*) parts. *Beatus vir* and the *Magnificat* both begin with the psalm tone in canon between tenor and bass. While in *Beatus vir* the tone reappears only at the end of the work, in the *Magnificat* the cantus firmus returns twice more, each time in durations that set it apart from the surrounding musical fabric.

Gagliano also preserves the bipartite verse structure of the psalm and Magnificat texts. In nearly every verse of each psalm, he punctuates the *mediatio* with a cadence then shifts texture, sometimes quite dramatically, for the second half of the verse. The *terminatio* also concludes with a strong cadence, most often to the modal final. In general the musical settings are jubilant but conservative: the harmonic vocabulary is quite narrowly arranged around the modal final, and each setting contains at least one section in triple meter.

But the composer also used his musical settings to highlight the meanings of words and phrases. Some of these musical illustrations are fairly superficial, such as extensive melismas on particularly affective words, triple meter at expressions of exultation, or choral homophony at phrases such as "omnes generationes" or "Abraham et emini eius in secula," to use two examples from his setting of the *Magnificat*. Others are subtler, and rely on the textural variety and harmonic control that are so characteristic of these settings. At the end of verse six of *Confitebor tibi*, for example (ex. 7.2), Gagliano divides the closing versicle into two parts: the absence of any vocal activity in the surviving parts after the opening versicle suggests that the now lost alto joined the tenor for a duet at "opera manuum eius," while all five voices then participated in imitative polyphony for "veritas et iudicium." Gagliano stretches out this phrase through repetition, but he also heightens anticipation by means of the four 4–3 suspensions that precede the final cadential preparation. The cadence to A thus truly delivers the judgment promised in the psalm verse.

Gagliano demonstrates yet another affective confluence of texture and harmony in his setting of *Laudate pueri*. Based on the eighth psalm tone and with a G final, flat harmonies appear sparingly in the setting. The first occurrence

is in the second half of verse 5, an aural contrast to the half cadence to E that punctuates the question posed in the opening versicle: "Quis sicut Dominus Deus noster" (ex. 7.3). The isolated G-minor chord calls attention to the special nature of the word "humilia." The same flat harmonies reappear only once more in the psalm, juxtaposed with sharper A-major and E-major chords in verse 7, "ut collocet eum [i.e., pauperem] cum principibus, cum principibus populi sui"—musical confirmation that the humble will indeed dwell with princes.

Other surviving works by Florentine composers might also have been performed at the Crocetta. In his 1636 collection of *alternatim* hymn settings, Filippo Vitali, who provided the convent music in May of 1622, included *Vexilla regis prodeunt* with the sixth stanza text alteration proper to the Invention of the Cross.[81] Marco da Gagliano published three different *alternatim* settings of the Magnificat in his *Sacrarum cantionum* of 1622, and he composed several settings of the Mass Ordinary.[82]

Between them the younger Gagliano and his brother Marco also composed three motets in praise of the holy cross that would have been appropriate for performance on the convent's two principal feasts. *Crucem tuam adoramus Domine* (ex. 7.4), Marco's solo motet for soprano and continuo from his *Sacrarum cantionum* (Venice, 1622), sets the antiphon text that follows the Reproaches in the solemn afternoon liturgy for Good Friday. But its first four words also present a reordering of "Tuam Crucem adoramus, Domine," the opening of the responsory verse after the fourth lesson of Matins on both Holy Cross feasts. In *Crucem tuam* Gagliano restrains the florid vocal writing that characterizes many other works in this collection: the motet is predominantly syllabic, and the composer generates much of its length by simply repeating musical phrases beginning on a variety of pitches. Gagliano divides the text into three parts: (1) "Crucem tuam adoramus Domine," (mm. 1–9); (2) "et sanctam resurrectionem tuam laudamus et glorificamus," (mm. 9–20); and (3) "Ecce enim propter lignum venit gaudium in universo mundo" (mm. 21–42). Each section ends with a cadence to the modal final, D, as well as a transposed repetition of the final musical phrase. Since each of these clos-

81. Filippo Vitali, *Hymni* (Rome, 1636), no. 15. Vitali identifies his setting as "In Festo Inventionis S. Crucis Tempore Paschali." James Pruett provides a transcription of the entire collection in "The Works of Filippo Vitali" (Ph.D. diss., University of North Carolina, 1962), vol. 2.

82. The Magnificats can be found in Marco da Gagliano, *Sacrarum cantionum unis ad sex decantandarum vocibus . . . liber secundus* (Venice, 1622), 37–48. For a brief overview of the collection, see James Erber, "Marco da Gagliano's *Sacrae Cantiones II* of 1622," *Consort* 35 (1979): 342–47.

ing phrases features images of praise and joy, Gagliano's use of repetition serves both expressive and structural purposes. To conclude the first section he simply repeats measures 3–6 down a third, enabling him to reach cadential closure on D. He subjects the second section to slightly more extensive elaboration, repeating the musical material of measures 12–15 a third higher, but then returning to the original pitch for a final repetition of the closing words and another cadence to D. Gagliano maintains this pattern of ever-increasing repetition in the motet's closing section. The somber mood of the first half of the motet bursts into a cheerful triple meter in an aural recognition of the joyous aftermath of the crucifixion. While Gagliano's setting of "venit gaudium in universo mundo" cadences to D and thus from the harmonic point of view reaches its necessary conclusion at measure 32, the universal impact of the event requires greater elaboration. Gagliano repeats the phrase in its entirety, transposed down a fourth, reversing the direction of the scalar melisma on "universo." A second repeat of this closing melisma returns the phrase to its original pitches and prepares the final arrival to D.

The Gagliano brothers also each composed a motet entitled *Crux fidelis.* Although the two motet texts diverge after the incipit, both derive wholly or in part from the Office texts for the two Holy Cross feasts. Marco's motet for six voices without continuo, manuscripts of which survive in the archives of both Santa Maria del Fiore and the parish church of San Lorenzo, sets a text that, although also proper to the Good Friday liturgy, recurs several times during the Mass and Office of the Holy Cross feasts: the complete text is identical both to the responsory after the second lesson of matins and stanza 3 of the lauds hymn *Lustris sex,* while the phrase "dulce lignum, dulces clavos" is also found in the first vespers Magnificat antiphon and alleluia versicle for both feasts.[83] The beginnings of text stanzas 1 and 4 of Giovanni Battista's motet also derive from *Lustris sex.*[84] Neither motet appears dependent on preexisting musical material.

Both motets use musical means to call attention to the image of the cross. Marco da Gagliano set his *Crux fidelis inter omnes* in two repeated parts, each of which cadences to G (ex. 7.5). At the end of part 1, two quasi-antiphonal quartets stress nature's inability to create foliage equal to the Holy Cross ("nulla silva talem profert"), exploring both the sharpest and flattest har-

83. I-Fd, Archivio musicale, parte seconda, 18, fols. 80v–83r; I-Fl, Archivio parrocchiale di S. Lorenzo, manoscritti musicali II.5, openings 32–36. The two are nearly identical musically, although the repeats are written out in the duomo manuscript.

84. Giovanni Battista da Gagliano, *Il secondo libro di motetti a sei et otto voci per concertarsi nell'organo, et altri strumenti* (Venice, 1643).

monies of the motet before yielding to "fronde, flore, germine." Both choral
homophony and then cascading flourishes confirm the superiority of the
cross. After a similar treatment in part 2 (mm. 32–39), Gagliano concludes
with a jubilant alleluia, in which all six voices sing variants of a four-note mo-
tive and its inversion. The presence of the alleluia makes the motet unsuit-
able for the nonpaschal liturgy of Good Friday but quite appropriate for the
Invention of the Holy Cross.

Giovanni Battista da Gagliano's motet introduces even greater textural va-
riety (ex. 7.6). Solo tenor and soprano stanzas alternate with a triple-time
choral refrain for stanzas 2 and 4. As he did in his settings of the vespers
psalms, the composer uses both textural variety and harmonic control to cre-
ate a tightly organized work. He clarifies the modal final of D by using it to
conclude each of the motet's subsections except the soprano solo, which
cadences on A. Clarity of phrase structure characterizes the twenty-three-
measure choral refrain: all six voices sing the first two lines of the stanza in
isorhythmic four-measure phrases, then smaller ensembles within the group
(duets and trios) sing overlapping phrases of the same length. The phrases
become shorter and the distance between imitative entries narrower for the
final six measures of "facis spem," whose repetitions affirm the hope offered
by the cross (mm. 28–33). Each phrase completes a cadence arranged along
the circle of fifths (i.e., D–G, G–C, C–F), building momentum to "vire-
scere" and the final arrival on D.

Like the paintings that adorned the high altar and left side chapel, these
motets emphasized musically the hope and victory promised by the Holy
Cross, and the nuns of the Crocetta undoubtedly listened to them with great
pleasure. The delivery of these themes through the concerted sounds of voices
and instruments allowed the nuns to convey a message, as well—one also
resonant with the surrounding altarpieces: in contemporary Florence women
continued to make significant contributions to the church. The Crocetta's ac-
cess to court and cathedral musicians confirmed its stature as one of the city's
important institutional patrons.

Christine of Lorraine

These convent-sponsored performances by musicians with important Me-
dici connections are indicative of an increased closeness between the convent
and the court. But how did the Crocetta gain access to the Gaglianos, Fran-
ciosini, and other such musicians? The most likely link appears to be Grand
Duchess Christine of Lorraine. The documentary evidence does not reveal

precisely when the grand duchess first learned of the Crocetta and its founder; Ignazio del Nente states only that by 1611 she had developed a particular devotion to Domenica, for in that year she ordered improvements in access and decoration for the reverend mother's sepulcher.[85] Christine commissioned del Nente to write Domenica's biography, and she may have exerted the influence that appears to have led to the prior's transformation of Domenica into a Medici court saint. Possibly due to the discrepancies between his account and that of Domenica's confessor, del Nente—who apparently completed the biography around 1622—was unable to secure its license for publication, a delay appealed by Christine.[86] The grand duchess asked Archbishop Alessandro Marzi Medici to initiate the process for Domenica's beatification, and she was present throughout the proceedings. Pope Urban VIII conceded the former grand duchess free and unrestricted access to the Crocetta in 1629, and after her death in 1636, the convent said daily masses for her soul.[87]

But Christine's involvement with the convent may date back even further. The evidence for this is circumstantial but compelling. Certainly her interest in the city's female monasteries dates from her earliest years in Florence: in

85. According to Moriconi (*Venerabile Suor Domenica*, 699, 722) the tomb was finished 26 May 1631.

86. I-Fas, MDP 6014 (n.p.) contains two letters to Christine that attest to her concern that the license was not forthcoming. The first is from Rome, dated 14 December 1629, from Niccolo Ridolfi, the newly elected master general of the Order of Preachers, who came from a prominent Florentine family and was the nephew of Pope Leo XI (Alessandro de' Medici, d. 1605), the former archbishop of Florence whose support had been so crucial to the convent's expansion of 1584–86. Ridolfi reported that he had been unsuccessful in convincing Pope Urban VIII to grant the license, but he expressed his belief that they would have better luck after the canonization hearings. On Ridolfi's election and tenure as the master general of the Dominicans, see [Daniel Antonin] Mortier, *Histoire des Maitres Généraux de l'Ordre des Frères Prêcheurs*, 8 vols. (Paris, 1902–20), 6:282–492, 512–31. The second letter, sent nearly a year later (30 November 1630), is from Tegrimo Tegrimi, bishop of Assisi, who reports his hopes that the *Vita* would soon be published.

87. Urban's license is mentioned in the Settimani diary entry for 12 October 1629 (I-Fas, Manoscritti 134, fol. 584v). The Crocetta documents (Croc 102, ins. 6, no. 7) include a reference to the convent's perpetual obligation for a daily Mass at the high altar, funded by an annual payment of 50 scudi to the Monte di Pietà. Another list of obligations, this one preserved in the convent's archives (Monastero di S Croce, detto la Crocetta, Armadio B, fol. 5r) confirms that Christine herself endowed the daily Masses for both herself and her daughter, Princess Maria Maddalena (d. 1633) and that Grand Duke Ferdinando II had authorized continued payments in support of his grandmother's wishes. I would like to thank Professor Suzanne Cusick for sharing with me her transcription of this document.

1592 Pope Clement VIII granted her license to enter Florentine convents during the day and to take her daughters with her.[88] The Crocetta would have been an especially appropriate location for the grand duchess's attention, for its members shared her particular devotion to the Holy Cross, a fragment of which constituted their most prized relic.[89] Pieraccini reports that, beginning with Christine's engagement, she began adding a cross to her signature, a practice that became more frequent in her later years.[90] For Christine, the Holy Cross—while undeniably the object of true spiritual devotion, was also a potent symbol of her family's glorious history: after all, she was a descendent of Godfrey of Bouillon, the military leader of the First Crusade. That Florentines recognized the importance of cross and crusader images to the Lorraine dynasty is apparent from accounts of the festivities that celebrated Christine's marriage to Ferdinando in the spring of 1589. Paintings depicting the heroic deeds of Godfrey dominated the third triumphal arch along the route of Christine's entry into Florence—a structure designed to demonstrate "the extent and the foundation of the greatness of the house of Lorraine."[91] During the same celebrations, the Compagnia di San Giovanni Evangelista performed Giovan Maria Cecchi's *L'esaltazione della croce*, a play whose *intermedi* (set to music by Luca Bati) traverse the full history of the cross, from its place in Old Testament prophesies to its defense by modern military orders of knights.[92] Cesare Agolante dedicated a sonnet and canzone on the subject of the cross to the grand duchess on 20 April 1590.[93] On 27 August 1593 she received a particle of the holy cross from Clement VIII, who granted her in-

88. I-Fn, Magl. XXV.277bis, fol. 9r. In 1613 Paul V expanded the license to include Archduchess Maria Magdalena of Austria and her daughters, as well as princes age seven and younger (fols. 10v–11r).

89. Richa, *Notize istoriche*, 2:264.

90. Pieraccini, *La stirpe*, 2:309.

91. "Il punto, e il fondamento della grandezza della casa di Loreno [*sic*], e di Guisa, dal cui splendore, esce la Serenissima luce della nuova Granduchessa" (cited in Giovanna Gaeta Bertelà and Annamaria Petrioli Tofani, eds., *Feste e apparati Medicei da Cosimo I a Cosimo II: Mostra di disegni e incisioni* [Florence, 1969], 70).

92. For a modern edition of the play, *intermedi*, and a contemporary description, see Alessandro d'Ancona, ed., *Sacre rappresentazioni dei secoli XIV, XV e XVI*, 3 vols. (Florence, 1872), 3:1–138. On the historical and immediate context of the work, see Michel Plaisance, "'L'Exaltation de la Croix': Comédie religieuse de Giovanmaria Cecchi," *Voies de la création théâtrale* 8 (1980): 12–41. See also John Walter Hill, "Florentine *Intermedi Sacri e Morali*, 1549–1622," in *La Musique et le rite sacré et profane: Actes du XIII' Congrès de la Société Internationale de Musicologie*, ed. Marc Honegger and Paul Prevost, 2 vols. (Strasbourg, 1986), 2:265–301.

93. I-Fn, Magl. VII.4.

dulgences when she prayed in front of it.[94] And in May of that year, the Crocetta's music budget swelled to nearly three times its previous size.

Unlike some of their better known religious sisters, the nuns of the Crocetta appear not to have been outstanding composers or performers. Their fame stemmed instead from the blessedness of their founder and what was seen as her long and mutually beneficial relationship with Florence and with the Medici family. Recognition of Domenica's possible sanctity apparently inspired the convent to commit its financial resources to major architectural and artistic projects between 1584 and 1593. The inaugural performance of polyphony in 1593 punctuated the conclusion of this decade of expansion and renovation while initiating a new era of even closer ties between the convent and the grand ducal family. Just as its newly commissioned artworks affirmed women's active presence in Christianity's defining moments, the Crocetta's patronage of some of Florence's best singers and instrumentalists allowed the convent to confirm its own contributions to the city's political and spiritual life.

Documents for Chapter 7

Document 7.1. I-Fas, Croc 21, Entrata e Uscita, Giornale, 1 June 1591–30 June 1596. Payments for polyphonic music, Feasts of the Invention of the Cross and Exaltation of the Cross (the Sacra).[95]

Fol. 67r (5 May 1593): "Fate credito cassa, et debito spese di sagrestia . . . £67.14 per la festa di Santa Croce, e l'uffizio Anniversario di detta festa; et £9 sono per elemosina di 9 Messe piane, £14 a 7 preti e 6 cherici nel Coro della festa e £40.14 a i Musici, et all'horganista, per Messa, et Vespro di Musica il giorno di Santa Croce, et £6 al Maestro di essa Musica, £26.13.8 a dieci cantori a quattro giulii per testa, £5.6.8 all'horganista, e £2.13.8 a dua frati della Nunziata per la mattina solo et cantorno; e £4 per elemosina di 4 Messe piane, e 7 preti et 2 cherici in coro; per l'uffizio de Morti sopradetto."

Fol. 83r (16 September 1593): "£11.13.4 sono per elemosina di 18 Messe piane, £70.13.4 à Musici per i duoi Vespri et Messa grande di Musica, £10 à quattro soprani, £37.6.8 à i sonatori di più varii strumenti, cioè la Traversa, il Trombone, il Violino, la Viola, il Cornetto, il Leuto, et un contr'alto, e £11 a i preti per il coro ordinario."

Fol. 98r (5 May 1594): "£48 à Musici, che furon 9; e di più tre soprani, per i duoi Vespri et Messa grande di Musica, £45.6.8 à i sonatori di più varii strumenti, cioè il Violino, il Cornetto, il Trombone, il Leuto, la Traversa, il Violone et il chitarrone, e £12.10 à 5 preti, et 6 cherici per il coro ordinario, et servir le Messe." [See also 228–29.]

94. I-Fn, Magl. XXXV.277bis, fol. 6r.

95. English translation is not provided for this and the following documents, since they are summarized in tables 7.1–7.3.

Fol. 108v: "£6.3.4 portorno con*tanti* 7 preti, fra gli è il Maestro di Cappella, et di più dua contralti, et dua Cherici, in coro per l'uffizio di Morti anniversario [added: cantato di Musica] celebrato per la Molto Veneranda Madre no*s*tra con dua Messe piane, oltr'a l'ordinaria."

Fol. 111r (September 1594): "£21.6.8 portorno con*tanti* 4 sonatori di strumenti per la Musica, cioè, Violino, Viola, Leuto, e Flauto, à £5.6.8 per uno, serviti alla Messa grande, et al Vespro del giorno proprio della festa £51 portorno con*tanti* 13 Musici, per i due Vespri et Messa cantata di Musica fra i q*u*ali era 3 voci di Basso, 3 tenori, 3 contralti, 2 soprano per cantare con gli strumenti, e dua altri per la Musica; e il Maestro di Capella e'l organista; £14 portorno con*tanti* 4 Preti e 4 Cherici di S*an*ta M*ar*ia Nuova per il coro ordinario, pagato t*utt*o per mano di M. Romolo Nann*ucc*i n*ost*ro Cappellano, et Camarlingo di S*an*ta M*ar*ia Nuova."

Fol. 126r (5 May 1595): "£63 portorno con*tanti* 12 Musici [added: £14.13.4] e 6 sonatori di strumenti, cioè Violino, Cornetto, Trombone, Viola, Leuto, et strumento; per i dua Vespri et Messa Cantata di Musica [added: £8 al m*aest*ro di Cappella]; £13.6.8 per elemosina di 10 Messe piane per la festa et £20.10 portorno con*tanti* 7 Preti e 6 Cherici per il coro ordinario et s*er*vir le Messe; et £6.16.8 per elemosina di 7 messe piane de Morti e 6 Preti 2 Cherici et un fanciulletto per far' la voce dell'alto nella Musica per la Messa grande dell'uffi*zio* anniversario che fu com'è d*ett*o di musica."

Fol. 148v (16 September 1595): "£13.6.8 pagati à cinque sonatori di più varii strumenti, serviti alla Messa grande di Musica, et al vespro del giorno proprio della Festa, et £48.10 pagati à i Musici, al Maestro di Cappella all'organista et a i Preti et Cherici del coro ordinario."

Fol. 170r (30 June 1596): "Nella Festa di S*an*ta Croce . . . £54.10 portorno con*tanti* tredici Musici, Il Maestro di Cappella; tre soprani e 4 cherici parati; £40.6.8 à otto sonatori di più varii strum*en*ti cioè, Organo, Trombone, Violino, Traversa, Leuto, Viola, Gravicembolo, et soprano. Et £9.3.4 per il Coro dell'Uffizio Anniversario di d*ett*a festa, cantato di Musica; che furno in t*utt*o nu*mer*o 14, tra preti, cherici, maestro di cap*ell*a, organista, et altri cantori; pagato t*utt*o per mano di M. Romolo Nannucci nostro Cappe*ll*ano et Camarlingo di S*an*ta M*ar*ia Nuova."

Document 7.2. I-Fas, Croc 22, Entrata e Uscita, Giornale, 1596 – 1602.

Fol. 8r (14 September 1596): "£31 pagate à 10 Musici; £24 à 5 sonatori di più varii strumenti cioè, l'Organo, il Trombone, Violino, flauto, et Cornetto; servito t*utt*o à tutt'a dua i Vespri, et Messa grande di Musica."

Fol. 22v (13 May 1597): "£46.10 per i Vespri e messa grande di Musica della Festa di S*an*ta Croce, [dove] s*er*vivono 8 preti, 4 cherici parati, (above: tutti di S*an*ta M*ar*ia Nuova) con altri 10 musici, nel q*u*al nu*mer*o sono anco i soprani."

Fol. 22v (13 May 1597): "£7 à l'Organista et à un'altro che sono il Violone per la festa di S*an*ta Croce."

Fol. 36r (15 September 1597): "£42 portorno con*tanti* 14 Musici, con il Maestro e'l organista, £16.13.4 portorno con*tanti* 5 Preti e 8 Cherici per il Coro ordinario, e s*er*vir le Messe. Pagato t*utt*o per mano di M. Romolo Nann*u*cci n*ost*ro Cappellano e Camarlingo di S*an*ta M*ar*ia Nuova. Et £13.6.8 portorno con*tanti* 9 preti per elemosina di 9 Messe piane à £1.6.8 per cia-

scu*no*, che in d*etta* soma di £13.6.8 si è computato £1.6.8 che ebbe di più un di d*etti* preti [above: forestiero] per essersi parato a suddiacono alla Messa Cantata dal R*everendo* Pad*r*e e da noi al-tre Monache; et denari 13.4 al prete che cantò l'Evangelio à d*etta* Messa."

Fol. 47r (25 March 1598): "£18.13.4 *pagati* portorno con*tanti* 6 preti, il Maestro di Cappella con 4 Musici, *tutto* per Uffitiatura della Settimana Santa; che il venerdì cantarno di Musica il Pas-sio, cioè la Turba; pagato d*etta* Uffitiat*ura* per mano di M. Romolo Nannucci *nostro* Capp*el*l*ano* et Cam*erlingo* di S. Maria Nuova, del quale spedale furono li preti e Musici."

Fol. 51v (30 May 1598): "£38 à tredici Musici à 3 cori (cioè i Vespri e Messa grande di d*etta* festa); £11 à tre preti è cinque Cherici per il Coro ordinario; et £42 per il concerto di stru-menti, e voci; pagate al Sig. Giovanni Bat*tista* con otto persone per sonare e cantare."

Fol. 51v (30 May 1598): "£11.16.8, che £4.3.4 portorno con*tanti* 3 preti, e 4 Musici con il Mae-stro di Cappella, et sono per l'Uffizio dell'Anniversario celebrato nella *nostra* Chiesa £6.3.4 dati à 6 preti, e al Maestro di Cappella con 4 Musici, per l'Ufitio de Morti celebrato per una *nostra* sorella passata à miglior vita, cioè la R*everenda* M*adre* Suor Caterina."

Fol. 64v (18 September 1598): "£59.10 pagati a 10 Musici con il Maestro di Cappella; à l'orga-nista e 4 musici di strumenti; £19 portorno con*tanti* sei preti in Coro, quattro Cherici per le vite, e 2 per l'Incensi, et il Maestro che accordò l'organo (ch'ebbe £5 in d*etta* soma) pagato *tutto* quant'e *detto* per mano di M. Cosimo Zati *nostro* Procc*urato*re."

Fol. 76v (4 May 1599): "£123.13.4 portò da noi con*tanti* M. Cosimo Zati nostro Procc*urato*re, che tanti disse havere spesi per noi nella *nostra* festa di S. Croce, cioè per i Vespri, e Messa Grande di Musica, che £100 à 8 Musici, et Maestro di Capp*ella* con 4 soprani e 7 sonatori di diversi strumenti, cioè, cornetto e traversa, trombone, violino, leuto, viola, tiorba, et organo. £18.6.8 alli preti del canto fermo, num*ero* 6 e 5 cherici et £5.6.8 à 7 preti e 2 cherici in coro per l'uffizio Anniversario di d*etta* festa."

Fol. 96v (15 September 1599): "£81 portò da noi contanti M. Cosimo Zati nostro Procc*ura*-*tore* de quali disse haverne pagati £36 a 12 Musici, £20 per 5 strumenti di fiato, £19 à 7 preti e 5 cherici in coro, per 3 cori; che i preti à un *giulio* per coro, e i cherici à quattro cratie (*1 crazia* = 1/12 lira); et £6 dati à l'istesso M. Cosimo, che £4 per sue fatiche della festa, et £2 datili ac-ciò li dessi per noi à F. Bast*iano* di S. Tomaso per il med*esimo* effetto; et £8 haveramo pagati per elemosina di 12 messe piane; che tutto fui per la nostra festa della sacra (e più £14 spesi in far accr*esce*re un suono)."

Fol. 110r (4 May 1600): "£82 pagati à 5 musici, 4 fanciulli soprani, e 5 sonatori di vari stru-menti cioè organo, buon accordo, cornetto, trombone, traversa, e violino; £24.13.4 à 6 preti in coro per il canto fermo; e Uffizio Anniversario di essa festa, e 5 cherici per vite, incenso, e servire le messe; pagato *tutto* per mano di M. Cosimo *nostro* Procc*urato*re"

Fol. 125v (15 September 1600): "£59 pagati a 14 Musici per la Messa grande e secondo Vespro, £17 a 6 Preti in Coro per il canto fermo, e 6 Cherici per vite, et incenso; £4 dati a M. Cosimo per sue fatiche della festa, £6.13.4 per elemosina di 10 messe piane *denari* 13 e 4 per ciasc*una* £2 dati a preti che cantorno l'epistola et evangelio alla prima messa cantata della croce, e 2 cherici che servirno a d*etta* messa £1.13.4 in far rassettare li strumenti, e denari 13.4 in Mon-tella per d*etta* festa."

Fol. 141r (5 May 1601): "£109 portò da noi con*tanti* M. Cosimo no*s*tro Proc*cu*ratore che tanti disse haver pagati à i Musici, preti, e cherici in coro al canto fermo in questa Festa di Sa*n*ta Croce et Uffi*z*io Anniversario di essa; cioè £81 al Maestro di Cappella con 4 soprani, e 12 musici con varii strumenti ad ambidue i Vespri e Messa grande; e £32.8 à 10 preti e 6 cherici in coro per il canto fermo a *de*tta festa, et uffi*z*io."

Fol. 157r (15 September 1601): "£39 al Maestro di Cappella con 2 fanciulli soprani e 7 Musici; e £24.6.8 a 12 preti in coro per il canto fermo, e 7 cherici per vite e incenso, £17.10 pagati a l'organista e 3 sonatori; £7.6.8 per elemosina di 11 messe piane *de*nari 13.4 al prete che canto l'evangelio alla messa cantata della croce, e £3.10 dati al sopra*de*tto M. Cosimo per sue fatiche, *tu*tto per la festa della sacra."

Fol. 172v (4 May 1602): "£94.4 portò da noi con*tanti* M. Cosimo nostro Proc*cu*ratore che £56 disse haver pagati a 10 Musici e sonatori di diversi strumenti e à 4 fanciulli soprani; e £38.13.4 a 14 preti e 6 cherici in coro per il canto fermo, al p*rimo* e 2.o vespro, Messa, e Uffi*z*io de Morti Anniversario di *de*tta festa . . . £4 dati al sop*ra de*tto M. Cosimo per sue fatiche della festa £7 si spese per far'accordare un buon accordo, e £2.13.4 per accordar' l'organo."

Document 7.3. I-Fas, Croc 23, Entrata e Uscita, Giornale, 1602–8.

Fol. 8r (16 September 1602): "£44 portorno contanti 7 Musici e sonatori li più vari strumenti; m*aes*tro di Cappella, organista, e 3 soprani; £27.6.8 à 13 preti e 6 cherici in coro per il canto fermo; pagato *tu*tto per mano di M. Cosimo no*s*tro Proc.re £3 a *de*tto M. Cosimo per sue fatiche della festa . . . e £2.13.4 per far'accordar l'organo."

Fol. 23v (6 May 1603): "£55.6.8 portorno contanti 8 Musici, e sonatori di più vari strumenti cioè traversa, cornetto, e trombone, organista, m*aes*tro di cap*pe*lla e 3 fanciuli sopranni; £22.6.8 à 13 preti in coro per canto fermo al p*rimo* e 2.o vespro, messa grande di Sa*n*ta Croce, e Uffizio Anniversario di *de*tta festa."

Fol. 41r (17 September 1603): "£50 pagati à 10 Musici e sonatori di più vari strumenti e à 4 fanciulli soprani; £20.6.8 a 7 preti e 7 cherici in coro per il canto fermo, £2.13.4 per elemosina di 2 Messe piane (che altre 3 non si pagorno per essere stati gli preti à desinare), £2.13.4 per accorda*tu*ra dell'organo."

Fol. 55v (4 May 1604): "£70 portorno con*tan*ti 11 Musici, e sonatori di più varii strumenti, cioè Violino, Trombone, Traversa, Cornetto, Organista, Maestro di Cappella, e 3 fanciulli soprani; £16 a 8 preti in coro per il canto fermo, al p*rimo* e 2.o vespro, e Messa grande di Sa*n*ta Croce, . . . e £3 si spese per far'accordare l'organo."

Fol. 73v (15 September 1604): "£35.13.4 pagati a 7 musici, e sonatori di più varii strumenti, e a 3 Fanciulli sopranni; £24.13.4 à nove preti, e 8 cherici in Coro per il canto fermo; £8 per elemosina di 12 Messe piane e £3 per accordatura dell'organo."

Fol. 90v (6 May 1605): "£37.6.8 portorno con*tanti* 7 Musici, e sonatori di Violino, et Organo, e 3 fanciulli sopranni; £30.13.4 dati à 11 preti, e 6 cherici in coro per canto fermo al p*rimo* e 2.o vespro Messa Cantata di Sa*n*ta Croce, et Uffizio Anniversario di *de*tta festa; . . . e £2 per elemosina di altre 4 messe de morti celebrate questa mattina nella no*s*tra Chiesa per la fel*ice* memoria del sommo Pontefice Leone XI che per il coro serv*imm*o noi altre monache."

Fol. 104r (15 September 1605): "£36.6.8 pagati a 7 musici, e sonatori di più varie strumenti, e à 3 fanciulli soprani, £27.13.4 à 10 preti, e 9 cherici in coro per il canto fermo."

Fol. 118r (5 May 1606): "£54.13.4 pagati contanti a 10 musici, e sonatori di più vari strumenti, cioè Organo, Violino, Cornetto, Traversa, e Trombone, e à 3 fanciulli soprani, servirno al 2.o vespro e Messa Cantata di detta nostra festa, £39.6.8 dati a preti e cherici per il canto fermo al primo e 2.o vespro, messa cantata, di Santa Croce, et Uffizio Anniversario di detta festa; £4 per accordatura dell'Organo, pagato tutto per mano di M. Cosimo Tati nostro Proccuratore."

Fol. 133v (16 September 1606): "£43.13.4 dati all'organista, à 7 musici, 3 fanciulli soprani, 6 preti, e 3 cherici per il canto fermo; £6.13.4 per elemosina di 10 messe piane £2.13.4 per accordatura dell'Organo, e £2 dati al R.do M. Cosimo Tati nostro Proccuratore per sue fatiche della festa."

Fol. 147r (5 May 1607): "£50.13.4 pagati contanti a 10 Musici, e sonatori di più 257vari strumenti cioè Organo, Violino, Cornetto, e Traversa, e à 3 fanciulli soprani, servirno al 2.o vespro e Messa cantata di detta nostra festa, £33.6.8 dati à Preti e cherici per il canto fermo, al primo e 2.o vespro, Messa Cantata di Santa Croce, e Uffizio Anniversario di detta festa, £2.13.4 per accordatura dell'Organo, pagato tutto per mano di M. Cosimo Tati."

Fol. 164v (15 September 1607): "£46.13.4 dati à l'organista, a 7 Musici, e sonatori di più vari strumenti, cioè cornetto, traversa, e violino, e à 3 Cherici che fecero il soprano; £34 a 15 preti, e 4 cherici in coro per il canto fermo, e £2.13.4 per accordatura dell'organo pagato tutto per mano di M. Fabio Comunelli nostro Cappellano."

Fol. 180v (6 May 1608): "£85.13.4 dette contanti M. Fabio Comunelli nostro Proccuratore d'haver pagati a 10 Musici, e sonatori di più vari strumenti; tre soprani, e 12 preti in coro per il canto fermo, e a più cherici per le vite e servir le messe, £2.13.4 per accordatura dell'organo."

Document 7.4. I-Fas, Croc 24, Entrata e Uscita, Giornale, 1608–14.

Fol. 8r (14 September 1608): "Pagati che tanto s'è speso ne Vespri, e Messe della Sacra; che £47.13.4 pagati a 7 Musici, e sonatori di più varii strumenti, e 3 soprani; £2.13.4 per accordatura dell'organo; £42.3.4 dati a 18 preti e 7 Cherici in coro per il canto fermo; tutto per mano del Reverendo M. Fabio Comunelli nostro procuratore."

Fol. 21r (4 May 1609): "£60.6.8 dati a 14 Musici, e sonatori di più vari strumenti; £36.10 a 17 Preti, e più Cherici in coro per il canto fermo; £2.13.4 per accordatura dell'organo."

Fol. 34v (14 September 1609): "£40.3.4 a 15 preti, 5 cherici e l'organista . . . per 12 Vespri, e Messa Cantata di detta Festa, tutto di canto fermo senza punto di musica."

Fol. 50r (4 May 1610): "£55 dati a 12 Musici, e sonatori di più varii strumenti; £34 a 19 preti; £9 a 9 cherici per il canto fermo; £2 per accordatura dell'organo."

Fol. 66v (16 September 1610): £42 . . . tutto di canto fermo."

Fol. 84r (4 May 1611): "£47 pagati a 11 Musici et sonatori di più vari strumenti; £36.16.8 a 18 preti e 5 cherici per il canto fermo."

Fol. 98r (16 September 1611): "£51.17.4 dati a 12 Musici e sonatori di più vari strumenti compresoci l'accordatura dell'Organo; £74.16.8 dati a 16 Preti et quattro Cherici in Coro per il canto fermo."

Fol. 114v (5 May 1612): "£59 pagati a 13 Musici e sonatori di più vari strumenti; £33.6.8 a 16 Preti e 8 Cherici per il canto fermo; £5 per accordatura dell'organo."

Fol. 130v (15 September 1612): "£29.6.8 dati a 9 Musici; £32.6.8 dati a 14 Preti e 8 Cherici compresoci l'organista; £2.13.4 per accordatura di *detto* organo."

Fol. 149r (8 May 1613): "£47.6.8 pagati a 14 musici, e sonatori di più vari strumenti, £32.6.8 a 14 preti e 6 cherici in Coro per il canto fermo; £3.6.8 per accordatura dell'organo."

Fol. 167v (September 1613): "£41.6.8 dati a 11 Musici; £31.6.8 dati a 14 preti, e 6 Cherici in Coro per il canto fermo; £4 per accordatura dell'organo."

Fol. 184r (May 1614): "£64.6.8 pagati a 14 Musici, e sonatori di più vari strumenti; £29.6.8 a 14 preti e 6 cherici in Coro per il canto fermo; £1.6.8 all'organista al *primo* Vespro, £3 per accordatura di *detto* organo."

Document 7.5. I-Fas, Croc 25, Entrata e Uscita, Giornale, 1614–18.

Fol. 8r (16 September 1614): "£37.6.8 dati a 10 musici, £27.6.8 dati a 13 preti e 6 cherici in coro per il canto fermo; £5.6.8 all'organista £3.10 per accordatura dell'organo."

Fol. 23r (5 May 1615): "£54 pagati a 12 Musici, e sonatori di più vari strumenti, £32 a 11 Preti e 7 Cherici per il Canto fermo, conpresoci l'acordatura dell'organo."

Fol. 37r (16 September 1615): "£37.6.8 dati a 10 Musici, £34 dati a 13 preti, e 7 cherici, in coro per il canto fermo, e all'organista, £3.10 per accordat*u*ra dell'organo."

Fol. 54r (5 May 1616): "£36.13.4 dati a 8 Musici, e sonatori di più vari strumenti, £29 a 13 preti e 7 cherici in coro per il canto fermo, . . . £3.10 per accordat*u*ra dell'organo."

Fol. 73r (16 September 1616): "£41 dati a 12 musici conpresoci l'Organista £32.6.8 dati a 14 preti e 7 cherici in coro per il canto firmo, £3 per accordat*u*ra dell'organo."

Fol. 92r (8 May 1617): "£66 pagati a 14 musici e sonatori di più vari strumenti, £33 dati a 15 preti e 7 cherici, in coro per il canto firmo . . . £3.10 per accordat*u*ra dell'organo."

Fol. 109r (16 September 1617): "£38 dati a M. Horatio Grazi sotto maestro di Cappella, che fece la Musica, £35.13.4 dati a 15 preti, e 7 cherici in coro per il canto fermo, £6 a M. Lorenzo Bandini per sonar l'organo, £3.10 per accordat*u*ra di esso."

Fol. 128v (5 May 1618): "£52 pagato a 10 Musici, e sonatori di più vari strumenti, £6 all'organista, £30.6.8 dati a 13 preti e 7 cherici in coro per il canto fermo, . . . £3.10 per accordat*u*ra dell'organo."

Document 7.6. I-Fas, Croc 26, Entrata e Uscita, Giornale, 1618–23.

Fol. 8v (15 September 1618): "£39 dati a Maestro Oratio Grazij per la Musica à 2 Cori à 4 strumenti e 6 voci; £34.13.4 dati à 14 Preti, e 7 Cherici in Coro per il Canto fermo, £5 à Maestro Lorenzo Bandini per sonar l'Organo, £3.10 per accordatura di esso."

Fol. 28r (5 May 1619): "£46 a 11 Musici e sonatori di più vari strumenti, . . . £3.10 per accordatura dell'organo."

Fol. 45r (16 September 1619): "£14.6.8. a Musici, . . . £5 all'organista, £3.10 per accordatura dell'organo."

Fol. 64r (5 May 1620): "£47.8 pagati à 12 Musici, e sonatori di più vari stromenti; £35 dati à 14 Preti e 9 Cherici, in Coro per il Canto fermo; . . . £5 all'organista; £3.10 per accordatura dell'organo."

Fol. 80r (16 September 1620): "£26.6.8 pagati à Musici, . . . £5 all'organista; £3.10 per accordatura dell'organo."

Fol. 98v (8 May 1621): "£48 pagati à 12 Musici e Sonatore di più vari strumenti, £32 dati à 14 Preti e 7 Cherici, in Coro per il Canto fermo, . . . £5 all'organista; £3.10 per accordatura dell'organo."

Fol. 113r (16 September 1621): "£30.13.4 pagati à 8 Musici, e sonatori di più vari strumenti . . . £4.10 all'organista; £2 per accordatura dell'organo."

Fol. 129r (7 May 1622): "£56 pagati à M. Filippo Vitali per la Musica 3 Cori; £33.6.8 dati à 14 Preti e 6 Cherici in Coro per il Canto fermo."

Fol. 144r (16 September 1622): "£35 pagati à M. Giovanni Batista da Gagliano per la Musica; £32.13.4 dati à 14 Preti e 7 Cherici in Coro per il Canto fermo; £5 all'organista; £3.6.8 per accordatura dell'organo."

Fol. 160r (9 May 1623): "£42 pagati à M. Gio. Battista da Gagliano per 2 Cori della Musica; £32 dati à 13 Preti e 7 Cherici in Coro per il Canto fermo; £4.10 all'organista; £3.10 per accordatura dell'organo."

EXAMPLE 7.1. Giovanni Battista da Gagliano, *Dixit dominus, tertii toni,* odd-numbered verses (I-Fd, Archivio musicale, parte seconda, 22, fols. 43v–47r): "The Lord said to my Lord: Sit thou at my right hand" (v. 1, first half). "The Lord will send forth the scepter of thy power out of Sion: rule thou in the midst of thy enemies" (v. 3). "The Lord hath sworn, and he will not repent: thou are a priest for ever according to the order of Melchisedech" (v. 5). "He shall judge among nations, he shall fill ruins: he shall crush the heads in the land of many" (v. 7). "Glory be to the Father, and to the Son, and to the Holy Ghost" (v. 9).

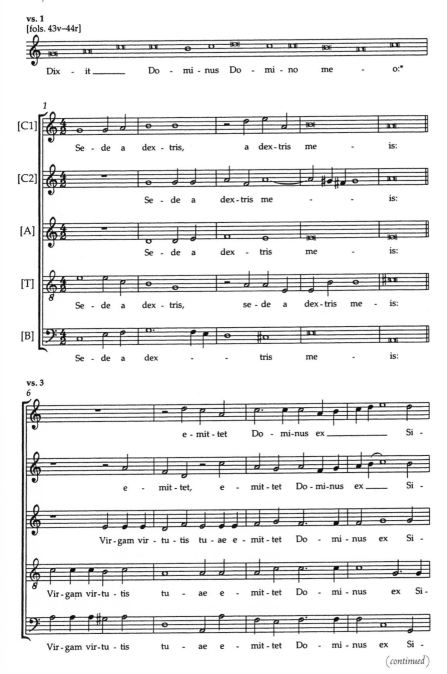

(continued)

EXAMPLE 7.1. (*continued*)

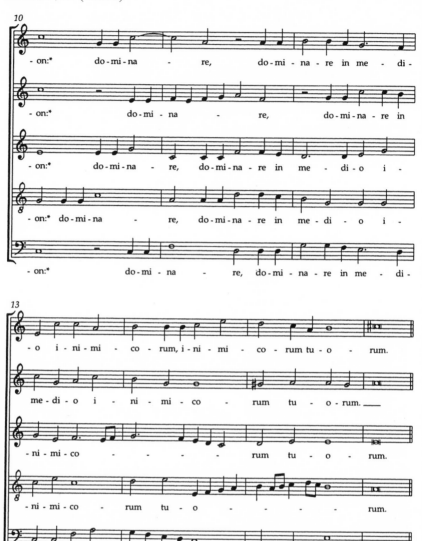

EXAMPLE 7.1. *(continued)*

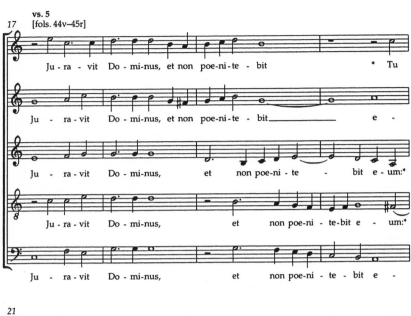

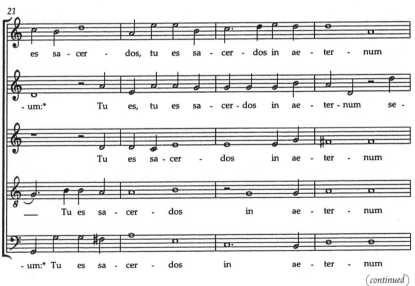

(continued)

EXAMPLE 7.1. *(continued)*

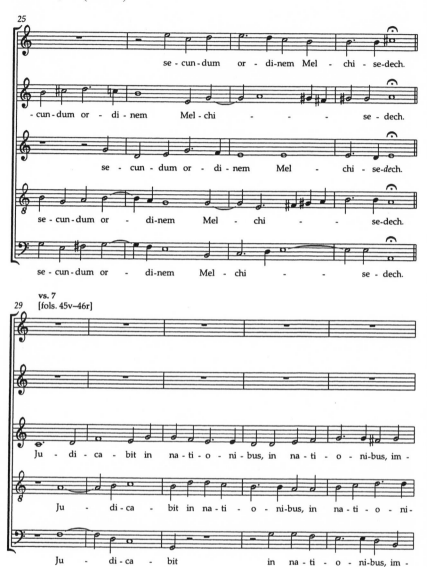

EXAMPLE 7.1. *(continued)*

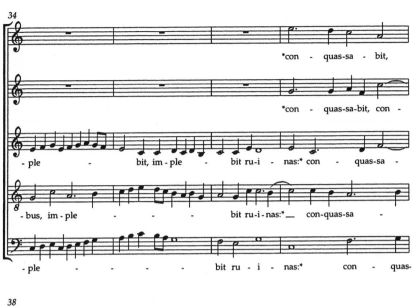

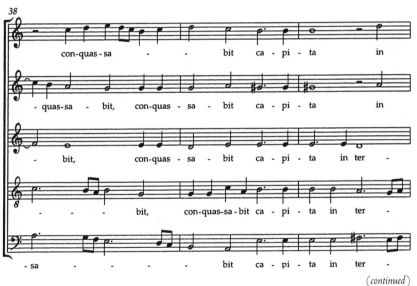

(continued)

EXAMPLE 7.1. (*continued*)

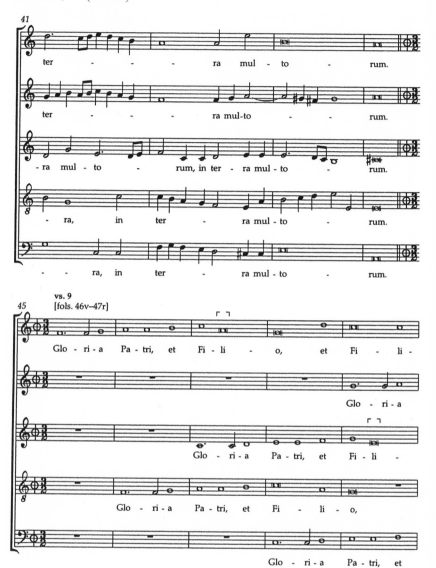

EXAMPLE 7.1. *(continued)*

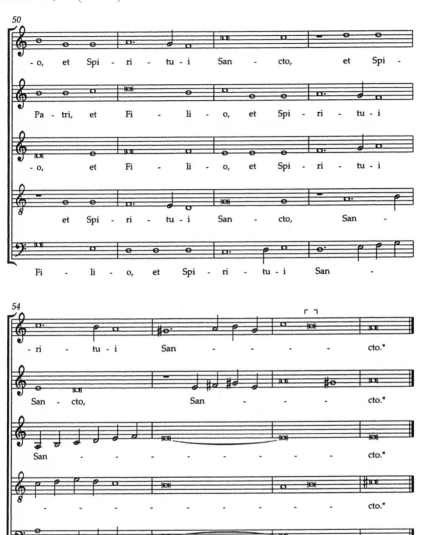

EXAMPLE 7.2. Giovanni Battista da Gagliano, *Confitebor tibi, Domine, primi toni* (v. 6), in *Psalmi vespertini* (Venice, 1634): "That he may give them the heritage of the Gentiles: the works of his hands are truth and judgment."

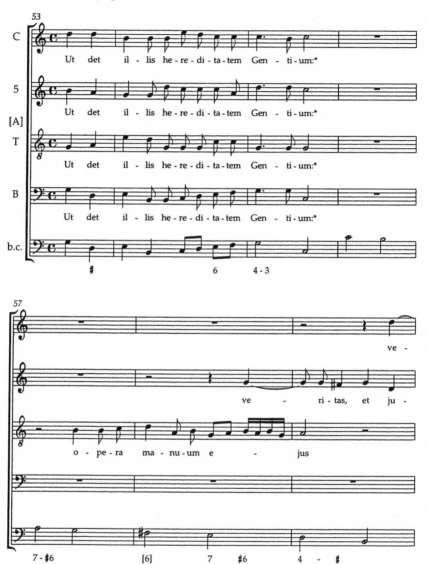

EXAMPLE 7.2. *(continued)*

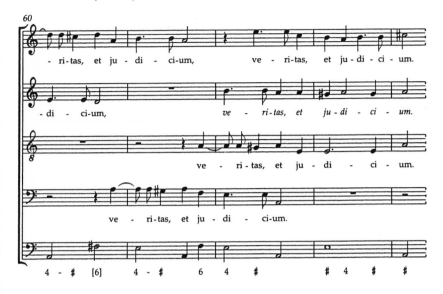

EXAMPLE 7.3. Giovanni Battista da Gagliano, *Laudate pueri, octavi toni* (vv. 5 and 7), in *Psalmi vespertini* (Venice, 1634): "Who is as the Lord our God, who dwelleth on high: and looketh down on the low things in heaven and in earth?" (v. 5). "That he may place him with princes, with the princes of his people" (v. 7).

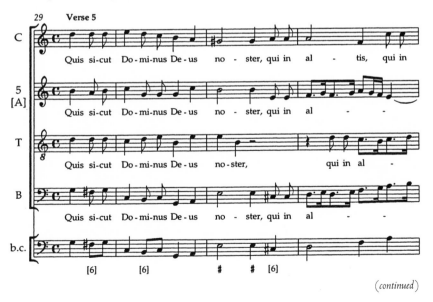

(continued)

EXAMPLE 7.3. (*continued*)

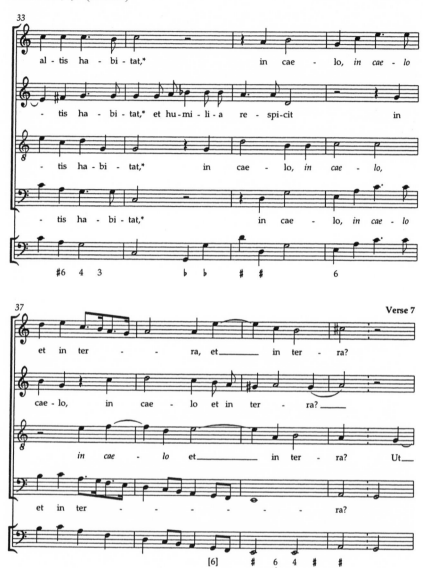

EXAMPLE 7.3. *(continued)*

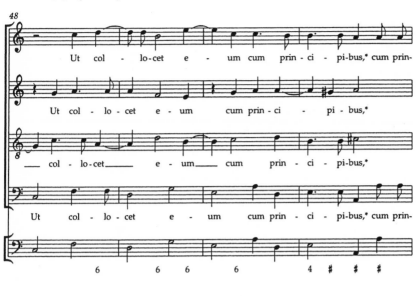

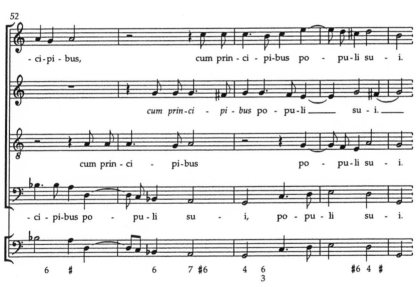

EXAMPLE 7.4. Marco da Gagliano, *Crucem tuam adoramus*, in *Sacrarum Cantionum* (Venice, 1622), 7–8: "We adore your cross, Lord, and we praise and glorify your holy resurrection. Behold, indeed, that because of this wood, joy comes to the entire world."

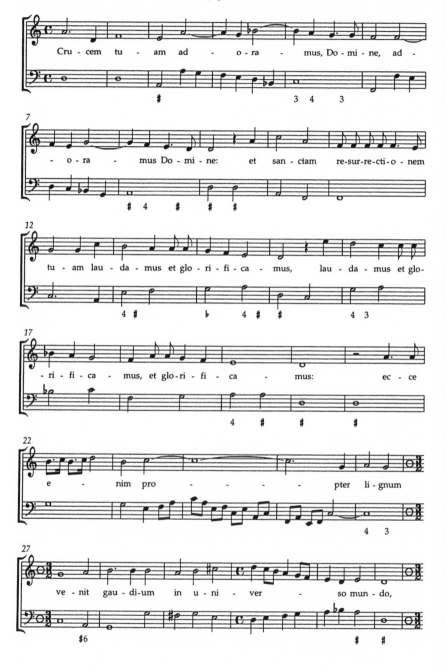

EXAMPLE 7.4. (*continued*)

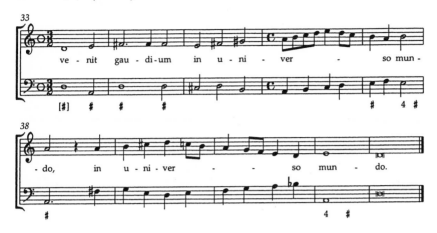

EXAMPLE 7.5. Marco da Gagliano, *Crux fidelis* (I-Fd, Archivio musicale, parte seconda, 18, fols. 80v–83r): "O faithful Cross, most beautiful among trees: no forest has ever produced such a leaf, a flower, a fruit as this. O sweet the wood, sweet the nails, sweet the burden they sustain, alleluia." (Translation in *The Roman Breviary* [London, 1937].)

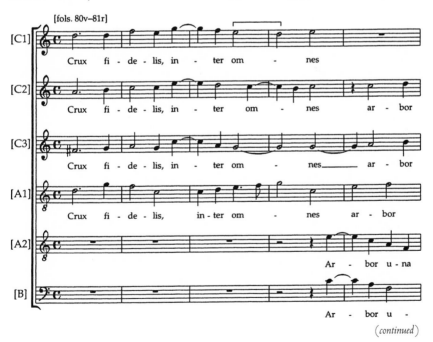

(*continued*)

EXAMPLE 7.5. (*continued*)

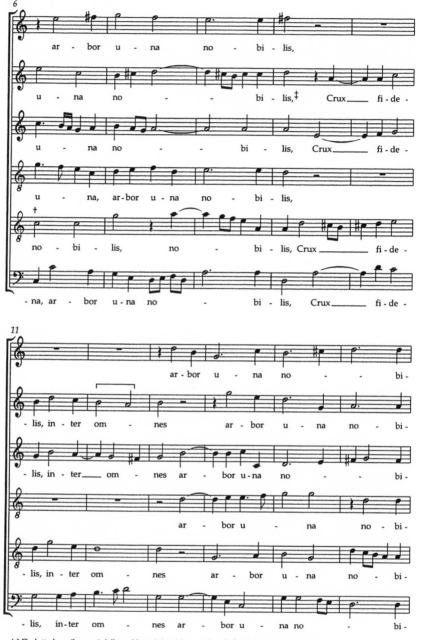

† I-Fl: dotted semibreve c′, followed by minim c′ (note values halved in the transcription)
‡ I-Fl: "crux fidelis inter omnes"

EXAMPLE 7.5. *(continued)*

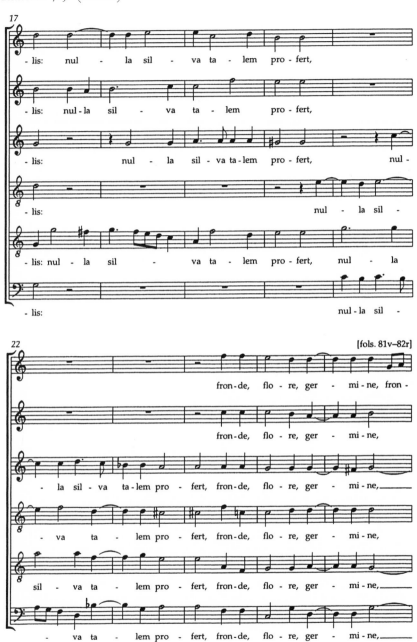

- lis: nul - la sil - va ta - lem pro - fert,

- lis: nul - la sil - va ta - lem pro - fert,

- lis: nul - la sil - va ta - lem pro - fert, nul -

- lis: nul - la sil -

- lis: nul - la sil - va ta - lem pro - fert, nul - la

- lis: nul - la sil -

[fols. 81v–82r]

fron - de, flo - re, ger - mi - ne, fron -

fron - de, flo - re, ger - mi - ne,

- la sil - va ta - lem pro - fert, fron - de, flo - re, ger - mi - ne,____

- va ta - lem pro - fert, fron - de, flo - re, ger - mi - ne,

sil - va ta - lem pro - fert, fron - de, flo - re, ger - mi - ne,____

- va ta - lem pro - fert, fron - de, flo - re, ger - mi - ne,____

(continued)

EXAMPLE 7.5. *(continued)*

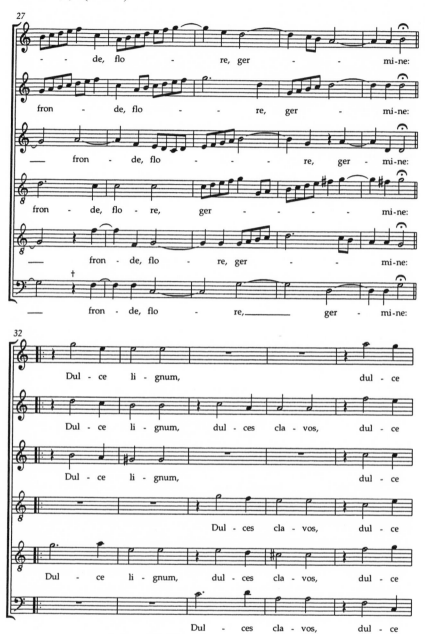

† I-Fl: f (dotted semibreve) begins one minim earlier

EXAMPLE 7.5. *(continued)*

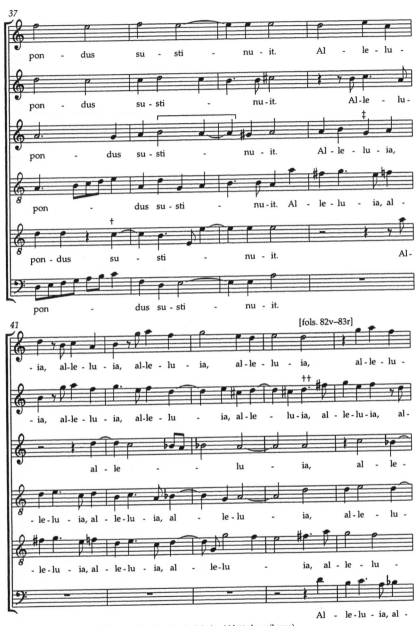

† I-Fl reads c' (minim) - b (dotted minim) - e (semiminim) - e' (dotted semibreve)
‡ I-Fl: b' - c''
†† I-Fd: both the d'' and f#'' are notated as minims in the written-out repeat

(continued)

EXAMPLE 7.5. (*continued*)

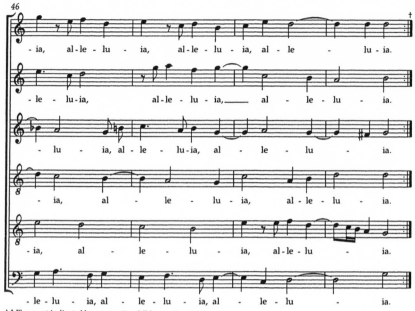

† I-Fl: repeat indicated by repeat sign; I-Fd: repeat written out

EXAMPLE 7.6. Giovanni Battista da Gagliano, *Crux fidelis*, in *Il secondo libro de motetti a sei et otto voci per concertarsi nell'organo, et altri strumenti* (Venice, 1643): "Faithful cross, armor of Jesus Christ the commander, you guide me, you govern me and lead me above the stars of heaven. Sacred, fruitful tree, pleasant and leafy tree, flower violet, beautiful rose, you make hope flourish. O blessed, holy wood I dedicate my song to you, I dedicate my lament to you, I dedicate my tears to you. Bend your branches so that I may touch you, that I may lament my leader Jesus, indeed that I may also always commiserate with the Virgin Mary. Alleluia." (Thanks to Leofranc Holford-Strevens for his help with this translation.)

EXAMPLE 7.6. *(continued)*

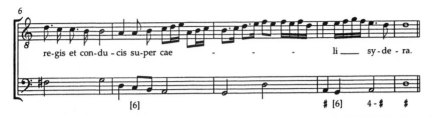

re-gis et con-du - cis su-per cae - - - li____ sy-de - ra.

[6] # [6] 4 - # #

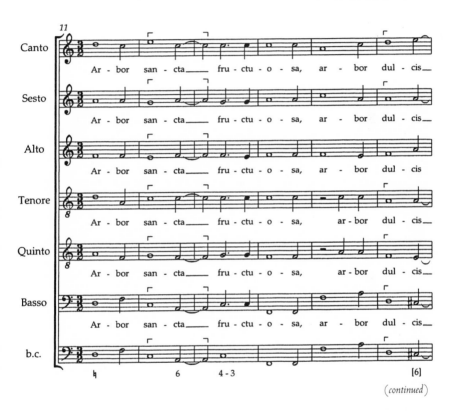

Canto Ar - bor san - cta____ fru - ctu - o - sa, ar - bor dul - cis____

Sesto Ar - bor san - cta____ fru - ctu - o - sa, ar - bor dul - cis____

Alto Ar - bor san - cta____ fru - ctu - o - sa, ar - bor dul - cis

Tenore Ar - bor san - cta____ fru - ctu - o - sa, ar - bor dul - cis____

Quinto Ar - bor san - cta____ fru - ctu - o - sa, ar - bor dul - cis____

Basso Ar - bor san - cta____ fru - ctu - o - sa, ar - bor dul - cis____

b.c.

♮ 6 4 - 3 [6]

(continued)

EXAMPLE 7.6. (*continued*)

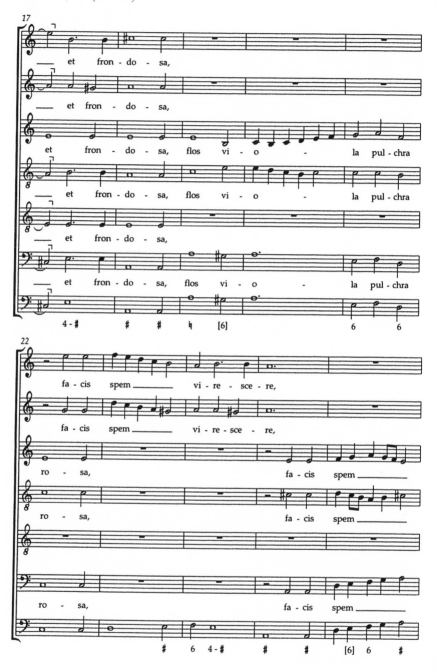

EXAMPLE 7.6. (*continued*)

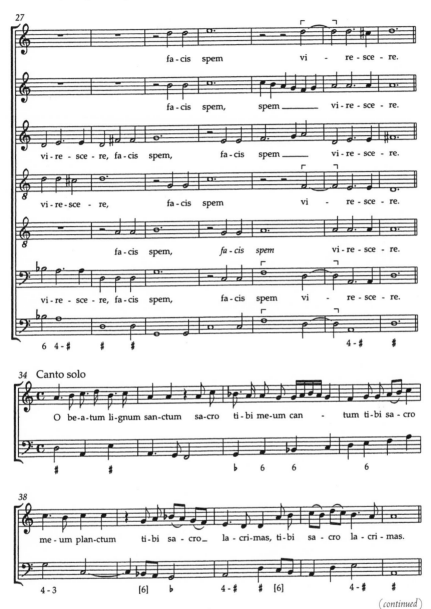

(*continued*)

EXAMPLE 7.6. (*continued*)

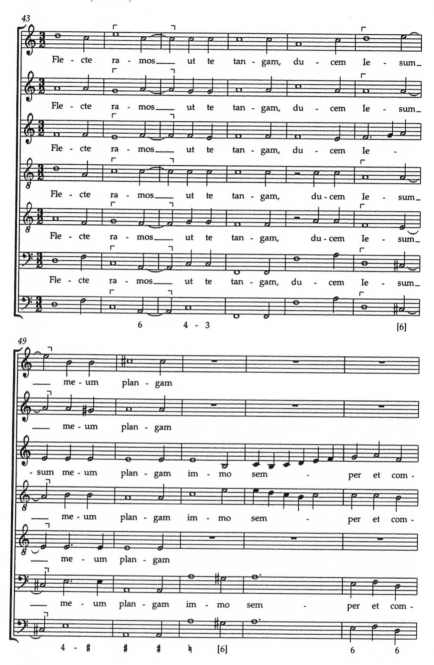

EXAMPLE 7.6. (*continued*)

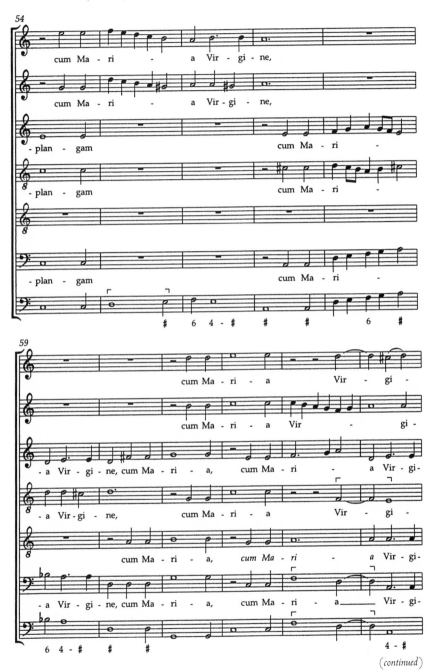

(*continued*)

EXAMPLE 7.6. (*continued*)

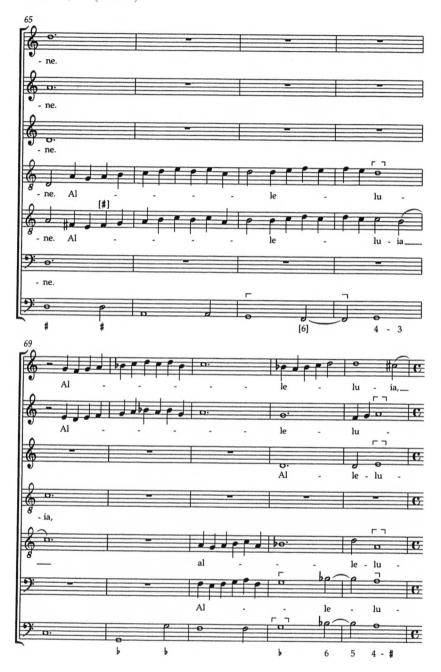

EXAMPLE 7.6. (*continued*)

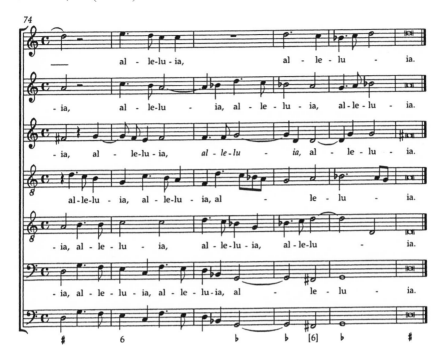

"Queens of the Arno"

Medici Princesses and the Crocetta

Christine's devotion to Domenica da Paradiso and her demonstrated interest in the Crocetta undoubtedly influenced the decision of her daughter—Princess Maria Maddalena (1600–1633)—to enter the convent in 1621. Maria Maddalena's situation was unusual, for unlike other noble or middle-class families, forced to cloister all but one daughter due to the financial burden of marriage dowries, the Medici used their daughters to forge strategically important marriage alliances.[1] Maria Maddalena was one of only two legitimate daughters of Medici grand dukes to enter a convent (her niece Maria Cristina was the other), and she may well have done so due to a physical abnormality that rendered her unmarriageable by seventeenth-century standards. The diarist Paolo Verzoni refers to her as *storpiata* [handicapped], while Gaetano Pieraccini proposed, based on a surviving full-length portrait, that the princess had unusually short legs (fig. 8.1).[2] Ironically, the princess's debility allowed her a degree of freedom almost unimaginable by the majority of seventeenth-century women, who were compelled to *maritar* or *monacar*. Her family built her a residence connected to the convent. She received an allowance from the grand ducal treasury, had six servants to look after her, was not required to wear a habit, did not profess vows, had a papal dispensation to receive overnight visits from her relatives, and could leave for short peri-

1. Judith Brown estimates that of Florentine girls born into aristocratic families, nearly half entered convents ("Everyday Life, Longevity, and Nuns in Early Modern Florence," in *Renaissance Culture and the Everyday,* ed. Patricia Fumerton and Simon Hunt [Philadelphia, 1999], 116).

2. I-Fn, Magl. XXV.462, fol. 47r, cited in Gaetano Pieraccini, *La stirpe de' Medici di Cafaggiolo: Saggio di ricerche sulla trasmissione ereditaria dei caratteri biologici,* 3 vols. (Florence, 1924–25), 2: 53–54.

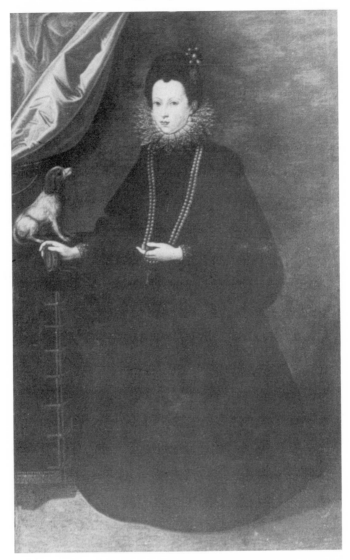

FIGURE 8.1. Anonymous portrait of Princess Maria Maddalena de' Medici (Florence, Uffizi)

ods of time.[3] For the Crocetta, the presence of a Medici princess granted the convent a new level of prestige.

Aside from the brief attention that Pieraccini accords Maria Maddalena,

3. According to an extract of treasury expenses, the princess received an allowance of 600 scudi in (possibly fiscal year) 1625 (I-Fas, Misc. Med. 264, ins. 44). In the final testament of Christine of Lorraine (I-Fas, Misc. Med. 601), in the event of Christine's death the princess was granted use of her mother's villa La Quiete "in order to go there sometimes for recrea-

scholars know very little about the princess or her life before entering the convent. In his retrospective history of Florentine events, Francesco Settimanni offers a bleak description of her birth: "Grand Duchess Madama Christine gave birth to a girl, who was baptized privately by Monsignor del Pozzo, Archbishop of Pisa, and he gave to her the name Maria Maddalena. No festivities were held."[4] A list of the members of the Medici family from a report dated 1620 describes her merely as "Princess Maria Maddalena, who is said to want to become a nun due to her disability."[5] Richa notes that she was "deformed in her limbs, in which state she grew up" [*malcomposta nelle membra, nel quale stato cresciuta*], while late in the eighteenth century Riguccio Galluzzi cites the princess's weak health as the reason why she was not considered a potential bride for Emperor Ferdinand II.[6] She remains conspicuously absent from most family correspondence until 1619, the year in which she made her decision to enter the Crocetta.

The princess declared her intentions as early as 8 July 1619 to the consternation of the Murate, the more affluent Benedictine convent that had enjoyed a longtime connection to the Medici family and in which at least some of her kinswomen lived.[7] Her family must have moved quickly, for in a letter to the archbishop of Florence dated 24 August 1619, the Sacred Congregation re-

tion" [*per andarvi qualche volta a' recreazione*]. The relevant paragraphs are transcribed in Gabriele Corsani, "Le trasformazioni architettoniche del complesso della Quiete," in *Villa La Quiete: Il patrimonio artistico del Conservatorio delle Montalve*, ed. Cristina De Benedictis (Florence, 1997), 20–21. Christine outlived her daughter by three years.

4. This appears to contradict Pieraccini's statement (based on I-Fn, Gino Capponi, 261, vol. 2, fol. 258r) that the princess's baptism was delayed until she was nine years old (*La stirpe*, 2:50).

5. "*Principessa* Maria Mad*dalen*a che si dice voler monacarsi per sua indispositione" (I-Fn, Ms. II-226, fol. 145r).

6. Giuseppe Richa, *Notizie istoriche delle chiese Fiorentine*, 10 vols. (Florence, 1754–62; reprint, Rome, 1972), 2:267; [Jacopo] Riguccio Galluzzi, *Istoria del Granducato di Toscana sotto il governo della Casa Medici*, 5 vols. (Florence, 1781), 3:388.

7. On 8 July 1619, Christine of Lorraine wrote the following to her daughter Catherine de' Medici Gonzaga: "The Princess Maria Maddalena has resolved to withdraw [from the world], and therefore a beautiful and comfortable place in the Crocetta is being prepared for her, having first calmed the Murate" [*La Princ. Maria Maddalena si è resoluta di ritirarsi et però se gli va apprestando un bello et comodo luogo nella Crocetta, havendo prima quietato le Murate* (I-Fas, MDP 6110, cited in Pieraccini, *La stirpe*, 2:49)]. This may be the basis for Karla Langedijk's assertion (*The Portraits of the Medici: 15th to 18th Centuries*, 3 vols. [Florence, 1981–87], 2:1302) that the princess had earlier lived at the Murate. On that convent's historical Medici connections, see Enrica Viviani Della Robbia, *Nei monasteri fiorentini* (Florence, 1946), 17–28; and Domenico Di Agresti, *Sviluppi della riforma monastica Savonaroliana* (Florence, 1980), 18–19n43.

sponded to what appears to have been a complicated request for approval to build not only an apartment linked to the convent but also a corridor joining the apartment to the church of the Santissima Annunziata (doc. 8.1). The grand duchess commissioned court architect Giulio Parigi to build the apartment and corridor, and the cost for the project reached 24,114 scudi by January 1621, according to grand ducal treasury figures.[8] Christine also lobbied Archbishop Volpa, bishop of Novara, to influence the Sacred Congregation, so that the license might be amended to include the corridor within clausura, thus enabling the nuns of the Crocetta to accompany the princess when she attended services at the Annunziata.[9] On 22 May 1621, just two days before the entrance of the princess, the Congregation responded to the archbishop of Florence, with the following conditions: the princess could take only one nun at a time with her to the Annunziata, the prioress had to approve of each excursion, the nuns could not enter the corridor without the princess, and the door to the corridor was to be fitted with two keys, one each in the possession of Princess Maria Maddalena and the prioress.[10]

Christine also sought to ensure continuity between the old and new lives of the princess: she persuaded Pope Gregory XV to include Maria Maddalena and the nuns of the Crocetta in his recent bull, which granted indulgences to those members of the Medici household who prayed for the concord of princes, extirpation of heresy, and exaltation of the Catholic church at seven chapels within the Pitti palace in lieu of the seven pilgrimage churches of Rome. Her intent was that the princess would receive an equal opportunity for these indulgences, at altars to be erected in her apartment and in the original part of the convent.[11] Christine also made sure that whenever she

8. I-Fas, DG 1006, no. 534. According to Florentine secretary of state Curzio Picchena, the corridor was completed by 17 March 1620 [1621] (I-Fas, MDP 6108, fol. 1040v). The palace survives as part of the Museo Archeologico of Florence, and visitors can still walk along the corridor to the Annunziata and look down on its high altar.

9. The request was one of several made by the grand duchess, to which the archbishop responded in a letter of 7 May 1621 (I-Fas, Misc. Med. 5, ins. 1, fol. 76r). This same folder contains correspondence between Christine and various church officials concerning the requests (fols. 33r–v, 39r–v, 86r–v, 90r–v).

10. I-Faa, Filze di Cancelleria, 11, n.p.; two copies are also in I-Fas, Misc. Med. 5, ins. 1, fols. 15r–16v. This letter must not have reached the archbishop by 24 May 1621, for the license states explicitly that the corridor would remain outside clausura (I-Fas, Misc. Med. 5, ins. 1, fols. 19r–v); it was amended 1 July 1621 (I-Faa, Filze di Cancelleria, 11; copy in I-Fas, Misc. Med. 5, ins. 1, fols. 21r–v).

11. I-Fas, Misc. Med. 5, ins. 1, fols. 9r, 57r, 59r, 66r, 68r, 76r, 86r–v, 90r–v. On 14 May 1621 Pope Gregory issued a brief including Princess Maria Maddalena and her ladies in the original bull (fols. 11r–13r), which he amended on 7 August 1621 to extend to the nuns (fols. 26r–v).

wished she could spend the night at the convent—in the company of three of her serving ladies, of course.[12] Princess Maria Maddalena entered the convent on 24 May 1621, and within three years she was joined by her sister, the young widow Claudia, and Claudia's one-year-old daughter Vittoria della Rovere, already destined to marry her first cousin, Crown Prince Ferdinando II de' Medici.[13] Another niece, Princess Anna de' Medici (1616–76), resided in the convent from 8 January 1628 [1629] until 28 November 1636, the date on which both Anna and Vittoria della Rovere left for good.[14] Archduchess Maria Magdalena even contemplated retiring there.[15] For the arrival of additional Medici princesses, Christine and her grandson Ferdinando ordered the enlargement of the palace, accomplished by purchasing several contiguous houses. The new structure was declared within clausura in July 1624.[16]

Most of the documents concerning Princess Maria Maddalena were written on her behalf by her family or members of the religious establishment. Yet several of her surviving letters offer a more personal glimpse into the life of this otherwise invisible princess. She wrote to her brother Prince Don Lorenzo on 12 May 1619 boasting of the great strides she had made in playing an unnamed musical instrument.[17] Pope Urban VIII granted a license on 22 June 1633—just six months before her death—which allowed the princess and her niece Anna to play musical instruments in the convent, while also conceding to Francesca Caccini the license to retire there.[18] The princess died on 28 December 1633, and in conformity with her wishes, she was buried in the convent church opposite Domenica da Paradiso. Her monument displayed the grand ducal arms and an inscription by court poet Andrea Salvadori.[19]

12. Pieraccini, *La stirpe*, 2:50.

13. Claudia and Vittoria entered the Crocetta on 7 January 1623 [1624] (I-Fas, Misc. Med. 106, ins. 14, fol. 27r).

14. Monastero di S. Croce, detto la Crocetta, archivio, Armadio B, fol. 5v. The same document (fol. 6r) indicates that on 22 October 1637 Grand Duke Ferdinando II ordered the destruction of the corridors and overpasses connecting the palazzo to the convent. My thanks to Professor Suzanne Cusick for sharing her transcription of this document with me.

15. I-Fas, Misc. Med. 100, ins. 27.

16. The court architect Giulio Parigi described the new rooms in a letter dated 10 July 1624 to an unknown recipient (I-Faa, Filze di Cancelleria, no. 11 [n.p.]). Another surviving document lists the houses purchased to expand the palace (I-Fn, II.III.499, ins. 18).

17. I-Fas, MDP 5172, fol. 54r, cited in Pieraccini, *La stirpe*, 2:54.

18. Gerardo Antignani, *Vicende e tempi di Suor Domenica dal Paradiso* (Siena, 1983), 252.

19. Richa, *Notizie istoriche*, 2:266–67, which includes a transcription of the inscription. An autograph of the princess's final testament survives in I-Fas, Misc. Med. 5, ins. 1, fols. 116r–v.

Princess Maria Maddalena's entrance intensified the relationship between the Crocetta and the Medici family. The convent's acquisition of a regular maestro—Giovanni Battista da Gagliano—occurred after her arrival. Attendance by the princess's relatives at the convent's banquets and theatrical performances suddenly warranted inclusion in the court diary, suggesting that Cesare Tinghi perceived these events to be court performances, given official recognition by the participation of the Medici family. Between 1621 and 1633, the Crocetta assumed the status of a satellite court.

Princess Maria Maddalena also maintained close ties to many of the best-known members of Florence's artistic and literary establishments. The interior of her garden chapel was frescoed circa 1621 by Giovanni da San Giovanni [Giovanni Mannozzi] (1592–1636), a painter who had already established close ties to the Medici family.[20] The frescoes focus on scenes of the Virgin Mary immediately surrounding the birth of Jesus: Filippo Baldinucci singled out the altar painting *Rest on the Flight into Egypt* as an early masterpiece of the young artist, praising in particular the painter's invention and use of color.[21] In the chapel's vault frescoes, a scene of the visitation appears opposite the wedding of Mary, flanked on one side by allegorical representations of the virtues—Faith, Purity, and Meekness—and on the other by archangels.[22] Andrea Salvadori dedicated two books of poetry to the princess in 1623:

20. Filippo Baldinucci, *Notizie dei professori del disegno da Cimabue in qua*, ed. Ferdinando Ranalli, 5 vols. (Florence, 1845–47), 4:225–27. In 1788 Grand Duke Pietro Leopoldo ordered the chapel dismantled and reconstructed in what is now the Accademia di Belle Arti. See also Walter Paatz and Elisabeth Paatz, *Die Kirchen von Florenz: Ein kunstgeschichtliches Handbuch*, 6 vols. (Frankfurt am Main, 1940–55), 1:707; Ilaria Della Monica, ed., *Giovanni da San Giovanni: Disegni* (Bologna, 1994), 14–15, 42; Odoardo H. Giglioli, *Giovanni da San Giovanni (Giovanni Mannozzi— 1592–1636): Studi e ricerche* (Florence, 1949), 53–54; and Anna Banti, *Giovanni da San Giovanni: Pittore della contraddizione* (Florence, 1977), 13–14, 56. Baldinucci claimed that the works were executed in 1621, a date accepted by Giglioli and Della Monica, although Banti has suggested, on stylistic grounds, that they may date from much later (14).

21. Baldinucci, *Notizie*, 4:227.

22. According to Paatz and Paatz (*Die Kirchen von Florenz*, 1:707) the convent also owned a painting on a related subject—Francesco Curradi's *Flight into Egypt*. Since 1867 this work has resided in Santa Maria a Pontanico in Fiesole; see Odoardo H. Giglioli, *Catalogo delle cose d'arte e di antichità d'Italia: Fiesole* (Rome, 1933), 301. The Crocetta documents reveal that the convent commissioned other paintings from Curradi somewhat earlier: on 28 April 1617 they paid him £196 for two large paintings on the subjects of Saint Dominick and Saint Mary Magdalen (I-Fas, Croc 25, fol. 91r). These paintings may be lost, although in 1983 Giuseppe Cantelli (*Repertorio della pittura Fiorentina del Seicento* [Fiesole, 1983], 54) reported two paintings by Curradi in private collections or for sale that fit these descriptions.

Fiori del Calvario and *La natura al Presepe,* a sacred panegyric performed on Christmas 1623.[23] *Fiori del Calvario* consists of fifty-six sonnets chronicling scenes from the Passion, beginning with Christ's entry into Jerusalem and concluding with the triumph of his resurrection. According to Salvadori, Christine of Lorraine initially commissioned these poems as inscriptions for the frescoes that decorated her daughter's corridor to the Annunziata.[24] Two poems addressed to the princess frame the sonnets. In the first, Salvadori contrasts the mythological activities typically associated with springtime to the coterminous events of the Passion and resurrection. He praises Princess Maria Maddalena for choosing to honor the latter, and in the final quatrain he introduces a topos that would inform the princess's iconography throughout her short life—the dual nature of symbols of power (109):

Godi in sacro diporto anima bella,	Enjoy sacred pleasure, beautiful soul,
e sprezza scettri di mortale orgoglio:	and disdain scepters of mortal pride:
ch[é] più ch'aver di tutt'Europa il soglio,	because to be called a virgin handmaiden of God is more [valuable]
[è] chiamarsi di Dio vergin' ancella.	than to have the throne of all of Europe.

Salvadori recalls his juxtaposition of terrestrial and celestial symbols in the final tercets of the collection's concluding sonnet (166):[25]

Deponga il regio crin le gemme, e l'oro,	Let the royal head put aside gems and gold,
e de fior, che ti dan le Sacre Spine	and with the flowers that the sacred thorns give you,
formi il pietoso cor nobil lavoro.	let the pious heart form a noble work.
Condotta poi del mortal corso al fine,	Led then to the end of mortal life,
vedrai di quanto avanzi ogni tesoro,	you will see how much it exceeds every treasure,
la Corona di Cristo aver sul crine.	to have the crown of Christ upon your brow.

The preface to *Fiori del Calvario* also encouraged Princess Maria Maddalena to enjoy sacred pleasure, and documents, music, and plays from this period

23. The Florentine publisher Cecconcelli issued both works in 1623, and he appended *Fiori del Calvario* to his 1625 ed. of the libretto for *La regina Sant'Orsola.* I have used the 1625 ed. for the quotations that follow.

24. Salvadori, preface to vol. 2 of his *Poesie,* cited in Suzanne G. Cusick, "'Who Is This Woman . . . ?': Self-Presentation, *Imitatio Virginis* and Compositional Voice in Francesca Caccini's *Primo Libro* of 1618" *Saggiatore musicale* 5 (1998): 33n31, who notes that at least one of the sonnets must predate the corridor, since Francesca Caccini published a musical setting of a slightly altered version of "Che fai, misero core?" in her *Primo libro delle musiche* of 1618.

25. The renunciation of the crown, jewels, and gold recalls the exchange between priest and novice during the veiling ceremony. See Robert L. Kendrick, *Celestial Sirens: Nuns and Their Music in Early Modern Milan* (Oxford, 1996), 131 and n 45.

confirm that this is precisely what she did. She exploited her family connections to secure for the Crocetta the city's best musicians and playwrights, and she arranged for the nuns to borrow costumes for their theatricals. The surviving musical and theatrical works perpetuate the theme introduced by Salvadori in the *Fiori*, namely, the princess's renunciation of worldly power in favor of the more elevated status as a bride of Christ. Nowhere was this imagery more persistent than in the music likely performed at the convent's clothing and profession ceremonies.

Rites of Passage at the Crocetta

The presence of a Medici princess in the Crocetta appears to have affected the degree to which polyphonic music was incorporated into the ceremonies that marked the stages in a nun's life in the convent. The first of these stages was investiture, during which a young woman became a novice in a convent and assumed its habit. Typically a year later, the novice would profess her vows, take the black veil, and become a full-fledged member of the community.[26] While before 1621 the tradition at the Crocetta appears to have been the payment of two to three lire to priests and clerics for a sung Mass (i.e., in plainchant), during the period of Princess Maria Maddalena's residence at the convent the account books record substantially larger payments of between twenty-eight and thirty-five lire for music by professional musicians at both investitures and professions, suggesting that polyphony or concerted music was performed. Most records also note the individuals responsible for this special music, naming three musicians (see table 7.3): Orazio Grazi was paid £2 on 14 April 1624 for singing contralto at the profession of Suor Maria Christina Peruzzi, while Marco da Gagliano received £35 on 11 May 1625 for providing music at the investiture ceremony of Maria Vettoria Medici. Most often the convent paid their regular maestro Giovanni Battista da Gagliano, who received £28 for the profession of Maria Christina Peruzzi (the same occasion for which Grazi sang contralto), £35 on 3 June 1624 for the investiture of Suor Anna Maria Peres (possibly Perez), daughter of the Spaniard Don Alonso Peres, and another £35 for the same nun's profession the following year.

26. For discussion of these ceremonies and their musical components elsewhere in Italy, see Dominican Sisters of San Sisto, *Chroniques du Monastère de San Sisto et de San Domenico e Sisto à Rome*, 2 vols. (Levanto, 1919–20), 2:573–80; Craig A. Monson, *Disembodied Voices: Music and Culture in an Early Modern Convent* (Berkeley, 1995), 183–94; Kendrick, *Celestial Sirens*, 132–36; Colleen Reardon, "*Veni sponsa Christi*: Investiture, Profession and Consecration Ceremonies in Sienese Convents," *Musica Disciplina* 50 (1996): 271–97, and *Holy Concord within Sacred Walls: Nuns and Music in Siena, 1575–1700* (Oxford and New York, 2002), 50–74.

Among the surviving sacred music by the Gagliano brothers are four works that, although not necessarily composed specifically for the convent, would have been suitable for these ceremonies. Marco da Gagliano included a setting of a particularly Dominican variant of the text *Veni creator spiritus* in his *Sacrarum cantionum* of 1622.[27] *Veni creator spiritus* is the vespers hymn for Whit Sunday, but it was also performed at both the investiture and profession of a nun. In ceremonials from Milan and Bologna that prescribe the order of events in the profession ritual, the nuns themselves sing the hymn.[28] This may have been the context for Gagliano's four-voice setting as well, which is scored for three sopranos and a tenor, plus continuo. The sole surviving part-book (*basso generalis*) contains music only for the even-numbered verses of the hymn, suggesting *alternatim* performance.

Another polyphonic work that would have been appropriate for perfor-mance during these rites of passage is Giovanni Battista da Gagliano's *Venite virgines*, a motet for two SATB choirs plus basso continuo published in his second book of motets (Venice, 1643). The centonized text is built on phrases from *Prudentes virgines*, the Magnificat antiphon for the Common of Virgin Martyrs and an antiphon that figured prominently in the ceremony for the consecration of virgins: "Prudent virgins, make ready your lamps: behold the Bridegroom comes, go out to meet him" [*Prudente Virgines, aptate vestras lampades: ecce Sponsus venit, exite obviam ei*].[29] The text set by Gagliano offers a similar mes-sage, but makes explicit the rewards for such a choice: "Come virgins, this is the day in which you are called to glory. Hurry, behold your bridegroom comes, go out to meet him. Prudent virgins, come and rejoice, because your reward is great in heaven. Alleluia" [*Venite Virgines, haec est illa dies in qua vocatae estis ad gloriam. Festinate ecce Sponsus venit, exite obviam ei. Prudentes Virgines, venite et exultate, quia merces vestra multa est in caelis. Alleluia*].[30]

Gagliano captures the joyousness of this text in his musical setting, but he also creates a motet that stresses those images that would have been of particular importance to nuns (ex. 8.1). Throughout the work he uses the

27. Emmanuel Suarez, ed. *Processionarium juxta ritum sacri ordinis prædicatorum* (Rome, 1949), 153–54. The principal differences consist of a reordering of the words in verse 2 and a slight word alteration for verse 6 (*te* rather than *teque*).

28. Kendrick, *Celestial Sirens*, 133; Monson, *Disembodied Voices*, 184.

29. On the consecration of virgins, see René Metz, *La consécration des vierges dans l'Église Ro-maine: Étude d'histoire de la liturgie* (Paris, 1954), esp. 411–55; and Monson, *Disembodied Voices*, 195–97. Kendrick (*Celestial Sirens*, 134) also notes the use of the antiphon in profession ceremonies in Milan.

30. The shared phrase "ecce sponsus venit, exite obviam ei" comes directly from the parable of the wise and foolish virgins in Matthew 25:6.

two choirs antiphonally, bringing them together homophonically only four times—at "dies" (m. 7), "ad gloriam" (mm. 12–14), "et exultate" (mm. 24–25), and "[multa est] in caelis" (mm. 31–33)—phrases that within the context of the motet celebrate the heavenly rewards of an earthly life of virginity. The opening half notes of the initial "venite" literally call the virgins to glory. Bass motion by fifths similarly hurries the virgins along (*festinate*) in order to reach the F harmony (m. 15), whose coincidence with "ecce sponsus venit" explains the reason behind such haste. Gagliano also re-creates the immensity of the heavenly rewards of virginity though an expanded musical setting at the text "quia merces vestra multa est in caelis" (mm. 26–33), featuring first an antiphonal pronouncement of the entire phrase, then subsequent antiphonal alternations on "multa est."

The younger Gagliano brother also composed two settings of *Veni sponsa Christi*, the Magnificat antiphon for the Common of Virgins that was often sung as a part of both investiture and profession ceremonies, as well as for the consecration of virgins. A setting for double SATB choir plus continuo appeared in the composer's first book of *Mottetti per concertare* (Venice, 1626), while a motet for six voices (SSATTB) and continuo came out in the second book of 1643. Gagliano paraphrases loosely the plainchant antiphon in both works, but as with so many of his compositions, overall organization depends principally on harmonic and textural control. In the double choir motet he divides the text into a series of short phrases, sung by each choir in turn—at the same pitch or transposed—often concluding with a homophonic statement in all eight voices (ex. 8.2). Textural logic is matched by harmonic clarity: the musical phrases of individual choirs and the combined group typically end with a cadence, most often to the modal final of F. Throughout the first statement of the text (mm. 1–30), Gagliano treats only the word "coronam" to melismatic elaboration (mm. 9–14), allowing the word to stand out against the otherwise syllabic text setting and the homophonic texture. Coronation imagery was important to the nuns and the profession ceremony, for the symbol of the crown served as the visual confirmation of their spousal relationship with Christ.[31] At measure 31, Gagliano repeats the opening measures, not only providing musical closure but high-

31. Gabriella Zarri, "Ursula and Catherine: The Marriage of Virgins in the Sixteenth Century," in *Creative Women in Medieval and Early Modern Italy: A Religious and Artistic Experience*, ed. E. Ann Matter and John Coakley (Philadelphia, 1994), 262–63. See also Kate Lowe, "Secular Brides and Convent Brides: Wedding Ceremonies in Italy during the Renaissance and Counter-Reformation," in *Marriage in Italy, 1300–1650*, ed. Trevor Dean and K. J. P. Lowe (Cambridge, 1998), 41–65.

lighting, as well, the significance of "sponsa Christi" by using it as the motet's concluding text. A second repetition of the phrase (m. 38) allows him to continue his emphasis on bridal imagery, and by means of exuberant scalar melismas on "sponsa" he creates an aural association between the bride and the crown that both confers and confirms her status.

Gagliano reuses many of these compositional techniques in his later setting of the *Veni sponsa* text (ex. 8.3). It, too, closes with a repeat of the opening material. Although this motet is quite short, the composer once again introduces widely varied textures, from the nearly homophonic opening command to the more leisurely imitation at "accipe coronam" (mm. 7–16). Alternating trios at measure 19 re-create the antiphonal nature of the 1626 motet, as does the third statement of the text in all voices. Melismas on "coronam" and "sponsam" once again underscore musically the virgin's status as an honored bride. In all three of these motets Gagliano's musical settings seem calculated to call attention to images that would have resonated with the lives and ceremonies of the women who lived in the Crocetta.

Theatrical Life of the Convent after 1621

These same concepts received a similar dramatic treatment in the plays performed at the Crocetta during the residence of Princess Maria Maddalena and her sister and nieces. Although the convent's theatrical life might always have been an active one, after the entrance of Princess Maria Maddalena, court diarists record these performances more regularly. On 8 February 1622 the princess participated in some type of theatrical event, and the court diarist recorded the presence of Archduchess Maria Magdalena and Grand Duchess Christine, as well as two princesses (probably Margherita and Anna), at its performance.[32] The following year the princess planned what appears to have been an even more elaborate production, and, thanks to her influence at court, the nuns recited their roles in costumes borrowed from the Medici storerooms. Christine had once again interceded on her daughter's behalf: in early February 1623 she requested costumes and props for such diverse characters as a general, a senator, Vanity, Deceit, a siren, furies, and virgins (doc. 8.2). Her instructions to provide the virgins wigs, jewels, and false pearls suggest that they were of the foolish variety. In his response, Vincenzo Giugni approved the request with a note that the Guardaroba would arrange for the

32. I-Fn, Gino Capponi 261, fol. 471v, in Angelo Solerti, *Musica, ballo e drammatica alla corte Medicea dal 1600 al 1637: Notizie tratte da un diario, con appendice di testi inediti e rari* (Florence, 1905; reprint, New York, 1968), 161.

princess's new dress, but made of taffeta not wool. He promised to deliver used costumes and props for Vanity, Deceit, the siren, and the furies. Gowns for the five virgins were also to be lent, with a note that the costumes intended for the Saint Ursula opera were to be left alone. Prince Don Lorenzo would supply the costumes and items belonging to most of the male characters.

On 22 November 1623, Archduchess Maria Magdalena once again gathered up the two princesses, as well as the six-year-old Prince Leopold, and they joined Christine and Princess Claudia at the convent for the performance of a "Dialogo del[l']anima et del corpo."[33] Solerti has proposed that the work performed was the fifteenth-century *Rappresentazione sacra di anima e di corpo;* it might also have been the dialogue on the same topic written by Crocetta's founder, Domenica da Paradiso.[34] The court diary also mentions two small-scale celebrations (*festicine*) in 1625 (5 February and 27 November), both of which the archduchess and her daughters attended.[35]

Although most of the documents that confirm dramatic performances at the Crocetta date from after 1620, its theatrical activity began long before that.[36] As early as the late fifteenth century, members of Florentine female

33. I-Fas, Misc. Med. 11, fol. 3v, reprinted in Solerti, *Musica*, 170.

34. The dialogue was included in Ignazio del Nente's "Meditazioni e divine intelligenze della gran serva di Dio e veneranda Madre Suor Domenica dal Paradiso" (I-Fr, Ricc. 2633, fols. 157v–160r [*olim* fols. 155v–158r]). Another work with this title appears in a collection of spiritual *laude* owned by a woman named Lucia, servant of Princess Anna de' Medici, with indications that at least part of the dialogue was to be sung (I-Fn, Magl. VII.432, fols. 5v–17v). I would like to thank John Walter Hill for calling my attention to this manuscript.

35. I-Fas, Misc. Med. 11, fols. 106, 150. Regardless of post-Tridentine concerns that persons extraneous to the convent not attend its plays, they often did. In Florence, women born or married into the Medici family frequently sponsored or attended such performances: Giulia de' Medici, daughter of Duke Alessandro de' Medici, commissioned and supported financially the performance of two plays at the Monastery Regina Coeli, called Di Chiarito, around 1560. See Viviani della Robbia, *Nei monasteri fiorentini*, 245. Grand Duchess Giovanna of Austria attended a 1575 performance of Giovan Maria Cecchi's *La morte del re Acab* by the nuns of Spirito Santo. See Cecchi, *Drammi spirituali inediti*, ed. Raffaello Rocchi, 2 vols. (Florence, 1895), 1:xxii. Grand Duchess Vittoria della Rovere witnessed a performance of Suor Maria Clemente Ruoti's *Giacob patriarca* (pub. 1637) at the convent of San Girolamo and San Francisco, called San Giorgio. See Elissa B. Weaver, "Suor Maria Clemente Ruoti, Playwright and Academician," in *Creative Women in Medieval and Early Modern Italy*, ed. Matter and Coakley, 282 and 292n5.

36. Elissa Weaver has traced two sixteenth-century plays to the Crocetta: Beltramo Poggi's *Invenzione della croce di Gesù Cristo* (Florence, 1561; and I-Fr, Ricc. 2978, vol. 3, fols. 1r–46v) and *Lotta spirituale dell'angelo con il demonio* (I-Fr, Ricc. 2974, vol. 7); discussed in her *Convent Theatre in Early Modern Italy: Spiritual Fun and Learning for Women* (Cambridge, 2002), 67, 76–78, 83, 88–89,

convents sponsored performances of plays that fulfilled the interrelated purposes of diversion and instruction.[37] To their ecclesiastical superiors, the nuns' plays were vehicles to inculcate the values deemed important for Christian monastic women. Convent plays probably did help teach younger women the values of the wider female community. Spectators not only passively witnessed the spiritual messages around which authors constructed the plots of these sacred comedies but, for the women who acted in them, typically the younger nuns most in need of instruction, a play allowed its actresses to become the exempla of Christian virtue they portrayed. With some exceptions, most church authorities allowed the plays, provided the works were performed in an appropriate location, in the nuns' regular habits, and, especially in light of the post-Tridentine concern for stricter enclosure, for members of the convent only. In 1601 Archbishop Alessandro de' Medici proclaimed support for convent theater, provided that the plays were based on the Bible or lives of the saints, had been preapproved, and were free from lasciviousness and error. Nuns were expressly forbidden to perform plays wearing any clothing but their habits—specifically illegal were men's stockings.[38] But like their sisters in other Florentine convents, the nuns at the Crocetta disregarded these proscriptions.

Convents drew their theatrical repertory from a variety of sources. As Elissa Weaver has demonstrated, the nuns themselves composed many of the plays. They also performed traditional *sacre rappresentazioni*.[39] Others staged existing or newly commissioned works by male playwrights. In the late sixteenth century, the Florentine convent Santa Caterina da Siena di Firenze received much of its repertory from Giovan Maria Cecchi, whose grand-

132–33. Curzio Picchena mentions the transfer of costumes to both the Crocetta and the Murate during the carnival season of 1620 (I-Fas, MDP 6108, fol. 1026r).

37. The main authority on Florentine convent theater is Elissa Weaver, most recently in her book, *Convent Theatre in Early Modern Italy*. See also Alessandro d'Ancona, *Origini del teatro italiano*, 2d ed., 2 vols. (Turin, 1891), 2:155–62; Richard Trexler, "Florentine Theater, 1280–1500: A Checklist of Performances and Institutions," *Forum italicum* 14 (1980): 471; Antonia Pulci, *Florentine Drama for Convent and Festival: Seven Sacred Plays*, trans. James Wyatt Cook (Chicago, 1996); and Gabriella Zarri, "Monasteri femminili e città (secoli XV–XVIII)," in *Storia d'Italia*, annali 9, *La chiesa e il potere politico dal Medioevo all'età contemporanea*, ed. Giorgio Chittolini and Giovanni Miccoli (Turin, 1986), 359–429, esp. 395.

38. Cited in Zarri, "Monasteri femminili," 395; translated in Elissa B. Weaver, "The Convent Wall in Tuscan Convent Drama," in *The Crannied Wall: Women, Religion, and the Arts in Early Modern Europe*, ed. Craig A. Monson (Ann Arbor, MI, 1992), 74–75.

39. D'Ancona, *Origini*, 2:157–62.

daughter was a nun there.[40] In some instances playwrights may have offered unsolicited plays to convents, hoping to acquire some of the "spiritual capital" that the convent possessed.[41] Others likely sent their works in order to please the noble families whose daughters resided there.

This second explanation probably accounts for two surviving plays, both by Jacopo Cicognini, that can be connected to the Crocetta during the period of Maria Maddalena's residence. Throughout his life Cicognini attempted to secure a position at the Medici court. Although he never gained an official post, his position as the playwright for several Florentine confraternities did earn him court recognition, such as the regents' request for a revival of his Saint Agatha play in 1622. He may have hoped to capitalize on his toehold into court life, for in 1625 he dedicated *Il martirio di Santa Caterina* to Princess Maria Maddalena. As a saint of particular importance to Dominicans, Catherine of Alexandria was an especially suitable theatrical protagonist for the nuns of the Crocetta. The convent had commissioned a painting of the virgin martyr from Cosimo Gamberucci in 1617.[42] In a possible reference to Princess Maria Maddalena's fondness for Saint Catherine, sometime shortly after her death her mother commissioned Giovanni da San Giovanni to fresco the central soffit of the princess's palace with a depiction of

40. Konrad Eisenbichler, "The Religious Drama of Giovan Maria Cecchi" (Ph.D. diss., University of Toronto, 1981), 223. Some plays were specifically requested by nuns (e.g., *L'Eduina*, 1581); Cecchi sent others on his own initiative, e.g., *Santa Agnese*. See also Elissa B. Weaver, "Le muse in convento: La scrittura profana delle monache italiane (1450–1650)," in *Donne e fede: Santità e vita religiosa in Italia*, ed. Lucetta Scaraffia and Gabriella Zarri (Rome and Bari, 1994), 253–276, esp. 265, and "Spiritual Fun: A Study of Sixteenth-Century Tuscan Convent Theater," in *Women in the Middle Ages and the Renaissance: Literary and Historical Perspectives*, ed. Mary Beth Rose (Syracuse, NY, 1986), 173–205, esp. 178.

41. The term "spiritual capital" is from Kendrick, *Celestial Sirens*, 35.

42. I-Fas, Croc 25, fol. 98v, dated 30 June 1617, records the payment to Gamberucci (ca. 1560–1621) of £196 for two large paintings, one of Saint Catherine of Alexandria and the other of Catherine of Siena. The previous year the nuns had paid Gamberucci £35 for a painting of Saint Margaret (I-Fas, Croc 25, fol. 62r). All three paintings are apparently lost, although Simona Lecchini Giovannoni notes, based on information related by Giuseppe Cantelli, that Gamberucci's painting of Saint Margaret currently in Florence at Santa Maria da Ricci (formerly in the church of Santa Margherita), shares stylistic characteristics with an anonymous painting of Saint Catherine of Alexandria in the duomo of San Miniato al Tedesco. See her "Cosimo Gamberucci: Aggiunti al catalogo. Problemi attributivi nelle cartelle di disegni di Santi di Tito degli Uffizi e del Louvre," *Antichità viva* 21, nos. 5–6 (September–October 1982), 13–14, 27n47. In his book, Cantelli (*Repertorio*, 92) attributes both paintings to Gamberucci.

the angels' transportation of Catherine's body to its new resting place on Mount Sinai (fig. 8.2).[43]

Cicognini's play, previously thought to have been lost, survives in a collection of manuscript plays in the Biblioteca Riccardiana, where Silvia Castelli uncovered it in 1988.[44] *Santa Caterina* was likely the work performed on 27 November 1625, a date that falls just two days after the saint's feast day. Cicognini recycled the work for the Compagnia di San Antonio di Padova, which presented it during the carnival season of 1627.[45] But he clearly intended the play for a convent, for he addresses the work's prologue, sung by Divine Wisdom, specifically to an all-female audience (*spettatrici*). The prologue also contains the types of stage directions that would have been necessary for an actual performance, for example, "Here a solo voice should sing, as Signora Francesca knows, then the entire chorus should repeat the first stanza, that is, 'Noi dell'eterno Amore.'"[46] Signora Francesca most likely refers to Francesca Caccini, suggesting that by at least 1625, the Crocetta had access to one of the court's most prized musicians.[47]

Cicognini also composed at least one other play for nuns—*Le vittorie di*

43. Odoardo H. Giglioli, *Giovanni da San Giovanni*, 111–13 and plate 84. His proposed dates of 1634–36 stem from the fresco's relationship to a similar scene painted by the artist in the Catherine chapel of the Palazzo Rospigliosi in Pistoia, which dates from 1633. Giglioli (113) credits Christine of Lorraine, for whose villa La Quiete the painter provided artwork ca. 1627, for the commission. While Giglioli judges the Crocetta fresco to have surpassed its counterpart in Pistoia, Anna Banti (*Giovanni da San Giovanni*, 30, 78) takes a more dismissive view, and the fresco has disappeared quietly from recent studies of the painter's works.

44. I-Fr, Ricc. 3470, fols. 325r–429r. See Silvia Castelli, "La drammaturgia di Iacopo Cicognini" (Tesi di Laurea, Storia dello spettacolo, Università degli studi di Firenze, Facoltà di lettere e filosofia, 1988–89), 53.

45. The company's records note three performances in February 1627, listing three performers: Giova[n]maria Truchi, Raffaello Santi, and Giovambattista Carretti, who took the title role (I-Fas, CRS 134, no. 2, fol. 42v; no. 3, fol. 69v).

46. "Qui una voce sola doverebbe cantare, come sà la Sig.ra Francesca, e poi replicare tutto il Coro la prima stanza, cioè Noi dell'eterno Amore" (fol. 327v).

47. Caccini may have enjoyed a close relationship with Princess Maria Maddalena: a letter written by the princess to her brother, Cardinal Carlo de' Medici, on 15 October 1623 (I-Fas, MDP 5183, fol. 474r), mentions that she has been reminded of her obligation to correspond with him due to "l'occasione della Francesca che canta che ne viene a Roma." Caccini left Florence for Rome after 7 October and arrived on 28 October. The dating of Maria Maddalena's letter suggests that Caccini departed sometime around 15 October and that she took the letter with her. On Caccini's sojourn in Rome, see Warren Kirkendale, *The Court Musicians in Florence during the Principate of the Medici with a Reconstruction of the Artistic Establishment* (Florence, 1993), 321.

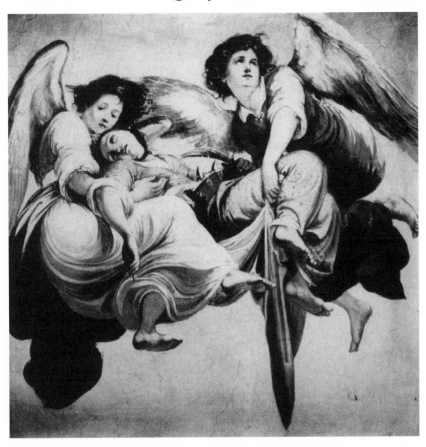

FIGURE 8.2. Giovanni da San Giovanni, *Angels Carrying the Body of Saint Catherine of Alexandria* (Florence, Museo Archeologico)

Santa Tecla, now located in the Biblioteca del Seminario Maggiore in Florence (manuscript C.V.25). The unfoliated manuscript appears to be the work of multiple hands, and it represents varying stages of the work's composition, with pages featuring light emendations to others of near fair copy quality. Its prologue—addressed to *spettatrici,* "queens of the Arno" and "sacred virgins"—indicates that the work was also intended for a Florentine monastery.[48] The play's final *intermedio* confirms that this convent was the Crocetta,

48. Mario Sterzi ("Jacopo Cicognini," *Giornale storico e letterario della Liguria* 3 [1902]: 393– 95) first reported the location of the work, and he also identified it as a Dominican convent play, without, however, giving his reasons for associating it with a particular order. One or more of the confraternities with which Cicognini was associated may have performed the work subsequent to its performance at the Crocetta: in the final scene of act 5, the word re-

for when the allegorical personage of Virginity confirms the queenly status of the audience, that is, "brides of the king of glory," she notes that they already wear the insignia of their rank: "[Your] scepter will be this vermillion cross that I impress on your breast" [*scetro sarà questa Vermiglia Croce / che nel seno io v'impresso*]—a clear reference to the distinctive habit of the Crocetta.

These two surviving works may not constitute Cicognini's only contributions to the convent, for in the prologue of *Santa Tecla* Virginity reminds her audience that five other exemplary virgins had crossed their noble stage: Saints Catherine, Dorothy, and Cecilia, as well as the prudent virgin Lucinda and the daughter of Jephtha.[49] Virginity's inclusion of Catherine establishes that *Santa Tecla* was performed sometime between 1625 and 1633, the year in which both Cicognini and Princess Maria Maddalena died. The Thecla play may date from the years 1630–31, as plague threatened the city. Thecla's intercession was believed to have saved the town of Este from the plague—Cicognini and the nuns may have invoked her name hoping for similar protection on behalf of Florence.[50]

The two plays are similar in many respects. Both are in prose, divided into five acts, and with the double plot construction that we have already encountered in Cicognini's *Il martirio di Sant'Agata*. Each play begins with a verse prologue that is directed specifically toward an all-female audience and delivered by an allegorical personage and chorus. These prologues affirm the didactic intent of the works, which in the case of the Thecla play is corroborated by the actual presence of the personages Delight (Diletto) and Use-

ferring to an all-female audience—*aspettatrici*—has been altered to read *aspettatori*, suitable for an all-male or mixed gender gathering.

49. Cicognini may very well have been the author of all six plays, although only the Catherine and Thecla works are known to have survived: a 1690 inventory of the furniture owned by the Compagnia dell'Arcangiolo Raffaello (I-Fas, CRS 155, p. 20) notes that manuscripts of several of his plays were found in a cupboard, including *Il voto di Jefte*, and *La vergine prudente*. The company performed *La vergine prudente* ten years after Cicognini's death, during the carnival season of 1643, with music by Baccio Baglione. See Guido Burchi, "Vita musicale e spettacoli alla Compagnia della Scala di Firenze fra il 1560 e il 1675," *Note d'archivio per la storia musicale*, n.s., 1 (1983): 43. It seems unlikely that the play featuring the daughter of Jephtha should be identified as Cicognini's *Il voto di Effette chiamata il voto d'Oronte* (I-Fs, A'.I.3 [*olim* C.V.25]), even though its manuscript was at one time bound with the Thecla play: despite its title, *Il voto* is drawn from the biblical story of Jephtha (Judg. 11:30–40) only in that its title character—Oronte—makes a similar vow. Neither Jephtha nor his daughter actually appear in this work.

50. On Thecla's attributes, see Louis Réau, *Iconographie de l'art Chrétien*, 3 vols. (Paris, 1955–59), 3.3:1251; and Maria Chiara Celletti, "Tecla di Iconio, venerata a Seleucia. Iconografia," *Bibliotheca sanctorum*, 13 vols. (Rome, 1961–70), 12:178. The Catholic church removed Thecla from the canon of saints in 1969.

fulness (Utilità). Choral *intermedi* related to the plot follow each of the acts in both works. In the case of *Santa Caterina* each *intermedio* consists of three or four stanzas sung by a chorus representing different groups—priestesses of Pallas Athena, Bacchantes (!), ladies-in-waiting of the empress, virginal followers of Saint Catherine, and angels—but probably performed by the same ensemble of singers. While *intermedi* 1, 2, and 4 of *Le vittorie di Santa Tecla* are also of this type, the third and fifth *intermedi* include choruses preceded by spoken verses.

Cicognini's poetic choices provide clues to the nature of the music, now apparently lost. In both sets of *intermedi*, stanzas of four-, five-, and eight-syllable lines suggest musical *canzonette*, sung homophonically or in unison by a chorus of female voices. The prologues also feature solo singing. In *Tecla*, after Virginity's lengthy spoken monologue she sings three six-line stanzas of mixed *ottonari* and *quaternari*. Cicognini also uses stanzaic poetry for Divine Wisdom's solo verses in the *Santa Caterina* prologue, although this time the allegorical personage sings four quatrains of *endecasillabi*. In both cases, the performers most likely would have delivered their lines using special recitative, the expressively neutral, formulaic style apt for stanzaic verse. The stage directions to *Santa Caterina* also indicate that Francesca Caccini had already composed, and possibly would sing, an aria appropriate for insertion in the prologue. Caccini had published just such a work in her 1618 monody collection: "Deh chi già mai potrà Vergine bella," which prepares the listener for the presentation of the story of a holy virgin.[51] The praise offered to the new bride could be interpreted as a reference to Catherine's mystical marriage with Christ, but it also would have resonated personally with the nuns in attendance, who knew themselves to be brides of Christ.

Recreation and Re-creation

Catherine and Thecla were appropriate models for this community of female religious. Both were exempla of the rewards awaiting those who chose a life of virginity, and, in Cicognini's dramatic treatments of their legends, both founded communities of like-minded religious women. But the two surviving plays communicate more than simply models for nuns' behavior; both functioned as idealistic illustrations of convent life itself, promoting not only monastic values but activities as well, framed within a narrative of sanctity that affirmed the nuns' choices to devote their lives to the service of God. This emphasis on a young woman's choice contrasts with images of forced

51. Francesca Caccini, *Il primo libro delle musiche a una, e due voci* (Florence, 1618).

imprisonment encountered in many convent plays composed by nuns, as noted by Elissa Weaver.[52] It also reinforces the post-Tridentine ideal of a freely chosen religious vocation, rather than the reality of coerced monasticism. Undoubtedly this difference stems, in part, from the male gender of the author—an outsider to the realities of convent life. Yet the issue of patronage also plays a significant role. Although Cicognini dedicated the Saint Catherine play to Princess Maria Maddalena, he may have hoped to leverage this connection to gain a more lucrative position with the Medici family. And whether or not the princess retired to the convent of her own free will—and the surviving documents demonstrate that she was offered some incentive to do so—her family certainly had a vested interest in propagating the version of events that stressed her choice, thereby drawing attention away from the stigma of a disabled child.

This complicates the question of communication—whose message was transmitted by these plays and to what audience? Certainly the emphasis not only on free will, but, in the case of Thecla and Catherine, the evaluation of convent life as the better choice, a message already affirmed in Salvadori's *Fiori del Calvario,* may have been directed toward the princess herself. But the coincidence of Maria Maddalena's residence with the nuns' canonization efforts on behalf of their founder does suggest that the nuns of the Crocetta sought to promote the elevated status of convent life. The plays then become conduits of reciprocal communication, at once stressing the holiness of the spiritual life and congratulating those young women wise enough to have sought it.

Cicognini confirms the lofty status of both his protagonists and his audience by stressing their shared positions as brides of Christ. Liturgical custom conferred this status on Catherine and Thecla. Christ himself bestowed the title on Catherine, first in his presentation of the ring that signified their mystical marriage and immediately before her death, when he called to her: "Come my delight, my bride, behold the door of heaven, that is open to you, and to those who celebrate your passion I promise the desired aid from heaven."[53] The text expands the *Veni sponsa Christi* antiphon proper to the feast

52. Weaver, "Convent Wall," 75–76.

53. "Vienne, diletta mia, sposa mia, ecco la porta del cielo, che t'è aperta, e a coloro che faranno festa de la tua passione prometto il disiderato aiuto da cielo" reads the text from a fourteenth-century Tuscan translation of the Golden Legend, reproduced in Jacobus de Voragine, *Leggenda aurea: Volgarizzamento Toscano del Trecento,* ed. Arrigo Levasti, 3 vols. (Florence, 1924–26), 3:1500.

days of both saints. Although in his play Cicognini includes theatrical representations of neither the mystical marriage nor her bridegroom's final invitation, he does allude to Catherine's bridal status throughout the play and its *intermedi.* His dramatic choices reveal an awareness of medieval versions of the life of the saint, as well as more recent theatrical works. For medieval Italian writers the most influential sources were the eleventh-century *passio* by Basil II and Jacobus de Voragine's *Golden Legend* from the thirteenth century (summary in app. A).[54]

In both vitae Emperor Maxentius alternates his orders of torture with attempts to seduce Catherine by promises of power and prestige. In each of these encounters, Catherine rejects the offer by asserting her relationship to her true spouse. She furthermore informs Maxentius that he is wasting his time: "Christ has accepted me as His spouse; I have desired that I be a spouse to Christ, by an unbreakable bond. He is my glory, He is my nobility, He is my love, He is my sweetness and my delight. Once I have been declared His, neither the enticements of earthly things nor special torments can ever frighten me away from confessing Him."[55] Catherine also teaches the empress the difference between a mortal and a heavenly husband, encouraging her, saying, "Do not fear, queen elected by God, for today you will exchange realms, and you will be given the eternal for the transitory and, instead of a mortal spouse, you will gain the immortal one."[56] These speeches and images continued to influence Italian redactions of the Catherine legend. The angel who announces the fifteenth-century *Devota rappresentazione di S. Caterina vergine, e martire,* a play whose popularity is demonstrated by a large number of reprints lasting well into the seventeenth century, offers Catherine as a model, describing her as "the maiden who married her beloved God" [l[']ancilla . . .

54. Anne Wilson Tordi, ed., *La festa et storia di Sancta Caterina: A Medieval Italian Religious Drama* (New York, 1997), 4. For the *Passio,* see the English translation by Nancy Wilson Van Baak that is included as an appendix to Tordi's book (249–91). I have relied on two editions of the *Golden Legend* by Jacobus de Voragine: *The Golden Legend: Readings on the Saints,* trans. William Granger Ryan, 2 vols. (Princeton, 1993), 2:334–41, and *Leggenda aurea* , ed. Arrigo Levasti, 3:1490–1504. Another fourteenth-century Italian legend (in I-Fas, Magl. XXXV.173) appears in Francesco Zambrini, ed., *Collezione di leggende inedite, scritte nel buon secolo della lingua Toscana,* 2 vols. (Bologna, 1855), 2:141–58.

55. *Passio,* trans. Van Baak, 272. An abbreviated version of the speech appears in the *Golden Legend.*

56. "Non temere tu, reina eletta da Dio, però che oggi cambierai reame, e saratti dato lo eternale per lo passatoio e, per lo sposo mortale, guadagnerai il non mortale" (from Voragine, *Leggenda aurea,* ed. Levasti, 1498).

che si spos[ò] al suo diletto Dio].[57] Throughout the *rappresentazione*, Catherine refers to herself and is described by others as the *sposa* of God.

Although Cicognini focuses the action of his play on the events following the arrival of the philosophers summoned to debate her, compressed into a single twenty-four-hour period, he either reproduces or refers to all the principal events of the *passio*. His addition of a devil, Astarotto, who poses as one of the philosophers and goads the emperor into his rash decisions, appears to be an embodiment of the accusations that Catherine levels against the philosophers in the *sacra rappresentazione*: "your idols are deceptions that the devil works on you and on other people" [*e vostri idoli sono ingannamenti / che [']l diavol fa a voi, & l[']altre genti*] and "you are in the pillory with the devil" [*state col diavolo in gogna*].[58] Her claim to be "harder and stronger than the diamond" [*et son più dura, e forte che [']l Diamante* ([A3]v)] returns in Cicognini's play (act I.9) as part of her prayer before the debate with the philosophers: "My breast made into unbreakable diamond, it will instead turn back the arrows of false arguments toward their archers" [*Anzi fatto il mio seno infrangibile diamante farà rivolgere i dardi de i falsi argomenti verso gli stessi saettatori* (fol. 346v)]. Cicognini even exhibits a possible familiarity with a more recent play on the subject, Lucillo Brammini's *Tragedia di Santa Chaterina V.M.* (Rome, 1595), by the dramatic weight he gives the character of Catherine's nurse.[59]

In general, Cicognini's version of the martyrdom of Saint Catherine conforms closely to the medieval legend. As with his Saint Agatha play, what gives the work its individuality is its secondary plot—the addition of situations and characters designed to sharpen the play's didactic meaning. These characters include numerous servants, both clever and slow-witted, a foolish old man named Timoteo, and Madame Antilia, characterized in the list of interlocutors as an *hipocrita*. Antilia appears as a dramatic foil to Catherine—she claims to possess spiritual powers, including the ability to cure and exorcize by means of incantations, but her powers are fraudulent, and her words are ineffectual. She fails in her attempt to drive out the demon that has possessed the house of Timoteo, part of a larger comic subplot carried out by the wily servant Lupo, by which General Porfirio hopes to gain access to Catherine's prison cell. When the real demon Astarotto takes over the dwell-

57. *La devota rappresentatione di S. Caterina vergine, e martire: Nuovamente ristampata* (Florence, 1561), sig. A[1]v; reprinted in *Sacre rappresentazioni Toscane dei secoli XV e XVI*, ed. Paolo Toschi (Florence, 1969).

58. *La devota rappresentatione*, sig. B[1]v.

59. Cicognini names his nurse Faustina, which in Brammini's play is the name given to the empress. The play has been published in a modern edition: Lucillo Brammini, *Tragedia di Santa Chaterina V.M.*, ed. Fabio Carboni (Rome, 1993).

ing, only the Christian hermit Cleto may expel him. By contrast to Antilia's failure, the words of Catherine convert the fifty philosophers, the empress, and Porfirio. The appearance of the angels who destroy the wheel of torture confirms the efficacy of her prayers.

Building on the themes and dramatic procedures in his principal sources, Cicognini uses these secondary characters and situations to illustrate the contested meanings of several concepts, especially wisdom, eloquence, crown, and spouse. That the play will focus on the nature of true wisdom is evident beginning with the prologue. In her first two quatrains Divine Wisdom explains the meaning of her costume—one clearly inspired by Ripa's description of Wisdom (Sapienza) in his *Iconologia*—and her words frame the nature of the debate.[60]

Son' la Divina Sapienza eterna,	I am the eternal divine wisdom
ch'à mio voler' sò dominar' le stelle,	who knows how to dominate the stars at my will;
questo scetro immortal', queste fiammelle,	this immortal scepter, these little flames,
mostrano à voi mia potestà superna.	demonstrate to you my heavenly authority.
In terra non si pregi alcun' mortale	No mortal on earth may pride himself
acquistarmi con l'uso, ò con fatica;	on acquiring me through custom or with effort;
l'eternitade è mia Nutrice Antica,	eternity is my old nursemaid,
et è mio Genitor spirto immortale.	and an immortal spirit is my parent.

(fol. 327r)

The final stanzas single out Catherine as the recipient of such wisdom and present her as a model to the audience:

D'illustrar' mi compiacque una bell'Alma	It pleased me to illustrate a beautiful soul
chiusa nel casto sen' di Caterina,	enclosed in the chaste breast of Catherine,
che purissima, à Dio fatta vicina,	the purest, made close to God, who
havrà d'alto saper' verace e palma.	will have the true palm of lofty wisdom.
Incidete nel Cor sì bella Historia;	Etch such a beautiful story in your heart,
Ò mie dilette, e fide spettatrici:	oh my beloved and faithful [female] spectators.
Con l'esempio di lei fatte felici	Made joyful by her example,
attendete dal Ciel pace, e Vittoria.	await peace and victory from heaven.

(fol. 327r)

In the play itself, Cicognini contrasts the divine wisdom that Catherine possesses not only to the knowledge claimed falsely by Antilia but also to that traditionally associated with the goddess Minerva (Pallas Athena), called by both her Roman and Greek names in the play. The soon-to-be defeated philosophers offer sacrifices at her altar before the debate with Catherine, and a chorus of her priestesses sings the stanzas of the first *intermedio*, in which

60. Cesare Ripa, *Iconologia* (Padua, 1611; reprint, New York and London, 1976), 467–69.

they ask their goddess to "change the pitiless soul of that heart of hard rock" [*cangia l'alma dispietata / di quel cor' di duro scoglio* (fol. 347r)]. They express their belief that Catherine will be conquered by wisdom and eloquence ("tal da saggio, et eloquente / vinta sia la Giovinetta" [fol. 347v]). But of course events turned out a bit differently.

The theme of true wisdom returns in the speech with which the empress renounces her earthy power. The empress seems to address the nuns directly, commending them for choosing to serve Christ: "oh happy [are] those wise souls, who from tender ages abandoned the world, and, ruling over their senses, became female servants of Jesus Christ" [*o felici quell'Anime saggie, che sin da i teneri anni abbandonarono il mondo, et imperando à i sensi divennero serve di Giesu Christo* (fol. 402v)]. Like Princess Maria Maddalena, the empress exchanges an earthly diadem for a celestial crown and the possibility of a mortal, royal spouse for the king of kings.

Over the course of the play the empress—the most realistic of the play's female characters—emerges as the character with whom an audience of nuns might most closely identify. While the steadfast Catherine retains her position as a bride of Christ throughout the play and its *intermedi*, audience members actually witness the empress making the choice to renounce the secular world. And whereas in the medieval sources it is Catherine who promises the empress that through martyrdom she will exchange her earthly kingdom and mortal husband for an eternal realm and an immortal spouse, in Cicognini's play the empress herself asserts the validity of her choice. The empress's praise of Christ's handmaidens emerges as the logical conclusion of an earlier confrontation with her husband—a debate that hinges on the contested meanings of four interrelated terms: "life," "rule," "crown," and "spouse." Massenzio orders the empress to choose: "Tell me, Empress, do you want to live or die? Do you want to rule or, like an evildoer, undergo tortures [and] a cruel and untimely death? Is the royal crown or the sword dear to you? Do you love your consort or disdain him? Tell me, what is your decision?" [61] His wife's response—"I resolve to live, to rule, to accept the crown, and to unite myself to my husband"—thrills Massenzio until she clarifies the meaning of her words: "I want to live, but in heaven; I long to rule, but as a servant of Jesus Christ, I ask for the crown, but that of martyrdom, and I call as my spouse not Massenzio but Jesus Christ, true husband of my soul." [62] The empress re-

61. "Dimmi Augusta vuoi tu vivere ò morire? Vuoi tu regnare ò come rea sottoporti à i tormenti, à fiera, et intempestiva morte? Ti è cara la real Corona, ò il ferro tagliente? Ami tu il consorte ò pur lo disprezzi? Dimmi, che resolutione è la tua?" (fol. 401v).
62. "Risolvo di vivere, di regnare, di accettar la Corona, e di Unirmi al mio Consorte"

iterates her choice immediately before her execution, as related by Brunello in his account of her death in act 5.2: "A more handsome husband awaits me, heaven calls me to a new marriage . . . my husband Jesus prepares for me another throne, another realm, another mantle, another crown."[63]

Cicognini mirrors the confrontation between Massenzio and the empress with a more didactic question-and-answer scene between the empress and Saint Catherine in act 4.8 (fols. 405r–v). Here the empress assumes the role of the novice, responding to the catechism administered by her maestra:

CATHERINE: What virtue made you so strong?

EMPRESS: The example of the fifty philosophers whom you converted, who, not fearing the flames, received the crown of martyrdom.

CATHERINE: Who made you recognize the true God, who for us made himself man and submitted himself to die for us?

EMPRESS: Your pious erudition, your admirable responses to which there can be no reply.

CATHERINE: What resolution causes you today to disdain your kingdom and this brief and fleeting life?

EMPRESS: A firm faith, a lively hope of reaching the realm of heaven by way of torments and death.

CATHERINE: Oh faith, oh hope, oh fortitude, you are those things that lead to God, therefore farewell, dear Empress, farewell, beloved Augusta, farewell, glorious martyr, and with good reason I said farewell [go with God], because it permits me to hope that he in his goodness must soon receive our souls and make them worthy of eternal glory.[64]

(fol. 401v); then "Io voglio vivere, mà in Cielo; bramo regnare mà come serva di Giesu Christo, chieggio la Corona, mà quella del Martirio, chiamo lo sposo non già Massenzio mà Giesu Christo vero sposo dell'Anima mia" (fol. 402r).

63. "Un' più bel' sposo mi attende, à nuove nozze m'invita il Cielo, . . . altra sede, altro regno, altro manto, altra corona il mio sposo Giesù à me prepara" (fol. 415r).

64. CATERINA: Qual virtù vi fece sì forte?

AUGUSTA: L'esempio dei cinquanta filosofi da voi convertiti che non temendo le fiamme riceverno la corona del martirio—

CATERINA: Chi vi fe conoscere il vero Dio, che per noi se fece huomo e volse per noi morire?

AUGUSTA: La vostra santa Dottrina, le vostre ammirabili risposte alle quali non si può replicare—

CATERINA: Qual resolutione vi fa hoggi sprezzare il Regno, et questa vita breve e fugace?

AUGUSTA: Una ferma fede, una viva speranza di pervenire al regno del Cielo, per la via de tormenti, et della morte.

CATERINA: O fede, o speme, o fortezza, voi sete quelle, che ne conducete a Dio, dunque a

The nuns who witnessed this scene would likely have been reminded of their own periods of education in the convent, and the dialectical exchange reinforces Catherine's position as a spiritual teacher. But through the answers of the empress, it also affirms the efficacy of learning by example, the ostensible purpose of convent theater. Cicognini also asserted the didactic nature of convent plays in the second surviving work, *Le vittorie di Santa Tecla*, a play in which he continued to explore the double meanings of crowns and brides.

Lions and Tigers and . . . Seals: *Le vittorie di Santa Tecla*

Thecla was also an appropriate object of devotion for a female monastery—the widespread nature of her early cult was due principally to communities of virgins.[65] But unlike Saint Catherine or the heroic protagonists of the regency operas, Thecla, the church's first female martyr, was not represented by a widespread artistic or dramatic tradition in Florence. The principal Italian centers of devotion to Thecla were at Este and Milan. Without significant dramatic models, Cicognini appears to have relied heavily on book 3 of the apocryphal *Acts of Paul and Thecla*, which he undoubtedly knew from the Italian translation that appeared in numerous editions as part of the *Leggendario delle santissime vergini* (summary in app. B).[66] Although Cicognini retains many of the characters and events from his source, he once again respects the unities of place and time in his play, compressing the narrative so that it takes place only in Iconium and within a single twenty-four-hour period. Thecla is condemned twice, faces both fire and wild beasts, is baptized, founds a community of like-minded women, and converts the entire city in one very busy day. Cicognini fills the plot with stock comic characters, including both

Dio, Imperatrice cara, a Dio, Augusta diletta, à Dio, martire gloriosa e ben con ragione dissi a Dio, poiche mi lice sperare, che egli per sua bontà deva in breve ricever l'anime nostre e farle degne dell'eterna gloria.

65. Stephen J. Davis, *The Cult of Saint Thecla: A Tradition of Women's Piety in Late Antiquity* (Oxford, 2001); Lynne C. Boughton, "From Pious Legend to Feminist Fantasy: Distinguishing Hagiographical License from Apostolic Practice in the *Acts of Paul/Acts of Thecla*," *Journal of Religion* 71 (1991): 378.

66. The full title of the work is *Leggendario delle santissime vergini le quali vollero morire per il nostro Signore Gesù Cristo e per mantenere la sua santa Fede e [la] loro verginità*. Alain Cullière ("*La conversion de sainte Thècle*, de Guillaume Reboul [1602]," *Travaux de littérature* 13 [2000]: 100) cites editions of 1587, 1593, and 1600; I have been able to consult an edition published in Rome in 1854 in which the entry on Thecla appears on 140–44. I have used the English translation of the *Acts* by Robert McLachlan Wilson, in *New Testament Apocrypha*, ed. Edgar Hennecke, 2 vols. (Philadelphia, 1963–66), 2:353–364.

foolish (Trastullo) and wise (Franco) servants, a parasite (Mangia), and a vain, but inept soldier (Captain Brandimarte). As in *Santa Caterina*, a secondary plot accomplishes much of the didactic work, in this case the story of Delia, a slave girl and secret Christian, who yearns to join Thecla, her inspiration. Delia's desires are fulfilled in the final act of the play, when it is revealed that she is really Verginia, the long-lost daughter of Trifona (= Tryphaena), who had been stolen by gypsies. Thus Tryphaena's daughter, whose spirit directs her mother's actions in the *Acts of Paul and Thecla*, serves as a living model for emulation in Cicognini's plot.

Although he composed a play whose dramatic action remains faithful in spirit to his principal source, Cicognini made significant alterations to the plot besides those necessary to preserve the Aristotelian unities of time and place. In *Santa Tecla* the future martyr's fiancé Tamiro (= Thamyris) is as anxious as Thecla to avoid marriage, in Thamyris's case so that he might continue his dissolute lifestyle of fighting and gambling. He pretends to agree to the marriage so that his father (Damiano) will continue to give him money, but meanwhile he enlists the help of his wily servant Franco to extricate him from his predicament. At the end of the play, after witnessing the miracle that saved Thecla from the wild beasts, he converts to Christianity. Cicognini treats the mother of Thecla, here renamed Artemisia, in a similar fashion: rather than the bloodthirsty character who calls for her daughter's execution in the *Acts*, Artemisia's only concern is for Thecla's safety, and she herself converts to Christianity in act 3. By the end of the play, Thecla's miraculous deliverance from certain death—twice—results in the conversion of every character in the play, even the proconsul.

But Cicognini's most significant alteration concerns the event that had proven contentious even in the first centuries after the composition of the *Acts*—Thecla's self-immersion in the pool of seals after Paul admonishes her to delay her baptism. At the beginning of the third century, Tertullian condemned what he saw as the use of the Thecla story to "defend the liberty of women to teach and to baptize."[67] Ambrose simply passed over the baptism incident to stress the power of Thecla's virginity to tame wild beasts, and most church fathers focused solely on her position as an exemplar of virginity.[68] As noted in chapter 3, editions of many of these patristic treatises on

67. "Ad licentiam mulierum docendi tinguendique defendere" (Tertullian, *De baptismo* 17, quoted and translated in Davis, *The Cult of Saint Thecla*, 7).

68. Ambrose of Milan, *De virginitate* (2.3), vol. 3 of *A Select Library of Nicene and Post-Nicene Fathers of The Christian Church*, 2d ser., ed. Philip Schaff and Henry Wace (New York, 1896; reprint, Grand Rapids MI, 1976), 376. See Léonie Hayne, "Thecla and the Church Fathers,"

virginity appeared in the second half of the sixteenth century, demonstrating their continued currency during Cicognini's lifetime. Juan Luis Vives placed Thecla first in his list of holy virgins, and elsewhere in his treatise on the education of a Christian woman he reiterated Ambrose's assertion of the miraculous powers of Thecla's virginity.[69] In the decade that preceded *Santa Tecla*, the reissued print of *Vitae sanctorum ex probatis authoribus* (1617–18) by Laurent Surius appended the words of Ambrose to the entry on Thecla, and the author made no mention of her self-baptism.[70] Cicognini similarly omits all mention of the pool from his plot; in act 3.6, before Thecla's trial with the wild beasts, he forestalls any possibility of the heterodox reading such an omission might allow by including a scene in which Paul baptizes both Thecla and her mother in the house of Onosifero [= Onesiphorus]. Cicognini may have been familiar with an earlier treatment of the Thecla story with a connection to Florence, Guillaume Reboul's *La conversion de sainte Thècle par saint Paul et son martyre miraculeux*, published in Rome in 1602 and dedicated to Queen Maria de' Medici of France, the cousin of Princess Maria Maddalena. In Reboul's novel Paul baptizes Thecla while he is in prison, on the second night of the story.[71] Cicognini creates similarly a title character who, unlike her biblical counterpart, neither preaches nor baptizes. Her story ends with the foundation of a house of women whose virginity is consecrated to Christ.

This is the point of the play. Cicognini offers Thecla and her follower Delia not only as examples of female virginity but also as archetypes of the nuns themselves. He makes this point explicit in the speeches by Virginity (Verginità) that frame the dramatic action. In the prologue Virginity praises the resolve of her audience, whom she identifies as consecrated virgins and queens of the Arno. She promises them that the story of Thecla will provide them with yet another demonstration that virginity is their sure escort to heaven ("da suoi nobil gesti apprenderete, / ch'io son per gir'al Ciel scorta sicura"), and her companions Delight and Usefulness—the two oft-cited justifications for the very existence of convent theater—confirm Thecla's appropriateness as a model for nuns. Virginity offers to use song to narrate the

Vigiliae Christianae 48 (1994): 209–18; Monika Pesthy, "Thecla among the Fathers of the Church," in *The Apocryphal Acts of Paul and Thecla*, ed. Jan N. Bremmer (Kampen, 1996), 164–78; and Cullière, "*La conversion de sainte Thècle*," 89.

69. Juan Luis Vives, *The Education of a Christian Woman: A Sixteenth-Century Manual*, trans. Charles Fantazzi (Chicago and London, 2000), 69, 82.

70. Cullière, "*La conversion de sainte Thècle*," 91n91. The scene is also missing from the *Leggendario delle santissime vergini*.

71. Cullière, "*La conversion de sainte Thècle*," 97–99.

perquisites of virginity ("e spiegherò col canto / della Verginitade il pregi[o], e 'l vanto"), then makes good on her promise in a three-stanza *canzonetta:*

Io son fior d'ogni altro fior	I am a flower above all other flowers,
santo ardor	a sacred ardor
che riscaldo i vostri petti.	which burns your breasts.
Fugga pure ogni altro foco,	May every other fire flee,
ceda il loco	surrender the place
à purissimi diletti.	to purest delights.
Io son scala al Ciel sereno,	I am the stairway to serene heaven,
puro seno,	pure breast [e.g., heart],
cinto va' d'eterni fregi,	which goes surrounded by eternal glories,
e' al candor d'una bell'alma	and, with the innocence of a beautiful soul,
havrà palma	will have the palm
su nel Ciel dal Re de' Regi.	from the king of kings up in heaven.
Io racchiusi in scura cella,	I enclosed in a dark cell,
verginella,	little virgin,
mia grandezza e mio tesoro	my greatness and my treasure.
Io la tolsi al Mondo rio,	I took it away from the evil world,
et à Dio	and to God
vò condurla al sommo Coro.	I will bring it to the supreme choir.

This same "little virgin" singled out by Virginity is also addressed by the chorus that concludes the prologue, in a repetition of the poetic structure—and therefore probably music—of Virginity's preceding stanzas. The chorus exhorts the chaste and beautiful virgin to give her heart to her eternal spouse:

Godi dunque, o Verginella	Then rejoice, oh little virgin,
casta e bella,	chaste and beautiful,
dona il core à sposo eterno	give your heart to your eternal spouse,
e da questo albergo fido	and from this faithful house
voli il grido	let fly the cheer
di sua gloria al Ciel superno.	of its glory to heaven above.

The advice delivered in the prologue does not appear to be aimed at Thecla or to any other character in the play but, rather, to a member of the audience. This *verginella* joins a sorority of brides whose membership already includes Thecla, as reiterated in each of the play's five acts.[72] Cicognini con-

72. The reference to Thecla as a bride of Christ represents an accretion to the narrative as related in the *Acts* or the Latin *Passio,* one that stems likely from both the liturgical practice of reciting the *Veni sponsa Christi* antiphon to commemorate her feast every 23 September and references made by patristic writers. See Pesthy, "Thecla among the Fathers," 167, 173; Hayne, "Thecla and the Church Fathers," 211.

tinues to evoke bridal imagery in the final *intermedio*, delivered by Virginity and a chorus of nuns. Virginity ("senza cantar") asks her audience to honor a new bride of Christ, possibly referring to Thecla but also to the *verginella* from the prologue. Her speech is suggestive of the ceremonies by which a convent welcomed its new members. References to items of dress, namely, the golden crown and vermillion cross, recall both the investiture liturgy in general and also the specific habit of the nuns of the Crocetta:

Spose del Re di Gloria	Brides of the king of glory,
per segno d'inefabile dolcezza	as a sign of ineffable sweetness
movasi spassi omai: rendete honore	let us put aside pleasures: honor
a questa di Giesu sposa diletta.	this beloved bride of Jesus.
Gitene tutte liete	Go, all happy,
e gemmata Corona il crin vi cinghia,	and may a jeweled crown encircle your brow,
acciò conosca il mondo	so that the world recognizes
che alla Verginitade	that to virginity
degniamente si dona	is given worthily
titolo di Regina —	the title of queen,
e che su nel olimpo	and that up in heaven
h[a]vrà seggio più degnio	she will have a worthier seat,
chi nel Ciel porterà vergineo fiore	whoever will carry into heaven a virginal flower,
intatto et puro al Immortal signore.	one intact and pure, to the immortal lord.
Io già vi cinsi le Corone d'oro:	I already crowned you with golden crowns;
scetro sarà questa Vermiglia Croce	[your] scepter will be this vermillion cross,
che nel seno io v'impresso	which I impress on your breast
e del cui sacro segnio	and by which sacred sign
armo la vostra mano	I arm your hand,
onde ciascuna valorosa e forte	so that each one, valorous and strong,
gli atti gli espressi nel morir la morte.	will express her deeds in dying [her] death.

Cicognini's emphasis on themes of transition, consecrated virginity, brides of Christ, and articles of clothing suggests that *Santa Tecla*, if not composed specifically for an investiture or veiling ceremony, certainly would have constituted an appropriate celebration of such a milestone. Theatrical performances often highlighted these rites of passage for a young nun, which were also often occasions for elaborate feasts and gift exchanges.[73] Archival records for the Crocetta demonstrate that such celebrations were not unknown at the convent, although possibly undertaken at a modest level: for example, on 14 April 1624, the date on which the convent paid Giovanni Battista da Gagliano and Orazio Grazi to provide music for the veiling ceremony of

73. Colleen Reardon, "*Veni Sponsa Christi*," 271–97.

Suor Maria Christina Peruzzi, they also bought thirty pounds of cookies and four pounds of "pasta alla Genovese."[74]

The promise of a banquet also dominates the plot of *Santa Tecla*. Initially the household of Artemisia plans the upcoming feast to celebrate the marriage between Thecla and Thamyris. Mangia, the parasite servant, awaits the meal hungrily, but Cicognini also whets the appetite of the audience, building anticipation through continued reference to the event while withholding its arrival. Peasant women bring baskets of flowers and fruits to decorate the hall in *intermedio* 1, and the same performers return as cooks in *intermedio* 3, singing three stanzas in which they describe their tasks in mouth-watering detail:

Al suon di padelle	To the sound of frying pans
cantiam dolcemente	let us sing sweetly,
amabile gente	amiable people,
le glorie novelle;	the new glories.
Sù, lieta brigata,	Come on, happy brigade,
tu pela i capponi,	you, pluck the capons,
tu trova i schidioni	you, find the spits,
tu pesta l'agliata.	you, mash the garlic.
Ciascuna oggi s'affanni acciò perfetto	Today let each one busy herself so that, perfect,
si goda in queste nozze un bel banchetto.	a fine banquet is enjoyed for this marriage.
Su liete donzelle	Come on, happy damsels
con dolce armonia	with sweet harmony
mostriamo allegria	let us demonstrate happiness
al suon di padelle.	to the sound of frying pans.
Tu vanne in cucina,	You, go into the kitchen
e volgi l'arrosto,	and turn the roast,
tu vanne in cantina	you, go into the cellar
e attingi del mosto.	and draw some of the must.
Ciascuna oggi s'affanni acciò perfetto	Today let each one busy herself so that, perfect,
si goda in queste nozze un bel banchetto.	a fine banquet is enjoyed for this marriage.
Su liete donzelle	Come on, happy damsels,
cantiam' dolcemente	let us sing sweetly,
amabile gente	amiable people,
le glorie novelle.	the new glories.
Tu vanne in dispensa,	You, go to the pantry,
tu trova buon vini	you, find good wines,
tu para la mensa	you, set the table
con candidi lini.	with white linens.

74. I-Fas, Croc 27, fols. 23v–24r, notes that the *biscottini* cost 23 soldi per pound, while for the Genoese pastries the convent paid 43 soldi per pound, resulting in a total of 43 lire 2 soldi, roughly one-and-a-half times their expenditure for music on the same occasion.

Ciascuna oggi s'affanni acciò perfetto Today let each one busy herself so that, perfect,
si goda in queste nozze un bel banchetto. a fine banquet is enjoyed for this marriage.

By its arrival at the end of act 5, this much anticipated wedding feast has been transformed into a celebration of Thecla and the newly converted Christians. Cicognini uses its occasion both to conclude the play and to acknowledge the audience. Ermete, the *maestro di casa* for Thecla's mother, invites the other characters to join him inside for "a wonderful banquet" [*un bel convito*], and he asks Thamyris to dismiss the audience so that he might join them. Thamyris's *licenza*, in turn, enables the nuns to adjourn to their own feast. *Santa Tecla* thus provided the nuns both a model for and an idealized recreation of their lives, in particular the festivities that marked a woman's entrance into the larger female community. Like the families of the women in the Crocetta, particularly the relatives of Princess Maria Maddalena, the mothers and friends of Thecla and Delia not only support but celebrate their decisions to dedicate both their virginity and their lives to their heavenly bridegroom.

In the second, added plot of *Saint Tecla*, Cicognini provided the protomartyr with a female companion and spiritual sister, and, with their mothers, these women formed a community consecrated to Christ. This was the communal life experienced by the nuns of the Crocetta and the Medici princesses who lived with them. Although Princess Maria Maddalena had ostensibly renounced the secular world for the spiritual solace of the convent, a court functionary's letter of 19 December 1628 informed the Florentine secretary of state that "when the Sig.ra Princess Maria Maddalena entered the Monastery of the Crocetta, she did it with the condition that she might have everything that she had in the Pitti" (doc. 8.3). Although the letter refers to Christmas gratuities for the princess's servants, on a broader scale it also summarizes her life in the convent. With the frequent visits of her family, music performed by court musicians, and regular performances of costumed plays, Maria Maddalena, with her mother's help, created just such a court environment, but in this court she and her spiritual sisters were the true queens.

Conclusion

The cases of Princess Maria Maddalena, the nuns of the Crocetta, and the regents Maria Magdalena of Austria and Christine of Lorraine illustrate ways in which aristocratic women in early modern Florence reiterated their values and commented on their circumstances through the patronage of art, music, and theater. These women commissioned works that presented positive im-

ages of themselves and their gender for their own enjoyment and edification, as well as to the outside world. Inside the Crocetta, the nuns and Princess Maria Maddalena celebrated models of female religious communities, while in their public church, altarpieces commemorated women's importance to the history of the holy cross. At court, musical spectacles responded to recent political events within contexts dominated by politically and spiritually active women, often singled out for their heroic virtue.

In these theatrical genres—spoken and musical, sacred and secular— women's speech became both a reality and an issue for female characters and for the composers and performers (of both genders) who produced them. Poets created characters through language and syntax choices, while in the early seventeenth century, composers had both the theoretical charge and the musical means to construct these characters vocally. Music could illustrate traits such as seductiveness, decisiveness, or passivity. How characters spoke (or sang) became crucial to an understanding of a work's overall meaning.

As I have argued throughout the preceding chapters, these works also gave voices to the women who commissioned them. Although they lived in an era in which their actual speech was often discouraged, the women whose lives have been described here had stories to tell, about themselves, their place in history, and their gender. Instead of delivering their messages in words or speech, these women communicated through patronage. In so doing they helped shape the artistic life of Florence.

During the decade of the 1630s many of these actual voices were silenced: Maria Magdalena died in 1631, followed by Princess Maria Maddalena (1633) and Christine of Lorraine (1636). Death also claimed many of these women's principal artistic and musical collaborators: Jacopo Peri in 1633, the same year in which Jacopo Cicognini committed suicide, Andrea Salvadori in 1634, and Ferdinando Saracinelli in 1640. Yet the works commissioned and created by these individuals lived on—historical vestiges of voices that had disappeared. *La Giuditta* was translated into German, where it influenced subsequent generations of German and Scandinavian poets and composers. Its sacred subject, use of chorus, and comic scenes provided a likely inspiration for Giulio Rospigliosi's Roman libretti of the 1630s and 1640s.[75]

In his funeral oration for Archduchess Maria Magdalena, Andrea Salvadori predicted accurately that her role as a patron would (eventually) determine history's perception of her, a prediction that might, in varying degrees, reasonably be extended to each of the patrons studied here: "For her, the noblest geniuses toiled, now on canvases, now in marble; for her, melody re-

75. Margaret Murata, *Operas for the Papal Court, 1631–1668* (Ann Arbor, MI, 1981), 16–17.

turned to its first glory; for her, theater saw its ancient greatness; therefore if, due either to envy or ingratitude, the voices of men kept silent in praise of her, the arts stimulated by her, and the sciences nourished by her would loosen a tongue of immortal eloquence to her glory."[76]

Documents for Chapter 8

Document 8.1. I-Faa, Filze di Cancelleria, no. 11 (n.p.); copy in I-Fas, Misc. Med. 5, ins. 1, fols. 7r–v. Letter of 24 Aug 1619 to the archbishop of Florence [Alessandro Marzi Medici] from Cardinal [Anton Maria] Gallo, Rome.[77]

Ill.mo et R.mo Monsignore come fratello. Desiderando la Principessa Maria Maddalena figlia del già Gran Duca Ferdinando di ritirarsi, e stare con l'habito secolare in cotesto Monastero delle Monache di S. Croce: si contenta la Santità di Nostro Signore che V.S. conceda licenza al Gran Duca Cosimo fratello della sudetta Principessa di far' edificare per servitio d'essa un apartamento nel medesimo Monastero, et edificato che sarà ridurlo insieme col suo giardino in clausura, avvertendo, che non vi si facciano finestre, ne altri fori da guardare in strada, e che la clausura riesca così ben sicura, e ben munita, che non vi sia pericolo di disordine alcuno. Che inoltre V.S. dia licenza alla sudetta Principessa d'entrare, e stare à suo beneplacito con l'habito secolare in detto Monastero, et di menare seco quattro zitelle, e due vedove, che la servano: mentre però le Monache capitularmente, e per voti segreti si contentino di riceverle, modestamente vestano, osservino le leggi della clausura, et di Parlatorij come le Monache istesse, et uscite, che saranno una volta non possano più rientrarvi senza nuova licenza. Si contenta di più la Santità Sua, che V.S. possa dare licenza di fabricare un Corritore [= Corridore], che dall'apartamento della sudetta Principessa, e longo il muro di dentro della clausura del medesimo Monastero venga per mezzo d'un cavalcavia à congiongersi con la Chiesa della Santissima Annuntiata, nel cui muro si possa col consenso però de Frati Serviti fare una fenestrella, che guardi in Chiesa, e sopra l'Altare di quella miracolosa Imagine, alla quale fenestrella la Principessa suddetta, e le sue donne solamente possano andare à sentire la messa, e fare l'altre loro divotioni. La fenestrella doverà essere con la sua ferrata grossa, e stretta, e di più metteravisi una gelosia, o craticulato di legno, che la pigli tutta, e sia incastrata, et stuccata nel muro d'essa, e senza sportelli d'alzare in maniera, che la sudetta Principessa, e le sue donne possano guardare in Chiesa; ma non essere in modo alcuno vedute. Nel Corritore, et nel cavalcavia non siano finestre, ne altri buchi da guardare, e parlare in strada, ordinando, che la porta d'entrare dall'apartamento nel corritore sudetto sia ben ferma, e con due chiavi di-

76. "Per lei ora in tele, ora in marmo sudarono nobilissime Ingegni per lei tornò la melodia alla sua prima gloria: per lei vide il Teatro la sua antica grandezza; si ché quando ò per invidia, ò per ingratitudine tacessero le lodi di lei, le voci degl'huomini, scioglierebbono à gloria sua lingua d'immortal facondia, l'arti da lei fecondate, le scenzie da lei nutrite" (Andrea Salvadori, *Orazione panegirica*, in *Poesie*, 2 vols. [Rome, 1668], 2:417).

77. A copy of this letter is also preserved in I-Rasv, Sacra Congregazione dei Vescovi e Regolari, Reg. Regularium 13 (1619), fols. 291r–v, kindly communicated to me by Professor Craig Monson.

verse, una delle quali stia appresso la Priora del Monastero e l'altra in mano alla medesima Principessa, ne sia lecito alle Monache per qualsivoglia accidente di mettere il piede in detto Corritore, il quale insieme col cavalcavia doveranno per questo effetto dichiararsi da V.S. fora di clausura, e poi dare licenza alla prenominata Principessa, e sue donne solamente di potervi andare, e stare per le loro divotioni, e ritornare in clausura, che con la presente per ordine della Santità Sua si dà a V.S. tutta l'autorità necessaria per questo effetto.

The Princess Maria Maddalena, daughter of the previous grand duke Ferdinando, desiring to retire and live with secular habit in that monastery of the nuns of S. Croce, his Holiness is satisfied that Your Lordship should concede license to Grand Duke Cosimo, brother of the above-named princess, to have an apartment in the said monastery built for her use, and built so that, together with its garden, it will be cloistered, warning, that no windows should be made there, nor other outlets from which one can look into the street, and that clausura remains so secure and well fortified that there will be no danger of any disorder there. Moreover, Your Lordship should give license to the above-mentioned princess to enter, and to be at her pleasure in secular habit in said monastery, and to take with her four maids and two widows to serve her; nevertheless, as long as the nuns, corporately and by secret votes are willing to receive them, they should dress modestly, observe the rules of clausura and of the parlors, just as the nuns themselves [do], and, if they should leave [even] once, they may not reenter without a new license. His Holiness is also content that Your Lordship should give license to build a corridor from the apartment of the above-named princess along the wall inside the enclosure of the same monastery, which arrives by means of an overpass to join with the church of the Santissima Annunziata, in whose wall, with the consent, however, of the Servite Friars, can be built a little window that looks into the church at the altar of the miraculous image, to which little window only the above-named princess and her ladies may go to hear mass and to make their devotions. The window must be [fitted] with iron grillwork of large, closely spaced bars, and besides that, a wooden shutter or grate should be put there, which covers everything and is embedded and plastered into the wall itself, and without means of being lifted, so that the above-named princess and her ladies can look into the church, but not be seen in any way. In the corridor and in the overpass there should be no windows, nor other openings to look or speak into the street, with the further provision that the entrance door from the apartment into the said corridor be well locked and with two different keys, one of which is in the possession of the prioress of the monastery and the other in the hand of the same princess, nor is it allowed to the nuns for any reason to set foot in the said corridor, which, together with the overpass must be for this reason declared outside clausura by Your Lordship, and then to give license to the above-named princess and her ladies only to be able to go and remain for their devotions and to return to enclosure, so that with the present [letter] by order of His Holiness is given to Your Lordship all necessary authority for this result.

Document 8.2. I-Fas, GM 391, fols. 1017r–v. Letter signed by Christine of Lorraine, with response from Guardaroba [indicated by parentheses] dated 10 February 1622 [1623].

L'ecc.ma Sig.ra Principessa Maria Madalena nel Convento della Croce vorebbe le infrascrite cose che anno da servire per fare una comedia in deto convento:

- Isole: che [è] la deta Sig.ra Principessa, habito bianco di lana con bel sucinto e questa vuole essere nova (facciasi solo una vesta di taffetta bianco nuova dalla Guardaroba generale)
- il generale: una palandrana nobilissima con una banda et un bastone da generale dipinto (si havra dal Principe Don Lorenzo)
- Leone un senattore: Una vesta al ebr[hole in paper] a uso di senattore (si proveda da[l] quale)
- per dui giovani: dui feraglioli et due Casacce che siano bele guarnite d'oro et sieno di Colore (il Principe Don Lorenzo li presta)
- per cinque verggine: cinque habiti di tocca bianca con cinque traversse di colore (la guardaroba generale proveda di quelle che son fatte fuori di quelle di Sant'Orsola)
- per la vanita: una vesta di tocca di colore (la guardaroba generale proveda)
- per l'Ingano: Una sopra vesta di taffeta incarnato con un'arco et un carcasso (la guardaroba generale proveda)
- per la Sirena: una vesta come si vesta da sirena et una nicchia arggenttata piena di Corali, perle et altre gemme et una cappeliera lunga (la guardaroba generale proveda il tutto)
- per cinque furie: cinque habiti come si sogliono fare ad usanza di furie (la guardaroba generale proveda)

di più per le verggini: cappegliere et gioie e perle false (la guardaroba generale proveda) et per domenica mattina prossima un vestito da Re cio[è] per gli quattro febrare (la guardaroba generale proveda) e l'altre sopradete cose si mettano al'ordine con più comodit[à] e mandino [dal?] guardaroba uno al Convento che agiusti il servicio conforme ad bisogno e a tempo. (Il Bali Giugni dia ordine à Marco Papi che si pigli cura di provedere tutte le sudette cose, et come le saranno tutte in essere lo faccia sapere à Madama et il medesimo Marco Papi procuri di haver dal Prencipe Don Lorenzo quello che potrà dare, et il restante la Guardaroba Generale supplisca, con fare anco la veste nuova di taffeta bianco alla Principessa con che ogni cosa benche minutia si restituisca alla Guardaroba et à chi occorra, Benedetto Barchetti per comand.ta di S.A.)

Her excellency Sig.ra Princess Maria Maddalena in the convent of the Holy Cross would like the following items, which are needed in order to present a play in the said convent:

- Isole: who is the said Signora Princess, a white woolen dress with a nice belt [possibly waistband], and it is to be new (only a new dress of white taffeta to be made by the Guardaroba Generale)
- The general: a very noble man's dressing gown with a stripe and a painted staff [characteristic] of a general (it will be acquired from Prince Don Lorenzo)
- Leo, senator: A gown used by a senator (supplied by the same)
- For two youths: two cloaks and two colorful blouses nicely trimmed with gold (Prince Don Lorenzo will lend them)
- For five virgins: five gowns of white *tocca* [silk interwoven with silver and gold threads] with five bands of color (the Guardaroba Generale should supply some of those that have already been made, besides those for Saint Ursula)
- For Vanity: a gown of colored *tocca* (the Guardaroba Generale should supply)

- For Deceit: an overdress of rose taffeta with a bow and a quiver (the Guardaroba Generale should supply)
- For the siren: a dress like sirens wear, and a silver conch shell full of coral, pearls, and other gems and a long wig (the Guardaroba Generale should supply everything)
- For five furies: five gowns such as it is customary to make for furies (the Guardaroba Generale should supply)

In addition for the virgins: wigs and jewels and false pearls (the Guardaroba Generale should supply) and for next Sunday morning, that is, February 4, a suit for a king (the Guardaroba Generale should supply), and the other, above-named things should be ordered more slowly, and someone should be sent to the convent by the Guardaroba to arrange the service in conformity with the need and the time. (Bali Giugni should order Marco Papi to take care of providing all the below-named items, and when everything is being made let Madama [Christine of Lorraine] know, and the same Marco Papi should arrange to get from Prince Don Lorenzo that which he will be able to give, and the Guardaroba Generale should supply the remainder, including making the new dress of white taffeta for the princess, and with the [stipulation] that everything, even minutiae, should be returned to the Guardaroba, and to whomever needs them. Benedetto Barchetti by command of Her Highness.)

Document 8.3. I-Fas, Misc. Med. 5, ins. 1, fols. 108r–v. Letter of 19 December 1628 to Andrea Cioli from Benedetto Barchetti.

Quando la Sig.ra Principessa Maria Maddalena entrò nel Monasterio della Crocetta lo fece con condizione che ella dovesse havere tutto quello che haveva ne Pitti, et così il Granduca Cosimo se ne contentò[;] oltre all'altre cose è stata sempre solita per il natale haver cento scudi dalla Depositeria per dar le mance alla sua servitù si come è seguito fin hora sempre per mandato sottoscritto da Madama dal quale mando a V.S. copia . . .

When the Sig.ra Princess Maria Maddalena entered the Monastery of the Crocetta, she did it with the condition that she might have everything that she had in the Pitti, and therefore Grand Duke Cosimo agreed to that; besides everything else, it was always customary on Christmas for her to have 100 scudi from the treasury to give gratuities to her servants, as has always been done until now, by the undersigned mandate from Madama [Christine of Lorraine], of which I am sending Your Lordship a copy. . . .

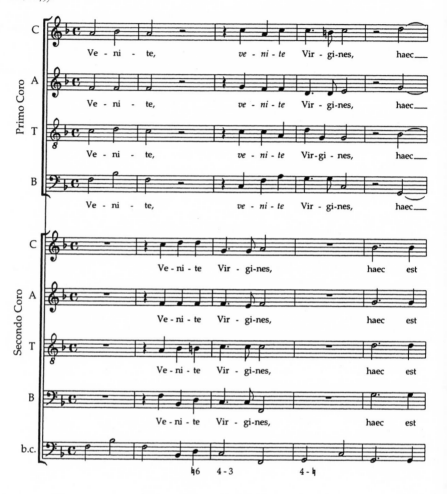

EXAMPLE 8.1. (*continued*)

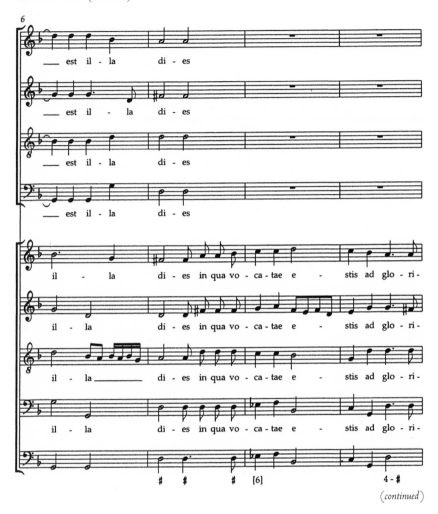

(*continued*)

EXAMPLE 8.1. *(continued)*

EXAMPLE 8.1. (*continued*)

(*continued*)

EXAMPLE 8.1. (*continued*)

EXAMPLE 8.1. *(continued)*

(continued)

EXAMPLE 8.1. (*continued*)

EXAMPLE 8.1. (*continued*)

(*continued*)

EXAMPLE 8.1. *(continued)*

EXAMPLE 8.1. (*continued*)

(*continued*)

EXAMPLE 8.1. (*continued*)

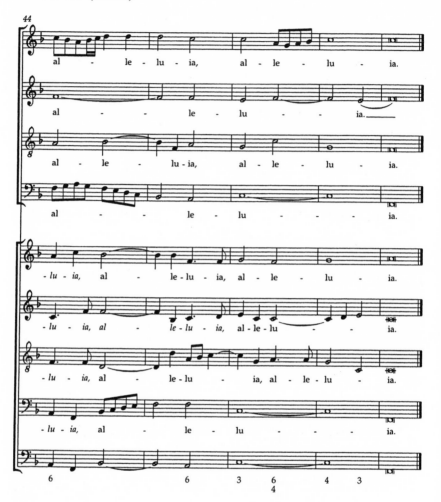

EXAMPLE 8.2. Giovanni Battista da Gagliano, *Veni sponsa Christi*, in *Mottetti per concertare* (Venice, 1626): "Come, bride of Christ, receive the crown that the Lord has prepared for you in eternity."

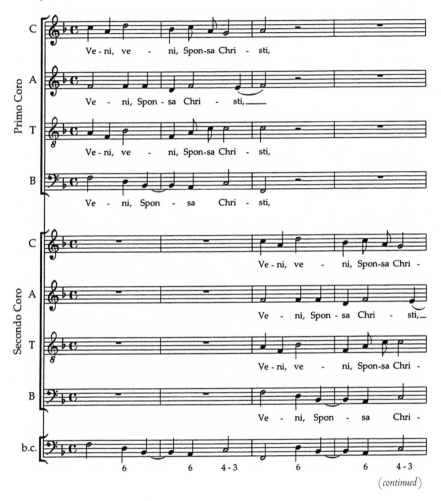

(*continued*)

EXAMPLE 8.2. (*continued*)

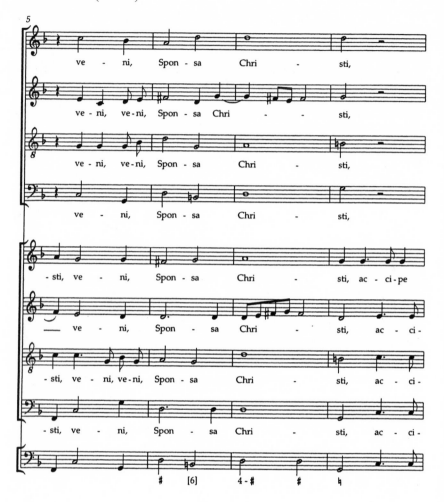

EXAMPLE 8.2. (*continued*)

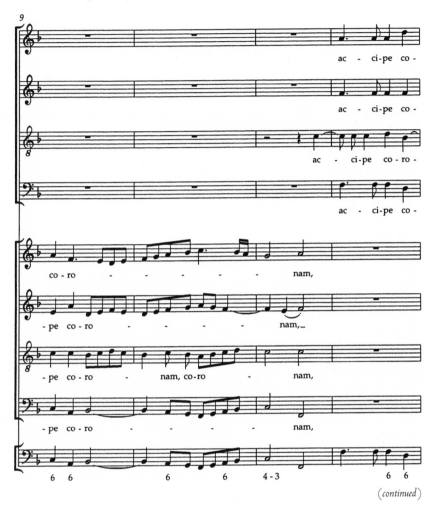

(*continued*)

EXAMPLE 8.2. (*continued*)

EXAMPLE 8.2. (*continued*)

(*continued*)

EXAMPLE 8.2. (*continued*)

EXAMPLE 8.2. *(continued)*

(continued)

EXAMPLE 8.2. (*continued*)

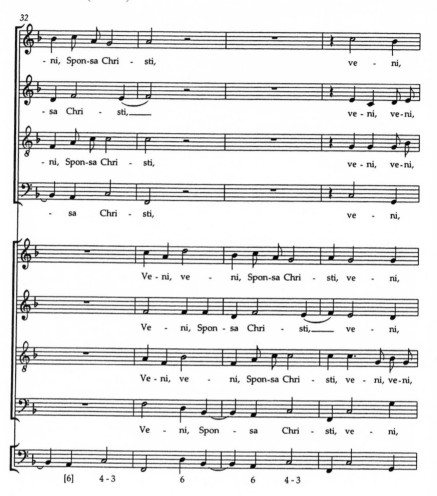

EXAMPLE 8.2. *(continued)*

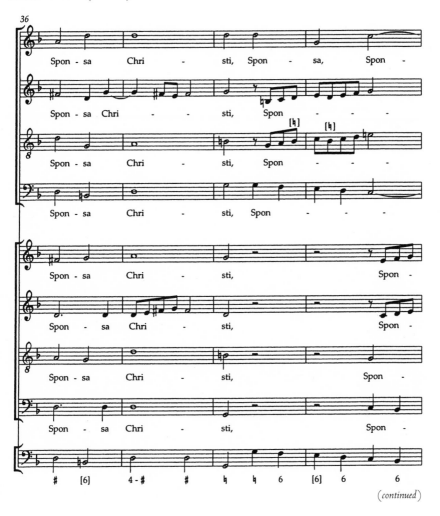

(continued)

EXAMPLE 8.2. (*continued*)

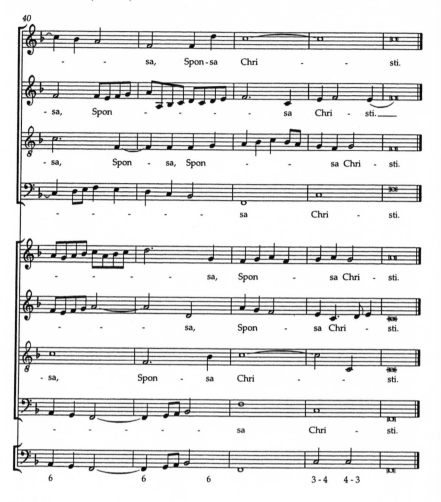

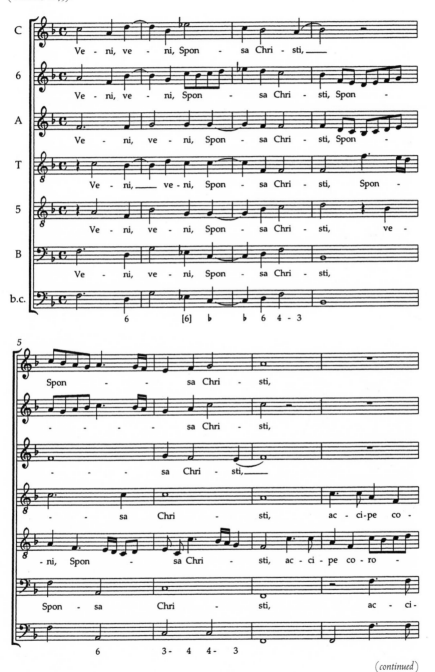

(*continued*)

EXAMPLE 8.3. *(continued)*

EXAMPLE 8.3. *(continued)*

(continued)

EXAMPLE 8.3. (*continued*)

EXAMPLE 8.3. (*continued*)

Female Worthies Depicted in Lunette Frescoes in the Audience Room, Villa Poggio Imperiale

Augusta of Treviso, also known as Augusta of Serravalle (fifth century), saint, was the daughter of the duke of Friuli, whose hatred of the Christian faith led him to decapitate his daughter after subjecting her to various tortures, including fire.[1]

Catherine of Alexandria (fourth century), saint, learned daughter of King Costus, who debated successfully against fifty of the empire's best philosophers, converting them and the empress before her torture on a wheel and eventual execution (by means of beheading) on the order of the emperor Maxentius. After her death, angels carried her body to Mount Sinai. A later accretion to the legend told the story of the saint's conversion and her mystical marriage with Christ.[2]

Clothilde (ca. 474–545), saint, queen often credited for the conversion to Christianity, in 496, of her husband Clovis, king of the Franks, thereby securing subsequent generations of French kings for the church.[3]

Constance of Hohenstaufen (1249–1302), queen of Aragon and, after 1282, Sicily; ruled as regent for her young son, the Infante James.

Elizabeth, queen of Portugal (1271–1336), daughter of Constance of Hohenstaufen; canonized in 1625. Known for her generosity, one of the miracles

1. Filippo Caraffa and Antonietta Cardinali, "Augusta di Serravalle," *Bibliotheca sanctorum*, 2:588–91.

2. Dante Balboni et al., "Caterina di Alessandria," *Bibliotheca sanctorum*, 3:954–78; René Coursault, *Saint Catherine d'Alexandrie: Le mythe et la tradition* (Paris, 1984).

3. Christine de Pizan, *The Book of the City of Ladies*, trans. Earl Jeffrey Richards (New York, 1982), 151–52 [II.35.1]; Agrippa, *Declamation*, 78; and Vives, *The Education of a Christian Woman*, 264.

credited to Elizabeth was the transformation of gold she was delivering secretly to the poor. When questioned by her husband, Elizabeth claimed to carry roses; upon inspection, the gold had been changed into flowers.[4]

Galla Placidia (388 or 389–450), daughter of Roman Emperor Theodosius the Great, who was carried off by the Goths after their attack on Rome in 410 and later (414) married the Gothic king Athaulf. Placidia's influence was believed to have persuaded Athaulf to rebuild the city of Rome rather than destroy it. She ruled the Western Empire on behalf of her young son Valentinian III from 424 to circa 437.[5]

Isabella (1451–1504), queen of Castile, patron of Christopher Columbus, was the sole ruler of Castile beginning in 1474, and from 1479 governed jointly with her husband Ferdinand of Aragon.

Matilda (1046–1115), countess of Tuscany, ruled her lands independently from 1071. Besides a lifetime of military and political service on behalf of the papacy, she donated much of her property to the Catholic church.

Pulcheria (399–453), saint, niece of Galla Placidia, who ruled the Eastern empire, first as regent for, then jointly with, her younger brother Theodosius II; later in her life she ruled jointly with her husband, Marcian (450–53). Although married, Pulcheria maintained a vow of virginity throughout her life.[6]

Ursula (fourth- or fifth-century), saint, princess of Brittany and fiancée of Prince Ethereus of England, martyred in Cologne along with 11,000 virgins and (in some versions), Pope Cyriacus, Ethereus, and other Christian nobles. Ursula had been granted a three-year delay in her marriage whereby she and her companions might make a pilgrimage to Rome. Her beauty initially spared her from the massacre, but when she refused the sexual advances of Julian, the Huns' leader, she too was martyred.[7]

4. *Acta sanctorum Iulii*, II (Paris and Rome, 1867), 208; Luigi Chierotti and Maria Chiara Celletti, "Elisabetta (port. *Isabel, Isabella*), regina del Portogallo," *Bibliotheca sanctorum*, 4:1096–99.

5. Stewart Irvin Oost, *Galla Placidia Augusta: A Biographical Essay* (Chicago and London, 1968); John Matthews, *Western Aristocracies and Imperial Court, A.D. 364–425* (Oxford, 1975), 317; and Herwig Wolfram, *History of the Goths*, trans. Thomas J. Dunlap (Berkeley, 1988), 163.

6. Salaminius Hermias Sozomen, *Ecclesiastical History* (9.1, 9.3), in *Nicene and Post-Nicene Fathers*, vol. 2, *Socrates, Sozomenus: Church Histories*, 2d ser., ed. Philip Schaff and Henry Wace (New York; reprint, Peabody, MA, 1999), 419–21.

7. Jacobus de Voragine, *The Golden Legend*, ed. Ryan, 2:256–60; Johannes Emil Gugumus and Mariella Liverani, "Orsola," *Bibliotheca sanctorum*, 9:1252–71.

Summary of Book 3 of the "Acts of Paul"

Thecla, a young, upper-class woman from the city of Iconium, breaks off her engagement to Thamyris and chooses virginity after hearing the preaching of the apostle Paul. Both Thamyris and Thecla's mother Theocleia greet her news with rage, and Thamyris convinces the proconsul to imprison Paul for enticing the city's young women away from their wifely duties. Thecla secretly visits Paul in prison and, when discovered, gladly goes to the flames to which the proconsul—encouraged by her own mother—condemns her but from which a sudden deluge saves her. Not yet baptized (due to Paul's refusal to do so), Thecla then accompanies Paul to Antioch, where the unwanted advances of a well-to-do Syrian named Alexander cause her to embarrass him publicly. Alexander arranges to have Thecla condemned to battle wild beasts as part of the upcoming games, but in the arena a lioness sacrifices her own life to protect the martyr from lions and bears. Thecla remains unharmed, even when she is tied to enraged bulls or when she jumps into a pool of seals in order to baptize herself. During this ordeal a wealthy widow named Tryphaena, at whose house Thecla resided until her ordeal, faints. Fearing for his own political future, since Tryphaena is a kinswoman of the Roman emperor, the proconsul of Antioch orders Thecla's release. Tryphaena adopts the young woman, following the advice related by a vision of her recently deceased daughter, and Thecla spends the next eight days at her benefactress's house, where she instructs female members of the household in the word of God. She returns to Iconium to attempt the conversion of her mother, and she eventually relocates to Seleucia, where she continues to preach until her death.

Select Bibliography

General Manuscript Sources

I-Fas, Croc 1–7, 20–33, 35–44. Account books of the Monastero di Santa Croce, 1517–1680.

I-Fas, GM 479. Inventory of Villa Poggio Imperiale, 17 March 1624 [1625].

I-Fas, Misc. Med. 5, ins. 1. Letters, briefs, licenses concerning Princess Maria Maddalena de' Medici.

I-Fas, Misc. Med. 11. Court diary of Cesare Tinghi, 1623–44.

I-Fn, Gino Capponi 261, 2 vols. Court diary of Cesare Tinghi, 1600–1623.

I-MOas, AF 48–49, 53, 55, 59. Ambassadorial correspondence from Modena's ambassadors in Florence, 1621–29.

Manuscript Sources: Plays and Literary Treatises

Bartolommei, Girolamo. *Il riscatto d'Amore.* I-Fn, Magl. VII.1386, fols. 83–130.

Bronzini, Cristofano. "Della dignità, e nobiltà delle donne." Days 1–24, plus indices. I-Fn, Magl. VIII.1513–38.

———. Excerpt from day 12 of "Della dignità, e nobiltà delle donne." I-Rvat, Barb. lat. 4059, fols. 105r–119v.

Cicognini, Jacopo. *Il martirio di S. Caterina.* I-Fr, Ricc. 3470, fols. 325r–429r.

———. *Le vittorie di Santa Tecla.* I-Fs, C.V.25.

———. *Il voto di Effette chiamata il voto d'Oronte.* I-Fs, A'.I.3 [*olim* C.V.25].

Del Nente, Ignazio. "Meditazioni e divine intelligenze della gran serva di Dio e veneranda Madre Suor Domenica dal Paradiso." I-Fr, Ricc. 2633, fols. 157v–160r [*olim* fols. 155v–158r]).

Paponi, Girolamo. *Maggio dialogo di Zefiro e Flora.* I-Fn, Magl. VII.265.

Salvadori, Andrea. *La Giuditta.* I-Rvat, Barb. lat. 3839, fols. 66r–94v.

———. "Orazione panegirica." I-Fn, Manoscritti II.II.505, *olim* Magl. XXXVII.169.

———. *La regina Sant'Orsola.* I-Fn, Magl. VII.1285, fols. 276r–316bis.

Scarlatti, Filippo Maria Baldassare. "Ristretto della vita della molto R.da Suor Domenica dal Paradiso fondatrice del Monastero della Croce di Firenze." I-Fr, Moreniana, 331.

Printed Sources

Adimari, Alessandro. *La Quiete: Ovvero sessanta emblemi sacri.* Florence: Zanobi Pignoni, 1632.

Aercke, Kristiaan P. *Gods of Play: Baroque Festive Performances as Rhetorical Discourse.* Albany: State University of New York Press, 1994.

Agresti, Domenico di. *Sviluppi della riforma monastica Savonaroliana.* Biblioteca della Rivista di storia e letteratura religiosa, studi e testi 6. Florence: Olschki, 1980.

Agrippa, Henricus Cornelius. *Declamation on the Nobility and Preeminence of the Female Sex.* Translated by Albert Rabil, Jr. Chicago and London: University of Chicago Press, 1996.

Allacci, Leone. *Drammaturgia.* Venice: Giambatista Pasquali, 1755. Reprint, Turin: Bottega d'Erasmo, 1961.

Anderson, Jaynie. "Rewriting the History of Art Patronage." *Renaissance Studies* 10 (1996): 129–38.

Annibaldi, Claudio, ed. *La musica e il mondo: Mecenatismo e committenza musicale in Italia tra Quattro e Settecento.* Bologna: Società editrice il Mulino, 1993.

———. "Per una teoria della committenza musicale all'epoca di Monteverdi." In *Claudio Monteverdi: Studi e prospettive,* edited by Paola Besutti, Teresa M. Gialdroni, and Rodolfo Baroncini, 459–75. Accademia Nazionale Virgiliana di Scienze Lettere e Arti, Miscellanea 5. Florence: Olschki, 1998.

———. "Towards a Theory of Musical Patronage in the Renaissance and Baroque: The Perspective from Anthropology and Semiotics." *Recercare* 10 (1998): 173–82.

———. "Uno 'spettacolo veramente da principi': Committenza e recezione dell'opera aulica nel primo Seicento." In *"Lo stupor dell'invenzione": Firenze e la nascita dell'opera,* edited by Piero Gargiulo, 31–60. Quaderni della Rivista Italiana di musicologica, Società Italiana di musicologia 36. Florence: Olschki, 2001.

Antignani, Gerardo. *Vicende e tempi di Suor Domenica dal Paradiso.* Siena: Edizioni Cantagalli, 1983.

Antolini, Bianca Maria. "La carriera di cantante e compositore di Loreto Vittori." *Studi musicali* 7 (1978): 141–88.

Ariosto, Ludovico. *Orlando furioso.* Edited by Lanfranco Caretti. 2 vols. Turin: Einaudi, 1992.

Aumale, H[enri] d'Orléans, duc d.' *Histoire des princes de Condé pendant les XVI^e et XVII^e siècles.* 7 vols. Paris: Calmann Lévy, 1863–96.

Baccini, Giuseppe. *Notizie di alcune commedie sacre rappresentate in Firenze nel secolo XVII.* Florence: Libreria Dante, 1889.

Bagnoli, Alessandro, ed. *Rutilio Manetti, 1571–1639.* Exhibition catalog, Siena, Palazzo Pubblico, 15 June–18 October 1978. Florence: Centro Di, 1978.

Baldinucci, Filippo. *Notizie dei professori del disegno da Cimabue in qua.* Edited by Ferdinando Ranalli. 5 vols. Florence: V. Batelli, 1845–47.

Baltzer, Otto. *Judith in der deutschen Literatur.* Stoff- und Motivgeschichte der deutschen Literatur 7. Berlin and Leipzig: Walter de Gruyter, 1930.

Banti, Anna. *Giovanni da San Giovanni: Pittore della contraddizione.* Florence: Sansoni, 1977.

Barberi, Francesco. *Paolo Manuzio e la stamperia del popolo Romano (1561–1570) con documenti inediti.* Rome: Ministero della educazione nazionale, 1942. Reprint, Rome: Editrice Gela, 1985.

B[ardi], F[erdinando]. *Descrizione delle feste fatte in Firenze per le reali nozze de Serenissimi Sposi Ferdinando II Grand Duca di Toscana, e Vittoria Principessa d'Urbino.* Florence: Pignoni, 1637.

Baring-Gould, S[abine], and John Fisher. *The Lives of the British Saints.* 4 vols. London: Honourable Society of Cymmrodorion, 1907–13.

Belardini, Manuela. "'Piace molto a Giesù la nostra confidanza': Suor Orsola Fontebuoni a Maria Maddalena d'Austria." In *Per lettera: La scrittura epistolare femminile tra archivio e tipografia secoli XV–XVII,* edited by Gabriella Zarri, 359–83. Rome: Viella, 1999.

Benassi, Umberto. "I natali e l'educazione del Duca Odoardo Farnese." *Archivio storico per le province Parmensi,* n.s., 9 (1909): 99–227.

Bennett, Bonnie, and David Wilkins. *Donatello.* Oxford: Phaidon, 1984.

Berner, Samuel. "Florentine Political Thought in the Late Cinquecento." *Il pensiero politico* 3 (1970): 177–99.

———. "Florentine Society in the Late Sixteenth and Early Seventeenth Centuries." *Studies in the Renaissance* 18 (1971): 203–46.

Biagioli, Mario. *Galileo, Courtier: The Practice of Science in the Culture of Absolutism.* Chicago: University of Chicago Press, 1993.

Bianconi, Lorenzo. *Music in the Seventeenth Century.* Translated by David Bryant. Cambridge: Cambridge University Press, 1987.

Bibliotheca sanctorum. 13 vols. Rome: Istituto Giovanni XXIII nella Pontificia Università lateranense, 1961–70.

Bireley, Robert. *Religion and Politics in the Age of the Counterreformation: Emperor Ferdinand II, William Lamormaini, S.J., and the Formation of Imperial Policy.* Chapel Hill: University of North Carolina Press, 1981.

Bissell, R. Ward. *Artemisia Gentileschi and the Authority of Art: Critical Reading and Catalogue Raisonné.* University Park: Pennsylvania State University Press, 1999.

———. "Artemisia Gentileschi—a New Documented Chronology." *Art Bulletin* 50 (1968): 153–68.

Blok, Anton. "Notes on the Concept of Virginity in Mediterranean Societies." In *Women and Men in Spiritual Culture, XIV–XVII Centuries: A Meeting of South and North,* edited by Elisja Schulte van Kessel, 27–33. The Hague: Netherlands Government Publishing Office, 1986.

Boccaccio, Giovanni. *Famous Women.* Edited and translated by Virginia Brown. I Tatti Renaissance Library 1. Cambridge, MA, and London: Harvard University Press, 2001.

———. *Libro di M. Gio. Boccaccio delle donne illustri.* Translated by Giuseppe Betussi. Venice: [Comin da Trino di Monferrato], 1545.

Boiardo, Matteo Maria. *Orlando innamorato.* Translated and edited by Charles Stanley Ross. Berkeley: University of California Press, 1989.

Borea, Evelina. *Caravaggio e caravaggeschi nelle gallerie di Firenze.* Florence: Sansoni, 1970.

Borghini, Raffaello. *Il riposo.* Florence: Giorgio Marescotti, 1584. Reprint, Milan: Edizioni Labor, 1967.

Brammini, Lucillo. *Tragedia di Santa Chaterina V.M.* Edited by Fabio Carboni. Rome: Bagatto Libri, 1993.

Bronzini, Cristofano. *Della dignità, e nobiltà delle donne.* 8 vols. Florence: Zanobi Pignoni, 1622–32.

Brown, Howard Mayer. *Sixteenth-Century Instrumentation: The Music for the Florentine Intermedii.* Musicological Studies and Documents 30. n.p.: American Institute of Musicology, 1973.

Brown, Judith C. "Everyday Life, Longevity, and Nuns in Early Modern Florence." In *Renaissance Culture and the Everyday*, edited by Patricia Fumerton and Simon Hunt, 115–38. Philadelphia: University of Pennsylvania Press, 1999.

———. "A Woman's Place Was in the Home: Women's Work in Renaissance Tuscany." In *Rewriting the Renaissance: The Discourses of Sexual Difference in Early Modern Europe*, edited by Margaret W. Ferguson, Maureen Quilligan, and Nancy J. Vickers, 206–24. Chicago and London: University of Chicago Press, 1986.

Brown, Peter. *The Body and Society: Men, Women and Sexual Renunciation in Early Christianity.* Lectures on the History of Religions, n.s., 13. New York: Columbia University Press, 1988.

Brown, Rawdon, et al., eds. *Calendar of State Papers and Manuscripts Relating to English Affairs Existing in the Archives and Collections of Venice and in Other Libraries of Northern Italy.* 38 vols. London: Longman and Her Britannic Majesty's Stationery Office, 1864–1947.

Bugge, John. *Virginitas: An Essay in the History of a Medieval Ideal.* Archives internationales d'histoire des ideas, series minor 17. The Hague: Martinus Nijhoff, 1975.

Bujić, Bojan. "'Figura poetica molto vaga': Structure and Meaning in Rinuccini's *Euridice.*" *Early Music History* 10 (1991): 29–64.

Burchi, Guido. "Vita musicale e spettacoli alla Compagnia della Scala di Firenze fra il 1560 e il 1675." *Note d'archivio per la storia musicale*, n.s., 1 (1983): 9–50.

Butterfield, Andrew. "The Evidence for the Iconography of David in Quattrocento Florence." *I Tatti Studies: Essays in the Renaissance* 6 (1995): 115–33.

Bynum, Caroline Walker. "'. . . And Woman His Humanity': Female Imagery in the Religious Writing of the Later Middle Ages." In *Gender and Religion: On the Complexity of Symbols*, edited by Caroline Walker Bynum, Stevan Harrell, and Paula Richman, 257–88. Boston: Beacon Press, 1986.

Caccini, Francesca. *La liberazione di Ruggiero dall'isola d'Alcina: Balletto composto in musica.* Florence: Cecconcelli, 1625.

———. *Il primo libro delle musiche a una, e due voci.* Florence: Zanobi Pignoni, 1618.

Callahan, Leslie Abend. "Ambiguity and Appropriation: The Story of Judith in Medieval Narrative and Iconographic Traditions." In *Telling Tales: Medieval Narratives and the Folk Tradition*, edited by Francesca Canadé Sautman, Diana Conchado, and Giuseppe Carlo Di Scipio, 79–99. New York: St. Martin's Press, 1998.

Calvi, Giulia. *Storie di un anno di peste*, translated by Dario Biocca and Bryand T. Ragan, Jr. as *Histories of a Plague Year: The Social and the Imaginary in Baroque Florence.* Berkeley: University of California Press, 1989.

Cantelli, Giuseppe. "Mitologia sacra e profana e le sue eroine nella pittura fiorentina della prima metà del Seicento." *Paradigma* 3 (1980): 147–69; 4 (1982): 139–51.

———. *Repertorio della pittura Fiorentina del Seicento.* Fiesole: Opus Libri, 1983.

Capozzi, Frank. "The Evolution and Transformation of the Judith and Holofernes Theme in Italian Drama and Art before 1627." Ph.D. diss., University of Wisconsin—Madison, 1975.

Carter, Tim. "A Florentine Wedding of 1608." *Acta musicologica* 55 (1983): 89–107.

———. "Intriguing Laments: Sigismondo d'India, Claudio Monteverdi, and Dido *alla parmigiana* (1628)." *Journal of the American Musicological Society* 49 (1996): 32–69.

———. *Jacopo Peri (1561–1633): His Life and Works.* 2 vols. New York and London: Garland, 1989.

Castelli, Elizabeth. "'I Will Make Mary Male': Pieties of the Body and Gender Transformation of Christian Women in Late Antiquity." In *Body Guards: The Cultural Politics of Gender Ambiguity*, edited by Julia Epstein and Kristina Straub, 29–49. New York: Routledge, 1991.

———. "Virginity and Its Meaning for Women's Sexuality in Early Christianity." *Journal of Feminist Studies in Religion* 2 (1986): 61–88.

Castelli, Silvia. "La drammaturgia di Iacopo Cicognini." Tesi di Laurea, Storia dello spettacolo, Università degli studi di Firenze, Facoltà di lettere e filosofia, 1988–89.

Chafe, Eric. *Monteverdi's Tonal Language*. New York: Schirmer, 1992.

Chappell, Miles, ed. *Cristofano Allori, 1577–1621*. Florence: Centro Di, 1984.

Cicognini, Jacopo. *La finta mora*. Florence: Giunti, 1625.

———. *Il martirio di Sant'Agata*. Florence: Giunti, 1624.

Ciletti, Elena. "Patriarchal Ideology in the Renaissance Iconography of Judith." In *Refiguring Woman: Perspectives on Gender and the Italian Renaissance*, edited by Marilyn Migiel and Juliana Schiesari, 35–70. Ithaca, NY, and London: Cornell University Press, 1991.

Cioni, Alfredo. *Bibliografia delle sacre rappresentazioni*. Florence: Sansoni, 1961.

Cipolla, Carlo M. *Money in Sixteenth-Century Florence*. Berkeley: University of California Press, 1989.

Cloke, Gillian. *"This Female Man of God": Women and Spiritual Power in the Patristic Age, A.D. 350–450*. London and New York: Routledge, 1995.

Clubb, Louise George. *Italian Drama in Shakespeare's Time*. New Haven, CT, and London: Yale University Press, 1989.

———. "The Virgin Martyr and the *Tragedia Sacra*." *Renaissance Drama* 7 (1964): 103–26.

Cochrane, Eric. *Florence in the Forgotten Centuries, 1527–1800: A History of Florence and the Florentines in the Age of the Grand Dukes*. Chicago and London: University of Chicago Press, 1973.

Colomb de Batines, Paul V., comp. *Bibliografia delle antiche rappresentazioni sacre e profane stampate nei secoli XV e XVI*. Milan: G. G. Görlich, 1958.

Connolly, Thomas H. "The Legend of St. Cecilia." *Studi musicali* 7 (1978): 3–37; 9 (1980): 3–44.

———. *Mourning into Joy: Music, Raphael, and Saint Cecilia*. New Haven, CT, and London: Yale University Press, 1994.

Consoli, Giuseppe. *S. Agata V. M. Catanese*. 2 vols. Catania: Stab. Tip. "La Cartotecnica," 1951.

Conti Odorisio, Ginevra. *Donna e società nel Seicento*. Biblioteca di cultura 167. Rome: Bulzoni, 1979.

Contini, Roberto, and Gianni Papi, eds. *Artemisia*. Exhibition catalog, Florence, Casa Buonarroti, 18 June–4 November 1991. Florence: Leonardo–De Luca Editori, 1991.

Cooper, Tracy E. *"Mecenatismo* or *Clientelismo?* The Character of Renaissance Patronage." In *The Search for a Patron in the Middle Ages and the Renaissance*, edited by David G. Wilkins and Rebecca L. Wilkins, 19–32. Medieval and Renaissance Studies 12. Lewiston, NY: Edwin Mellen Press, 1996.

Corsani, Gabriele. "Le trasformazioni architettoniche del complesso della Quiete." In *Villa La Quiete: Il patrimonio artistico del Conservatorio delle Montalve*, edited by Cristina De Benedictis, 1–21. Florence: Le Lettere, 1997.

Cortellazzo, Angela Teresa. "Il melodramma di Marco da Gagliano." In *Congresso internazionale sul tema Claudio Monteverdi e il suo tempo: Relazioni e comunicazioni*, edited by Raffaello Monterossi, 583–98. Verona: Stamperia Valdonega, 1969.

Cox-Rearick, Janet. *Dynasty and Destiny in Medici Art: Pontormo, Leo X, and the Two Cosimos.* Princeton, NJ: Princeton University Press, 1984.

Crinò, Anna Maria. "Documenti inediti sulla vita e l'opera di Jacopo e di Giacinto Andrea Cicognini." *Studi seicenteschi* 2 (1961): 255–86.

Crum, Roger J. "Controlling Women or Women Controlled? Suggestions for Gender Roles and Visual Culture in the Italian Renaissance Palace." In *Beyond Isabella: Secular Women Patrons of Art in Renaissance Italy*, edited by Sheryl E. Reiss and David G. Wilkins, 37–50. Kirksville, MO: Truman State University Press, 2001.

Culley, Thomas. "The German College in Rome: A Center for Baroque Music." In *Baroque Art: The Jesuit Contribution*, edited by Rudolf Wittkower and Irma B. Jaffe, 111–28. New York: Fordham University Press, 1972.

———. *Jesuits and Music*, vol. 1, *A Study of the Musicians Connected with the German College in Rome during the Seventeenth Century and of Their Activities in Northern Europe.* Sources and Studies for the History of the Jesuits 2. Rome and St. Louis: Jesuit Historical Institute and St. Louis University, 1970.

Cullière, Alain. "*La conversion de sainte Thècle*, de Guillaume Reboul (1602)." *Travaux de littérature* 13 (2000): 81–100.

Cummings, Anthony M. *The Politicized Muse: Music for Medici Festivals, 1512–1537.* Princeton, NJ: Princeton University Press, 1992.

Cusick, Suzanne G. "Of Women, Music, and Power: A Model from *Seicento* Florence." In *Musicology and Difference: Gender and Sexuality in Music Scholarship*, edited by Ruth Solie, 281–304. Berkeley: University of California Press, 1993.

———. "Thinking from Women's Lives: Francesca Caccini after 1627." *Musical Quarterly* 77 (1993): 484–507.

———. "'Who Is This Woman . . . ?': Self-Presentation, *Imitatio Virginis* and Compositional Voice in Francesca Caccini's *Primo Libro* of 1618." *Il saggiatore musicale* 5 (1998): 5–41.

D'Accone, Frank. *The Civic Muse: Music and Musicians in Siena during the Middle Ages and the Renaissance.* Chicago and London: University of Chicago Press, 1997.

———. "The Florentine Fra Mauros: A Dynasty of Musical Friars." *Musica Disciplina* 33 (1974): 77–137.

———. "The Musical Chapels at the Florentine Cathedral and Baptistry during the First Half of the Sixteenth Century." *Journal of the American Musicological Society* 24 (1971): 1–50.

———. "Repertory and Performance Practice in Santa Maria Novella at the Turn of the Seventeenth Century." In *A Festschrift for Albert Seay: Essays by His Friends and Colleagues*, edited by Michael D. Grace, 71–136. Colorado Springs: Colorado College, 1982.

———. "Singolarità di alcuni aspetti della musica sacra fiorentina del Cinquecento." In *Firenze e la Toscana dei Medici nell'Europa del '500*, edited by Gian Carlo Garfagnini, 2:513–37. 3 vols. Biblioteca di storia Toscana moderna e contemporanea 26. Florence: Olschki, 1983.

———. "The Sources of Luca Bati's Sacred Music at the Opera di Santa Maria del Fiore." In *Altro Polo: Essays on Italian Music in the Cinquecento*, edited by Richard Charteris, 159–77. Sydney: Frederick May Foundation for Italian Studies, University of Sydney, 1990.

D'Ancona, Alessandro. *Origini del teatro italiano.* 2d ed. 2 vols. Turin: Ermanno Loescher, 1891.

————, ed. *Sacre rappresentazioni dei secoli XIV, XV e XVI.* 3 vols. Florence: Successori le Monnier, 1872.

Davies, Norman. *God's Playground: A History of Poland.* 2 vols. New York: Columbia University Press, 1982.

Davis, Stephen J. *The Cult of Saint Thecla: A Tradition of Women's Piety in Late Antiquity.* Oxford: Oxford University Press, 2001.

Del Nente, Ignazio. *Vita e costumi ed intelligenze spirituali della venerabil madre Suor Domenica dal Paradiso fondatrice del Monastero della Croce di Firenze dell'ordine di S. Domenico scritta dal Padre Fr. Ignazio del Nente del medesimo ordine.* 2d ed. Florence: Francesco Moücke Stampatore Arcivescovile, 1743.

Dempsey, Charles. *The Portrayal of Love: Botticelli's Primavera and Humanist Culture at the Time of Lorenzo the Magnificent.* Princeton, NJ: Princeton University Press, 1992.

La devota rappresentatione di S. Caterina vergine, e martire. Nuovamente ristampata. Florence: Badia, 1561.

Diaz, Furio. *Il Granducato di Toscana: I Medici.* Storia d'Italia 13, no. 1. Turin: Unione Tipografico-Editrice Torinese, 1976.

Doni, Giovanni Battista. *Annotazioni sopra il compendio de' generi e de' modi della musica.* Rome: Fei, 1640.

Draper, Jerry Lee. "Vasari's Decoration in the Palazzo Vecchio: The *Ragionamenti* Translated with an Introduction and Notes." Ph.D. diss., University of North Carolina at Chapel Hill, 1973.

Drawetz, Hannes. "Die geistliche und weltliche Dramatik an der Grazer Universität." *Zeitschrift des historischen Vereines für Steiermark* 53 (1962): 337–48.

Dubarle, A[ndré] M. *Judith: Formes et sens des diverses traditions.* 2 vols. Analecta Biblica, Investigationes Scientificae in Res Biblicas 24. Rome: Institut Biblique Pontifical, 1966.

Enslin, Morton S., trans. *The Book of Judith.* Edited by Morton S. Enslin and Solomon Zeitlin. Jewish Apocryphal Literature 7. Leiden: E. J. Brill, 1972.

Erber, James. "Marco da Gagliano's *Sacrae Cantiones II* of 1622." *Consort* 35 (1979): 342–47.

Fabbri, Paolo, and Angelo Pompilio, eds. *Il corago, o vero alcune osservazioni per metter bene in scena le composizioni drammatiche.* Florence: Olschki, 1983.

Fabris, Dinko. *Andrea Falconieri Napoletano: Un liutista-compositore del Seicento.* Rome: Torre d'Orfeo, 1987.

Faini Guazzelli, Fiammetta. "La volticina del Poggio Imperiale: Un'attribuzione sbagliata." *Antichità viva* 7, no. 1 (January–February 1968): 25–34.

Federhofer, Hellmut. *Musikpflege und Musiker am Grazer Habsburgerhof der Erzherzöge Karl und Ferdinand von Innerösterreich (1564–1619).* Mainz: B. Schott's Söhne, 1967.

Ferguson, George. *Signs and Symbols in Christian Art.* New York: Oxford University Press, 1954.

Flozinger, Rudolf. "Musik im grazer Jesuitentheater." *Historisches Jahrbuch der Stadt Graz* 15 (1984): 9–26.

Forster, Kurt W. "Metaphors of Rule: Political Ideology and History in the Portraits of Cosimo I de' Medici." *Mitteilungen des Kunsthistorischen Institutes in Florenz* 15 (1971): 65–104.

Francovich, Géza de'. "Benedetto Ghirlandaio." *Dedalo: Rassegna d'arte* 6 (1925–26): 708–39.

Fumagalli, Elena. "Pittori senesi del Seicento e committenza medicea: Nuove date per Francesco Rustici." *Paragone* 479–81 (1990): 69–82.

Fumagalli, Elena, Massimiliano Rossi, and Riccardo Spinelli, eds. *L'arme e gli amori: La poesia di Ariosto, Tasso e Guarini nell'arte fiorentina del Seicento*. Florence: Sillabe, 2001.

Gaeta Bertelà, Giovanna, and Annamaria Petrioli Tofani, eds. *Feste e apparati Medicei da Cosimo I a Cosimo II: Mostra di disegni e incisioni*. Gabinetto disegni e stampe degli Uffizi 31. Florence: Olschki, 1969.

Gagliano, Giovanni Battista da. *Psalmi vespertini cum litaniis Beatissimae Virginis quinis vocibus modulandi . . . opus tertium*. Venice: Alexandrum Vincentium, 1634.

————. *Il secondo libro di motetti a sei et otto voci per concertarsi nell'organo, et altri strumenti*. Venice: Alessandro Vincenti, 1643.

————. *Varie musiche*. Venice: Alessandro Vincenti, 1623.

Gagliano, Marco da. *La Flora*. Florence: Pignoni, 1628. Reprint, Bologna: Forni, 1969.

————. *Sacrarum cantionum unis ad sex decantandarum vocibus . . . liber secundus*. Venice: Gardano, 1622.

Galasso Calderara, Estella. *Un'amazzone tedesca nella Firenze Medicea del '600: La Granduchessa Maria Maddalena D'Austria*. Genoa: Sagep Editrice, 1985.

Galilei, Galileo. *Le opere di Galileo Galilei*. Edited by Antonio Garbasso and Giorgio Abetti. 20 vols. Florence: Barbera, 1929–39.

Galilei, Vincenzo. *Dialogo della musica antica et moderna*. Edited by Fabio Fano. Florence: Giorgio Marescotti, 1581. Reprint, Rome: Reale Accademia d'Italia, 1934.

Galluzzi, [Jacopo] Riguccio. *Istoria del Granducato di Toscana sotto il governo della Casa Medici*. 5 vols. Florence: Gaetano Cambiagi, 1781.

Garbero Zorzi, Elvira, and Mario Sperenzi, *Teatro e spettacolo nella Firenze dei Medici: Modelli dei luoghi teatrali*. Florence: Olschki, 2001.

Gardner, Julian. "Nuns and Altarpieces: Agendas for Research." *Römisches Jahrbuch der Bibliotheca Hertziana* 30 (1995): 27–57.

Gargiulo, Piero. *Luca Bata, madrigalista fiorentino*. Historiae Musicae Cultores Biblioteca 60. Florence: Leo S. Olschki, 1991.

————. "Strumenti musicali alla corte Medicea: Nuovi documenti e sconosciuti inventari (1553–1609)." *Note d'archivio*, n.s., 3 (1985): 55–71.

Garrard, Mary D. *Artemisia Gentileschi: The Image of the Female Hero in Italian Baroque Art*. Princeton, NJ: Princeton University Press, 1989.

Ghisi, Federico. "Ballet Entertainments in Pitti Palace, Florence, 1608–1625," *Musical Quarterly* 35 (1949): 421–36.

————. "Luca Bati maestro della cappella granducale di Firenze." *Revue belge de musicologie* 9 (1954): 106–8.

Giacomelli, Gabriele, and Enzo Settesoldi. *Gli organi di S. Maria del Fiore di Firenze: Sette secoli di storia dal '300 al '900*. Historiae Musicae Cultores Biblioteca 67. Florence: Olschki, 1993.

Giambullari, Pierfrancesco. *Apparato et feste nelle nozze del Illustrissimo Signor Duca di Firenze, et della Duchessa sua consorte, con le sue Stanze, Madriali, Comedia, et Intermedii, in quelle recitati*. Florence: Giunti, 1539.

Gibbons, Mary Weitzel. "Cosimo's *Cavallo*: A Study in Imperial Imagery." In *The Cultural Politics of Duke Cosimo I de' Medici*, edited by Konrad Eisenbichler, 77–102. Aldershot: Ashgate, 2001.

Giglioli, Odoardo H. *Giovanni da San Giovanni (Giovanni Mannozzi—1592–1636): Studi e ricerche*. Florence: Società tipografica editrice Toscana, 1949.

Gilbert, Creighton E. "What Did the Renaissance Patron Buy?" *Renaissance Quarterly* 51 (1998): 392–450.

Giovannetti, Alessandra. *Francesco Morandini detto il Poppi.* Florence: Edifir, 1995.

———, ed. *Francesco Morandini detto il Poppi: I disegni, i dipinti di Poppi e Castiglion Fiorentino.* Poppi: Edizioni della Biblioteca Comunale Rilliana, 1991.

Graff, Theodor. "Grazer Theaterdrucke: Periochen und Textbücher. 16.–18. Jh." *Historisches Jahrbuch der Stadt Graz* 15 (1984): 245–51.

Gregory of Nyssa. *Saint Gregory of Nyssa: Ascetical Works.* Translated by Virginia Woods Callahan. The Fathers of the Church: A New Translation 58. Washington D.C.: Catholic University of America Press, 1967.

Gundersheimer, Werner L. "Patronage in the Renaissance: An Exploratory Approach." In *Patronage in the Renaissance,* edited by Guy Fitch Lytle and Stephen Orgel, 3–23. Princeton, NJ: Princeton University Press, 1981.

Hale, J. R. *Florence and the Medici: The Pattern of Control.* London: Thames & Hudson, 1977.

Hamilton, Edith. *Mythology.* Boston: Little, Brown & Co., 1942.

Hammond, Frederick. "Musicians at the Medici Court in the Mid-Seventeenth Century." *Analecta Musicologica* 14 (1974): 151–69.

Hanning, Barbara Russano. "Glorious Apollo: Poetic and Political Themes in the First Opera." *Renaissance Quarterly* 32 (1979): 485–513.

———. *Of Poetry and Music's Power: Humanism and the Creation of Opera.* Studies in Musicology 13. Ann Arbor, MI: UMI Research Press, 1980.

Harness, Kelley. "*Amazzoni di Dio:* Florentine Musical Spectacle under Maria Maddalena d'Austria and Cristina di Lorena (1620–30)." Ph.D. diss., University of Illinois at Urbana-Champaign, 1996.

———. "Chaste Warriors and Virgin Martyrs in Early Florentine Opera." In *Gender, Sexuality and Early Music,* edited by Todd Borgerding, 71–121. New York: Routledge, 2002.

———. "*La Flora* and the End of Female Rule in Tuscany." *Journal of the American Musicological Society* 51 (1998): 437–76.

———. "Habsburgs, Heretics, and Horses: Equestrian Ballets and Other Staged Battles in Florence during the First Decade of the Thirty Years War." In *L'arme e gli amori: Ariosto, Tasso and Guarini in Late Renaissance Florence: Acts of an International Conference, Florence, Villa I Tatti, June 27–29, 2001,* ed. Massimiliano Rossi and Fiorella Gioffredi Superbi, 2:255–83. 2 vols. Florence: Olschki, 2004.

———. "Le tre Euridici: Characterization and Allegory in the *Euridici* of Peri and Caccini." *Journal of Seventeenth-Century Music* 9, no. 1 (August 2003). http://sscm-jscm.org.

Haskell, Francis. *Patrons and Painters: A Study in the Relations between Italian Art and Society in the Age of the Baroque.* Rev. ed. New Haven, CT, and London: Yale University Press, 1980.

Haskins, Mary. *Mary Magdalen: Myth and Metaphor.* New York: Harcourt Brace, 1993.

Hayne, Léonie. "Thecla and the Church Fathers." *Vigiliae Christianae* 48 (1994): 209–18.

Held, Julius S. "Flora, Goddess and Courtesan." In *Essays in Honor of Erwin Panofsky,* edited by Millard Meiss, 201–18. 2 vols. De Artibus Opuscula 40. New York: New York University Press, 1961.

Hennecke, Edgar. *New Testament Apocrypha.* 2 vols. Edited by Wilhelm Schneemelcher. Translated by Robert McLachlan Wilson. Philadelphia: Westminster Press, 1963–66.

Hill, John Walter. "Florence: Musical Spectacle and Drama, 1570–1650." In *The Early Baroque Era from the Late Sixteenth Century to the 1660s*, edited by Curtis Price, 121–45. Englewood Cliffs, NJ: Prentice Hall, 1993.

———. "Florentine *Intermedi Sacri e Morali*, 1549–1622." In *La musique et le rite sacré et profane: Actes du XIII^e Congrès de la Société Internationale de Musicologie*, edited by Marc Honegger and Paul Prevost, 2:265–301. 2 vols. Strasbourg: Association des Publications près les Universités de Strasbourg, 1986.

———. "The Musical Chapel of the Florence Cathedral in the Second Half of the Seventeenth Century: Vitali, Comparini, Sapiti, Cerri." In *Atti del VII centenario del duomo di Firenze*, vol. 3, *"Cantate Domino": Musica nei secoli per il Duomo di Firenze*, edited by Piero Gargiulo, Gabriele Giacomelli, and Carolyn Gianturco, 175–94. Florence: Edifir, 2001.

———. "Oratory Music in Florence, pt. 1, *Recitar Cantando*, 1583–1655." *Acta musicologica* 51 (1979): 108–36.

———. *Roman Monody, Cantata, and Opera from the Circles around Cardinal Montalto*. 2 vols. Oxford: Clarendon Press, 1997.

Holford-Strevens, Leofranc. "'Her Eyes Became Two Spouts': Classical Antecedents of Renaissance Laments." *Early Music* 27 (1999): 379–93.

Jacobus de Voragine. *The Golden Legend: Readings on the Saints*. Translated by William Granger Ryan. 2 vols. Princeton, NJ: Princeton University Press, 1993.

———. *Leggenda aurea: Volgarizzamento Toscano del Trecento*. Edited by Arrigo Levasti. 3 vols. Florence: Libreria Editrice Fiorentina, 1924–26.

Janson, H. W. *The Sculpture of Donatello*. Princeton, NJ: Princeton University Press, 1963.

Jerome. *Letters*. Translated by Charles Christopher Mierow, introduction and notes by Thomas Comerford Lowler. Ancient Christian Writers 33. Westminster, MD: Newman Press; London: Longmans, Green & Co., 1963.

Johnson, Géraldine A. "Imagining Images of Powerful Women: Maria de' Medici's Patronage of Art and Architecture." In *Women and Art in Early Modern Europe: Patrons, Collectors, and Connoisseurs*, edited by Cynthia Lawrence, 126–53. University Park: Pennsylvania State University Press, 1997.

Jones, Ann Rosalind. *The Currency of Eros: Women's Love Lyric in Europe, 1540–1620*. Bloomington and Indianapolis: Indiana University Press, 1990.

Jordan, Constance. *Renaissance Feminism: Literary Texts and Political Models*. Ithaca, NY, and London: Cornell University Press, 1990.

Kaftal, George. *Iconography of the Saints in Tuscan Painting*. Florence: Sansoni, 1952.

Kelso, Ruth. *Doctrine for the Lady of the Renaissance*. Urbana: University of Illinois Press, 1956.

Kendrick, Robert L. *Celestial Sirens: Nuns and Their Music in Early Modern Milan*. Oxford: Clarendon Press, 1996.

Kent, F. W., and Patricia Simons. "Renaissance Patronage: An Introductory Essay." In *Patronage, Art, and Society in Renaissance Italy*, edited by F. W. Kent and Patricia Simons, 1–21. Canberra: Humanities Research Center; Oxford: Clarendon Press, 1987.

King, Catherine. "Medieval and Renaissance Matrons, Italian-Style." *Zeitschrift für Kunstgeschichte* 55 (1992): 372–93.

———. "Women as Patrons: Nuns, Widows, and Rulers." In *Siena, Florence and Padua: Art, Society, and Religion, 1280–1400*, edited by Diana Norman, 2:243–66. 2 vols. New Haven, CT, and London: Yale University Press, 1995.

King, Margaret L. *Women of the Renaissance.* Chicago and London: University of Chicago Press, 1991.

Kirkendale, Warren. *The Court Musicians in Florence during the Principate of the Medici with a Reconstruction of the Artistic Establishment.* Historiae musicae cultores 61. Florence: Olschki, 1993.

———. *Emilio de' Cavalieri "Gentilhuomo Romano": His Life and Letters, His Role as Superintendent of All the Arts at the Medici Court, and His Musical Compositions.* Historiae musicae cultores 86. Florence: Olschki, 2001.

Kirschbaum, Engelbert, Günter Bandmann, and Wolfgang Braunfels, eds. *Lexikon der christlichen Ikonographie.* 8 vols. Freiburg im Breisgau: Herder, 1968–76.

Kliemann, Julian. *Gesta dipinte: La grande decorazione nelle dimore italiane dal Quattrocento al Seicento.* Milan: Silvana Editoriale, 1993.

Langedijk, Karla. "Baccio Bandinelli's Orpheus: A Political Message." *Mitteilungen des Kunsthistorischen Institutes in Florenz* 20 (1976): 33–52.

———. *The Portraits of the Medici: 15th to 18th Centuries.* 3 vols. Florence: Studio per edizioni scelte, 1981–87.

Lavin, Irving. "Lettres de Parmes (1618, 1627–28) et débuts du théâtre Baroque." In *Le lieu théâtral à la Renaissance,* edited by Jean Jacquot, 105–58. Paris: Éditions du Centre national de la recherche scientifique, 1964.

Lawrence, Cynthia, ed. *Women and Art in Early Modern Europe: Patrons, Collectors, and Connoisseurs.* University Park: Pennsylvania State University Press, 1997.

Lecchini Giovannoni, Simona. *Alessandro Allori.* Turin: Allemandi & Co., 1991.

Leopold, Silke. "Das geistliche Libretto im 17. Jahrhundert: Zur Gattungsgeschichte der frühen Oper." *Die Musikforschung* 31 (1978): 245–57.

Levine, Saul. "The Location of Michelangelo's *David:* The Meeting of January 25, 1504." *Art Bulletin* 56 (1974): 31–49.

Librandi, Rita, and Adriana Valerio. *I sermoni di Domenica da Paradiso: Studi e testo critico.* Florence: Sismel, Edizioni del Galluzzo, 1999.

Liebowitz, Ruth P. "Virgins in the Service of Christ: The Dispute over an Active Apostolate for Women during the Counter-Reformation." In *Women of Spirit: Female Leadership in the Jewish and Christian Traditions,* edited by Rosemary Ruether and Eleanor McLaughlin, 131–52. New York: Simon & Schuster, 1979.

Liedtke, Walter. *The Royal Horse and Rider: Painting, Sculpture, and Horsemanship, 1500–1800.* New York: Abaris, 1989.

Lightbown, Ronald. *Sandro Botticelli.* 2 vols. Berkeley: University of California Press, 1978.

———. *Sandro Botticelli: Life and Work.* New York: Abbeville Press, 1989.

Lomeri, Annibale. *Cicilia sacra in drammatica poesia . . . recitata in Siena all'A.A. Sereniss., di Toscana il 18 Giugno 1621.* Arezzo: Ercole Gori, 1636.

Lorini del Monte, Niccolò. *Elogii delle più principali S. donne del sagro calendario, e martirologio romano, vergini, martiri, et altre.* Florence: Zanobi Pignoni, 1617.

Lottini, Giovanni Agnolo. *Giuditta: Sacra rappresentazione.* Florence: Michelangelo Sermartelli, 1602.

Lowe, Kate. "Elections of Abbesses and Notions of Identity in Fifteenth- and Sixteenth-Century Italy, with Special Reference to Venice." *Renaissance Quarterly* 54 (2001): 389–429.

————. "Nuns and Choice: Artistic Decision-Making in Medicean Florence." In *With and Without the Medici: Studies in Tuscan Art and Patronage, 1434–1530*, edited by Eckart Marchand and Alison Wright, 129–53. Aldershot: Ashgate, 1998.

————. "Secular Brides and Convent Brides: Wedding Ceremonies in Italy during the Renaissance and Counter-Reformation." In *Marriage in Italy, 1300–1650*, edited by Trevor Dean and K. J. P. Lowe, 41–65. Cambridge: Cambridge University Press, 1998.

Macey, Patrick. "*Infiamma il mio cor:* Savonarolan *Laude* by and for Dominican Nuns in Tuscany." In *The Crannied Wall: Women, Religion, and the Arts in Early Modern Europe*, edited by Craig A. Monson, 161–89. Ann Arbor: University of Michigan Press, 1992.

Maclean, Ian. *The Renaissance Notion of Woman: A Study in the Fortunes of Scholasticism and Medical Science in European Intellectual Life*. Cambridge: Cambridge University Press, 1980.

Mamone, Sara. *Il teatro nella Firenze medicea*. Problemi di storia dello spettacolo 9. Milan: Mursia, 1981.

Marangoni, Matteo. *La villa del Poggio Imperiale*. Florence: Fratelli Alinari, n.d.

Marrow, Deborah. *The Art Patronage of Maria de' Medici*. Studies in Baroque Art History 4. Ann Arbor, MI: UMI Research Press, 1982.

Masera, Maria Giovanna. "Una cantante del Seicento alla corte Medicea: Arcangiola Palladini." *La rassegna musicale* 16 (1943): 50–53.

————. *Michelangelo Buonarroti il Giovane*. Turin: Vincenzo Bona, 1941.

McClary, Susan. *Feminine Endings: Music, Gender, and Sexuality*. Minneapolis and Oxford: University of Minnesota Press, 1991.

McInerney, Maud Burnett. "Rhetoric, Power, and Integrity in the Passion of the Virgin Martyr." In *Menacing Virgins: Representing Virginity in the Middle Ages and Renaissance*, edited by Kathleen Coyne Kelly and Marina Leslie, 50–70. Newark: University of Delaware Press; London: Associated University Presses, 1999.

McNamara, Jo Ann. "Sexual Equality and the Cult of Virginity in Early Christian Thought." *Feminist Studies* 3 nos. 3/4 (Spring–Summer 1976): 145–58.

McOmber, Christina. "Recovering Female Agency: Roman Patronage and the Dominican Convent of SS. Domenico e Sisto." Ph.D. diss., University of Iowa, 1997.

Medri, Litta. "La *Quiete* di Giovanni da San Giovanni." In *Villa La Quiete: Il patrimonio artistico del Conservatorio delle Montalve*, edited by Cristina De Benedictis, 103–8. Florence: Le Lettere, 1997.

Mellini, Domenico. *Ricordi intorno ai costumi, azioni, e governo del Sereniss. Gran Duca Cosimo I*. Edited by Domenico Moreni. Florence: Magheri, 1820.

Meloni Trkulja, Silvia. "Appendice: I quadri della Sala dell'Udienza." *Antichità viva* 12, no. 5 (September–October 1973): 44–46.

Metz, René. *La consécration des vierges dans l'Église Romaine: Étude d'histoire de la liturgie*. Paris: Presses Universitaires de France, 1954.

————. "La couronne et l'anneau dans le consécration des vierges: Origine et évolution des deux rites dans la liturgie latine." *Revue des sciences religieuses* 28 (1956): 113–32; reprinted in René Metz, *La femme et l'enfant dans le droit canonique medieval*. Variorum Reprint CS222. London: Variorum Reprints, 1985.

Minor, Andrew C., and Bonner Mitchell. *A Renaissance Entertainment: Festivities for the Marriage of Cosimo I, Duke of Florence, in 1539*. Columbia: University of Missouri Press, 1968.

Minucci del Rosso, Paolo. "Le nozze di Margherita de' Medici con Odoardo Farnese duca di Parma e Piacenza." *La rassegna nazionale*, ser. 1, 21 (1885): 551–71; 22:550–70; and 23: 19–45.

Monson, Craig A. *Disembodied Voices: Music and Culture in an Early Modern Convent.* Berkeley: University of California Press, 1995.

Moore, Carey A., ed. *The Anchor Bible Judith: A New Translation with Introduction and Commentary.* Garden City, NY: Doubleday & Co., Inc., 1985.

———. "Why Wasn't the Book of Judith Included in the Hebrew Bible?" In *"No One Spoke Ill of Her": Essays on Judith*, edited by James C. VanderKam, 61–71. Society of Biblical Literature: Early Judaism and Its Literature 2. Atlanta: Scholars Press, 1992.

Moriconi, Aladino. *La venerabile Suor Domenica dal Paradiso: La popolare mistica taumaturga del secolo d'oro fiorentino, 1473–1553.* Florence: Scuola Tipografica Salesiana, 1943.

Mosco, Marilena, ed. *La Maddalena tra sacro e profano.* Milan: Mondadori, 1986.

Murad, Orlene. *The English Comedians at the Habsburg Court in Graz, 1607–1608.* Salzburg Studies in English Literature, Elizabethan and Renaissance Studies 81. Salzburg: Institut für englische Sprache und Literatur Universität Salzburg, 1978.

Murata, Margaret. *Operas for the Papal Court, 1631–1668.* Studies in Musicology 39. Ann Arbor, MI: UMI Research Press, 1981.

Nagler, A. M. *Theatre Festivals of the Medici, 1539–1637.* New Haven, CT, and London: Yale University Press, 1964.

Naselli, C. "'Il Martirio di S. Agata' di un drammaturgo del Seicento: Jacopo Cicognini." *Archivio storico per la Sicilia orientale* 23–24 (1927–28): 195–220.

Nettl, Paul. "Equestrian Ballets of the Baroque Period," *Musical Quarterly* 19 (1933): 74–83.

Newby, Elizabeth A. *A Portrait of the Artist: The Legends of Orpheus and Their Use in Medieval and Renaissance Aesthetics.* New York and London: Garland, 1987.

Nowak, F. "Sigismund III, 1587–1632." In *The Cambridge History of Poland*, vol. 1, *From the Origins to Sobieski (to 1696)*, edited by W. F. Reddaway et al., 451–74. Cambridge: Cambridge University Press, 1950.

Okayama, Yassu. *The Ripa Index: Personifications and Their Attributes in Five Editions of the Iconologia.* Doornspijk: Davaco, 1992.

Ovid. *Fasti.* Edited and translated by Robert Schilling. Paris: Belle Lettres, 1993.

Paatz, Walter, and Elisabeth Paatz. *Die Kirchen von Florenz: Ein kunstgeschichtliches Handbuch.* 6 vols. Frankfurt am Main: Vittorio Klostermann, 1940–55.

Padovani, Serena, and Silvia Meloni Trkulja, eds. *Il cenacolo di Andrea del Sarto a San Salvi: Guida del Museo.* Florence: Libreria Editrice Salimbeni, 1982.

Pagliai, Ilaria. "Luci ed ombre di un personaggio: Le lettere di Cristina di Lorena sul 'negozio' di Urbino." In *Per lettera: La scrittura epistolare femminile tra archivio e tipografia secoli XV–XVII*, edited by Gabriella Zarri, 441–66. Rome: Viella, 1999.

Palisca, Claude. *Studies in the History of Italian Music and Music Theory.* Oxford: Clarendon Press, 1994.

Panichi, Ornella. "Due stanze della villa del Poggio Imperiale." *Antichità viva* 12, no. 5 (September–October 1973): 32–43.

———. *Villa di Poggio Imperiale: Lavori di restauro e di riordinamento, 1972–1975.* Florence: Editrice Edam, n.d.

Panofsky, Erwin. *Perspective as Symbolic Form.* Translated by Christopher S. Wood. New York: Zone Books, 1991.

―――. *Studies in Iconology: Humanistic Themes in the Art of the Renaissance.* Oxford: Oxford University Press, 1939. Reprint, New York: Icon Editions, Harper & Row, 1972.

Parisi, Susan. "Ducal Patronage of Music in Mantua, 1587–1627: An Archival Study." Ph.D. diss., University of Illinois, 1989.

Parker, Geoffrey, ed. *The Thirty Years' War.* 2d ed. London and New York: Routledge, 1997.

Pastor, Ludwig. *The History of the Popes from the Close of the Middle Ages.* Translated by F. I. Antrobus, R. F. Kerr, and Ernest Graf. 40 vols. St. Louis, MO: B. Herder; London: Kegan Paul, Trench, Trubner & Co., 1910–53.

Peri, Jacopo. *Le musiche di Iacopo Peri . . . sopra L'Euridice.* Florence: Marescotti, 1601. Reprint, New York: Broude Brothers, 1973.

Pesthy, Monika. "Thecla among the Fathers of the Church." In *The Apocryphal Acts of Paul and Thecla,* edited by Jan N. Bremmer, 164–78. Kampen: Kok Pharos Publishing House, 1996.

Petrarca, Francesco. *Rime, Trionfi e poesie Latine.* Edited by Ferdinando Neri et al. La letteratura italiana storia e testi 6. Milan and Naples: Riccardo Ricciardi, 1951.

Pieraccini, Gaetano. *La stirpe de' Medici di Cafaggiolo: Saggio di ricerche sulla trasmissione ereditaria dei caratteri biologici.* 3 vols. Florence: Vallecchi Editore, 1924–25.

Pigler, A[ndor]. *Barockthemen: Eine Auswahl von Verzeichnissen zur Ikonographie des 17. und 18. Jahrhunderts.* 2d. ed. 3 vols. Budapest, Akadémiai Kiadó, 1974.

Pirrotta, Nino, and Elena Povoledo. *Music and Theatre from Poliziano to Monteverdi.* Translated by Karen Eales. Cambridge: Cambridge University Press, 1982.

Pizzorusso, Claudio, "Un documento e alcune considerazioni su Cristofano Allori." *Paragone* no. 337 (March 1978): 60–75.

―――. "'La Quiete': Giovanni da San Giovanni e Alessandro Adimari." *Artista: Critica dell'arte in Toscana* 1 (1989): 86–97.

―――. *Ricerche su Cristofano Allori.* Accademia Toscana di scienze e lettere "La Colombaria," studi 60. Florence: Olschki, 1982.

―――, ed. *Sustermans: Sessant'anni alla corte dei Medici.* Exhibition catalog, Florence, Palazzo Pitti, July–October 1983. Florence: Centro Di, 1983.

Plaisance, Michel. "'L'exaltation de la Croix': Comédie religieuse de Giovanmaria Cecchi." *Les voies de la création théâtrale* 8 (1980): 12–41.

―――. "La politique culturelle de Côme Ier et les fêtes annuelles a Florence de 1541 a 1550." In *Les fêtes de la Renaissance,* edited by Jean Jacquot and Elie Konigston, 3:133–52. 3 vols. Paris: Éditions du centre national de la recherche scientifique, 1956–75.

Poliziano, Angelo. *Stanze Orfeo Rime.* Edited by Sergio Marconi. Milan: Feltrinelli, 1981.

Polizzotto, Lorenzo. *The Elect Nation: The Savonarolan Movement in Florence, 1494–1545.* Oxford: Clarendon Press, 1994.

―――. "When Saints Fall Out: Women and the Savonarolan Reform in Early Sixteenth-Century Florence." *Renaissance Quarterly* 46 (1993): 486–525.

Pope-Hennessy, John. *Donatello Sculptor.* New York: Abbeville Press, 1993.

Prato, Cesare da. *R. Villa del Poggio Imperiale oggi R. Istituto della SS. Annunziata: storie e descrizioni.* Florence: B. Seeber, 1895.

Prosperi Valenti Rodinò, Simonetta, ed. *Disegni fiorentini 1560–1640 dalle collezioni del Gabinetto Nazionale delle Stampe.* Rome: De Luca, 1979.

Pulci, Antonia. *Florentine Drama for Convent and Festival: Seven Sacred Plays.* Translated by James Wyatt Cook. Chicago and London: University of Chicago Press, 1996.

Purdie, Edna. *The Story of Judith in German and English Literature.* Bibliothèque de la Revue de Littérature Comparée 39. Paris: Librairie Ancienne Honoré Champion, 1927.

Quilligan, Maureen. *The Allegory of Female Authority: Christine de Pizan's Cité des Dames.* Ithaca, NY, and London: Cornell University Press, 1991.

Radke, Gary. "Nuns and Their Art: The Case of San Zaccaria in Renaissance Venice." *Renaissance Quarterly* 54 (2001): 430–59.

La rappresentazione di Juditta Ebrea. Siena: Loggia del Papa, 1610.

La rappresentazione di Sant'Agata Vergine, e Martire. Florence: Giovanni Baleni, 1591.

Reardon, Colleen. *Holy Concord within Sacred Walls: Nuns and Music in Siena, 1575–1700.* Oxford and New York: Oxford University Press, 2002.

———. "*Veni sponsa Christi*: Investiture, Profession and Consecration Ceremonies in Sienese Convents." *Musica Disciplina* 50 (1996): 271–97.

Réau, Louis. *Iconographie de l'art Chrétien.* 3 vols. Paris: Presses Universitaires de France, 1955–59.

Reid, Jane Davidson. *The Oxford Guide to Classical Mythology in the Arts, 1300–1990s.* 2 vols. New York and Oxford: Oxford University Press, 1993.

Reiner, Stuart. "Preparations in Parma—1618, 1627–28." *Music Review* 25 (1964): 273–301.

Reiss, Sheryl E., and David G. Wilkins, eds. *Beyond Isabella: Secular Women Patrons of Art in Renaissance Italy.* Kirksville, MO: Truman State University Press, 2001.

Rice, Eugene F., Jr. *Saint Jerome in the Renaissance.* Baltimore and London: Johns Hopkins University Press, 1985.

Richa, Giuseppe. *Notizie istoriche delle chiese Fiorentine.* 10 vols. Florence: Pietro Gaetano Viviani, 1754–62. Reprint, Rome: Soc. Multigrafica Editrice, 1972.

Richelson, Paul. *Studies in the Personal Imagery of Cosimo I De' Medici, Duke of Florence.* New York and London: Garland, 1978.

Rinuccini, Camillo. *Descrizione delle feste fatte nelle reali nozze de' Serenissimi Principi di Toscana D. Cosimo de' Medici, e Maria Maddalena Arciduchessa d'Austria.* Florence: Giunti, 1608.

Rinuccini, Ottavio. *Poesie.* Florence: Giunti, 1622.

———. *Versi sacri cantati nella cappella della Serenissima Arciduchessa d'Austria G. Duchessa di Toscana.* Florence: Zanobi Pignoni, 1619.

Ripa, Cesare. *Iconologia.* Padua: Tozzi, 1611. Reprint, New York and London: Garland, 1976.

Roberts, Ann M. "Chiara Gambacorta of Pisa as Patroness of the Arts." In *Creative Women in Medieval and Early Modern Italy: A Religious and Artistic Renaissance,* edited by E. Ann Matter and John Coakley, 120–54. Philadelphia: University of Pennsylvania Press, 1994.

Romano, Ruggiero. *L'Europa tra due crisi: XIV e XVII secolo.* Turin: Piccola Biblioteca Einaudi, 1980.

Rossi, Massimiliano. "Francesco Bracciolini, Cosimo Merlini e il culto Mediceo della croce: Ricostruzioni genealogiche, figurative, architettoniche." *Studi seicenteschi* 42 (2001): 211–76.

Rousseau, Claudia. "The Pageant of the Muses at the Medici Wedding of 1539 and the Decoration of the Salone dei Cinquecento." In *"All the world's a stage . . .": Art and Pageantry*

in the *Renaissance and Baroque*, edited by Barbara Wisch and Susan Scott Munshower, 2: 417–57. 2 vols. University Park: Pennsylvania State University, 1990.

Sabbattini, Nicola. *Pratica di fabricar scene, e machine ne' teatri.* Ravenna: Pietro de' Paoli and Gio. Battista Giovannelli, 1638. Reprint, Rome: Carlo Bestetti, 1955.

Salvadori, Andrea. *Canzone delle lodi d'Austria.* Florence: Pietro Cecconcelli, 1624.

———. *La disfida d'Ismeno.* Florence: Pignoni, 1628.

———. *Fiori del Calvario.* Florence: Cecconcelli, 1623.

———. *La Flora.* Florence: Cecconcelli, 1628.

———. *Le fonti d'Ardenna.* Described by Simoncarlo Rondinelli. Florence: Cecconcelli, 1623.

———. *Guerra d'amore.* Florence: Pignoni, 1616.

———. *La natura al Presepe.* Florence: Cecconcelli, 1623.

———. *Poesie.* 2 vols. Rome: Michele Ercole, 1668.

———. *La regina Sant'Orsola.* Florence: Cecconcelli, 1625.

Saracinelli, Ferdinando. *La liberazione di Ruggiero dall'isola d'Alcina: Balletto rappresentato in musica.* Florence: Cecconcelli, 1625.

Saslow, James. *The Medici Wedding of 1589: Florentine Festival as Theatrum Mundi.* New Haven, CT, and London: Yale University Press, 1996.

Saunders, Steven. *Cross, Sword, and Lyre: Sacred Music at the Imperial Court of Ferdinand II of Habsburg (1619–1637).* Oxford: Clarendon Press, 1995.

———. "The Hapsburg Court of Ferdinand II and the *Messa, Magnificat et Iubilate Deo a sette chori concertati con le trombe* (1621) of Giovanni Valentini." *Journal of the American Musicological Society* 44 (1991): 359–403.

Savage, Roger, and Matteo Sansone. "*Il Corago* and the Staging of Early Opera: Four Chapters from an Anonymous Treatise *Circa* 1630." *Early Music* 17 (1989): 495–511.

Savio, Francesco, et al., eds. *Enciclopedia dello spettacolo.* 9 vols. Rome: Casa editrice Le Maschere, 1954–62.

Scarpellini, Pietro. *Perugino.* Milan: Electa, 1984.

Scavizzi, Giuseppe. "The Myth of Orpheus in Italian Renaissance Art, 1400–1600." In *Orpheus: The Metamorphoses of a Myth,* edited by John Warden, 111–62. Toronto: University of Toronto Press, 1982.

Schröder, Thomas, ed. *Jacques Callot: Das gesamte Werk.* 2 vols. Munich: Rogner & Bernhard, 1971.

Schulenburg, Jane Tibbetts. *Forgetful of Their Sex: Female Sanctity and Society ca. 500–1100.* Chicago and London: University of Chicago Press, 1998.

———. "The Heroics of Virginity: Brides of Christ and Sacrificial Mutilation." In *Women in the Middle Ages and the Renaissance: Literary and Historical Perspectives,* edited by Mary Beth Rose, 29–72. Syracuse, NY: Syracuse University Press, 1986.

Scott, John Beldon. *Images of Nepotism: The Painted Ceilings of Palazzo Barberini.* Princeton, NJ: Princeton University Press, 1991.

Segni, Bernardo. *Storie fiorentine.* 3 vols. Milan: Società Tipografica de' Classici Italiani, 1805.

Il Seicento fiorentino: Arte a Firenze da Ferdinando I a Cosimo III. 3 vols. Florence: Cantini, 1986.

Seznec, Jean. *The Survival of the Pagan Gods: The Mythological Tradition and Its Place in Renaissance Humanism and Art.* Translated by Barbara F. Sessions. New York: Pantheon Books, 1953.

Shearman, John. "Cristofano Allori's 'Judith.'" *Burlington Magazine* 131 (1979): 3–10.

Smith, Douglas Alton. "On the Origin of the Chitarrone." *Journal of the American Musicological Society* 32 (1979): 440–62.

Smith, Webster. "On the Original Location of the *Primavera.*" *Art Bulletin* 57 (1975): 31–40.

Solerti, Angelo. *Musica, ballo e drammatica alla corte Medicea dal 1600 al 1637: Notizie tratte da un diario con appendice di testi inediti e rari.* Florence: Bemporad, 1905. Reprint, New York: Benjamin Blom, 1968.

Sperling, Christine M. "Donatello's Bronze 'David' and the Demands of Medici Politics." *Burlington Magazine* 134 (1992): 218–224.

Sternfeld, F. W. *The Birth of Opera.* Oxford: Clarendon Press, 1993.

Sterzi, Mario. "Feste di corte e feste di popolo in Firenze sui primordi del secolo XVII (Jacopo Cicognini e il suo teatro)." *La Rassegna,* ser. 4, 33 (1925): 114–23.

———. "Jacopo Cicognini." *Giornale storico e letterario della Liguria* 3 (1902): 289–337, 393–433.

Stocker, Margarita. *Judith, Sexual Warrior: Women and Power in Western Culture.* New Haven, CT, and London: Yale University Press, 1998.

Strong, Roy. *Art and Power: Renaissance Festivals, 1450–1650.* Woodbridge, UK: Boydell Press, 1984.

———. *Splendor at Court: Renaissance Spectacle and the Theatre of Power.* Boston: Houghton Mifflin Company, 1973.

Suarez, Emmanuel, ed. *Processionarium juxta ritum sacri ordinis prædicatorum.* Rome: S. Sabinae, 1949.

Tarchi, Rossella. "Una lettera di Maria Maddalena d'Austria sulla reliquia della Santa Croce in S. Maria Impruneta." *Rivista d'arte* 41 (1989): 159–65.

Tasso, Torquato. *Gerusalemme liberata.* Edited by Lanfranco Caretti. Turin: Einaudi, 1993.

———. *Jerusalem Delivered: An English Prose Version.* Translated by Ralph Nash. Detroit: Wayne State University Press, 1987.

Tervarent, Guy de. *La légende de Sainte Ursule dans la littérature et l'art du Moyen Age.* 2 vols. Paris: Les Éditions G. Van Oest, 1931.

Tomlinson, Gary, ed. *Italian Secular Song, 1606–1636.* 7 vols. New York and London: Garland Publishing, 1986.

———. *Monteverdi and the End of the Renaissance.* Berkeley and Los Angeles: University of California Press, 1987.

Tordi, Anne Wilson, ed. *La festa et storia di Sancta Caterina: A Medieval Italian Religious Drama.* New York: Peter Lang, 1997.

Toschi, Paolo, ed. *Sacre rappresentazioni Toscane dei secoli XV e XVI.* Florence: Olschki, 1969.

Trexler, Richard C. *Dependence in Context in Renaissance Florence.* Binghamton, NY: Medieval and Renaissance Texts and Studies, 1994.

———. "Florentine Theater, 1280–1500: A Checklist of Performances and Institutions." *Forum italicum* 14 (1980): 454–75.

Valentin, Jean-Marie. *Le théâtre des Jésuites dans les pays de langue allemande: Répertoire chronologique des pièces représentées et des documents conservés (1555–1773).* 2 vols. Stuttgart: Anton Hiersemann Verlag, 1983–84.

Valerio, Adriana. "Domenica da Paradiso e la mistica femminile dopo Savonarola." *Studi medievali,* ser. 3, vol. 36 (1995): 345–54.

————. *Domenica da Paradiso: Profezia e politica in una mistica del Rinascimento.* Spoleto: Centro Italiano di studi sull'Alto Medioevo, 1992.

————. "La parole influente: Domenica da Paradiso (1473–1553)." In *Women Churches: Networking and Reflection in the European Context,* edited by Angela Berlis et al., 126–32. Yearbook of the European Society of Women in Theological Research 3. Kampen and Mainz: Kok Pharos and Matthias-Grünewald Verlag, 1995.

Valone, Carolyn. "Piety and Patronage: Women and the Early Jesuits." In *Creative Women in Medieval and Early Modern Italy: A Religious and Artistic Renaissance,* edited by E. Ann Matter and John Coakley, 157–84. Philadelphia: University of Philadelphia Press, 1994.

————. "Roman Matrons as Patrons: Various Views of the Cloister Wall." In *The Crannied Wall: Women, Religion, and the Arts in Early Modern Europe,* edited by Craig A. Monson, 49–72. Ann Arbor: University of Michigan Press, 1992.

Vasari, Giorgio. *Le opere.* Edited by Gaetano Milanesi. 9 vols. Florence: G. C. Sansoni, 1906.

————. *Le vite dei più eccellenti pittori, scultori ed architetti.* Edited by Carlo L. Ragghianti. 4 vols. Milan: Rizzoli & Co., 1942–49.

Vives, Juan Luis. *The Education of a Christian Woman: A Sixteenth-Century Manual.* Translated by Charles Fantazzi. Chicago and London: University of Chicago Press, 2000.

Viviani Della Robbia, Enrica. *Nei monasteri fiorentini.* Florence: Sansoni, 1946.

Vogel, Emil. "Marco da Gagliano: Zur Geschichte des florentiner Musiklebens von 1570–1650." *Vierteljahrsschrift für Musikwissenschaft* 5 (1889): 396–442; 509–68.

Vogel, Emil, et al., eds. *Il nuovo Vogel: Bibliografia della musica italiana vocale profana pubblicata dal 1500 al 1700.* 3 vols. Staderini: Minkoff Editori, 1977.

Warner, Marina. *Alone of All Her Sex: The Myth and the Cult of the Virgin Mary.* New York: Vintage Books, 1983.

————. *Monuments and Maidens: The Allegory of the Female Form.* New York: Atheneum, 1985.

Weaver, Elissa B. *Convent Theatre in Early Modern Italy: Spiritual Fun and Learning for Women.* Cambridge: Cambridge University Press, 2002.

————. "The Convent Wall in Tuscan Convent Drama." In *The Crannied Wall: Women, Religion, and the Arts in Early Modern Europe,* edited by Craig A. Monson, 73–86. Ann Arbor: University of Michigan Press, 1992.

————. "Le muse in convento: La scrittura profana delle monache italiane (1450–1650)." In *Donne e fede: Santità e vita religiosa in Italia,* edited by Lucetta Scaraffia and Gabriella Zarri, 253–76. Rome and Bari: Editori Laterza, 1994.

————. "Spiritual Fun: A Study of Sixteenth-Century Tuscan Convent Theater." In *Women in the Middle Ages and the Renaissance: Literary and Historical Perspectives,* edited by Mary Beth Rose, 173–205. Syracuse: Syracuse University Press, 1986.

————. "Suor Maria Clemente Ruoti, Playwright and Academician." In *Creative Women in Medieval and Early Modern Italy: A Religious and Artistic Renaissance,* edited by E. Ann Matter and John Coakley, 281–96. Philadelphia: University of Pennsylvania Press, 1994.

Weaver, Robert L., and Norma W. Weaver. *A Chronology of Music in the Florentine Theater, 1590–1750.* Detroit Studies in Music Bibliography 38. Detroit: Information Coordinators, 1978.

Wind, Edgar. *Pagan Mysteries in the Renaissance.* Middlesex: Penguin Books, 1967.

Winkelmes, Mary-Ann. "Taking Part: Benedictine Nuns as Patrons of Art and Architec-

ture." In *Picturing Women in Renaissance and Baroque Italy*, edited by Geraldine A. Johnson and Sara F. Matthews Grieco, 91–110. Cambridge: Cambridge University Press, 1997.

Wogan-Browne, Jocelyn. "Saints' Lives and the Female Reader." *Forum for Modern Language Studies* 27 (1991): 314–32.

Wright, Alison, and Eckart Marchand. "The Patron in the Picture." In *With and Without the Medici: Studies in Tuscan Art and Patronage, 1434–1530*, edited by Eckart Marchand and Alison Wright, 1–18. Aldershot: Ashgate, 1998.

Wright, David Roy. "The Medici Villa at Olmo a Castello: Its History and Iconography." Ph.D. diss., Princeton University, 1976.

Zambrini, Francesco, ed. *Collezione di leggende inedite, scritte nel buon secolo della lingua Toscana.* 2 vols. Bologna: Società Tipografica Bolognese e Ditta Sassi, 1855.

Zarri, Gabriella. "Living Saints: A Typology of Female Sanctity in the Early Sixteenth Century." In *Women and Religion in Medieval and Renaissance Italy*, edited by Daniel Bornstein and Roberto Rusconi, translated by Margery J. Schneider, 219–303. Chicago and London: University of Chicago Press, 1996.

———. "Monasteri femminili e città (secoli XV–XVIII)." In *Storia d'Italia*, Annali 9, *La chiesa e il potere politico dal Medioevo all'età contemporanea*, edited by Giorgio Chittolini and Giovanni Miccoli, 359–429. Turin: Giulio Einaudi, 1986.

———. "Ursula and Catherine: The Marriage of Virgins in the Sixteenth Century." In *Creative Women in Medieval and Early Modern Italy: A Religious and Artistic Experience*, edited by E. Ann Matter and John Coakley, 237–78. Philadelphia: University of Pennsylvania Press, 1994.

Zeller, Berthold. *Richelieu et les ministres de Louis XIII de 1621 a 1624: La cour, le gouvernement, la diplomatie d'après les archives d'Italie.* Paris: Librairie Hachette, 1880.

Index